SKOPAS OF PAROS

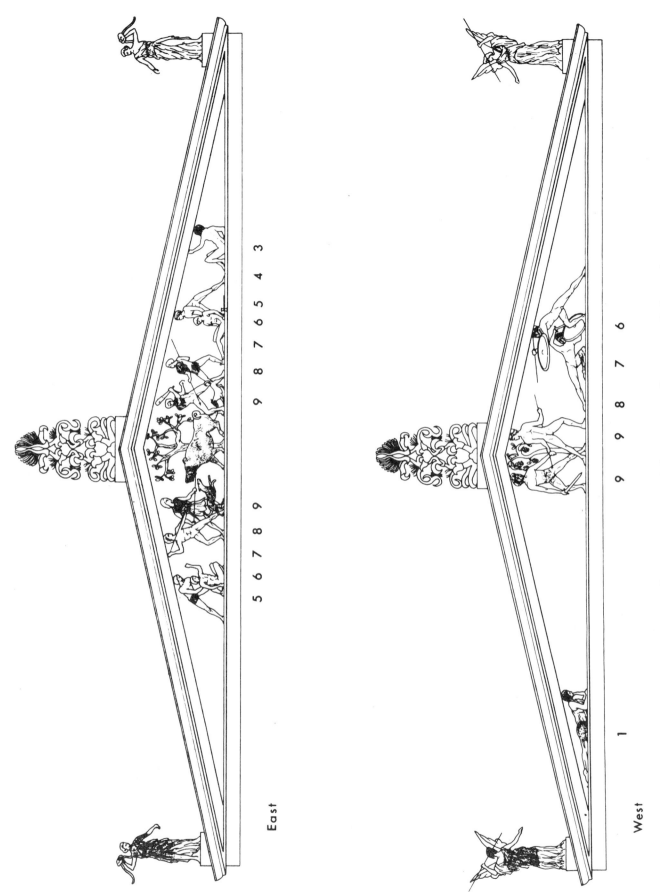

East

West

Suggested reconstruction of the Tegea pediments and akroteria

SKOPAS
OF
PAROS

by

ANDREW F. STEWART

NOYES PRESS

PARK RIDGE, NEW JERSEY

Published in the United States by
NOYES PRESS
Noyes Building
Park Ridge, New Jersey 07656

Stewart, Andrew F.
 Skopas of Paros.

 Bibliography: p.
 Includes index.
 1. Scopas, fl. 4th cent. B.C. 2. Tegea,
Greece. Temple of Athena Alea. 3. Marble
sculpture, Greek—Greece—Tegea. 4. Tegea,
Greece—History.
NB104.S73 730'.92'4 77-149
ISBN 0-8155-5051-0

PREFACE

Since the discovery of the Tegea fragments, so many discussions of Skopas' style and *oeuvre* have appeared that another might be thought superfluous; yet, as Morgan showed almost forty years ago, 'the difficulties remain, however rarely they are mentioned' (*Studies presented to Edward Capps* [1936], 253), and much modern scholarship has proved his point by either ignoring them, or pressing them to extremes to justify extreme conclusions. Furthermore, as will become apparent in the discussion of the Tegea sculptures, the easy availability of stock descriptive epithets has tended to inhibit analysis and interpretation of a deeper kind, with the result that work on Skopas has lagged behind that on other fourth-century sculptors. I hope that this study will fill at least some of the lacunae, although it is only to be expected that in the long run the problems, like the heads of the Hydra, will only be sprouting up in even greater profusion than before.

Dunedin, New Zealand *Andrew Stewart*
November, 1976

ACKNOWLEDGEMENTS

Originally a Cambridge Ph.D. thesis submitted in the summer of 1972, this study could not have been written without the help of a great many people: in particular, I would like to thank Professor R. M. Cook for his patient criticism of my ideas and for his useful comments upon the drafts; Dr. N. Yalouris for suggesting the subject to me, for allowing me access to the Epidaurus sculptures and for permitting me to make use of some of his conclusions; Professor Chr. Christou and Dr. A. Demakopoulou for letting me work on the fragments recently excavated by them; Dr. A. Delivorrias and Dr. G. Steinhauer for their permission to make use of the Tegea material formerly and presently under their care; Mr. P. M. Fraser and Dr. H. Catling for their tireless energy in obtaining permits from the Greek authorities; and Professor B. Ashmole for his invaluable advice and support, and for his excellent photographs of the Mausoleum friezes, here reproduced on plates 34-41.

My thanks also go to Professor E. B. Harrison, Professor P. W. Lehmann, Professor C. M. Robertson, Professor A. H. F. Thornton, Professor A. D. Trendall, Dr. M. Gjödesen, Dr. G. M. A. Hanfmann, Dr. H. Plommer, Dr. M. Vickers, Dr. G. B. Waywell, Mrs. B. R. Brown and Mrs. S. Karouzou for the information and assistance they have supplied; to Dr. P. Houghton for his help with points of anatomy; to the staffs of the various museums in which I have worked (especially the British Museum, the Museum of Classical Archaeology in Cambridge, the National Museum in Athens, and the Tegea Museum); to Mrs. Barbara Hird, Mrs. Margot Wylie and my wife for their help with secretarial work at Tegea and in Athens; to Mrs. Elizabeth Glass and Mrs. Susan Stark for typing the manuscript; and to Miss Marion Steven for agreeing to read and check it.

As for illustrations, the drawings are largely the work of Mr. Murray Webb; my photographs were printed by Mr. Evan Jones, Mr. Morris Seden and Mr. Martin Fisher. Plate 45a is reproduced by permission of the Archivio Fotografico dei Musei Communali (Museo Capitolino); plates 34b; 35a, b; 36; 37a, b; 38a, b; 39; 41b and 46b by kind permission of Professor B. Ashmole; plates 26, 27a and 47a by permission of the Deutsches Archäologisches Institut (Athenische Abteilung); plates 27b and 28c by permission of the Deutsches Archäologisches Institut (Istanbuler Abteilung); plates 33c and d; 46a; 50c and d and 51b by the Deutsches Archäologisches Institut (Römische Abteilung); plate 45b by permission of the Director of Antiquities and the Cyprus Museum; plate 44a by courtesy of the Fogg Art Museum, Harvard University; plate 49b by kind permission of Dr. J. Frel; plate 42a and b by permission of the J. Paul Getty Museum; plates 24c and 49a by permission of Hirmer Fotoarchiv, Munich; plate 48b and c by permission of Kaufmann, Munich; plate 31a-c by permission of the Los Angeles County Museum of Art; plate 49c and d by permission of the Metropolitan Museum of Art; plate 45c by permission of Savio, Rome; plate 32d by permission of the Skulpturensammlung, Dresden; plates 28b; 29c; 43a-c by permission of the Staatliche Museen, Berlin; and plates 34a; 40; 41a and c by courtesy of the Trustees of the British Museum.

Finally, I wish to record my gratitude to the Department of Education and Science, to the Walston Fund, and to the University of Otago Grants Committee for awarding the grants without which this book could not have been written.

Andrew Stewart

CONTENTS

LIST OF ILLUSTRATIONS

(at end)

FIGURES

PLATES

ABBREVIATIONS

AA	*Archäologischer Anzeiger*
AAA	*Athens Annals of Archaeology*
AbhBerlAkad	*Abhandlungen der Berliner Akadamie*
ActArch	*Acta Archaeologica*
Adam, *Technique*	S. Adam, *The Technique of Greek Sculpture (BSA Suppl 3 1966)*
ADelt	*Archaiologikon Deltion*
AE	*Archaiologike Ephemeris*
AJA	*American Journal of Archaeology*
AkrM	Akropolis Museum
AM	*Athenische Mitteilungen*
Ann	*Annuario della Scuola Archeologica di Atene*
AP	*Antike Plastik*
Arias	P. E. Arias, *Skopas* (1952)
Arias and Hirmer	P. E. Arias and M. Hirmer, *Greek Vasepainting*, revised by B. Shefton (1962)
Arndt, *GNC*	P. Arndt, *La Glyptothèque Ny-Carlsberg* (1896)
Arnold	D. Arnold, *Die Polykletnachfolge (JdI Erg 25, 1969)*
ARV²	J. D. Beazley, *Attic Red-figure Vase Painters²* (1963)
Ashmole, *Architect and Sculptor*	B. Ashmole, *Architect and Sculptor in Classical Greece* (1972)
AZ	*Archäologische Zeitung*
BABesch	*Bulletin . . . van de Antieke Beschaving*
B-B	Brunn-Bruckmann, *Denkmäler Griechischer und Römischer Sculptur*
BCH	*Bulletin de Correspondance Hellénique*
Bieber	M. Bieber, *The Sculpture of the Hellenistic Age*, revised edition (1961)
Billedtavler	F. Poulsen, *Billedtavler til Kataloget over antike Kunstvaerker* (1907); with supplements (*Tillaegen*) 1915 and 1941.
Blümel, *KatBerlin*	C. Blümel, *Katalog der Antike Skulpturen im Berliner Museum* (1928–40)
Blümel, *KGS*	C. Blümel, *Die Klassisch Griechischen Skulpturen der Staatlichen Museen zu Berlin* (1966)
BM	British Museum
Boardman, et al., *Art and Architecture*	J. Boardman, J. Dörig, W. Fuchs, M. Hirmer, *The Art and Architecture of Ancient Greece* (1967)

BSA	*Annual of the British School at Athens*
BullComm	*Bullettino della Commissione Archeologica Communale di Roma*
BullMetrMus	*Bulletin of the Metropolitan Museum of Art* (New York)
Burford	A. Burford, *The Greek Temple Builders at Epidauros* (1969)
Buschor	E. Buschor, *Maussolos und Alexander* (1950)
BWPr	*Berliner Winckelmannsprogramm*
C	A. Conze, *Die Attischen Grabreliefs* (1893–1922)
Coll	Collection
CRend	*Comptes rendus de l'Académie des Inscriptions et Belles-lettres*
Crome	J. F. Crome, *Die Skulpturen des Asklepiostempels von Epidauros* (1951)
CVA	*Corpus Vasorum Antiquorum*
Diepolder	H. Diepolder, *Die Attischen Grabreliefs* (1931)
Dinsmoor	W. B. Dinsmoor, *The Architecture of Ancient Greece*, 3rd edition (1950)
Dugas	C. Dugas, J. Berchmans, M. Clemmensen, *Le Sanctuaire d'Aléa Athéna à Tégée*
EA	P. Arndt, W. Amelung, *Photographischer Einzelaufnamen Antiker Skulpturen*
EncAA	*Enciclopedia dell'Arte Antica*
EncWA	*The Encyclopedia of World Art*
Erg	*Ergänzungsheft*
FR	A. Furtwängler and K. Reichhold, *Grechische Vasenmalerei* (1900–1932)
Fuchs, *Vorb*	W. Fuchs, *Die Vorbilder der Neuattischen Reliefs* (*JdI Erg* 20, 1959)
Furtwängler, *Masterpieces*	A. Furtwängler, *Masterpieces of Greek Sculpture*, edited by Eugenie Sellers (1895)
von Graeve *Alexandersarkophag*	V. von Graeve, *Der Alexandersarkophag und seine Werkstatt* (*Istanbuler Forschungen* 28, 1970)
Helbig[4]	W. Helbig, *Führer durch die offentlichen Sammlungen klassischer Altertümer in Rom*, 4th edition by H. Speier (1963–1972)
Hesp	*Hesperia, Journal of the American School of Classical Studies at Athens*
IG	*Inscriptiones Graecae* (1873–)
IstMitt	*Istanbuler Mitteilungen*
JdI	*Jahrbuch des deutschen archäologischen Instituts*
JHS	*Journal of Hellenic Studies*
Journ RIBA	*Journal of the Royal Institute of British Architects*
Karouzou, *Guide*	S. Karouzou, *National Archaeological Museum, Collection of Sculpture* (1968)
KiB	F. Winter, *Kunstgeschichte in Bildern I* (1900)
Lawrence, *GRS*	A. W. Lawrence, *Greek and Roman Sculpture* (1972)
Lawrence, *LGS*	A. W. Lawrence, *Later Greek Sculpture* (1927; reprinted in 1969)
LCS	A. D. Trendall, *The Red-figured Vases of Lucania, Campania and Sicily* (1967)

Lippold, *Kopien*	G. Lippold, *Kopien und Umbildungen Griechischer Statuen* (1923)
Lippold, *Plastik*	G. Lippold, *Die Griechische Plastik (Handbuch der Archäologie iii.1, 1950)*
Lullies and Hirmer	R. Lullies and M. Hirmer, *Greek Sculpture*, 2nd edition (1960)
Mansuelli, *Uffizi*	G. A. Mansuelli, *Galleria degli Uffizi, Le Sculture* (1958–1961)
Marcadé, *Recueil*	J. Marcadé, *Recueil des Signatures de Sculpteurs Grecs* (1953, 1957)
MetMus	Metropolitan Museum of Art, New York
MonPiot	*Monuments et Memoires, Fondation Piot*
Mustilli, *MusMuss*	D. Mustilli, *Il Museo Mussolini* (1939)
MuZ	E. Pfuhl, *Malerei und Zeichnung der Griechen* (1923)
NCP	F. Imhoof-Blumer, P. Gardner, *A. Numismatic Commentary on Pausanias* (repr. from *JHS* 5 [1885]–7 [1887])
Neugebauer, *Studien*	K. A. Neugebauer, *Studien über Skopas* (1913)
NM	National Museum, Athens
NS	*Notizie degli Scavi di Antichità*
NyC	Ny-Carlsberg Glyptotek, Copenhagen
ÖJh	*Jahreshefte des österreichischen archäologischen Instituts in Wien*
Paribeni, *Cirene*	E. Paribeni, *Catalogo delle sculture di Cirene* (1959)
Picard, *Man*	C. Picard, *Manuel d'Archéologie Grècque ii-iv (Sculpture),* 1939–1963
Praktika	*Praktika tis Akadimias Athinon*
RA	*Revue Archéologique*
RE	Pauly-Wissowa, *Real-Enzyklopädie der klassischen Altertumswissenschaft*
REA	*Revue des Études Anciennes*
REG	*Revue des Études Grècques*
Reinach, *Repertoire*	S. Reinach, *Répertoire de la statuaire grècque et romaine* (1893)
Richter, *MetMus*	G.M.A. Richter, *Catalogue of Greek Sculptures in the Metropolitan Museum of Art* (1954)
Richter, *Sc*[1-4]	G.M.A. Richter, *The Sculpture and Sculptors of the Greeks*, 1st edition (1929), 2nd edition (1930), 3rd edition (1950), 4th edition (1970)
RivIst	*Rivista del Reale Istituto d'Archeologia e Storia dell'Arte*
Rizzo	G. E. Rizzo, *Prassitele* (1932)
RM	*Römische Mitteilungen*
Robertson	D. S. Robertson, *Greek and Roman Architecture* (1929)
Roscher	W. H. Roscher, *Ausführliches Lexikon d. griechischen u. römischen Mythologie* (1884–)
Roux	G. Roux, *L'Architecture de l'Argolide aux IVe et IIIe siècles avant J-C* (1961)
SbBayAkad	*Sitzungsberichte der Bayerischen Akademie der Wissenschaften*
Schefold, *KV*	K. Schefold, *Kertscher Vasen* (1930)
Schefold, *U*	K. Schefold, *Untersuchungen zu den Kertscher Vasen* (1934)
Schlörb	B. Schlörb, *Timotheos (JdI Erg 22, 1965)*

SEG	*Supplementum Epigraphicum Graecum*, 1923–
Shoe, *PGM*	L. T. Shoe, *Profiles of Greek Mouldings* (1936)
SIG³	E. Dittenberger, *Sylloge Inscriptionum Graecarum* (1915–24)
Smith, *BMCat*	A. H. Smith, *A Catalogue of Sculpture in the Department of Greek and Roman Antiquities, British Museum* (1892–1904)
SQ	J. Overbeck, *Die antiken Schriftquellen* (1868)
Stuart-Jones, *MusCap*	H. Stuart-Jones, *The Sculptures of the Museo Capitolino* (1912)
Stuart-Jones, *PalCons*	H. Stuart-Jones, *The Sculptures of the Palazzo dei Conservatori* (1926)
Süsserott	H. K. Süsserott, *Griechische Plastik des 4 Jahrhunderts vor Christus* (1938)
SVM	W. Amelung, G. Lippold, *Die Skulpturen des Vatikanischen Museums* (1903–1956)
Svoronos	J. N. Svoronos, *Das Athenaer Nationalmuseum* (1908)
Züchner, *Klappspiegel*	W. Züchner, *Griechische Klappspiegel* (JdI Erg 14, 1942)

INTRODUCTION: METHODS OF APPROACH

It is generally acknowledged that Skopas of Paros was one of the greatest of the Greek sculptors; this, at least, was the opinion of antiquity, and a few today would seriously dispute it, even though our acquaintance with his achievements is slight, and it is almost certain that no original from his hand has survived. We do not know when he was born or died, nor do we have exact dates for any of his works; the titles of some two dozen commissions, and sufficient information to indicate that his career spanned the central decades of the fourth century are little enough indeed to go on. Nevertheless, it seems that his role in the creation of what has come to be known as the High Classic style was crucial, and thus his influence upon the subsequent development of European art probably extensive: justification enough for a critical study.

Although we know so little about the details of his life, the main lines of the chronology have long been established and, meagre as they are, require little discussion. They are as follows:[1]

(1) architect at Tegea some time after 395;

(2) employed on the Mausoleum, which was begun after 368 (probably c. 360), and still building after 353-1;

(3) perhaps at Ephesus some time after 356;[3]

(4) at Thebes before 335.[2]

He was thus well-travelled,[3] and is generally reckoned to have been active between c. 375/370 and c. 335/330; he was perhaps born around 395/390.[4] His father seems to have been Aristandros of Paros,[5] employed on the Aegospotami dedication at Amyklai in 405, in which case the Skopas mentioned by Pliny as *floruit* Ol. 90 (420–417) could just conceivably have been his grandfather.[6]

Many students, following Urlichs, have attempted to translate a geographical classification of his work into chronological terms (i.e. 'Attic', 'Asiatic' and 'Peloponnesian' periods), although as Lippold rightly objected, the one by no means presupposes the other.[7] Although Urlichs' conclusions are the fruit of prodigious scholarship, perhaps the best answer is to reserve judgement and to let the various works to be considered speak for themselves.

'There are three main sources of information relating to ancient sculptors: monumental, epigraphical, literary. Of these the monumental is the most interesting, but by itself the least trustworthy; the epigraphical often informative, but in the case of Skopas, irrelevant;[8] the literary, voluminous and varied. A combination of two of these sources has many times the value of a single one; and no attributions are tenable unless they agree reasonably well with such testimony as is furnished by all the related material, however attractive the ascription may be, or however long it has been accepted.'[9]

These premises are exemplary, but require further investigation: in particular, we should note that both 'literary gathering' and 'stylistic gathering'[10] have their limitations and shortcomings, and that rules of procedure peremptorily applied to Greek art as a whole, or even to a period within it, no matter how restricted, are worthless and misleading: it is the individual artist that counts, for since each of our sources of information will vary with individual cases, so must our reliance on them vary in proportion.

A favourite method for disinterring the personalities of Greek artists and sculptors, 'literary gathering' is the more dangerous, because the more alluring.

Pollitt, Ridgway and Lawrence in recent years have laid down the fundamentals of what our approach should be when confronted with an ancient literary text on the subject of a work of art; their recommendations can be summed up in two words: extreme caution.[11] No scholar, though, has yet emphasised sufficiently what is surely the major drawback to the usefulness of the many hundreds of notices in Pliny, Pausanias and others for sustaining attributions: most are cryptic in the extreme.

As an example, in Pliny's account of Greek bronze sculpture in Book xxxiv. 53-93 of the *Natural History,* about 180 statues are named and assigned to rather under half that number of sculptors. A hundred or so of these names, like 'Discobolus' or 'Pseliumene', teil us something more about the statue than the mere statement of the existence of a Minerva, Hercules or Diana 'quos fecit x' that is found all too often in the pages of the *Natural History* and elsewhere. Even where our knowledge is extended in this way, however, several examples of each type by different sculptors may be cited, with no distinction made between them by the author. Most serious, though, is that of these 180 statues listed by Pliny only seven merit a description of more than two or three words, and of these seven only one has been positively identified in copy: the Sauroktonos of Praxiteles.[12]

As a result, wide-ranging attributions of the kind so often ventured by students of fifth or fourth century sculpture can in many cases only be regarded as speculative in the extreme, especially if they involve artists of the second or third ranks. In the case of the **Polykleitan school,** for instance, **where no certified** originals remain, we are told absolutely nothing of the personal styles of the various sculptors (apart, that is from their general allegiance to Polykleitan principles), and no full description of their works survive, only titles.[13] Is it really legitimate, then, to attribute so freely as seems to be customary here, particularly when Pausanias complicates the matter further by naming a multitude of Polykleitan athletes, clearly all very much alike, that stood in the Altis in his day, and Pliny delivers what should surely be the coup de grâce by listing no fewer than 26 sculptors, some recognis**ably from the school and many** ἅπαξ λεγομένοι who made athletes' in bronze?[14] *Mutatis mutandis,* in the present state of our knowledge any talk about the *personal* styles of these men must be completely vacuous. Although I would not go as far as some in asserting that

the literary sources are virtually useless or even actively malign to our purpose, it should be apparent that much discretion is called for in this field if results of any validity are to be achieved, now or in the future.

In the case of Skopas,[15] the shortcomings of the literary evidence are serious, and may be summarised under six heads:[16]

(1) Skopas is named as an ἀγαλματοποιός[17] and indeed it would appear from the sources that the bulk of his output consisted of cult statues,[18] few of which are likely to have survived.

(2) In contrast to Praxiteles and Lysippos, few of his works were of allegorical or genre types, or athletes, which are relatively easy to identify. He made no portraits.

(3) We cannot assume that our literary evidence on him is complete. Despite his reputation it is nowhere near equal in bulk to that on Praxiteles or Lysippos, mainly, it seems, because none of Pliny's principal sources was interested in him.

(4) There are few descriptions of his works, and nothing reliable is said of his style; our only clues are his omission from Quintilian's account of those fourth century sculptors who 'ad ueritatem . . . accessisse optime',[19] a 'persistent parallelism' in the sources between him and Praxiteles,[20] including no less than three cases where ancient critics were unable to decide to which of the two certain works should be attributed,[21] and the fact that his name is never mentioned in connection with Lysippos or any of the members of the Argive-Sicyonian school.

(5) Skopas is given no 'master', and no pupils either.

(6) Few of his works are dated.

Of these, the disputes over authorship are by far the most puzzling; omitting the possibility that the desire for a famous name lay at the heart of the matter (on three separate occasions?), they may be explained in three ways—the Roman critics depended on signatures on the bases and were lost without them; the works in question were eclectic; or the styles of the two sculptors were so alike in some respects that at a distance of three to four hundred years it was occasionally impossible to distinguish between them. The coin-

cidence is even more remarkable considering what we know (or think we know) of the two styles; as Beazley says of the Tegea sculptures: 'The massive heads . . . are the opposite of everything Praxitelean . . .'[22]

Of these disputed works the Niobids alone are extant (if they are copies of Pliny's group at all), and these would suggest that eclecticism is the correct explanation (although Pliny's 'haesitatio' could well apply to modern critics too), were it not that we have additional evidence that some links existed between the styles of the two sculptors: Skopas' name is mentioned in connection with Praxiteles on six more occasions (accounting in all for one-fifth of all the references to him in ancient literature), but never in connection with Lysippos, and, finally, such disagreements are rare in Pliny and never occur elsewhere in his work on such a scale.[23]

Certainly, one suspects that for works to be produced at all from a fusion of the two styles some common ground must have existed between them in the first place; as Morgan concludes, 'The gleanings are scanty, but, surprisingly, point in a single definite direction.'[24]

'Stylistic gathering' is also strewn with pitfalls:

(1) The Tegea sculptures are our sole body of authenticated evidence, but are atelier pieces and apparently untypical (see above, 'literary gathering',[1]).

(2) *Pace* Morgan, it is quite probable that nothing by Skopas' own hand has survived (again, see 'literary gathering'. [1]).

(3) Because of the difficulties involved in copying cult statues, we may expect considerable variations in any copies of these that do come to light.

(4) It is impossible to know how far the comparative method is reliable in determining personal style when the evidence of the monuments is scanty, unrepresentative, and complicated by the problem of copies and workshop pieces. Clearly the 'Skopaic eye' alone is not sufficient, for we simply do not know how far sculptors were prepared to go in taking over the mannerisms of others.

(5) The existence of at least one other Skopas and the possibility (I would put it no higher—'Skopas Minor'[25] is what his name suggests, a minor figure)[26] that

some of our works are to be attributed to him further aggravate our problems, already considerable.

However, we may gain some encouragement from the fact that he worked in marble[27] and that his output was apparently smaller than Praxiteles' or Lysippos'. This means that we are unlikely to have to face marble translations of bronze originals on a grand scale (as with Lysippos) and the changes of approach these entail,[28] nor the problem of a large circle of loosely-related works at several stages of removal from his personal style, but sufficiently close to it for them to be confusing. Furthermore, if our impressions are correct, Skopas' style was a fairly personal one and his works thus ought to be separable from those of his imitators, pupils and so on.

Thus, the testimony from both our main sources for Skopas' career falls considerably short of the ideal; in fact, it would appear that there is relatively little overlap between the two, a deficiency which compels us to return to the Tegea fragments, as our only considerable body of well-authenticated evidence (provided, that is, that one accepts the conclusions arrived at in Part I), and to proceed in the following manner:

Only those works will be considered that display a fairly close degree of kinship with the Tegea fragments; here the heads are clearly of prime consideration, followed by the more equivocal witness of the treatment of the body and its movement. It will, I hope, become clear that to a certain extent the development of these features in the works to be discussed has already been encountered in microcosm in the Tegea sculptures;[29] here Parts I and II will complement each other—indeed each vindicates the conclusions reached in the other, and to this end the two are inseparable.[30] Lists of the various copies will be found, together with bibliographies, in Appendix 4 to which the numbers appended in the text refer.[31] More doubtfully 'Skopaic' works—that is, those where the copies are untrustworthy for various reasons, and those possibly by imitators, followers and others—will be relegated to a separate Appendix at the end of each chapter.

Because of the problems of working at second hand, with Roman copies of originals instead of the originals themselves, the copies upon which the attributions are based have been limited to those produced mechanically, by the pointing process, in the Hadrianic and Antonine periods, when every effort was ap-

parently made to reproduce the original as faithfully as possible. The pieces are usually somewhat lacking in inspiration, and there is occasionally a tendency to omit or change 'accessories' such as rocks, cloaks and so on (as in the Meleager statues), but as far as one can tell from the general correspondence among the replicas of any one type at this time, especially in the matter of details such as eyes, mouths, ears and so on, they seem to be accurate enough.

Any pieces suspected of being copies of copies, like, for example, the Meleager head in Copenhagen (F 28), have been left severely alone; here again the only criteria are comparison with the Tegea sculptures and the general impression left by the whole series of 'major' copies. Hellenistic copies, like the Kalydon Meleager (F 14), the Capitoline Aphrodite head (PLATE 46a) and the Ares head in Vienna, are another matter. These were probably not reproduced mechanically, so are likely to be capricious over matters of detail; on the other hand, the information they can provide is often unexpectedly helpful, and because their carving is generally better, they can often be a closer guide to the spirit of the original than their doggedly pedestrian successors of the second century A.D. All these types are listed as 'copies' in the lists in Appendix 4, for their relative value still remains to be fully assessed; on the other hand, statues modified to suit Roman taste have been relegated to sections entitled 'variants' or 'versions', according to their distance from the main series.

To prevent the 'attribution game' getting out of hand, the main series has been limited to those statues which may be accommodated within the framework of a fairly strict internal development, outside that proposed in the previous paragraphs. The foundations for this line of approach were first laid down by Neugebauer in 1913, in his analysis of the movement of the Dresden Maenad (PLATE 32),[32] the salient feature of which he found to be a double *contrapposto*: the body twists in a spiral to the right, pivoting around the engaged leg, while the head turns back on this movement towards the 'free' side, thus 'opening up' the figure on this side (Fig. 1). The head is therefore inevitably turned toward the raised shoulder.

More recent students have resorted to linear models to clarify the relationship between the various works they attribute to Skopas; although these do have a part to play, as the following chapters will

show, as a complete explanation they must be judged inadequate, being essentially two-dimensional in character, and thus failing to take account of that overriding concern with sculpture as construction *in space* which distinguishes fourth century sculptors in particular from their predecessors.[33]

This series of works will be linked to the name of Skopas at some points by literary and other evidence; lost works, or those only preserved on coins, gems or other media of this kind will be discussed in the Appendices.

Finally, we come to the question of how to distinguish a work by Skopas from those of his followers, imitators, and so on. Here the 'Meleager' is the classic example of a statue that is obviously very closely related to the Tegea sculptures but is never mentioned once in the literature. The literary references do, of course, give us a fairly solid foundation to build on (taking into account the reservations expressed earlier), but it is obviously inadmissible to treat them as a closed corpus, since we have no idea of how complete they are. At the other end of the scale we may, I think, take it for granted that Skopas never touched a grave relief in his life (*pace* the NM guides!). Given a secure grasp of the central personality, the disciples and wider entourage should readily be discernible, but there seems no point, when confronted only with copies, in attempting to distinguish between the style of a sculptor and his 'manner'—often, at least in vase-painting, a very considerable part of the whole.[34] Not only are mechanically reproduced copies already, in a sense, in the 'manner' of the creator of the original, but there is the more fundamental problem of our own limitations as critics of style. To press distinctions to this degree of fineness when judging *any* work of art at second-hand is surely to delude oneself as to the extent of the powers of reconstruction attainable by the trained eye.

In general, then, it looks as though we shall apparently have to resign ourselves to accepting that any major name in Greek sculpture will always remain something of a composite personality. This leaves considerable scope for individual judgement in the no man's land around, an area where hard and fast rules can never come to operate. Since most (if not all) of the works in question remain to us only in copy, it seems unlikely that we can ever arrive at a solution that is generally acceptable.

Part I: The Tegea Sculptures

SELECT CATALOGUE

This catalogue lists thirty-two of the one hundred and fifty pieces of sculpture in Tegea and Athens attributable to the akroteria, pediments and metopes of the Tegean temple. Although the conclusions reached in this book are based on study of the entire corpus of extant remains from the site, publication rights to the fifty or sixty fragments discovered after Dugas' *Le Sanctuaire d'Alea Athéna à Tégée* appeared in 1924 belong elsewhere, ruling out a full catalogue for the present. I would like, however, to thank Professor C. Christou, Dr. A. Delivorrias, Dr. G. Steinhauer, and Dr. A. Demakopoulou for enabling me to describe and illustrate all the major pieces of sculpture from the temple: included with their permission are nos. 3, 7, 8, 10, 15, 19, 21, 27-32.

Criteria for the attribution of architectural sculpture to the akroteria, pediments or metopes of a temple are usually five in number: the findspots, the iconography of the sculptures (which may or may not be supplemented by literary evidence from ancient sources), the marble used, the technique, and the scale of the figures (in no particular order of precedence).

In the case of Tegea,[1] the evidence of the *findspots*[2] does not, I think, apply except perhaps as regards no. 13. The widely scattered proveniences of the fragments testify eloquently to the thoroughness of the destruction and plundering of the temple at the end · of the Roman period; unlike those of the temple of Asklepios at Epidaurus and the temple of Zeus at Olympia,[3] many of the Tegea sculptures seem to have been carried far for use as building material (the Nike akroterion fragment no. 3, which must weigh nearly a ton, was transported almost a quarter of a mile to the house in which it was found in 1964, for instance). On the wide Arcadian plain, rock outcrops of any sort are conspicuously absent, and field-stones provide nothing that is comparable in size for housebuilding. Furthermore, we can draw no conclusions from those fragments actually found within the temple area: the boar's head (no. 5), which must belong to the east pediment according to Pausanias (Appendix 1, no. 36) was found to the northwest; the head with the lionskin cap (no. 16), which ought to come from the west pediment, to the northeast of the temple; and the new arm fragment with a shield grip (no. 21), again probably from the west pediment, in the walls to the northeast. It seems that either we accept the evidence of the findspots, and are thus forced to assume that Pausanias misread his own notes (an unlikely possibility in view of his extended description of the sculptures in the east pediment, obviously taken down on the spot) or ignore them completely and concentrate on alternative methods of restoring the sculptures.

Thus, in the catalogue, all fragments for which no specific provenience is given were

found built into the walls of the late Roman or Byzantine houses between the east façade of the temple and the church. That we have so few large pieces from the west pediment is perhaps to be explained by the reluctance of the builders of these houses to move sculptures from one end of the temple to the other when the fragments of the east pediment were so handy—in which case, it is possible that they are still lying, more or less *in situ*, to the west of the temple, under the modern houses there. This would not have applied to the smaller fragments, of course, which could explain why so many of the pieces of limbs that were found in the houses to the east are apparently attributable to the west pediment.

The *iconography* of the Tegea figures[4] has been discussed in relation to the text of Pausanias (Appendix 1, no. 36) by many authorities, notably Neugebauer, Dugas, Pfuhl and Picard, and provides the primary criterion for their attribution in the present catalogue; some new suggestions are offered in Chapters 2 and 3. Only those pieces whose origin can be proved by their attributes have been included in the first part of each section; unfortunately, this only holds good for the akroterial and pedimental fragments, since despite Picard's researches we are still very much in the dark as to the subjects of the metopes,[5] and the remains themselves give little or no clue either as to their own identity or as to the subjects of the metopal scenes. The architrave blocks inscribed with the names of Auge, Telephos and (?)Aleos, and the Kapheidai, cannot with certainty be linked to any of the surviving fragments from the metopes.

The *marble*[6] used for all the sculptures of the temple was apparently the local variety from the quarries at Dolianà, some five miles to the south of the present village of Alea. Furtwängler's original hypothesis that the draped female torso no. 1 was of Parian marble, chosen because of its finer quality for the central figure of 'Atalante' (as he identified her) and possibly for the other figures of the east pediment with the exception of the boar, has been the subject of controversy ever since. The theory gained immediate acceptance by Gardner, but other authorities, notably Neugebauer, Dugas and Pfuhl, remained sceptical. More recently it appears to have experienced a revival at the hands of Picard and Bieber, although no new comments on the subject have been offered since the discovery of 'Atalante's' 'twin sister' in 1964. Although lately even the possibility of distinguishing between the different kinds of Aegean marble has been questioned, recent research suggests that Carbon-13 and Oxygen-18 variations in Greek marbles probably offer the best chance for determining provenances. It is hoped that the Tegean marbles can be analysed along these lines in the near future, but since this would have unduly retarded publication, conclusions reached by visual examination have been retained in the text in the meantime.

The quality and origin of the marble are discussed in Chapter 1; suffice it to say here that after close study of the marble used for akroteria, pediments and metopes, I can find no differences that are sufficiently striking to suggest that it could have come from more than one source. In every case the marble has been examined on fresh breaks, and only variations from the norm described in Chapter 1 are noted in the catalogue.

External evidence is limited to Pausanias' statement that Skopas' two cult statues were of Pentelic marble (Appendix 1, no. 16). If we can trust him or his guides (was he told, or did he use his own judgement?) this seems to have been the preferred variety at Tegea where high quality was required. In any case, the Pentelic quarries were nearer than the Parian, and it is hardly likely that the Tegeans would go to the trouble of importing two types of marble for their temple.[7]

The *technique* of the sculptures is generally of secondary importance in distributing them among the akroteria, pediments or metopes, although in a few cases it has become the deciding factor. A fragmentary female head (no. 4) has a square hole in the crown found on none of the other heads, for a spike (μηνίσκος) to prevent birds from perching on it, and so must be assigned to the akroteria. Some small fragments whose backs were clearly prepared (though with varying carefulness) for adhesion to a relief background

(nos. 28, 29 and others in the Tegea store) must have come from the metopes. With the majority of the large fragments that can only have been part of the pediments, the chief value, in this respect, of the technique is the corroborative evidence it provides, although its importance for the restoration and placing of the figures within the compositions is immense.

Crucial to the attribution of the majority of the fragments is their *scale*. The metopal fragments, carved to fit into a frame measuring only 1.022 x 0.881 m, are easily recognisable by their small scale (which, however, seems to vary quite considerably, perhaps in response to the demands of individual scenes).

For the pediments, all previous studies have followed Neugebauer and Dugas in asserting that the scale of the figures diminished towards the corners,[8] citing the Nereid monument at Xanthos and the Alexander Sarcophagus as fourth century parallels. The temple of Asklepios at Epidaurus is added by Crome. Neither of the two former examples seems to me to provide good comparative material; the pediment of the Nereid monument is half life-size, in relief and provincial, and the differences in scales between the figures echo those to be found within the friezes; that of the Alexander Sarcophagus is in very small scale, partly in relief, and late. Both are offshoots from large scale temple architecture and in some respects special cases; neither possesses the monumentality of true temple sculpture—a monumentality particularly evident, in the eyes of all observers, in the architecture and sculpture of Tegea.[9]

The only real comparison seems to be with Epidaurus, as the sole example of an important temple with well-preserved pedimental sculpture in the fourth century. Here, however, Yalouris has detected a significant increase in scale from the west to the east pediment, the figures of the latter being about one-eighth larger than their counterparts to the west. The reasons for this are not altogether clear, although a factor may well be the presence of horses in the west pediment; aesthetic considerations may also play a part (the number of figures, counting horses and excluding the Palladion in the east pediment, was apparently the same—22 in each composition, according to information from Dr. Yalouris). There is indeed a slight decrease in scale towards the corners, but nowhere so great that any major fragment could be misplaced between the two pediments, nor again so great as to be noticeable from the ground.

I believe that a similar difference existed at Tegea, though reversed; that is to say, the figures of the west pediment were carved on a larger scale (by about one-sixth) than those of the east. As can be seen by a glance at Table I, the well-preserved heads, five in number, are divided with near complete precision into two groups (nos. 9, 10; 16–18) by a comparison of the vertical measurements of the face, and in particular by the variation in the distance between the underside of the chin and the canthus (inner corner of the eye), which usually equals slightly less than one-half the height of the head, or rather under one-fifteenth the height of the figure in fourth century non-Lysippic sculpture (taking the related statue of Meleager in the Vatican, PLATE 44b, as a base, where the proportion head height:total height is 1:7.33). On this scheme, therefore, the heights of the standing figures ought to be about 1.60 m and 1.90 m respectively. The horizontal measurements do not agree, however, and it is this that gives the impression that the fragments are of different scales. The discrepancies are partly due to the general employment of optical corrections (see Chapter 2) and partly, it would seem, to the fact that close supervision of the atelier was not deemed necessary in this respect: presumably it was enough for appearances if the general proportions and especially the heights of the figures tallied.

Such precision in the vertical measurements, however, is remarkable, and three points ought to be noted in connection with it:

(a) the proposed difference in scale between the figures of the two pediments nowhere conflicts with and is often supported by the iconographic evidence for the placing of the heads;

(b) two of the heads (nos. 9 and 19, probably from the east and west respectively) must be placed some way from the centres of their pediments, and thus might be expected to decrease in scale accordingly, which they do not. Furthermore, the female torso fragment no. 20, which probably belongs to the left-hand corner of the west pediment, is of large scale, as a comparison with the other fragmentary female torso, no. 8, makes clear; a figure of decreased scale placed next to her in the compositon would make her look ridiculously large in comparison;

(c) this difference of scale can be traced down into the torsos and even the smaller pieces; although their fragmentary state makes measurement difficult and sometimes impossible, visual separation of the two series and matching with pieces of known scale is possible. For instance, of the fragments of hands, only four are sufficiently preserved to take measurements (Dugas 6, 46, 48, 51: PLATE 20c-e); all are of significantly larger scale than Dugas 45 and 49, which are both of the same scale. The four measure from 0.115 to 0.117 m across the knuckles, a variation of only 2 mm. Dugas 48—a left hand—is half curled round a cylindrical object which can hardly be a spear-shaft since this would require a proper grip (probably in the form of a drill-hole through the closed fist); the most plausible alternative is a shield-grip, which also fits in with the action of the thumb. Shields would be necessary in the Kaïkos battle represented on the west pediment, while in the Calydonian hunt, represented on the east, they never appear again after the odd occurrence in the Archaic period. Dugas 51 is a right hand, and is closed around an object, forming on the inside a smooth conical channel with its wider end near the thumb. The only attribute that could plausibly fit here is a sword hilt; again, the weapon for boar-hunts, almost exclusively, is a boar-spear, which would require a cylindrical channel. Not only, then, is the variation in scale among these four small pieces negligible, but there is strong evidence to suggest that two belong to the west pediment and that the group as a whole is larger in scale than the other hand fragments; in their turn, several fragments of arms also match the two groups of hands in scale.

The akroteria are worked to a slightly smaller scale than the figures of the west pediment; the distance between the points of the breasts of no. 1 is 0.260 m, which in fourth century figures is usually roughly equal to the height of the head from the underside of the chin to the crown. This measurement in fact coincides quite closely with the height of the head no. 4 (not measurable exactly, since the point of the chin is lost and the hair not worked at the crown: the measurement from chin to canthus is about 12 cm, which would give a height of about 0.255 m).

For comparison, the proportion breasts:head height:total height of the figure in the Cnidian Aphrodite, measured on a cast of the Vatican copy, is almost exactly 1:1:7.5; the Aphrodite of Arles also gives the same results. Taking the distance between the breasts, then, to be equal to between one-seventh and one-eighth of the height of the figure, we arrive at a height of about 1.85 m for the standing figure (although the actual height would have been greater, since one arm in each case was probably raised above the level of the top of the head). A cross-check to this result is that the distance from the underside of the chin to the canthus and that from the corner of the mouth to the same point recorded for the akroterion head, no. 4, differ slightly from those in the heads ascribed to the west pediment; as we have already noted the precision attained by the Tegea workshop in this respect, this can hardly be fortuitous.

This slight difference in scale between akroteria and pedimental figures also occurs at Epidaurus; there, Yalouris restores Schlörb's 'Neoptolemos',[10] carved to a slightly smaller scale than the figures of the east pediment, as part of the central akroterion of that pediment (the height, with plinth, is 0.95 m, whereas the conjectured height for the central figures of the pediment, which do not have plinths, is about 1 m). A similar relationship exists between the akroteria and the pedimental figures of the west pediment.

I was unable to find any joins to add to the few made by Berchmans in the original publication, though in several cases (nos. 1, 2; 3, 4; 12, 13; 16, 26; 19, 20) it looks as if two

fragments originally formed part of the same figure. Considering that only about 110 fragments are preserved from a total of perhaps 36 pedimental figures, the absence of joins should not cause too much surprise.

The positioning and identification of the major fragments are discussed in Chapter 2. All measurements are in metres unless otherwise stated; 'H', 'W', 'D', 'C' refer to the height, width, depth and circumference of the fragment or part concerned. Detailed measurements of the heads are given in Table 1 (p. 34), and a study of the anatomy of the sculptures in Table 2 (p. 36). Left and right refer to the proper left and right of the fragment, left hand and right hand to the spectator's.

The bibliographies are not exhaustive but contain, to the best of my knowledge, references to every publication that has had something worthwhile to say about the piece in question since Dugas' *Sanctuaire d'Aléa Athéna* of 1924, where references to earlier publications will be found.

A. THE AKROTERIA

The roof decoration of the Tegean temple consisted of a large floral open-work akroterion,[11] probably about 2.10 m high, above the apex of each pediment, and a standing female figure, originally about 1.85 m high, above each corner (cf. PLATE 53). No bases for these akroteria have been found, and their exact positions are thus a matter of conjecture.

(1) Tegea 59. Dugas 1. PLATES 1-2c

Striding female figure, clad in a long peplos.

Found among the Byzantine foundations between the east front of the temple and the road, about 3 m from the road.

Hard, medium to fine grained marble with many crystals and a slight bluish tinge.[12]

H 0.99; W at waist 0.297; D at waist 0.280.

Neck, preserved height 0.065; circ. c. 0.41. Between breasts, width 0.260. Girdle to pit of neck 0.256.

Torso, mended from several fragments, and missing head, left wrist and hand, right arm and both legs from above knees; remainder fairly intact. Right hand perhaps preserved in a non-joining fragment (no. 2). Ridges of many folds chipped, some broken away completely on right side. Weathering uniformly light, though shoulders, arm and right thigh severely pocked; original surface remains behind right thigh, in cavities of some folds and over parts of lower torso where originally protected by apoptygma. The back and rear left side only planned with point and claw-chisel.

Dugas, 80-84 and pls. 96-98,A (partly from casts); Picard, *Man* iv.1 (1954), 196-200 and fig. 87; Bieber, 24 and fig. 58; Richter, *Sc*⁴ (1970), 208-9 and fig. 743.

The weight of the figure was carried on the right leg, with the left withdrawn; the upper torso twists gently to the spectator's right, and the head was turned rather further in the same direction and inclined a little. The right arm was raised, so that the upper arm was approximately at right angles to the torso, while the left remained by her side. The left forearm was semi-pronated, so that the hand faced the body palm inwards. In view of the steadiness of the pose and the almost complete absence of drapery blown upwards by air-currents, it seems likely that she was represented as walking with her right foot set firmly on the ground, and not as alighting from above.

She is wearing a heavy Doric peplos, open on the right side, which bares the right shoulder, breast and thigh. It is pinned on the left shoulder, though no trace of a pin survives (if ever there was one), and is folded over at the top to form an apoptygma; both this and peplos proper are girdled just below the breasts. The lower hem of the apoptygma is missing; originally it would have run at a slight angle downwards to the spec-

tator's right, deeply undercut over the stomach and covering much of the peplos here, as the presence of tool-marks in this area shows.

The arrangement of the open side is rather confusing at first sight: as can be seen from the folds that meet at the top of the thigh, the back portion of the peplos overlies the front. The apoptygma naturally follows the peplos proper, but because the latter has been pulled down as well as forward, the overfold that runs down between the breasts to the right side has overlapped its counterpart appearing from behind and flutters gently in the breeze. The same action has rucked up the side hem and part of the apoptygma below the girdle to form a heavy bundle of cloth that swings forwards and upwards with the motion of the figure. The peplos is broken at the back of the thighs and where it covers the left thigh, but it seems more than likely that it once descended right to the ground. The whole arrangement reappears in a very similar but slightly more simplified form in the very late fourth century Nike NM 159 from the temple of Artemis at Epidaurus.[13]

Although the figure wears only one garment, the cloth is not treated in a homogeneous manner over the whole body. On the right side where it is blown back by the wind, the apoptygma covers the outside of the thigh with dense, woolly layers of cloth, which even so are not rendered without a certain hardness, in flat, rather aggressive planes. Rather less dense is the peplos proper, where its hem sweeps down the inside of the right thigh, in the fold triangle across the stomach and on the outside of the left thigh.

In complete contrast is the material over the front of the left thigh, almost devoid of undercutting, tense, light and smooth, and more like linen than wool. However, the loss of the apoptygma brings this area into greater prominence than would have been the case originally; whatever the length of the apoptygma, it is clear that these folds, and the right hand fold of the triangle over the stomach, originally disappeared under its fluttering hem.

Midway between these two extremes lie the folds of the peplos behind the right thigh where they appear below the apoptygma, carved in straight, stiff ridges often with a central depression and no undercutting, and the treatment of the main part of the apoptygma above and below the girdle by the left breast. Here, small, fussy folds spray out from the girdle in a network of thin, wedge-shaped ridges, which lose themselves abruptly where the cloth is pulled tight over the breast, and at the break below.

As for the nude parts, the weathering and severe pitting makes any detailed discussion difficult. The main characteristic is the amplitude of the forms, the thighs in particular; it is difficult to avoid calling them anything less than massive, for their volume is far greater than that of any fragment yet found from the pediments, despite the similarity of scale between the two. The shoulders are also well developed, and the breasts full. The modelling is broad, transitions as such undetectable (with the single exception of the cut under the right armpit), and the movement firm and assured,[14] neither dance-like (Picard), nor particularly abrupt (Alscher).[15]

To this statue probably belongs:

(2) Tegea 56. Dugas 98.[16] PLATE 2d
Right hand.
L 0.192; W 0.109; D at wrist 0.054; C at wrist 0.197. Width of wrist 0.69; at knuckles 0.092. Length from head of ulna to tip of second finger 0.240.
Broken across wrist; most of fourth finger missing, with some of stone object held in hand. Surface weathered, some pocking on back of wrist and hand. Original surface on palm.
Dugas, 120 and pls. 111,A; 115,B.

The weathering and pocking of the surface, together with the colour of the piece and its marble, indicate that this fragment is the right hand of no. 1. It is rather smaller in scale than the hands Dugas 6, 46, 48, and 51 (PLATE 20c-e), which should all belong to the west pediment—reflecting the general difference in scale between the west pediment and the akroteria as a whole. The weathering shows that the palm faced downwards.

The hand was lightly flexed on the arm, and seems to have held two objects: a tab with a raised rim terminating in a circle, pressed against the index finger by the pad of the thumb, and a curved piece of metal which fitted through a hole, 0.018 m across, in a roll of stone grasped in the fingers. Traces of iron remain in the section gripped by the third finger. The modelling is soft and delicate, and the movement relaxed. The fingers are thin and tapering, and a fingernail is even discernible on the index.

The most likely attributes are a *taenia* and a wreath (στεφάνη). Furtwängler believed the 'tab' to be the hem of the apoptygma of no. 1, while Neugebauer thought it looked more like a *taenia;* following out his own hypothesis that no. 1 probably held a mantle across her back, he was thus forced to doubt whether the hand belonged at all. Berchmans followed Furtwängler in part, but ascribed the piece to the Hygieia in the temple, with the head NM 3602.

The character of the 'tab' rules out a segment of drapery, and suggest rather a ribbon or strap. Picard's suggestion, a hydria handle, is less happy, for then its top could not have joined the vase at all.[17] Chariots or horses did not, as far as I can tell, appear except in the metopes (no. 30), which excludes reins. By a process of elimination, the end of a *taenia* seems the only explanation.

As for the other object, the position of the fingers suggests that it was curved, and from the condition of the surface the hand was clearly held palm downwards, which is the usual way for a wreath to be held in Greek art,[18] and which rules out a spear. The roll of stone and surviving fragment of metal (a peg ?) would then be explained by the need to support the wreath near the little finger, which was only slightly flexed; if a parallel is required, a spear in the hand of a dying warrior from Aegina was supported in a similar way.

Wreath and *taenia* are common attributes of Nikai (PLATE 28b) and in fact on several vases depicting the preparations for and aftermath of the hunt the heroes are shown crowned in this way; these, together with the problem of whether the akroteria are Nikai or not, will be discussed further in Chapter 3.

(3) Tegea 2288. PLATE 3
Female figure, clad in a long peplos and himation.
From the garden of N. Panagopoulos, 300 m south of the temple, with no. 15.
H 0.86.
Torso, broken across just above knees, above girdle at back, and diagonally across from just above girdle on right side to above left breast. In addition, apoptygma hem, much of fold-billow by right hip and loose fold of drapery behind left breast missing; drapery below girdle on right side battered away and parts of surface, especially on torso and below girdle at back, chipped, severely weathered and pocked; otherwise, weathering moderate. The back is only planned with point and chisels. The head is possibly preserved in a non-joining fragment (no. 4).
Preliminary notice by Christou and Demakopoulou, *ADelt* 20.B.1 (1965), 170 and pl. 151α-γ; Megaw, *JHS Archaeological Reports* 1966, 8 and fig. 10; Daux, *BCH* 92 (1968), 808-10 figs. 1-3.

In proportions, this figure is very close to no. 1; her pose is also similar, but more extreme: although the twist of the body to the spectator's right is only slightly increased, the right hip, supposedly carrying the weight, is raised so high that it is clear that the

right foot cannot have been in proper contact with the ground.

She is clad in a peplos, open on the right side and girdled over the apoptygma, and a himation.

The peplos is arranged similarly to that of no. 1, with the exception that this time the drapery on the front overlies that from behind where the two meet on the right side. Because of the extent of the damage it is almost impossible to decide what belongs to peplos, apoptygma or himation and where exactly the two edges of the peplos overlap; possibly the arrangement was not exactly clear before the damage occurred.

The figure was clearly conceived as alighting from above against an updraught of air, which has caught the heavy folds that on no. 1 were represented as sweeping back against her right side and turned them into a swirling billow below the right arm, in a manner similar to the little Nike from Epidaurus, NM 162 (PLATE 26a).[19] The floating effect that results from this, although marred by the heaviness of the straight, flat folds plastered against either side of her right thigh, is enhanced not only by the confused and contradictory lines of the drapery, but also the way in which the sculptor has followed nature in allowing the girdle to rise with the right hip, shoulder and arm, in contrast to no. 1. The broken area where the straight folds of the peplos across the inside of the right leg meet the apoptygma may mean that a counterpart to the free-flying 'knot' of no. 1 existed on this piece also.

Unlike her sister, this figure also carried a himation slung diagonally across the back and presumably once draped over the (raised) right arm. Since it seems to add little to the composition (contrast Paionios' Nike[20] and NM 162), it is difficult to see why this was included unless it had some iconographic significance. A similar scheme is found on a striding Nike from Cyrene,[21] dated to the early fourth century by Paribeni but surely more at home in the second half rather than the first, considering the generally derivative nature of Cyrenaic sculpture.

The drapery is treated in a very similar fashion to that of no. 1, although the effect here is much harsher and more aggressive, due in part to the less subtle use of the running drill, and the sculptor's failure to recarve and vary the lines of the channels and to modulate and shape the flat, hard planes of the folds. On the whole, the drapery is far less three-dimensional than that of her sister, and the addition of the apoptygma billow does little in this respect to make up for the complete lack of body in the folds that form the inverted V over the front of the right thigh. Particularly noteworthy is the way in which the subtle use of thin, dart-like folds originating at the girdle to model the breast has been lost on the sculptor of no. 3, who has both increased their size and changed their direction, thus enormously reducing their effectiveness in depicting the growing tension of the cloth towards the point of the breast. The same criticism could be repeated (in slightly differing terms), for almost every detail of the drapery that varies from the norm established by no. 1. Since, technically speaking, she is also finished with considerably less finesse than her sister, the tools used (the running drill in particular) being much coarser, it seems only reasonable to assign her to the western, or rear façade of the temple, and no. 1 to the eastern.

To this statue probably belongs:

(4) Tegea 61. Dugas 106. PLATE 4
Female head.

Found in 1914 in a supporting wall of the village school, about 100 m south of the temple. H 0.315; W 0.145; D 0.229.

For other measurements see Table 1.

Broken across at base of neck; back of head and most of right side split away, though line of jaw and some hair behind right ear remain. Crown of head roughed out with the point only; in the centre, a hole 2.8 cm deep x 1 cm wide x 1.8 cm from back to front. Face

and neck lightly weathered, though features chipped in places, with scoring below left ear. Hair battered, original surface remains only in channels between locks.

Dugas 124-25 and pl. 116; Pfuhl, *JdI* 43 (1928), 35 fig. 11; Picard, *Man* iv. 1, 166 and fig. 77.

The head was turned and inclined towards the figure's left shoulder. There is a difference between the degrees of tension on either side of the neck, and on the left two folds of skin are included for emphasis. Part of the shoulder remains on this side, but is too battered to give any further clue to the movement.

By analogy with no. 1, where the neck is preserved, the pose is exactly that which one would expect for the head of her sister, no. 3—a possibility supported by several other pieces of evidence. Not only in its weathering, colour and graining is the marble very similar indeed to that of no. 3, but the technique of the head strongly suggests that it is not from the pediments. A patch about 8–10 cm in diameter on the crown is only roughed out with the point, and in its centre there is a rectangular hole. Since on the pediments it is clear that tenons or dowels were not in general use for fixing the heads of the figures to the soffit of the raking cornice, it seems most likely that this hole was for an iron spike or μηνίσκος to keep birds away. This is attested for heads belonging to the only other two monuments to possess lateral figural akroteria erected during this period: at the temple of Asklepios at Epidaurus one appears in the head of NM 157, but not, so far as I am aware, in any head from the pediments; and at the temple of Artemis in the same sanctuary, all three preserved akroterion heads were prepared for spikes.[22]

Secondly, although the back of the head is missing, the hairstyle so far as it is preserved agrees well with that of the akroteria from the temple of Artemis, where the hair was drawn back into a bun; in our head, the direction of the few locks behind the right ear is upward, not downward as would be expected from hair streaming freely in the wind. That the hair on the Tegea piece seems much looser is due to the free use of the running drill, which of course was not practicable on the miniature heads from the Artemision.

Finally, the head is slightly smaller in scale than those of the west pediment, and considerably larger than those ascribed to the east, which both rules out the suggestion of Pfuhl and Picard (loc. cit.) that it could have belonged to Atalante, and makes an attribution to the west pediment unlikely.

The features are severely classical. The line of the jaw forms a strong oval when seen from the front, and the underside of the chin is clearly separated from the neck by a very sharp line to the left, which is gradually effaced the nearer it approaches to the ear. The skin on the right is shown as being in tension, so a broad hollow transition replaces the line here.

The face has more anatomical detail in it than the very ample surface treatment reveals at first sight—not only is the soft pad of flesh above the corner of the mouth indicated, but also slight depressions indicate the extent of the cheek and the beginning of the transitions to nose and jaw. The forehead protrudes a little over the outer part of the eye and again over the bridge of the nose. The temples are slightly hollowed.

The eye is fairly deep-set, and its surroundings soft though not lacking in strength; it is modelled in the canonical manner (see Table 2) and canted forward somewhat. The ear is rather low—usually at Tegea the top of the helix lies a little below the line of the brow, whereas here it would hardly come up to the level of the canthus. (This accounts for the unusually short distance between the ear and underside of the chin: see Table 1.) When seen from in front, the ear protrudes increasingly towards the top.

The hair was modelled in chunky, thick locks where it would have been visible to the spectator, each divided into two or three wavy strands. The channels between the locks are deep, even now when most of the surface has gone, and the sculptor was clearly after broad contrasts in highlight and shadow. The hairline, a subtle double curve in profile, may have curved up to a slight point in the centre where the parting was, although the damage here makes it difficult to tell exactly: the parting alone may have provided the point.

Smaller pieces which could belong to the akroteria are the large drapery fragment Dugas 2, the arm fragment Dugas 36, the hand Dugas 52, and a large leg fragment in the Tegea store with a long break down its posterior face, possibly a join to the long peplos of one of the figures. If this were in fact the case, it would give another point of contact with the akroteria from the Epidaurus Artemision, whose similarity in other respects to nos. 1, 3 and 4 has already been noted.

B. THE EAST PEDIMENT

According to Pausanias (Appendix 1, no. 36), the sculptural decoration of the east pediment (the Hunt of the Calydonian boar), comprised either fifteen or, more likely, eighteen figures; drawn up to their full height, each would have been about 1.60 m high. The pedimental frame was 1.90 m high x 16.45 m long. Major fragments of seven are preserved, together with those of three animals: the boar, and two dogs.

Certainly belonging are nos. 5-8:

(5) NM 178. Dugas 3. PLATE 5a
Head of the Calydonian boar.
Found in the later walls in front of the northwest angle of the temple, with nos. 9 and 17.
Medium grained crystalline marble, off-white in colour.
L 0.42; H 0.29; D 0.245.
Width of mouth 0.144.
Broken across diagonally from throat to cranium; snout missing, and underside of jaw and cheekbone battered on left. Left upper eyelid and brow chipped, right battered away. Surface weathered, but more so on left than right. Right side unfinished, two rectangular holes behind the mouth here: (1) depth 3.5 cm, width 4 cm; (2) depth 2 cm, width 2 cm.
Dugas, 84-85 and pl. 108,A;Arias, 120 and pl. 8,27; Picard, *Man* iv.1 (1954), 166-67 and fig. 78.

The throat muscles are in tension at the break, showing that the head was stretched forward on the body. The mouth seems to have been open, but no signs of teeth or tusks remain. The right side was not completed, and the two rectangular holes behind the mouth on this side are a puzzle.[23] They were originally recognised as holes for spears or arrows, but some scholars have expressed alternative opinions. Berchmans, considering that the angle was wrong, conjectured two rods supporting the (lowered) head of the boar and attached to the geison soffit. Compared with that in the shoulder of no. 7, the holes are perhaps a little small for struts yet are indeed set at an improbable angle for arrows or spears (forwards and downwards); the question thus remains open.

The planes of the head are broadly conceived and the bone structure massive. Particularly prominent are the long, broad nasal bone, the solid cranium, the wide, flat cheekbone and the sharp transition from the jawbone to the soft skin of the neck and underside of the chin. The hide is thick and richly modelled, especially around the corners of the mouth and the eyes, and is covered in a mat of short, curly hair, not coarse and bristly as one would expect, but abraded to a soft, almost silky finish. The method of carving the hair, in S-shaped locks divided into two or three strands, is the same as used on the other two NM heads, nos. 9 and 17.

The modelling of the eye calls for some comment; as has often been remarked, its form recalls to a great degree the notorious 'pathetic eye' of some of the pedimental heads. Human not ursine it undoubtedly is, and the expression of ferocity that results from the combination of deep lower lid, protruding eyeball and overhanging, fleshy orbital is enhanced by the development of the ocular portion of the upper eyelid, also prominent on some of the pedimental heads, especially no. 17. Here, this is taken to ex-

and neck lightly weathered, though features chipped in places, with scoring below left ear. Hair battered, original surface remains only in channels between locks.

Dugas 124-25 and pl. 116; Pfuhl, *JdI* 43 (1928), 35 fig. 11; Picard, *Man* iv. 1, 166 and fig. 77.

The head was turned and inclined towards the figure's left shoulder. There is a difference between the degrees of tension on either side of the neck, and on the left two folds of skin are included for emphasis. Part of the shoulder remains on this side, but is too battered to give any further clue to the movement.

By analogy with no. 1, where the neck is preserved, the pose is exactly that which one would expect for the head of her sister, no. 3—a possibility supported by several other pieces of evidence. Not only in its weathering, colour and graining is the marble very similar indeed to that of no. 3, but the technique of the head strongly suggests that it is not from the pediments. A patch about 8–10 cm in diameter on the crown is only roughed out with the point, and in its centre there is a rectangular hole. Since on the pediments it is clear that tenons or dowels were not in general use for fixing the heads of the figures to the soffit of the raking cornice, it seems most likely that this hole was for an iron spike or μηνίσκος to keep birds away. This is attested for heads belonging to the only other two monuments to possess lateral figural akroteria erected during this period: at the temple of Asklepios at Epidaurus one appears in the head of NM 157, but not, so far as I am aware, in any head from the pediments; and at the temple of Artemis in the same sanctuary, all three preserved akroterion heads were prepared for spikes.[22]

Secondly, although the back of the head is missing, the hairstyle so far as it is preserved agrees well with that of the akroteria from the temple of Artemis, where the hair was drawn back into a bun; in our head, the direction of the few locks behind the right ear is upward, not downward as would be expected from hair streaming freely in the wind. That the hair on the Tegea piece seems much looser is due to the free use of the running drill, which of course was not practicable on the miniature heads from the Artemision.

Finally, the head is slightly smaller in scale than those of the west pediment, and considerably larger than those ascribed to the east, which both rules out the suggestion of Pfuhl and Picard (loc. cit.) that it could have belonged to Atalante, and makes an attribution to the west pediment unlikely.

The features are severely classical. The line of the jaw forms a strong oval when seen from the front, and the underside of the chin is clearly separated from the neck by a very sharp line to the left, which is gradually effaced the nearer it approaches to the ear. The skin on the right is shown as being in tension, so a broad hollow transition replaces the line here.

The face has more anatomical detail in it than the very ample surface treatment reveals at first sight—not only is the soft pad of flesh above the corner of the mouth indicated, but also slight depressions indicate the extent of the cheek and the beginning of the transitions to nose and jaw. The forehead protrudes a little over the outer part of the eye and again over the bridge of the nose. The temples are slightly hollowed.

The eye is fairly deep-set, and its surroundings soft though not lacking in strength; it is modelled in the canonical manner (see Table 2) and canted forward somewhat. The ear is rather low—usually at Tegea the top of the helix lies a little below the line of the brow, whereas here it would hardly come up to the level of the canthus. (This accounts for the unusually short distance between the ear and underside of the chin: see Table 1.) When seen from in front, the ear protrudes increasingly towards the top.

The hair was modelled in chunky, thick locks where it would have been visible to the spectator, each divided into two or three wavy strands. The channels between the locks are deep, even now when most of the surface has gone, and the sculptor was clearly after broad contrasts in highlight and shadow. The hairline, a subtle double curve in profile, may have curved up to a slight point in the centre where the parting was, although the damage here makes it difficult to tell exactly: the parting alone may have provided the point.

Smaller pieces which could belong to the akroteria are the large drapery fragment Dugas 2, the arm fragment Dugas 36, the hand Dugas 52, and a large leg fragment in the Tegea store with a long break down its posterior face, possibly a join to the long peplos of one of the figures. If this were in fact the case, it would give another point of contact with the akroteria from the Epidaurus Artemision, whose similarity in other respects to nos. 1, 3 and 4 has already been noted.

B. THE EAST PEDIMENT

According to Pausanias (Appendix 1, no. 36), the sculptural decoration of the east pediment (the Hunt of the Calydonian boar), comprised either fifteen or, more likely, eighteen figures; drawn up to their full height, each would have been about 1.60 m high. The pedimental frame was 1.90 m high x 16.45 m long. Major fragments of seven are preserved, together with those of three animals: the boar, and two dogs.

Certainly belonging are nos. 5-8:

(5) NM 178. Dugas 3. PLATE 5a
Head of the Calydonian boar.
Found in the later walls in front of the northwest angle of the temple, with nos. 9 and 17.
Medium grained crystalline marble, off-white in colour.
L 0.42; H 0.29; D 0.245.
Width of mouth 0.144.
Broken across diagonally from throat to cranium; snout missing, and underside of jaw and cheekbone battered on left. Left upper eyelid and brow chipped, right battered away. Surface weathered, but more so on left than right. Right side unfinished, two rectangular holes behind the mouth here: (1) depth 3.5 cm, width 4 cm; (2) depth 2 cm, width 2 cm.
Dugas, 84-85 and pl. 108,A;Arias, 120 and pl. 8,27; Picard, *Man* iv.1 (1954), 166-67 and fig. 78.

The throat muscles are in tension at the break, showing that the head was stretched forward on the body. The mouth seems to have been open, but no signs of teeth or tusks remain. The right side was not completed, and the two rectangular holes behind the mouth on this side are a puzzle.[23] They were originally recognised as holes for spears or arrows, but some scholars have expressed alternative opinions. Berchmans, considering that the angle was wrong, conjectured two rods supporting the (lowered) head of the boar and attached to the geison soffit. Compared with that in the shoulder of no. 7, the holes are perhaps a little small for struts yet are indeed set at an improbable angle for arrows or spears (forwards and downwards); the question thus remains open.

The planes of the head are broadly conceived and the bone structure massive. Particularly prominent are the long, broad nasal bone, the solid cranium, the wide, flat cheekbone and the sharp transition from the jawbone to the soft skin of the neck and underside of the chin. The hide is thick and richly modelled, especially around the corners of the mouth and the eyes, and is covered in a mat of short, curly hair, not coarse and bristly as one would expect, but abraded to a soft, almost silky finish. The method of carving the hair, in S-shaped locks divided into two or three strands, is the same as used on the other two NM heads, nos. 9 and 17.

The modelling of the eye calls for some comment; as has often been remarked, its form recalls to a great degree the notorious 'pathetic eye' of some of the pedimental heads. Human not ursine it undoubtedly is, and the expression of ferocity that results from the combination of deep lower lid, protruding eyeball and overhanging, fleshy orbital is enhanced by the development of the ocular portion of the upper eyelid, also prominent on some of the pedimental heads, especially no. 17. Here, this is taken to ex-

tremes, so that the lid flares up to form a wide flange above the eyeball—a device which, so far as I am aware, occurs on no other animal heads of this period and reappears only in the head of the charging warrior Patras 207 from the pediments at Masi.[24]

The piece seems to have been carefully made by a competent sculptor, and does not deserve Berchmans' remark that 'la technique de ce morceau est sommaire'.[25]

(6) Tegea 89. Dugas 5. PLATE 5 b-c
Head of a dog.
L. 0.161; H 0.127; D 0.106.
Broken across behind ears and on snout; chipped in places. Moderately weathered all over; claw chisel marks on right.
Dugas, 86 and pl. 109, F-G.

The neck muscles may have been in tension, in which case the head was probably raised or thrust forward.

The bone structure of nose, cranium and cheek is again fairly prominent, as on the boar's head (no. 5), and the flesh modelled with a similar richness, although the forms seem in general to be smoother and rather softer on the left. The sharp transition from the right side of the face to the underside of the chin is analogous to that of the unfinished right side of no. 5. The modelling around the eyes on both sides is very pronounced and powerful, and the orbital again sags over the top of the eyeball. An ear is carved only on the left.

(7) Tegea, unnumbered. PLATE 6a
Torso of a dog.
Found in 1965 with no. 8 and other smaller pieces in the walls of a Byzantine house in the orchard of N. Reppas, c. 300 m to the south of the temple.
H 0.50; L 0.55.
Head missing, also all four legs from above knees. Strut between forelegs broken and battered around break. Weathering and encrustation worse on right than left; some surface chipping and scratching on both sides. Tenon hole in left shoulder, another (for the tail) in the rump.
Preliminary notice by Christou and Demakopoulou, *ADelt* 21. B. 1 (1966), 154 (no. B. 3).

The dog was leaping upwards, with both forelegs in the air; the right was set rather to the side and below the left. A metal tenon, inserted into a rectangular hole in the left shoulder, secured the animal to the tympanon, whilst a marble strut between the forelegs supported it from below. The tail was inset. The neck strains upwards and the sterno-cleido-mastoid on the right is massive and prominent; its direction suggests that the head was turned to the right, counter to the twist of the body to the left (which brings the ribs on the right into high relief and effaces those on the left).

The musculature is chiefly remarkable for the strength and solidity of the forms, and for the lack of really detailed modelling; the dual origin of the sterno-cleido-mastoid is hardly represented at all; the shoulders, ribs, haunches and nape of the neck are all similarly treated, with emphasis on breadth rather than detail. The hard, protruding lump on the nape of the neck is, I think, unique, though possibly a development of the high shoulders of, for instance, the sixth century Akropolis dog and the dog in the National Museum, NM 4763,[26] and tends to give the animal a very stocky appearance. The skin is rendered as stretched taut over the protruding ribs and by the haunches near the groin in a very naturalistic manner, and on the whole the different surface values and tensions are well defined beneath the thick hide of the animal. The musculature on the left is more summarily treated than on the right.

(8) Tegea 2297. PLATE 6 b-c

Draped upper torso (female).

For provenience, see no. 7.

H 0.26; W 0.30.

Broken diagonally across below breasts; large chip below left breast and himation. Shoulders battered, ridges of folds chipped in places. Right arm and head inset, the former alone secured by a dowel. Back of left shoulder sectioned diagonally into flat, rectangular plane tapering towards the top, worked with the point into long furrows. Considerable encrustation, weathering worse on front than back.

Preliminary notice by Christou and Demakopoulou, *ADelt* 21.B.1 (1966), 153 (no. A.2) and pl. 147 δ; A. Delivorrias, *ADelt* 24.B.1 (1969), 130 and pl. 117 β.

Together, the angle of the sectioned area behind the left shoulder (originally placed against the tympanon), the girdle and the line of the shoulders show that the right shoulder was raised, the left side was contracted, and that she lunged to her left. The left arm was never carved at shoulder height; as the direction and length of the cavities show, her right arm was probably lowered and her head was turned to her left. The left breast is rather further from the neck cavity than the right, indicating that the width of the (withdrawn) left side was somewhat increased. The torso is worked to a much smaller scale than the lying woman from the corner of the west pediment (no. 20) and agrees in scale with nos. 9-15. Since Pausanias mentions only one female figure in the east pediment, it seems likely that this is she—the heroine, Atalante.

She is clad in a chiton girdled close under the breasts and a himation slung over the left shoulder and wrapped around the waist, crossing the back diagonally from left shoulder to right hip, in a style usualy found on representations of Artemis.[27]

The chiton was drawn tight across the body, forming taut, sharp-edged folds often split into a double ridge by a central trough and undercut at the sides. There was little recutting of the edges, accounting for much of their hard, uncompromising character. Over the breasts, flat step folds with no undercutting show the increased tension of the cloth here and its changing character as it responds to the body forms below. The himation in front forms thick but still angularly sectioned folds, and partly covers the left breast. At the back, the drapery is flat and characterless.

The following are probably to be attributed to this pediment:

(9) NM 179. Dugas 17. PLATES 7, 8a-b, 38c-d, 52b-c

Head of a youth.

For provenience, see no. 5.

H 0.214; W 0.204; D 0.215.

See also Table 1.

Broken across neck 2 mm below chin. Cranium sectioned obliquely with long strokes of point, to rather above top of right ear. Nose battered; left ear, cheekbone, eyebrow chipped, minor chipping elsewhere. Deep diagonal gouges in hair above bridge of nose, above right temple and by right ear, all roughly parallel and perhaps made by a pick or spade. Original surface preserved in patches on left side of neck, cheek, nose, forehead, in internal angle and on orbital portion of upper lid of left eye; on the right, at corner of mouth, angle of jaw and along jawbone, below and in internal angle of eye, side of nose and temple. Elsewhere, weathering moderate (left side) to light (right side); some encrustation and fire-blackening, neck pocked below jawbone on right.

Dugas, 91-92 and pl. 102, B; Riis in *Festskrift Poulsen* (1941) fig. 7 to pp. 24-25 (cast); Lippold, *Plastik,* 251 and pl. 90, 4; Arias, 120 and pl. 9, 31; Picard, *Man* iv.1 (1954), 182,

190 and fig. 83; Alscher, *Griechische Plastik* iii (1956), 158 and fig. 56a, b; Richter, *A Handbook of Greek Art* (1959), 136 and fig. 197; Hanfmann and Pedley, *AP* 3 (1964), 63 and fig. 9; Arias, in *EncAA* vii (1966), 367 and fig. 459; Ashmole, in *EncWA* xiii (1967), 58 and pl. 42; Richter, *Sc⁴*, 53, 208 and fig. 737 (cast); Lawrence, *GRS* pl. 49b (cast).

The head was *appliqué* to the soffit of the raking cornice, and vigorously inclined and turned towards the left shoulder. The right side of the face pushes forward rather more strongly than the left, though the modelling is flatter and the eye less deeply set and less strongly curved; the axes of eyes and mouth seem parallel, though the nose angles slightly towards the spectator's left. The right side is on the whole less finished than the left, especially around the eye and ear. Apart from a few locks above the left temple, the hair was not modelled in detail.

The most obvious feature of the head, as has often been remarked, is its form, more cubic than most of the other heads; following this basic structure, the sculptor has tended to group the features at the front and sides, giving it, at least at first sight, a somewhat schematic appearance.

The bone structure, though overlaid by a surface treatment more opulent and rich than appears on any other head from the temple, is still solid and substantial, and the facial contours are determined chiefly by the obtrusive, widely-spaced cheekbones and broad cheeks, converging rather towards a short, fairly pointed chin and strong jaw, the broad nose with its heavy bridge, and the wide plane of the forehead. Anatomical distinctions are not unsubtle, though reduced greatly in intensity by the sheer volume of the flesh surfaces that overlie the muscles.

The neck is columnar and very thick, even in comparison with the other pedimental heads, although much of the added volume is due to the great contraction of the left sterno-cleido-mastoid. In profile, two features strike the eye immediately—the great depth of the head wth its rather flattened skull, and the out-thrust jaw and consequently slightly retreating forehead, its upper part already recessed to some degree. The occiput and the back of the neck form a single straight line (a feature characteristic of many Greeks to this day), instead of the gentle curve familiar among more Western peoples.

The focal points of the face are the eyes and mouth, both modelled in a strongly individualistic and emphatic manner. The left eye (more finished than the right) is treated in a way not previously encountered in Greek sculpture (PLATES 8b, 52b no.1).[28]

The structure of the eyesocket is in essence identical to that of no. 4; here, however, the sculptor has increased the volume of the outer part of the upper orbital enormously, so that it now bulges right over the eye to obscure the ocular portion completely towards the corner (cf. no. 18, where the weak and insipid treatment has caused the upper lid to take on a more 'normal' form).

The eye itself is thus not only isolated from the cheek by the well-defined transition to the lower orbital, but also deeply embedded in the head, enclosed by the fleshy swellings of the brow and cheekbone above and below, and the wide, tightly curved plane of the socket elsewhere. The eyeball is large and the glance is directed slightly upwards but not to either side, and the lower lid is stretched and depressed in the centre by the action of the pupil as it expands for distant focusing; the result is a rather unfocused gaze that derives what intensity and concentration it has more from the set of the head and the generally tense character of the facial muscles than from any definite force or vigour of its own.

The eyebrow is articulated as a slight ridge, which tends to disappear toward the outer corner of the eye as the swelling of the orbital increases. The modelling of the lower part of the forehead is canonical; the upper part is rectangular, flat and somewhat recessed, and the transition between the two is straight and hard.

The lips are thick and full, although battered; they and the flaring nostrils are firmly

embedded in the structure of the face, and the mouth is slightly open and tense—an impression which is strengthened by the contraction of the levator muscle and of the risorius (which runs diagonally down towards the jaw from the corners of the mouth), although the mouth itself remains straight. The upper lip is drawn up towards the nose, and this and the flaring nostrils create the unmistakable impression that the figure was panting. The heavy jaw, solid chin, firm modelling above the upper lip and around the mouth, and wide, bony nose pressing close upon it, both intensify and hold the expression steady, subordinating it to the facial structure.

The head is turned to the left; since the neck is so thick, and the head is also inclined, this means that the jawbone as such disappears on the figure's left side, although no folds of skin are shown whereas in life there would be many, and only a single hard line marks off the head from the neck.

The hair is battered, although on the left a little of the general pattern is clear; the locks are short, and two, better preserved than the others, are divided by furrows into three strands. Except near the hairline, most of the hair is not worked in detail.

The right ear was not carved, but the left is well modelled, cauliflowered, and protrudes increasingly towards the top (PLATE 52c, no. 1). The hair bulges over it above.

The scale of the piece, corresponding almost exactly with that of the female torso, no. 8, indicates that it belongs to the east pediment; it is certainly appreciably smaller than the heads nos. 16-18. The 'standing height', about fifteen times the measurement from the underside of the chin to the canthus, was about 1.60 m.

Since wounded warriors are often shown with their helmets off,[29] the lack of headgear is by no means conclusive as regards the attribution (though apparently accepted as so by Neugebauer), but is still valuable as contributory evidence, since the majority of classical representations show the hunters as bareheaded (see Appendix 2).

(10) Tegea, unnumbered. PLATE 8c-d
Male head.
From shelf marked ΝΑΟΣ ΑΛΕΑΣ ΑΘΗΝΑΣ in store.
H 0.260; W 0.192; D 0.216.
Broken across at base of neck; very badly weathered and battered, especially on left and in front. A metal dowel remains in its hole on the underside of the neck.

The head was turned and inclined to the figure's right. In form, the face seems to be more like no. 18 than any of the other heads, although the fragment is again too severely battered to be certain. In profile, the skull shows similar characteristics to those remarked upon in no. 9 and the silhouette at the back is especially close.

On the right side of the neck there is a bulge which can hardly be a muscle and ought therefore to be a join to another limb. The right ear was not modelled, neither was the hair on this side.

In scale, the piece is identical to no. 9, suggesting an attribution to the east pediment.

(11) Tegea 65. Dugas 21. PLATE 9 a-b
Upper torso (male).
H 0.27; W 0.392; D 0.238.
Neck, height 0.065; width 0.146; depth 0.140; circ. 0.480. Pit of neck to break on sternum 0.130.
Two fragments joined; broken across neck and chest. Left shoulder, right arm from insertion of deltoid, most of back missing. Front, especially neck and sternum, weathered, back pitted and chipped. Back finished only with point and claw around left shoulder-blade, and letter B cut into flesh at this point.
Dugas, 93 fig. 35 and pl. 105, A-B.

The head was inclined and turned fairly vigorously to the figure's right, and the right arm was pressed hard against the chest; the join continues as far as the sternum.

The sterno-cleido-mastoids dominate and dictate the character of the movement of the neck. The right is contracted, distorted by the movement into a dense roll of flesh that bulges out over the muscles of the shoulder, a sharp cut marking the transition; folds of skin on the neck heighten the effect. The left is stretched to become broad and tense although still fairly thickly modelled, its double origin well visible but disappearing rapidly towards the break. The clavicles are prominent, although the skin that covers them is thick and the forms rounded and fleshy.

The action of the right shoulder is extreme; as the hero swings his weapon back over his left shoulder in preparation for the slashing down-stroke, the arm pulls the shoulder forwards and inwards; the skin is stretched taut over the shoulder, just revealing the acromion, and the soft skin of the armpit and the insertion of the latissimus dorsi are visible between the pectoral and the enormous bulk of the deltoid. The anatomy of the back of the shoulder is treated similarly to no. 12 (see Table 2).

The piece would appear to be from the east pediment, considering its scale. Of the two measurements possible, one (between the pit of the neck and the acromion) is rendered unreliable by the compression of the shoulder. The other, the width of the pectoral from armpit to median line, is 24 cm on both this torso and no. 12; placed next to each other, these two pieces seem very close in scale. Also, I doubt whether the neck is thick enough for no. 11 to be from the same pediment as nos. 16-18.

(12) Tegea 64. Dugas 22. PLATES 9c, 10
Upper torso (male).
H 0.310; W 0.360; D 0.251.

Apex of shoulder to centre 0.190; outside of shoulder to centre, 0.235; apex of shoulder to just above waist 0.305. Superior border of trapezius to lower angle of scapula c. 0.205. Below serratus to pit of neck 0.230. Hollow between clavicles to depression of pectoralis major on clavicle 0.121.

Broken at neck, no part of which remains, and diagonally across from right side of neck to waist at left. Anterior finished only with claw and badly weathered, but weathering ceases abruptly along crest of shoulder and down exterior surface of arm. The original surface, slightly chipped in places, remains on part of apex of shoulder and shoulder-blades. On the left flank by a break, a dowel hole 0.9 cm in diameter and 2 cm in depth. A reddish patch on the trapezius by the neck could be a trace of paint.

Dugas, 93-94 and pl. 103.

(13) Tegea 1309. Dugas 23. PLATES 9c, 11
Lower torso (male).

Found immediately to the north of the fountain (i.e. c. 15-20 m north of the northeast angle of the temple).[30]

H 0.352; W 0.373; D 0.249.

Iliac crests, width 0.342; spinal furrow to level of left iliac crest 0.145, of right 0.190. Waist, width to left from spine 0.130, to right 0.165; circ. 0.875.

Broken across above inferior boundary of buttocks and just above waist. Most of front split away, leaving only waist intact (finished with claw); almost all of surface of right buttock missing. On the left hip, a puntello, 7.3 cm long by 5.3 cm wide, projecting to a maximum of 3 cm. Weathering fairly severe on back, light on left side, light to moderate on front. Some surface chipping and scoring, particularly on back.

Dugas, 94-96, fig. 37 and pl. 104. On both these fragments see ibid., 134-36 (Appendix III).

It would appear that these two fragments belong to the same figure. Berchmans'

argument that they do not rests on two counts: (1) that their scales are dissimilar and (2) that the movement of no. 12 is very different from that of no. 13.

Since the right side of no. 13 has clearly been deliberately broadened, as the measurements of the piece and PLATE 11a show, it would appear that the lateral dimensions, upon which Berchmans bases his case, are rather fallible indicators of scale. In fact, as the montage, PLATE 9c shows, the two pieces are of the same scale; the photographs were taken from a distance of exactly six feet. Taking the two individually, the figure of which no. 13 formed a part was certainly considerably smaller than the warrior represented by no. 26, who must have been about 1.90 m tall. Unfortunately, though, on no. 13 no sure vertical measurements are possible; on no. 12, the only reliable ones are those from the superior border of the trapezius to the lower angle of the scapula, and from below the serratus to the level of the pit of the neck, which on the related 'Meleager' both equal the head height. The former is 0.205 or a little more and the latter 0.230, indicating a correspondence in scale with no. 9 and a 'standing height' of c. 1.60 m.

Secondly, as the montage also shows, the two pieces are quite compatible from the point of view of their musculature and movement. I quote an opinion from Dr. Philip Houghton (Department of Anatomy, Otago Medical School):

> On no. 13, the right gluteal group is firmly contracted, the left more relaxed. On the left side the vastus lateralis and iliotibial band appear to be contracted. This is consistent with the centre of gravity of the body being over the right leg, which was clearly taking most, if not all of the weight. The leg was presumably slightly flexed and also externally rotated, the foot pointing to the side. The left leg was extended to the side, the sole of the foot being in contact with the ground. From the back, the protrusion of the muscles on the right and the curve of the spine show that the torso was inclined and twisted slightly in this direction; the abdomen shows the line of the recti muscles under contraction, indicating that, in addition, the upper part of the body was leaning slightly forward.
>
> From the back, the spinal curvature of no. 12 continues that of no. 13. The shoulder is slightly hunched, and the arm extended back at at least 30°, with deltoid and biceps strongly contracted. The head was turned to the left, as the remains of the sterno-mastoids show.
>
> The general physique and muscular contraction of the upper and lower fragments are entirely consistent with their belonging to one another.

Technically speaking, too, the two pieces are finished in an identical manner. Neither is completed on the anterior, where marks about 1.5 cm long from a claw chisel (3t/8 mm) are visible on the abdomen of no. 13 and the left pectoral, ribs and anterior of the arm of no. 12.

The scale, anatomy and technique of the two pieces, then, indicate that they came from the same figure, a warrior seen in back view recoiling to his right, and the scale alone that the warrior belonged to the east pediment. Although Rhomaios' account is not completely clear, the find circumstances of no. 13 would seem to support this. It was apparently found *in situ* (before the northeast angle of the temple), together with the architrave inscribed ΚΑΦΕΙΔΑΙ, itself a further argument that neither had been disturbed since it, too, seems to have come from the eastern end of the temple.

Finally, one or two further points of technique and style should be discussed. On the left hip of no. 13 there is a puntello, and on the left flank of no. 12 a dowel hole at the waist, angled downwards to the left. Before the figure was broken, the two were perhaps about 14 cm apart. Although it is likely that the puntello supported the forearm, the purpose of the dowel, too high up for this, is uncertain; a shield is probably not the answer, since the figure is almost certainly one of the hunters from the east pediment. More likely is a chlamys, perhaps wrapped round the arm and flying free past the body, or even a join to another figure (cf. no 28).

The hero is well-proportioned, with broad shoulders, a heavy, fairly short torso, and

wide hips. The musculature is powerful, convincing, and on the whole anatomically correct, though the left shoulder-blade (the inferior angle of the scapula) should probably be slightly lower than depicted; its high position is, however, at least consistent with a slight hunching of the shoulders. The sculptor has not aimed at a separate rendering of each muscle (he has not, for instance, distinguished the lateral and medial heads of the sacro-spinales, nor the teres minor and major over the shoulder-blade)—an approach that is in direct contrast with that of Lysippos and other contemporaries (cf. PLATE 29b). Instead, the flesh surfaces are deep and richly modelled and the transitions smooth and at times hardly discernible, so that of the stresses and strains set up by the movement ('véritablement brusque et violent'),[31] little evidence actually reaches the surface through the dense and heavy flesh layers above.

(14) Tegea 66. Dugas 24.	PLATE 12 a-b
Lower torso (male).
H. 0.380; W 0.350; D. 0.220.
Between anterior superior iliac spines c. 0.200; from navel to bottom of pubes, 0.220.
Broken across waist and top of right thigh; left side from boundary of abdomen split off. Front of thigh and part of lower abdomen chipped away, but otherwise original surface on anterior and right flank fairly well preserved. Left of abdomen lightly weathered. Back sectioned diagonally with long strokes of point, claw and point marks around.
Dugas, 96-97 fig. 38 and pl. 105, C-D.

Together, the position of the testes, which give the axis of the torso, the back (*appliqué* to the tympanon) and the small section of the left thigh remaining near the groin, show that the hero was lunging to the spectator's right. The external oblique is shown in tension, supporting the weight of the torso, and the abdomen is slightly distended (as in no. 13); the upper part of the body may have been leaning forward somewhat. From the position and degree of tension of the right gluteus it would seem that the right leg was extended, and the apparent contraction of the vastus lateralis and iliotibial band near the break indicates that the knee was off the ground.
 The style is similar to nos. 12-13 but finer; the flesh surfaces are more springy and less heavy, the carving clean and crisp.
 As for the scale, the measurement between the two anterior superior iliac spines, and the distance from navel to below the testes should equal aproximately the height of the head, which groups the torso firmly with the smaller scale figures of the east pediment.

(15) Tegea 2292.	PLATE 12 c-d
Lower torso and fragment of left thigh (male).
For provenience see no. 3.
H 0.19; W 0.30.
Broken across waist and below iliac spines; entire right flank missing. Fragment of left thigh and groin chipped, but otherwise surface on left better preserved, though still weathered, than on right. Left flank and back cut to a flat plane running the width of the fragment, by coarse strokes of the point.
Preliminary notice by Christou and Demakopoulou, *ADelt* 21.B.1 (1965), 170 and pl. 152α (upside down); Daux, *BCH* 92 (1968), 810 fig. 4 (again upside down).

The left thigh was partially flexed and set forward on the trunk. A heavy fold of flesh on the break above shows that the figure, *appliqué* to the tympanon wall, was bending forward from the waist and twisting to his left. The modelling is similar to no. 14, if rather more lumpy.

The accidents of preservation mean that no really conclusive measurements are possible, though it is clear when the three are placed side by side that this and nos. 13 and 14 are the same scale.

Smaller pieces which, by their scale, could belong to this pediment include a number of fragments of arms (Dugas 31, 34, 38, 42 and 44), two hands (Dugas 45 and 49), some pieces of legs (Dugas 60, 65, 68 and 89, together with some unpublished pieces in the Tegea museum) and perhaps the foot, Dugas 70.

C. THE WEST PEDIMENT

Pausanias does not tell us how many figures were shown in the west pediment, only that the subject was the battle between Telephos and Achilles on the plain of the Kaïkos (Appendix 1, no. 36). Major fragments of about eight or nine of the heroes are preserved, and it is clear that they were somewhat larger in scale than the figures of the east pediment, standing as they did to a height of c. 1.90 m.

Certainly belonging are nos. 16-21:

(16) Tegea 60. Dugas 7. PLATES 13, 14 a-b, 52 b-c
Male head wearing lionskin cap.
Fine to medium grained crystalline marble, with micaceous veins on the break at the neck.
H 0.314; W 0.239; D 0.266.
See also Table 1.

Joined from two fragments, broken diagonally across base of neck, small fragment of left shoulder remains. Part of chin and most of mouth and nose battered away, also much of cap behind left ear. Surface in poor condition, the original only surviving on parts of mane behind, and before left ear; elsewhere, badly weathered and striated. Rough point work appears on the crown of the head towards the back, though the area is not actually sectioned, as, for instance, on no. 9. It is just possible that part of the torso of this figure has been preserved in a non-joining fragment (no. 26).

Dugas, 87-88 and pls. 99, A; 100, A-C; Rodenwaldt, *Die Kunst der Antike* (1927) fig. 380,.2 (cast); Johnson, *Lysippos* (1927), 52-53 and pl. 8B; Pfuhl, *JdI* 43 (1928), 32 fig. 9; Beazley and Ashmole, *Greek Sculpture and Painting* (1932), 56 and fig. 120 (cast); Picard, *Man* iv. 1 (1954), 182-83, 186-88, figs. 81, 85 and pl. 4; Alscher, *Griechische Plastik* iii (1956), 158 and figs. 57a,b; Arias, in *EncAA* vii (1966), 367 and fig. 457; Boardman et al., *Art and Architecture* (1967), 441 fig. 170 (incorrectly captioned); Ashmole, in *EncWA* xiii (1967), 58 and pl. 41; Richter, *Sc⁴* (1970), 53, 208 and fig.739 (cast); Ashmole, *Architect and Sculptor* (1972), 147, 177 and fig. 167 (cast); J. Charbonneaux, *Classical Greek Art* (1972), 224 and fig. 255; Delivorrias, *BCH* 97 (1973), 121-27 figs. 2-4.

The head was turned vigorously and inclined to the figure's left, and the left shoulder was raised. The hero wears a lionskin cap whose modelling recalls to some degree the softly swelling forms of the head of the dog, no. 6; the mane is carved in an identical manner to the lion spouts from the lateral sima of the temple.[32] Its eyes were not carved. A lionskin cap is not an attribute that would characterise any of the participants in the Calydonian hunt, so this head should come from the west pediment of the temple. The figure it belonged to had a 'standing height' of about 1.90 m.

The left side of the face is wider and less finished than the right; the cheek is broader and less rounded, the eye rather flatter and its socket and eyebrow longer. The axes of eyes and mouth converge slightly to the left, and the centre of the cap lies above the internal angle of the left eye, though the fangs are symmetrically placed.

The oval of the face is short and heavy, but dominated by the relief of the cheeks and the

prominence and width of the cheekbones—here massive and almost angular, not really fleshy and full as those of no. 9. The forehead is divided as usual (see Table 2) but rounds off more towards the temples and lacks the strong rectangularity of that of no. 9.

The features, too, are less subtly modelled and more solid. The orbital again sags right down over the eye, concealing the ocular portion completely at the sides (PLATE 52b, no. 2); the glance is given a slight but definite direction to the spectator's right. The nostrils were dilated; remains of teeth are just detectable despite the poor condition of the mouth; the ears, finally, are cauliflowered. The hair is modelled similarly to no. 9 in thick, short curls divided into two or three strands.

The treatment of the neck and jaw also deserves comment. Lacking any distinction between medial and lateral heads, the sterno-cleido-mastoid muscles are solid and plate-like, each modelled as a single volume, framing the Adam's apple with their two tense, strong ridges at the front. The soft concavity found in life is completely absent from the transition between neck and jawbone; a sharp cut, emphasised with the corner of the flat, takes its place.

(17) NM 180. Dugas 9. PLATES 14 c-d, 15, 35 c-d, 52 a-c

Helmeted male head.

For provenience, see no. 9.

Medium grained crystalline marble, off-white on the break.

H 0.326; W 0.228; D 0.262.

See also Table 1.

Two fragments, joined through right side of face, the edges of the break battered. Most of chin, much of nose missing; broken across base of neck. Minor chipping on helmet and brows, other features battered. Original surface in patches on forehead, temples and eyes, and on much of right side of face and neck. Right side of face fire-blackened. Cranium sectioned similarly to no. 9, and right side left unfinished. The head itself may have been inset, for the right side and nape of the neck also seem to be cut flat, the two planes meeting at right angles, though no tooling is visible and the surfaces are somewhat convex.

Dugas, 89-90 and pl. 102, A; Rodenwaldt, *Die Kunst der Antike* (1926) fig. 380, 1 (cast); Johnson, *Lysippos* (1927), 52-53 and pl. 8A (cast); Pfuhl, *JdI* 43 (1928), 33 fig. 10 (cast); Riis in *Festskrift Poulsen* (1941) fig. 8 to pp. 24-25 (cast); Lippold, *Plastik*, 250-51 and pl. 90, 3; Arias, 120 and pls. 8, 28-29; 9, 30; Picard, *Man* iv. 1 (1954), 182, 188-89 fig. 82 and pl. 5; Richter, *A Handbook of Greek Art* (1959), 136 and fig. 196; Bieber, 24 and fig. 55; Hanfmann and Pedley, *AP* 3 (1964), 63 and figs. 7 and 8; Holden, *The Metopes of the Temple of Athena at Ilion* (1964), 26 and pl. 29, 54; Arias in *EncAA* vii (1966), 367 and fig. 456; Becatti, *The Art of Ancient Greece and Rome* (1966), 208 and fig. 181; Richter, *Sc⁴* (1970), 53, 208 and fig. 738 (cast); Delivorrias, *BCH* 97 (1973), 127-131, figs. 6-8.

The hero wears an Attic helmet, with a neck-guard and frontlet terminating in volutes.[33] Since helmets are not worn by the hunters of the Calydonian boar in mainland Greek art, it seems almost certain that this head is from the Kaikos fight; in scale, the piece is identical to no. 16.

The warrior's head, once *appliqué* to the soffit of the raking cornice, is turned very slightly and inclined to his left, and his neck is stretched forward. The right ear, together with the adjacent areas of hair and helmet are only roughed out, although the anatomy of the neck on this side is careful; the undetailed mass of the hair is identical in form to the corresponding parts of nos. 9 and 10. This side also has more breadth to it than the other, the cheeks are flatter, the eye-socket longer and the eyeball less curved. The right eyebrow has less volume to it than the left, although it swings further to the side; this gives the appearance that the horizontal axis of the eyes and mouth converge slightly to the spectator's left,

although the actual difference in the measurements from mouth to eye in each case is negligible; the axis of the nose inclines strongly to the spectator's right. Furthermore, on the right the mouth could be longer and is certainly set less deeply into the face.

The forms are handled for the most part in a manner virtually identical to no. 9, even down to details like the pattern of the hair over the left temple, the modelling and position of the horizontal transition across the forehead, and the treatment of the preserved portions of the left ear. The differences as regards detail are either minor—such as the slightly broader flange of the ocular portion of the upper eyelid, its visibiliy throughout its entire length and the slightly longer eyes—or attributable to a change in the context and action—for instance the direction of the glance to the spectator's right as well as upwards, and the open mouth and teeth. The forehead, however, lacks the rectangularity of the other, and rounds off strongly towards the temples. More serious still are the proportions: the face is a heavy oval, whereas the cheeks of the broader proportioned no. 9 are shorter, and they and the jaw slightly richer and fuller. These differences seem to preclude the possibility that the two heads are by the same hand, although their carvers certainly do seem to have had a great deal in common.

The treatment of the neck and jaw shows some sensibility towards anatomical distinctions, as the muscles at the front and side are pulled taut by the movement. The Adam's apple is firmly framed between the massive sterno-cleido-mastoids, of which only the right is preserved to any extent, and folds of skin are shown below it. The two heads of the sterno-cleido-mastoid are just apparent above the break, but disappear rapidly well below the jaw. The skin, though everywhere fairly thick, is stretched tight over the muscles, but still fairly elastic under the jawbone, forming a concave transition as dictated by the movement.

(18) Tegea 61 (number shared with no. 4). Dugas 8. PLATE 16
Helmeted male head.

Found in a wall built in the interior of the fountain (to the north of the northeast corner of the temple).

Medium grained crystalline marble with a slight bluish tinge and micaceous veins on the break.

H 0.301; W 0.195; D 0.137.

See also Table 1.

Broken across base of neck (break badly battered); back of head split away. Large chip on front of helmet; behind, cranium roughly punched in a manner similar to no. 16. Chin, nose, hair, eyebrow on right, eyebrow, hair and ear on left battered. Weathering moderate and fairly even; considerable pitting, especially on cheeks.

Dugas, 88-89 and pl. 99, B; 101, A-B; Rodenwaldt, *Die Kunst der Antike* (1927) figs. 381, 1 and 2 (cast); Picard, *Man* iv. 1 (1954), 188 and fig. 86; Richter, *Sc*[4] (1970), 53, 208 and fig. 740 (cast); A. Delivorrias, *BCH* 97 (1973), 125 and fig. 5.

The hero wears a helmet identical to that carried by no. 17, and was clearly worked to the same scale. On the crown of the head, the marble rises about 1 cm to the edge of the break, suggesting perhaps that an arm may have joined here. A small, rather battered marble tab projects downwards from the centre of the frontlet of the helmet, and may be the remains of a measuring point.

The head is inclined and turned to the right.[34] The right side is both slightly wider and less finished than the left, the eye is less deeply set but more strongly curved, and the modelling in general rather flatter.

Despite the surface damage, it is clear that the anatomy is rather weak and the forms at first sight seem only distantly related to the other heads. On the face, this apparent

discordance in the styles is especially noticeable in the cheeks, at the corners of the mouth, and around the eyes.

It should be emphasised at the outset that the structure of the eyes is canonical, the sole divergence from the normal scheme being the failure of the upper lid to cross the lower at the outer corner; the planes of the upper orbitals, brow and inner corner are arranged in exactly the same way as on the other heads, and the lower lid is again deep and down-drawn. Accordingly, it is to the sculptor's approach towards the surface modelling that we must turn for an explanation of the striking differences in appearance which have, surprisingly enough, attracted little attention since Neugebauer.

This is irresolute and tentative; the richness and strength of the other heads are missing, with the result that no longer do the rounded forms of the cheeks, brows and orbitals swell out to enclose and enframe the eyes and dictate the facial structure; instead, the volumes are reduced and the modelling insipid, and it is the oval of the face that dominates. The cheekbones have been given little prominence, and the arrow-shaped area beyond the outer corners of the eyes, although present, has become indistinct. The upper ocular is visible along its entire length. The muscles of the cheeks and lids, especially the lower orbital, which slides rather vaguely into the cheek, are slack and unstressed; this, together with the shallower setting of the eye that results, and the unfocused gaze, creates an expression that is far weaker than that characteristic of the other Tegean heads.

The mouth is damaged, but was again drawn up towards the nose; although it seems set hard, as if in fear, the quadratus muscle is hardly contracted, and the naso-labial furrow is shallow.

The lower forehead, unusually, forms two separate bulges over the bridge of the nose, and is divided off from the upper part by two sharp, curved transitions set side by side and meeting in the centre, instead of a single straight flat one as elsewhere. The hair is completely different from that of the other heads and is rather womanish, forming a single compact mass into which the separate strands have been lightly engraved. The proportions of the face are virtually identical to those of no. 17.

The modelling of jaw and neck is similar to that of the face. The right sterno-cleido-mastoid gives the direction of the movement, and two folds of skin are indicated on its surface, although in general it is less massive than usual, and the fibres at the front no longer build a V-shaped frame around the Adam's apple; the left is hardly indicated. The strong distinctions usual in the surface tension of the skin on the two sides below the jawbone resulting from the movement of the head are considerably muted; the jawbone is not so prominent, and the flesh seems flaccid and lifeless. A comparison with no. 9, where the movement is similar but more definite, makes the point clear. In profile, finally, the strong thrust forward of the lower part of the face and the powerful and definite line of the jawbone are absent.

(19) Tegea, unnumbered. PLATE 17a
Fragmentary female head.
From shelf marked ΝΑΟΣ ΑΛΕΑΣ ΑΘΗΝΑΣ in store.
H 0.282; W 0.202; D 0.135.
Back of head, neck and underside of jaw alone preserved, though badly battered. Hair weathered towards crown, neck lightly so. The crown was flattened with strokes of the point in a manner similar to nos. 16 and 18, and the back has been roughly punched in long strokes towards the left. This head may once have formed a part of the same figure as no. 20.

On the right, the sterno-cleido-mastoid is in tension, and the front of the neck also seems to be stretched; despite this, however, the transition between chin and neck is

sharply cut, not modelled as on no. 17. The head seems to have been inclined slightly to the figure's right. The hair is modelled in chunky S-curls, and one that has escaped damage shows a division into three strands. The curls are longer and finer than those of nos. 9, 16, and 17, and the hair forms a solid mass with little surface modulation. A narrow fillet is carved in the hair on the right side of the head, but disappears round the back and to the left.

The head amost certainly belongs to the west pediment. The neck is far too large to fit no. 8, and no further female figures are attested by Pausanias for the east pediment. A head height of about 26 cm agrees with either the akroteria or the west pediment, but the hair style, completely different from that of no. 4, clinches the matter.

(20) Tegea 194. Dugas 10. PLATE 17b
Central part of a lying female figure, on a plinth.
L 0.530; H 0.415; D 0.355.
Broken at top of thigh, just above waist, and around edges of plinth. Weathering on completed (right) side moderate, with some encrustation, although the cushion (?) on which the figure lies and the recesses of some folds retain their original surface to a great extent. The left side is only planned with the point and various chisels. The head, no. 19, may be part of this figure.
Dugas, 90 fig. 34 and pl. 107, C-D; Picard, *Man* iv. 1 (1954), 190-91 and fig. 84.

The figure was lying rather on her left side, on what would appear to be a folded cushion, but could just conceivably have been part of the himation, as shown by the similarly worked 'plinthenartig' area of drapery on which the river god Kladeos (Olympia east pediment P) lies. The (?) Hellenistic Lapith woman U from the other pediment is shown lying on a cushion, but to my knowledge no parallels are available in lying figures of a secure fifth or fourth century date.[35] The question thus remains open.

She was clad in a peplos, girdled round the waist below the apoptygma, and a himation, which crosses the apoptygma at the bottom. The peplos is stretched tight over the thighs and buttocks, and gathered in towards the waist, where the folds are soft, thick and wooly, although the softness is a little exaggerated by the extent of the weathering. The folds of the himation are fairly wide and a little undercut, and here the edges are battered in addition.

It seems possible that the head, no. 19, belonged to this figure. It was raised on the neck and seems to have been inclined slightly toward the left shoulder, which would fit the pose of the lower fragment as reconstructed by Berchmans. It was also unfinished on the left side.

Since no female figures apart from Atalante are attested for the east pediment by Pausanias (Appendix 1, no. 36), and since the torso and head are both of large scale, as a comparison with no. 8 shows, it is almost certain that this figure belonged to the west pediment. It should be noted that the presence of such a large female figure probably in the corner of the pediment is one of the most telling arguments against a diminution in the scale of the figures towards the corners.

(21) Tegea, unnumbered. PLATE 17c
Left arm with shield-grip.
Found early in 1971 in the retaining wall of the house of Alexis Konstantinopoulou by the steps down into the site (i.e. opposite the northeast angle of the temple).
Medium grained crystalline marble with a bluish tinge, and traces of micaceous veins on the break.
L 0.210; W 0.187; D 0.123.

Broken diagonally across below the elbow, and just above the wrist. Bottom of grip missing. Original surface on grip over arm, though flesh surfaces weathered and exterior battered. The exterior of the arm is flattened and roughly punched, and traces of the claw are evident on the back of the shield-grip.

The arm was flexed, but no individual muscles are modelled. It is surrounded near the elbow by the *porpax* or arm-grip of a hoplite shield, the tab below serving as an attachment to the shield proper (cf. BM 1016.25).[36] The edges of the grip are stiffened by two flanges, of which the one nearest the wrist bows out a little below. The top is unbroken, and suggests, together with the rough flattening at the back and the lack of a dowel-hole, that the shield was cut into the tympanon and painted. For this and the type, see BM 1013-14. 28, 30, 32, etc. Since the anterior and medial surfaces of the arm faced the spectator, it seems clear that the fragment belonged to a warrior who was facing to the spectator's right.

Compared with some of the smaller fragments, it is clear that this piece is of large scale; this and the armour assign it, in all probability, to the west pediment. Like no. 10, it came to my notice after the division of the fragments between the two pediments, and thus provides fairly firm independent corroboration of the conclusions already reached.

In addition to this piece, six fragments of shields (Dugas 11-16) must belong to the west pediment.

The following are probably also to be attributed to this pediment:

(22) Tegea 63. Dugas 18. PLATE 18a
Fragmentary male head.
H 0.156; W 0.132; D 0.088.
See also Table 1.
Only chin, anterior of neck, mouth and nostrils remain. Original surface visible on neck and jaw to left, and on patch on neck to right; otherwise severely weathered.
Dugas, 92 and pl. 100, D.

The head was raised and inclined to its left. The anatomy of the face is given similar treatment to no. 9, and the modelling, even when the surface is in such bad condition, seems to have been rich and powerful. The jawbone is solid and definite, and the skin below responds to the movement, wrinkling a little on the left. The weathering indicates that the right side probably faced the spectator, although since there seems no difference in the quality of work between the two sides, the chances are that the head was meant to be seen in three-quarter view. The expression of anguish on the face suggests that it belonged to a wounded or dying warrior, looking up at his adversary, or lying on the ground.[37]

The scale of the piece indicates an attribution to the west pediment. Where comparable, the measurements correspond closely with those of nos. 16-18.

(23) Tegea 62. Dugas 19. PLATE 18 b-c
Fragmentary male head.
H 0.220; W 0.183; D 0.209.
See also Table 1.
Broken at base of neck and diagonally across face and back of head. Original surface preserved on anterior of neck, under jawbone, and on neck and shoulder to right. Left side badly weathered. Short strokes of the point appear on the back of the neck.
Dugas, 92 and pl. 101, C-D.

The head was raised on the neck and vigorously inclined and turned towards the right shoulder, a little of which still remains. The pose seems to have been a more extreme version of no. 16, but in mirror-image, and technique and weathering suggest that the piece was to be seen in three-quarter view from its left.

Two factors support an attribution to the west pediment: a ridge running from above the ear to the back of the head for about 12 cm along the break, possibly the remains of a helmet (the edge of the helmet of no. 17 lies in exactly the same place), and the scale, which fits with that of nos. 16-18.

As for the features, the jaw is heavy, solid and prominent, especially on the left (cf. no. 16 here), and the cheeks broad and flat. The ear and hair are too battered to make any discussion worthwhile. The anatomy of the neck and its relation to the jaw strongly recall no. 16, with the massive, plate-like sterno-cleido-mastoids, neither of which has received any internal modulation, framing the Adam's apple and the omohyoid; the right is contracted and its dense mass compressed and distorted towards the horizontal into the interval between the side of the jaw and the shoulder, greatly intensifying the action (cf. no. 11). The transition between neck and chin is rendered as a sharp cut on the right, and—unlike no. 9—the jawbone is still prominent, showing how the movement of the other is yet more violent still; on the left the cut disappears into a rather hard, concave transition which again leaves the line of the jawbone as the dominating element.

(24) Tegea 1597. Dugas 20. PLATE 19a
Fragmentary male head.
Found near Ayios Ioannis.
H 0.262; W 0.103; D 0.132.
See also Table 1.
Part of left side of head and neck alone preserved; hair split away from about 3 cm above ear. Hair, ear, underside of jaw weathered. Modelling incomplete: hair roughed out with point, earhole drilled twice with 5 mm drill (the first attempt presumably being too low down); earlobe never carved.
Dugas, 92-93 and pl. 112, B.

The head was turned and inclined slightly to its left, for the sterno-cleido-mastoid is contracted, though the action is totally lacking in power and the forms weak and fluid. It was also raised on the neck. Considering the weakness of the muscle and the omission of the helmet, the hero could thus have been represented as dying or dead, lying on the ground with his head thrown back, as, for instance, were several of the warriors on the Alexander sarcophagus.[38] The finish suggests that the part preserved was not directly visible to the spectator.

The hair is similar to that of no. 9, and the ear is thickly modelled.

The scale of the piece groups it with those already attributed to the west pediment. The height of the head was at least 26 cm, and the distance from the earhole to the underside of the jaw (measured vertically) at least 11.9 cm. This agrees well with the corresponding measurements for nos. 16-18 given in Table 1, and visually the piece seems identical in scale to no. 17 (cast in the Tegea Museum) which would seem to justify an assignment to the west pediment, even though no helmet appears to have been worn. (The correction of the sculptor's mistake in drilling the earhole confirms its validity as a measuring-point.)

(25) Tegea, unnumbered. Dugas 26. PLATE 19b
Part of left upper arm and side of torso (male).
H 0.168; W 0.239; D 0.242.

Broken across at height of armpit and just above interior angle of elbow; fragment of torso from third to fifth ribs preserved. Serratus and biceps badly weathered, original surface remains between arm and body only. The back of the torso and posterior surface of the arm were sectioned with coarse strokes of the point for the whole height of the fragment as, for instance, on no. 14.

Dugas, 98 and pl. 109, B.

The figure was *appliqué* to the tympanon, which puts him in a three-quarter position, facing to the spectator's right. The arm was held close in to the side of the body; its individual muscles do not seem to have been modelled, though the origin of the brachioradialis is just visible on the break below. The three serratus muscles are very prominent.

Since the volumes of the serratus and arm are much greater than on no. 12, the fragment presumably comes from the west pediment.

(26) Tegea 67. Dugas 25. PLATE 19 c-d
Lower torso (male).
H 0.442; W 0.378; D 0.254.
Iliac crests, width 0.380. Between anterior superior iliac spines, 0.253; median to right anterior superior iliac spine 0.137; to left 0.131. Waist, width 0.350; circ. 0.940. Navel to pubes, 0.150.
Broken at tops of both legs and split away above waist at front; most of buttocks and back except area of waist missing. Surface fairly intact behind and between legs, though weathering in front moderate, heavier to left. Considerable chipping and scoring. The preserved portion of the back and part of the right flank are claw-chiselled. See no. 16 for a fragment that could just possibly belong.
Dugas, 97-98 fig. 39 and pl. 106, A-B; Picard, *Man* iv. 1 (1954), 171 and fig. 80.

The right buttock is set higher than the left, showing that the right leg was set forward and the left withdrawn. The curve of the spine, the depth of the linea alba and projection of the rib-cage over the external oblique on the left, together with the slight angling of the testicles to the axis of the torso show that the latter was inclined and twisted somewhat to the figure's left. The relief of the sacrospinales is not as great as on no. 13, suggesting that they are tensioned to support the weight of the torso, which was bending forwards a little.

Again, the main features of the musculature are the deeply modelled, massively rounded forms and hardly detectable surface modulations (except where the movement has to be defined, as in the case of the deep transition between the rectus abdominis and the external oblique on the left). The heavy, bulging iliac crests balance the wide, fairly flat abdomen, which gently swells out towards the navel into two low convex planes, separated by the shallow depression indicating where the linea alba fades out below the waist. The navel is small and round (as opposed to triangular on no. 15), and the abdomen is only marked off from the pubis by the projection of the hair, and not by the 'rounding off' of the rectus so common in much fourth century sculpture (compare PLATE 37b).

The scale of the piece indicates that it belonged to the west pediment. The distance between the anterior superior iliac spines would give a head height of almost exactly 26.0 cm; this coincides with the three heads nos. 16-18 and also with the projected 'standing height' of c. 1.90 m given above.

Many of the small pieces of limbs excavated by Dugas seem to belong to this

pediment, for example the arms Dugas 28 (PLATE 20a-b), 29, 30 and 32, the hands Dugas 46-48 and 51 (PLATE 20c), and the large fragment Dugas 6 (PLATE 20d-e). As for legs and feet, Dugas 53-58 (PLATES 21-22c), 61-63, 66, 69, 71 and the new piece, Tegea 2299 (PLATE 22d) are all definitely larger in scale than those already ascribed to the east pediment.

A number of fragments of drapery in the Tegea store, only some of which have been published (Dugas 73-86) can be ascribed on general grounds to the pediments and akroteria, though in the absence of new joins it is of course impossible to go any further than this.

D. THE METOPES[39]

Since Pausanias does not describe the metopes, the subjects of the twelve reliefs must be deduced from the surviving architrave fragments from the pronaos and opisthodomos that are inscribed. Apparently scenes from Tegean legend and history occupied the east porch, and the life of Telephos the west. Only a few pieces of sculpture, about eighteen in all, are preserved, and none is certainly attributable to any definite scene. The figures were *appliqué*, as is clear from the treatment of the backs of some of the fragments and from the remains of the panels themselves. All are of small scale, from figures varying in height from 60 cm to about 1.4 m; in comparison, the frame measured 1.022 by 0.993 m, including the crowning *taenia* in the latter measurement.

(27) Tegea, unnumbered. PLATE 23 a-b
Male head.
From shelf marked ΝΑΟΣ ΑΛΕΑΣ ΑΘΗΝΑΣ in store.
H 0.221; W 0.113; D 0.181.
Right side of head, large patch of hair on left missing; broken across at base of neck. Front rather weathered, left side less so. Features battered, point of chin missing. Minor chipping on face and around edges of breaks. Sides fire-blackened.

The head was inclined and turned slightly to the left, and shows occasional variations in detail from the majority of the pedimental heads, especially in the treatment of the upper lids, which bulge out towards the corners only slightly, although the 'gap' at the side of the eye, the deep lower lid, the crossing of the lids, and the canthus are all present. The damage to the eyebrows both makes it impossible to say whether the planes were arranged in the same fashion as on the pedimental heads, and gives the expression a more agonised character than would have been the case originally. The formation of the eye is perhaps closest to no. 18, out of all the large scale heads from the temple.

The only variation in the modelling of the forehead is the absence of a definite cut to distinguish the lower part from the upper; the cheeks are very similar to those of no. 17, as are the general proportions of the face. The naso-labial furrow, deep and prominent, increases their rounded and fleshy appearance. The mouth again seems to have been drawn up towards the nose, the nostrils were flaring, and the deep drilling of the corners gives the face an agonised expression. The jaw was firm, and as usual separated from the neck by a sharp cut; the muscles of the neck do not seem to have been modelled, although the damage around the break is extensive.

The ear was only planned, and covered above by the hair, which is long and wavy. The carving seems of high quality.

The weathering and more summary treatment of the hair behind the ear suggest that the piece was to be seen in three-quarter view, with its right side facing the spectator. The height of the head (0.19) gives a total height of around 1.4 m, so the figure could not

have been shown standing upright within the metopal frame.

(28) Tegea, unnumbered. PLATE 23a

Female head.

On shelf with no. 27.

H 0.220; W 0.111; D 0.127.

Broken at base of neck, edges of break battered; badly weathered all over, and encrusted on left. Back and top of head flattened with short strokes of the point; a metal dowel, diam. 4 mm still remains in the right cheek.

The head was apparently turned violently to the figure's right, for the bulge of the sterno-cleido-mastoid on the right of the neck is very prominent. From the position of the flattened area at the back it is clear that the piece faced very slightly to the spectator's right; the dowel presumably supported a join to another figure. The flattened part on top could suggest that the head overlapped the fascia above the metope proper, to rest directly against the soffit of the block which crowned the frieze.[40] The scale is very slightly smaller than that of no. 27, and the original height of the woman therefore around 1.30 m.

(29) Tegea, unnumbered. PLATE 23 a-b

Female head.

For provenience see no. 27.

H 0.201; W 0.124; D 0.125.

Very weathered all over; the bottom of the neck is battered, though the underside is not broken but rounded off, indicating that the head was once inset. There is a large drill hole in the back of the neck, 1.4 cm across by 1.5 deep, and at least seven others, smaller and shallower, below it.

The face is too battered to enable any discussion of the modelling, although the eyes seem to have been deep-set. The hair seems to have been held in place by a fillet, and was modelled similarly to that of no. 19. The head seems to have been held erect, and from the position of the large dowel-hole in the back apparently faced rather to the spectator's right. The figure it belonged to was perhaps about 1.15 m tall.

(30) Tegea, unnumbered. PLATE 23a

Draped male torso.

Found with fragments of the architectural decoration of the temple and with five other pieces from the metopes at the back of the museum garden in 1971.

H 0.166; W 0.188; D 0.132.

Circ. of waist 0.468; girdle to shoulder 0.153.

Broken at waist and diagonally across right side; left arm missing from just below shoulder. Anterior rather weathered and encrusted, posterior uncarved. There are three rough gouges behind the left shoulder that could perhaps have been made with the point.

The figure was clad in a long tunic, girdled at the waist, which forms sharp, flattish folds on the anterior. It was clasped on the left shoulder by a brooch, and some object hung down in front, covering the girdle in the centre. The piece seems smaller in scale than any of the heads; the measurement from waist to shoulder would give a head

height of c. 10 cm, and an overall height of c. 75 cm. The long tunic seems to identify the figure as a charioteer.[41]

(31) Tegea, unnumbered. PLATE 23 a-b
Male torso.
Found with no. 30.
H 0.124; W 0.140; D 0.080.
Broken at waist and neck. Right arm and most of left missing, though break down left flank shows that this once joined here. Anterior moderately weathered, posterior less so.

The pose seems to have been virtually identical to that of no. 12, with the torso leaning to the figure's right and the left arm withdrawn. On the anterior, the pectorals are well modelled, as is the deltoid, and the muscles of the back are virtually a small-scale edition of those of the larger fragment—the deltoid, trapezius, teres major/minor/infraspinatus, and latissimus dorsi groups are all clearly visible. The scale is very small, and gives a rough height for the standing figure of c. 60 cm. Since the two sides are equally well worked, and there is little to choose between them in the weathering, it is possible that the fragment was shown in profile or nearly so.

(32) Tegea, unnumbered. PLATE 23a
Lower torso and upper thighs, perhaps of a baby.
From shelf marked ΝΑΟΣ ΑΛΕΑΣ ΑΘΗΝΑΣ in store.
H 0.163; W 0.167; D 0.107.
Broken diagonally across below right buttock and towards lower end of left thigh; some chipping on breaks and flesh surfaces. Anterior of torso badly weathered and battered, posterior less so. The top is flattened in the centre just below waist height, presumably for a join, though no tool marks or dowel holes are visible.

The right leg was set forward somewhat. The flesh surfaces on the back are elastic and modelled with an amplitude almost unparalleled in the other temple fragments. The front is too badly weathered to comment upon. The piece could be from a child or baby. If this is so, the original height could have been around 70-80 cm.

In addition, a number of fragments of limbs and pieces of drapery in the museum store, some of them published by Dugas (his nos. 90-96), also belong to the metopes.

CONCORDANCES

1. With Neugebauer, *Studien*, 22-24:

Neugebauer	Catalogue	Neugebauer	Catalogue
a	9	f	13
b	17	g	(Dugas 53-4)
c	16	h	
d	18	i	5
e	26	k	6

2. With Dugas, 80-125.

Dugas	Catalogue	Dugas	Catalogue
1	1	20	24
3	5	21	11
5	6	22	12
7	16	23	13
8	18	24	14
9	17	25	26
10	20	26	25
17	9	98	2
18	22	106	4
19	23		

TABLE 1: MEASUREMENTS OF THE HEADS

KEY: *top cut away; H helmet rim; + roughed out only.

Attribution:	Akroteria	East pediment		West pediment						
Catalogue no.:	4	9	10	16	17	18	19	22	23	24
(1) GENERAL										
total height	31.5	21.4	26.0	31.4	32.6	30.1	28.2	15.6	22.0	26.2
max. width	14.5	20.4	19.2	23.9	22.8	19.5	20.2	13.2	18.3	10.3
max. depth	22.9	21.5	21.6	26.6	26.2	13.7	13.5	08.8	20.9	13.2
(2) HEAD: VERTICAL										
total height	c.25.5	*20.7	21.8	*24.8	*25.0	26.3	*25.9			*26.2
chin to hairline	c.18.0	15.5								
below chin to base of nose		05.9		06.9	06.9	06.9		07.0		
below chin to canthus	12.0	10.4	10.5	12.3	12.3	12.4				
below chin to bridge		12.5		14.3	14.4	14.4				
below chin to hairline	19.1	16.8		H18.0	H18.3	H18.1				
base of nose to bridge		06.6		07.4	07.5	07.5				
bridge to hairline	05.0	04.4		H03.7	H03.9	H03.7				
outer corner of mouth to canthus	07.0	06.1	06.1	07.2	07.1	07.2				
(3) HEAD: HORIZONTAL										
outermost locks of hair		19.8	19.3	20.3	21.8	19.5				
temples		13.2		14.1	14.0	13.8				
before tragus of ear		15.7	15.1	17.0	15.9	15.8				
outer corners of eyes		09.5		10.2	09.7	10.2				
cheekbones		10.5		11.9	11.5	11.4				
(4) HEAD: DEPTH										
nose to outermost locks		23.5	21.5	26.8	26.8				14.0	
earhole to underside of chin	12.5	13.5		13.9	14.0	14.0				c.14.0

Attribution:	Akroteria	East pediment		West pediment						
Catalogue no.:	4	9	10	16	17	18	19	22	23	24
(5) DETAILS										
mouth length		04.7		05.3	05.3	05.3		05.2		
left eye length	02.8	02.8		03.3	03.3	03.3				
left eye height	01.4	01.4		01.7	01.5	01.5				
right eye length		+02.8		03.3	+03.0	03.1				
right eye height		01.4		01.8	01.4	01.4				
left ear length		05.4		+06.5	06.8	07.2				06.6
right ear length		-		07.0	+06.5	06.5				
(6) NECK										
preserved height to join of chin	06.1	00.2	02.4	07.0	09.0	03.5	02.2	03.3	05.4	
max. width	13.1	14.5	13.8	16.1	14.5	14.5	12.0	11.4	15.6	
max. depth	14.3	14.7	16.0	15.5	18.0			14.0	15.2	
circumference at chin height	42.7	45.0	50.0	50.5	53.0				50.5	

TABLE 2: ANATOMICAL ANALYSIS

Notes: (1) little or no attempt was made to model areas invisible
to the spectator; here, only finished surfaces are investigated;
 (2) when muscles are said to form a 'group', no internal
subdivision is detectable.

THE HEAD		
Skull	4, 9, 10 16-19, 22-4, 27-9.	General structure varies between heavy oval (18) and trapezium (9, 16); deep, but usually rather undeveloped at back (except 27), and fairly flat on top. Chin tends to jut and angle of jawbone often prominent. Nose broad, cheekbones massive. Lower forehead bulges and divides into 3 parts: central, trapezoidal section to summit of superciliary arch and two bulges at sides; upper forehead somewhat recessed. Temples hollowed. Bones of cheek and forehead meet rather behind outer corner of eye, leaving concave, hour-glass shaped patch of skin between them.
Ear	4, 9, 16-18, (23), 24, (27)	Position of top of helix varies from level with summit of superciliary arch (9) to level with outer corner of eye (16). Ear of 4 abnormally low, of 24 corrected and moved up. Protrudes increasingly towards top, and usually very fleshy. Antihelix always prominent.
Eye	4, 9, 16-18, 27 (28, 29)	Setting varies between fairly shallow (18, 27) and deep (9, 16). Deep lower lid always well distinguished from cheek; upper eye-socket and orbital formed by two planes, upper of which narrows and disappears towards bridge of nose, lower widens to sweep in tight curve around inner corner of eye and merges into side of nose. Volume of upper lid varies between normal (4, 18, 27) and swollen (9, 16) within same basic scheme, gradually covering upper ocular. Upper lid crosses lower except on 18. Eyeball usually strongly curved in horizontal, fairly flat in vertical plane; canthus and lachrymal caruncle regularly marked.
Mouth	9, (16), 17, (18), 22	Lips thick and full; upper regularly protrudes over lower and drawn up to base of nose. Teeth indicated in 16, 17, but not individually modelled.
Hair	9, 16-19, 23-4, 27-9	Much variation; short, chunky, thick locks common for males, 2-3 strands sometimes indicated; finer strands in single mass in 18. For females, either long and flowing (4) or shorter and rather curly (19); forms ogival arch over forehead in 4, 28, 29.
NECK	1, 4, 9-11, (12), 16-19, 22-4, 27-9	Usually thick and heavy; transition to jaw often sharp, even when movement dictates otherwise. Sterno-cleido-mastoids invisible on most female heads (1, 4, 19, 29), relatively undeveloped on 10, 18. Otherwise massive and solid, sometimes abnormally so (9), dual origin rapidly effaced. Adam's apple regularly modelled, omohyoids only on 11, 22 and 23.

TORSO, FRONT	1, 3, 11-15, 25-6, 31	Broad-shouldered, stocky and heavy. No complete example preserved of male, one only of female (1).
Median line	11-15, 26, 31	Deep, broad trough swiftly effaced below navel.
Lower boundary of thorax	-	Nowhere preserved.
Rectus abdominis	13-15, 26	Broad and swelling, deep lineae semilunares. Waist disappears as definite line.
Navel	15, 26	Triangular, overlaid by skin fold (15), round and open (26).
Lower abdominal boundary	14, 26	Semicircle, flattened and not outlined across upper edge of pubes.
TORSO, BACK	11-13, 26, 31-2	
Spine	11-13, 26, 31	Wide, V-shaped trough; no vertebrae indicated.
Musculature	11-13, 26, 31-2; Dugas 27	Infraspinatus, teres minor and major, inferior angle of scapula grouped into single broad volume. Lateral and medial heads of sacrospinales not distinguished.
ARM	1, 2, (11), 12, 21, 25; Dugas 28-44, 90-94 and others in Tegea store	Individual muscles virtually indistinguishable on female (1, 5; Dugas 36, 39, 41, 90); metopal fragments model biceps only (Dugas 91 and others). Modelling on male pieces from pediments varies from extremely tense and detailed (Dugas 28) to smooth and flowing (Dugas 29); most pieces fairly fleshy. Brachialis and various heads of triceps grouped into single volume, except Dugas 28 where former distinguished; same applies to brachioradialis and extensor carpi radialis longus on forearm. Extensor carpi radialis brevis and extensor digitorum communis never separately modelled, stressed as group by Dugas 28 alone. At wrist, muscles on anterior regularly generalised into 3 groups: flexor carpi radialis, palmaris longus and flexor digitorum sublimis, flexor carpi ulnaris; these distinctions are effaced fairly rapidly above wrist. Head of ulna usually clear, head of radius prominent only on Dugas 50, pisiform bone on Dugas 42.
Hand	2; Dugas 6, 45-9, 51-2	Anatomy generalised: on palm, opponens, abductor and flexor pollicis muscles form one group, palmaris brevis the other; folds of skin regularly represented. On posterior, extensor digitorum muscles only on Dugas 46, 48. Fingernails on all preserved fingers (2; Dugas 6).

LEG	1, 3, 13-15, 32; Dugas 53-72 and others in Tegea store	Only gastrocnemius distinguished on female. On male, modelling varies between broad and flowing (Dugas 53) and very detailed (Dugas 56). On thigh, two heads of rectus femoris not distinguished; sartorius treated as broad, flat transition to abductor longus/gracilis/semitendinosus group. No fragment models posterior of thigh. Construction of anterior of knee (Dugas 53, 55-7, 63, 65; 66; and others) generalised, and consists of four elements only, separated by deep transitions: patella, condyles to sides, bulge of vastus medialis above, regardless of position of joint. In life, femoral and tibial condyles not only distinct (here, Dugas 56 only), but partially hidden by patella when leg extended or only slightly flexed. Bulge of vastus effaced by extreme (Dugas 53, 4), not partial flexion of leg (Dugas 56).
		Biceps femoris and iliotibial band distinguished on exterior of knee on pediments unless flexion extreme (Dugas 53), not on metopes; former regularly runs directly into soleus/peroneus group, omitting head of fibula. Tibia usually curved. On medial, soleus and flexor digitorum longus form single volume characterised by sharp, raised ridge and deep transition to tibia; joins medial malleolus on Dugas 60, correctly modelled behind it on Dugas 56; volume occasionally abnormal (Dugas 59, 60). Two heads of gastrocnemius never distinguished.
Foot	Dugas 69-72, Tegea 2299	Modelling generally broad; instep regularly high, once abnormally so (Tegea 2299). Extensor digitorum longus and metatarsals only distinguished near toes, though treatment of Dugas 69 more detailed. Second toe always longer than first, toenails regularly shown (Dugas 69-71).

Veins are to be found on 9 fragments of arms, hands and feet. In four cases (Dugas 41, 69, 70 and a wrist in the Tegea store) these seem to be in the correct positions, and in three (Dugas 38, 47, 49) not; surface damage makes the other two (Dugas 46, 50) doubtful.

In general, it seems to me that such knowledge of the anatomy of the human body as these sculptures betray could have been obtained without the aid of dissection. The introduction of this technique is occasionally ascribed to the classical or even to the archaic period; here, I follow Edelstein, who shows that it was not practised systematically, if at all, before Herophilos and perhaps Erasistratos in third century Alexandria.*

*L. Edelstein, *Ancient Medicine*, 247 (='Die Geschichte der Sektion in der Antike', *Quellen und Studien zur Geschichte der Naturwissenschaften und der Medizin*, iii.2 [1932], 50 [p. 100 of the volume]). I thank Prof. I. M. Lonie for this reference. Cf. also P. M. Fraser, *Ptolemaic Alexandria* (1972), 347-56.

Chapter One

TECHNIQUE

The marble used for the sculptures was fine to medium grained, often with a tinge of blue to it and strongly crystalline.[1] It has a tendency to flake, especially after long exposure to the elements, when it turns a grey colour, while surfaces in contact with the earth become red-brown. These qualities find their best parallels in samples both from the fabric of the temple (excluding the foundations) and the local quarries at Dolianà, some five miles to the south of the village of Alea and the temple of Athena. I have visited the area twice and have collected twenty samples of the marble, concentrating on the vicinity of the rock wall itself where the largest outcrops, most suitable for monumental sculpture and for building, are to be found.

Since it was impossible to take samples from the temple sculptures themselves, examination was visual only, with the aid of a magnifying glass. Micaceous veins appear in one sample, as they do in nos. 16, 18 and 21. In particular, I can find no characteristics in the marble of the akroterion fragment no. 1 that are not paralleled elsewhere among the temple sculptures (e.g. no. 14) or the samples; the degree of compaction of the grains seems to me to be no argument and varies with the weathering, since even the extremely friable state of some of the smaller pieces recurs on parts of the ruined Artemis temple near the quarry site, and the hard, close-packed marble of the torso no. 1 reappears on two of the samples and the occasional piece from the pediments or metopes (e.g. nos. 14 and 27). What seems to separate no. 1, and less surely no. 2 from the majority of the fragments is not that their marble comes from a different source, but that it is better quality marble from the same quarry.

In this context, it is worth noting that in the accounts of the temple of Asklepios at Epidaurus, 2240 drs. were paid to the sculptors of each set of akroteria, as against only 3010 drs. for a pediment (each comprising twenty-two figures—including horses but excluding the Palladion);[2] perhaps, then, the better quality of the marble of the akroteria above the east pediment at Tegea reflects the higher esteem in which these (as freestanding statues ?) were evidently held. Their greater degree of exposure to the elements may also have counted in the choice of better material.

Point, claw, flat chisel, drill, rasp and emery, ranging from coarse to fairly fine, were used for the carving—in other words, the full range of tools available to a sculptor at the time. The methods employed by Greek stonemasons using these have been admirably elucidated by Adam and thus, as in general the evidence firmly supports her conclusions, only certain special points require further comment.

Probably the most striking feature of the technique of the Tegea sculptures is the variety of ways in which the parts that were invisible to the spectator were treated. The backs of the akroteria were planned with short 'masons's strokes' of a medium point, followed by long, broad strokes of the flat, and then worked over in places with the corner of the tool (PLATE 2c), a sequence that recurs occasionally on late fourth century works.[3] Prior to this period akroteria were usually finished at the back, lacking only the final smoothing, since to an observer looking at the side of the temple this area would have been at least partially visible; examples are the 'Aura' from the Palatine, the Nikai ascribed by Picard to the temple of Apollo at Bassae, the Nereids from Formia in Naples, and the akroteria from the temple of Asklepios at Epidaurus. At the very end of the fourth century, the Nikai from the temple of

Artemis at Epidaurus were left unfinished, although the work proceeded farther than on their Tegean sisters.[4]

The invisible areas of the pedimental figures range from those fully modelled in the round (e.g. nos. 12, 13 and 26: PLATES 10c, 11c) to some that are cut flat by a coarse point driven in long furrows over the surface (nos. 8, 14, 15, 25: PLATES 6c, 12b and d). Since this 'sectioning' seems to have been fairly well tailored to fit the tympanon wall or (in the case of the heads) the soffit of the raking cornice, it seems unlikely that what we have here is 'the punched surface of the original block' as Adam believes;[5] on some fragments (e.g. nos. 15 and 25) the cutting is drastic and the figure would have more resembled an appliqué relief than part of a pedimental composition in the round.

Such summary treatment of the backs is a novelty in architectural sculpture—contrast the care bestowed on the pedimental figures from Aegina, the Hephaisteion, the Parthenon, the Argive Heraeum and the temple of Asklepios at Epidaurus;[6] although the Parthenon figures were hacked about after completion to fit them into the architectural frame, this was the result of a mistake and presumably not general policy.[7] Once again, one has to turn to the second half of the fourth century fo find parallels—the statues of two women in the Metropolitan Museum, for example.[8] Apart from any evidence that such truncated figures may furnish for the composition of the pediments, could they also possibly be an indication that sculptors were realising that once a figure was fully formed in the round in the imagination, there was no need to translate the concept literally into stone to evoke the same impression in the mind of the observer? Thus, the uncarved backs of the statues from the Olympia pediments,[9] though superficially similar in form, are really poles apart from their Tegean counterparts; the point is perhaps best illustrated by Rhys Carpenter's remark that 'the statues at Olympia were still not fully emancipated from the category of relief carvings', compared with the 'sense for solid form' manifested in the figures of the Parthenon pediments and later.[10]

The pediments of the temple of Apollo at Delphi, believed until recently to have been wholly lost, show us the next stage.[11] Here, some at least of the figures were not only sectioned but actually hollowed out at the back, again with rough strokes of the point, to reduce their weight. Since the style of these figures (and especially of the drapery) dates them to c. 330 or a little later, a clear development in technique can now be traced over about seventy years of pedimental sculpture, from Epidaurus in the 370s through Tegea in the middle of the century, to Delphi at or near its end.

The backs of other fragments were shaped roughly with a medium point and then left, for instance no. 21 and Dugas 55. Several of the Mausoleum heads are worked in the same manner as nos. 4, 10, 16, 18 and 19, where the crown of the head shows dents or short striations with the point that have not been removed, e.g. BM 1051. On nos. 23 and 24 (PLATES 18c, 19a) the hair has been pounded into shape with a point held at right angles to the stone, and was presumably not intended to be visible (contrast no. 27 where a very fine point was used all over the hair to model it).[12]

The back of Dugas 6 is properly worked in the round and shows both preliminary shaping with the point and then some rough claw-chisel work where the sculptor obviously thought that more modelling was required; also chiselled are nos. 11-14, 20, 21 and 26 (cf. PLATES 10c, 11c, 12b), although the tool used is often coarse (3t/8 mm or 1 cm) and the quality of the work varies: on the anterior of nos. 12-13, for instance, it is quite reasonable. On some of the shields (Dugas 11-14) a claw was used, not because any modelling was needed, but presumably owing to the sculptor's fear that blows with mallet and punch would probably fracture the marble; the tools used vary from 4t/5 mm to 4t/1 cm.

Small patches of claw work appear on the backs of nos. 1, 5 and 6. A very fine claw (3t/3 mm) removed the marble from behind the right ear of no. 18, and it also appears once on the bottom of a plinth (Dugas 53: 4t/1 cm), but in general the evidence for the use of the tool at Tegea is very slight, reflecting a general dearth of surviving claw work on modelled surfaces in the fourth century.[13] The general standard of claw work on unfinished surfaces at Tegea is not nearly up to that of the sculptors of the Epidaurus pediments, as Adam points out, although nos. 12 and 18 show that the Tegea sculptors could rise to the standards of the earlier temple when necessary.

Although the traces of its use have usually been removed by later smoothing or by weathering, marks on the jawbone of no. 9 and on the side of the feet, Dugas 70 and 71, show that the flat chisel was in general use at Tegea as a modelling tool for the nude parts of statues. Its suitability for cutting convex surfaces that needed to be both regular and smooth made it the tool par excellence for finicky jobs like eyeballs (no. 5), eyelids (e.g. nos. 4, 5, 9, 16) and presumably toe- or fingernails, although in this case rasp and emery have removed all evidence. Hair was also regularly carved

with the flat (nos. 5, 16 and the lion's head gargoyles from the temple); the work is careful and the curls are generally short and crisp as a result, with pointed ridges and V-shaped valleys between. The helmets of nos. 17 and 18 were cut with long strokes of the flat, which the sculptor evidently found no need to remove, as was the back of the akroterion, no. 1, and there is much evidence for the use of the tool to recut and shape the hard ridges left by the running drill on drapery:[14] the marks remain on no. 1, and on no. 3 it is painfully evident where its lack of use has left the folds over the right thigh looking harsh and dry. The sculptor of no. 11 employed it to carve the letter B behind the left shoulder, and much of the detailing of the frontlets and volutes on the helmets of nos. 17 and 18 was done with oblique strokes of the tool.

On several drapery fragments as well as on no. 1 the chisel has been tilted and its corner used to penetrate the awkward channels caused by deep undercutting of the marble, presumably by the drill, reshaping and smoothing the recesses of the folds in long, curving strokes (Dugas 2, 79, 85, 96). Not only does the adaptability of the tool make it especially useful for working in such confined spaces, but its sharp edges also enable the sculptor to exploit it to assist him in defining joins and obtaining clearcut transitions between planes when he requires them; thus, its most frequent occurrences at Tegea are on the interior angles of fingers, wrists and elbows (no. 2 and Dugas 30, 45, 47-50, 52), on legs and feet (Dugas 53, 70, 71) and even armpits (no. 1). Its use on the join between chin and neck becomes almost a mannerism of the atelier where the movement does not actually prohibit it (nos. 4, 16, 19, 22, 27-29, and possibly nos. 9 and 10 as well). As far as I can tell, this sharply schematic change of plane regardless of the action only occurs exceptionally in the Classical period before the Mausoleum, where it appears on the heads BM 1052 and 1056, and on the Amazon frieze slabs BM 1007/8.41 and 1012.50 (PLATES 38a, 41b); it may be prefigured to some extent at Epidaurus (female head and lying figure from the west pediment: PLATE 27a) and even on the Argive Heraeum.[15]

Surface creases in the skin seem to have been cut with the corner of the flat, for example on the necks of nos. 4, 16, 17 and 18, on the foreheads of 9 and 17, and on the palms of the two hands Dugas 47 and 48;[16] the fleshy, bulging sterno-cleido-mastoid of no. 11 was marked off from the trapezius by a long, deep furrow of this kind, indicating how far the use of this tool for this purpose had progressed—indeed, some sculptors

who worked on these pediments seem to have found even this inadequate and in their quest for even greater emphasis on the joints of their figures turned to the running drill for an answer (see below).

Relatively little remains of the considerable amount of work with the simple drill that must have taken place at an early stage in the carving, to block out and shape the figures before the actual modelling could begin. Here, the best example is the eye of the fold-billow of no. 3 (cf. PLATE 3), but a proper description must be reserved for the final publication of the statue by Christou. The holes at the back of the plinth of Dugas 54 and on the head no. 29 (PLATE 23b) are perhaps two further instances of such preliminary drilling.

On one or two fragments the hems of the drapery were undercut with bore holes from the simple drill (e.g. no. 1; Dugas 76 and 81), but it is important to note that the various methods of 'honeycombing' so widely used to cut fifth century drapery folds never make an appearance at Tegea; in this field the running drill seems to have held undisputed sway.[17]

Drill holes were also needed both for *Ansätze* (extra pieces of marble added to complete the figure)[18] and for attachments in metal. These will both be discussed separately below, and suffice it here to single out in the former category the extraordinary technique of Dugas 44, where a dozen drill holes are detectable; on Dugas 31, a tenon-hole was laid out with a line of drill holes, then its core removed after the marble had been sufficiently weakened. The same method appears on some arm fragments of freestanding statues from the Mausoleum (BM basements: unnumbered).

Metal attachments were fairly common at Tegea; not only was the hand belonging perhaps to no. 1 (no. 2) drilled through to receive whatever it was holding (a crown ?), which was then secured by a small metal dowel, but also hands that held swords or other weapons (e.g. Dugas 51). The hole for the spike (μηνίσκος) of no. 4 was undoubtedly drilled, as were the two holes in the jaw of the boar's head, no. 5, whatever these were for.

Drill holes were often, though not always, used to give accentuation to such features as the inner corner of the eye (e.g. nos. 4, 5:PLATE 4d), the corners of the mouth (4, 9, 16-18, 22, 23, 27), and the navel (no. 15), as well as on such obvious places as nostrils (e.g. no. 18); on no. 16 we have the anomaly that although the nostrils of the lionskin cap were drilled, those of the hero were not. Ear-holes were also drilled, and on no. 24 the sculptor has made two attempts, placing his

hole too low the first time and then correcting it
(PLATE 19a).

Running-drill work is everywhere apparent at
Tegea, although it is seldom so blatant as on nos. 3 and
4; its most frequent occurrence is on drapery. The tools
used on no. 1, a well-carved piece by any standards,
range from 4 mm to 7 mm diam., though on some
other pieces, e.g. Dugas 74, a fine 3 mm drill was used.
The technique that seems to have been employed in-
volved firstly the planning of the folds with point and
flat chisel (as encountered before on the backs of no. 1
and Dugas 55); these were then cut with the running
drill and later worked over with the flat, used
obliquely in awkward corners where necessary, to a
greater or lesser degree depending upon the skill and
patience of the sculptor. Rasping and possibly polish-
ing with emery completed the job. The effects pro-
duced were legion (see nos. 1, 3, 8, 20; Dugas 2, 31, 55,
73-86 and 95: PLATES 1-4, 6, 17) and the techniques
range from long, deliberately hard channels (nos. 3,
and in a different way, 8), to short slashes and cross-
cuts (e.g. no. 20). As on Dugas 55, the drill was usually
employed for the deep, heavy folds; the fine, criss-
crossing ridges were probably left to the chisel alone
(see also Dugas 57).

Hems are almost always undercut with the run-
ning drill; the Tegean *locus classicus* for this is provided
by the hem of the apoptygma of no. 1 (PLATE 2c). On a
fragment in the Tegea store, the drill was run down
between the leg and what could be an adjoining frag-
ment of drapery to emphasise the division, an occur-
rence common enough in work of the second half of
the fourth century; in the same way, drill channels
outline the lionskin cap of the head no. 16, the helmet
of no. 18 (but apparently not that of the better quality
no. 17), the (?) cushion of no. 20 and the division
between the foot and its plinth on Dugas 71, though
here the chisel was used for this purpose on the side
which presumably faced the spectator, as on Dugas
53 and 54.

No. 4 is the only head whose hair was cut with the
running drill (PLATE 4d); the hair of the other female
head, no. 19, apparently wasn't. The technique of the
long flowing locks is best paralleled on the Triton in
Berlin (PLATE 43a, c),[19] convincingly dated between
c. 350 and 320 by Neugebauer and Blümel and closely
related in style to the Tegea heads; in general, the run-
ning-drill work is carried further than on the 'Mausso-
los' from Halicarnassos (BM 1000),[20] the roots of
whose hair are chiselled, not drilled as is the rest. On
the Tegea piece the drill has been used to separate the

locks only; the intermediate strands, as is usual in the
fourth century, were chiselled. Little or no attempt
was made to remove the drill marks, which are every-
where still apparent.

'The habit of distinguishing one part of the work
from another by a furrow made with the running drill
is kept in control by fourth century sculptors, but in-
creases disastrously later.'[21] Whereas on the free-
standing and relief sculpture of the Mausoleum the
drill seems to have been used fairly infrequently for
this purpose,[22] at Tegea sharply defined channels of
uniform depth and width, presumably products of the
running drill and often found in places where other
fragments would lead us to expect a sharp line from
the corner of the flat, are fairly common and from their
freshness must have been cut at a relatively late stage
in the carving. Traces of this kind are preserved on the
following fragments:

Akroteria:	(2)	between the fingers (PLATE 2d)
Pediments:	(5)	across the back of the mouth.[23]
	(13)	perhaps between the buttocks (PLATE 11a)
	(14)	on the testes
	(22)	perhaps between the lips (PLATE 18a)
	(26)	perhaps on the testes
	(Dugas 6)	between the fingers (PLATE 20d)
	(Dugas 28)	internal angle of the elbow (PLATE 20a)
	(Dugas 37)	internal angle of the elbow
	(Dugas 39)	internal angle of the elbow
	(Dugas 48)	between the fingers
	(Dugas 53)	perhaps between the calf and thigh on exterior (PLATE 21a)
	(Dugas 54)	between the calf and thigh on both sides
	(Dugas 69)	between the toes
	(Dugas 70)	between the toes
	(Dugas 71)	between the toes

In addition, a 4 mm diam. drill channel is visible
under the left armpit of no. 1, performing the double
function of defining the limb and marking the hem of
the drapery.

The use of the rasp at Tegea requires little com-
ment. Traces of it are especially common on the small
fragments, where, as with other tool marks, the sculp-
tors have neglected to remove them on the parts which
were invisible to the spectator. Some rasping remains
on the helmet of no. 17 and the shields Dugas 11, 12

and 15, however, all of which could probably have been seen; perhaps deliberate texturing was intended, as on the drapery.

On some drapery fragments the sculptor has almost certainly tried to impart a definite sense of texture to the cloth with the rasp (parts of nos. 1 and 3, and e.g. no. 8 and Dugas 2, 6, 73, 74, 77, 78, 82, etc.). Such conscious pursuit of evocative 'notional' textures in drapery is characteristic of the latter half of the fourth century, as Adam has pointed out, and must be distinguished from the occasions on which the sculptor has merely neglected to remove the rasping from awkward corners, as also occurs at Tegea (e.g. Dugas 54).[24]

Although *Ansätze* and joins will be dealt with below, a good example of rasp work deserves mention here; it appears on the sectioned plane of the hand fragment Dugas 6 (PLATE 20e), which was first flattened, then filed smooth, and finally picked with a point and prepared with tenon holes preliminary to the actual join.

Visible flesh surfaces, on the other hand, seem in general to have been smoothed with emery till all tool marks were removed and then polished, although occasionally (as on the foot of Dugas 70 and around the puntello of no. 13), where previous tooling had bitten too deeply into the marble, neither rasp nor emery was able to iron out the traces completely. Hair is left unpolished, presumably again to attempt to capture its special texture.

Although there is no actual evidence for a workshop, it seems only common sense to assume that the sculptures were not carved *in situ* but on the ground: among others, the elaborate ἐργαστήρια at Olympia, Athens and Epidaurus provide the analogies, and the crude correction of errors in simple mathematics on the Parthenon the evidence of what could go wrong when such a procedure was adopted.[25] We do not know how many of the finishing touches, here comprising the *Ansätze* (presumably, but not necessarily, finished separately and added at a comparatively late stage), the addition of metal accessories and the painting of the sculptures, were executed *in situ*.

I am inclined to believe that the bulk of this kind of work could have been completed before hoisting, and that on grounds of pure convenience the tendency was to minimise the amount that had to be done from scaffolding, which could be awkward and even perilous at times. As usual, however, the approach presumably varied with the problems encountered: swords, for instance, would get in the way and could

easily be fitted *in situ*, whereas on the east pediment at Olympia the spears of G and I and the staffs of N and L[26] must have been in place before the figures were moved into position, since their length and the proximity of the statues to the tympanon wall preclude any other possibility. Yet the head of the last-named 'seer' is obviously unfinished—was this detail the sort that was generally left until after installation, and then simply neglected here? One such case of this apparently occurs at Tegea, so the point may be instructive (no. 18).

Still at Olympia, it seems that the Zeus of Pheidias was assembled complete in the workshop before it was moved to the temple and re-erected. For such a complex and expensive statue such a procedure would certainly not have been otiose; would the same care have been taken over pedimental compositions? Clearly this would again vary in particular cases; the Parthenon figures were probably hurriedly corrected and realigned *in situ*, perhaps, one might imagine, by inferior masons after the main force of sculptors had been paid off.

At Tegea, the differing methods of treating the backs of the figures discussed earlier in the chapter, the prevalence of three-quarter poses on figures that seem in general to have been made out of single blocks of marble rather than joined in groups of two or three as, for example, on the west pediment at Olympia and on both pediments of the Epidaurian Asklepieion, and the variety of optical corrections (for which, see Chapter 2) all imply compositions of considerable depth and complexity, and suggest that preliminary assembly on the ground might well have been necessary here. It should be repeated that the sectioning of the heads does not seem analogous to the corrective methods employed a century earlier on the Parthenon. In conclusion, if this were indeed the procedure adopted, then it would naturally follow that all *Ansätze*, and possibly some metal accessories also, were attached at this point.

No evidence exists for when the sculptures were painted, but it would seem more likely for this to have been done in the workshop under cover—provided, that is, that the carving was complete by the time that the sculptures were taken out and installed in place.

Turning to the metopes, the appliqué technique would have enabled the carving to have been done at the sculptors' leisure, while not holding up the building operations in any way—a procedure that had been of value on the technically similar Erechtheum frieze,[27] where by the time building stopped in 415 the

North porch was complete (except for rafters and roof), yet the sculptures were not carved and dowelled on until 409 or later when the temple as a whole was nearly finished.

Cases of *Ansätze* at Tegea are fairly numerous. The akroteria seem to have been made in one piece, thus continuing the practice current in figural akroteria during the classical period—one, indeed, with more than a touch of the virtuoso about it (as an extreme case I would cite the 'Epione' from Epidaurus, NM 155, especially since the new pieces have been added by Yalouris).[28]

On the pediments and metopes a variety of methods was used. With heads, the most common method is a join involving a marble tenon but no dowel (nos. 8, perhaps 17, and 29: PLATES 6b, 15a, 23a-b). If no. 8 is indeed the torso of Atalante, then it is worth noting that on both the east pediment of the Hephaisteion and the west pediment of the Parthenon the statues of Athena that occupied the centres had inset heads[29] (for the same reasons as suggested below for this piece?). The head no. 10 was also inset but held by a dowel.

For limbs the technique seems to have been to smooth the plane surface carefully, pick it with a fine point to give a key to the cement, and then insert a square or rectangular dowel for safety (e.g. Dugas 6, 31 and 38: PLATE 20e). The practice is exactly paralleled on the Mausoleum (arm fragments, BM basements, unnumbered). No. 32 does not seem to have had a dowel, and the tail of the dog, no. 7, was inserted in the same way, to carve the whole animal from a single block of marble being both ridiculously wasteful and very difficult. No. 21 is awkward to fit into this scheme, since the carving is too rough to be a preparation for a join. No doubt it was *appliqué* to a shield cut into the tympanon wall, as suggested in the catalogue; on the analogy of the dog's tail, the marble shields would presumably have been carved separately and added later, although at Epidaurus they were always of a piece with the statue.[30]

The dowel in the side of the male torso, no. 12 (PLATE 10b), was presumably intended not for an *Ansatz* but to strengthen a potentially weak spot, and the same may be true, as Berchmans suggested, for those in the jawbone of the boar's head, no. 5. On no. 28 (PLATE 23a) the dowel in the right cheek could perhaps have been a join to another figure, although it is difficult to visualise how; alternatively, it may have served to fix the head to the background. In fact, while on the subject of joins, *marble* puntelli that could be

joins to other figures only number two or three, and of these the one on the left hip of no. 13 could well have supported a cloak. Pausanias is little help, suggesting only two (balancing?) groups in the east pediment, comprising Peleus and Telamon, and Ankaios and Epochos.[31] In general, then, the practice of using many pieces of marble for convenience and metal dowels wherever necessary, allied to that of making the figures singly, seems to have been the rule at Tegea, and is poles apart from the Epidaurian atelier's almost obsessive determination to exploit single massive blocks of marble to the utmost—for instance, in the west pediment, the three figures of the central group (Penthesilea, her fallen opponent, and the lunging Greek to her left) were all from the same block.[32] Again, the Mausoleum sculptures, with their many *Ansätze*, seem very close indeed.

The marble figures were completed with a considerable number of metal accessories, but evidently not so many as had hitherto been customary; one thinks immediately of Aegina in this context. Whatever was held by the hand attributed to the akroteria (no. 2), be it a wreath or no, was in metal since traces remain, yet what I have conjectured to be the end of a *taenia* was carved in stone; the rest may have been added in metal, but the arrangement is curious: analogous perhaps are the stone shield-grips and bronze shields of the Aegina warriors. The difference would no doubt have been covered up by the paint. The μηνίσκος of no. 4 was metal.

On the east pediment, boar spears (and axes and swords, if any) would have been of bronze or iron, but there is no other evidence here for the use of anything but marble apart from this. On the west, helmets (nos. 17, 18) and shields (Dugas 11-16) were of marble, as was the case at Epidaurus, although again swords would have been of metal, and possibly some shield-grips too (Dugas 46, 48 and 51, but cf. no. 21: PLATES 17c, 20c). Metal was presumably employed on the metopes as well, although the fragments are too scanty to give any help; the charioteer, no. 30, would have held reins of bronze, in all probability.

As for paint, there are very few traces, if any; none is mentioned in the early publications, and I can detect possible remains on only two pieces (no. 12 and Dugas 71). It goes without saying that the sculptures would have been coloured, and some details of the carving would require paint on them to show up—for instance, the tab under the thumb and the fingernails of no. 2, the toenails on Dugas 70, the lion's teeth on no. 16 and those of the warrior, no. 17, and the hairband of no. 19;

perhaps veins were also painted a slightly different hue from the skin around. Probably, also, the plinths were coloured (e.g. Dugas 6, 70, 75, etc.). The whole question has been closely examined by P. Reutersward in his book *Studien zur Polychromie der Plastik*, and this study has nothing concrete to add to his conclusions.

The arrangements for securing the sculptures in place on the building are interesting and worth a brief description. No evidence exists for the akroteria, so the discussion will be confined to the pediments and metopes (cf. FIGS. 2 and 3).

The floor of the pediment was strengthened by thickening the blocks of the horizontal geison by about 5.2 cm and recessing the forward edge 2.7 cm from the geison face to create a step (FIG. 2, 6). Although a step is found at Corfu, on the Aegina temple and on the Hephaisteion, neither the temple of Zeus at Olympia nor the Parthenon was provided with one, and at Epidaurus we find that although the floor is thickened, an irregular bevel replaces the step, suggesting to some extent a running groundline for the sculptures (cf. FIG. 2).[33]

Areas of plinth are preserved on eight fragments (no. 20; Dugas 6, 53, 54, 69, 70, 71; Tegea 2299: PLATES 17b, 20d, 21a-c, 22d). Of the five feet preserved, only one (Dugas 72) has no plinth, and on the others it seems that the plinths were deliberately kept as small as possible, seemingly in imitation of rocks or large stones. Thickness, finish, and treatment of the underside show considerable variation, as is normal in pedimental sculpture: the plinth of Dugas 53 was only 3.8 cm thick, of Dugas 71, 10 cm. The majority of the plinths are very roughly finished with the point on the visible surfaces, suggesting real rocks to some extent, whilst the plinth of Tegea 2299 has been very carefully smoothed at the sides and a V-shaped channel cut between it and the exterior of the foot; perhaps it was set into the front of the pediment step. Modern plaster bases have made it impossible to examine the undersides of most, but Dugas 53 has been worked with a claw (4t/1 cm), and Dugas 71 seems to have been pointed.

Judging from the few fragments of the horizontal cornice that remain, the plinths were placed on top of, but not set into, the floor of the pediment, upon areas that had been roughly pointed to receive them (cf. FIG. 3). As Roux says,[34] the tooling was probably done to measure on a trial and error basis when the statues were being installed.

Previously, it had been the practice to inset the plinths when a step formed part and parcel of the cornice (Aegina and the Hephaisteion: FIG. 2, 1 and 3); where this did not obtain, they were merely placed upon the pediment floor or upon a step consisting of separate blocks of stone, the relevant areas of which were specially pointed to receive them (Olympia, and with one exception, the Parthenon: FIG. 2, 2 and 4). No evidence exists for the Argive Heraeum, but at Epidaurus, judging from the scanty fragments that remain, the second method was adopted although the geison was thickened (FIG. 2, 5). Since one set of sculptures here seems to have had plinths and the other not, it is, I suppose, still just possible that the blocks which we have all come from one end of the building and that each master prepared the bedding for his statues as it suited him, although the evidence as it stands would tend to point towards a growing reluctance on the part of Greek architects and master-sculptors to accept any weakening of the pediment floor, supporting as it did many tons of sculpture upon a cantilever already comparatively thin in section at its root.

A trend towards greater overhangs and thinner sections that would explain this reluctance can be inferred from FIG. 2; in particular, the considerable difference in this respect between the example from Epidaurus and Tegea should be noted. Indeed, the Tegean cornice is so extreme that perhaps it would not be going too far to conjecture that some further form of reinforcing may have been employed, in the form of iron bars supporting the plinths and counterweighted at the other end by the tympanon wall, as on the Parthenon.[35]

Returning to the sculptures themselves, the preference for very small plinths or for none at all has only one forerunner in classical times, the east pediment of the temple of Asklepios at Epidaurus, generally acknowledged to be the more 'progressive' of the two.[36] This is contrary to previous practice, which had been to stand the figure on a large plinth, rather as toy soldiers do today, to spread the weight and make for greater stability. At Tegea, the lying and reclining figures (e.g. no. 20 and Dugas 6) were presumably fairly stable, though I doubt whether the same could have been said of the standing ones. Accordingly, these were first dowelled to the tympanon wall, then fixed with clamps to the pediment floor, and perhaps glued as well.

Of the four feet with plinths, only one preserves evidence of clamping (Dugas 71): here a hook-clamp rested in a notch cut into the upper surface of the plinth. Dugas publishes a cornice block with a clamp-hole in its upper face, so it would seem that this was

indeed the system preferred at Tegea, as at Olympia a century or so earlier (cf. FIG. 3).[37]

Although the blocks of the western tympanon published by Dugas show dowel-cuttings clearly intended for the pedimental sculptures,[38] again only a single fragment of those remaining, the recently excavated torso of a dog from the east pediment, no. 7, was definitely secured in this manner. Shown as leaping into the air, and supported by a crudely worked strut between the forelegs, the animal was also held in place by an iron bar of rectangular section sunk into its left shoulder (cf. FIG. 3). The treatment of the backs of the rest of the figures has already been described and thus needs no further discussion here. None of the heads that remain were dowelled into the soffit of the raking cornice; the two that were sectioned and pointed (nos. 9 and 16) may have been glued, but considering the pains usually taken when such an operation was contemplated (cf. Dugas 6: PLATE 20e), this seems rather unlikely.

Parallels for the sectioning of the heads have already been discussed by Neugebauer. On architectural sculpture the device seems to have been rare, and exact reasons for using it difficult to pin down. It occurs in the Classical period once only at Olympia and once on the Parthenon; of these the latter is definitely the result of a mistake, suggesting that the former may be also, although in smaller pediments in relief, sectioning is commonly employed to enable the figures near the angles to be as large as possible.[39]

Neugebauer believed, I think correctly, that the employment of this device at Tegea was 'eine weniger primitive Erklärung als die der kleinen Reliefgiebel.'[40] If, as I believe, there was little if any diminution of the figures of each pediment in scale towards the angles, sectioning of this kind could have served a double purpose: to fit the figures into the architectural frame, remembering that the restored 'standing height' of those from the west pediment was about equal to the height of the apex of the pediment itself, so that only the very central figures could stand upright, and secondly to create the aesthetic impression that the figures were bursting out towards the spectator, an impression certainly in keeping with the general atmosphere of dynamism they create, even today in their battered and mutilated state.

The metopal figures were made separately from their backgrounds and then dowelled on; nos. 28 and 29 (PLATE 23b) were fixed in this manner, and all the drapery fragments (Dugas 95 and others) were carefully flattened and then picked with a fine point at the back, probably as a key for glue, just as if the join were an ordinary *Ansatz* (cf. Dugas 6: PLATE 20e). Dugas also publishes some blocks of the interior architrave and frieze[41] which show that dowels were used both below the feet and on the bodies of the figures, although due to the accidents of preservation dowel holes do not appear on any of the fragments apart from the two heads just mentioned. That none of the torsos shows any signs of sectioning would seem to indicate that much of the metopal sculpture may have been completely in the round, the only concessions to 'relief' being the dowelling of the figures to a background in the first place and the reduction in the volumes of the areas invisible to the spectator (e.g. no. 32). The names of the figures were inscribed in letters 2.5 cm high on the architrave below.[42]

As far as I know, there is no parallel to this appliqué technique in metopal sculpture of the Classical period. Its two ancestors are to be found in the frieze which decorated the base of the cult statues of the Hephaisteion (421-415), and the Erechtheion frieze (410-406);[43] the next temple to have carved metopes, that of Athena at Ilion, returned to traditional relief sculpture for its decoration.[44] Presumably the nearly complete emancipation of the statues from their backgrounds and the difficulty of carving such figures in true relief made such a short cut both practical and extremely attractive. Aesthetic reasons apart from this do not apply, since in contrast to the blue Eleusinian limestone and white Pentelic marble of the Erechtheion frieze, at Tegea Dolianà marble was employed for both figures and backgrounds. A further advantage in the adoption of the appliqué technique lay in the fact that the carving was no longer tied to the schedule for the completion of the architecture, as had hitherto been the case.

A few general points may be mentioned in conclusion. The evidence of technique is both valuable for its own sake, as a record of sculptural expertise or otherwise, and at times useful also for chronological purposes. The Tegea sculptures show a fairly high degree of technical accomplishment, though it is clear that sculptors of pediments were beginning by this time to make more use of short cuts than had hitherto been customary, leaving areas invisible to the spectator unsmoothed, merely planned or even completely uncarved. Unless the figure was actually *appliqué* to the tympanon wall, however, the sculptor still preferred to complete it as far as was necessary for him to feel that it was flesh and blood under his hands, and no

hollow sham. The finish of the visible areas is usually excellent, especially on the east akroteria and the pediment heads, which is what one would expect from the high price current for the former and the rôle of the latter as foci of the spectator's attention.

The Tegea pediments, then, may not be used as evidence of a decline in sculptural standards during the fourth century (from the point of view of technique, the Olympia pediments are analogous to the Tegea ones in many ways, as Berchmans points out),[45] but rather of an unwillingness to go to the extremes of perfection essayed by the Parthenon sculptors and others of their time. For, as Adam says, 'although the Greeks were willing to spend the long time necessary to achieve the high standard at which they aimed, they saw no virtue in spending longer than was necessary'.[46]

Two points of technique have considerable value for determining the date of the sculptures. Firstly, the way in which the backs are sectioned places them between c. 370 and 330, though closer to Delphi than to Epidaurus. In broad agreement with this is the way in which the running drill is employed (drapery apart, fairly extensively on naked flesh surfaces and on the roots of the hair of no. 4), suggesting a date after the Mausoleum and the middle of the century.

Chapter Two

COMPOSITION

The reader is referred to PLATE 53 throughout. The reconstructions of the pediments are not intended to be anything more than hypothetical; they are sketches to indicate possible positions for the figures more economically than can be done by words alone, and for quick reference later. It is to be hoped that the new excavations planned by the Archaeological Service will soon require their modification as new fragments come to light. The descriptions and arguments have their own value, however, and may be found useful by future students even when fuller evidence becomes available.

This chapter explores the possibility of restoring the composition of the sculptural decoration, as far as the small quantity and bad state of preservation of the significant pieces will allow. It attempts to reconstruct the positions and poses of the figures, with special attention to the possibility of visual links between the akroteria, pediments and metopes, and to the question of optical corrections. Attributions for the major pieces have already been ventured in the catalogue, and, building on this foundation, I propose the following as criteria for the reconstructions:

1. The restored heights of the figures.
2. The technique and degree of finish of the fragments.
3. Sculptural differentiation in the modelling.
4. Asymmetry and perspective distortions.
5. Weathering (although the possibility of secondary weathering is raised by the find circumstances of many of the pieces, e.g. no. 12).
6. The identities of the figures and the text of Pausanias (Appendix 1, no. 36).[1]

Nos. 1, 2, 5 and 6 require no further comment; the others are less straightforward, however, and call for a brief note. In ideal circumstances, sculptural criteria alone (nos. 3 and 4) should give an optimum visual angle for the piece concerned, and thus its place on the building, although as the mountain of literature devoted to the composition of the east pediment at Olympia shows, the results obtained from this method can be contradictory and misleading, and by no means provide a final answer even when the figures are well preserved.

Clues from sculptural differentiation and perspective distortions are particularly subject to misinterpretation, since not only have we virtually no knowledge of theories of perspective in Greek art before Euclid, but also it is clear from the remains that the extent of such adjustments in sculpture varied at different times and that hard and fast rules were probably never applied.[2]

Solutions were empirical and ad hoc, governed perhaps by whether the sculptor wished to assist the three-dimensional impression created by a figure turned slightly away from frontal, or to counteract the near disappearance of the far side of a strongly three-quarter or near profile figure—the former would require a decrease in the volume of the withdrawn side, the latter an increase.[3] Equally important would be the viewpoint intended for the observer; the Corfu pediment, 17.02 m wide, seems to have been designed for a central viewpoint, but opinion is divided as to whether this held true for the east pediment at Olympia (width, 26.40 m): Pfuhl, for instance, conjectured at least three viewpoints.[4] Although there are in fact some indications that a central viewpoint was intended at Tegea (pediment width, 16.45 m), it is likely that in any case the strong distortions logically demanded by a strict central viewpoint were avoided or

toned down, not least because of the unpleasant effect these would have had upon a spectator viewing the compositions from elsewhere in the sanctuary.

Further *caveats* have been brought to my attention by Professor Ashmole, who believes that even under ideal viewing conditions, only one-third of the surface area of a pedimental figure was visible to a spectator, and that such optical corrections as were employed in Classical times were generally too slight to have had much effect on any spectator, regardless of his position (although here one can, of course, separate the sculptor's intention from the results actually obtained). Clearly, then, the whole question of optical corrections must be treated with extreme caution.

The Akroteria

No. 1: the weathering, more or less equal on all sides, identifies her as an akroterion or free-standing figure. The finish of the statue and the sharp transition between front and right side, marked clearly by shadowed masses of drapery, makes it clear that she was intended for viewing either in profile on this side, or from a frontal or three-quarter position on the other side (PLATE 1a-c), with the lower part of her body frontally posed and the right side parallel to the side of the temple. The intervening viewpoint (from a three-quarter position to the spectator's left), renders the statue unbalanced, the movement obscure and the drapery confused, as Dugas pl. 96, B shows clearly. From the side, however, the movement is clear and crisp, and from the front the accents of the folds lead the eye diagonally across the figure from the left knee to the right hip, and then back to the left shoulder.

There seems no doubt that this was intentional. As an akroterion, the principal viewpoints would be from the side of the temple and from the façade; the figure therefore fits best in a position above the left-hand corner of either the east or the west pediment. The strongly shadowed folds of the apoptygma down the outside of the right thigh form an effective visual boundary on this side to the spectator approaching from the front, and the crisscrossing and hardly undercut diagonals of the drapery leading to the right positively direct the eye this way, and invite him to look at the statue in three-quarter view—in other words, from a point opposite the centre of the façade. Furthermore, the strange heaviness and breadth of the upper part of the torso which Berchmans found so unattractive ('peu gracieuse')[5] is now explicable as an optical correction to prevent the figure from seeming to taper away to a point, placed as high as she is (the

sculptural counterpart of that phenomenon known to photographers of architecture as 'converging verticals').[6]

The pose, with the engaged leg and active arm on the 'closed' side, the shoulders and the head slightly twisted towards the 'open' side (the former about 15°, the latter slightly more), greatly reinforces the effect of the drapery. The girdle, in defiance of nature, serves to establish a firm horizontal axis around which this composition, unchiastic and thus potentially unbalanced as it is, can pivot without 'falling apart' visually (contrast no. 3).

Thus, the composition is, in fact, fully effective either when seen in profile from the side of the temple, or throughout a 20° arc from full frontal to a near three-quarter view on the right hand, and so neatly positions the spectator in the centre of the façade, the best place to appreciate the pedimental compositions.

Stylistically, the figure is considerably superior to her newly found sister (no. 3) and thus ought to belong above the east pediment; the arguments advanced here place her at the southeast angle of the temple.

Nos. 3 and 4: the arguments are again much the same as for no. 1, whose pose and composition she echoes. Whereas, though, the sculptor of no. 1 stresses the way she strides, vigorously and purposefully, along the ground, the sculptor of no. 3 is at pains to characterise his figure as free-floating and weightless, without, however, jeopardising her essential kinship with the other—a difficult task. His solution was to retain the same basic pose and dress (only adding a himation across the back), while making slight alterations in the details of the composition to achieve the intended effect.

Firstly, he has altered the arrangement of the peplos so that the front overlies the back portion where they cross on the right hip, reversing the scheme of no. 1 and accentuating the fold across the inside of the thigh at the expense of the outside. What had been a subordinate diagonal accent on no. 1 now becomes a major one, breaking through the visual barrier formerly established on the outside of the thigh by the heavily shadowed masses of wind-blown apoptygma and peplos. Secondly, the billowing apotygma, in its turn, no longer 'closes' this side, but deals another blow to the strongly directed system of accents established in the other figure. Thirdly, by allowing the girdle to rise with the right arm and shoulder, the sculptor has traded in its 'binding' effect

for a loose, undirected and at times deliberately self-contradictory scheme that does much to enhance the impression of weightlessness and freedom that he is trying to create. The folds of the apoptygma by the left breast, too, now diverse in direction, no longer carry the eye singlemindedly inwards, and only the lines of the apoptygma and peplos below the girdle are left to do the job.

Composition apart, this piece seems markedly inferior in overall effect both to no. 1 and to earlier flying figures of a similar type, for example Paionios' Nike and the so-called 'Epione' from Epidaurus, NM 155.[7] It should thus be obvious that her poorer quality, both technically and aesthetically, must be the deciding factor in placing her at the other end of the temple, above the northwest corner. If the head no. 4 belongs, it was again turned rather towards the centre of the pediment, directing the spectator's eye inward.

Trustworthy parallels for the kind of visual link between akroteria and pediments suggested here are at present restricted to the fourth century. The 'Aurai'[8] over the west pediment of the temple of Asklepios at Epidaurus were positioned obliquely to the spectator (though whether galloping towards the centre or away from it is at present uncertain), and thus seem to have 'conditioned' him to a central viewpoint. The little girl Nike, NM 162 (PLATE 26a) clearly belonging above the southeast corner, could also have been similarly placed. The akroteria reused on the temple of Poseidon at Hermione,[9] dated to c. 400 by Bielefeld and analogous in pose to the 'Aurai' also lend themselves to such a setting, although in the absence of architectural remains this cannot be proved. At Tegea, though, the twist in the torso seems likely to have been intended to carry the eye inwards unaided by any oblique positioning of the figure—a definite advance upon its predecessors.

How far away from the temple was the spectator expected to stand in order to be able to appreciate the composition at its best? Speculative though any attempted answer may seem, the results obtained by projecting a line along the restored line of sight of the missing head of no. 1 until it cuts the long axis of the temple are surprising enough almost to make them convincing (FIGS. 4 and 5): the intersection lies within the foundations of the altar, 26.25 m away from the temple krepis, near enough where the top of the steps would have come and the priest of the cult performed his sacrifices. Is there any external evidence, firstly from the Tegean ruins themselves, then from else-where, to support an integral plan for temple and altar of so advanced a character?

It seems clear that the altar at Tegea[10] was indeed contemporary with the temple: its foundations were laid at the same level and are similar in thickness; both Shoe and Dugas agree in ascribing moulded cornice-blocks to it whose 'style is similar to the blocks of the temple but less fine'.[11] A priori, then, we might expect some relation between the two.

In a recent article, Bammer gives some details of the lengths of some late fourth century altars and their distances from their respective temples. At Priene and Magnesia these were roughly equal; at Tegea the altar stood 26.25 m from the temple and was about 28.00 m long, perhaps slightly less. Bammer has also postulated a very close relationship between the fourth century altar of the Ephesian Artemision and the temple pediment.[12]

If this is so, it would appear that some form of connection between the decoration of the temple (representing the theology of the cult, as it were) and the priest sacrificing to its guardian deities, is by no means out of the question at the period with which we are concerned. In this context, one must resist the temptation to view the temple as primarily intended for aesthetic contemplation; first and foremost it was a religious shrine, and in the choice and positioning of the decoration religious considerations were probably paramount.

The Pediments

The east pediment (the hunt of the Calydonian boar)[13]

Since Pausanias' account is so crucial to any discussion of the composition, I quote it here in full; the figures are numbered from the corners towards the middle, since the accuracy of his description of the centre is questionable:

'And as for the pediments, on the front is the Hunt of the Calydonian boar; the boar is exactly in the centre, and on one side are Atalante (9), Meleager (8), Theseus (7), Telamon (6) and Peleus (5), Polydeukes (4), Iolaos (3), Herakles' partner in most of his labours, and also the sons of Thestios and brothers of Althaia, Prothoos (2) and Kometes (1); behind the boar, in addition, are Ankaios (6), who has already been gored and has dropped his axe, with Epochos (5) supporting him. Behind him come Castor (4), Amphiaraos (3) the son of Oïkles, and next Hippothoos (2) the son of Kerkyon, son of Agamedes, son of Stymphalos; last of all is Peirithoos (1).'[14]

Pausanias thus names nine figures in the left *kerkis*

of the pediment and six in the right, with the boar as the pivotal point of the composition—an arrangement whose 'fatale Asymmetrie'[15] has caused endless argument. The best discussion is still Neugebauer's and I find his conclusions still the most acceptable.

Briefly, two principles must determine any attempt to reinterpret Pausanias' account: that no violence must be done to the text as it stands, and that the solution proposed must satisfy the canons of Greek art known to have existed in the fourth century.[16] Contributory evidence that could weight the argument either way is provided by other fourth century representations of the hunt, here assembled in Appendix 2.

Firstly, such asymmetry has no parallel in fifth or fourth century pedimental sculpture; one extra figure might have been permissible, but three are rather too much to stomach. Secondly, most attempts to reinterpret the text have led so far either to the body of the boar being placed in the right *kerkis*, usually with Atalante in the centre—an expedient that might disguise the absence of one figure but not two or three—or to one or two figures being shifted across from left to right. Neugebauer has shown that μάλιστα when applied to pediments probably means 'exactly':[17] at any rate, it seems improbable that Zeus, indeed in the exact centre of the east pediment at Olympia, should be given a μάλιστα with this meaning, while the boar at Tegea, also centrally placed in the east pediment (the only other one described in detail by Pausanias) should be given a μάλιστα meaning something else.

However, Pausanias' account does have certain elements of symmetry about it: Ankaios (6) and Epochos (5) in the right *kerkis*, with Castor behind them (4), seem to have been answered in the left by a group of Telamon (6) and (τε καί) Peleus (5), with Polydeukes behind them (4). In Ovid's account, Telamon tripped on a root and was helped up by Peleus.[18] Yet this symmetry can only remain potential while three extra figures stand between Telamon and the boar, with no answering group on the other side, and the only solution capable of bringing it into play and at the same time respecting the principles we have laid down is Welcker's, endorsed by Neugebauer, that three figures behind the boar (i.e. 9, 8, and 7 on the right) have been omitted from the text, either by Pausanias himself or by later copyists.

All fifth and fourth century representations of the hunt support the introduction of at least one figure behind the boar (Appendix 2, nos. 4-14, also no. 16: PLATE 28), as do a class of Roman sarcophagi, and an

attempt to match two of the torso fragments (nos. 12 and 13) with a hero commonly shown here will be made below.

No. 5 (head of the Calydonian boar):[19] the left side faced the spectator and the animal ran to the left, possibly with its head raised (see further, no. 7). Pausanias describes it as being κατὰ μέσον μάλιστα, and this placing has been followed in the reconstruction (PLATE 53). Neugebauer restores the original length as c. 1.70 m, which seems reasonable.

No. 6 (head of a dog): the more summary modelling of the right side suggests that this may have been turned to the tympanon, although weathering and technique seem opposed to this. The pose could have been three-quarter or profile, with the animal perhaps running to the left;[20] it is obviously impossible to say exactly where this head belongs, save for a general attribution to the right *kerkis*.

No. 7 (torso of a dog): the technique and modelling show that the left side faced the tympanon and that the animal was leaping to the right. The pose corresponds to the dog often found leaping at the boar's throat in other representations of the hunt (PLATE 28c);[21] from the position of its neck it is clear that its muzzle was at least ¾ m from the ground, suggesting that the boar's head may indeed have been raised.

No. 8 (female torso): the figure was lunging to the right in three-quarter pose, her left shoulder placed against the tympanon and her right arm probably lowered (cf. BM 1010.15 from the Mausoleum Amazonomachy, PLATE 40b).[22]

She may therefore have stood to the left of centre of the pediment, looking down and to her left, her height (probably c. 1.50 m, considering the pose), and the inset head and arm suggest an important figure and one close to the centre. Since Pausanias only mentions one female figure, and no other appears on any representation of the hunt in antiquity, there can be little doubt that this torso belongs to the heroine, Atalante. Like the Athenas of the east pediment of the Hephaisteion and the west pediment of the Parthenon, the separately worked nude parts may have been carved by the leading sculptor of the atelier. Atalante appears in this pose, normally reserved for Meleager (cf. PLATE 28) on a Severan coin of Tegea (PLATE 29a);[23] our reconstruction thus seems virtually assured.

No. 9 (head of a youth): the sectioning shows that the head was probably *appliqué* to the soffit of the cornice, and from the expression it would seem that the hero was wounded. The incompleteness of the carv-

ing of the right side of the face, together with its flatter modelling, indicates that it was probably to be seen in three-quarter or even near profile view, looking out to the spectator's left. Neugebauer lists three poses available for a figure with a head in this position, which are as follows (in order of probability):

> (1) sitting, looking inwards, close to the right-hand corner of the pediment (i.e. Amphiaraos [3] or Hippothoos [2]).
>
> (2) sitting, with head bowed and looking out, near the left-hand corner (Prothoos [2] or Kometes [1] ?).
>
> (3) standing, in the left *kerkis*, again with the head bowed.

Certainly, a contorted, wounded figure in the right-hand corner, gazing in apprehension towards the centre, seems to be the best solution (PLATE 8a). Such figures filled the corners of the Aegina and Epidaurus pediments, and Peirithoos may have suffered the same fate as Ankaios, if Neugebauer's interpretation of Ovid is correct.[24]

No. 10 (battered male head): the summary finish of the right side and its greater volume argue for a three-quarter pose, with the glance towards the spectator's left; it may have touched the soffit of the cornice and perhaps the tympanon wall as well, as the two roughly pointed areas show.

No. 11 (male upper torso): the anterior faced the spectator and the torso was probably to be seen in three-quarter view, with the left shoulder withdrawn (the back of the right shoulder alone is modelled). What little evidence can be extracted from the torso musculature would suggest that the figure was lunging to the spectator's left, but possibly (not certainly) standing fairly erect; he may have held a sword or a club.[25]

If this is correct, the height of the figure may have been little less than the full 'standing height', i.e. c. 1.50 m, placing him as an opposing accent to Atalante (no. 8), directly behind the boar in position 9 in the right *kerkis*. The meaning of the letter B on his back remains unclear, unless the boar was taken as no. 1 in both *kerkides*, and it is to be read as 'second figure to the right of centre, right *kerkis*'.

Nos. 12 and 13 (male figure):[26] the appearance of severe weathering *and* tool marks on the anterior of no. 12 poses a problem: if the front of the torso was visible, why was it left unfinished; if not, why is it heavily weathered? A shield or drapery would have protected the front from the elements, and furthermore it is unlikely that the back would have been finished so care-fully, when even Atalante's was not and the backs of so many other fragments were only roughly carved. The good surface on the apex of the shoulder, divided from the weathering on the anterior by a line whose clarity is unique at Tegea, further gives the lie to this argument.

Since the piece was found built into a wall, the only hypothesis that seems to account for all the facts is that the severe weathering on the anterior occurred after the figure had fallen, and the back was protected when in place on the temple by the overhanging cornice, and after it had fallen by its position on the inside of a wall. It is unfortunate that the excavators left no record of the find circumstances.

The hero was perhaps set fairly well back, and braced to deliver a blow to the left. Since the position of the spine and the back muscles show that the hero was probably standing, his position would have been in the right *kerkis*, fairly close to the centre, his head turned to his left.[27] Since we have already restored an opposing accent to Atalante in position 9, position 8 becomes the most attractive proposition. A similar figure appears often on representations of the hunt (PLATES 28a and c), and also on BM slab 1010 (PLATE 40b), although on our fragment the arm was apparently flexed, and the hunter seems to have been delivering a two-handed thrust downwards with a spear into the boar's flank, like a figure on the Alexander Sarcophagus (PLATE 27b); the restored 'standing height' of c. 1.50 m leaves plenty of room for his raised right arm and spear. There is no evidence as to his identity.

No. 14 (male torso): judging by the position of the sectioned area at the back, the muscles of the stomach, and the testes, it seems that the figure was shown against the tympanon wall, between three-quarter and frontal views, stooping slightly and moving to the right (the relation between thighs and torso seems to me to be wrong for a kneeling figure, as Berchmans conjectures, taking a kneeling youth from the west pediment at Epidaurus for comparison).[28]

Slabs 1014 and 1010 (PLATE 40b) of the Mausoleum Amazonomachy show figures whose lower torso and thighs are in similar positions, and whose actual height is diminished by about one-quarter as a result; proportionately, assuming that our figure's head once touched the cornice, his height would be reduced from c. 1.60 m to c. 1.20 m, and the head would have occupied a position about 3 m from the centre, in the left *kerkis*. The most likely candidates then become Poly-

deukes (4) or Peleus (5), perhaps helping the fallen Telamon (6). Certainly, the fragment would fit a man stepping behind his fallen companion and helping him up, as is shown by a group on the right of one of the slabs of the Bassae frieze, BM 531; an analogous group appeared in the east pediment at Epidaurus, NM 4642, so perhaps we can tentatively restore this piece here (i.e. position 5).[29]

No. 15 (male lower torso): from the angle of the sectioned plane on the left side it is clear that the fragment was originally poised between the profile and three-quarter views, facing to the spectator's right; the waist was apparently horizontal, the trunk twisted a little to the left; this position also accords with the slight difference between the volumes of the two sides. The figure could thus have been shown either as standing, as for instance the Mausoleum warrior BM 1007.38 PLATE 40a), or kneeling, in the pose of the Alba Youth (Appendix to Chapter 8, no. 1), although it must be admitted that other positions are possible and that the remains are insufficient for a convincing reconstruction.

The only other figures which we can reconstruct with any confidence are Meleager (left, 8) and Ankaios and Epochos (right, 6 and 5); since Atalante was set so far back, it seems reasonable that Meleager should overlap her, perhaps in the pose of the hero to the left of the boar on nos. 3, 5, 8, 9, 10, 11 and 14 from Appendix 2, recoiling the other way (cf. PLATE 27b). For Ankaios and Epochos a group perhaps similar to two Amazons from Bassae seems not unreasonable.[30]

In fine, it does appear that some evidence exists (in the form of nos. 11, 12 and 13) to support the hypothesis of a lacuna in Pausanias' text. However, the most striking feature of the composition as here reconstructed—certainly in the case of Atalante and possibly as regards the other figures too—is its degree of independence from the hitherto dominant iconography of the hunt, perhaps Polygnotan in origin.[31]

To place Atalante in front of the boar, her head some 1.30 m from the centre, also explains what has emerged as the most puzzling feature of the sculptures themselves—the difference in scale between the two pediments: there being no figures between boar and tympanon, the width and height of the remaining areas of the pediment simply left no room to accommodate 18 (or even 15) figures, 1.90 m in height. Even allowing for a reduction of 30/40 cm the composition must in any case have been extremely crowded.

The tree in the centre of the pediment has been restored from the coin (Appendix 2 no. 22: PLATE 29a)

which alone of the representations listed seems to reflect the composition under discussion. Of the others, the original of nos. 3-15 may have been the source for a few of the poses used at Tegea, though here the figures are given new identities (left 9, right 9 and 8), while no. 16 is idiosyncratic and no. 21 probably reflects yet another late Classical version of the same theme, perhaps a painting.[32]

The west pediment (the battle between Telephos and Achilles on the plain of the Kaikos)[33]

Representations of this subject in ancient art are extremely rare (see PLATE 29c) and the composition thus difficult to restore; Pausanias merely gives the principal contestants and names the site of the battle: 'and on the rear pediment is represented the battle between Telephos and Achilles on the plain of the Kaikos',[34] although it is just possible, I think, that the order in which the two heroes are named may reflect their positions. Accepting that the high point of the battle, the wounding of Telephos by Achilles, was chosen for portrayal, about the only secure statement one can make a priori is that the vine sent by Dionysos (for reasons that remain obscure) to trip up the Tegean hero was almost certainly included. Being the focus of the action it was presumably in the centre of the pediment, the protagonists being disposed symmetrically about it.

Following Neugebauer's lead, reconstructions have been attempted in varying degrees of detail by Pfuhl, Picard, Dörig and Delivorrias. The number of figures is unknown, although they were definitely rather larger in scale than those from the east pediment (c. 1.90 m as against 1.60 m), presumably because it was now possible to make use of the central section of the pediment, and thus also its full height of 1.90 m. We may perhaps assume as a working hypothesis that the composition of the battle scene was as crowded as that of the hunt.

No. 16 (male head, with lionskin cap): any attempt to restore the central group of the west pediment turns inevitably on the identification of this head, hitherto, and virtually unanimously, considered to be Herakles.

The pose is fairly easy to restore, as Neugebauer has shown.[35] Briefly, the top of the head was probably close to the soffit of the cornice; it was turned to the hero's left and intended to be seen in three-quarter view; the shoulders were slanted, the left being raised. The best examples of this kind of pose appear on the long battle frieze of the Amazon sarcophagus and on the Mausoleum Amazonomachy (BM 1007-8.41, cf.

1012.50: PLATES 34a, 41b); a more extreme example is a small Hellenistic bronze in Paris.[36]

Neugebauer's estimate of an actual height of c. 1.75m (standing height c. 1.90m) seems fairly near the mark, since the action of the head is perhaps somewhere between the Amazon BM 1007-8.41 (PLATE 41b) and the bronze. His calculation of the figure's position, resting as it did on Dörpfeld's incorrect reckoning that the height of the pediment was 2.25 m and its width 18 m, must be emended. From the true measurements (1.90 m x 16.45 m), the head should come only about 0.50 m from the centre, in the left *kerkis* of the pediment (cf. PLATE 13b).

Are we to identify the head as Herakles, protecting the (now lost) Telephos, or as Telephos himself? Herakles is nowhere attested as present at the Kaïkos battle, and to circumvent the difficulty of conjecturing a local form of the legend, Gardner, Bieber and Delivorrias have suggested that no. 16 is in fact Telephos himself;[37] however, I can find no example in Greek art where Telephos wears a lionskin. We are therefore faced, it would seem, with two identifications that are not only diametrically opposed but equally improbable; applying Occam's Razor, does further evidence exist that will tip the balance one way or the other?[38]

In Herakles' favour are the gain in dramatic intensity and the plausibility of Telephos' escape that could result from employing a 'deus ex machina', and the availability of a well-established type of 'warrior defending fallen comrade'.[39] (It is here that Dörig's restoration seems to lack conviction; not only is the pose of his Herakles rather weak, contrasted with the intense movement of no. 16, but the mode of his intervention itself looks ineffective and, as far as I know, has no parallel elsewhere.)

Against an identification as Herakles are the evident youth of the hero and the actual form of his headdress. Herakles is always shown as already bearded and middle-aged when depicted with Telephos as a baby, and appears thus on a fourth century Skopaic head from a statue in the sanctuary, Tegea Museum 48 (PLATE 47a).[40] One feels that to represent the father as in no. 16 then to place him next to his son would have seemed incongruous and not a little absurd, even allowing for the transformations wrought by deification; one is reminded of W. S. Gilbert's lines:

'This gentlemen is seen with a maid of seventeen
A taking of his *dolce far niente;*
And wonders he'd achieve, for he asks us to believe
She's his mother and he's nearly five-and-twenty !'

On the positive side there seem no insurmountable obstacles to the head being that of Telephos. The pose of the Paris bronze has the merit of placing his left foot just where it could be trapped by Dionysos' vine (presumably in the centre), and the left leg would then be open to Achilles' lance. Telephos is represented in exactly this position on the small frieze at Pergamon (PLATE 29c).[41] The age fits, also the look of fear on the face, quite plain when viewed from below, although it is true that the expression is a generalised one and could serve as well for the father's anxiety as for the son's fear.

On balance, then, the evidence seems to point to Telephos, but by no means conclusively. Yet, while the hypothesis of a local form of the legend can (just) account for Herakles' presence, the wearing of a lionskin cap by Telephos still requires explanation;[42] at this point a look at his position among Herakles' many sons may help.[43]

The status of Telephos as the most heroic of the Heraklids and the most like his father is underlined in the sources and, apparently, in the Tegean cult, from what little we know of it;[44] certainly, it hardly seems out of the question for Telephos, as Herakles' son, to be wearing a lionskin cap at Tegea for identification, both of the scene and of himself as the principal character in it, if Alexander the Great was to be represented with this same attribute only a few years later.[45] At any rate, as a way round the impasse this explanation seems just as likely as postulating a local legend of a deus ex machina, protected by a decree of silence,[46] and receives better support from the subsequent history of the lionskin as an attribute of what one might call 'aspiring Heraklids'. If Herakles had intervened in the fight, this would hardly have been overlooked at Pergamon,[47] with its strong antiquarian spirit and links with Tegea; Dionysos appeared in person on the Telephos frieze to trip Telephos (PLATE 29c), and one feels that with such a precedent, the temptation also to bring in Herakles to rescue him would have been irresistible.

To sum up, although prima facie it seems more likely that any head wearing a lionskin cap once belonged to a figure of Herakles, in this case it is certainly possible that no. 16 did not; furthermore, the possibility would seem to be increased by contributory evidence from the piece itself, other representations of Herakles and Telephos, and the literary sources.

For a torso fragment that may belong, see below, no. 26; Achilles is restored after the composition on the Pergamon Altar (PLATE 29c).

No. 17 (helmeted head): the head clearly formed part of a figure lunging to the spectator's left, and was *appliqué* to the soffit of the cornice. Again it is the volume of the withdrawn side that seems to have been increased, and its modelling is less rich; yet the quality of this side of the face makes it unlikely that the head was to be seen in profile. A three-quarter view also accords with the movement, a turn to the figure's left: PLATE 15a shows the original position of the piece. Since the axis of the neck is at a slight angle to that of the head, the left shoulder was probably raised, throwing the neck off slightly to the right (cf. no. 4); the right leg could have carried the weight.

Some doubt must remain as to the original angle of the torso, and thus also as to the distance of the figure from the centre. The expression and force of the head seems to rule out a reclining, 'Kladeos'-type pose,[48] yet Neugebauer's other analogy, the Borghese Warrior,[49] is surely altogether too extreme to be trustworthy. Perhaps the closest parallel to our figure is to be found in the head of the Mausoleum charioteer, BM 1037,[50] whose upper torso is inclined to about 40° to the horizontal; transferred, this would mean a height of about 1.30 m for the Tegea figure and a position about 2.40 m from the centre. The distance could perhaps have been greater, but given that the warrior was lunging and his head *appliqué* to the cornice it could scarcely have been any less; at any rate, if, as seems reasonable to suppose, the two protagonists were placed symmetrically about the centre of the pediment, the fragment can hardly have belonged to Achilles, as Pfuhl and Delivorrias have suggested.[51] Furthermore, a central group of two figures such as 16 and 17, *both* inclined and moving to the spectator's left, would surely have seemed intolerably unbalanced, and would be without precedent in Greek pedimental sculpture.

For the face to have been visible in three-quarter view, the figure must have been represented as lunging out rather at an angle to the tympanon wall, perhaps indicating either that the warrior's leg was shown extended behind another figure, or that he was lunging past a figure in front of him, or both.

See also no. 26 for a torso fragment that has been conjectured as belonging.

No. 18 (helmeted head): the pose has already been reconstructed by Neugebauer (and accepted by Dörig),[52] although Berchmans essayed no restoration. Finish and technique suggest that the piece was to be seen in three-quarter view from the spectator's right, and that it did not touch the cornice; the right shoulder was hunched and the right arm could have crossed the front of the helmet. The pose that fits most obviously is the 'Dexileos' type; others are possible,[53] although the amount of space available and the vague look of fear on the hero's face make the former more likely.

In this case, the reduction in the height of the figure could have been up to 45 percent, giving an actual height (minimum) of around 1.00 m; the neck does not seem sufficiently contorted for this, however, although any restoration can only be a rough guess, since the pose is adaptable within quite wide limits to the space available.

Since the head did not touch the cornice it is impossible to calculate its distance from the centre; the restoration in PLATE 53 is therefore a guess, and shows the hero being protected by the lunging warrior, no. 17. It is (just) possible that Dugas 54 belonged to this figure. An answering figure in the other *kerkis* is suggested by Dugas 53 (PLATE 21a-c).

Nos. 19 and 20 (reclining female figure):[54] the position of the figure, lying with her weight on her left side, is hardly in doubt; the front and right side faced the spectator, and the pose is a well-known one for corner figures in pediments, recalling that of the river-god 'Kladeos' from Olympia, and fitting well into the left-hand corner of the pediment.[55]

No. 26 (male lower torso): the figure stood clear of the tympanon, although the back was clearly invisible to the spectator, and weathering and finish indicate that the right hip may have been slightly withdrawn. The slight difference in the volumes of the two sides may echo this, with the greater volume then being on the withdrawn side. The twist round to the figure's left makes it likely that the figure was shown moving to the spectator's left, but directing his action against a figure behind him (thus making Neugebauer's *rapprochement* with no. 17 unlikely).[56] To judge from the remains of the thighs and pubis, the figure was bending slightly forward; at most the diminution was only ten to fifteen percent of the 'standing height', so that the actual height would have been perhaps 1.70/.80 m and the distance of the head from the centre about 40/70 cm. Two or three examples of this pose appear on the Mausoleum Amazonomachy, of which the best for our purposes is BM 1008.43 (PLATE 40b); a torso with almost identical musculature and movement once formed part of one of the central groups of the Epidaurian east pediment, possibly Neoptolemos killing Priam (PLATE 26b).

By now it should be clear that the piece ought to be-

long to the central group—either to Telephos or Achilles, or to their immediate neighbours. The problem of its attribution, however, does not seem to me to be capable of more than provisional resolution at this stage; the remains are too fragmentary and for the two outer figures there are other candidates as well (i.e. no. 17). The similarity of the musculature and pose of this torso to the torso of Telephos on the Pergamon altar (PLATE 29c) is undeniable, and would make it very tempting to say that our piece, with no. 16, once formed part of Telephos himself, were it not that the left shoulder of no. 16 was definitely raised and is thus difficult to reconcile with the apparent contraction of the left side of no. 26.

Yet exactly this did occur at Pergamon, as PLATE 29c indicates, and has good fourth century precedents (cf. PLATE 37b). Should we then revise our ideas slightly about the pose of no. 16, and assert only that the left shoulder was raised in relation to the neck, and not *necessarily* in relation to the torso? Thus, PLATE 53 shows the torso provisionally reconstructed with the head no. 16, here identified as Telephos, on the analogy of the Pergamon altar.

No other figures in the west pediment can be restored with any confidence, and no heads certainly attributable to Herakles, Athena or Dionysos remain to support Picard, Dörig and Delivorrias in their introduction of the Gods into the composition.[57] Here, Delivorrias' arguments in particular are strong, but apart from the lack of material remains (not in itself decisive), three reasons above all others seem to render their presence unlikely.

In the first place, the vine in the centre of the pediment with Telephos (no. 16) to the spectator's left leaves no room for the three deities as envisaged by Delivorrias, grouped between the two contestants; it is still (just) possible that Herakles and Dionysos stood immediately to the outside of Telephos and Achilles, though in this position their intervention would have been rather indecisive and the transition mortal-god-mortal on each side of the centre would have been an awkward one. Secondly, as already noted, Herakles appears in the legend in none of the sources, and considering the strong links between Pergamon and Tegea one would surely expect him to have been included in the Telephos frieze had any precedent existed on the Tegean temple. Thirdly, the vine renders the actual presence of Dionysos rather otiose, in dramatic terms at least; although he appears both on the vase by Phintias in Leningrad,[58] which shows another part of the battle, and on the Telephos frieze

(PLATE 29c), again no literary text testifies to his physical presence on the battlefield, and without a balancing deity (i.e. Herakles) in the left *kerkis*, the asymmetry of the arrangement on the frieze would have been intolerable when transferred to a pedimental composition.

On these arguments, if Dionysos was included in the west pediment at all, it could only have been in one place: directly in the centre, behind the vine. Although on the face of it this seems reasonable, it again ignores what was apparently normal Greek practice in architectural sculpture, which was to balance the compositions in the two pediments as far as possible or to give the main 'weight' to the east. Where central figures are adopted, they either appear in both pediments, as at Corfu, Aegina and Olympia, or only in the east, as on the Hephaisteion and the Parthenon—and we know for certain that there was no deity in the centre of the east pediment at Tegea.

The composition of both pediments seems to have been extremely crowded, with much overlapping and drastic curtailing of figures set back against the tympanon wall. Puntelli indicating joins between our figures, a feature of the Epidaurus pediments, are very rare indeed and a further clue as to the degree of freedom in space allowed to them. In view of this, we may conjecture that Clemmensen was correct in favouring the rearward position for the tympanon wall at Tegea, since this alone could have given sufficient space in the pediment for the composition to have developed in depth to the extent we have noted (i.e. 0.70 m to the step at the front, as opposed to 0.62 m); at Epidaurus the pediment seems to have been much shallower in relation to its height (cf. FIGS. 2 and 3).[59]

As regards optical corrections at Tegea, we may draw, it seems, three conclusions from the preceding sections: firstly, that on the akroteria at least, the width of the upper part of the body was increased and the eyes canted forward to compensate for distortions in the vertical plane (nos. 1-4); secondly, that for the pedimental figures the practice was to increase the width of the withdrawn side of the figure (definitely, nos. 16-18; probably, nos. 8, 13, 15 and 26; possibly, nos. 11 and 12), with one exception, no. 9, which is virtually symmetrical; thirdly, that on all the heads the modelling on the withdrawn side is flatter and the features embedded less deeply into the face (nos. 9, 16-18).

It would thus appear that the sculptors were attempting to compensate—and, what is important,

fairly uniformly—for the near disappearance of the far side of figures seen in strongly three-quarter or near profile poses. Certain sculptors at Olympia seem to have approached this problem in the same way;[60] at Epidaurus, however, according to Yalouris, it is the withdrawn side that is curtailed in breadth, possibly because three-quarter poses are generally rare and the sculptors were anxious to increase the three-dimensionality of their figures. Our conclusions accord so far with what we have observed from the treatment of the invisible areas of the figures, that three-quarter poses were the rule at Tegea rather than the exception.

Other perspective distortions are few: it seems that the nearer eyebrow is usually slightly higher and more curved than the further, and the axis of the nose of no. 17 inclines strongly towards the spectator. These distortions seem to correspond, to judge from the restored positions of the heads, with Stucchi's observation that the apparent displacement relative to one another of points placed on a vertical or horizontal line above and to one side of the spectator was a phenomenon known to the Greeks and often corrected in their sculpture.

In general, then, my conclusions confirm Stucchi's, and on the whole there seems no reason to doubt that optical corrections were employed by the Greeks from an early period. What we cannot say, however, is how far optical theory had progressed and was being applied in practice by fourth century sculptors—there is a world of difference between arriving at a certain result through systematically applied theory and arriving at the same result by trial and error. At Tegea, the apparent exception to the rule is the virtual symmetry of no. 9, which will serve to illustrate our dilemma.

Here two explanations are equally possible: either not so much trouble was taken with figures near the corner (which seriously damages any idea of a consistently applied theory of optical corrections), or it was felt that the great distortion logically required by the much increased distance of the piece from the centre would be intolerable. The former needs no further comment, but if the latter was the case, we have stumbled upon a remarkable, and, as far as I know, unique example in the ancient world of the application of a theory of central projection to architectural sculpture and its subsequent modification to suit what was tolerable in practice.

Before this is dismissed as too speculative for words, it is perhaps worthwhile pointing out that an exactly analogous procedure was adopted again during the Renaissance (in many ways strikingly close

to Classical Greece, especially in its preoccupation with 'rational thought undisturbed by sentiment'),[61] by Raphael in his 'School of Athens',[62] where the eye is led to a central position by the strict perspective of the architecture, yet the figures are actually *drawn* from a number of subsidiary points of projection to ameliorate distortions that would become unpleasant as one moved around the room.

Yet even accepting Gioseffi's reconstruction of a central vanishing point and two distance points for the Alexander mosaic (original, c. 320–300)[63] where likewise no strongly anamorphic distortions occur, any question of a parallel in ancient sculpture must remain pure supposition. On the material evidence as it stands, we cannot but conclude that although a central viewpoint was probably provided for at Tegea, it is not possible to say with any confidence whether anything beyond the rule-of-thumb corrections often applied in the case of pedimental figures—more precisely, the systematic integration of the pediment groups into an overall scheme of central projection—was ever envisaged by the designer or carried out in practice by the atelier.

With one possible exception (no. 13) it does not seem to me that these corrections were drastic enough to make much difference, even to an observer standing quite near the temple. It is almost impossible to detect them on no. 16, for example, when on its shelf only some 12 feet from the ground; in position on the temple it would have been almost 50 feet from the ground. Ashmole's caveat would thus seem to be justified.

The Metopes

Pausanias did not describe the metopes, and our only clues as to their subjects are two inscriptions: ΚΑΦΕΙΔΑΙ on an architrave block found to the northeast, and ΑΥΓΑ ΤΗΛΕΦΟΣ Α[ΛΕΟΣ ?] on another found to the west.[64] The former suggests that the pronaos metopes portrayed the exploits of the children of Kepheus (son of Aleos and brother of Auge), and the latter that over the opisthodomos were scenes taken from the life of Telephos.[65]

No. 30 (male torso, clad in a long tunic). This fragment, probably part of a charioteer, is one of the only two from the metopes that can be placed with any hope of correctness. Its provenience is unknown.

Where does a charioteer fit into this scheme? The twenty sons of Kepheus cannot have fought in chariots in the restricted area of a metope measuring only

1.022 m x 0.993 m, and chariots, either in battle or in funeral games, appear nowhere else in the Kepheus legends that I can discover.[66] On the opisthodomos metopes, however, a life of Telephos would have presented one occasion for the appearance of a chariot—in the battle scene by the Kaïkos, when his wife, Hiera, is unanimously agreed by the sources to have fought from a chariot prior to her death; here, then, is where our charioteer should perhaps belong.

No. 32 (lower torso, probably of a baby or small child). The most likely possibility is that this is the young Telephos. The ΑΥΓΑ ΤΗΛΕΦΟΣ Α[ΛΕΟΣ ?] metope of the western series presumably showed Aleos' discovery of the child; his exposure on Mount Parthenion and suckling by the deer was perhaps represented on the next panel along.[67] It is, of course, quite impossible to decide between them.

Picard's conjectures do, however, suggest another identification: that the baby is the young Aeropos, son of Aerope by Ares and suckled by her even after her death in childbirth.[68] In this case, the torso would belong to a metope of the eastern series showing the sequel to the seduction scene; I prefer the other identification, if only because it is securely documented, but this must obviously remain a possibility considering the inadequacy of the evidence.

Although the conditions for an appreciation of the composition of the metopal scenes as such no longer exist, the choice of the appliqué technique and the scale of some of the fragments (the original 'standing height' of no. 27, for instance, was c. 1.4 m, whereas the metopes themselves, even including the crowning fascia, were only 0.993 m high) do, I think, allow the suggestion that there existed important points of contact with the pediments, especially as regards the much increased three dimensionality of the figures and the way in which they, too, would have appeared as if bottled up within their architectural frame.

FIG. 5 shows that the metopes were easily visible from the position previously calculated for our ideal observer, being one course lower than normal. Columns were growing loftier, Doric metopes proportionately smaller and further away, and Skopas was concerned enough to try to counter this tendency by moving the architrave and frieze of the pronaos and opisthodomos down a course. The frieze was accordingly more easily visible from outside, countering the loss of importance that resulted from its elevation.[69] That Greek architects went to no small trouble even over such refinements as these has been convincingly demonstrated for the Parthenon frieze by Stevens and Stillwell.[70]

Chapter Three

ICONOGRAPHY AND INTERPRETATION

Since the discovery of the Tegea sculptures, the difficult problem of the relationship of their subjects to the cult of Alea Athena and local mythology has received rather short shrift: Neugebauer, Dugas, Pfuhl and others have had little to say on the subject, and, apart from a recent article on the west pediment by Delivorrias, only Picard, in a series of three articles, has attempted a thorough study; to this Lapalus has added nothing new.[1] However, unlike Lapalus, I find Picard's diffuse and circumstantial attempt to prove Dionysos and Herakles (strange bedfellows!) the twin *éminences grises* behind the themes chosen neither convincing nor particularly in tune with the evidence; that Alea Athena herself plays such a minor part in his scheme only serves to increase my reservations. As we shall see, she was more than a mere local *Potnia*. Since the extended critique that Picard's arguments would require could, ultimately, never be more than inconclusive, the interpretation advanced here is intended not merely as an alternative, but also as a further step towards a deeper understanding of the more complex relationship between architectural sculpture and religion that, together with Picard, I believe to have been characteristic of the fourth century as against the fifth.[2]

THE CULT OF ALEA ATHENA

It seems absolutely clear that whatever her concerns in the prehistoric or dark ages, by the fourth century the role of Alea Athena in the Tegean cult was a dual one, in that she functioned both as a war-goddess and as a goddess of help and refuge. As a war-goddess she appears fully armed on a sixth century Tegean bronze, in what is possibly a reflection of Endoios' cult statue (saved from the fire of 395 and reinstalled in the new temple), and certain coin types seem to depict her replacement, the Athena Hippia of Manthyrenses, also a war-goddess, which was substituted after Augustus removed Endoios' image to Rome. On one type she is even shown clasping hands with Ares.[3] Significant here are the battle offerings dedicated to her in the temple and described by Pausanias.[4]

Pausanias elsewhere explicitly states that her temple was the place of refuge for suppliants in the Peloponnese, and names three examples, two of them Spartan kings.[5] Skopas himself carved the statues of Asklepios and Hygieia that stood to either side of Endoios' statue on the same base, which themselves help to underline this conception of her,[6] and it is obvious that her care for Telephos and Auge, her priestess, falls squarely within this sphere of her activity. We shall have cause to return to this particular occasion for the exercise of the goddess' compassion below.

THE AKROTERIA

The Tegean akroteria are something of a puzzle. On looking at the photographs of the two surviving torsos, nos. 1 and 3, several questions, none immediately answerable, come to mind. Who are these enigmatic figures? Why are they so similar, yet clearly differentiated in their dress by the addition of the himation on no. 3? Why is no. 1 striding and no. 3 floating? Why is no. 1 wingless, and was no. 3 ever winged? Clearly, the designer of the two sets of akroteria was trying to make a point, and some detective work will be necessary to determine what it was.

The most urgent of these questions is the final one:

was no. 3 ever winged? Certainly, no remains of *marble* wings survive, as on the 'Epione' from Epidaurus, NM 155, but this is not in itself a bar, since no. 3 was almost half as big again as the 'Epione' and wings would have been tremendously laborious and difficult to carve from the same block as the statue, as well as being extremely expensive in marble. Doliana marble, too, is not as homogeneous in its structure as Parian (used for Paionios' and the Epidaurian Nikai) and tends to split, so that the Tegean atelier tended to prefer to make the parts of their statues that could be troublesome separately and to dowel them on. Unfortunately, the back of the torso is split away, and with it any evidence of wing-sockets, so unless the missing piece is recovered we are forced to fall back upon arguments from probability alone: it is *likely* that any floating figure dressed as a Nike will have wings, and if no. 3 had wings, it is *likely* that they were of metal and set into sockets in the missing part of her back (as with the akroteria from the Artemision at Epidaurus some 40 years later).

Certainly, the dress of no. 3 proclaims her as a Nike: the scheme of her drapery, peplos and billowing himation, is modelled on that of the little girl-Nike from the temple of Asklepios at Epidaurus, NM 162 (PLATE 26a), furthermore, a Nike from Cyrene, possibly carved towards the end of the fourth century, carries a himation in a manner identical with hers, and is furnished with sockets in her back for wings. If the head no. 4 is rightly attributed to no. 3, we have further corroboration from the hair style, so similar to that of the Artemision Nikai. On the whole, then, it seems reasonable to suppose that our statue, once poised high above the left corner of the west pediment, was indeed a winged Nike, though her exact significance in the context of the Kaïkos battle remains to be established.[7]

What, then, of her sister, no. 1? Could she be an example of that rare and disputed phenomenon, a *wingless* Nike?[8] After not a few changes of mind on this score, I now think not. For one thing, her feet were almost certainly on the ground; for another, it seems to me that the sculptor (or rather, the designer) has taken care to underline the *differences* between her and a conventional Nike in an emphatic manner, while yet preserving the link with the bringer of Victory through the pose, the arrangement of her peplos, and, if the attribution of the hand fragment no. 2 is correct, the attributes (ταινία and στεφάνη).[9] The intended impression is clear: not a Nike as such, she is a Nike-like being, introduced to fit some special circumstances

connected most probably with the theme of the east pediment—the Hunt of the Calydonian boar.

To me, the most likely of the various categories of semi-divine beings are the forest nymphs, or Dryads.[10] In the context of the Calydonian hunt these would be particularly appropriate, since not only do we know from Ovid (and from the Tegean coin, PLATE 29a) that it took place in the forest, but the mountain and forest nymphs—companions of the goddess of the chase, Artemis herself—were highly revered by hunters, as many sources tell us.[11] If parallels be required for an association with victory on their part, on a fourth century vase in Munich[12] a nymph in a long peplos offers the crown with her right hand at the Judgement of Paris. In the Arcadian glens, home of hunters, numphs were particularly honoured and particularly numerous, as Pausanias' narrative confirms,[13] and Arkas, whose name the land still bears, is said to have married one, a Dryad named Erato, from whom the Tegean dynasty was descended (see Appendix 3). Atalante, it must not be forgotten, was herself a nymph and Erato's great-great-great granddaughter, and hunted with Artemis until she earned the displeasure of the goddess for her child by Meleager, Parthenopaios (which happened after the Calydonian expedition and should not therefore have affected the iconography of the Tegean temple).[14]

On the whole, then, it seems fairly reasonable to assume that the eastern akroteria were Arcadian Dryads, the νύμφαι ὀρεσκῷοι of the Homeric Hymns, striding forward to bestow the emblems of victory upon their companion Atalante, Artemis' favourite, and the other hunters. On the vases, not only are the heroes crowned with a *taenia* or wreath (στεφάνη) in almost every case, but these attributes even occur on the one painting showing them setting out for the hunt (Appendix 2, no. 1); a youth holding a *taenia* leads them into the fray. On the pelike in Leningrad (Appendix 2, no. 6: PLATE 28a), all wear *taeniae* except Atalante, and on the Berlin krater (Appendix 2, no. 9: PLATE 28b) Atalante wears cap and diadem, Meleager a wreath, and the others *taeniae*. Finally, the head of Meleager from the heroon at Calydon (Appendix 4, no. 14) had a *taenia* and was also prepared for a crown of some kind, as the attachment holes show.[15] If a tree really were portrayed in the centre of the pediment, as the coin type (PLATE 29a) would suggest, then to guess the identity of the akroteria would not have required much effort on the part of anyone, Tegean or visitor, who knew a little mythology—for in Arcadia, nymphs are never very far away.

THE EASTERN PEDIMENT AND METOPES

The hunt of the Calydonian boar, depicted on the east pediment, was one of the great myths of antiquity, and Pausanias' somewhat laconic account perhaps requires amplification.[16] Briefly, the story as the fourth century would have known it would have run as follows: Oeneus, king of Calydon and father of Tydeus, Meleager and Deianeira, was careless enough to overlook Artemis in his harvest sacrifice, so in revenge she sent a mighty boar to ravage the country. Meleager responded by inviting the most renowned heroes of the time, Theseus, Telamon, Peleus, and others, together with the Tegean princess, Atalante, to join him in slaying the beast. Many lost their lives in the struggle, but eventually the monster was slain. In the version that includes Atalante,[17] Meleager, in love with her, gave her the head and hide of the animal as prizes of victory (for she had been the first to shoot at and hit the boar), whereupon the two sons of Thestios, Prothoos and Kometes (brothers of Meleager's mother Althaia) took them from her, alleging that the prizes belonged to them as next of kin, if Meleager renounced his claim. In anger, Meleager killed the two of them, and restored the head and hide to Atalante. When Althaia heard of the fate of her brothers, she angrily extinguished the torch which the Fates had given her on Meleager's birth and to which his life was tied. Finally, on learning of her son's death, she killed herself in remorse.

As regards the iconography of the pediment, Pausanias, the coin type (PLATE 29a) and our fragment no. 8 all tell the same story—that the principal character in the drama was Atalante, the daughter of Iasos or Iasion, son of Lykourgos of Tegea, and thus the Tegean heroine par excellence.[18] Inside the temple itself, this was yet more heavily underlined by exhibiting the hide and tusks of the boar as Atalante's prizes.[19]

The heroine was clad in a light hunting chiton, with her himation slung over her shoulder and rolled around her waist to keep it out of the way; Artemis often wore it in this manner, and indeed, Picard and others have seen in Atalante a kind of 'crypto-Artemis',[20] with, I think, some degree of probability, but our lack of evidence hardly allows us to speculate on how large a part such associations actually played in this composition. On the coin-type she wears a hunting cap, so this might well have been her garb here.

Considering her well-known prowess with the bow, embodied in the legend that she was the first to shoot at and hit the boar, it is surprising that no re-mains of bow or quiver are detectable on no. 8 (the quiver does appear on the coin-type). Perhaps, following the dictates of logic and good hunting practice, they had already been laid aside for close-quarter work with the boar spear; certainly, as a satisfactory way of filling the left-hand corner of the pediment, to show them there would be killing two birds neatly with one stone.

Meleager seems to have taken second place, although the elements of the later squabble over the spoils and ensuing tragedy were indeed present, in the form of the two sons of Thestios, Prothoos and Kometes.[21] The distance between our pediment and the earlier, 'Polygnotan' scheme, perhaps echoed by some of the vase paintings, is obvious, although without fuller evidence it is impossible to gauge either the extent of the differences or how far they could perhaps have reflected Euripides' rehandling of the story.

The other heroes were either Tegeans (Ankaios, Epochos and Hippothoos) or came from outside Arcadia, like Meleager and Peleus. The identities of the three I have restored to the right of the boar remain a mystery. The sources tend to swell indiscriminately the number of the heroes who took part in the hunt, so their names are really anyone's guess; to me, the most likely possibilities are Kepheus or Jason, and the two sons of Aphareos, Idas and Lynkeus. If the Tegean version of the story took precedence in the right *kerkis* as in the left, then Kepheus, named only by Apollodorus of the three complete lists of hunters, is the natural choice as a close relation of Atalante and the major Tegean hero of the older generation;[22] if not, then Jason, named by all three lists and found on a black-figure picture of the hunt in Munich,[23] is the best substitute. As for the others, Idas later became an adversary of Telephos, and the two sons together were deadly rivals of their cousins the Dioscuri, who were certainly represented, so here, too, the elements of later tragedy could have been discreetly alluded to. Alternatives are Admetos and Dryas, both again named by Ovid, Apollodorus and Hyginus, but both rather colourless and hardly suitable to balance Meleager and Theseus; or Mopsus and Kaineus (only in Ovid and Hyginus). Eurytion, who again appears in all three sources, cannot have been shown, since Peleus speared him by mistake long before the boar was slain; he was thus already dead before the moment chosen for representation in the Tegean pediment.

Considering the east pediment as a whole, one particularly striking feature of its iconography is its independence from earlier sources, both artistic and lit-

erary. Unique is the dominant rôle given to Atalante, who actually spears the boar in place of Meleager instead of merely shooting at it from afar—though this incident must already have taken place to provide the occasion for Ankaios' assault and death ('See how far superior to a woman's weapons are those of a man' is his chauvinistic cry in Ovid).[24] Unique, too, is the appearance of Epochos to comfort his dying brother; neither he nor Iolaos and Hippothoos are mentioned by Apollodorus, who is normally considered to be reflecting Euripides' verson in the *Meleager*.[25] With these points in mind, it seems unwise to talk of the Tegean pediments in terms of Euripidean drama (and particularly dangerous, therefore, in the case of the west pediment, which is so fragmentary that its restoration turns on how faithful it was to tradition), or to assert, as Picard has done, that 'C'est plutôt de la tradition même des dramaturges que Skopas a hérité à Tégée.'[26] True, the Tegean sculptures are dramatic, but petrified Attic tragedy they certainly are not.

The subjects of the metopes I take to have been scenes from Tegean history and legend, and in particular, the exploits of Kepheus (son of Aleos, the founder of the sanctuary and builder of the old temple) and his children. As Dugas has shown, the ΚΑΦΕΙ-ΔΑΙ[27] of the only inscription that survives probably did not refer to Aerope, Kepheus' daughter, and her child by Ares, Aeropos, for the inscription is off-centre, below the left-hand side of the metope, and should, like the ΑΥΓΑ ΤΗΛΕΦΟΣ Α[ΛΕΟΣ] inscription, have named the two individually if these were meant. Far more appropriate to the placing and use of the collective would be the battle between Kepheus' sons and the sons of Hippokoon, from Sparta, a very patriotic theme; in this case, the word ΙΠΠΟΚΟΩΝ-ΤΙΔΑΙ would presumably have filled the missing space. The story ran that after the death of Iphitos, Herakles was refused purification by the Hippokoontidai, who then compounded the insult by killing his young cousin Oeonos for knocking down, with a stone, a house dog that had attacked him. Herakles rounded upon them, but received a wound in the thigh and retired to Tegea; when his wound healed, he led the sons of Kepheus against the Spartans and roundly defeated them, killing Hippokoon and his sons, and placing Tyndareos on the Spartan throne.

As for the other metopes, the seduction of Aerope by Ares must remain a possibility, as must the receipt of the Gorgon's lock (Eruma, or 'defence')[28] from Athena—Picard's most plausible suggestion. The story, both mentioned by Pausanias and depicted on

the Tegean coinage, was that Kepheus' attention to the cult of Athena resulted in her giving him a boon, that Tegea should never be captured while time should endure; as a token of her tutelage over the city, she cut off some of the hair of Medusa, presumably from her own symbol of protection, the aegis, and gave it to him to keep.

Another theme could perhaps have been the victory of Marpessa and the Tegean women over a Spartan invasion force,[29] resulting in the extraction of an oath from the captured Spartan king, Charillos, that the Spartans would never again attack Tegea (an oath they promptly broke as soon as he was released). Pausanias makes much of the tale, and in the temple it was given further prominence by the dedication of the Spartans' fetters and Marpessa's shield. Finally, there is the combat between Kepheus' grandson Echemos and Hyllos, perhaps the most splendid exploit in the legendary history of Tegea, which both appears on the coins and on a relief seen by Pausanias, and recently found at Tegea.[30] The occasion was the first Dorian invasion of the Peloponnese, before the Trojan war, led by the Herakleidai. The two armies met at the Isthmus of Corinth and resolved to decide the issue by single combat; after a hard fight, Echemos killed the Dorian leader, Hyllos, and the Dorians promised not to attempt to invade again for a century. The Achaeans were saved—for a time, at least—and it was a Tegean and a son of Kepheus who had saved them.

From what we know of the nature of Alea Athena, such warlike scenes seem to me more likely than Picard's pacific ones, bolstered as they are by a theology of chthonic deities and gods of the dead for which evidence is both scanty and uncertain. Furthermore, except for the Eruma story, Picard's themes have virtually no connection with the cult of Athena and were celebrated elsewhere in the city; why, then, duplicate them on Athena's temple? To me, all likelihood appears to be against it.

We can perhaps summarise the links that have emerged between the cult and the decoration of the east front of the temple in the following way: the metopes mainly depicted the exploits of Kepheus and his children and grandchildren, the descendants of Aleos, with a helping hand from the goddess herself at times;[31] these culminated on the pediment with the great battle with the boar (although this need not necessarily have been the latest of them in time), where Lykourgos' granddaughter Atalante, his sons Ankaios and Epochos and perhaps Kepheus himself played leading parts. The themes are martial and

heroic, well in tune with the character of Alea Athena and even Asklepios, himself once an Argonaut and, according to Hyginus, a participant in the Calydonian hunt.[32]

THE WESTERN PEDIMENT AND METOPES

'Aid in battle' and 'aid in adversity' are really two sides of the same coin; however, in order to understand the difference in spirit between the decorative schemes of the two façades, we must hold to the distinction, no matter how pettifogging it may have seemed to a Greek of the fourth century. Just as on the east façade the goddess Alea Athena can be referred to continually as the power behind the success of the Tegean dynasty in war, so on the west is the true meaning of the Telephos legend equally incomprehensible if all reference to the involvement of Alea Athena, this time primarily as a source of help and succour, be omitted.

The single inscription ΑΥΓΑ ΤΗΛΕΦΟΣ Α[ΛΕΟΣ?] preserved from the architrave of the opisthodomos tells us that the six metopes above carried scenes from the life of Telephos. The series has been reconstructed by Picard, although the existence of the charioteer's torso (no. 30) seems to cast doubt on where the sequence actually ended; instead of closing with Auge's arrival in Mysia it might even have reached as far as the Kaïkos fight—forming, in effect, a miniature precursor of part of the Telephos frieze at Pergamon.

The Telephos myth is complex and not particularly well known, and the Tegean version of it will perhaps bear a brief retelling. Auge, the daughter of king Aleos of Tegea, sister of Kepheus,[33] and priestess of Alea Athena, was seduced near the fountain in the sanctuary and made pregnant by Herakles. At this violation of her sacred temenos, the goddess, herself a virgin, sent a blight upon the country. Here the story divides, but to judge from the ΑΥΓΑ ΤΗΛΕΦΟΣ Α[ΛΕΟΣ] inscription, the version preferred on the temple[34] was that in which Auge hid her newborn son in the precinct but was discovered by Aleos when, consulting an oracle, he was told the cause of the blight. He then promptly nailed his daughter up in a box and cast her out to sea, and left the baby Telephos to die on Mount Parthenion.

Fortunately, a hind found the child and suckled it, and, even more luckily, Herakles appeared (perhaps after wringing the truth from Aleos) and gave him to shepherds to bring up. When he became a man, and, wanting to know who his real parents were, consulted

the oracle at Delphi, Telephos was told that he would find his mother in Mysia (near Pergamon), whither her box had drifted, married to the king of that land, Teuthras. Teuthras welcomed his wife's son, married him to his daughter Hiera, and at his death appointed him his successor.

Shortly afterwards, the Greek army landed in Mysia on their way to Troy, and, mistaking it for Troy itself, began to plunder the countryside. Telephos, now king, met them in battle by the river Kaïkos and even put a section of the Greek army to flight but, having failed, unlike Agamemnon, to make a sacrifice to Dionysos in advance, caught his foot in the roots of a vine which the god had caused to appear, tripped, and was speared in the thigh by Achilles after Protesilaos had managed to seize his shield. After wreaking further havoc, including killing Hiera, the Greeks then withdrew. The wound refused to heal, and an oracle revealed that it could only be healed by whoever had inflicted it. Telephos then disguised himself as a beggar and went to Argos, whither the Greeks had been driven back by a storm.

Gaining admittance to the palace, he revealed himself to Clytemnestra, herself thirsting for revenge for the death of her daughter Iphigeneia at Agamemnon's hand. At her suggestion, he seized Agamemnon's infant son, took refuge on an altar, and compelled the king to make Achilles cure his wound. This Achilles did, by applying rust from the lance that had caused it; the two sides were then reconciled, and Telephos on his part agreed to guide the Greeks to Troy.

Athena's regard for her priestess Auge, daughter of Aleos and sister of Kepheus and Lykourgos, and her son Telephos throughout their lives and wanderings (parallel in some ways, this not the least, to the Odyssey) was both writ large at Tegea and amplified by later sources. Besides the fact that their story occupied half the decoration of Athena's temple, not only did a picture of Auge hang there, but a side door and ramp gave access to the fountain usually identified as that where according to local legend, she met Herakles; several Tegean coin types also show Alea Athena on the obverse and Telephos being suckled by the doe on the reverse.[35] In Euripides' *Auge*, even more was made of Athena's part: apparently reflecting the tragedy, Apollodorus (iii.9.1) tells us that Auge laid the newborn babe in Athena's sanctuary, and Strabo (xiii.613) says that after being cast adrift in her box she came to the coast of Mysia 'through Athena's foresight'. It also seems fairly certain that just as Telephos was adopted by nearby Pergamon as its founder, so

Auge was regarded as having founded the sanctuary of Athena there.[36] Finally Auge's assimilation to Eileithuia[37] at Tegea shows how she, in turn, became a symbol of help in need, and thereby an echo of her great patroness, to the Tegean people.

Yet, appropriate though this theology may have been for the metopes, how far can it be shown to apply to the pediment,[38] where Telephos was represented at the very moment of humiliation and defeat? Of earlier students, only Picard and Delivorrias have treated the problems of this scene in any depth, and since their interpretation differs from mine so widely, it seems best to clear the air a little before beginning.

Firstly, if the evidence for the restoration of the composition advanced in the previous chapter is accepted, all the indications are that a battle scene involving probably sixteen to eighteen combatants was depicted, not a duel with the Gods as spectators as Picard suggests, nor the battle with the Gods separating the contestants for which Delivorrias so cogently argues. Like the east pediment, then, the west would seem to have been fairly independent in its iconography and emphasis. There is no evidence for chariots, and Picard's attribution of the helmeted male head, no. 17, to Athena is patently nonsense. The Gods, especially Dionysos and Athena, were thus not *directly* involved in the action, which rather weakens Picard's hypothesis as to the extent of Dionysos' role, both overt and covert, in the whole affair—a role which in any case seems to me to be distorted out of all proportion to the evidence, just as is Herakles'. I will return to this point later in the chapter.

Surely it is to Alea Athena, in her guise as protectress in adversity, and if necessary further, to Asklepios and Hygieia, that we must turn to find the answer to this unparalleled tableau of the great hero of Tegean mythology apparently shown *in defeat* on the major temple of the city. First of all, a clue is given by Telephos' probable position in the pediment: to judge from both the Pergamon frieze (PLATE 29c) and the word order of Pausanias' text (Τηλέφου πρὸς Ἀχιλλέα μαχήν),[39] Telephos was shown to the left of centre, the side of (ultimate) victory; this would be further corroborated if we could be sure that our no. 16 was really the head of Telephos himself.

The second clue comes from the known history of the Kaïkos battle; as Pindar tells us, Telephos was brought down in the moment of triumph:

 . . . ἀλκάεντας Δαναοὺς τρέψαις ἁλίαισιν

 πρύμναις . . . ἔμβαλεν.[40]

Not even defeated, then, but only checked from his rightful victory.

The third clue comes from the akroteria which, as we have seen, are probably Nikai. As bringers of victory from Athena to Achilles they would hardly be appropriate, but as messengers of hope, promising ultimate victory, even as rescuers, they become both possible and relevant. Their attributes are unknown; the wreath and taenia conjectured for the east akroteria (see no. 2) seem unlikely, a palm hardly more possible, perhaps they carried spears (cf. PLATE 28b). Again, if Telephos were shown as a Heraklid, Athena's intervention on his behalf could then be seen as a simple extension of her favour towards his father during the Labours, retailed in graphic detail on the metopes of the temple of Zeus at Olympia.

But the relationship between wounded hero and cult would appear to go deeper than this. According to the sources, Asklepios also enters the story, albeit obliquely, in the persons of his two sons, Podaleirios and Machaon, who apparently tried to heal the wounded Telephos at Troy. Telephos himself was celebrated in hymns at the Pergamene Asklepieion (although his son Eurypylos was omitted as having killed Machaon at Troy), as Pausanias tells us more than once;[41] although this evidence is late and rather circumstantial, it does seem to indicate a further bond uniting Telephos, Asklepios and Athena, especially if one remembers that it was Athena's gift of the Gorgon's blood that gave Asklepios his powers in the first place, to use for good or ill.[42]

What of the iconography of the remainder of the pediment? Here it is unfortunate that we have so very little to go on.[43] The Phintias krater in the Hermitage shows not Telephos but Patroklos and Diomedes, which leaves us with the Telephos frieze alone (PLATE 29c).

I think the vine was certainly shown; it appears not only on the frieze but in most written sources. As for the Kaïkos, mentioned by Pausanias, was the appearance of the vine sufficient to set the scene (together with, perhaps, the lionskin on Telephos' head) or was he alluded to by the inclusion of, for instance, a fish, or did he even appear in person, reclining in the right-hand corner of the pediment? The figure in the other corner (no. 20—and 19?) remains a mystery, For her, Picard suggests Teuthrania, an attractive possibility as a counterpart to Kaïkos; the parallel with Olympia is clear. His other suggestion for the right-hand corner, Arcadia,[44] is less happy, since the same need to localise the action that led to her inclusion in the Herculaneum painting of Telephos being suckled by the doe would logically lead to her exclusion from a battle in Mysia. It is impossible to identify the other partici-

pants; Philostratos, cursive and longwinded, furnishes plenty of names, but the Telephos frieze is unhelpful. Protesilaos, who was said to have taken away Telephos' shield, and Hiera, who fell valiantly fighting against the Greeks, are both probable.[45] Lack of interest apart, the reason for Pausanias' brief description may have been that the names of the other combatants were unknown to him and to his guides also, as suggested below.

What, then, of Dionysos and Herakles? Picard derives Dionysos' presence in the sanctuary from the representation of the birth of Zeus on the Altar and Pausanias' remark that it was first erected by Melampous (Dionysos' prophet and priest); however in all his description of Tegea Pausanias nowhere mentions Dionysos, and it is perhaps worth remembering that the connections Picard sees between the various Dionysiac traditions of Corinthia, the Argolid and Arcadia are at best rather tenuous, resting as they do on Melampous' supposed progress across the Peloponnese, the exclusion of Oenoe from the otherwise similar composition on the Table at Megalopolis and Callimachus' Hymn to Zeus, and a remark by Pausanias apropos of the place Oenoe that it was named after Oeneus, since he died there.[46] The sources are all very scattered and neither Pausanias nor Callimachus refer to Dionysos in the passages cited.

Thereafter, the argument becomes labyrinthine: Althaia, Oeneus' wife, bore Deianeira, sister of Meleager and wife of Herakles, either by Dionysos or Oeneus.

> Dionysos était représenté dès l'autel par le souvenir d'Oineus, personnage à comparer au Phytalos de la Hièra-Syké, au Triptolème de Raria, puisqu'il avait reçu et transféré au Peloponnèse le don du premier plant de vigne; le cortège des Nymphes et des Muses, a l'Autel fédéral, a été mystiquement *bachique* encore. -Dans la série des métopes du *sékos*, a l'Est, nous retrouvions l'Arès-Dionysos infernal, souche de la dynastie des Cépheides, après son union avec Astéropé-Aéropé. Dionysos a été représenté sur le fronton même de la Chasse, par Méléagre, à la fois sa victime et son protégé, selon l'équation éleusinienne, où la morte ouvre la vie. Vers l'ouest, c'est Héraklès d'abord, associé ordinaire du fils de Sémélé, qui va être l'introducteur du dieu; héros plus *apparent* d'abord, et en principe, que le Nyctélios, le dieu de la fête des Ombres d'Aléa (Skiereia)![47]

Picard's exclamation mark seems well placed. Would anyone have remembered all this, or had time for it, even in antiquity?

Here, though there is a more fundamental point at issue than the correctness or otherwise of an interpretation: the problem of meaning itself in the context of a classic style.[48] If I am not mistaken, Picard distinguishes several different 'levels of meaning' within the religious, each successively more mystical and each bearing with it a host of further connotations and allusions to other cults and religions or semi-religious beliefs. This multiplicity of meaning is, to my mind, totally at variance with everything we know about the Classic as a mode of human expression. Though the Baroque certainly delights in suggestion and manifold meaning, in Classic art, 'The major . . . theses would be unity and universality. A work would have a single meaning, though illustrated by particulars, and everything in the work would go to show that one meaning. The style would be appropriate to the one meaning and stay that way throughout.'[49] Other authorities, like Gombrich and Panofsky, have endorsed this view, so let multiple meanings remain the property of Hellenistic and Roman art, not of the fifth or fourth centuries B.C.

In terms of what we know for sure, Dionysos intervened in Mysia—and then not in person—only to trip Telephos, and even the reason for this is disputed. Daux and Bousquet suggest that the 'Sphaleotas'[50] as he consequently came to be called (in accordance with the major tradition), only vented his rage upon Telephos because Agamemnon propitiated him in advance; unless further evidence appears and since there seems to be no question of, for instance, a feud between Athena or Herakles and Dionysos which would explain his motives in a less primitive manner, any question as to a deeper meaning behind the action of the god must remain open.

With Herakles we are on firmer ground. His presence is indeed all-pervading—possible on the east metopes and probable on those of the west, implied (by Iolaos) on the east pediment and either implicit or explicit on the west. Yet although I admit the plausibility of Picard's vision of a suffering, tragic Herakles for the west façade,[51] I would prefer a less melodramatic note, seeing him rather as a kind of Tegean 'Pater Patriae', still active and present in the affairs of the city with which he had had so much to do in the past. Such other evidence as we have supports this conclusion, to my mind, rather more firmly than it does Picard's.

Stripped of its intervening immortals, chariots and other paraphernalia, this very human composition could explain what has hitherto been the most puzzling aspect of the description of the pediment in Pau-

sanias—its extreme brevity. For, apart from its very unusual subject, which the *Guide to Greece* duly notes, to the ordinary tourist it can really have been little more than just another battle scene; it seems that no attempt was made to distinguish the various personalities involved (viz. nos. 17 and 18, both Greeks to judge by their helmets), so that unless the names were painted on the architrave below, or the local guides remembered who was who—an unlikely possibility if both sides were virtually in uniform—there was simply nothing more to relate about the pediment than had been said in the half-sentence already devoted to it.

On the whole, it does not seem to me that this iconographic scheme for the sculptural decoration would have required a particularly elaborate programme. Something like Pausanias' description of the Calydonian hunt may well have sufficed for the pediments, and for the akroteria a few words would have been enough. No doubt the problem of how to make the eastern set easily identifiable was left to the artist—subject, of course, to approval by the committee, the ἐσδοτῆρες of the building inscription. As for the metopes, the subjects were probably listed and the *dramatis personae* named; as an example, 'Telephos and the hind on Mount Parthenion' would have been quite sufficient in terms of instructions.

CONCLUSION: THE TEMPLE AND TEGEAN HISTORY

From the catastrophic fire of 395 were saved only the ivory image of the goddess by Endoios and a few precious relics. At some time after that date, a new temple arose, the work of Skopas the Parian, and so magnificent that even half a millennium later it appeared to a not unsagacious traveller 'to surpass all other temples in the Peloponnese both in size and style.'[52] Can we say anything about the spirit in which this great work was conceived, and can this be of any help in determining when, or even for what purpose, it was built?

The theme of the east pediment, the Hunt of the Calydonian boar, seems decidedly Panhellenic in spirit, but with a peculiarly Tegean twist to it; heroes from all over Greece were united under the leadership of Meleager against the scourge, yet in this version not only did the palm go to the Arcadian, or, more specificaly, Tegean heroine Atalante, but she was also shown, uniquely, actually in the act of killing the animal. Although the subjects of the pronaos metopes cannot be fully established, they seem to be telling the same story—bringing Tegean heroes to the fore, this

time in the struggle against Sparta, and stressing their close relationship with the city's guardian goddess, Alea Athena. The theme of the west pediment and metopes, the life of Telephos, was more specifically a Tegean concern, but relates just as closely to Athena and to her protégé, Asklepios.

Athena's rôles as goddess of fighting and war on the east façade and of help and succour in time of need on the west are, as I have remarked, complementary. In addition to this neatly balanced exposé of her powers, however, one senses other contrasts and analogies between the two ends of the temple, admittedly more tenuous, resting as they do on incomplete evidence, but worth noting all the same.

In their attentions to the descendants of Aleos, contemporary of Herakles and the king who was, above all, responsible for forming the identity of Tegea as a sovereign community and leader of Arcadia, the two sets of sculptures seem to be both complementary and contrasted. On the east, Kepheus, Lykourgos and their children are successful in their endeavours and win glory, prosperity and protection for their city through their reliance on the goddess. On the west, however, their sister Auge insults her and thereby incurs tragedy for herself and her child, yet (if the interpretation is correct) is forgiven at least to some extent and given the benefit of her protection. Alea Athena is as merciful to her and to Telephos, in the end, as she is to those arch-enemies of Tegea, the kings of Sparta, who now and again throw themselves at her feet.

As for the pediments, on both a deity slighted is at the root of the trouble and suffering: in the east, Artemis, and in the west, Dionysos. The goddess, working through the heroes of Tegea, cannot avert the disasters, only seek to repair things when the damage has been done; the warning would, I think, have been clear.

For analogies to certain (not all) of these features, we must turn to Athens. Here, Herington's studies of the Parthenon and its meaning for Periclean Athens has shed much light upon the bonds that encompassed art, religion and contemporary feeling at that time.[53] Can it be mere coincidence that the Athenas of the two cities are very alike in many respects? Both the ancient and Pheidias' Parthenos were fully armed,[54] as was (probably) Endoios' Athena at Tegea; both warrior-types were associated with the idea of victory for their respective cities, and both were distinguished from a (peaceful ?) Athena Polias,[55] who was accomodated elsewhere, in a separate sanctuary; both were celebrated in local festivals,[56] at which foreign contestants might compete, and, finally, both seem to have been

unthinkable without Zeus,[57] who at Athens occupied the centre of the east pediment of the Parthenon and at Tegea the central panel of the altar.

When we turn to the temples, a similarly persistent parallelism recurs. At Tegea we have the myth with the more universal significance occupying the east pediment—as on the Parthenon—while the west pediment caters more specifically for local patriotism; on the east façade of the Parthenon in particular, the metopes,[58] whilst orchestrating the theme of *hubris*, refer in no uncertain manner to the defeat of the Persians—as (probably) at Tegea, only substituting Spartans for Persians. The ever-present spirit of Athena herself in the sculptures of both temples needs no further comment.

When would this great ensemble, with its decidedly nationalist overtones, have been most appropriate? My guess is immediately after the battle of Leuctra in 371,[59] when half the Spartan army was annihilated by the Thebans, and Spartan power and prestige irreparably damaged. The result was the liberation of Arcadia from the Spartan yoke, and the formation of a free alliance of Arcadian states—the Arcadian League —in an atmosphere of triumphant nationalism. For Tegea it was the first taste of real independence for a century, since Dipaea in 466.[60]

Monumental building in Greece tended to be sporadic, as in all ages, and seems to have depended more on chance and availability of funds than the advent of any particular occasion or situation that deserved to be immortalised in stone. In this, the Parthenon is really an exception, the expression of a feeling that was comparatively short-lived; the Tegea temple may have been another, for the following reasons:

Until 371 Tegea was nominally an ally, effectively a subject of the Spartans. The stern retribution following the defiance of Mantinea in 385/4 and Phlius in 381[61] made plain what any show of independence could expect from that quarter—hardly an appropriate time for the erection of a temple at Tegea with such a nationalistic (and thus anti-Spartan) flavour to it. We may reinforce this argument with an art-historical one: the horizontal and raking simas of the temple owe much to those of the temple of Asklepios at Epidauros,[62] completed probably in the 370s, justifying us in making this temple an architectural *terminus post* for Tegea.

The anti-Spartan character of the Arcadian alliance was clear from the beginning,[63] and the liberation of Arcadia provided not only an occasion for going ahead with the building, but also, it appears, with a fair degree of inspiration for its decoration, translated, of course, into traditional mythological language. The very sumptuousness of the building (temples entirely of marble were always a rarity in Greece) also presupposes a time of confidence and relative prosperity, and here again the early 360s appear most likely. The result of Leuctra was the elevation of Tegea to the status of a major power and the formation of the Arcadian League with Tegea, Mantinea and a new capital, Megalopolis, at its head, a triumph celebrated throughout Arcadia by the commissioning of many works of architecture and sculpture, as we shall see.

The League was founded on the high tide of Pan-Arcadian feeling,[64] and its members were sure—too sure—of their own success. Yet for this very reason, to say that 'the tumultuous period of the Boeotian incursions into the southern Peloponnese after Leuctra would hardly have been conducive to big architectural projects',[65] is to miss the point; the Boeotians came as friends, not enemies, to ensure that a defeated Sparta remained in her place, and to carry the war into Achaea and Laconia. In Elis the triumphant Arcadian League too went over to the offensive.[66] Athenian wartime building projects in the fifth century should also warn us against carrying such arguments too far —indeed, the older Parthenon was begun at a time of sporadic war with Aegina, and possibly (as a thank offering?) after one Persian invasion had been repulsed and another was expected at any time.[67] As Burford puts it, 'War was a permanent fact of life, not an unusual state of affairs; and while there is no positive evidence that war was a direct impediment to beginning a building, there is plenty of evidence to show that temples could perfectly well be put up at times where there was war somewhere in Greece'—indeed, she might have added, the Tegean building contract seems to have been drawn up with a war situation particularly in mind.[68]

The equation 'war = no building' also loses much of its validity when we look at exactly what works of sculpture and architecture were commissioned in Arcadia after Leuctra. The city of Mantinea was probably rebuilt in 370, and the Bouleuterion, parts of the Agora and theatre, and a Heroon would appear to be contemporary with the new city walls;[69] the group of Leto and her children by Praxiteles,[70] carved in the third generation after Alkamenes (fl. Ol. 83 or 448-444) surely belongs in this perod. The new federal capital of Megalopolis, with its great assembly hall for the League Council of Ten Thousand, the Thersilion,[71] was begun 'a few months after the battle of Leuctra',

according to Pausanias;[72] the theatre[73] could also belong in this period, to which we can date with near certainty Leochares' masterpiece, the Zeus Brontaios,[74] usually ascribed to his ἀκμή (372-369). A cult statue of Zeus Philios[75] was also commisioned from a Polykleitos (II ?). Finally, the League itself erected at Delphi a row of statues of Arcadian heroes with Apollo and Nike 'from booty taken from the Lacedaemonians', placing it provocatively right across the front of the Spartan monument of the same type to Lysander's victory at Aegospotami.[76]

Thus, in the years succeeding 371, we find the Arcadian cities not only rebuilding but also in a moment of patriotic fervour commissioning new cult statues and monuments from young sculptors. The careers of Leochares and Praxiteles,[77] at least, cannot have begun much before that date, and neither can that of Skopas. Amid this sudden flurry of activity the Tegeans seem rather to have been left standing, if the silence of our sources is to be belived—unless, of course, the great new temple of Alea Athena was, in fact, their contribution.

It is here, I think, that the Altar may find its place;[78] it was probably contemporary with the temple, and its cornice, at least, seems to have been executed in a hurry. I think that Picard may well be right: this may indeed have been a *Federal* Altar, with a counterpart at Megalopolis. If so, it was probably the altar where the Tegeans—with Theban spears at their backs ?—swore allegiance to the peace of 363/2.[79]

A date in the second quarter of the century has also been argued for the temple on architectural grounds by, among others, Schede, Robertson, Shoe and Plommer,[80] and in a compelling summary of both architectural and technical details Roux dates it to c. 370-360, saying, 'Toute se passe comme si les mêmes ouvriers avaient construit et le temple de Tégée et la première partie de la Tholos, aux environs de 360.[81] Yet I wonder whether the *same* workmen could have built the two at the same time, which is what Roux seems to imply. Is it not more likely that the team moved from one building to the other (i.e. from Tegea to Epidaurus, since the Tholos is clearly the more advanced architecturally), or—as I would hazard as a working hypothesis—was paid off in part from one, the excess workers moving to the other?

The period 360–330 was that favoured by the excavators, followed by Pfuhl and Lawrence, chiefly relying on the historical arguments which I have, I believe, already shown to be false. Dinsmoor believed that the temple was not begun until Skopas' atelier began re-

turning home from Asia sometime in the late fifties, backing his thesis by the Ada and Idreus relief (which could equally as well have been dedicated by a Tegean artisan who had followed Skopas to Asia); Hanfmann would date the beginning of construction as late as 338.

Yet as a monument erected to the broken-backed League that remained after the squabbles of 364–362 and the Pyrrhic victory of Mantinea (362), the temple cannot but be regarded as an anticlimax. A late date for its inception also seems to me to be ruled out by the character of its architecture—the analogies with Bassae,[82] completed probably towards c. 380, in the design of the cella and the planning of the peristyle, the unique use of a hawksbeak as a coffer moulding, and the unique forms of the raking sima, the peristyle and pronaos upper epikranitis and the superbly designed interior toechobate; unusual, too, is the reversal of the positions of the ovolo and cyma reversa of the interior pilasters.[83] A late dating of these elements of the decoration, which together lend an impression of freshness, innovation and originality to the architecture, would surely assume an architectural conservatism that is not borne out either by the character of the features themselves or of the building as a whole. A comparison with its derivative, the temple of Zeus at Nemea,[84] built probably in the decade 330–320, shows what a thoroughly different impression architectural conservatism really makes.

Having thus established a possible date for the commissioning and foundation of the temple, can we make any guess as to the date of its completion?

A *terminus ante* for the horizontal sima,[85] probably one of the last parts of the building to be erected, is given for us by the completely integrated rinceau and 'gesprengte' palmette of the sima of the temple of Apollo at Delphi,[86] dated by inscription to 342/0, and the reversed rinceau and incurving palmette leaves of its probable contemporary, the sima of the Tholos at Epidaurus (c. 340–335 ?).[87] The lions' heads[88] appear to be early—and, curiously enough, completely lack the 'Skopaic' bulge over the outer corners of the eyes —when compared with those of the Tholos and Apollo temple. The top palmette of the central akroterion, with its subsidiary set of leaves staggered *behind* the main set, is also clearly less advanced than the palmette of the Tholos akroterion,[89] where they were placed in front, a scheme taken up slightly later by, for example, the antefixes of the Leonidaion at Olympia.[90]

These comparisons, taken together, indicate a

period of construction of ten years or more from c. 370, and in fact evidence does exist (but has hitherto tended to be ignored) to support this. Not only does it seem highly improbable that the temple could have been completed in less than ten to fifteen years, considering its sumptuous decoration and Tegea's limited resources (for comparison, the temple of Zeus at Olympia and the Parthenon at Athens, both backed by enormous funds, took fourteen and fifteen years respectively to finish,[91] and in the fourth century when money was more scarce, the Tholos at Epidaurus took well over twenty-one years and the temple of Apollo at Delphi over forty), but also it seems quite clear that Tegea was running into financial difficulties by 364/3 when her officials, the League treasurers, were found to have been 'milking' the funds at Olympia, probably for the benefit of their city.[92]

This, I would hazard, was about the time that construction could have been run down and some workers paid off to work on the Tholos (see above); as Burford says, 'Monumental building in all ages has been started when there was only money enough for the first stages, and abandoned when funds ran out.'[93] Tegea was never particularly prosperous at any time, and the contracts as preserved seem to indicate a more than usual preoccupation with war and with possible labour troubles;[94] again, to quote Burford, 'They must have been published in order to solve some problem peculiar to Tegea . . .',[95] but without further evidence as to the nature of the difficulty we are really groping in the dark. It is perhaps no coincidence, though, that a Theban garrison was sent to Tegea in 363 and there was trouble in the city itself in 362.[96] The Spartans ravaged the surrounding countryside during the campaign of that year, and it is clear that after Mantinea itself Arcadia, and particularly eastern Arcadia, was totally exhausted.[97]

For the relative chronology of the architecture and sculpture of the temple, although this properly belongs to the next chapter, we could do worse than to bear the example of the Parthenon in mind, since although its structure was certainly finished in 438, the pediment sculptures were not even *begun* until that date, and not finished until 432, despite Athens' great reserves of men and money at the time; as we have seen, at Tegea the schedules for architecture and sculpture were completely independent, and the technique of the sculptures themselves strongly suggests a date after 350.

To sum up: it seems unlikely that, even if the temple had been begun immediately after Leuctra, the fabric could have been completed until c. 355 at the earliest; the sculpture may have taken several years longer. Perhaps, then, we may be forgiven for imagining that in the years following 362, straitened circumstances and an unhealthy political situation may have made the great temple appear more of a liability than an asset in the eyes of those citizens of Tegea who had seen it begun with such high hopes a decade and more before.

Chapter Four

STYLE

With two or three notable exceptions, most students of the Tegea sculptures have tended to concentrate on their wider significance and usefulness as a springboard to the discovery and attribution of copies of lost works by Skopas. Consequently, detailed comment on the pieces themselves is rare. Of those who studied the fragments before 1924 (the date of Dugas' publication), Neugebauer was easily the most sensitive, although the discussions by Treu, Graef and Benson are still useful. Berchmans' study in the 1924 publication is by far the most detailed, although I disagree with his judgement on the style as a whole. To turn to the more recent studies, there are remarks of value in those of Pfuhl, Lippold and Picard, although at times it does seem as though with the repetition of some of the standard clichés many other modern critics have considered their readers (and, by implication, themselves ?) adequately informed on the subject.[1] Of late too, in addition to a standard phraseology, errors of plain fact have crept in and have been transmitted from writer to writer[2]—an indication, perhaps, that it is time a fresh look was taken and the cobwebs dusted away.

Yet, before beginning, there is one potential obstacle that must first be removed: the possibility that the organisation at Tegea was similar to that at Epidaurus, where four ateliers worked on the two sets of pediments and akroteria of the temple of Asklepios, and four distinct styles are distinguishable. Naturally, an allocation of the work at Tegea along similar lines would make nonsense of any attempt to isolate and interpret a 'Tegea style' as such.

Fortunately, this seems unlikely; although there are differences in the heads, for instance, they do seem to me to fit into a development within one style, and

inequalities of execution are to be expected—as we know from the Parthenon,[3] sculptors may differ enormously in quality and progressiveness and yet still be working broadly within the same style. The akroteria (like the heads, from both ends of the temple) indeed differ in quality and approach, but were clearly carved to the same design; the difference is considerably less than that separating NM 156 from NM 157, both being corner akroteria of the *same* west pediment of the Asklepios temple. The eye of no. 4 is very close indeed to those of the pedimental heads and especially to that of no. 18 (PLATES 4c, 16d), which gives the link between pediments and akroteria.

A seemingly bizarre, but quite useful way of distinguishing carvers, and one that has been used successfully by Lehmann at Samothrace,[4] is the form of the navel: at Tegea, no. 15 has a triangular navel, no. 26 a round one; the former was drilled, the latter not, and both pieces were clearly by different sculptors. Yet although the latter is unquestionably the better piece, in style they are uniform, as an examination of the forms of the rectus abdominis and iliac crest reveals. Taking the argument down to the minor pieces or to the heads, we find the same phenomena: unevenness of execution, development within the one style, but no essential difference.

To begin with the treatment of the nude. If the fragments are representative, very few figures at Tegea were draped, and it seems that the nude was the main preoccupation of the sculptors there. Only a few pieces are able to give any clear indication of how the sculptor tackled the body as a whole, yet the overall impression they give is striking even so; in essence, the salient features of the style may be reduced to three in number: the way in which a sense of action, firm,

decisive and strong, pervades the whole body; the compactness and rugged strength of the muscles; and the remarkable richness, complexity and depth of surface characterisation.[5]

The action of the body is seen as a unity, and special emphasis is laid on articulating it at the joints. Deep pools of shadow are created by the condyles of knees or elbows;[6] at the ankles the malleoli and Achilles' tendon are stressed[7] and the power of the wrist in particular is remarkable.[8] For greater visual impact, the internal angles of wrists, elbows and knees are often marked with cuts or even drill-channels. Along with this goes a tendency to simplify the musculature at these points for grand effects.[9] The shoulder and neck are studied, and a strong expressiveness imparted to the twist of the head (via the massive sterno-cleido-mastoids)[10] or the pull of the arm (via the deltoid).[11] Throughout, there is evidence of a new feeling for mass and movement, which is rendered with a maximum of lucidity and a single-mindedness hitherto unknown in fourth century sculpture; such emphasis on the joints does put in an appearance on the Argive Heraeum,[12] and acquires new breadth at Epidaurus on the more progressive east pediment,[13] but compared with Tegea the trend towards large and ample forms has advanced little beyond its infancy. There is also little of the free-standing sculpture of the Mausoleum,[14] either among the major or minor fragments, that may bear comparison; closer are certain parts of the friezes where the style seems more advanced, although the poor surface of many of the slabs prohibits any final judgement.

As examples, we may take the torso of a man slashing across his body at a foe who once stood in front of him (no. 11), attributed here to the east pediment (PLATE 53, right 9), the two fragments nos. 12 and 13 attributed to figure 8 in the right *kerkis* of the same pediment, and the head attributed to Telephos, no. 16.

Berchmans found the movement of the first both unconvincing and characterless, I feel unjustly;[15] the pose is absent from Epidaurus and the Mausoleum friezes, and the only figure that comes anywhere near our piece in intensity is BM 1021.62, from what is generally acknowledged to be one of the most advanced parts of the Amazonomachy in style. The movement of the head recurs on BM 1012.48 (PLATES 34a and 36), but in neither case is the sterno-cleido-mastoid on the side to which the head is turned used with such great effect to articulate the action. It is only when we reach the Lysikrates frieze (dated to 335/4) that we find worthy parallels in some (but not all) of the figures (PLATE 51c).

The figure of which nos. 12 and 13 probably formed a part was braced to deliver a blow to his left, and every fibre seems tensed in expectation. By comparison, the slim youth BM 1020.54 seems to have outgrown his strength; BM 1010.14 (PLATE 41c) is sturdier and more compact, and much closer in spirit to his Tegean counterpart.

As was shown in Chapter 2, the pose of no. 16 could have been fairly close to BM 1007-8.41 (PLATE 41b). Yet how different a spirit animates the Tegean figure. Only when seen as it should be, from below, can the grandeur of the conception and the sculptor's single-mindedness in carrying it out come into full play (PLATE 13b). BM 1012.50 (PLATE 34a) and 1013.28[16] are nearer, but here again we must turn to the Lysikrates frieze for true analogies, the best being figure 23 (PLATE 51c).

Just as important as the movement of the figure are its proportions and size. The torso is sturdy, with broad hips and massive shoulders, yet any impression of stockiness must have been speedily dispelled by the fairly long legs. Feet and hands are broad and strong, arms and necks muscular and powerful, and heads squarish and massive. The size of the figures relative to the frame has also increased; whereas those of the west pediment at Epidaurus were only just under 1 m high at the most (in relation to a pediment height of about 1.15 m) and those from the east were slightly larger (by about one-ninth), in the west pediment at Tegea where the composition allowed it, and probably on the metopes too, they filled the entire height of the frame and more. As already mentioned in Chapter 2, physically restricting their energy in this way must have added considerably to the drama of the battle and the dynamism of the composition as a whole.

The compact power of the torso is also expressed in the treatment of its musculature. Although the anatomy is certainly perfectly plausible, it is clear that a separate rendering of each muscle was not the aim of the sculptor.[17] Forms are generalised, planes broad and swelling, and more often than not several muscles are grouped together within a single volume, as a glance through many of the descriptions in the catalogue will reveal. In view of this, Berchmans' charge of 'unbridled naturalism'[18] hardly seems to fit the facts. The style has moved away from the grandeur and simplicity of the fifth century towards a more even balance with nature, it is true, but what fourth century style did not? At Tegea the predominance of the abstract idea, of the major forms over the minor, is never really in doubt, and the approach of the sculptors in

general towards the whole question of anatomical realism is surely poles apart from that of the masters of the Delphi Agias (PLATE 51a), the Oilpourer (PLATE 29b) or the 'long man', BM 1020.57, which seem at any rate to be far more open to such strictures.[19] Some pieces are better than others, of course; no. 15 is coarse, lumpy and unconvincing beside no. 14, but although the quality of the fragments may vary, the essentials of the style they express remain constant.

Berchmans' other points concern a lack of co-ordination in the musculature, and lack of stability in the surface forms. Although he presents them, perhaps rather patronisingly, as criticisms of the execution of the pieces, to me they seem to have more to do with the style itself than with indifferent or negligent carving on the part of the atelier.

To me, both appear to be intimately bound up with the approach of the atelier as a whole towards the problem of characterising the muscles as forms in their own right, whilst at the same time preserving the overall unity of the body. Each major group of muscles is treated as an equal and separate entity, acting upon and affected by its neighbours and the movement as a whole, but pressed into no artificial overall *schema*. The difference is most striking if one compares the metopes of the Argive Heraeum (PLATE 24b), or certain torsos from the west pediment at Epidaurus,[20] where the body seems as if built up from clearly defined masses around a linear, almost two-dimensional framework: the 'cuirasse esthetique', in fact, of Polykleitan invention.

On the east pediment of the Asklepios temple, on the other hand, a more organic feeling for structure and the volume and plasticity of individual muscles may be sensed, especially in the torso shown in PLATE 26b, to which torsos like nos. 13, 14 and 26 from Tegea seem very closely related.[21] Unfortunately, no fragment from Tegea preserves the anterior of the torso complete, and thus we have no idea how in particular the important section from waist to lower thorax was represented, but from a general comparison of the styles of Epidaurus east and Tegea, one can, I think, say that the Tegea sculptors were considerably further along the road towards seeing the natural design of the human frame, simply and lucidly translated into sculptural terms, as the model on which their figures should be based.

This easy lack of schematisation and absence of artificiality in the musculature is accompanied by a rich, fleshy modelling which, by its undulating surface and near-absence of definable transitions (except at the internal angles of the joints), contributes much to the suppleness of the movement of the figure. Occasionally, violent muscular tension is in the ascendant,[22] but often the density and 'opaqueness' of the flesh tends to damp down muscular activity,[23] and, in a few extreme cases, little of it permeates through to affect the surface forms.[24] Surprisingly, the vigour and energy of the movement seem little affected by these changes in emphasis (which have little to do with quality); here again no. 11 is a good example. The changes are often slight, it is true, but I suspect that if anything it is the richer, smoother pieces which can be called the more 'advanced', although the proof will have to wait until more joins come to light. The typology of the heads, to be discussed below, seems broadly speaking to support this, as does the close relationship between Dugas 28 (PLATE 20a-b) and some of the fragments from the east pediment of the temple of Asklepios, e.g. NM 4750.[25]

The line between 'continuity' and 'fluidity' (with the implication of a dissolution of form) is dangerously fine, and in some cases (e.g. Dugas 53 and 54: PLATE 21a-c) I can only say that Berchmans' charge is justified and that the sculptor does seem to have neglected the stability of his forms in favour of a surface richness which can only be called extreme. In general, however, it seems reasonable to conclude that the unity of the figure, which might otherwise have been threatened by abandoning the Polykleitan schema, is now assured not only by the solidity and strength of the internal structure and the sense of movement and action that seemingly pervades the whole body from head to foot, but also externally, by the continuity and sheer depth of the surface modelling and the refusal to allow the transitions to break up the body into its constituent parts. The heavy accentuation of the joints noted already would also have done much to arrest any such incipient loosening of the formal structure of the body as a whole, and I would suggest that his strictures are really only applicable to a minority of the pieces (of his examples, both seem to me the right side of the line, though no. 12 rather more so than no. 11),[26] and that, as a general criticism of his whole approach to the problem of the Tegea style, his concentration on the unequal abilities of certain sculptors from the atelier has perhaps tended to deflect him from important aspects of the style in which they were working.

There are several distinctive features (mannerisms) of the style which deserve special mention together, although some have been noted already in other contexts. These include an abnormally high instep to the

foot,[27] the curved shin-bone (supposedly a by-product of an athletic physique),[28] the great exaggeration of the pad of the vastus medialis above the knee,[29] the way that the rectus abdominis is not rounded off above the pubic hair,[30] the great relief of the rectus and the disappearance of the waist as a structural feature in its own right,[31] the massive, plate-like sterno-cleido-mastoids, whose dual origin is only distinguished near the collar-bone,[32] and the marking of important transitions at the joints of limbs by sharp cuts or drill channels. Creases in the skin are regular on the neck and the hands;[33] veins are occasionally found.[34]

The Tegean heads have long been recognised as unique in Greek sculpture, and constantly described with words like 'forceful', even 'wild'; yet, as may be expected, the easy availability of such emotive epithets seems in general to have deterred investigation of a deeper kind, and only Neugebauer and (to a lesser extent) Berchmans have tried to get to the root of the problem.[35]

The descriptions in the catalogue should make it plain that the heads are by no means completely uniform in proportion, modelling or intensity of expression, so before proceeding any further it seems necessary to establish a sequence of some kind. Together with the majority of students, I see the heads as carved in one style, but representing differing stages of development within it.

The type evolves at Tegea in the following way: the outline of the face moves from a closed oval to a more open form, chiefly by widening the upper part at the level of the eyes and temples, moving the cheekbones further apart, then shortening the chin and bringing the plane of the cheeks and the jawbone more into prominence. This leads to an increase in breadth in the lower part of the face, the chin becoming massive and square, so that the facial outline begins to look like a broad-based and rather low trapezium. As the head becomes almost cubic, the features tend to concentrate more in the frontal plane: the forehead of no. 9 is almost flat (though this is exceptional), and the muscles around and above the outer corners of the mouth push forward with increasing vigour until on no. 16 they lie in nearly the same plane as the lips. The neck thickens and the head sits more firmly upon it, so that in profile the silhouette is nearly square.

It is hardly surprising that as the proportions become more compressed and the structure more uncompromising and self-evident, the potentialities of the type as an effective and forceful vehicle for conveying emotion are greatly increased. Yet the hero's

situation still has its part to play, which is why the expression actually reaches its peak of intensity with no. 17, although the stark cube of no. 9 displays an extreme concentration of form that has virtually severed all links with the past and would seem to offer most for the future.

Hand in hand with these developments go a thickening of the features and an increasing degree of richness and complexity in the modelling, particularly around the eyes and lips; the eyebrow gains in volume until it reaches a uniform heaviness over its whole length, and the fold of the upper orbital increases in size until the upper lid is completely covered near the corner of the eye, and the eye is itself set into the head at a near-uniform depth throughout (PLATES 4c, 8b, 14b, 15c, 16d, 52b). At the same time, the ocular portion of the upper lid thrusts forward to an increasing degree and the lower lid rises and distends, effacing the fold of skin usual at the base of the eye-socket and giving the eye the appearance of straining upward to focus upon some distant object. There is not enough detailed modelling in the hair for this to be of any use for the typology.

Taken together, these observations would induce me to consider no. 18 the least advanced of the heads, and nos. 9 and especially 16, with its broad, square jaw, the most advanced. To these last two may perhaps be added nos. 22 and 23, with no. 17 (and no. 24?) somewhere between the two groups. No. 10 seems closest to no. 9, taking into account the similarities between the two in proportions, facial outline, and profile view. No. 27 perhaps belongs between nos. 18 and 17; the modelling and proportions are closer to the latter, the rather weak expression to the former. The series thus runs: 18, 27, 17, (24?), (10), 9, (22 and 23), 16.

It has long been realised that, taken as a whole, the means of rendering emotion used at Tegea with such remarkable uniformity are not only eclectic but self-contradictory and thus impossible for a living person to display, yet nevertheless remarkably effective.[36] Heads displaying emotion are not rare in fifth and early fourth century sculpture, although (with the notable exception of the east pediment and metopes of the temple of Zeus at Olympia[37]) usually confined to battle scenes (PLATES 24 and 26).

At Olympia, poised on the point of transition from the Archaic to the Classical, the introduction of facial expression to indicate differing states of feeling (so-called *ethographia*) as a fundamental principle in the composition of the peaceful scene on the east pedi-

ment is little short of revolutionary, and succeeds because in general it is handled with a restraint and sureness of touch that can only be called monumental. In battle scenes, however, the best that can be managed is still only a grimace—which can, indeed, be remarkably effective at times, but which appears increasingly out of place in the context of late fifth century classicism. The point is perhaps driven home most effectively if one mentally tries to join up one of the snarling heads from the Argive Heraeum with the almost academically Polykleitan body on the metope NM 1572 (PLATE 24a-b): the net result is, to say the least, incongruous.[38]

This is not to say that the repertoire of devices for portraying emotion available to these artists was particularly limited;[39] as we shall see, their stock-in-trade was actually *wider* than that preferred by the Tegea sculptors, who in fact invented little on their own account. The problem was not to be solved by increasing the range—this was to bring other troubles in its train—nor to be circumvented by placing expressionless heads upon bodies in violent action, which involved a further glaring inconsistency in its turn, this time with every man's experience of reality.[40]

The formal devices open to the fifth and early fourth century sculptor who wished to put some emotion into his heads were the following:

The *mouth* may be contorted, with or without opening it and showing the teeth.

The *nose* may have its nostrils dilated.

The *eyes* (1) may look in a fixed direction; (2) may be focused on a near or distant object; (3) may be wide open or nearly closed. (4) The eyebrow may begin to angle upwards toward the root of the nose and (5) the orbital portion of the upper lid to sag over the outer corner of the eye. (6) Vertical furrows may appear above the root of the nose and (7) horizontal ones across the forehead. It is important to note that physiologically these last four are linked, in that (4) causes (5)-(7).

In addition, the eyes may be deep-set into the head, the lower part of the forehead may protrude and the eyebrows gain in heaviness, although strictly speaking these are anatomical peculiarities rather than elements of facial expression, being outside human control. The head may also be flung back, and tilted on the neck.

At Tegea, on the other hand,[41] the mouth is drawn up in the centre and slightly opened, showing the teeth; the quadratus muscle is contracted, deepening the nasolabial furrow, yet the lips do *not* rise towards

the corners, very effectively increasing their tension, although anatomically such an opposition is virtually impossible.[42] The nostrils are dilated. Clear, almost schematic planes surround the eyes, which are set deep into the head, and tend to look slightly upwards and to the side, as if focused on a fairly distant object; they are wide open, almost starting, and the overall impression is one of considerable intensity. The orbital sags over the outer portion of the eye (even in no. 18, which is clearly an earlier stage: PLATE 16d), yet neither do the eyebrows angle up towards the root of the nose (4), nor do vertical lines appear there (6). The line across the forehead is flat and straight in all but no. 18, and articulates the jutting lower forehead; it is not a consequence of any movement in the brows or at the root of the nose (7). The head is usually flung back or to the side on the neck.

No. 18, which we have already noted as stylistically the earliest in the series, alone of the male heads has only a very slight bulge over the outer corners of the eyes (compare here no. 4: PLATE 4c), but two separate bulges over the bridge of the nose and two sharp, curved transitions meeting in the centre to divide the upper and lower forehead. The eyes are not so deeply set, and the mouth and its surrounding area are much weaker.

Thus, not only are the means of expression preferred by the Tegea sculptors eclectic, in that the full range of possibilities available at the time was not made use of, but both Neugebauer and Berchmans would seem to be correct in their judgement that from the anatomical side, the formula adopted by the atelier is open to question at many points. In which case, is it not strange that the head which is typologically the *least* advanced (no. 18) should be anatomically the *most* correct in its treatment of the brows and forehead? Even more unexpectedly, it appears that (as far as we can tell), the first sculptor to have made use of every means of expression available and to have co-ordinated them in a convincing fashion was perhaps the unknown master who carved the head of Priam, NM 144, from the east pediment of the temple of Asklepios at Epidaurus (PLATE 26d)—a monument that is unanimously dated *earlier* than Tegea (i.e. c. 380–370).[43]

Yet the Tegea sculptors (apparently) chose to turn their backs on this advance and to commit several anatomical 'howlers' in the process. They must have known of the Epidaurus head, for we have already noted stylistic affinities between the Tegea nudes and those from the selfsame pediment in which Priam occupied a prominent position, and incompetence in

anatomy is no explanation, since everyone agrees that anatomically Tegea was well up to date. A more likely explanation would seem to be this. To modern eyes the 'Priam' head appears both reasonable and effective as a sculptural study in pure terror; yet the net result of the sculptor's quest for a true-to-life appearance is a play of loose, shifting surfaces and a dissolution of the classic regulariy of the features (particularly through the angling of the eyes and eyebrows) that must have seemed nothing less than revolutionary to many of his contemporaries and surely had an unpleasant effect on not a few; a second century head of a Gaul from Cos[44] shows just where this kind of approach could lead.

In the head no. 18 from Tegea we see the Priam 'toned down', so to speak—the eyes and eyebrows return to their time-honoured position—but the forehead still retains its puckered flesh and 'grief lines'. In the other heads even these are excised, so that with the selection of such devices from the repertoire as are more suited to the sculptor's art than to that of the modeller, and the invention of one or two more, we find the expression once more adhering closely to the structure of the face and the emotional intensity actually heightened, as it were by the very act of forcing it into the classic mould.[45]

The originality of the conception thus lies exactly where we would expect to find it in those styles which are more widely accepted as classic: in the economy with which suitable motifs are selected and their co-ordination in the most effective way possible. For the first time in Greek sculpture a formula was arrived at that produced a generalised, yet seemingly realistic method of retailing the emotions that not only availed with equal success and little modification for victor and vanquished alike, but at last brought the fighting figure into line with the dictates of common sense and classic sensibility. Yet although the general impression would still have been striking enough, considering the distance from which the compositions had to be viewed, Richter's comment concerning the fifth century still remains essentially true: that for success in conveying the emotions of his figures to the spectator, the sculptor still had to rely to a great extent on 'the attitude of the figure, which would moreover be equally telling nearby and at the long distance at which most of the architectural sculpture was seen.'[46] Here at least, as we have observed, the Tegea sculptors had little to learn.

Along these lines, a chronology for the heads is not difficult to establish; most clearly comparable with no.

18 is BM 1056, particularly in the set and proportions of the head and the modelling of the forehead (PLATE 41d). Nothing from the Mausoleum can compare with the degree of intensity exhibited by no. 17, however, not even the charioteer, BM 1037, the heads from the Genoa slab, BM 1022, or the Persian, BM 1057;[47] the only heads to approach it are to be found on BM 1012 (PLATE 35); these will be further discussed in Chapter 8. The female head, no. 4, seems closely comparable to the head of the Amazon, BM 1007-8.41 (PLATE 41b) although perhaps again the movement and expression are a little more concentrated in the Tegea piece. Technically she is more advanced than the 'Maussolos' (BM 1000), as was demonstrated in Chapter 1. As for nos. 9 and 16, the most developed of the heads, the best comparisons are the head of Meleager, particularly the Medici and Fogg versions (PLATE 44a, d), the heads from the coffer reliefs of the propylon to the Temenos at Samothrace,[48] very probably from Skopas' workshop and carved between c. 340 and c. 330, and the head of figure 23 from the Lysikrates frieze, dated to 335/4 (PLATE 51c). This would place all the heads quite firmly in the period 360–340, a conclusion which confirms our earlier observations on the technique and the character of the action of certain of the figures.

The origins of the type are difficult to trace,[49] which invites the suspicion that the degree of indebtedness to earlier tradition was not great. Pfuhl saw a remote ancestor in a head from the Parthenon metopes, with, I feel, some justification. Sculpture from the Parthenon frieze onwards takes another road, but at the very end of the fifth century a more angular facial type with a strong jaw appears occasionally in sculpture and painting; as examples, compare the craggy-featured giants on the great Gigantomachy vases by the Suessula painter and others, and their cousins from the metopes of the Argive Heraeum, with their broad skulls, snarling mouths and heavy, beetling brows (PLATE 24). Kjellberg, Schuchhardt and Neugebauer saw a kinship with heads from the akroteria and friezes of the Nereid Monument, albeit in varying degrees; to me the comparisons do not seem particularly compelling, and Neugebauer was perhaps right in censuring Kjellberg for pressing it rather too strongly. Schlörb rightly sees a head from the east pediment of the temple of Asklepios at Epidaurus (PLATE 26c) as nearest in structure to Tegea; the head of a warrior Patras 207 from Masi[50] is a contemporary example of a similar heavy, square-jawed type with prominent cheekbones, although the face is much longer, recal-

ling the heads of BM 1006 and a completely different stylistic circle.[51] *In summa*, each element of the Tegea style seems to have its own private ancestry, but no single antecedent apparently anticipates more than a small part of the whole.

Only the hair now remains to be described; it is always left unpolished, and seems to have been treated in a wide variety of ways, ranging from the waved-back mass of no. 18, to the quite deeply drilled locks of no. 4. No. 19 has short locks which were curled slightly and adhere closely to the head, while nos. 9, 16 and 17 have a slightly looser scheme, the locks being short, quite curly and divided into three or more strands in places. The hair of the lionskin cap of no. 16 and that of the boar, no. 5, are coarser versions of this.

For the rendering of the female form, the fragments from the akroteria (nos. 1-4) give us a fairly complete idea of the sculptor's approach. In general, what we have already observed concerning the anatomy and movement of the male figure holds good for the female one as well, with obvious qualifications. Of the two torsos, no. 1 is undoubtedly the better; no. 3 is dry and rather harsh.

If no. 1 is compared with the little girl-Nike from Epidaurus, NM 162 (PLATE 26a), the most striking difference is surely that between the ample forms and firm, emphatic movement of the former and the slim, undeveloped body and elegant, almost dance-like action of the latter. At Tegea the sculptor is no longer interested in what Thomas Hardy once called 'the provisional curves of immaturity'; the draperies no longer play around the body, but conform to its movement and set it off in a severe, almost matter-of-fact way. The wilder movement and swirling apoptygma of no. 3 do echo the earlier figure to some degree, it is true, but in spirit the figure is much closer to her Tegean sister than to the Epidaurus Nike; the scheme of the drapery, for instance, is an exaggeration of that zigzag movement across the body which was apparent in no. 1, from the free leg up to a focal point at the engaged (right) hip, then back again to the left shoulder, following the fold of the apoptygma. Indeed, it is this last fold, running as it does in the opposite direction to that of NM 162, to which much of the difference in the character of the action of the Tegean akroteria is attributable, in that it helps to stabilise the unchiastic movement of the figure, instead of accentuating it as before.

The idea of using the same scheme for the two sets of akroteria was a bold one, though I am not sure that it has really been successful. Apart from the rather pro-

saic drapery, acceptable and even apposite in a striding figure but out of character in a flying one, the addition of the girdle in no. 3 is a little restrictive; although the Nike of Paionios is girdled, the sculptor has laid little stress on the fact, and on NM 155 from Epidaurus its omission does a lot to improve the sweep of the movement. At Tegea, the designer probably felt that a striding figure such as no. 1 needed a girdle to give cohesion and firmness to the action; since, however, the need was somehow to get her identity across to the spectator (she was probably a Nike-like nymph, as was explained in Chapter 3), and this could only be done by making her resemble a Nike to a certain extent, he was forced to add the girdle to no. 3 to make his point clear.

As Neugebauer saw, the immediate descendants of the Tegea Nikai are those from the temple of Artemis at Epidaurus, carved around 300; the scheme of the roof decoration was also similar, comprising Nikai at the angles, and floral akroteria in the centre.[52] Not only is the arrangement of the drapery of NM 159 a more fussily pictorial version of our no. 1, but the movement of all the Epidaurian Nikai presupposes the existence of a *contrapposto* such as we find on the Tegean figures and elsewhere.

The quality of the head no. 4 is middling,[53] though its eye and ear are quite delicately carved. The forms are full, though seemingly with more structure behind them and less puffy than those of the head BM 1007-8.41 (PLATE 41b) from the Amazon frieze. The proportions perhaps indicate a place among the most advanced of the pedimental heads, although (as may be expected in a female figure) the orbital portion of the upper lid does not sag so heavily over the outer corner of the eye. Turning to the limbs, we find that the sculptor has not failed to articulate the elbow of no. 1 or the wrist of no. 2, even through their thick cloaking of flesh. Planes, as before, are large and simple, although the carving by no means lacks delicacy, as the fingers of nos. 2 and Dugas 52 may show.

The Tegean akroteria must, I feel, be contemporary with or, more likely, later than the Mausoleum; the pose of no. 1 is close to that of the Amazon BM 1020.58, with which she has affinities in the arrangement and detailing of the drapery; the girdles of the Tegea figures, a good indication of date after the mid-fourth century, are higher than those of any of the figures from the Mausoleum or the Ephesus bases,[54] although lower than those of the dancing girls on the acanthus column at Delphi,[55] now dated to c. 332–322 by Roux and others. Figures on the decree reliefs of c. 340 to c. 330 have girdles at about the same level as those of our

figures,[56] as does the statue of Sisyphos I from the Daochos dedication (336–332) which, however, seems slightly more advanced in its movement and its dominance of the space around it.[57] Perhaps contemporary with our akroteria were the originals of the Herakles of Lysippos in Copenhagen and the Lykeios of Praxiteles, both dated to the period c. 355–340 by Arnold and others.[58] As mentioned above the technique of the hair of no. 4 also points to a date after 350.

Pace Richter,[59] a date in the 340s is also possible considering the drapery alone. In its feeling for mass and solidity the peplos of no. 1 has many points of contact with the drapery of 'Maussolos', BM 1000;[60] the apoptygma, for instance, is just as thick as his himation, and the inverted V of folds over the right thigh and their meeting point below the girdle are, if anything, more plastically conceived. Furthermore, the running figure on the base from Ephesus mentioned above and dated certainly after 356, when the old temple was burnt, is also very close, especially to no. 3. Finally, the drapery of Sisyphos I compares well, not only in the general density of the cloth, but even in such details as the darts above the girdle and the treatment of the cloak hanging over the support, which is very similar in texture to the folds up the inside of the right thigh of no. 3. Interestingly, these reappear with almost no modification on the part of the himation lying in the lap of the seated woman on the stele NM 870,[61] perhaps datable to c. 340 and by a sculptor whose style is generally recognised to have many affinities with Tegea.

This brings us to the style of the drapery as a whole.[62] Only four figures allow us to form any complete idea of how the sculptor went about draping his figure: nos. 1, 3, 8 and 20; three more (Dugas 6, 55 and 57: PLATES 20d, e, 22a-c) help with some useful contributory evidence, and in addition there are some twenty or so smaller fragments from the pediments and akroteria, and half a dozen from the metopes (including the charioteer), from which we may conclude that the number of draped figures in the pediments was not large.

The pieces are not homogeneous in style, although together they seem to fit quite snugly within the third quarter of the century, a date which is sustained by the high girdle of no. 8 (cf. also nos. 1 and 3). Nos. 1 and 3 were clearly carved to the same general plan, although by sculptors of quite different approach and ability; no. 8 has few points of contact with either, and no. 20 seems closest, if anything, to no. 1. On the whole the preference is for fairly thick cloth which veils and obscures rather than reveals the contours of the body, for straightish lines and 'spray' folds rather than calligraphic patterns, and for a rather hard texture. Each generalisation has its exceptions, of course, but on the whole what one could call the 'residual linearity' of the drapery styles of the Mausoleum friezes has at last been left behind.

Even so, occasional points of contact with earlier modes of treatment occur not infrequently: no. 20 recalls BM 1048 in some details,[63] notably the treatment of the darts below the girdle, and BM 1018.11 in the general relationship between body and cloth; BM 1018.10 has the hardness and complicated section of the chiton folds on no. 8, especially between the legs where the himation leaves the chiton uncovered. The way the drapery covers the leg on Dugas 55 is especially close to BM 1010.15 (PLATE 40b) and 1018.10, and the general resemblance between the scheme of BM 1020.58 and our no. 1 has already been noted. Finally, the cloth heaped over hands or feet on Dugas 6 and a fragment in the Tegea museum recalls the woolly textures of the drapery of the west pediment at Epidaurus.[64]

In such details as the treatment of the folds of the apoptygma between the breasts or at either side of the girdle, there is in no. 1, if compared with its fifth or fourth century predecessors, a trend towards simplification, almost severity, which in its own way seems to conform quite well with the general impression of the character of the Tegean style which we have gained hitherto. On Attic work of c. 420–390 we find an undulating, fluttering overfold, and two or three looped tubular folds at the sides; the tendency towards a very rich and diverse treatment of these motifs culminates at Epidaurus, and (in a rather tired way) on certain figures from the Mausoleum Amazonomachy. Other slabs, however, are much closer to Tegea in spirit, as is the Artemision column base, BM 1200, from Ephesus.[65] At the end of the century a woollier texture and more fussy treatment prevail, making great use of the running drill for shadow effects, for instance on the statue of a woman in New York and the akroterion NM 159 from Epidaurus.[66]

Rather hard, sharp-edged, flat folds stretched across a thigh or towards a knee or breast are common at Tegea;[67] an early example of this occurs on the right thigh of the 'Andromache' from Epidaurus, NM 146,[68] and thereafter frequently, though usually in softer form, on the Mausoleum sculptures and elsewhere.

Many of the drapery fragments have not received a final smoothing, and in some cases, at least, it is clear that this was a deliberate attempt to texture the cloth;

elsewhere the sculptor may have been concerned merely with saving himself trouble. In general, perhaps the one was a convenient excuse for the other, with the added advantage that the rasping provided a key for the paint.

Lastly, the animals; in style they are little different from the humans; the 'pathetic eye' of the boar (no. 5) is notorious (although there is perhaps more ferocity in it than most commentators have cared to admit), and Neugebauer was clearly correct in discerning a close relationship in modelling and expression between the boar and dog (no. 6)[69] and the heads from the pediments. The new dog (no. 7) would appear to confirm this; we may note the vigour of the movement itself and the clarity with which it is articulated, especially at the neck, then the solidity of the bone and muscular structure and the thickness of the hide, and compare our findings with what has already been said with regard to the human figures.

Probably because it has been done so often before, to pronounce judgement on the style of the Tegea sculptures seems almost presumptuous, and to do it with any economy virtually out of the question, all possibilities in that direction having long since been exhausted by the writers of the handbooks. The task is made yet more difficult by the confused state of scholarship as regards the fourth century as a whole—both the period itself and our knowledge of it seem just as hopelessly fragmented, and even the application of the word 'classic' to it is disputed by some.[70]

If we deliberately restrict our definition of the word to contain only the styles of Pheidias, Polykleitos and some of their contemporaries, they cannot help but be right; but this is begging the question, and if we adopt more general criteria, such as 'consistency', 'economy', 'clarity' and the supremacy of formal design,[71] it would be perverse not to admit that under these conditions much (but not all) of what was produced around the middle of the fourth century, say from c. 370–c. 330, was indeed Classic in spirit. With the 'rich style' one senses the stirrings of new interests—in the possibility of exploiting different kinds of touch in marble carving to vary the tone of the surface, in psychology and mood, and finally in a new conception of the human figure as a geometrical construction *in space* —and when towards the end of the first quarter of the century the accompanying 'frenzy of decorative dissipation'[72] was at last nearing exhaustion, it was precisely these features that served to temper the formalism that held so strong a sway over the age of Pheidias and Polykleitos into a more subtle and more

flexible vehicle for artistic expression. In Carpenter's words: 'Classic abstract formalism is becoming modified into formalised naturalism. But the past is still strong upon it, to give it stylistic character and structural power.'[73]

On these terms, the Tegea sculptures would appear to be in the final stages of stabilising a new classicism, and on the evidence of both style and technique are probably to be dated between the Mausoleum (c. 360–350) and monuments like the Daochos dedication and the Lysikrates frieze, erected in the 330s. The style derives much of its inspiration from the sculptures of the temple of Asklepios at Epidaurus, but its genesis can be traced back even further, to the Argive Heraeum and the late fifth century.

Although new departures are made in surface characterisation and anatomical realism, the unity of the body and its action again become of concern to the sculptor. Movement is vigorous and energetic, sometimes vehement and brusque, but never at variance with the laws of anatomy; the extreme preoccupation of an earlier age with unbridled muscular tension shows itself in but a few fragments, its shattered rhythms and jerky movements in none. In the more advanced pieces, the eye finds large and coherent planes and richly characterised surface forms, and the style as a whole seems in process of awakening to a mature appreciation of the weight and solidity of the human body and the need to articulate and present it in the most lucid and effective way possible.

Facial expression, hitherto a discordant element in the context of a classic style, is regularised and harmonised with the action and situation of the figure, and, despite the fragmentary state of the pedimental figures, we may perhaps surmise that not only did an intensely dramatic atmosphere prevail, but that the space within the architectural frame was activated by physical means also—we have already noted the crowding and sheer size of the figures in relation to their frame, and (equally important) the predominance of three-quarter poses. When, as here, these expedients are employed in association with powerfully rounded and undulating body forms, it is difficult to escape the conclusion that the intention was to present to the observer an array of continually receding surfaces that must have contributed greatly towards the overall three-dimensionality and spatial interplay of the composition.

Of particular significance is the deliberately conservative approach to facial expression adopted by the

atelier, since it seems to call into question the possibility of applying Carpenter's oft-repeated dicta that Greek sculpture was essentially 'an anonymous product of an impersonal craft',[74] its evolution determined by a constant and consistent 'trend toward mimetic fidelity to objective appearance',[75] to the overall development of the art in the fourth century without important qualification. Given that the attention paid to expressing the emotions is one of the most distinctive features of the Tegea sculptures, and that in other respects, as we have seen, Tegea fits fairly neatly into fourth century sculptural development, it would clearly be begging the question to dismiss the problem as an aberration or a mere nostrum of the second rate. Pursuing the argument to its logical conclusion, we are in effect virtually bound to consider that this retrenchment was due to the will of a single individual, and carried out at his behest by the sculptors employed under him. Although the consequences of this conclusion for theories of Greek art in general are obviously not insignificant, it would be out of place to discuss them here.

In the foregoing paragraphs I have deliberately refrained from making more than the occasional allusion to the subject of quality, in order to be able all the more easily to investigate the style of the sculptures without prejudice. In general, it seems that those students (the majority) who regard them as not first-rate are correct, although the criticisms of some are really too harsh.[76] It is unwise to be dogmatic, of course, but a few particular points are perhaps worth making.

Firstly, any overall judgement must take into account that the execution is by no means completely uniform—here one only has to remember the akroteria. Yet, even despite this, as one handles the fragments themselves, or even looks around the room in the Tegea museum where twelve or fifteen of the larger pieces are on show, one has the irresistible feeling that all are intensely alive, almost bursting with vigour and energy. Although subjective (as, of course, is any assessment of quality in art), this very strong impression is not of the kind usually engendered by third-rate sculpture.

Secondly, the 'Herakles/Telephos' head, no. 16, would seem to cast serious doubts on any simple assumption that Greek ideas on what constitutes quality in architectural sculpture necessarily coincided with our own. The head must come from the centre of the west pediment, and is therefore (presumably) the work of one of the leading sculptors of the atelier, yet

in Berchman's words, 'la facture de ce morceau est assez sommaire'.[77]

In fact, as almost every student to consider the problem has recognised, the intention was clearly to make the head effective from afar; the sculptor obviously knew quite well that exquisite carving was not only lost at a distance of a hundred feet or more, but could actually impair his figure's effectiveness, and simplified his conception accordingly. This was common practice in architectural sculpture, but, as so often in the Tegea publication, Berchmans prefers to stand the evidence on its head, and resorts to explaining it away as one of a series of lapses on the part of the artist, 'qui, à une certaine distance, ne devaient pas être sensibles'.[78]

The result of the sculptor's efforts, as Picard saw,[79] is a work of impressive grandeur and remarkable appeal, and we should perhaps take the undoubted success of the sculptor's efforts to reach a compromise as a warning not to be too precipitate in passing adverse judgement on the quality of the Tegea sculptors.

In conclusion, it is perhaps worth considering whether the influence or presence of any local school is detectable at Tegea. There are certainly strong grounds for suspecting that the majority of the sculptors were of outside origin, since Tegea could hardly have supported a school of its own (at least, of any pretensions); there is nothing in the style which could arouse suspicions of any debt to bronze-work, of whatever school, and if 'Peloponnesian'[80] be identical with the style of Polykleitos and his followers, we have already rejected that possibility. Attica is even less likely, unless (to quote out of context a remark by Ashmole) 'we are blind to what a thousand grave reliefs show us of Attic style in the fourth century'.[81]

Many students see Ionian influence in the opaque, smoothly undulating surfaces,[82] but we have really so little to go on, and even the existence of significant local, as opposed to personal schools outside Attica seems to be highly questionable in the fourth century, especially towards its end. Furthermore, in this particular case, local characteristics seem irreconcilable with the internal development of the style. If we call Dugas 53 (PLATE 21) 'Ionian', can we call Dugas 28 (PLATE 20), so different in approach, 'Ionian' too? If not, we are logically committed to withdrawing our assertion that the style is a unity. Clearly, without a closer study and a larger number of originals of both undisputed provenience and higher quality than we at present possess, tags like these can hardly enlighten, only obscure.

Chapter Five

SKOPAS IN TEGEA

The Tegean temple apparently took quite a long time to build, perhaps as long as thirty years, and must, it seems, belong within the period between c. 370 and c. 340; the design of the building fits best in the earlier part of the period, and the style of the sculptures in the later part. However, from Pliny and others (Appendix 1, nos. 34 and 35) we know for sure that Skopas was in Asia for at least part of that time, around 353–351; there is a problem here, and, to point the way towards a solution, a few remarks on what being an ἀρχιτέκτων in the ancient world really involved would seem to be in order.

Greek architecture was a highly conservative and traditional craft, not an experimental science as today. By the fourth century, the design and building of a temple took place according to a well-tried and quite closely defined system; as (to a certain extent) in sculpture, the individual craftsman knew fairly well what was expected of him on any particular job and how to go about achieving it himself, given certain basic information. The scope for originality and individual enterprise on the part of the architect was thus limited more or less to those features which lay outside the sphere of pure craftsmanship: the plan of his temple, its proportions, and its decoration.[1]

Presented with the decision by the Tegean demos that he should design their new temple, Skopas' primary task would have been to draw up a description (συγγραφή) of his building, embodying precisely these points, and including the major dimensions (which would, of course, determine the proportions). Only one such 'plan' of this kind has survived from antiquity, the description by Euthydomos and Philo of their arsenal in Piraeus,[2] built c. 330, but from stray references in other inscriptions we can infer that this was

the normal procedure, at least after c. 450. This, in its turn, would enable specifications for materials to be determined and contracts[3] (of which many examples have come down to us)[4] to be advertised and let out as building went along; the architect would supply models (παραδείγματα),[5] or engage others to do so under his direction, for decorative details such as the Corinthian capitals, simas and so on.

Euthydomos' part in the arsenal project would seem to have stopped at the planning stage, before actual building commenced. Philo, however, was still required, as was Theodotos on the temple of Asklepios at Epidaurus and Philagros on the Prostoon at Eleusis. The question is, was Skopas?

Since a priori it seems unlikely that such a promising young sculptor as Skopas would have remained out of sight and out of mind in Tegea for very long (and we know of only one other work of his in Arcadia),[6] and since, as already noted, it is likely that the building of the Tegean temple took a long time, perhaps as much as fifteen years, and its sculptures even longer, the answer, at first sight at least, would seem to be no. The difficulty is that normally the architect was required to be on hand to give instructions (ἀναγραφεῖς)[7] for the solution of specific problems that could only have been tackled on-site, of which perhaps one of the most important at Tegea would have been the co-ordination of the gross length of one unit (1 triglyph + 1 metope) of the frieze of the peristyle with the inward lean of the columns on the façades and the disparity between the intercolumniations here and on the flanks.[8]

At Tegea, and very unusually, Skopas seems to have made every effort to ensure that adjustments were unnecessary: although the standard façade inter-

columniations exceeded those on the sides by 2.8 cm, the inward lean of the columns of the fronts was so managed as to reduce the length of the frieze unit here to 1.791 m—six Arcadian 'feet' of 0.2985 m, and exactly equal to the unit utilised on the flanks.[9] Other features of the construction are also highly schematic; one in particular was repeated, it seems, on the contemporary temple of Apollo at Delphi, also designed in the early 360s, and described by Bundgaard as follows:

> The block distribution of the cella walls depends on the division of the peristasis, which is carried across the aisles in the flag joints. The joints of the toechobate alternate with those of the flags, those of the orthostate with those of the toechobate, and those of the wall-courses with those of the orthostate, in such a way that the length of each orthostate is divided between two wall ashlars. Thus the wall ashlar corresponds to ¼ column bay = ½ frieze unit. It cannot have been difficult to calculate the subsidiary measurements for this temple.[10]

Likewise for Tegea, where the length of a wall ashlar was exactly three Arcadian 'feet'. Furthermore, as the excavators noted, an unusually large number of the measurements of the Tegean temple, both vertical and horizontal, from peristyle to interior colonnade and from exterior sima to interior architrave, can be expressed in round numbers of such 'feet'.

It looks very much, then, as though the general intention behind this almost obessive pursuit of regularity on Skopas' part was to minimise the degree of intervention necessary on the part of whoever was supervising the construction. Such problems as remained (for instance the calculation of the widths of the elongated corner metopes) would have been easily soluble by either the contractor in charge of that particular section or an assistant, like Astias or Kallinos,[11] assistants of Theodotos and Spintharos at Epidaurus and Delphi respectively. With this in mind, it is surely reasonable to conclude that in the first instance Skopas did little more than plan the temple and its sculptures, oversee the early stages of the building, and look after such details as the Corinthian capital, leaving a supervisor in charge to carry on the job. He would, no doubt, have returned at intervals to keep an eye on affairs, with a final visit in the early 340s to carve the cult statues and possibly to supervise the architectural sculpture as well.

In fact, as is well known, Pausanias gives us no explicit information as to who was responsible for the decorative sculpture of the temple, remarking only that its architect was 'Skopas the Parian, who made images in many places of ancient Greece, and some in Ionia and Caria'.[12] Whether or not it is implicit in the text that architect and sculptor were the same man, I leave it to others to judge; Skopas certainly carved the cult statues, as Pausanias tells us a little later.[13]

Most students, while noting Pausanias' silence on the matter, have taken it to imply that Skopas was responsible for all the sculptures of the temple—in A. W. Lawrence's words, 'because the singular individuality of the work postulates the employment of a great sculptor'.[14] The inference is justified, and indeed finds striking support in the picture revealed in the previous chapter, of an original and resourceful mind in control, seeking new solutions to current artistic problems, yet working all the while within the context of the classic tradition and sternly rejecting any novelty that implied, or could cause, a break with that tradition.

The strength of this argument must not, however, blind us to others that may lead to the same conclusion or, at least, help to rule out the possibility that different ateliers worked on the temple and on the sculptures. In this latter category, we may place, for instance, the strong resemblance that exists between the mane of Telephos' lionskin cap (PLATE 14a) and those of the lion's head gargoyles[15] from the temple—a not insignificant piece of evidence considering the great diversity of gargoyle styles during the fourth century. The styles of the sculptures and of the architectural ornament also seem to be linked in another way, less straightforward and certainly more tenuous. To me, the strongly sculptural acanthus decoration of the sima and Corinthian order displays the same quality of rich surface characterisation and intense vitality that are so emphatically a sine qua non of the pedimental sculptures themselves.[16] Both are seemingly derived from a common source, a style of dynamic yet formalised naturalism that should, on balance, be associated with Skopas himself.

The sculptures themselves certainly presuppose a single guiding hand; as we have seen, it is difficult to posit anything but a single designer for the two surviving akroteria (nos. 1 and 3). Furthermore, the integration of temple and altar into a unified decorative scheme by means of the akroteria can hardly have been accidental, and surely points to an experienced planner in overall control—who else but Skopas?

We can only make guesses as to how deeply his influence was felt in the atelier, and any attempt to see his own hand at work on any of the surviving pieces is more conjectural still. There seems no doubt, though, that at the very least he was responsible for the designs.

In which media architectural sculptures in particular were designed is much disputed, and the matter is complicated still further by the problem of Timotheos' τύποι at Epidaurus.[17] Sketches were presumably the first stage, as Pausanias tells us was the case for the shield reliefs of Pheidias' Athena Promachos.[18] These would fix the initial conception of the sculptor, perhaps for approval by the committee appointed to oversee the rebuilding of the temple, but by themselves would be insufficient to guide an atelier of, say, ten or fifteen carvers through the complicated process of translating such interlocked and crowded compositions into stone and accommodating them to the architectural frame.

For this, models of some kind would be necessary.[19] Questions of style apart, the exact scales of the figures and their relationship to the architecture could not be fixed without them; particularly important in this respect would have been their heights, since mistakes in this direction, once the composition was decided upon and the figures carved, would have compelled decidedly Procrustean methods of correction.

Carpenter and others regard small models as indispensable to the creation of truly three-dimensional sculpture in the round. Yalouris believes that this was indeed the procedure adopted at Epidaurus, and at Tegea where joins were few and the figures even more interlocked and freely moving in space, we may surmise that preliminary studies in the round were even more imperative. Calculating the various degrees of optical correction and finish required would then have been a comparatively simple job for the carvers.

To speculate a little further in the same direction, it seems to me that for an idea of what the kind of model used at Tegea and elsewhere may have looked like, one could do worse than to turn to a fourth century terracotta archetype in Heidelberg,[20] published by Neutsch and discussed and illustrated by Higgins; its original height was about a foot. Models of this size, carved from hard clay with the chisel and easy to adjust and experiment with before firing, would have been quite sufficient for establishing the major relationships (such as the proportions, scale dimensions and poses of the figures), together with the place of each figure in the pedimental composition as a whole and its position vis-à-vis the raking cornice.

As for the transition from model to full-size statue, the heights of the figures (and perhaps one or two other basic dimensions) seem to have been transferred by means of a rudimentary 'pointing' system requiring the use of a plumb-line.[21] This was not the evolved three co-ordinate system of the copyists, but more likely a simpler method involving only verticals or verticals and horizontals, which took as its major co-ordinate a point on the hairline in the centre of the forehead. This area is left uncarved in a number of the heads from Olympia,[22] the remains either taking the form of an indentation in the hairline or a puntello-like boss of marble; the head from Tegea no. 18 preserves a puntello in exactly this position (PLATE 16a), evidently for the same purpose. If the models were carved to an exact fraction of the heights of the finished statues, the sculptor would not have needed even a numerical scale to transfer his measurements from model to figure: a pair of calipers would have sufficed to give the proportional relationships, measured at, say, $1:4$ or $1:6$ along a rod or stick. This would circumvent the fundamental problem faced by all concerned with mathematics in the ancient world: that it simply was not possible to go into a shop and buy an accurate ruler.[23]

Some would go no further in descrying the personalities of the great masters at work upon architectural ensembles of this kind.[24] The situation must have varied from monument to monument, however, and other factors, like the size of the atelier, the importance of the work, or the need to complete other commissions must have played a part. Ashmole sees the guiding hands of master sculptors at work even on the friezes of the Mausoleum, 'for how otherwise can one account not only for the variety but also for the excellence of the styles?'[25] Wace, on the other hand, believed that 'the most we could attribute to them with any certainty would be the designs.'[26] We will return to this problem later when discussing the Mausoleum; for the moment, however, it must suffice to say that quality apart, any assessment of the role played in architectural sculpture by a sculptor of the standing of Pheidias or Skopas must rest on the degree of homogeneity within the corpus of surviving sculpture, and not upon hard and fast rules laid down in advance.

At Tegea the evidence of the fragments is uneven. In some respects (e.g. facial expression and the treatment of the nude) there is considerable, but not complete, homogeneity, but although the sequence into which we have fitted the heads is quite tidy and has few loose ends, its range is really too great to admit of as close a degree of control by a master as does the tightly-knit group of heads on BM slabs 1013-15.[27] The drapery shows much variety, as we have seen; no doubt it was only indicated very roughly on the models.

Two fragments, nos. 8 and 16, are most probably

to be assigned to the centres of their respective pediments, where Skopas would have intervened personally if anywhere. Of these the former had an inset head (and arm), like the Athenas of the Hephaisteion and the Parthenon, and we may be almost certain that these were made separately by the leading carver of the atelier (although in this case we can not know whether he was identical with Skopas); the latter, though a remarkable piece on any terms, is perhaps not quite of the standard which we should expect from a sculptor of Skopas' ability.[28] Since it comes from the west pediment and was not inset, we may hazard that it was the work of a lesser artist, and that Skopas undertook the carving of the head of Atalante (no. 8) himself, in addition to planning the composition, leaving the rest of the work to his assistants. These were able to reproduce his personal style with some degree of homogeneity, although we can no longer tell how directly the carving of the surviving fragments reflects his personal guidance.

Certainly it must be said that the quality of the work, although by no means poor, does not exactly encourage us to see the hand of Skopas at every turn. Perhaps in part, at least, this unevenness is attributable to a fairly loose degree of control over his atelier, perhaps even to his absence in Asia; the truth may possibly lie somewhere between the two, and in any case we are in no position to be able to choose between them.

The design of the temple and its sculptural decoration, and some degree of supervision over their execution, were two of Skopas' three major concerns during his visits to Tegea; the third was the carving of the cult statues.

These, an Asklepios and Hygieia flanking the archaic statue of Athena by Endoios,[29] were set on a base about 7 m long, of which the substructure survives, stretching almost the full width of the cella.[30] To give an unobstructed view of them the cella was designed without the usual free-standing internal colonnades; these were reduced to half-columns engaged in the cella wall, while to avoid distracting the spectator's attention from the three figures the rear wall was left blank. Pilasters occupied the corners, and the whole arrangement was obviously inspired by and an improvement on the cella at Bassae.

Endoios' Athena was perhaps the one now known from an archaic bronze statuette from the sanctuary, although there is no real clue as to the size or style of the original. Of Skopas' figures, a tentative attempt will be made to identify a copy of the Asklepios in Chapter 9, and two candidates present themselves for the Hygieia: the fine marble head NM 3602,[31] and a torso in the Tegea store recently published by Delivorrias.

Neither the style nor the find circumstances of NM 3602 give grounds for much confidence in her claims to be a Skopaic original. The quiet, withdrawn expression and nervous features are completely at variance not only with generally held opinions as to Skopas' style, but also with the only well-preserved female head from the temple sculptures, no. 4; the eyes in particular are completely different.

Some students have likened this piece to the head of the Hope Hygieia;[32] to me, however, it seems to fit better with work of the last quarter of the fourth or the first decade of the third centuries in the general orbit of the sons of Praxiteles. The profile of a late fourth century head of Nike from a Rhamnuntine relief compares well with that of our head;[33] in this context I find Ashmole's succinct definition of the style particularly illuminating: 'Its distinctive marks, apart from the long oval of the cheeks, are the small, compressed mouth and drawn in nostrils, which make one think that the owner is smiling or on the point of speaking.'[34] The 'Ephraim' head in the Louvre and the head of a woman on the very late grave-relief from Rhamnous, NM 833, also seem close, and the eyelids of the Tegea head are modelled in an identical manner to those of the head from Chios now in Boston, and usually dated at or near the end of the century.[35] A more generous grouping might include the Nikai from the Artemision at Epidaurus and the Muses of the Mantinea base;[36] in any case, whatever it may be, the head is not Skopas as I have come to think of him.

Perhaps more convincing to the sceptics are the find-circumstances.[37] The piece was found apparently *in situ*, by a base at the southeast angle of the temple, immediately below a column drum and rather above the fourth century ground level (defined as the top of the temple foundations). The obvious inference is that the head belonged to the statue which stood on the base, and was broken when the adjacent part of the temple fell at the end of the Roman period. The ground had risen considerably by then, as, between them, the levels of the Byzantine and fourth century foundations show, and the position of the head directly beneath the drum is hardly explicable by any other hypothesis. Furthermore, if the head really did go with the base, this would give a firm mid-century *terminus post* for it, since the statue could scarcely have been erected while building was still in progress.

Although apparently (not certainly) a Hygieia-type, the head is unlikely to have belonged to the Hygieia for another reason, although this is admittedly more tentative: its marble does not seem to be Pentelic. Pausanias' information about the marble must have come from his guides (he could hardly have examined the statue himself) and one can, I think, imagine a situation in which just this kind of fact could have been handed down intact from the fourth century; the marble of the head, however, is generally agreed to be Parian.

More likely, though unsupported in his article by any arguments except its unweathered surface and relatively high quality, is Delivorrias' attribution of a female torso fragment in the Tegea museum store.[38] Although the execution seems to me a little hard, and the parallel running drill channels below the girdle surprising for a cult statue by a first rate sculptor (compare the superb technique of Euphranor's Apollo Patroos in the Agora at Athens),[39] certain details of the drapery—the fold divided by a running drill channel above the girdle by the right breast, and the flat folds reaching out to the points of the breasts from girdle and shoulders—do seem to be reflected in the pedimental sculptures, especially no. 8 (compare also the folds down the left leg of no. 1, where the same hardness recurs).

Not only this, but the scheme of the draperies and the probable turn of the head do seem to coincide with a well-known Hygieia type, of which a relief in the Louvre is a good example,[40] probably contemporary with Skopas' statues (i.e. c. 350–330). The original to which our fragment belonged was over life-size —the measurement across the breasts would give a head height of about 29 cm and a total height of c. 2.10 m. The marble could also be Pentelic.

Thus there does seem to be some probability that this piece once formed part of a Hygieia related in style to the Tegea sculptures, though its quality perhaps militates against its being a cult statue. In any case, such are the accidents of preservation that it can tell us little or nothing about Skopas' personal style.

The phenomenon of the architect-sculptor has long been of fascination to scholars, but in contrast to the mass of evidence concerning the work and careers of such figures as Brunelleschi, Michelangelo and Bernini, and the correspondingly numerous studies consecrated to them, our evidence for their counterparts in the Greco-Roman world is pitifully small. In the fourth century the sculptors Skopas, Polykleitos (II or III ?) and Leochares all turned their

hands to architecture,[41] yet all are shadowy figures to us today, with the possible exception of Skopas.

Only Pfuhl has attempted to study sculptural and architectural style at Tegea in tandem, concluding that: 'Als Ganzes ist das tegeatische Kapitell von höchst persönlicher Eigenart: mit gedrungener Kraft, Wucht and Fülle verbindet es einen entschieden trapezförmigen Umriss, welcher durch die Schräge der grossen Voluten betont wird. Die gleiche Grundformen zeigen die Köpfe der Giebelstatuen.'[42] One wonders whether to carry a search for 'Grundformen' into such detail is not misplaced; the restoration of the Tegean capital is not yet beyond doubt, and has been emended since the discovery that those from Nemea were more or less faithful copies.[43] Furthermore, as Roux cautions: 'Forme et dimensions du chapiteau sont déterminées chaque fois par la situation dans laquelle il se trouve et, autant que cette situation l'autorise, par la libre fantaisie de l'artiste.'[44]

Roux' more relaxed attitude is evident in his analysis of the Tegean capital itself, and he stresses that: 'Avec le chapiteau de Tégée, nous abordons un tout autre courant [i.e. from Bassae or Delphi]. Par ses proportions ramassées, par la caractère naturaliste de sa décoration végétale, il ne rappelle en rien ses prédécesseurs; Scopas oriente l'évolution du style corinthien dans une direction qu'il ne quittera pas désormais.'[45] As for the character of the architecture in general, Robertson has noted that here, as elsewhere, 'a new spirit is moving in the traditional forms';[46] the relatively severe Doric of the exterior, 'si peloponnésien de style',[47] cloaked an interior which was both progressive in design and boldly innovative in decorative detail.

Of course, architecture and sculpture by the same man do not necessarily follow the same paths—here one only has to remember Bernini. At Tegea, although in character not far removed from the sculptor, the architect is perhaps more experimental, particularly in his handling of the interior arrangements of the cella.[48] He also seems to have been inexperienced, to judge from the very archaic method he adopted for calculating the proportions of the platform and peristyle. Finally, the deliberate choice of unique or unusual combinations of mouldings betrays a touch of idiosyncracy, and the placing of the side door in the cella a touch of crudeness (in comparison with Bassae) that may possibly be explained by the design of the temple being an early undertaking in Skopas' career. The other alternative, that the sculpture is the work of a different mind, seems less likely but still not completely out of the question.

Part II: Skopas

Chapter Six

ANTECEDENTS

As the preceding chapters have shown, the roots of the Skopaic style lie in the sculpture of the two generations that separated the masters of the second classicism from their predecessors of the first. This period, or at least the latter part of it, is often considered as one of artistic stagnation or even decline—Rhys Carpenter, for instance, speaks persuasively of a 'euphuistic delight in the distractions of artifice at the expense of significant content', leading to 'a veritable frenzy of decorative dissipation'.[1] Yet, in apparent paradox, the same era was to see some bold experimentation and, occasionally, some striking successes, particularly in the representation of emotion.[2]

The frieze of the temple of Athena Nike,[3] carved in all probability between c. 427 and c. 424, does show definite signs of a new energy and determination in the carving of parts of its battle scenes, together with occasional attempts at greater three-dimensionality with the use of complex overlappings and bold foreshortenings. Yet for the first significant attempts to recognise and deal with the problems that Skopas was to tackle so successfully half a century and more later, we have to turn to two slightly later monuments outside Athens herself—the temple of the Athenians at Delos, built probably between 425 and 417, and the Argive Heraeum, rebuilt after the disastrous fire of 423, and almost certainly complete by the end of the century.

Although the publication of the Delos akroteria is unfortunately so poor that very little can be ascertained from it alone, one thing at least does seem clear: the Delos sculptors had become interested in torsion, and in reconciling torsional poses with formal *contrapposto*.[4] The Oreithyia from the eastern akroteria twists through about 45°, the turn of the head to her right (away from the 'relaxed' side of her body) completing the movement. Such spiral torsion ('Schraubenbewegung') is by no means unique at this time, as both sculptors and painters try to escape from the restrictions of the self-contained classic silhouette by enticing the eye beyond the figure, so activating the space around it. We find it on the contemporary Diadoumenos of Polykleitos,[5] on the so-called 'Protesilaos' (of more uncertain date and style),[6] and on a number of vases by the Meidias and Talos painters,[7] among others; a double twist, too, is not uncommon, especially in painting. This awakening regard for the possibilities of torsional poses, and for the as yet hardly appreciated problem of reconciling such three-dimensional compositons with formal *contrapposto*, was to be developed further during the first thirty years of the succeeding century.

It is unfortunate that the sculptures of the Argive Heraeum[8] are so badly preserved (in A. W. Lawrence's striking phrase, 'reduced to a cartload of shattered fragments'),[9] that we can derive virtually no information from them regarding their contribution (if any) toward the solution of the problem of composition in depth. Two figures, a warrior and a girl, probably an Amazon,[10] seem to have been spirally rotated, the warrior violently so, though insufficient remains of both to reconstruct the positions of the lower limbs, or even of the heads, with any confidence; in comparison with what we can learn from the heads (PLATE 24a),[11] the information provided by these fragments is meagre indeed.

'What distinguishes the combatants of the Heraeum is their striking brutality; faces distorted in pain, gaping mouths, bared teeth, eyes turned to left or right—all are present in quantity. Movement is vio-

lent, impetuous, and endows the inflated, fluttering draperies (free-flowing and almost completely decorative in Attic art) with a tension that is totally individual.'[12] So Arnold, in a compelling summary of the characteristics of this 'Argive rich style'.

It would, however, be wrong to jump to the conclusion that these sculptors were the *first* to realise that battle, in art as in life, must involve pain and brutality; recognition of this had come as early as a century before, at Aegina. Their contribution (or rather, the contribution of their unknown 'master') lay not in discovering this self-evident fact, but in being the first to refuse to tone down the ugliness and suffering to conform to the dictates of classic taste, as the atelier of Pheidias had done on the metopes of the Parthenon, for example. The stark realism of the Heraeum heads in this respect is all the more striking because the atelier must have been working under one of the followers of Polykleitos, supposedly the arch-idealists of their time.

In the field of facial expression, then, the Heraeum sculptors leave no device untried, even angling the eyebrows upward slightly at the bridge of the nose on one figure, apparently (to my knowledge) for only the second time in the history of sculpture.[13] Yet having thus avoided one inconsistency they have, by their single-minded, almost fanatical pursuit of realism, simply created another, one that their predecessors, in limiting and sometimes eschewing the use of facial expression in their work, had hitherto managed more or less to avoid. As was observed in a previous chapter, the point is perhaps made most effectively if one mentally tries to join up one of the snarling heads from the temple with the almost academically Polykleitan body on the metope NM 1572 (PLATE 24a-b); the net result is, to say the least, incongruous. The two are, in fact, irreconcilable, and it is clear that, in this respect at least, the Polykleitan school had worked itself into a cleft stick—which is, perhaps, why the sculptures of the Heraeum had no true successors. The Tegea sculptures are indebted to them only in a limited way— open mouths are retained, for instance, angled eyebrows not. As often as not, the Tegea sculptors improve on the style of their Argive predecessors: the 'Michelangelo bar' is straightened, the forehead gaining much in power as a result, and the inclination of the head on the neck, often rather weak and contrived on the earlier monument, is strengthened on the later by abnormally massive sterno-cleido-mastoids.

Although the torsos of the Heraeum adhere on the whole to the strict Polykleitan canons of formal defini-tion, the limbs are more realistic. Close attention was paid to the articulation of the movement, and the anatomy of wrists, elbows, knees and ankles is extremely detailed and precise.[14] This stress on the joints recurs at Tegea but there, as has been shown, the style turns more to breadth of treatment, omitting detail to gain power and muscular cohesion.

The Heraeum sculptures, then, mark something of an epoch in Greek sculpture, and can, for all their idiosyncrasies, in some respects be regarded as the remote ancestors of the Tegea style. The qualification needs to be stressed, for the similarities are more in aim than achievement, and in many areas (such as the structure of the heads and the design of the torso) the Heraeum style is completely at variance with the Skopaic.

It is a moot point whether the wholehearted conversion of the Heraeum atelier to what might be deemed 'expressionist sculpture' was original on their part, or influenced by developments in Athens. No contemporary *sculpture* from Athens exists that might support this contention, in fact rather the opposite, but before it is dismissed out of hand there are two considerations that support it to be taken into account. The first is that since the major component of the style of the sculptures of the Heraeum is the Polykleitan,[15] it is likely a priori that in the matter of facial expression the sculpture has taken its lead from elsewhere; and the second is that this 'expressionist' style recurs in a number of Athenian vase-paintings, dating from around 400, which are apparently versions of a single lost original, perhaps a large fresco or, as Walter has suggested, the woven peplos of Athena. The subject is the battle between the gods and the giants, and most of the motifs ultimately refer back to the shield of Athena Parthenos.

The styles of the vases,[16] though all seem to be by different painters, share certain characteristic features (cf. PLATE 24c). The figures are arranged in depth, with much overlapping and foreshortening, and many three-quarter poses. Violent action is the rule, though figures and even at times individual limbs seem to be considered in isolation from each other, with the result that (in conformity with the gradual disintegration in compositional rhythm which Speier has traced in two-figure groups of the period)[17] the movement of each figure not only lacks overall unity and drive, but there is no carrying over of the impetus of the action from one combatant to the next. Even so, muscles ripple and bulge freely on the strong, powerful bodies of the warriors, and there is again great emphasis on the joints at shoulder, elbow, hip and

knee. Heads are broad, sometimes almost cubic, with heavy chins, wide faces, and dishevelled, curly hair; much play is made with facial expression, where these figures are really the counterparts in paint of those from the Heraeum.

That these vases (and thus, presumably, their monumental original) are slightly more advanced in style than the Heraeum sculptures, however, is indicated by two distinctive mannerisms which do not occur on the latter: the prevalence of three-quarter faces, and the tendency to distort the waists of figures in torsional poses.

The first of these requires little comment. On the Heraeum, as Waldstein noted, the tendency was to frontal or profile views. On the vases, the opposite is true. Six figures are shown on PLATE 24c, for instance, and of these only one is in full profile, and one fully frontal; the rest, two-thirds of the whole, are seen in three-quarter view. This deliberate emphasis on recessive diagonals, combined with the use of lumpy modelling and three-quarter poses for torsos, does much to bolster the illusion that these figures are solid entities existing in properly three-dimensional space.

As for the second of the two, it would seem that the original of these paintings began a fashion which was to last well into the fourth century. Its development was rapid. On several of the giants, such as the kneeling figure attacked by Athena on the Louvre Amphora, the angular turn, as yet only in its infancy, is combined with the tightly drawn abdominal muscles and expanded chest pioneered for Lapiths on the metopes of the Parthenon,[18] and found on vases by Aison and others, as well as on the Heraeum (PLATE 24b). The next stage comes on the Athenian monument to those killed at Corinth in 394/3 (PLATE 25a). Here the distortion is extreme, as the defeated warrior twists through almost 180° to face his mounted assailant, his rib-cage protruding to an almost unnatural extent as he pants with exhaustion and fear. Broken rhythms and denial of reality for expressive ends could hardly go further, and hereafter, at Epidaurus and, eventually, on what seem to be the Skopaic slabs of the Mausoleum frieze, the angular turn is either toned down or used in a less conspicuous manner (cf. PLATES 34b, 37a).

These giants, then, almost exploding with energy, posed on the diagonal, and with their rugged, swelling muscles that lead the eye round the surface of the figure into the third dimension, are the true ancestors of the movement that was to result in the Tegea style. Yet one essential ingredient is still lacking—the reali-

sation that for them not to sound a discordant note within the context of a classic style, these new discoveries must be subjected to the same process of selection and subordination that in classic art should properly govern the rendering of the male body or of drapery. Staccato rhythms must be abandoned for concentration of form and unity of line; stilted gestures for broad, sweeping movements of arm or hand; florid, endlessly repetitive draperies for simple, functional costume; and distorted, agitated features for facial expressions of real power and intensity. Though the first generation of the new century was to some extent aware of these shortcomings, and went a certain way towards achieving the first two of these aims, it was left to Skopas to realise the others, and finally to fuse all into a new, passionate style fit to bear the name of classic.

The counterparts in stone of these Gigantomachies are the slightly later metopal sculptures from the Marmaria tholos at Delphi,[19] with one exception as yet not properly published. The temple was built between c. 400 and c. 380, though there seems no way of being more precise than that. In the battle scenes (PLATE 25b, c) the style seems to have changed little, though there is perhaps a little more body in the drapery of some of the figures, and others show a rather greater concentration in their movement than did their predecessors. Full torsional poses are found in plenty (e.g. nos. 4314, 4358 and the 'Theseus' torso), and dilated chests are also regular, even on females like 4309, together with the *caesura* at the waist (cf. PLATE 25c); rib-cages are occasionally—and quite inorganically—distorted to increase the effect (PLATE 25b).

With their often violently contracted muscles, twisted bodies and limbs seemingly projecting in all planes, these frenzied figures find their true successors only in the advanced Hellenistic period,[20] in statues like the Borghese Warrior, the Delos Gaul, and the Boy Jockey from Anticythera. Although only one head has yet been published, and that tells us little, the same would be true in general terms of what we know of facial expression at this time—up to and including the Priam from Epidaurus (PLATE 26d). As Ridgway aptly remarks in another context, 'This affinity . . . between . . . the periods . . . shows that similarity of content and goals is stronger than morphological or stylistic difference.'[21]

The monument that sums up all the achievements and shortcomings of this 'expressionist' wing of the rich style is the temple of Asklepios at Epidaurus.[22] Here we have unusually full information; for not only has sufficient of the building survived for a convincing

reconstruction, but also literally hundreds of fragments of sculpture and even the inscribed accounts, together with the names of some of the sculptors.

The date of the temple, which took just over four years and eight months to build, is disputed. The latest study of the sculptures, by Schlörb, opts for a date c. 390, whereas Arnold and most students of the architecture of the building prefer to locate it late in the decade c. 380–370. Certainly, since the sculptures are more advanced in style than any discussed hitherto, and since the architecture seems to follow closely upon that of the Delphi tholos, the later date is the more attractive. As for being more precise than that, Dionysios of Syracuse, who died in 367, set up a replica of Thrasymedes' cult statue in his own Asklepieion at Syracuse,[23] which gives us a firm *terminus ante*: the copy (from the original moulds ?) cannot have taken much less than four or five years to make, transport, and reassemble, so 370 (or preferably a little before) becomes the absolute lower limit. If the temple were begun just before one of the quadrennial festivals and finished in time for the next (a hypothesis, not a fact), the most likely date becomes 379–374, 375–370 being a little too close to Dionysios' death for comfort.

For our purposes, the best way to describe the sculptures is to work from west to east. The western akroteria consisted of a Nike in the centre (Crome's 'Epione') flanked by two riding Nereids or Aurai, set at an angle to the façade of the temple.[24] Of these, the Nike is the most interesting; not only is she a really virtuoso piece of marble carving, with almost paper-thin wings and drapery extending far back behind her body, but she also twists boldly through about 90° as she rushes through the air. Unfortunately, from the scanty remains of the neck it is impossible to know which way the head was turned, and thus whether the torsion was in the form of a single spiral or double twist; from the remnants I suspect the former, but nothing can be proved.

The subject of the west pediment was an Amazonomachy,[25] with which the Nike above was presumably connected in some way. This was the Trojan Amazonomachy, with Penthesilea the central figure, so the choice of subject could have had some reference to the sons of Asklepios, Podaleirios and Machaon. The style owes a certain amount to the Polykleitan, as Arnold has shown, but the most potent influence again seems to be that of the Athenian Gigantomachies and their successors. The tendency is towards a very soft and tender surface treatment, of both drapery and flesh, combined with the shattered rhythms and interlocked groups so characteristic of the vases; the heads, on the

other hand, are mask-like and expressionless. The composition was very crowded; Yalouris restores twenty-two figures, including horses.

As for individual figures, the *caesura* across the midriff and the dilated chest, by now almost a cliché, appear on the kneeling warrior recently reconstructed by Yalouris (NM 151), and another kneeling figure NM 4753, shows a pronounced distortion at the waist as he battles with the Amazon; both Yalouris' new figure and a third kneeling youth who grasps an Amazon's hair (NM 4752) twist in two directions, the body to the right and the head to the left or vice-versa.[26] This double twist, as mentioned in the Introduction, was to become of fundamental importance in Skopas' style, recurring, for example, in the Berlin Triton (PLATE 43a).

By far the most important of the figures from the Amazonomachy, however, are the two dead youths that occupied the corners of the pediment (cf. PLATE 27a).[27] Here it looks as though the sculptors were attempting to set off the two main varieties of torsion against each other, quite deliberately, for expressive effect. In the left corner the young man, his muscles relaxed in death, has turned slowly over onto his left side until his head lolls drunkenly over the edge of the rock that serves as his plinth, while in the right, in one of the most vivid of such studies in all sculpture, the contorted body of his comrade (PLATE 27a) still shows evidence of the agony of pain that preceded his end: his legs are crossed, his torso wrenched violently to the left, his head twisted back again to the right. The style of the vases could hardly be taken much further, and it is not surprising that if, as I believe, the Maenad of Skopas (PLATE 32) is the immediate successor to this statue, then here at least, Greek sculpture has opted for a slightly different approach, the possibilities of the old being exhausted.

The eastern akroteria consisted of a central group of a man apparently abducting a woman (Apollo and Asklepios' mother, Koronis?) flanked by two winged Nikai.[28] One of these (PLATE 26a), portrayed as a slim girl of no more than twelve or fourteen, has already been seen to be the immediate precursor of the Tegean akroteria in both costume and pose. As for the 'Apollo', he is remarkable for his very inarticulated and somehow rather inert and numb flesh surfaces, and for the curious style of his drapery, an oddly stilted imitation of that of 'Master B'[29] from the Nike temple parapet of almost 40 years before. His head is in bad condition, but the rather long face and heavy, rounded chin can still be made out.

The style of the east pediment,[30] an Ilioupersis

(and therefore again obliquely connected with Podaleirios and Machaon?) marks to some extent a turning-point in fourth century sculpture. From the few major fragments that remain, it seems that the sculptor is at least putting the disintegrated rhythms and uncertain movements of the last quarter century behind him.

Take, for instance, the youth who races forward to launch himself upon some Trojan foe,[31] his head thrown forward, his right leg extended, his left jack-knifed hard against his chest and taut as a steel spring —the direct ancestor, I would hazard, of our no. 17 from Tegea. Not for almost a century, since the lunging Lapith C from the west pediment of the temple of Zeus at Olympia, had a Greek sculptor carved a figure of such concentrated power. From the centre of the pediment there is the lower torso of a young man (PLATE 26b)[32] who moves energetically away from an opponent to his left. The volume of his muscles and the sheer surface richness of his skin brings us very close here to nos. 13, 14 and 26 from Tegea. The heads,[33] too, with their square chins, heavy jaws, and comparatively deep-set eyes (PLATE 26c), are not that far removed in style from their Tegean counterparts.

Yet these links, and they are very clear, between the east pediment of the Asklepieion and Tegea, should not blind us to the differences. Most of the Epidaurian figures still move rather abruptly, without the naturalness of their Tegean successors, and the drapery styles still blindly follow those current over thirty years previously. The most striking changes, involving as they do a complete reorientation of the sculptor's attitude toward facial expression, have yet to come; this was stressed in the discussion of the head of Priam (PLATE 26d) in Chapter 4, and does not require detailed repetition here. Considering how strange this head really is, especially in the context of what is normally thought of as a 'classic' style, it is hardly surprising that for some time it was mistaken for that of a centaur.[34] The gulf between Epidaurus and the styles of the middle of the century is wide indeed, and who else but Skopas can have been responsible for the changes?

As for free-standing statues, we have very few of real importance from the period c. 400–c. 370, and those only preserved in copies. For our purposes, the most significant of these are the Diskobolos attributed to Naukydes, and the Athena Rospigliosi, perhaps by Timotheos. Arnold dates the former to the 380s and Schlörb the latter to the 370s, which seems reasonable.

In contrast to his predecessors in the field of athletic sculpture, whose work tended to be self-contained and withdrawn, Naukydes has made his target

the evocation of atmosphere, and has somehow managed to reconcile the classic timelessness of the Polykleitan style with the immediacy of an athlete who exists here and now, a part of our experience.[35] The youth positions himself for the throw, involving us in his tension as the moment draws near; the lines of the composition radiate from the discus, stressing its importance. The whole stance of the Diskobolos, with his lowered head (turned, in a significant reversal of the normal Polykleitan scheme, to the 'open' side of the body), tensed right arm, and legs braced, bespeaks his concentration upon his task. He is poised on the diagonal, for only when observed from three-quarter view does he not seem to be starting forward or recoiling backward, the two movements being kept in uneasy equilibrium. By this device, too, the sculptor invites us to walk to one side and then the other, to view his figure through an arc of about 30–40°, and then to return to our starting-point as the only fully satisfactory one, thus emphasising the three-dimensionality of his figure whilst retaining a notional 'background' as a frame of reference for the observer.

Both in its composition and its subtle evocation of mood (though the two are really indivisible), the Diskobolos is something of a revolution, signifying that a change as profound as that which had come over architectural sculpture was now in the offing in the field of free-standing sculpture as well.

Of the Athena Rospigliosi[36] two versions are extant, one with a chiton that leaves the lower legs bare, the other with one that descends to the ground; it is not clear which is the original. Here the pose is both twisting and unchiastic, and were it not for the binding effect of the diagonals of the drapery, which carry the eye across the figure and away into the distance (emphasising the torsion of the body and the turn of the head), it would also be extremely ungainly. The head shows many analogies with that of the Leda (PLATE 25d), though the lower part of the face is narrower, the mouth not so strongly articulated, and the eyes smaller. Following Arnold, I would put the two about 10 to 15 years apart, with the Athena being the earlier.

The mood of the Athena is rather overtly emotional, with no real motivation that is apparent, though I suspect that in some of the copies the turn of the head, and with it the pathos of the statue, has been exaggerated. At any rate, Skopas must have known this figure, for he seems to have put its lessons to good use only a few years later, in his early statue of Herakles at Sicyon (PLATES 30-31), and it is to Skopas' career proper that we must now turn.

Chapter Seven

EARLY WORKS

In view of the considerable debt which the Tegea sculptures seem to owe to their counterparts from the temple of Asklepios, it seems reasonable to suggest that it was here, perhaps about 375, that Skopas received his apprenticeship in marble carving. Such humble beginnings were not unknown in the ancient world—Lysippos seems to have begun as a journeyman,[1] and many of the great Renaissance masters were to do so again two thousand years later. Although the Tegea sculptures seem to derive at least some inspiration from both sets of akroteria and pediments, since the vast majority of the correspondences we have noted are with the east pediment we may perhaps go further and imagine that Skopas' 'master' was either Hektoridas or the sculptor whose name is defaced in the building accounts.

Unfortunately, it has yet to be established exactly who was responsible for which pediment;[2] we only know that Timotheos took the akroteria above _____'s pediment, and Theo ____ those above Hektoridas'. Burford suggests that the missing name is Theo ____ (Theon or Theodotos ?), since the same guarantor appears in the accounts for both Theo ____'s akroteria and _____'s pediment; this is possible, but no more than that, for guarantors backing two, three, or even four contractors occur often in the building inscription. It would also require some similarity in style between one set of akroteria and the pediment at the opposite end of the temple. This rules out the east akroteria and west pediment, where there is no such similarity, though as regards the other pair it is just conceivable that the same sculptor was responsible for the 'Epione' and for certain of the figures of the east pedi-

ment, NM 146 and 4750 for example,[3] where the drapery style is not dissimilar.

As for external evidence, what there is tends to link the name of Timotheos with the eastern akroteria. To begin with, he was chosen to make the τύποι;[4] if these are moulded terracotta models as Blümel suggests (and the word would not be inappropriate here for pieces like the Hygieia discussed in Chapter 5), he would have been the leading sculptor and thus entrusted with these akroteria as the most important of the sculptures. That he is the only artist of the three whose name is known elsewhere only serves to strengthen this possibility.[5] Lastly, the drapery style of the 'Apollo' and the undeveloped body of the girl-Nike NM 162 (PLATE 26a) recur on the copies of the Leda, long attributed to Timotheos, though not mentioned in the sources.[6]

If these suggestions, admittedly based on very tenuous evidence, are correct, the sequence would be as follows: Timotheos, eastern akroteria; _____ (perhaps Theo____), east pediment; Theo ____, western akroteria; Hektoridas, west pediment. The name of Skopas' suggested 'master' thus remains unknown, or at best conjectural, though if it was at Epidaurus that he served his apprenticeship, it is clear that we need go no further to seek the reason why the style of Timotheos (if that be identical with the style of the Leda, PLATE 25d) was to influence him so heavily in the early part of his career.

The sole complete example of the type of Herakles with a vine, ivy or laurel wreath in his hair,[7] long thought to copy the statue carved by Skopas for the

gymnasium at Sicyon,[8] was never seen by Michaelis and has in consequence suffered neglect from archaeologists ever since; badly broken in the nineteenth century, it lay in the sandcaves near Deepdene House until its rediscovery after the sale of the Hope collection in 1917 and was eventually sold to the Los Angeles County Museum of Art, where it is to be found today (A1: PLATE 31a-c). The quality of the copy is mediocre, and it may date from the Antonine period. Its provenience is unknown.

Graef correctly likened the head type, best represented by the Genzano herm in the British Museum (A3: PLATE 30) to the Tegea heads (cf. PLATE 52); the proportions (Appendix 5) and structure strongly recall no. 17, as does the modelling of the brow and mouth, although the eyes are less deeply set and the features as a whole have less concentration and power in them than those of the Tegea heads (excluding no. 18). The plate-like sterno-cleido-mastoids are also characteristic of the Tegea heads, as is the rounded, heavy jaw; this and the long face recall the features of the 'Apollo' from the eastern akroteria at Epidaurus. The overall pose is repeated with little modification on the Telephos head, no. 16, although when viewed in profile it is clear that particularly as regards the structure of the head and its relation to the neck much work has yet to be done before the fully developed Tegean form is mastered.

Despite the copyist's addition of a support, there is no reason to suppose that the Los Angeles statue is a copy of an original bronze. Not only are there few projecting parts (the lion's skin acts as a support for the left arm, the club for the right) but the figure so closely resembles a Herakles on a Sicyonian coin of Geta (A21: PLATE 31d),[9] long suspected by scholars to depict Skopas' statue, that there can be little doubt that the Genzano-Hope type is in fact a copy of the work seen by Pausanias, and shows the hero with the Apples of the Hesperides after his gruelling period supporting the sky in place of the giant Atlas. It is clearly an early piece, although as an attempt at characterising physical exhaustion by no means unsuccessful. The turn of the head alone breaks the rigid frontality of the pose, which, as Linfert remarks, is unchiastic, with the result that the whole right side of the body 'hangs';[10] the work is obviously inspired by the original of the Herakles statuettes in Boston and Oxford, usually attributed to Myron.[11]

Unchiastic poses and references to the Severe style seem to have been in vogue during the early decades of the fourth century; the attitude of the feet of the Herakles (FIG. 6b) is virtually identical with the foot-

prints preserved on a series of bases of lost bronzes by the Argive-Sicyonian school, studied by Arnold. Perhaps the nearest is the Alektryon base from the Argive monument at Delphi, which she dates to c. 370–360 (FIG. 6c);[12] as far as preserved statues go, the Herakles clearly owes much to a type of Hermes known in many copies and ascribed by Arnold to Naukydes (cf. FIG. 6a),[13] but the affinities that are by far the most striking are clearly with the Athena Rospigliosi, as mentioned in the preceding Chapter.[14] Not only are the two very closely related in pose, but (in a rather unsophisticated bid to increase the three-dimensionality of the composition), each develops its full potential only when seen in three-quarter view; to some extent both pieces also suffer from a division of interest between the two sides of the statue.

However, the mood of the Herakles has undergone a subtle change; he is calmer, less restless than the Athena, whose emotion seems rather overstated, at least in the Uffizi copy. At this point the mediocre quality of the Los Angeles statue lets us down, but to judge from the Genzano herm the mood was one of heroic endurance, by which the sculptor, seeking to enlist the sympathy of the observer, strove to create an atmosphere around the statue and to draw him into it —a radical departure from the practice of the fifth century, apparently pioneered by certain sculptors (Naukydes and Timotheos in particular ?) working in the context of the Rich style in the early decades of the fourth. Yet for all this there is a tentative air about the figure which cannot be denied and which stamps it as an early work, perhaps carved only a year or two after the Athena, that is, c. 370 or even earlier; at this point Skopas would have been about twenty or twenty-five years old.

THE MAENAD

It seems quite clear that, however it may be restored, the Dresden maenad is a copy, albeit simplified and on a reduced scale, of that Maenad of Skopas[15] which is given such fulsome treatment by our authorities, Kallistratos in particular (B1: PLATE 32).[16] The connection was established over sixty years ago by Treu and Neugebauer, and to my mind has yet to be seriously challenged.

As both scholars saw, the facial type is closely related to no. 16 from Tegea (cf. PLATES 13 and 32d);[17] influence from Timotheos' Leda (PLATE 25d) is strong. However, several features like the lack of breadth in the lower part of the face (similar here to no. 17 and the Leda), and the comparatively small eyes,

whose lids are not covered completely by the fleshy orbitals, suggest that she reflects an earlier stage in the development of the style. This is supported by the height of the girdle, which places the piece well before the Tegean akroteria. The neck is massive and shows two creases in the skin; the chin is separated from it by a sharp cut, in violation of the laws of anatomy.[18] The body is softly and amply modelled, as one would expect, although muscles and joints are articulated with great power, as a glance at the shoulder, thigh and knee that are revealed by the drapery will show (PLATE 32c). The hair of the original seems to have been deeply drilled, as is that of the akroterion head, no. 4, and the drapery, especially over the right thigh, fits well with nos. 1 and 3. *Pace* Six and Lorenz, the copy corresponds well enough with Kallistratos' description, and confirms the original as indubitably Skopaic.

The movement is both the archetype and the most extreme example of that double twist ventured in the Introduction as the thread holding together the main series of Skopaic works (cf. FIG. 1). It is perhaps time that this were elaborated upon and 'Skopaic *contrapposto*' defined.[19]

Despite the apparent freedom of the movement, the figure itself remains fairly tightly (but at first not rigidly) enclosed within the boundaries of the block, and is held together by a strong central axis, so that the eye follows the twist of the body, moving from the foot of the 'free' left leg to the hips and across to the lowered shoulder, as if it were rising in a slow spiral across the curved face of a half or quarter cylinder (FIG. 1). However, just as the spectator reaches the point where he would begin to move round the back of the figure, the composition is closed, by the lowered arm and by the drapery (PLATE 32a), and the eye led back again along the rising diagonal of the shoulders to the head, where it rests for a moment before being carried out beyond the statue into its surroundings by the direction of the gaze. Thus, the sculptor deliberately avoids the spirally rotated pose, preferring instead a fairly restricted range of viewpoints and a latent three-dimensionality, where the idea of the sculpture existing as an autonomous construction in space is stimulated in the mind of the spectator without actually being made explicit. The work concerned remains something apart from him and preserves as a result much of the 'aloofness' distinctive of earlier phases of Greek art.

This variety of *contrapposto* seems unique to Skopas, and appears to have remained a hallmark of his works until the end of his career, though passing through several stages of development in the meantime. Of course, this is not to say that his style, once formed, immediately fell into a rut from which it never subsequently departed. The keynotes are stability and discipline, not sterility; like the great Renaissance artists, those of the fourth century were able to obtain an amazing range of effects from a formal vocabulary that was really quite limited in its scope, thereby successfully avoiding the trap of the restless seeking after novelty which did so much to dissipate and exhaust the energies of the Hellenistic schools.

To me, it seems fairly clear that the Maenad was intended to be related to a wall surface; even with the missing right arm in place, when seen from the right side she looks ridiculously off balance.[20] The composition is closed by the drapery on this side (PLATE 32a), and we may perhaps be justified in assuming that the arm with the knife and the swirling folds of the dress provided a background which ensured that the spectator did not move beyond a profile view on the other (PLATE 32c). Between these two points, the synthesis of the various views, covering an angle of about eighty degrees, is fairly well managed, although the occasional hiatus does occur; the front in particular is rather unsatisfactory (PLATE 32a), especially the abrupt and rather clumsy turn of the head, and it is possible that the viewing angle should be restricted even further.

It is now the fashion to date the Maenad late in the fourth century: Fuchs puts her in the 340s, Arnold in the 320s.[21] Yet, as we shall see, this is difficult, if not impossible, to reconcile with the evidence.

Some inspiration for the pose may have come from the central akroterion of the west pediment at Epidaurus, NM 155,[22] but since it is impossible to know which way the head was turned we cannot tell whether simple axial rotation or a double twist (as here) was the aim of the sculptor. More striking is the very close connection between our figure and the corpses of the two youths that lay sprawled in the corners of the west pediment, especially the one from the right-hand corner (PLATE 27a).[23] The pose is a true double twist, although the head turns towards the lowered shoulder, and on the whole it seems not unlikely, considering that Skopas may have worked on the temple, that it was this piece which first sparked his interest in the possibilities offered by this kind of movement, apparently first pioneered in Athens towards the end of the fifth century. If so, since the effect of a wild, convulsive movement is successfully attained in the Maenad without making the twist at the waist inorganic (as did the sculptor of the youth),

we can perhaps hazard a further guess that she is in some ways a conscious correction of the latter, which thus becomes a *terminus post*.

A *terminus ante* must be the Amazon frieze of the Mausoleum (B4). As almost all commentators since Treu have recognised, the sculptor of the Amazon on slab 1014 clearly knew the Maenad; yet, surprisingly, some still date her after the Mausoleum, and most seem to have failed to draw the obvious conclusion: not that slabs 1013-15 are 'Skopaic'—the style of the heads proves that they definitely are not[24]—but that the *inspiration* for the figure is, in a general way, Skopaic (in fact Amazon 48 on slab 1012 [PLATES 34a, 36] is far closer). At any rate, the inference must be that the Maenad was carved around 360 or before. As Treu noticed, the Maenad Hauser type 30 (B3), which Fuchs sees as an interpolation into the Kallimachean series, reproduces the attitude of our figure very closely, though the drapery has clearly been altered to conform with the Kallimachean types.

A far more assured work than the Herakles, the Maenad must accordingly date from the late 360s; since the Maenads on the coins of Sicyon and the altar of Vibia Pytheas reflect a later type, perhaps of the early third century,[25] it is no longer possible to argue from them that the Skopaic version was made for Sicyon, even though the theory may remain an attractive one. She must be seen as the climax of Skopas' early period, and, if her later fame is anything to go by, was perhaps instrumental in establishing him as one of the foremost sculptors of his time in Greece. As many have observed, every aspect of the composition is tuned to expressing the frenzy of the Bacchic dance with a stark realism that could hardly have been bettered within the confines of the Classic idiom. The result is a work of near genius. Closely confined within the block, she seems to assault space rather than move through it, yet, sucked into the vortex of her movement, the spectator cannot help but partake mentally in the religious ecstasy she experiences. Although the Dresden copy does not lack eloquence, for the expression of the original we really have to take Kallistratos on trust: 'Looking at her face, we stand speechless.'[26] Perhaps it was because Skopas felt that he had reached his limit in this direction that the Maenad is in fact the most extreme example of the double twist that we possess; the vision now begins to turn inward, and the relation between sculpture and spectator is increasingly approached from a standpoint that is more psychological than physical, apparently in strong contrast to trends in some other schools of sculpture, especially that of Lysippos.

As we have seen it is to this period of Skopas' career that his commissions to design the Tegean temple and to work on the Mausoleum must belong.[27] The next Chapter is therefore devoted mainly to his work in Asia, which, though not necessarily continuous, must have occupied at least the decade from 360–350, and perhaps more.

Appendix

1. Skopas' *Aphrodite Pandemos* at Elis (Pausanias vi.25.1: Appendix 1, no. 3) is known in several copies on coins and mirror-cases (C1-6: PLATE 33a); variants appear on Hellenistic terracottas and reliefs (C7-10). She seems to have been Skopas' only work in bronze, though I doubt whether there is much significance in this: the group would have been virtually impossible in marble. Her himation was probably held up by her right hand and billowed above her head; Schlörb's suggestion that the type stems from the (diagonally posed) Nereids of the temple of Asklepios at Epidaurus (Schlörb, 59 n. 182; Crome pls. 6-9) is certainly attractive, but the copies disagree on the pose of the body, and in particular on which way the legs were turned.

Züchner's date of c. 375 for C3 (PLATE 33a) should perhaps be lowered 10 years or so (Schlörb, loc. cit.), especially if the Epidaurus sculptures are to be dated c. 380–370. A date c. 370 for the Pandemos is also suggested by the fact that Elis became engaged in a protracted war with the Arcadian League shortly after Leuctra, one of the battles even being fought within the city itself (Xenophon, *Hellenica* vii. 4.12-32; Hammond, *History of Greece*, 506; Larsen, *Greek Federal States*, 189-90); bitter civil strife complicated the situation even further, and the period was hardly an auspicious one for artistic activity in the city.

2. A relief depicting the *Apollo Palatine* (Pliny, *Naturalis Historia* xxxvi.25; Propertius ii.31: Appendix 1, nos. 6-8), installed by Augustus with the Leto of Kephisodotos II and the Artemis of Timotheos in 28 in the temple of Apollo Palatinus, has been recognised by Rizzo on the base of Augustus at Sorrento (D7: PLATE 33b). The statue is known in four copies (D1-4), and two versions (D5 and 6), none of which

preserves the head. It also appears on the coins of Augustus and Antoninus Pius (D8-11). (The bibliography in Appendix 4 refers.)

The stance seems to have been not dissimilar to that of the Herakles Lansdowne, though it is perhaps a little more rigid, with the right leg relaxed, the right arm extended (holding a patera: Rizzo, 64) and the head turned towards this side (cf. Becatti, *BullComm* 64 [1936], 25 fig. 2). The height of the girdle also suggests that the Skopaic Apollo was earlier than Euphranor's (dated to 'the latter part of the third quarter of the fourth century' by Thompson, *AE* 1953–54 (1961) 3, 43). The piece may thus have been carved around 360, and the style of the drapery seems firmly within the Attic-Ionic tradition. Certain details, like the fold bundle over the girdle and the lack of a true 'Steilfalte' over the free leg, are remarkable (Lippold, *Kopien*, 227; id., *Plastik*, 253).

The place of origin of the Apollo is fairly certain: Urlichs, finding an ' Aedem Apollinis Rhamnusii' in a late topography of Rome (Appendix 1, no. 8), suggested this as its original provenience (*Skopas, Leben und Werke*, 67, 70; cf. Rizzo, 57).

3. An Artemis in the Bracchio Nuovo (*SVM* i, 123-24 no. 108 and pls. 15, 21; PLATE 33c, d) has a head and body which do not belong together, although both have many features in common with the style under consideration. The head (PLATE 33d), apparently an original and a product of Skopas' workshop, is discussed further in Chapter 10; the body (PLATE 33c) conforms closely to the Skopaic double *contrapposto* of the Apollo Palatine and the Meleager (cf. Fig. 1). The stance seems far less relaxed than in the latter,

less even than in the Herakles Lansdowne, perhaps indicating a date c. 360 for the original. The type is otherwise preserved in a number of loosely related versions, investigated by L. Curtius in *Die Antike* 6 (1930), 97-98 figs. 7-9.

Pausanias (ix.17.1: Appendix 1, no. 12) tells us that Skopas made an Artemis Eukleia for Thebes, presumably before the city was razed in 335; however, since we have no more information about her it is impossible to say whether the Vatican type is a reflection of the Theban statue or not (cf. Lucian, *Lexiphanes* xii: Appendix 1, no. 40).

4. A herm in the Palazzo dei Conservatori (Guerre Puniche 9: Graef 1 and pl. 9; Preyss 18; Mustilli 15; Arias 5; Linfert Bi; Stuart-Jones, *PalCons*, 130-31 no. 7 and pl. 47: the bibliography in Appendix 4, A refers) is almost certainly a Skopaic Dionysos, and apparently the sole replica of its type. The hair is bound with a fillet and vine-wreath, and drill-holes across the brow mark the attachment of another fillet in metal. The arrangement of the locks across the brow is related to the scheme of the Los Angeles-Genzano type but differs from it in several respects: the hook-curls are more numerous and less varied, uniformly pointing away from a parting over the inner corner of the left eye where a hook-curl and an S-curl are opposed. On the whole, the expression is rather weaker than that of the Genzano head, but considering the change in subject and the absence of further copies, it would be unwise to press this very far. According to Pliny, *Naturalis Historia* xxxvi. 22 (Appendix 1, no. 17) a Dionysos of Skopas stood in Knidos, but with only a single herm to go on, any attribution would clearly be premature.

Chapter Eight

SKOPAS IN ASIA

THE MAUSOLEUM AT HALICARNASSUS

There seems no good reason to doubt that Skopas was employed on the Mausoleum, together with Leochares, Bryaxis and Timotheos. Not only are there the explicit statements of Pliny and Vitruvius to that effect,[1] but all four sculptors were known to have undertaken a considerable number of commissions in Asia,[2] presumably at about this time. There is also the circumstantial evidence of the Ada and Idreus relief from Tegea which, whatever its value for the chronology of the Tegean temple, definitely links a craftsman there (from Skopas' atelier ?) directly with the Mausoleum itself.[3]

The authorship of the friezes is a more difficult problem; while many scholars accept that deep differences in style, not merely in execution, are detectable in the Amazon frieze, Wace concludes that: 'A frieze like the Amazon frieze of the Mausoleum must have been conceived and designed by one brain', otherwise: 'Can we imagine harmony in the result? '[4]

Yet this is to ignore the extensive evidence from the ancient world that master-sculptors did work together in this way. Our best evidence comes from the rows of statues (anathemata)[5] erected at Delphi by the Spartans (405) and the Arcadians (c. 370) and from the temple of Asklepios at Epidaurus.

Several sculptors of first rank were employed on the anathemata, as we know both from Pausanias' descriptions and from inscriptions and literary references recording further works by them. The practice was simple: to arrange the statues in a row, each master taking two, three or four. Furthermore, acknowledged masters often collaborated on smaller groups, like Lysippos and Polykleitos (II or III ?) at Thebes[6] or Lysippos and Leochares at Delphi.[7] It is quite clear

that, in the ancient world at least, master sculptors could work together in harmony, whether upon a design furnished by one among their number, or by general agreement between them all, and no one seems to have complained of the result.[8]

And so, for the temple of Asklepios, Wace's statement that 'Timotheos, Hektoridas, Theo—, and the nameless contractor are merely men who undertook various portions of the sculptural decoration according to the designs furnished them by the master artist'[9] would be largely irrelevant to our problem were it not obvious that these men were creative artists in their own right. Whoever designed the architectural sculptures, it is clear that at each end of the building two distinct *styles* are juxtaposed, proving that, whatever the status of Timotheos and his companions, the Greeks were by no means as worried over the magic word 'harmony' as we are today,[10] and that rigid distinctions like that between 'master' and 'journeyman' have very little relevance to the ancient world. Whatever distinctions there were between sculptors surely depended more upon personalities and more or less competent craftsmanship than upon the place of the individual on any professional step-ladder.

We may thus affirm that there was no reason why the four sculptors should not have been assigned a side each, as Pliny and Vitruvius say, a conclusion that seems to be borne out by the material remains of the friezes, as was mentioned in Chapter 5. This, of course, involves no presuppositions as to the extent of their *personal* contributions to the carving of the reliefs. Since they would no doubt have been preoccupied with the free-standing sculpture, after sketching the designs of the friezes their supervision of their pupils and journeymen carvers may not have been all that

close. Evenness of style thus probably depended more upon close training of the ateliers than on personal intervention by the masters themselves. Certain fundamentals must have been agreed in advance, it is clear—like the height of the relief, the arms, armour and dress of the combatants, and perhaps even the composition at the corners, where the ateliers met; this leaves us with the modelling, the style of the heads, the proportions, the character of the movement of the figures, and the mood of each slab as a whole upon which to base our attributions. Here, the most compelling contribution towards a solution is Ashmole's.[11]

BM 1013-15,[12] newly completed by a fragment in Bodrum, are usually attributed to Skopas on the grounds that they show remarkable homogeneity in execution, considerable daring in conception, and were found on the east side. Yet, as many commentators have remarked, they were clearly not *in situ* (that is undisturbed exactly where they had fallen),[13] and their style does not agree with that of the Tegean sculptures (the heads are completely different, as Ashmole's photographs make clear, and as he points out, 'given that the subject is similar, nothing could be further from the rugged forms . . . of Tegea than these smooth muscles, calm features and rhythmic poses').[14]

Furthermore, the movement of the figures, often angular and rather affected, differs from what we have seen at Tegea. Although the Amazon in the centre of slab 1014 was probably inspired by the Maenad, that is a far cry from saying she is 'Skopaic'; the *contrapposto* is completely different and only a certain similarity of mood, visible in other slabs as well and possibly symptomatic of a growing Skopaic influence on sculpture in general, unites the two. Apart from this figure, only one other, her opponent, appears in a three-quarter pose, compared with the prevalence of this view at Tegea. Finally, the originality of the composition is no argument; not only is there no particular reason to assume that Skopas should have been markedly more original than Leochares or Bryaxis, but originality in itself is so subjective a criterion that on its own it can hardly stand against the powerful arguments adduced for rejecting the attribution.

In fact, the sequence which seems most directly to reflect the style we are seeking is BM 1011-12 (PLATES 34-39),[15] which, as far as I know, has never been attributed to Skopas in all the century or so that the frieze has been an object of scholarly study. Not only is the Amazon 1012.48 (PLATES 34a, 36) more

directly dependent upon the Maenad than her sister on slab 1014, but the heads are strikingly close to the Tegean types, especially to nos. 9 and 17; they are also similarly poised, as PLATES 35 and 38 show. As a further clue, the hairline of the Amazon 1012.51 (PLATE 39a) describes the same ogival curve as is found on other Skopaic female heads (PLATES 4a, 32d, 33d, 46a, and cf. PLATE 45c). The figures seem similarly proportioned, and the three-dimensionality of the group 1012.47-9 is unparalleled elsewhere in the friezes.

However, it is also clear that they are at a slightly earlier stage in the development—the modelling of 1012.50 for instance, may indeed be very like that of no. 9 and her hairstyle similar to no. 4, but the face has not yet attained the compression of the Tegean pieces (cf. PLATE 38). The same is true of the body forms, as far as the weathering allows us to judge; the shoulder of 1012.47 (PLATE 34b), though more richly modelled, has much the same degree of stress in it as a leg fragment from the east pediment of the temple of Asklepios and the arm Dugas 28 (PLATE 20a, b) from Tegea discussed in Chapter 4. Compared with a piece of similar style from the same pediment of the temple of Asklepios, now in Athens,[16] the torso is slightly fuller and more rounded, but even here the twist at the waist is still inorganic (PLATE 37a) and the movement still slightly jagged and abrupt. The body of 1012.50 (PLATE 37b) is closer to the Tegean pieces, especially no. 26, though still not quite as rich. At Tegea, we see the style completing, here embarking upon a transition.

To return for a moment to the inorganic waist and dilated chest of 1012.47 (PLATE 37a): it is strange that the atelier of Skopas was still using this device, characteristic of the art of late fifth and early fourth century Athens and found several times at Epidaurus around 380–70, when the workshops of the other three sculptors had apparently already abandoned it as outdated (see, in general, Chapter 6).[17] Skopas' debt to Athenian art of the late fifth century for certain features of his style has already become apparent in the discussion of the Tegea sculptures and the Maenad; to this growing body of evidence is now added not only 1012.47 but also a magnificent study of a warrior from a mould in Corinth,[18] apparently Athenian inspired and quite closely related to the Tegea heads, whose waist is dislocated and chest distended in a similar manner. From these and other aspects of his work we may perhaps draw the general conclusion that Skopas was not as markedly avant-garde and independent of the general

artistic currents of his time as is sometimes claimed.

Of the three series from the Amazon frieze which Ashmole discusses, the nearest in style to our slabs is the long sequence BM 1007-8-10 (PLATES 40-41),[19] recently recomposed by him. The figures are more or less the same height, the proportions are close, and the head and richly modelled torso of 1007.38 (PLATE 41a), the back of 1010.14 (PLATE 41c), and the head of the Amazon 1007-8.41 (PLATE 41b) are very Skopaic in character. This last is quite closely related to the akroterion head, Tegea no. 4, although the treatment of the eye is more extreme—close, in fact, to no. 16; the apparent puffiness of the flesh may be a trick of the weathering, as on no. 16 itself. Two of the other heads (1007.39 and 1010.14) have a distinctly out-thrust jaw, though here the rest of the face is incomplete or missing. The convulsive jerk of the head of the Amazon 1008.44 finds its counterpart in 1012.48, and nowhere else on the extant friezes. Finally, the mood of the two sequences seems more or less the same; the struggle is pursued with grim determination, at times verging on brutality, in contrast to the wildness and speed of the action, frequently enlivened with decorative touches, in the series centred upon 1020-1, and the 'slight air of the ballet'[20] that accompanies the rather academically styled sequence 1013-15.

As Ashmole has noted, 1008-10 must be the centre-piece of one of the sides. Not only is it very long—over nine feet—but the tooling of the back[21] (uniquely, two *vertical* bands of smooth tooling appear) and the personalities depicted proclaim it to be so. The left hand side shows Herakles killing an Amazon, the right Theseus parrying another.[22] The only occasion when these two were together in a fight against the Amazons was in the Themiskyra expedition, when Herakles took the girdle from Hippolyte; in sculpture, the scene was shown on the throne of Zeus at Olympia[23] and apparently also at Bassae.[24] Hippolyte's axe was dedicated at Labranda, one of the three great shrines of Mylasa, ancient capital of Caria, in the temple of Zeus Stratios.[25] From this one would naturally expect that the story would stand high in local esteem, and its appearance on the Mausoleum comes as no surprise, but I think it is possible to go even further.

When Maussolos created Halicarnassus by *synoecismos* and moved his capital there from Mylasa in the 360s,[26] he paid great attention to Zeus Stratios.[27] Not only did he take upon himself the rebuilding of the sanctuary at Labranda, but he appears in addition to have commissioned a modernised version of the ancient cult image of the God, holding the famous axe, or rather a replica of it, to stand at Halicarnassus—one that gets pride of place on his coins and those of his successors and reappears, flanked by Idreus and Ada, on the votive relief fround at Tegea and now in the British Museum. In the words of G. E. Bean, with Maussolos 'the cult of Zeus Stratios was raised to an importance which it never afterwards lost'.[28] In the face of this impressive testimony as to his regard for the God, it would indeed be remarkable if the slab portraying the origin of his characteristic and exotic attribute did not have pride of place among the Amazonomachies ringing the podium of Maussolos' tomb. In other words, it would seem that, on iconographical grounds alone, there is a strong case for restoring the sequence BM 1007-8-10 in the centre of the east side of the Mausoleum, opposite to the propylon of the precinct, apparently left incomplete after Maussolos' death.[29]

These two long sequences, although battered, are of fairly even workmanship and relatively high quality, and show considerable originality in both design and execution. The motif of the Greek to the left of 1007, who pulls his spear from the body of a prostrate Amazon while under fire from a third is, to my knowledge, unique, and the pose of the adversary of 1007-8.41 is so complicated that with much of the surface gone the exact details of the action are very difficult indeed to make out.[30] Three-quarter poses are used whenever possible, and bodies and even whole groups twist and turn in space in the violence of their conflict. Neither designer nor carver seeks to spare us the horrors of war: the warrior has trouble extracting his spear from the corpse of his foe, Hippolyte is clubbed to death by a pitiless Herakles, and one of her compatriots is kicked to the ground by a Greek, who then knocks her senseless with his shield as he charges her companion. Although the anonymity of the Amazonomachy is a far cry from the rich characterisation of the Calydonian hunt, the sixteen surviving figures on these four slabs at least give us some picture, however blurred it may be, of what has been lost at Tegea.

The sculptures in the round are currently being prepared for publication by Dr. G. B. Waywell, and I am indebted to him for the following account:

> It is clear from Newton's accounts that very little sculpture at all came to light on the east side, and that which did was probably not *in situ*. The only pieces which can definitely be said to have been found in an eastish direction are:—BM 1047, colossal seated figure.[31] Found on the east side of the quadrangle—i.e. within the rock-cut foundations (which had been largely robbed by

the knights) and therefore not *in situ*. The colossal male (?) figure MRG 39, Reg. no. 57.12-20.236 was found at the east end of the north side.[32] A colossal left hand and two fragmentary forearms were sent home in crate 203, and so were presumably from the east side. And from crate 285, I have identified part of a statue base with the forepart of a bare left foot on it, MRG 74. The fragment of a draped colossal figure mentioned in the inventory for crate 285 cannot, I am afraid, be identified. There are a number of such fragments, but none bears the number 285 in red. Several simply carry the initials C.T.N., and no doubt the fragment in question is one of these.

Stylistically, there is virtually nothing among the free-standing sculpture which compares with Tegea;[33] the head of the Persian, BM 1057[34] from the north side has a fairly forceful expression, and the head BM 1056 (PLATE 41d) from the south side has already been compared with Tegea no. 18. However, it is clear that just as in the friezes (apart from slabs 1007-8-10 and 1011-12), this only reflects general Skopaic influence among the carvers (and to judge from the multiplicity of the styles that appear from the pieces found *in situ* on the north side,[35] these were both numerous and loosely controlled); unless more evidence comes to light, seeking for Skopas among the free-standing sculptures from the Mausoleum seems hopeless from the start.

The Mausoleum must have engaged the activities of a very large number of sculptors from all parts of Greece and Asia for a considerable time, and it is exceedingly tempting to see it as the point where Skopas' style, or at least those aspects of it that were communicable, began to modify the styles of his contemporaries; at any rate, as Chapter 10 will show, 'Skopaic' intensity in heads of quite different stylistic circles begins to appear from c. 350 onwards.

THE HERAKLES LANSDOWNE

Although both Graef and Furtwängler were emphatic that the statue of Herakles then in Lansdowne House (E1: PLATE 42a-c) had no connection with the Genzano type (A1, 3: PLATES 30-31) the two types have since become conflated, despite the lack of a wreath in the former, and serious discrepancies in the proportions (see especially Appendix 5), the structure of the head and the treatment of the hair and eyes.[36] The Lansdowne statue, furthermore, does not agree with the figure on the Sicyonian coin (A21: PLATE 31d). Few direct copies of it in fact exist,

although the considerable number of eclectic types dependent upon it and the Los Angeles statue have confused the issue enormously in recent years.[37]

Its proximity to the Tegean sculptures has long been recognised (cf. PLATE 52).[38] Compared with the Sicyon type, the features are more compact, the expression more intense, the face is broadening; however, the emphasis on the plane of the cheeks and jawbone has yet to succeed in transforming the facial outline from a closed oval to the more angular and open form of the most advanced of the Tegean heads. The eyes are more deep-set than those of the Genzano head, and the upper lids are now sagging quite far over their outer corners; the lower lid is deeper. The heavy nose and undulant, firm-set mouth are distinctive, and there is a tenseness in the upper lip and quadratus muscle that does not seem to have been present in the earlier work. The hair has lost much of its stylisation, especially at the front, although the parting remains above the right eye and the treatment of the individual strands is the same. The ear is cauliflowered similarly to that of no. 16 from Tegea (PLATE 52c, nos. 2, 5). Seen in profile, the head is squarer, more compact, and set more firmly on the neck.[39]

The body has long been a puzzle to scholars. Neugebauer even went so far as to declare that its severe formalism was stylistically in contradiction to the head. Arnold, whose recent study shows a fine eye for the niceties of Polykleitan style, gives an altogether more convincing and reasonable interpretation:

> It should hardly be necessary to re-establish the attribution of the Herakles Lansdowne to Skopas or to set out in detail what divides it from the works of the Polykleitan school. Indeed, in the Herakles the body is interpreted in a totally different manner from that adopted by Polykleitos' followers. The body is not built up from an organic arrangement of separate parts, each in definite relationship to the next, but comprehended as a single, heavy mass.[40]

In fact, for what appears to be the first time, a sculptor working outside the Polykleitan tradition felt able to make use of Polykleitan stance and *contrapposto* while remaining completely independent of the Polykleitan style itself. Arnold's belief that Skopas took as his model the Herakles of Antiphanes,[41] apparently preserved on a gem in the Ramsay collection, is an alluring one, fitting in well with our impressions of the formation of Skopas' style hitherto—anxious to learn what could be learnt from already established artists, he seems to have been well able to avoid coming under

the dominance of any of them (the reason why he is given no 'master' in the sources ?), while forging a new, independent style of his own in the meanwhile.

Naukydes' Diskobolos had earlier combined the turn of the head towards the 'free' side with the placing of the flexed arm on this side as in the Doryphoros;[42] yet despite what Arnold calls 'die den Athleten umgebende reich differenzierte Atmosphäre der Palästra',[43] the lowered head and the concentration of the athlete upon his task ensured that the figure remained a closed entity in space. By turning instead to the proudly erect head of Antiphanes' Herakles, Skopas was able to unlock the classical *contrapposto* completely for the first time. Thus, chiastic balance between tensed and relaxed limbs is retained, while the contrast between the two sides of the work ceases to be a cause of dissatisfaction and unease as on the Los Angeles Herakles (PLATE 31a, b), since here the figure is able to unfold, as it were, from a secure anchorage in the severe combination of verticals on the engaged side, out towards the observer (FIG. 1), and the actions of body and head now complement each other. Furthermore, the sculptor has abandoned the rigid frontality of the earlier piece, with its axis dividing the body in two like a ramrod, for a slight twist in the hips and torso and a more sinuous S-curve that are only really appreciable when the spectator moves around to his right to look at the head frontally (PLATE 42b).[44]

In the Herakles, we see the application of the Skopaic double *contrapposto* to the standing male nude for the first time. That the very nature of the subject makes this a more difficult task than in the case of the Maenad is obvious. The twist is still quite small and the number of really satisfactory viewpoints still limited to two (PLATE 42a, b), though more closely integrated through the action of the body than in the Sicyon Herakles. The spatial extension of the work outside the block is likewise fairly restricted, in fact to the out-thrust forearm only (compare the earlier Herakles and the Maenad, PLATES 31 and 32), since the left leg, though emphasising the opening of this side out into space, does not actually extend beyond the natural limits of the block.

There is nothing quite like the Herakles Lansdowne in ancient sculpture; as for more recent times, I suppose that, if anything, Michaelangelo's 'David' comes closest to it in mood, but perhaps the similarities are more superficial than deep-seated. As a work of art, just as the monumental simplicity of the composition tends to belie the complexity of its origins, there is more depth to the hero's personality than may at first be imagined. At first sight the figure seems to impose itself upon the observer in a truly heroic manner, yet below the veneer of the young hero's triumphant poise and perfect physique there is more than a hint of a tragedy that underlies the labours and the terrible and crushing burdens that are to come. Even so, the emotion is still unfocused, the pathos no more than a 'vague disquiet',[45] and the spectator's part in the composition still small, though it is growing; the sculptor has mastered his heritage, and the character of the hero and his response to the burdens placed upon him now emerges as his overriding concern. Yet, as with the Tegea heads, the question must be asked: how far can such individualism be taken and the statue still retain its classic timelessness? Clearly if a line could be drawn, the Herakles would be on the right side of it; the Meleager presents an altogether more difficult problem, which must be deferred until the next chapter.

The date of the Herakles is hardly in doubt;[46] almost all authorities date it to the 350s by analogy with the Knidia and the Athenian record reliefs.[47] Hair style, stance and proportions indicate a date perhaps ten or fifteen years later than the Sicyon statue (PLATES 30-1), and facial type one a little before the head no. 9 from Tegea; the proportions of the body are approaching those of the Tegea figures, and the physique has a strong suppleness about it which the earlier type lacks. The statue is copied on a *parastas* in Athens and a Kerch style pelike in the Hermitage[48] (E8, 9: detail, PLATE 42d), which more or less confirms that it stood in Athens. No ancient authority refers to it, but it could have been a private commission perhaps executed by Skopas on a visit to Athens from Halicarnassus;[49] at any rate, although we are compelled to argue its attribution to Skopas on the grounds of probability alone, there seems little doubt that the whole character of the work is perfectly in tune with the development of the personality we have reconstructed so far from the Tegea sculptures and the Sicyon Herakles.

SEA THIASOS

The Triton Grimani in Berlin (PLATE 43a, c)[50] has been strangely ignored in the literature devoted to Skopas. Dated to the Hellenistic period until Neugebauer restored it to its rightful place as a fourth century original, its importance has otherwise been recognised only by Picard and Arias, although its similarity in many respects to the Tegea sculptures is immediately striking.

Its state of preservation, particularly as regards the head, is poor. The nose, chin, and much of the hair have been restored, and the cheeks and jaw reworked; from the traces of the original surface, only slightly weathered, near the nose and mouth, it is clear that the modelling was once much stronger and the face considerably fuller than appears today. The restoration of the nose underestimates its thickness, especially at the bridge, and the hair and facial features in general have suffered considerably from the weather. A certain dryness which appears in the modelling of the torso seems largely due to the effects of weathering.

It is fairly clear that the figure was meant to be viewed from a distance, that the surface on which it stands is original, that it may have undergone repair in antiquity, and that it may have been part of a pedimental group, most of the upper part of the back having been cut flat.[51]

As PLATE 43a shows, the head is clearly modelled to be seen from below, and the jaw and cheek, now near to transforming the facial structure from the oval form dominant hitherto, are already startlingly similar to the heads nos. 16 and 23 from Tegea. Neugebauer has already noted the similarity of the face as a whole to the Tegea heads: 'Wenn aber Wangen und Kinn auch nur um ein Weniges voller und gerundeter war als jetzt.'[52] In fact, the amount that these areas have been reworked seems sufficient to account for the disparity, and the proportions of the head in its original condition would seem to me to fall somewhere in between those of Tegea no. 17 and the 'Telephos' head, no. 16. The modelling of the mouth is close to no. 22, of the brow to no. 18, and the hair to the Maenad (PLATE 32) and the female head from the akroteria, no. 4, although the drilling technique of the latter is more advanced.

The eyes, as Neugebauer remarks, are smaller than those of the Tegea heads. Yet the eyes of the Maenad are smaller still, and the Triton's themselves are very similar to the eyes of the Herakles from Tegea (PLATE 47a), and to those of the Genzano herm (PLATE 52b, no. 4). The lids sag slightly over the outer corners, about as far as do those of the warrior head from Tegea, no. 18. Furthermore, considering the unevenness of some of the work at Tegea, we ought not to be too surprised at the occasional failure to conform strictly to the 'Skopaic norm'; indeed, the head of the Triton is much closer to it than is no. 18 itself.

The body is powerful and muscular; the neck has the massive sterno-cleido-mastoids associated with the style of Skopas, and the modelling of the left shoulder in particular seems close to Tegea no. 12. The form of the abdomen recalls BM 1012.50 (PLATE 37b) and no. 26 from Tegea, although the modelling of the latter is rather richer. The high rectangle of the lower boundary of the rib cage and the layout of the thorax in general are strongly reminiscent of the Los Angeles Herakles (PLATE 31a), and are copied in a Triton in London from an interior frieze of the so-called Monument of the Bulls at Delos,[53] dated to c. 300, and two Roman Tritons in the Vatican.[54]

The Triton is not an easy work to assess; it is clearly not first class carving by any means, although as part of a large decorative ensemble it would have worked well enough. The forms and movement of the body seem less elastic than at Tegea, and solidity and stability seem to have been the aim of the carver. The *contrapposto* shows the double twist of the Maenad and Herakles Lansdowne (PLATES 32, 42), which confirms the existence of the figure as an entity in space without compelling the spectator to adopt more than a very limited range of viewpoints. Thus the work not only relates easily to a wall-surface behind (in this case a tympanon ?) but the sculptor avoids the pitfall inherent in simple axial rotation, that a figure designed for viewing from all angles ultimately tends to be fully satisfactory from none.

The pose of the Triton can be traced back to a figure from the west pediment at Epidaurus, NM 4752. Facial expression is sought by means identical to those employed at Tegea, though the effect is much falsified by the damage to the face. It is, however, safe to say that the overall result was rather weaker than in the majority of the Tegea heads. Neugebauer was certainly right in seeing in it close resemblances to Timotheos' Leda,[55] (PLATE 25d), perhaps carved c. 360, which prompts the conclusion that when the Triton was produced, some members of the atelier of Skopas were still under strong influence from that sculptor; the same carvers may even have worked for both on some occasions.

The Triton should perhaps be dated to the 350s, and to ascribe it to the great Sea Thiasos brought to Rome by Domitius Ahenobarbus and so praised by Pliny is exceedingly tempting, not least because the Thiasos is presumed to have been made in Asia, and Skopas was in Asia at the time.[56] The composition, so Pliny tells us, involved 'Poseidon himself, Thetis and Achilles, Nereids on dolphins, κῆτοι or hippocamps, Tritons, the chorus of Phorcus, pistrices and many other sea-creatures, all by the same hand',[57] and stood

in his day in the Circus Flaminius. The correctness of the attribution thus depends wholly on the findspot of the statue, and here the evidence is inconclusive—though there are a number of tenuous clues.

The Triton could have been acquired by Cardinal Domenico Grimani in Rome in the early sixteenth century, or by his nephew, Bishop Giovanni Grimani of Aquileia, in Italy in the late sixteenth century.[58] It is not recorded in any of the various inventories of the family effects, though this is not particularly significant, since none of these was more than partial; the two colossal statues of Agrippa and Augustus,[59] acquired before 1520 and reportedly from the Pantheon, equally escaped inclusion in the lists. Little or no weight should be placed upon an eighteenth century description of the Grimani palace in Venice,[60] where the Triton is mentioned, together with a female statue, a colossal torso of a 'guerriero' and a torso of a water-nymph, all standing upon 'urns' (probably altars or cippi) from Aquileia by the loggia containing the Agrippa statue. This by no means certifies the Triton as one of the many Greek originals from the East bought in Italy by Giovanni Grimani in the latter part of the century, for not only is the 'guerriero' mentioned in the inventory of 1523,[61] but Giovanni's brother, Marino,[62] Domenico's first heir, also bishop of Aquileia and a keen collector, could equally well have added the 'urns' to the collection before his own death in 1546. That the Triton was placed close to the Agrippa statue, which certainly came from Rome early in the century, and to the 'guerriero', which may also have come from there at the same time, perhaps supports to some degree the earlier date for its acquisition.

Less involved and certainly potentially more decisive is Sir Kenneth Clark's opinion that the Triton 'looks unbelievably Giorgionesque, and must have been known to Venetian artists of the early sixteenth century'.[63] Though hardly capable of proof in absolute terms, if this were true it would establish a Roman provenience for the statue beyond any reasonable doubt. Clark does not amplify his statement, but a number of paintings of the period do seem to support it; most strikingly similar are the copies of Gorgione's own self-portrait in Budapest and Brunswick attributed to Palma Vecchio (in Venice from 1510 until his death in 1528) and the St. Sebastian from a picture by Domenico Mancini (a close follower of Giorgione, active between c. 1510 and 1520) now in the Louvre.[64]

With this in mind, since the piece reflects the style of Skopas so closely, and is very similar indeed in action and mood to three or four other statues which have long been thought to copy Skopas' work, we may perhaps be justified in expressing a guarded optimism that our Triton is in fact the sole survivor of that magnificent group, brought from the East by Ahenobarbus to grace the Circus Flaminius.

The best of the supposed copies from the group is the little Nereid from Ostia (PLATE 43b, d).[65] Her almost mask-like face is nearly identical in structure to that of the Triton and again very reminiscent of the Leda (PLATE 25d), and the eyes show an advance on the Maenad, though (if the copyist is to be trusted) the lids hardly sag over them at all. The hair strongly recalls that of the Maenad, and as with her, it is the pose (the canonical double twist) which seems to be doing most towards producing that impression of ecstasy which is the most salient feature of the work; there seems no reason to assume much exaggeration by the copyist here, especially since the face has apparently not been tampered with. The body forms are almost as full and rich as those of the Tegean akroteria.

The similarity of the piece to the Maenad suggests a date within the decade 360–350 for the original,[66] and supports the conclusions arrived at with regard to the Triton.

If we are to believe Pliny, work on the Mausoleum continued into the 340s;[67] Skopas' other commissions in Asia may have been executed at about this time, but we have no means of telling for sure.[68] At any rate, it seems likely that he was back in Greece (at Tegea ?) shortly after 350, as the next chapter will show.

Appendix

1. The Alba Youth (NyC 400; *EA* 1789–92; Bulle, B-B 649; Pfuhl, *JdI* 43 (1928), 36-39 figs. 12, 13; Vagn Poulsen, *Griechische Kunst* [1962] fig. 79) has generally been accepted as Skopaic since Bulle's publication in 1912; Lippold alone prefers to ascribe it to Timotheos (*Plastik*, 221). Clemmensen (Dugas, 80 n. 1) could not make up his mind whether it belonged to the Tegean pediments or not.

I was able to examine it thoroughly in August 1971, and came to the conclusion that its provenience, marble, scale and technique (the large plinth and many *Ansätze* in particular) exclude this as a possibil-

ity; I am indebted to Dr. Mogens Gjødesen, director of the Glyptotek, for further information that has done much to strengthen my opinion concerning the first three of these points.

Firstly, the statue was almost certainly found in Italy—it was bought there by the 14th Duke of Alba between 1814 and 1823, and although nothing is known of the previous history of the individual items in the collection, all were acquired in Italy. Since the antiquities trade from Greece to Italy was virtually nonexistent at this time, it can safely be assumed that Tegea was not its place of origin. Secondly, the marble does not seem to be from the Dolianà quarries; not only does it lack the bluish tinge of most of the fragments, but it is also finer-grained. It could perhaps be Parian, but to settle the question a sample, kindly provided by the Glyptotek, is at present in the hands of Dr. H. Craig for C^{13}/O^{18} analysis. Finally, the statue is rather smaller in scale than the figures from the east pediment at Tegea, as the following measurements make clear:

Youth, NyC 400		Tegea East
Neck	W.0.130	0.145 (no. 9)
	C. 0.390	0.450 (no. 9)
Waist	C. 0.740	0.875 (no. 13)
Navel to pubic hair	L. 0.115	0.132 (no. 14)
Navel to below pubis	L. 0.195	0.220 (no. 14)
'Standing height'	c.1.46	c.1.65 (nos. 9-15)

To me, its kinship with the Tegea style is not particularly striking. The modelling nowhere approaches the power of, e.g., nos. 14 and 26, and there is virtually no emphasis on the joints—a characteristic of the Skopaic style from the beginning, even in female figures like the Maenad (PLATE 32). The youth of the boy warrior (a Niobid ?) thus seems no argument for the absence of the usual Skopaic clarity of articulation.

In fact, the most striking parallel to the Alba figure is Dexileos' adversary on his tombstone of 394/3, as Poulsen's excellent photographs make clear. Not only is the drapery over the left arms of the figures very similar, but the abdominal musculature, treatment of the waist and thorax, and most important, the proportions of the two almost exactly coincide. Severe weathering may account for much of the apparent hardness of the musculature of the warrior on the stele, though perhaps the slightly richer modelling of the youth, especially around the chest, abdomen and thighs, should place him somewhat later, say in the 380s.

2. In *JdI* 74(1959), 158-63 figs. 1-4, Bielefeld publishes a male head in Magdeburg under the title of 'Ein Skopasisches Meisterwerk'. His conclusion that it is a copy of a lost work by Skopas of c. 360–350 has been challenged by Arnold, 239-40, who believes it to be Lysippic and dates it to the 360s, and Ashmole, *EncWA* s.v. 'Skopas', 60-61, who sees a resemblance to Naukydes' Diskobolos.

There is a certain amount in it that is Skopaic, but the eyes, with their sharp brows, no bulge over the outer corner, and shallow lower lids, are very far from those of the Lansdowne Herakles (PLATE 52b), with which Bielefeld compares the piece. The face is also narrower and more rounded, in the manner of the Ilissos youth (PLATE 49a) rather than of the Herakles. In profile, however, the proportions follow those of the Herakles (cf. B-B 692).

The head should thus perhaps be assigned to a sculptor working under the influence of Skopas, perhaps in the decade 360–350, but more likely sometime shortly after the middle of the century, considering the date of the Herakles (c. 355 ?). It is perhaps worth noting that if its author was connected with the Polykleitan school, as on the face of it seems likely, it was at about this time that bronzes in the Peloponnesian style —for example the bronze statuette of an athlete in Paris and the rather later Anticythera 'Perseus' (Arnold pls. 21b, 27c)—began increasingly to show the impact of Skopas' innovations in the field of facial expression.

3. A head of a youth (? Herakles) in the NyCarlsberg (*EA* 1373-74, 4577-78; *Billedtavler* pl. 24 no. 365) was seen by Schweitzer as a work of the late second or early first centuries B.C., eclectically dependant upon early Skopaic types, and especially upon the Herakles Lansdowne (*ÖJh* 39 [1952], 101-11, figs. 41-44). The eyes have much that is Skopaic in them, it is true, and the modelling of the forehead follows no. 18 from Tegea; the pattern of the hair in the centre recalls the simplified scheme of some of the (poorer) Meleager copies (cf. F42, 43: *RM* 76 [1969], pls. 76 and 77, 2).

Yet in the dry, almost starved modelling, the proportions of the face (in particular, the length of the central part from eyes to mouth), and the fairly small, tightly curved chin, the piece seems to go its own way. Perhaps related in style and approach is the very youthful version of the head of the Meleager in the Terme (F42); the outline and proportions of the face recall those of the Herakles from the double herm recently published by von Heintze (*RM* 73-74 [1966-67], 251-55 and pls. 90-91).

4. Skopas' controversial appearance at Ephesus to carve one of the *columnae caelatae* there (Pliny, *Naturalis Historia* xxxvi.95: Appendix 1, no. 33), has already received a brief mention in the Introduction. None of the surviving fragments seem really close stylistically to the Tegea pediments: BM 1206 is weak, at least in comparison with anything at Tegea, and seems to be eclectic in style. The Hermes may be in the manner of the Polykleitan school in its final stages (Arnold, 215 and pl. 28b; *contra*, von Steuben, *Gnomon* 1972, 815), and the head of the 'Thanatos' so strongly recalls a head from a grave monument in the Kerameikos (Ker. 4134: Riemann, *Kerameikos* ii pl. 12; cf. Lawrence, *GRS* pl. 55) that it is safe to assume that this sculptor, at least, was an Athenian. Ashmole believes that BM 1214 is more Skopaic (*EncWA*, s.v. 'Skopas', 59; cf.

Bammer, *Die Architektur des jüngeren Artemisions von Ephesos* [1972] pl. 7f.). True, the body forms here are softer and more rounded, and the heads, like the new fragment recently found by the Austrians (Bammer, *AA* 1968, 406 figs. 8a, b; Dohrn, *AP* 8 [1968], 44 and figs. 20-22) recall no. 18 from Tegea, especially in the modelling of the eyes and forehead, but considered as a whole their style is so close to that of Hyde's 'Philandridas' head at Olympia (W. W. Hyde, *Olympic Victor Monuments and Greek Athletic Art* [1921], Frontispiece and 293 fig. 69; von Buttlar, *Griechische Köpfe* pls. 74-75; Dohrn, loc. cit. and figs. 17-19), normally considered to be 'Lysippic', that I am inclined to believe that the group stands somewhere between the two major trends, drawing eclectically upon both for its inspiration.

Chapter Nine

LATE WORKS

TEGEA; SKOPAS AND PRAXITELES

The Tegean sculptures must belong in the decade 350–340, as we have seen. Since the figures are so fragmentary, it is exceedingly difficult to connect up the movement of any of them with the development so far followed in Skopas' free-standing statues. All of the pedimental heads seem to have been turned to the raised shoulder, as the Skopaic double *contrapposto* requires, but really only the akroteria are complete enough for proper comparison; here, though, the movement—the torsion of the figure and the lowering of the shoulder on the 'open' side—is dictated by the requirements of their setting and purpose. To judge from the modelling of the body and the heads, however, it is clear that Skopas' style is in the process of emerging from a period of profound change.

In general, the sculptor seems less and less to need extreme muscular tension and strain to express what he has to say, a development perhaps already prefigured to some extent in the Herakles Lansdowne (PLATE 42) and the recoiling Greek on BM 1012 (PLATES 34a, 37b). An easier, more supple style has come to the fore, concerning itself with mass and volume, vigorous yet rhythmic movement and a rich, warm surface texture. At this distance the reasons for these changes are very difficult to assess—one is tempted to refer to the 'persistent parallelism' with Praxiteles in the sources, and on the whole it seems not unlikely that the two may have met in Asia around the middle of the century. They both worked in Knidos,[1] and there is certainly some evidence at least to suggest that Praxiteles was influenced by Skopas' style; not only does the Aberdeen head (an original in Praxiteles' style, if not by his own hand?) have a dis-

tinctly 'Skopaic' look about his eyes—although their actual structure is completely un-Skopaic—but the piece also seems to owe something to Skopas' style in both proportions and surface modelling as well, as PLATE 46 shows.[2] The 'Praxitelean' character of the Pothos (PLATE 45) has long been remarked upon.

THE 'MELEAGER'

Despite doubts by some scholars,[3] it seems fairly clear that the statue known in thirty-one copies (F1-31) represents the hero Meleager after his triumph in the Calydon hunt, but before his gift of the boar's head and hide to Atalanta.[4] It seems inconceivable, and would be without parallel in ancient art, that the twelve preserved full-length replicas and torsos should copy not Skopas' statue itself, but a later version of it (presumably Hellenistic or Roman), as Lippold and others suggest, and only the Fogg statue (F32) retain the scheme of the original. The Fogg statue must be a variant, though perhaps a more important one than is usually recognised, and the 'Perseus' from Ostia (F33) a version; a number of Roman portrait statues also derive more or less directly from the type (F34-42). The dog and the chlamys, present in the majority of the complete copies, may have been part of the original composition, the rock and the boar's head (known in only four copies) quite possibly not.[5] The statue is best reproduced in the Vatican (PLATE 44b), Ny-Carlsberg and Tripoli replicas (F1, 2, 5), the head alone in the copies at Calydon and in the Villa Medici (F13, 14: PLATE 44d, cf. 48d).

The Fogg statue[6] (PLATE 44a) is a puzzle. It seems to lean on a staff or short spear under the armpit (not a boar-spear, which would be too long), like the nearly

contemporary Copenhagen Herakles[7] ascribed to Ly-sippos. A chlamys was draped over its left forearm, not across the shoulders as is normal, but apart from these two modifications it follows the rest of the copies with fidelity; a dog was apparently included in the composition.

Although several Roman sarcophagi show Me-leager—with a chlamys draped around his *shoulders*—leaning on a staff,[8] it is at least possible that the Fogg statue is not a Meleager at all but a contemporary mod-ification to portray Asklepios.[9] Skopas is known to have made at least one beardless Asklepios,[10] and the earliest statue that we know of the god, by Kalamis,[11] was of this type. Here, if the object under the arm were a staff, it would then be the regular attribute of the God of Healing, and the dog the one that watched over him as an infant, also included in the cult-image by Thrasymedes at Epidaurus[12] and elsewhere; the snake, being the attribute of the mature Asklepios, was often omitted on statues of him as a youth. If, on the other hand, the object were a spear, it is worth re-membering that Asklepios was shown at least once in ancient art as a hunter, at Troezen, where the statue by Timotheos[13] was identified with Hippolytos, who

χλωρὰν δ' ἀν' ὕλην παρθένῳ ξυνὼν ἀεὶ
κυσὶν ταχείαις θῆρας ἐξαιρεῖ χθονός[14]

The age of the subject of the Fogg variant could also be significant—he is only in his late teens or very early twenties, whereas the other four complete copies and the Calydon head show Meleager as a mature man in his mid or late thirties; certainly, the accounts of the hunt all seem to presuppose that Meleager was no cal-low youth but a tried and tested leader with many ex-ploits behind him.

The Fogg statue, then, if the identification be ac-cepted, showed Asklepios as the young hero who ac-companied the Argonauts and even took part in the Calydon hunt;[15] although it would be an elegant solu-tion to the problem of the reasons for adapting the Meleager type rather than any other, the link with Meleager in the Calydon expedition should not be taken too seriously. Of our five lists of participants, Asklepios only occurs in Hyginus, whose list of names is suspiciously full.

In fact, such adaptations are not as rare in Greek art as might be thought.[16] In the sixth century the Winged Artemis of Ionian art was taken as the departure point for the iconography of Nike, apparently by Archermos of Chios;[17] in the fifth, the *locus classicus* is the strid-ing bronze god from Artemision, whose pose seems to have done duty both for Zeus and Poseidon

Soter;[18] in the fourth, an Eros type seems to have been adapted to serve as a portrait of Alkibiades,[19] ap-parently by Skopas or Praxiteles, if we can trust Pliny, and the Aberdeen head (PLATE 46c, d), possibly a young Herakles, directly copies the head of the Olym-pia Hermes,[20] though with the slightly more powerful modelling appropriate to the change of subject. Here, Skopas could have chosen the 'Meleager' motif for the original of the Fogg statue because it was nearest to the traditional Asklepios types, most of which were bearded and draped and thus unsuitable for adapta-tion.

The second of the two problem statues, the 'Per-seus' from Ostia (F33),[21] shows the hero with his left hand once holding a scythe, the right by his side grasping the Gorgon's head, and the chlamys across the shoulders. It is regarded as a classicising work freely derived from the Meleager by Brendel and more recently by von Steuben; both Lippold and Schauen-berg accept it as a copy of an original by the master of the Meleager, and Arnold wonders whether it is per-haps not derived from Antiphanes' Perseus. The de-ciding factors are the Gorgon's head, 'ein sanftes Mäd-chengesicht'[22] only thinkable in comparatively late antiquity, the combination of a Meleager-type body with a Polykleitan style head, and the stiff and irres-olute pose, so much weaker than any Meleager statue. It is perhaps safest to assume it to be an eclectic work by a rather inferior hand, perhaps Hadrianic in date.

The style of both the 'Meleager' and 'Asklepios' types is very close indeed to that of the most advanced of the Tegea sculptures. There is no need to dwell on the very close similarities between the Villa Medici head and the Herakles/Telephos head from Tegea, since PLATES 13b and 44d are eloquent enough. The Skopaic male head may here be said to have attained its final form; the structure is almost cubic and the facial outline has at last abandoned the closed oval for the broader, more open form of nos. 9 and 16; the modelling is rich, the hair a tousled mass.

The canonical double *contrapposto* recurs in the pose, and the body forms agree well enough with the more advanced of the Tegea pieces, although the rather small abdominal muscles and lower thorax boundary are in themselves unusual. Most students now agree on attributing the Meleager to Skopas, although there is no literary evidence for it; an attempt to explain this rather curious anomaly will be made later in the chapter. At any rate, nothing can alter the fact that both this and the 'Asklepios' are indisputably Skopaic in style.

Next to the Herakles Lansdowne, the Meleager seems a curiously ambivalent work; this is by no means accidental, being partly due to innovations in the *contrapposto* and partly also to the sculptor's subtle exploitation of the tensions (one might almost say ambiguities) inherent in his own approach to facial expression and character portrayal.

Firstly, the pose, which is clearly a derivation from Polykleitos' Doryphoros.[23] Essentially, the eye follows a path similar to that described in the sections on the Maenad and Herakles Lansdowne (cf. FIG. 1), and the emphasis is again on the three-quarter views, where the movement is at its richest (PLATE 44b). Here, however, not only is the stance looser, the axis more sinuous and the twist in the torso greater (resulting in a wider viewing angle than was the case with the Herakles), but the synthesis of the viewpoints and the return across the shoulders is better managed —the right arm now forms a smooth transition between flank and shoulder, whereas before it merely acted as a barrier to further progress (cf. PLATE 42b).

The most striking difference, however, comes in the composition of the hero's left side; no longer thrusting out boldly into space, it is now actually *closed* by the uncompromising vertical of the great boar-spear (and perhaps in the original by that of the chlamys too). The spectator's eye is still invited to rove within the area thus confined; it is the statue that no longer reaches out toward him. Meleager no longer stands, as Herakles did, foursquare to face the world; his stance is more equivocal, as he looks out toward the future while physically turning away from it.

If the Medici head is to be trusted, a similar conflict may be observed in the face—the expression seems to have turned to one of anxiety, yet the mask is still composed and heroic. Meleager may indeed have killed the boar, but even in the moment of triumph he is burdened by the perils ahead; we are reminded of what he cannot know, that the spoils he has won will cause dispute and bloodshed, and eventually result in his own death.[24] The spectator is invited to participate in the hero's forebodings in a much stronger way than was the case with the Herakles, yet even so is still kept at a distance by the classical aloofness of the pose and by the strictly controlled features, which prevent the emotion from becoming particularised. As G. M. A. Hanfmann writes: 'Thus the Meleager represents the last stage in which the increasing diversification of movement and the individuation of the *persona* could still be contained within a typical posture derived from the classic tradition....(He) is still primarily the coura-geous, tragic, defiant hero, and not an individual displaying those qualities.'[25]

With the Meleager, then, the sculptor is seen turning away from physical means of activating the space around the statue toward more subtle, purely psychological ones, attempting to create a more intimate rapport with the spectator by involving him more deeply in the inner life of the hero. This trend is in direct contrast with the methods adopted by the Lysippan school at the time, where simple axial rotation was increasingly coming to the fore as the chief way of overcoming the barrier between statue and spectator. A comparison between the Meleager and the Herakles in the Ny-Carlsberg attributed to Lysippos, makes this clear—the former preserves much of the frontality of classical art and with it much of its physical 'otherness', the latter, by its still tentative spiral rotation, has begun to break down that barrier, a move that will eventually reach its logical conclusion near the end of the century with the Herakles Farnese.[26]

In comparison with the Meleager, the Fogg statue is not so very different in character. This could, of course, be taken to indicate that too much is being read into the former, but there is another explanation, and perhaps a more satisfactory one. Like Meleager, Asklepios died by violence after performing a great boon for mankind; in his case, the discovery of how to raise the dead led to death from a jealous Zeus, and in Meleager's his generosity after killing the boar led to death from a vengeful Althaia. The two situations are not unlike, and lend themselves to similar treatment—perhaps another reason why the two types are so close. It must not be forgotten, though, that we still do not *know* that the Fogg statue is an Asklepios; even at this advanced stage in classical art it is still the attributes, not the characterisation, that identify the hero.

The Meleager and the 'Asklepios' must both be dated to the 340s; they are clearly close in time to the figures of the Daochos dedication, especially the Agias (PLATE 51a),[27] and the figure on the right of the 347/6 decree relief also seems quite near;[28] perhaps the best parallel is the right-hand boxer on the Panathenaic amphora of 340/39.[29] The Ny-Carlsberg Herakles is probably a little earlier, the bronze 'Perseus'[30] from Antikythera more or less contemporary and the dramatic, almost theatrical Apollo Belvedere[31] (PLATE 51b) perhaps a little later. Comparing these works (from the Lysippan, Polykleitan and Attic schools [Leochares ?] respectively) with the Meleager and with each other, it is striking how fast the major sculptors were moving away from each other at the

time, and how little Skopas seems to have in common with any of his great contemporaries represented in this selection.

With Praxiteles, it is a different matter; of his works in this period only the Lykeios seems to have come down to us,[32] but perhaps even here the enraptured expression, the restricted range of viewpoints and the sinuous curve of the axis would not have seemed altogether unrelated to the style which produced the Meleager, in the eyes of a Roman connoisseur at least.

Accepting for the sake of argument that the 'Meleager' copies and the Fogg statue are two distinct, though related types in Skopas' style, it is legitimate to ask why the former is never mentioned in the sources, whether the latter copies any of Skopas' statues that *are* mentioned in the sources, and where the originals of both may once have stood.

For the Meleager, it is possible that the first and last of these points may be connected with each other. In his discussion of the copies of the Meleager type, Becatti concludes that by far the most accurate of these is the Calydon head (F14), which because of the damage to its lower face and jaw has received little attention here. He attributes its excellence to the possibility of a full-length example at Calydon, now lost— but what if it was the *original* that stood there, on the actual site of the great struggle with the boar and of the later Heroon celebrating the heroes of the saga? Meleager was, after all, the Calydonian hero *par excellence*, renowned for many feats of arms in its defence, and son of Oeneus its legendary king;[33] since he was buried there, at a guess our statue could have been carved for his tomb. The town was ruined after Augustus depopulated it to settle his new city of Nicopolis, but some of its statues found their way to Patras and other nearby towns; Pausanias mentions these in his guide,[34] but it is clear from his account and from the ruins themselves that many were lost—the Meleager perhaps among them? Transmission of the type may have taken place through copies, as was the case with the Athena Mattei.[35]

As for the 'Asklepios', Skopas is known to have made two groups portraying this subject: one at Gortys and one at Tegea.[36] The Gortys group, where the Asklepios is known to have been unbearded, has been tentatively identified in two versions in the Vatican and Ny-Carlsberg, discussed in the Appendix to this Chapter, although both are apparently only indirectly related, if at all, to Skopas' style. Worth considering, though, is the possibility that the Fogg statue copies the Tegean Asklepios. Although Pausanias does not

tell us whether the Tegean statue was bearded or unbearded, if the Fogg statue does copy a fourth century original, not only would its date have been very close indeed to the time at which the Tegean temple would have been ready for its cult statues and Skopas working on them, but its kinship with one of the most important fragments from Tegea, the Herakles/Telephos head, is marked. Finally, the Tegean group was disposed to either side of Endoios' Athena, Asklepios to the left and Hygieia to the right, if Pausanias' text is anything to go by; the Fogg statue fits the bill for such a composition admirably.

SKOPAS IN SAMOTHRACE

Thanks to the excavations of the American School of Classical Studies at Athens, Skopas' visit to Samothrace, probably at or near the end of his career in the 330s, is now securely documented beyond Pliny's remark that he was responsible for the cult group of Aphrodite, Pothos and (?) Phaethon there (Appendix 1, no. 4). Excavation of the Propylon to the Temenos[37] has revealed coffers decorated with heads and busts in relief that are unmistakably from his workshop.[38] The proportions of the heads, all of reasonable quality but rather poorly preserved, echo those of the most advanced of the Tegea heads, nos. 9 and 16, and cannot be more than a few years later than them. One is very close indeed to the Herakles head from Tegea, PLATE 47a. In general, the modelling is rich, and the eyes deep-set and overhung by the baggy orbitals at the outer corners in a typically Skopaic manner; characteristic, too, are the swelling brows, jutting foreheads, flared nostrils, deep naso-labial furrows and square, out-thrust chins. The 'gap' at the outer corner of the eye is present in all the heads that are well-preserved enough to show it. Finally, only two of the seven heads are in frontal or profile poses, the rest, as at Tegea, being shown in three-quarter view.

In a recent lecture, Lehmann goes as far as to attribute the design of the Propylon itself, with its archaistic frieze of dancing maidens, to Skopas.[39] Since, being Ionic, the building is not directly comparable with the Tegean temple, the correctness or otherwise of the attribution must rest on the character of the architectural ornament. Here, Tegean affiliations do not seem particularly strong; the acanthus leaves, cauliculi and volutes of the rinceau sima are much further from those of the Tegean temple than are those of the sima of the Artemision at Ephesus, for instance;[40] the antefixes[41] seem to follow Samothracian prototypes, not Tegean ones, and the manes of the lion-

spouts are arranged and carved differently.[42] However, as Lehmann herself repeatedly stresses the provisional nature of her conclusions pending full publication of the Propylon, perhaps it is better to reserve judgement on the attribution of the architecture, and with it of the archaistic frieze, for the moment.

Lehmann dates the building on historical grounds to c. 340, seeing the marriage of Philip of Macedon and Olympias as the inspiration for the sculptural decoration, and thus their estrangement in 338/7 as a *terminus ante*—though as Pausanias tells us, Philip erected his Philippeion at Olympia, with chryselephantine portraits of himself, Olympias and Alexander, after this date, so this chronology, while remaining attractive, is by no means watertight.[43] Two factors, indeed, would seem to support a date rather after than before the middle of the decade—the portrait of Alexander on one of the coffer reliefs, where he certainly looks much older than sixteen, perhaps even around the age when the Azara-Geneva portrait was carved towards the end of the 330s,[44] and the quite remarkable similarity between the lion-spouts and those of the temple of Zeus at Nemea,[45] erected very probably between c. 330 and c. 320. Since the sima would have been one of the latest elements to be carved, to retain a date c. 340 for the Propylon would mean separating the two by as much as twenty years.

The statue of 'Apollo with the goose' (PLATES 45a, c), now known in over forty copies and versions, was recognised as reproducing the Pothos of Skopas at Samothrace by Furtwängler in 1901; the attribution has been challenged, in particular by Müller and Mingazzini, on the grounds that the style is not Skopaic, the pose is an impossible one for the fourth century, and that, in this period, too, hermaphrodites are 'unthinkable'.[46] The copies show a good deal of variation, not only in how far the figure leans out of plumb, but also in such details as the drapery,[47] the presence or absence of wings and goose, the hairstyle,[48] which was originally fairly complicated and has apparently been simplified by the copyists, and the action of the hands,[49] which has been altered by almost all the copyists and misunderstood by restorers of more recent times as well. The best copies are those in the Uffizi and in the Palazzo dei Conservatori (G1, 2, 4).

Before discussing the attributes and the problem of identification, it is perhaps best to begin by finding out how far, if at all, the work agrees in style with the Tegea sculptures and the attributions already made. The structure of the head of the Conservatori copy

(G1: PLATE 45c) is strikingly similar to no. 17 from Tegea, as is the modelling of the cheeks, nose and mouth, which strains upward and forward in an identical manner to that of the Tegea head (cf. PLATE 52a, no. 1). The eyes (though perhaps a little exaggerated) are similar to those of the female head from the Tegean akroteria, no. 4; the forehead is the same shape, the hairline describes the same ogival curve as this and other Skopaic pieces (PLATES 4a, 32d, 33d, 41b, 46a), and the locks are again marked off from each other by deep drill channels. There is thus a prima facie case for attributing the original of the Conservatori copy to the same stylistic circle as the Tegea heads.[50]

The body forms are more difficult. The scheme of the abdomen and chest seems to be fairly close to that of the Meleager (PLATE 44b), but some critics see the modelling as a whole as more Praxitelean than Skopaic;[51] however, since it is here if anywhere that we might expect the styles of the two sculptors to be in contact, and we have no originals of this type in marble from either school to go on, there seems little point in discussing this. The proportions are a long way from those of the works previously discussed, it is true; however, the Ilissos youth (PLATE 49a) is an example of the trend towards such slim proportions among Skopas' followers at about this time, and it seems likely a priori that he would have used proportions appropriate to his subject, which in this case was, to say the least, unusual.

As a comparison between PLATES 44 and 45 shows clearly, the *contrapposto* of the Pothos has developed out of that of the Meleager, and is in a very definite sense a 'tightening up' of the scheme of the earlier statue. The left leg is no longer 'free' in the accepted sense, for by being brought across in front of the right it now plays its part with the staff and drapery in closing off the left side of the body almost completely; the eye is drawn into the composition at the right foot, as before, but now travels up the body in a full S-curve within completely closed contours. The right arm is brought across the body both to assist it more forcibly in its journey up and to the right, and to integrate the staff more closely with the composition than was the case with the Meleager.[52]

The basic rhythm of the two works, then, is the same; what is different is that the action, with all its richness and diversity, is now compressed into one plane, and the double *contrapposto* flattened almost as if the figure were a cardboard cut-out. Both this and the strong direction given to the eye to travel up and beyond the figure can only, I feel, be explained by the

figure having originally been a subsidiary component in a two or three figure group, set against a wall.

The Meleager is a self-sufficient work; it itself invites the spectator to peruse it from a number of viewpoints, to discover, as he runs his eye over it, new volumetric relationships or muscular contrasts, and finally to ponder over the character and outlook of the hero. The Pothos, on the other hand, is meaningless, almost ridiculous as a figure on its own, or even—if it were of equal vaue with them—with others in a group; its whole *raison d'être* is to concentrate the spectator's attention elsewhere, focusing it upon a more important object for his contemplation, and it thus requires neither a complex character nor even a truly three-dimensional existence (in the sculptural sense) of its own, which could only succeed in distracting the spectator from the focal point of the composition.[53] With these points in mind, Mingazzini's objection that an unfocused, yearning gaze 'che vaga lontano, verso un punto romanticamente indefinito'[54] is inadmissible in the fourth century, true though it may well be in general terms, would seem somewhat irrelevant.

As for the date of the Pothos, the number of surviving copies and the discussion of the style of the head certainly points to the fourth century rather than any other, and on the evidence of the pose the statue need be no more than ten years later than the Meleager. The stance is certainly revolutionary, but for all its newness still rooted firmly in the traditions of the late Classical period; omitting figures which are propped up by a staff under the armpit, the following four types can be said to be its ancestors:

(1) 'Narcissus' type,[55]
(2) 'Paris' type,[56]
(3) The Sauroktonos of Praxiteles,[57] and
(4) The Artemis of Timotheos (PLATE 33b).[58]

It is the Artemis, leaning precariously on a spear that is set at a slight angle, and with her left leg crossed in front of the right, that is the closest direct ancestor to the Pothos, as Becatti and Neutsch have pointed out. Several votive reliefs from Athens,[59] dated to the last quarter of the century, also show figures in similar poses, but leaning against a pillar. Thus, whether the drapery is a part of the composition or not, since the essential preconditions for the Pothos would seem to have been in existence in the third quarter of the century,[60] Mingazzini's doubts about the ponderation would seem to be unjustified. As for those who would wish to date the statue to c. 300 or later,[61] not only is the motif used almost without modification for Pelops on an amphora from Ruvo,[62] datable to the last quarter

of the century, but a version of it also appears on a bronze mirror-case depicting Eros and Aphrodite and dated to the third quarter by Züchner.[63] In general, I can only say that I see more plausibility in such a radical and decisive step as the Pothos undoubtedly represents being the work of a distinguished sculptor in the second half of the fourth, rather than an unknown one at the beginning of the third century.

The final objection is that hermaphrodites are 'unthinkable' in the fourth century: the Pothos is not a hermaphrodite. Although it may seem to be splitting hairs to say it, in none of the statues is there any trace of breasts; 'effeminate youth' is thus perhaps a better description, and not only were Pothos and Himeros both depicted in just this form by the Meidias painter about eighty years earlier, but the Sauroktonos and the Marathon Boy show that such a figure was perfectly acceptable in the fourth century as well.[64]

To sum up: the statues under consideration reproduce a work by Skopas, perhaps datable to the 330s,[65] which originally formed part of a group of one, or at most two subsidiary figures placed in front of a wall beside a central figure.

Skopas in fact made two Pothoi, one at Megara and one at Samothrace,[66] but the possibility that it is the Megarian Pothos that is represented here seems to be ruled out, since at Megara there were *three* subordinate figures, apparently only distinguished by their attributes, which must have formed a properly three-dimensional composition (perhaps being placed in a semicircle around the Aphrodite).[67] A further argument against the Megarian Pothos is the very large number of extant copies. The Megarian cult is not mentioned elsewhere in ancient literature, as far as I know, but there is abundant evidence of the popularity of the Samothracian Mysteries with the Romans;[68] what more likely than the reproduction of part of one of its more renowned cult-groups?

How far are we able to reconstruct the original composition? The pose of the Pothos has been restored by Bulle, but considerable controversy has arisen over the attributes (wings, goose, drapery and 'staff'). More recently, a well-argued article by Kerényi has laid the foundations for a way out of the impasse.[69]

Kerényi's conclusions can be reduced to three in number:

(1) The reading of the manuscripts would suggest that a group of Aphrodite, Pothos *and Phaethon* stood at Samothrace.

(2) The material and literary evidence would

suggest that the subsidiary figures leant not on phalloi (Bulle) or thyrsoi (Müller) but torches (G33-5).

(3) Since a Pompeian wall painting (H4) shows Phaethon in a derivation from a 'Pothos' pose, it would seem at least possible that our figure is a statue not of Pothos but of Phaethon.

I agree with the first two conclusions, but not with the third, to which I shall put forward an alternative suggestion: that our figure is indeed a Pothos, but was balanced by a figure of Phaethon on the other side of Aphrodite, which now remains in two statues, one recently excavated at Salamis in Cyprus (PLATE 45b) and one (reversed) in the Torlonia Museum (H1, 2). Not only do the body forms of the Salamis torso agree exactly with those of the Uffizi and Capitoline Pothoi, as is clear from the photographs, but its pose exactly copies that of the Timothean Artemis and is reproduced on a Phaethon sarcophagus in the Ny-Carlsberg (showing Phaethon leaning against a seated Apollo) with almost no modification (H5: PLATE 45d). Phaethon is also shown similarly poised on two wall paintings in Pompeii and Rome (H3, 4); in both, he holds a torch and is given a cloak.

The composition of the group is restored in FIG. 7; apart from the torch, the restoration of the Pothos follows Bulle: the drapery (too long for a chlamys and possibly the sacred veil mentioned in the sources)[70] is retained as both a physical and visual support for the marble statue, and is balanced by the cloak of the Phaethon (better preserved in the Torlonia statue); the wings are a necessary attribute for the *daemon* as both Furtwängler and Bulle have shown, and are balanced on the Phaethon by the left arm (compare the Meleager, PLATE 44) and by the cloak again. Both figures hold torches,[71] and the altar with the snake is added to balance the goose—snakes around objects like candelabra and altars were a common feature of the Samothracian cult. The group may have been set as much as 1.50 m above the ground, according to Bulle.[72]

The Pothos and Phaethon are the last works that I am able to attribute to Skopas with any confidence; they would seem to have been produced around 335, at which time the sculptor would perhaps have been about fifty-five to sixty years old.[73] If the reconstruction is even close to being correct, the group was characterised by a remarkable sense of cohesion, both formal and emotional. The Pothos in particular seems to have reached the ultimate stage in that development which we have followed over the course of some forty years—the pose is still essentially derived from late classical types, but the contours are closed and the *contrapposto* keyed up as never before. The richly differentiated internal movement is compressed all into one plane, and the existence of the figure in three-dimensional space is hinted at only by the crossing limbs and the turn of the head, emphasizing the 'distancing' of the work from the spectator in a compelling manner. The face is still the Skopaic mask, forceful yet tightly controlled.

Yet nowhere is there any sense of strain; the genius of the creator of the Pothos lies in the success with which these elements are made to complement each other, to a degree found nowhere else in Skopas' works, to produce a figure whose whole being is focused on the Aphrodite with an economy of means and a single-mindedness unique, to my mind, in ancient sculpture; for all its sensuous beauty, it strives, like Michelangelo's *Risen Christ*,[74] to free itself from the prison of the body, as the youth commits himself to a love beyond the understanding of mortals.

'La forza d'un bel viso a che mi sprona?
C'altro non è c'al mondo mi diletti,
Ascender vivo fra gli spirti eletti . . .'

The climax of a lifetime of experiment and progress, the Samothracian cult group, even with its central figure apparently lost for all time,[75] is nevertheless one of the only two examples of what was Skopas' main field of activity to have survived in any significant form (the other being perhaps the Fogg 'Asklepios'), and on that account must serve to remind us yet more forcibly of the magnitude of our loss.

Appendix

1. Although its quality is poor, an Aphrodite head in the Vatican storerooms seems closely related in hair style, proportions and the modelling of the eyes to Tegea no. 4 (G. Kaschnitz-Weinberg, *Sculture del Magazzino del Museo Vaticano* [1937], 140 no. 287 and pl. 61; Rizzo pls. 90-92). Rizzo, 61-62, sees the style as Praxitelean; this seems unjustified, especially since he seems to be arguing more from a very touched-up restoration (cf. the modelling of the upper eyelids in the two heads) than from the original. A nude Aphrodite of Skopas is mentioned by Pliny (Appendix 1, no.

5) as being in the temple of Brutus Gallaecus, beside Skopas' colossal Ares (see Chapter 10, section 3). He adds the rather surprising statement that she 'surpasses even the Praxitelean goddess': another example of the parallelism between the two sculptors noted in the Introduction. However, with this in mind, if this head were a copy of Skopas' Aphrodite it is strange that it is the only known example of its type.

Skopas' Aphrodite has been much sought after by scholars; Furtwängler saw it in the Capuan type (*Masterpieces*, 384-94), Johnson in the Capitoline (*Lysippos*, 55-57). More recent scholarship prefers to call the Capuan Lysippic (Arnold, 237-38) and the Capitoline Hellenistic (Carpenter, *Greek Sculpture*, 217; Clark, *The Nude*, 76-81); certainly, none of the heads seems at all Skopaic in character, the stance of the Capitoline and related Medici type does not conform to the Skopaic double *contrapposto* (cf. FIG. 1), and the Capuan is spirally rotated. Skopas' Aphrodite seems curiously elusive but as Lippold has pointed out (*Kopien*, 52): 'Es ergibt sich, dass mit der Tatsache, dass sich ein "Meisterwerk" in Rom befand, keineswegs die Wahrscheinlichkeit gegeben oder gar besonders gross ist, dass wir Kopien davon erhalten haben. . . . Rom ist nicht einer der Hauptsitze der Kopisten, die dort befindlichen Werke sind nicht in erster Linie bei der Auswahl der Kopien berücksichtigt worden.' The copying would thus have depended upon when the original was removed to Rome and how accessible it was before.

2. A colossal Aphrodite head in the Capitoline Museum (PLATE 46a: Stuart-Jones, *MusCap*, 122-23 no. 49 and pl. 31; Helbig[4] 1235; B-B 265; Beazley and Ashmole fig. 196; Bieber fig. 724) was seen by both Graef and Becatti as a derivation from a **Skopaic** original (*RM* 4 [1889], 218; *RivIst* 7 [1940], 50 fig. 27). The piece is probably mid or late Hellenistic, and almost certainly copies a Skopaic original of the third quarter of the fourth century. The face, with its heavy jaw, wide open, deeply set eyes and swelling upper lids, is directly related to the akroterion head no. 4 from Tegea, even down to the 'gap' at the outer corners of the eye sockets where cheekbone and brow just fail to meet. Similar, too, is the hair style, of sweptback locks divided by deep drill channels, which in contrast to the Praxitelean triangular pattern, form an ogival arch over the forehead, as on the Maenad (PLATE 32d).

Compared with the Leconfield head in Petworth (PLATE 46b), probably an Aphrodite and in the late style of Praxiteles, the differences in style, as well as the similarities, are obvious. Both take as their model a mature woman in her late thirties, and both aim at a certain opulence of design and skin texture. Yet whereas the Leconfield head is the product of a warm

and sensitive personality, somewhat akin to the Raphael of the Roman Madonnas, the Capitoline is passionate, heroic, dominating, closer in fact to the mighty deities of the fifth century. Nowhere are the superficial links between the two sculptors, and the gulf that divides them at root, more clear than in these two heads.

3. Arndt, Lippold and Neutsch (*GNC*, 140-42 and pl. 96; *Kopien*, 230-31; *Plastik*, 252; *JdI Erg* 17 [1952], 17-28 and pls. 12-15) have seen in two groups in the Ny-Carlsberg and the Vatican versions of Skopas' unbearded Asklepios group for Gortys in Arcadia (Appendix 1, no. 15; cf. Arias, 124-25). Lippold (*Kopien*, loc. cit.) believes the bearded Vatican Asklepios to be the truer of the two, whereas Fuchs, *Vorb*, 145 sees both as very far removed from the Skopaic original. With Lippold, I believe the heads of the Copenhagen version (*GNC*, 141 fig. 78) to be closer to the Hypnos than to the Hope Hygieia (*Plastik*, 252-53; Schrader, *BWPr* 85 [1926], 19 fig. 15; Ashmole, *BSR* 10 [1927], 1-11 and pls. 1-5; Arias, 122-24), though none of these, *pace* Furtwängler and others, seems particularly Skopaic (*Masterpieces*, 395-96; Lippold, loc. cit., etc.; cf. the Hypnos head, Schrader, loc. cit. with the head of the Praxitelean satyr, Rizzo pls. 50, 55).

The pose of the Hygieia in the two versions is a different matter, however; as most students have remarked, it strongly recalls that of the Pothos (PLATE 45a). Some Skopaic **influence may therefore be** present in the type, although I doubt whether it goes much deeper than this.

The Gortys temple was apparently erected in the mid fourth century (Roux, 389) which thus becomes a *terminus post* for Skopas' group.

4. The following works, grouped geographically, are lost or at least only very dubiously identified, and on these I am unable to add more to the conjectures of earlier students:

Peloponnese: Hekate (Appendix 1, no. 18); T. Kraus, *Hekate* (1960), 112 n. 548.

Attica: Semnai (Appendix 1, nos. 22-25); Picard, *Man* iii. 2, 651-52; Mingazzini, *RivIst* 18 (1971), 82-83.

Megara: Eros, Himeros, Pothos (Appendix 1, no. 26).

Thebes: Athena Pronaia (Appendix 1, no. 14); Arias, 103: Picard, *Man* iii. 2, 662-66; cf. Schlörb, 60-63.

Troad: Apollo Smintheus (Appendix 1, nos. 9-10); V. R. Grace, *JHS* 52 (1932), 228-32; Arias, 110-11; Arnold, 129 n. 476; Lehmann, *Skopas in Samothrace*, 13 and fig. 50; on the temple, see H. Weber, *IstMitt* 16 (1966), 100-14.

Ephesus (Ortygia): Leto and Ortygia (Appendix 1,

no. 21); Arias, 112; Picard, *Man* iii.2, 673.

Knidos: Dionysos and Athena (Appendix 1, nos. 13 and 17); see the Appendix to Chapter 7, section 4.

Unknown provenience: Hestia, campterae, canephoros, later in Rome (Appendix 1, nos. 20 and 28); Arias, 103; Picard, *Man* iii.2, 667-70; *contra*, Fuchs, *Vorb*, 144-45.

Hermes herm (Appendix 1, no. 19).

Ares (Appendix 1, no. 11); see Chapter 10, section 3.

Aphrodite (Appendix 1, no. 5); see the Appendix to Chapter 9, sections 1 and 2.

Uncertain: 'Ianus pater' (Appendix 1, no. 38).

'Eros-Alkibiades' (Appendix 1, no. 39).

Artemis (Appendix 1, no. 40).

Chapter Ten

SKOPAS AND HIS SUCCESSORS

1. SKOPAS' STYLE

Though an innovator in the ways in which he used posture and facial expression to indicate the mood, character and emotions of his subjects, Skopas remained firmly rooted in the classic tradition, avoiding the more realistic approach evolved in the late fifth century by the sculptors of the Argive Heraeum and others, and echoed, at least in part, at Epidaurus. He borrowed liberally but selectively from both the Poly-kleitan and Attic schools; although within the latter he owed a lasting debt to Timotheos, nothing better illustrates the extent of Skopas' advance than the faces of Timotheos' Athena and Leda (PLATE 25d) placed alongside those of the Genzano and Lans-downe Herakles and the Maenad (PLATES 30, 32, 42). When he attempts figures in action, his early style shows a preoccupation with the use of extreme muscular stress, but as his style settles down, a more flowing harmony develops; the surface modelling of his figures becomes richer and his sense of design and structure grow stronger.

The discovery of the uninterrupted curving axis as a means to unify the action of the body seems to have come later to him than to Praxiteles;[1] but whereas in Praxiteles' hands it swiftly became the vehicle *par ex-cellence* for conveying the langour of an Elysian existence, almost Epicurean in its detachment,[2] with Sko-pas the quest is for a sculptural form that will articulate the various states of emotion (πάθη)—and in particular an upsurge of the soul and spirit in response to the divine—with clarity and directness; in consequence, all that would break the concord and unity of the action is progressively shorn away. Neither sculptor has anything in common in this respect with the interrupted rhythms and unsettled, momentary

poses favoured by Lysippos and his circle (compare PLATE 51a).[3]

Skopas shared with most other fourth century sculptors the ability to create an aura around his figures, which nevertheless remain a thing apart from the spectator; here, his use of the double *contrapposto* and a strictly limited viewing angle, which actually seems to decrease toward the end of his career, are in sharp contrast with Lysippic axial rotation and its consequences for the spectator. The emotions and characters of his heroes and gods are in general more focused than those of Praxiteles, who exist on an idyllic plane far removed from ordinary mortality (cf. PLATE 46b), but again the contrast with the gods and heroes of Lysippos, whose actions and emotions are firmly tied to the moment, is fundamental. It is clear that Skopas represents an alternative tradition to the Lysippic, and except for the use of crossing limbs and a generally more concentrated expression in the faces of figures by Lysippos towards and during the last third of the century, there seems to have been little contact between the two. Herein, perhaps, lies the reason why they are never mentioned together by the sources.

After the middle of the century Skopas' style seems to show a certain kinship with Praxiteles', and I would suggest that each may have modified the style of the other when both were in Asia around 360. This interaction between the two shows not only in their treatment of the male head and facial features, where Praxiteles may have been attracted by the possibilities inherent in the Skopaic manner, but also in the body forms, where Skopas was perhaps the beneficiary. His last preserved work, the Pothos, is perhaps his most 'Praxitelean' in this way, though

preserving a unique character of its own neverthe- less. His female heads, on the other hand, like no. 4 from Tegea and the goddess in the Capitoline Muse- um (PLATE 46a), while superficially similar in their sweptback hair and full features, are poles apart in feeling from Praxitelean female heads like the one in Petworth (PLATE 46b).

If the Capitoline head is indeed a copy of one of Skopas' cult statues, and representative of his output in this direction as a whole, it would seem that his major concern, at least in his late period, was to re- capture the majesty and sheer dominating *presence* of Pheidian cult statues, whilst animating them with a touch of drama and emotional involvement that is typically Skopaic. Like the sculptor of the Demeter of Knidos, 'Here is a man who has often walked on the Acropolis, has stood before the Lemnian, and has looked up at the Parthenos.'[4] Yet though the two may profess the same spiritual ancestry, the paths they have chosen away from it diverge sharply.

Fortunately, Skopas models female hair in a man- ner peculiarly his own, which helps to distinguish his female heads, even when fragmentary or reworked, from those of any other late classic sculptor. He divides the hair sharply into single locks by deep drill-channels, cuts the individual strands very dis- tinctly, arranges them with great variation and much overlapping and intertwining, and moulds the hair- line into the form of an ogival arch (PLATES 4a, 32d, 33d, 39a, 41b and especially 46). His rendering of male hair, too, especially in his later period, seems to have been slightly looser and more disordered than either Praxiteles' or Lysippos' (PLATE 44). His prac- tice of dividing it into short, chunky locks of coarse, often interwoven strands, is very different from the Lysippan approach, with its longer, much flatter locks divided into a number of very fine, parallel strands, as on the Apoxyomenos, Eros and Alex- ander Azara.[5]

In addition, Skopas seems to have retained at least two distinctive mannerisms to the end of his career: the 'gap' at the outer corner of the eye, where cheekbone and brow just fail to meet (PLATES 8a-b, 14b, 15b and, e.g. 38b and 44c-d), and the very broad treatment of the back muscles, with little or no attempt to model the infraspinatus and teres minor and major separately. On Lysippan statues, on the other hand, these muscles are always very distinct (cf. PLATES 9c and 29b).

It seems likely that Skopas was a deeply religious man. As the supreme exponent of the spiritual in ancient art, his major concern, like that of the trage- dians and apparently of Praxiteles too, was for the universal—the emotions and conflicts of heroes and immortals, not the life of ordinary men. It is not sur- prising, then, that he left the flux of human affairs to contemporaries like Lysippos and Silanion, and him- self made no athletic statues or portraits. His rare hu- man figures are conceived from the standpoint of the divine: such is the Maenad (PLATE 32), racked and anguished as futilely she tries to transcend the limita- tions of the body in answer to the call of Dionysos, a world away from the late fifth century and the deco- rative, 'Ducciesque' compositions of Kallimachos.[6] As time wore on, the vision mellowed; for the Pothos the struggle is over, and harmony achieved in total commitment:

'L'anima, della carne ancor vestita,
Con esso è già più volte aciesa a Dio.'

In this statue it was Skopas' genius, like Michel- angelo's in his later years, to be able to reconcile body and soul, not only without detriment to either, but through the one, to raise the other to the plane of divinity.

Despite this deeply-felt and unmistakable profes- sion of religious faith, it is nevertheless my impression that at the very heart of his work there lies a sense of unease that is sometimes only barely disguised. On other occasions, in the Meleager for instance, it is the very *sine qua non* of the work itself, which, perhaps, is why this is one of the most successful of his studies: the formulation in stone of the conflicts that lie right at the centre of the soul of the artist. His does not seem to be the unshakeable faith of Pheidias, confident and proud in the sure knowledge of an ultimately benevo- lent Pantheon:[7]

Χαίρετ' ἐν αἰσιμίαισι πλούτου.
χαίρετ' ἀστικὸς λεώς,
ἴκταρ ἥμενοι Διός,
Παρθένου φίλας φίλοι
σωφρονοῦντες ἐν χρόνῳ.
Παλλάδος δ'ὑπὸ πτεροῖς
ὄντας ἅζεται πατήρ.[8]

Rather, I would describe it as a religious fervour born almost of anxiety—not doubt as to the existence of the Gods (no man who spends his life making images of deities doubts their existence) but a profound appreci- ation of the inscrutability and limitless power of the spiritual world, tinged perhaps with an apprehension that the Gods, often capricious, might not, in the final analysis, be benign. Whether this was a crisis purely within the personality of the artist, or symptomatic of

what some see as a spiritual insecurity general among intellectuals of his time,[9] I leave to others to decide.

It is usually assumed that Skopas was a lesser artist than Praxiteles. In antiquity, he certainly failed to capture the popular imagination to anything like the same extent as the other, though this is not quite the same thing. It is a pity that of the two most acute of the ancient critics, Cicero only mentions him once, and that inconsequentially,[10] and Quintilian not at all. On the whole, his cautiousness and circumspection in the solutions he offered to current sculptural problems such as facial expression and the relation of the work to the spectator do not, perhaps, compare with the bold initiatives taken by Praxiteles in the fields of the female nude and of the evocation of atmosphere and mood. Unlike Praxiteles, however, who appears blissfully unaware (or at least unconcerned) that the veneer of civilisation and order is a thin and fragile thing, Skopas is all too sensitive to the maelstrom of passion, irrationality and sheer human savagery that seethes not so far below. Certainly, individual pieces of his, like the Maenad and the Herakles Lansdowne, are fit to be placed on a par with anything produced in the ancient world, or the modern one for that matter. If he is to yield the palm, it is not by much.

The silence of our sources suggests that not only had Skopas no 'master', in the accepted sense of the word in the ancient world, but also no pupils; on the evidence, this is hardly surprising, for not only did he create an 'alternative tradition', but he also seems to have carried it to its logical conclusion. The Meleager and Pothos represent the ultimate that could be achieved in their respective fields within this tradition, and in this sense Skopas' art was both highly individual and the sculptor himself a figure on his own. Thus, unlike Lysippos or Praxiteles, he founded no 'school'; the sculptor of the Niobids worked in his manner to some extent, but is a lone figure in the art of the period of the Diadochi; in general, after Skopas' death, there was really little for his successors to do but to make use of his mannerisms.

Yet, in a broader and shallower sense, his influence upon his contemporaries and immediate successors was enormous, as will become apparent.

2. SKOPAS' WORKSHOP AND IMITATORS

Outside what remains from the Mausoleum, Tegea, the Sea Thiasos, and the Propylon at Samothrace, three original heads from Skopas' workshop have survived—two male and one female.

A life-size head of Herakles in Tegea (PLATE 47a),

weathered and apparently from the Athena sanctuary, is clearly Skopaic, and from the weathering and the hole for a μηνίσκος on the crown probably comes from a free-standing statue, perhaps a group of Herakles and Telephos;[11] its quality is reasonable. It was originally turned towards the (raised) right shoulder, so the pose may have resembled the Herakles Lansdowne (PLATE 42). In its proportions it seems closest to nos. 9 and 16 from the pediments, but the modelling is less advanced—the forehead recalls no. 18, the eyes no. 18 and the Berlin Triton (PLATE 43a, c). The neck is massive, with prominent horizontal age-lines. The date should perhaps be c. 350–340.

A male head in Thasos (PLATE 47b, c)[12] is even closer to the Tegea style, and it is suggested by Devambez that it was made by a member of Skopas' workshop during his visit to Samothrace in the 330s. The proportions are not quite as compressed, and the modelling more watery than that of Tegea no. 9, which it recalls most strongly in treatment of details; the dangers inherent in increasing surface richness have already been noted in Chapter 4, and here the sculptor seems to have well overstepped the mark. The hair at the back of the head is very similar to the mane of Telephos' lionskin, PLATE 14a.

The head that has been set on the torso of the Artemis in the Bracchio Nuovo which was discussed in the Appendix to Chapter 7 (PLATE 33d) is apparently a Greek original, and thus assumes some importance as the only near complete Skopaic female head we possess from the fourth century. Although its quality is not particularly high, the restorations have left the face virtually intact (only the tip of the nose, the hair on the left side, and the knot and ornament on the crown being in plaster) and allow us to make a fair comparison with other Skopaic originals and copies.

The head has the heavy proportions, ample surface forms and characteristically modelled hair of the Tegea akroterion head, no. 4; the mouth is very similar indeed to that of no. 22. The hairline rises in the ogival arch of the Aphrodite in the Capitoline (PLATE 46a) but the face is a little wider and the chin not quite as deep, giving proportions that are relatively close to nos. 9 and 16 from the Tegea pediments. The date should perhaps lie within the forties or thirties of the fourth century.

Besides his own workshop, Skopas also had his imitators. It is, of course, virtually impossible to trace these in the copies, but four heads, all Greek originals from widely scattered proveniences, form a group within this category; the first two are so alike that they

may be imitating the same original. With the exception of no. 3, these are coarse products by second rate masons.

1. GALLIPOLI, Inv. 028 (limestone, exact provenience unknown): P. Noelke and U. Rüdiger, *AA* 1967, 369-76 figs. 1-6.

An inferior piece, apparently owing something to both the Meleager and Lansdowne types, although the hair over the forehead is most similar to the Genzano head. End of fourth century.

2. CYRENE 44 (marble, from Cyrene). Paribeni, *Cirene* pl. 46.

Almost identical in style to the Gallipoli head, even down to the small curls around the hairline and the longer locks above, though their arrangement is not the same and the mouth is closed. End of fourth century.

3. ATHENS, NM 195 (marble, unknown provenience). Apparently an imitation of Skopas' style of around the time of the Sicyon Herakles, though the modelling is rubbery and lacking in definition, and the expression in consequence rather weak. The hair is short and finicky, even more so than that of the Herakles. The date could lie anywhere between c. 340 and c. 300.

4. DELOS A6992 (marble, from Delos). J. Marcadé, *Au Musée de Délos* pls. 16, 17.

Similarly proportioned to NM 195, but with the more forceful expression and lumpier, more mobile hair of Skopas' later period. The facial features have some affinities in style with nos. 1 and 2, above. Perhaps c. 300.

In addition to these, a small bronze statue in Copenhagen[13] and a bronze statuette in Munich[14] would appear to imitate Skopas quite closely. The Copenhagen statue is thought by Lehmann to copy a Herakles that appears on the coins of Herakleia shortly after the mid fourth century, although the right hand of the Sicilian statue holds a club, whereas from the position of the fingers the bronze probably held a lion-skin. Since the poses agree and both carry a bow and arrows in the left hand, the change would apparently be due to the copyist. The pose imitates that of the Herakles Lansdowne, though the figure leans some way out of plumb and is given more attenuated, 'Lysippic' proportions. The head has the thin fillet of the Lansdowne type, which the facial features also recall, though the modelling is dry and harsh and the unadventurous scheme of the hair goes back further, to the Sicyon statue (cf. PLATES 30 and 42).

The Munich Herakles is more eclectic in its approach to its models. The stance is that of the Sicyon type in reverse, but the action of the arms has remained more or less the same—the left hand holds the apples, the right part of a bow. The proportions and body forms are more Skopaic this time, and the head is based on the Lansdowne type, again with the fillet. The piece is good enough to be a Greek original.

Of all the various late fourth century and Hellenistic statues of Herakles preserved to us in copies and countless versions from Roman times, none seems close enough to fall into the category of outright imitations of Skopas' style, though some, like the Louvre–Ny-Carlsberg type, imitate certain aspects of it (here, the pose and energy of the Herakles Lansdowne) or combine the attributes of the Sicyon statue with the stance of the Lansdowne type, usually with not altogether happy results.[15] Due to Hellenistic and Roman eclecticism the styles of these types are very difficult to disentangle, and the quality of many of them is so poor that the effort seems hardly worthwhile.

3. THE ARES LUDOVISI[16]

The Ares Ludovisi (PLATE 48) is perhaps one of the most puzzling statues of the fourth century; almost all scholars agree that it must copy a first class original and that its style is very close to that which we have been following, yet few can bring themselves to the point of attributing the piece to Skopas himself.

The head has a great deal in it that is Skopaic, and both in its modelling and general 'feel' owes much to Skopas' style of about the time of the Meleager (PLATES 44, 48d). The forehead, eyes and mouth are especially close; the last in particular, turned down a little at the corners and slightly open, its upper lip firm, distinctively undulant and pressing forward over the lower, groups the Ares with Tegea no. 17, the two Herakles statues and, of course, the Meleager, and dissociates it from the Apoxyomenos of Lysippos,[17] whose mouth and other features are detailed in a very different manner. The 'Skopaic bulge' over the eyes is exaggerated on the Vienna head, but not on the other copies, and the 'gap' behind the outer corner of the eye, not a Lysippic feature but a very Skopaic one, shows up clearly on the excellent but fragmentary head in Corinth. The hair is slightly less tousled than

that of the Meleager, and the locks shorter and far less twisted and intertwined.

Thus far, the style would suggest that the piece is indeed Skopaic, and slightly earlier than the Meleager in date. The problems and inconsistencies only begin when one looks at the shape of the face and the structure of the skull.

The jaw lacks the strong rectangularity of Skopas' later heads, and the face is a heavy oval, longer and rather narrower than that of the Meleager. If anything, its proportions are closest to those of the earliest of Skopas' preserved works, the Sicyon Herakles (PLATES 30-31), probably carved around 370. The skull is even more of a puzzle; while in profile the features greatly resemble those of the Meleager (PLATE 48d), the skull itself has far less depth to it, is rather higher, and much more rounded at the crown. As we have seen, Skopaic heads develop in an extremely consistent and logical manner with regard to their features and structure; the head of the Ares, on the other hand, is frankly eclectic.

The statue must, I feel, be by a very close follower of Skopas, one working virtually in his manner; it could even be a version of one of Skopas' own works. Most of the mannerisms are there, and the body is very Skopaic in its proportions and modelling, with, for example, no distinction being made between the teres minor and major and the infraspinatus as is common in Lysippic works (cf. PLATE 29b). Furthermore, if the left leg be considered the 'engaged' one, the statue would even seem to follow that double *contrapposto* which runs through the Skopaic series almost without exception; only the aberrant proportions and structure of the head betray it.

As for the composition, the shield and helmet may have been part of the original, the greaves probably not; the Eros, partially restored by Bernini, is controversial.[18] The pose owes much to that of the Ares from the East frieze of the Parthenon,[19] but the version of the statue from Pergamon proves that the original was not a first century creation by some classicising master, as has been suggested by some authorities.[20] It is reproduced, in exact mirror image and in the form of a satyr, on the Lysikrates frieze,[21] carved in 335/4; this and its style should date it to the 340s or early 330s. Another figure seems to have stood on the left of the Ludovisi and Vienna copies—another Eros or an Aphrodite?[22] The latter is included on the Campana plaque which preserves a version of the Ares, so perhaps we should be thinking of a group rather than a single statue.

It should be clear by now that the Ludovisi statue cannot directly copy Skopas' 'Ares sedens colossiaeus',[23] installed in the temple of Brutus Callaecus in Pliny's day.[24] Could it, though, have been a *version* of it, reduced to life-size, by a pupil or follower? Here, one can only argue from probability: ours is the only statue in Greek and Roman art that shows Ares as seated, and apart from Skopas', no other statues of this kind are recorded in the sources. Add to this that the style of the Ludovisi statue (or rather, group) is based on that of Skopas, and the coincidences become positively overpowering.

The sculptor, though perhaps possessed of a weaker personality than Skopas, was certainly a good one. His statue, at first sight calm and relaxed, seems on closer inspection to be full of inner movement, energy and agitation. As with the Meleager, and even in the empty forms and superficial execution of the Ludovisi copy, twice removed from what must have been a powerful original by Skopas himself, the whole character of the subject and what he stands for seems to have been concentrated into one instant, then captured and petrified by the sculptor.

4. SKOPAS' FOLLOWING

(A) The Ilissos and Aristonautes Sculptors

Skopas would appear to have had some following among sculptors active after the middle of the century, especially in Attica. The most important of these followers were the Ilissos sculptor, who himself had many imitators, and the Aristonautes sculptor. Frel has attributed these pieces to the Ilissos sculptor:[25]

1. NM 870: C 320.78; *EA* 686-89; Diepolder pl. 47; Himmelmann-Wildschütz, *Studien von dem Ilissos-relief* pls. 21-25; Adam, *Technique* pls. 64-66.

2. NM 869: C 1055.211; *EA* 698-701; Diepolder pl. 48; Himmelmann Wildschütz op. cit. pls. 18-20; Lullies and Hirmer pl. 226; Karouzou, *Guide* pl. 39; Adam, op. cit. pls. 67-69. PLATE 49a.

3. FLORENCE 13780 (head of an old man from a stele): *JdI* 42 (1927), 66 fig. 4.

4. PIRAEUS 131 (ditto): C 1287 fig. b [1278 fig. a, given under the same number, shows in fact another head, PIRAEUS 253].

5. LEIPZIG: *Listy filologické* 1966.i pls. 1-2; Frel, op. cit. pl. 31. PLATE 49b.

No. 1 should perhaps be dated towards 340, no. 2 before 330. The sculptor clearly takes his modelling, proportions and the type of his heads from Skopas' middle period, especially the Herakles Lansdowne (PLATE 42c), which could have stood in Athens; this type is represented at Tegea by no. 17. The head Frel no. 5 (PLATE 49b) is remarkably close to that of the Pothos (PLATE 45c) and undoubtedly belongs well into the 320s, though here the inner ends of the brows are raised, showing that the sculptor is moving away from the pure Skopaic style. The proportions of the Ilissos youth, with his broad shoulders and lanky legs, seem rather exaggerated, but the rounded and powerful modelling of the body forms is exquisite. The flat, zigzag folds in the seated woman's lap on his no. 1 recur on the new akroterion no. 3 from Tegea.

The Ilissos sculptor is very nearly a first class artist, his style a smoother, 'Atticising' version of Skopas'. Responsible for what virtually amounted to a revolution in Attic funerary art in his substitution of a truly emotional atmosphere for one hitherto only at most aspiring to a certain vague nostalgia, his influence was widespread—Frel lists 43 pieces imitating him or in his manner.[26]

The work of the sculptor of the stele of Aristonautes[27] seems to have had a more outspokenly emotional, almost neurotic character to it; the skin is stretched tight over the structure of the head, and the surface handling is more finicky and nervous than the Ilissos sculptor's. The neck, elbow and knees of Aristonautes are given great stress: the elbow in particular looks back to Skopas' earlier style, exemplified at Tegea by Dugas 28 (PLATE 20a-b). Whereas the Ilissos youth is firmly bound to the relief plane, his existence in three-dimensional space only emphasised by the slight turn of the body and the crossing limbs, Aristonautes stands in dramatic isolation, a tense but static figure within the enclosed space of his *naiskos*.

The relief should date from around or shortly after 330.

Near the Aristonautes is a fine Attic head in Paris.[28] The features are again rather taut and lacking in warmth, and the eyes penetrating and modelled very much in the Skopaic manner. On the whole, the piece looks rather like a precursor of the 'Ariadne' head, NM 182 (PLATE 50a),[29] but despite the energy and concentration of the expression the overt emotionalism and grandiose style of the 'Ariadne' group is missing here. This and the hairstyle of the Paris head, which seems a less developed version of that of the

'Ariadne', could suggest a date perhaps around 320–310.

(B) The Niobe-'Ariadne' Group

This group merits a special section to itself, as the only sculpture of the succeeding generation that can be said to point to the continuance of what might be termed the 'Skopaic tradition'. Its date is problematic, due to the eclecticism of most of the copies, though most scholars agree that the centerpiece of the Niobids, Niobe protecting her youngest daughter (detail, PLATE 50b) derives at least in part from the period of the Diadochi; some, however, would date the whole series to Pergamene or late Hellenistic times.[30]

Some kind of solution can perhaps best be reached by looking first at the Chiaramonti Niobid[31] and the 'Ariadne' head in Athens (PLATE 50a, c) rather than at the Niobe herself. The motif of the Chiaramonti statue is apparently derived from the 'Artemis' of the east pediment of the Parthenon;[32] here, then, if anywhere, one would expect stylistic discordances in the drapery if the piece were Pergamene or first century, but of the preserved copies she alone is homogeneous in style and of really high quality too. The drapery of the upper torso echoes that of the Themis of Rhamnus,[33] and even more closely a figure found in the Athenian Agora in 1971.[34] Both of these must be dated (the Themis on epigraphical grounds) to c. 300. The flying cloak derives ultimately from the style of the Amazon on the right hand end of slab BM 1015 from the Mausoleum; the nearest parallel to it and to the draping of the lower body as a whole is the Helios from the metope of the temple of Athena at Ilion now in Berlin, and dated to c. 290–280.[35]

Since Studniczka's fundamental study of the motif and style of the 'Ariadne',[36] it has been generally accepted that she is from the same workshop, if not by the same hand, as the original of the Niobe. The only difference between the two, the raised inner corners of Niobe's eyebrows, is explicable entirely by the requirements of two different situations, especially if the Athens head is not an 'Ariadne' at all but a Nike, as seems to be the case.[37] The colossal head in the Metropolitan Museum (PLATE 49c, d), its brother on the Alexander sarcophagus[38] and the Leipzig head (PLATE 49b) are exact parallels here, all pointing to a dissolution of the strict Skopaic canon of facial expression in the generation after his death.

The Athens head is almost undoubtedly a late fourth or early third century original; the face develops the nervousness and tension of the Aristonautes without, however, dissolving the surface into an unstable

mass of fluid forms as so often in later work. No signs of the running drill can be detected in the mouth or on the hair, which preserves the unity of the fourth century coiffure rather in the same way as the head from the Asklepieion at Cos, dated to c. 290–280;[39] at any rate, the piece cannot really be later than the statuette in Budapest,[40] usually dated to the second quarter of the century, whose hair is much looser, in the fashion of coming years. None of the heads studied by Horn in 1938 as a representative sample from Hellenistic times are comparable, and a look at examples like the women of the Lakrateides relief in Eleusis,[41] dated to shortly before 100, or the Aristonoe in Athens, which could belong within the first century, shows just how different classic and classicising styles can be.

We thus have one excellent copy and one original from this workshop, plus the Niobe herself which at least derives from it, all fairly closely datable to c. 300. Caution over the Niobe is necessary because her drapery and that of her daughter exhibits several traits which seem inconsistent with the style of the Chiaramonti piece, traits which are even more exaggerated in the reduced version of the Chiaramonti statue in the Uffizi.[42] The 'one-sidedness' of the Niobe is not in itself worrying; the composition goes back to Timotheos, as has often been remarked,[43] and the Tyche from Antioch gives an analogous example, contemporary with the originals of the Niobids, of crossing drapery lines leading the eye back into space to imply three-dimensionality in a group intended to be seen only from the front, placed as it was before a wall surface.[44]

Far less certain, at least at first sight, is the way the buttocks of the daughter are revealed by the fold bundle passing below them, and the finicky, silky handling of the drapery, which recurs on the Uffizi version of the Chiaramonti statue in an even more pronounced fashion. The former is to be found on all three copies of the Niobe,[45] but is not in itself as strongly suggestive of a late Hellenistic date as might at first be thought; its earliest occurrence appears to be on an early fourth century gem in Berlin,[46] and in monumental sculpture on the Capuan Aphrodite,[47] a copy of a Lysippan work of c. 330. What is Hellenistic is the treatment of the cloth, which does not recur on the other two copies and which seems to me, together with the drapery of the running girl in the Uffizi, to be blatantly Neo-Attic—the reliefs from the so-called 'Altar of Domitius Ahenobarbus' in Munich provide the parallel.[48]

As for the heads,[49] Müller has shown how close these are to the Pothos, although his photographs are perhaps slightly misleading, selecting as they do the classicising replica in Berlin (G18) for comparison with the Niobe. The hair of the original was much looser and the locks more interwoven, as in the Colle Cispio and Ny-Carlsberg copies (G1, 21); with this modification the Praxitelean elements in the style of the Niobe, remarked upon by Müller himself and discussed further below, become much clearer. The ultimate ancestor for both is the Leda of Timotheos (PLATE 25d); the profile views of the three heads chronicle the slow evolution of the language of pathos over an interval of about sixty years.

It therefore seems more than likely that the Niobids as we have them today are a mixture of copies and late Hellenistic versions of a group dating from around 300, which may or may not have been brought from Asia to adorn the temple of Apollo Sosianus in 32;[50] what is certain, though, is that on both stylistic and chronological grounds an attribution to Skopas himself must be ruled out.

Are these in fact Pliny's Niobids, variously attributed by ancient scholars to Skopas or Praxiteles?[51] On the question of style, more recent critics have been equally perplexed, which could perhaps suggest that they were—if this did not smack too much of a circular argument. If one agrees with Bieber that 'there is hardly any Praxitelean element, and very little that is genuinely Skopaic in it [i.e. the group] though some pathos in the style of the Tegean pediments may be found',[52] the answer would seem to be no, unless, that is, the Roman critics really were grossly incompetent judges of style. In fact, as we have seen, there is rather more that is Skopaic in the heads than Bieber assumes; apart from Niobe's eyebrows, the real differences arise when we turn to the hair.

Neither the hair of Niobe or the Uffizi version of her running daughter is deeply drilled in the Skopaic manner, nor does any of the female members of the group display the ogival hair-line of Skopaic style heads (PLATES 32, 33, 46, etc.); here, all seem very close to the tradition of Praxiteles' Knidia,[53] if the copies are not altogether deceptive on this point. Furthermore, we know today what the Romans could not: the Niobe must stem from the time immediately after Skopas' death, on the verge of the Hellenistic period proper, when his style was naturally subject to some dilution and extraneous elements were beginning to creep in (e.g. in the drapery and the treatment of the eyes). If, as I believe, the styles of Skopas and Praxiteles were close in some respects, and Roman critics were aware of the fact, in this situation the treatment of the hair—one of the main criteria for distinguishing between Greek sculptors of all periods—would have

become of crucial importance to them. The hypothesis that it was this anomaly—'Praxitelean' hair on a 'Skopaic' head—which finally threw them off balance when they came to attribute the Niobids (which may have come to Rome without a firm authorship in the first place), is at least worth entertaining.

The final member of the Niobe-'Ariadne' group is the statue of Apollo Citharoedus from the 'Villa of Marcus Brutus', now in the Vatican (PLATE 50d).[54] Characteristic is the modelling of the mouth and eyes, the hairstyle, the set of the head and the impetuous, rushing pose. The texture and mannerisms of the drapery, especially of the much better copy in Geneva,[55] recall the Chiaramonti statue (PLATE 50c) very closely; common to both pieces is the style of the folds which sweep back from the advanced left leg, also the scheme and texture of the cloth around the other leg. The heavy fold before the leg and the long one behind the knee occur on both Apollo and Niobid in identical fashion. Mannerisms peculiar to the two are the way in which each major fold between the legs is bifurcated over the left thigh by a trough that is wide and shallow to start with, then narrows and terminates in a semi-circle so that the two subsidiaries may join. The fold then tapers to a point to allow the sculptor to produce an updated version of the old trick of showing the folds as inflated tubes with an occasional nick to mark the curve—here, only a single nick is included, coming at about ankle height, and the change of direction is abrupt.[56] The cloth below fans out to form a triangle, which is then cross-cut and reworked.

The *contrapposto* of the Citharoedus clearly follows that developed by Skopas, both in the application of the double twist to a moving figure, already presaged in the Maenad (PLATE 32) and in the turn of the head to the 'free' side, but without the sinuous central axis; here it is ramrod straight. The statue was obviously intended to be seen from a fairly wide viewing angle, from its right profile around to a frontal position or perhaps even more. It is a measure of the sculptor's success with his composition that the sensation of motion never weakens wherever one stands, yet the statue remains perfectly balanced throughout; furthermore, each of the three main viewpoints (right profile, three-quarter and frontal) is equally interesting and shows both drapery and pose in a new light. The original must have been a masterpiece of its time, and its sculptor one of the most accomplished of his day; it is a pity we shall never know his name.

(C) The Rhodes Workshop[57]

Lawrence and, more recently, Frel have shown that the Alexander sarcophagus (PLATE 27b)[58] was a

product of the same Rhodian workshop as produced the colossal head, perhaps of Alexander, from Ialysos in New York (PLATE 49c, d).[59] The style of the workshop is not completely homogeneous, as a glance through Johannes' magnificent photographs of the heads from the sarcophagus will demonstrate; the sculptors were perhaps only assembled for this particular commission, the choice falling upon those whose styles were not too much at variance for a reasonable degree of harmony to be attained. Although each of the four friezes has something of a definable style of its own, this is largely because of the effort made to employ artists of similar approach on adjacent sections of the friezes, though more than one seems to have carved figures on two, or even three of the sides. The date of the sarcophagus, and thus of the workshop itself, is fixed by von Graeve in the penultimate decade of the century, perhaps c. 312 or just after.

Looking at the heads from the standpoint of the present discussion, the carvers may be divided into three classes: those that can definitely be said to follow Skopas' style, those that are merely influenced by it, and those that have little or nothing to do with it.

Into the first category fall the fragment in New York and a number of heads from the sarcophagus itself;[60] the New York head echoes the depth and richly modelled surface of the more advanced of the Tegea heads, but without developing either their compact proportions or trapezoidal structure; the chin and forehead are more rounded, less strongly articulated, and there is no prominent Michelangelo bar nor deep naso-labial furrow, although the eyes are pure Skopas. The hairstyle over the forehead echoes that of the Meleager (PLATE 44c, d). The sculptor was almost certainly employed on the sarcophagus; closest are the Alexander and two heads from the Alexander battle, and another from the battle scene on the short side. The last of these belongs to a terrified Persian whose hair and chin are gripped from behind by a muscular Greek, and who vainly tries to defend himself against his unseen assailant; his eyes begin to angle upwards and his eyebrows to rise in pure terror—a motif consistently eschewed by Skopas and his workshop, but (as here) gradually creeping back into favour among his followers in the years after his death.

The heads of this group stand in much the same relation to the style of Skopas as, for example, the Berlin-Terme youth does to that of Lysippos.[61] The style is smoother, with less emphasis on the osseous and muscular structure of the face, and shuns several of Skopas' more graphic mannerisms. The result is less forceful and concentrated, though it remains expressive in a general way, aided by the use of mobile brows

and open mouths where the situation requires it. The willingness of the sculptor to break up the closed 'Skopaic mask' in this way (shared with the Ilissos sculptor among others: PLATE 49b) signals a dissolution of the compromise achieved only thirty or forty years earlier, and augurs the final abandonment of the classic style for the more outspoken approach that was to reach its climax a century later with the Grand Guignol of the Pergamon altar.

A further three heads, possibly all by the same hand, develop another aspect of Skopas' style, his rich surface modelling.[62] Here the τιάρα or Persian cap-cum-headscarf covers the lower part and sides of the face, but the eyes and brows are very Skopaic, as are the rectangular foreheads. The modelling, however, is no longer merely rich but lumpy and soft, almost as if the face were moulded from dough. The style takes no account of changing textures over bone or muscle—in the context, this would only have been a solecism.

A few heads show Skopaic influence, largely in the proportions and generally fairly concentrated expression and deepset eyes.[63] A rather larger number seem to owe little or nothing to Skopas.[64] Such are the Alexander from the lion hunt, which is so close to Lysippos' Apoxyomenos that it must be by a follower, and several of the heads from the battle scene on the short side, which remind one of BM 1006 from the Mausoleum and look Attic.

Skopaic, Lysippic, Attic—the mixture repeats itself on the signed bases from the island.[65] A. W. Lawrence long ago denied any particular distinctiveness to Rhodian sculpture; such distinctiveness of style as there is in the sarcophagus is less in evidence at close range than at a distance, where the uniform drapery style, inconography, mood and technique of the friezes conceal the differing affiliations of the sculptors behind a harmonious and elegant façade.

Related to the heads of the sarcophagus is a youthful portrait head in the Rhodes museum[66] that echoes the uninspiring coiffure of the Genzano type (PLATE 30) and has extremely Skopaic eyes and neck muscles, but is longer in the jaw and apparently (although I know the piece only at second hand) rather characterless and hard. The Cupid's-bow lips are a caricature of some of the heads on the sarcophagus, to the wider circle of which, in Frel's opinion, it should be assigned. The workshop also had its imitators—a head in the Copenhagen National Museum from Trianda[67] is a clumsy and loutish version of the New York head; the coiffure again echoes that of the Genzano type.

The activity of the Skopaic section of this workshop does not seem to have lasted much, if at all, beyond 300. The particular reason for this seems to have been the increasing influence of Lysippos in the island; he is recorded to have made a statue of Helios in his chariot there, and signed a statue at Lindos. This was followed up by his pupil Chares of Lindos, whose colossal Helios established the supremacy of the Lysippan style on the island in the first decades of the new century.[68] The Skopaic style had lost its capacity for further development by then, and its swift disappearance from the Rhodian scene around 300 should surprise no one.

(D) Various (Late Fourth Century)

A number of heads from places as far apart as Rome and Cyrene show distinct echoes of the Skopaic style; in type, the majority follow the most advanced of the heads from the Tegean temple, nos. 9 and 16. All are close enough to the Tegea style to be by 'followers' of Skopas rather than sculptors who have merely fallen under his influence, although in the wider circle of Skopas' followers (e.g. nos. 2 and 5, below) it is difficult to distinguish between the two; given the mannerisms, I have taken the proportions and facial outline to be the touch-stone.

1. OXFORD (terracotta, from the Esquiline): L. R. Farnell, *JHS 7* (1886), 114-25 and plate.

This fine head, probably from a grave monument, is very closely related in type to the Meleager, although the hair is much looser and even more curly. Allowing a time lag, it perhaps dates from around 300.

2. ATHENS, NM 194 (marble, unknown provenience).

The miniature head is turned violently upwards and to the spectator's right, and could have been part of a battle group. In proportions and modelling it seems to resemble no. 17 from Tegea, but the damage is too great to say whether it actually came from Skopas' workshop; the chances are that it is from a pediment carved by a follower of Skopas between c. 340 and c. 320.

3. MUNICH, private collection (marble, from Greece): Bielefeld, *Pantheon* 25 (1967), 153-59, figs. 1-3.

The head is fairly close in its proportions and surface richness to Tegea no. 9, which the modelling of the forehead also recalls. The eyes, however, go their own way, turning the 'gap' at the outer corners into prominent crowsfeet. Perhaps c. 350–330.

4. CYRENE 43 (marble, from Cyrene): Paribeni, *Cirene* pls. 45-46.

The head has the hooded eyes and rather pointed

chin associated with the products of the Rhodes workshop, but is slightly narrower and, in profile, not so forceful. The model seems to be the Skopaic style of Tegea no. 17, but much watered down and refined; the date could be anywhere within 20 years or so of 300.

5. COPENHAGEN, NyC 252 (marble, from Athens): Arndt, *GNC* pl. 117; *Billedtavler* pl. 18 no. 252.

The modelling and individual forms are fairly Skopaic, especially the eyes, although the face is longer than that of Tegea no. 9, and has an individuality about it which the other lacks. The piece may date from the period of the early Diadochi (i.e., c. 320–300).

(E) Later Followers (Hellenistic)

A head set on the Uffizi Pothos (G5), but alien to it, is a copy of a work by a late follower of Skopas active early in the third century. The hair is very tousled, mobile and piled high on the head, which was turned vigorously to the figure's left shoulder. The model is the Meleager (PLATE 44c, d), but the statue to which this piece belonged must have been considerably later, for both hairstyle and proportions are beginning to show a decidely Hellenistic bias. The head itself, although still close to the style of the Niobids, is already developing that mannered smoothness and easy naturalism characteristic of so much early Hellenistic work;[69] the next stage, or next but one, is a mid-third century head once in Smyrna,[70] close in style to Doedalsas' Aphrodite, where what little that remains of Skopas' style is so watered down as to be virtually negligible.[71]

Although Skopas' Athenian followers cannot be traced to much beyond c. 300 even if we admit the sculptor of the Niobids to their number, the Skopaic style, like the Praxitelean, does seem to have enjoyed a minor revival there in mid-Hellenistic times. For this, the main evidence is the Asklepios from Munychia, now in the National Museum at Athens.[72]

Whether or not this is a cult-statue in Skopas' style, perhaps even by Skopas himself, has been disputed since Wolters' publication in 1892; Becatti and Arias accept his fourth century date, while others see the work as Hellenistic. A fresh look at the technique and style of the statue will perhaps help towards a solution.

Although the Asklepios was made from no fewer than five separate pieces of marble, attached to roughly pointed surfaces sometimes with, sometimes without iron dowels, this feature alone does not necessarily imply a Hellenistic date—the Alba youth and even the Tegea sculptures are almost as prodigal with

their *Ansätze*.[73] More fundamental is the technique of the head: the hair is only continued back for a short way on both sides, and the remainder of the skull pointed in very rough strokes; the crown was made separately and the drilling of the hair on the right is frankly crude.[74] Such negligence would be extraordinary in a cult-statue by a fourth century sculptor of the first rank, but has several parallels in Hellenistic times. Finally, the eyes were hollowed out and then inset, presumably in glass paste; this occurs occasionally in Severe style work, but to my knowledge is not then found again until the Zeus of Aegira in the late third century.

It is, in fact, with the Zeus of Aegira[75] that the major stylistic analogies are to be found. The modelling of the eyes, lips and moustache is almost identical, as is the way the nostrils are drilled and shaped. The beard and hair are in the same style, though here the Zeus, being on a much larger scale, is more detailed and colouristic. Finally, the pose of the Asklepios disqualifies it from being a fourth century work. In comparison with copies of fourth century leaning figures like the Fogg 'Meleager' (F32) and the Copenhagen Herakles, or even the Olympia Hermes,[76] it is clear that here the *déhanchement* and the forward movement of the hips are far more extreme, almost amounting to a dislocation—the *déhanchement*, in fact, of such 'centrifugally posed' figures as the Nike of Samothrace and the Venus de Milo,[77] with which in this respect the statue most closely compares.

If the Zeus is to be dated to the late third century, as Becatti suggests, this, too, is where the Asklepios should belong. The Zeus uses a toned-down version of the Skopaic eye, but little more; the Asklepios, very probably by an associate of Eukleides, is more venturesome, following Skopas' style more closely in such details as the turn of the head and the musculature of the torso, but updating it to meet the needs of 'modernised classicism' in the late third century.

5. SKOPAS' INFLUENCE

Skopas' influence on the other major sculptors of his time is a complex question, difficult to answer because of our lack of surviving originals. Arnold considers that his innovations in facial expression were an important factor contributing to the demise of the Polykleitan school in the third quarter of the century;[78] certainly, if the 'Perseus' from Anticythera is representative in this respect, she would seem to be right—there is little here of the closed features of Polykleitos' athletes or even Naukydes' Diskobolos. Skopas' influence on Lysippos has already been referred to briefly, and would seem to have been fairly

minimal, to judge from the faces of the Copenhagen and Farnese Herakles types, and the Apoxyomenos. As for the crossed legs of the Farnese Herakles, there are many other possible ancestors besides the Pothos, as we have seen; the motif even appears on the Parthenon frieze.[79] Seen in the context of fourth century sculpture as a whole, Skopas and Lysippos were clearly at opposite poles, and there they would seem to have remained.

In case of the sculptor of the Delphi 'Agias' and Leochares, however, Skopas' influence seems to have made itself rather more deeply felt, albeit in different ways. Let us examine the Agias first (PLATE 51a).[80]

The deepset eyes of the Agias—much deeper than those of the Apoxyomenos—have long been remarked upon; the right eyelid even hangs at the corner in something approaching a 'Skopaic bulge', yet neither the proportions nor modelling of the head are anywhere near Skopaic. There is a similar ambivalence in the motif of the pose, which must owe something to the Herakles Lansdowne, again, as many have recognised, although the central feature of the latter, the sinuous curve of the axis which passes up through the body without a break, is missing, and a composition of broken lines and disconnected rhythms substituted. As Beazley and Ashmole say, 'it belongs to the new age, and the Skopaic Herakles to the old.'[81]

How far is the Agias Lysippic? What evidence we have is mostly negative. Agias' inscription at Pharsalos[82] has an extra quatrain and Lysippos' signature; six statues from the Daochos dedication were not copies of Lysippos' Pharsalos group, though the Agias, Agelaos and Telemachos may have been versions of them; marble was not a material favoured by Argive-Sikyonian sculptors; finally, *pace* Arnold, the Agias seems to stand rather outside the Polykleitan tradition.

Recent publication of new photographs of both the Agias and the two copies of the Apoxyomenos by Dohrn and Schauenberg can, I think, help to solve the problem.[83] Not only does the head of the Agias seem well on the road to that of the Vatican Apoxyomenos, but the body structure and stance are also closely related. The differences are well accounted for by the twenty year gap between the two (Agias, 336–332; Apoxyomenos, c. 320–315), and the possibility that the Agias is not a direct copy, but a version arrived at via perhaps small clay models and a few measurements of the original. The Agias may thus pass for a work of the Lysippic circle, but by a sculptor who has picked up some of the more easily imitable aspects of Skopas' manner.

Leochares poses a different sort of problem, which is not made any easier by the sculptor himself suffering from something of a split personality. I find Ashmole's attribution of the Demeter of Knidos, the Alexander head (AkrM. 1331) and BM slabs 1013-15 convincing;[84] on the other hand, there is the Vatican Ganymede and the circle of works around that—the Apollo Belvedere (PLATE 51b) and the Versailles Artemis in particular.[85] We may perhaps call the first group Leochares I, and the second Leochares II. There does seem to be a link between the faces of BM 1013-15, especially the kneeling youth on BM 1013, and the Apollo, and also between the head of the Demeter and that of the Artemis, but to demonstrate this here would be to go beyond my brief.

Of the first group, the expression of the Demeter (seen from the proper angle) seems the most decidedly Skopaic. Bieber, in fact, goes so far as to attribute her to Skopas, which is clearly unjustified; the style, as Ashmole remarks, is Attic.[86] Yet one cannot deny that there is a concentration and tension in the eyes and mouth that speak clearly of Skopaic influence; we know that Skopas worked on the Mausoleum with Leochares, so perhaps here again we may surmise that the styles of the two may have interacted.

Turning to the second group, we find (apparently), the same double *contrapposto* that characterises the works of Skopas. At first sight this seems to jeopardise the whole fabric so carefully erected during the last four chapters. If the double *contrapposto* was not unique to Skopas and his followers, how can we possibly rely on it for our attributions? Yet a closer look reveals that while the two have the double twist and the turn of the head towards the 'open' side in common, the differences in other respects are fundamental (FIG. 1), for despite the strong central axis, the composition of the Apollo and Artemis is in essence centrifugal—they look one way, but move the other.[87] Considerable inner tension is the result, accounting for the abruptness of the movement and the feeling left in the spectator that the two are looking back at him, and will be gone in the next moment. Whether Leochares picked up the idea of the double *contrapposto* from Skopas or not, the use to which he puts it and the effects he sought to obtain could hardly have been more different; the two groups may or may not be by the same man, but clearly neither is Skopaic.

With original sculpture from fairly well dated monuments we are on firmer ground; in general, it is clear that Skopas' influence upon contemporary sculpture outside that associated with any particular school or master can almost be summed up exclusively in terms of his innovations in the field of facial expression. I have already referred to the appearance of a

'Skopaic' intensity of expression on some parts of the friezes and freestanding sculptures from the Mausoleum, which must reflect the presence of Skopas and Timotheos there. Since in this respect the style of the first would seem to have run on from that of the second, the present state of our knowledge hardly allows us to distinguish between the two where their influence is concerned, although we can perhaps be more confident that Skopas becomes the prime mover after the middle of the century.[88]

In the Amazonomachy, and apart from the 'pseudo-Maenad' of slab 1014, the least affected slabs appear to be 1006 and 1013-15, the most 1020-21 and 1022. As for the other reliefs, the glance of the charioteer BM 1037 is fairly penetrating, but rather exceeded in intensity by a centaur head illustrated by Buschor and perhaps from the coffer reliefs.[89] Skopaic influence upon the carvers of the heads BM 1056-58 has already been alluded to in Chapter 8.

Some Attic carvers were undoubtedly employed on the monument, as Ashmole and Jeppesen, among others, have pointed out (BM 1054, for instance, would fit well on a second-rate grave-relief of the time);[90] it is tempting to wonder whether future masters like the Ilissos sculptor may not have been among them. At any rate, sculptors returning from Asia in the 340s must have contributed greatly to the diffusion of Skopas' style in the later fourth century. Such journeymen may have carved the various heads from Rhodes discussed above, and worked on the Alexander sarcophagus. In the decades following the completion of the Mausoleum, the 'Skopaic' mannerisms of jutting brow and sagging orbitals become generally popular in all fields of sculpture—on grave-reliefs (e.g. NM 717, 737,[91] and a series of heads in the Ny-Carlsberg: nos. 212-14, 218),[92] on heads of athletes (e.g. Hyde's 'Philandridas' in Olympia, Berlin K233 and the early third century boxer in the Metropolitan Museum),[93] and on portraits (e.g. the Lateran type Sophokles, the Alexander/Herakles head in Boston and the Menander by the sons of Praxiteles).[94] As A. W. Lawrence has pointed out, the adoption of these mannerisms was not confined to any school or area, and their popularity was to increase in the Hellenistic period.[95]

Some vague Skopaic influence seems to have reached the carvers of the Ephesus column drum, BM 1206,[96] but it is clear that the styles this most reflects are the Polykleitan and the Attic; at least two sculptors seem to have been employed, and the approach is frankly eclectic.

A kneeling pirate from the Lysikrates frieze (PLATE 51c), dated to 335/4, has a distinctly Skopaic look about him. Not only is his torso richly and powerfully modelled like those at Tegea (compare e.g. nos. 14 and 15), but his head is so similar to no. 16 that it could almost be a copy. However, other figures from the same frieze, with their spirally rotated poses and almost complete spatial freedom should serve as a warning that such influence was often strictly limited; if Attic sculptors could make use of Skopas' intensity, so too could they pick up Lysippic screw-torsion, turning both to their own advantage in the process.

Fairly definite Skopaic influence seems to have reached the sculptor of the Vienna Amazon sarcophagus,[97] a finicky and otherwise rather unadventurous and conservative work of the last quarter of the century, to judge by the mannered style of the drapery. One of the Amazons, illustrated and discussed by Neugebauer, is quite a close relative of the Berlin Triton (PLATE 43a, c), though her face is rather longer from eyes to mouth and her chin not so deep. Her expression is reminiscent not only of Skopas but also of the heads by the sculptor of BM 1022 from the Mausoleum Amazonomachy. Apart from the central group, the figures on the long side lack the sense of drama and decisive action of Skopas' compositions (those to the sides are frankly conventional), and it should be clear that here again we would be unjustified in ascribing the work to the atelier, school or circle of any known 'master'. The same goes for the Alexander sarcophagus, which seems to belong around 312; many of the heads, as was remarked above, follow Skopas' style, but a larger number are either merely influenced by him in general terms or go their own way.

The metopes of the temple of Athena at Ilion, probably carved between 290 and 280, may serve to illustrate the extent to which the superficial aspects of Skopas' style had become virtually common coin in Greek sculpture by the period of the Diadochi. The reminiscences are uneven. Although one head could almost be a copy of Tegea no. 17, and, as Holden has noted,[98] the Helios from the only well-preserved metope has eyes that 'are deeply set and filled with Skopaic pathos', the style of the latter as a whole, with its 'soft, almost spongy' flesh, lacking 'emphasis on the underlying bone or muscular structure',[99] could not be further from Skopaic; the same may be said of the torsos that survive. Holden considers the style of the Ilion sculptures to be Rhodian;[100] however that may be, it is clear that by this time we can speak of 'Skopaic' only in the sense that Skopas' more notorious mannerisms had joined that *koine* of stock devices available to any sculptor who cared to make use of them; in the hands of most they were to become little more than clichés.[101]

EPILOGUE

Skopas' high place in the history of art is undisputed. His hold upon the sculptors of later generations, however, must be assessed in terms rather different from those which apply to his two great contemporaries, Praxiteles and Lysippos, even though with them he must bear much of the responsibility for the crisis of confidence in late fourth century sculpture and the failure of nerve that followed; the achievements of the fourth century masters left little room for manoeuvre to their successors of the third.

As the foregoing pages have shown, there is very little in the Hellenistic age or later that can be called 'Skopaic' in the way that we call so much of its portraiture Lysippic or its ventures into sensuality Praxitelean. Certain iconographic types of long duration may derive indirectly from his work (the Dionysiac processions and Sea Thiasoi on Roman reliefs and frescoes, for example), but in general, Skopas' importance to Western art lies not so much in the persistence of a distinct iconography or of vital traits of style, but rather in his initial discovery that there existed a further dimension to the realm of art, hitherto unrecognised or at best only vaguely and intermittently suspected—the emotional life of man and of the Gods created in his image.

Here his achievement was unique and his success **rivalled only by that of Michelangelo in a later age.** The nude of ecstasy, with all that the term entails for the later history of art, was his creation, and after his work at Tegea and on the Mausoleum the nude of energy, long known to the Greeks but its possibilities hitherto still scarcely realised, could never be quite the same again. As for his lost statues of the Gods, once the focus of his activity, our knowledge remains clouded, and all we can say is that if they even approached the originality and genius of the Maenad or the Pothos, their effect upon his contemporaries and successors in the field of sculpture must indeed have been powerful and profound.

Part III: Documentation

Appendix 1

THE LITERARY SOURCES

Concordance with *SQ*, Arias, *Skopas*, 60-93, and Marcadé, *Recueil* ii

	SQ	Arias		*SQ*	Arias	Marcadé
1	1149	1	27	1154	26	
2	942	-	28	1159	2	
3	755	27	29	1162	28	
4	1167	2	30	1163	29	
5	1174	2	31	1164	30	
6	1159	2	32	1175	2	
7	1160	3	33	1172	20	
8	-	-	34	1177	13	
9	1168	16	35	1178	14	
10	1169	17	36	1150	22	
11	1173	2	37	1180	32	
12	1166	12	38	1181	32	
13	1176	21	39	(1181)	-	
14	766	11	40	1182	33	
15	1152	24	41	1183	2	
16	1151	23	42	1184	-	
17	1176	21	43	1185	6	
18	1153	25	44	1186	5	
19	1161	10	45	1187	4	
20	1159	2	46	1188	-	
21	1171	19	47	1189	-	
22	1155	6	48	-	37	
23	1156	7	49	-	-	
24	1157	8	50	-	35	p. 10
25	1158	9	51	-	36	p. 10, *verso*
26	1165	31	52	-	34	p. 11

THE LITERARY SOURCES

A. ANCESTORS (?) (FIFTH CENTURY B.C.)

1. ... rursus [olympiade] LXXXX Polyclitus, Phradmon, Myron, Pythagoras, Scopas, Perellus [floruerunt].

Pliny, *Naturalis Historia* xxxiv.49

1. ... and again there flourished in the 90th Olympiad (420 B.C.) Polyclitus, Phradmon, Myron, Pythagoras, Scopas, Perellus.

2. Ἀρίστανδρος δὲ Πάριος καὶ Πολύκλειτος Ἀργεῖος ὁ μὲν γυναῖκα ἐποίησεν ἔχουσαν λύραν, Σπάρτην δῆθεν, Πολύκλειτος δὲ Ἀφροδίτην παρὰ Ἀμυκλαίῳ καλουμένην. οὗτοι δὲ οἱ τρίποδες μεγέθει τε ὑπὲρ τοὺς ἄλλους εἰσὶ καὶ ἀπὸ τῆς νίκης τῆς ἐν Αἰγὸς ποταμοῖς ἀνετέθησαν.

Pausanias iii.18.8

2. Aristandros of Paros made the statue of the woman with the lyre, supposedly Sparta, and Polykleitos of Argos the Aphrodite called 'beside the god of Amyklai'. The tripods are larger than the rest, and were dedicated from the spoils taken at the victory of Aegospotami.

B. SKOPAS
Cult statues
Aphrodite Pandemos, in Elis

3. ... περιέχεται μὲν τὸ τέμενος θριγκῷ, κρηπὶς δὲ ἐντὸς τοῦ τεμένους πεποίηται καὶ ἐπὶ τῇ κρηπῖδι ἄγαλμα Ἀφροδίτης χαλκοῦν ἐπὶ τράγῳ κάθηται χαλκῷ· Σκόπα τοῦτο ἔργον, Ἀφροδίτην δὲ Πάνδημον ὀνομάζουσι. τὰ δὲ ἐπὶ τῇ χελώνῃ τε καὶ ἐς τὸν τράγον παρίημι τοῖς θέλουσιν εἰκάζειν.

Pausanias vi.25.1

3. The sanctuary is surrounded by a wall, and within it there is a base, and on the base is a bronze statue of Aphrodite seated on a bronze he-goat; the group is by Skopas, and they call the Aphrodite the 'Pandemos'. As for the meaning of the goat, I leave the curious to guess.

Aphrodite, Pothos and Phaethon (?), in Samothrace

4. Is fecit Venerem et Pothon et Phaetontem,[1] qui Samothrace sanctissimis caerimoniis coluntur.

Pliny, *Naturalis Historia* xxxvi.25

4. He made the Aphrodite, Pothos and Phaethon, who are worshipped in Samothrace with the holiest ritual.

Aphrodite, later in Rome

5. ... praeterea Venus in eodem loco (templo Bruti Callaeci) nuda, Praxiteliam illam antecedens et quemcumque alium locum nobilitatura.

Pliny, *Naturalis Historia* xxxvi.26

5. ... and besides, there is a nude Aphrodite in the same place (the temple of Brutus Callaecus), surpassing even that of Praxiteles and sufficient to make famous any other place.

Apollo from Rhamnous, later in Rome

6. ... item [fecit] Apollinem Palatinum, ...

Pliny, *Naturalis Historia* xxxvi.25

6. ... he made, too, the Palatine Apollo, ...

7. Hic equidem Phoebo uisus mihi pulchrior ipso
 marmoreus tacita carmen hiare lyra; ...
 Deinde inter matrem deus ipse interque sororem
 Pythius in longa carmina ueste sonat.

 Propertius ii.31.5, 15

7. He really seemed to me more beautiful than
 Phoebus himself, a singer of marble with a silent
 lyre; ...
 And then there was the Pythian god himself,
 clad in a long robe and standing between his mother
 and sister, playing music.

8. Palatium, continet casam Romuli, aedem Ma' is
 deum et Apollinis Rhamnusii ...

 Notitia: descriptio urbis Romae, Regio X

8. The Palatium: it comprises the hut of Romulus,
 the sanctuary of the Mother of the gods and of Apollo
 from Rhamnous, ...

Apollo Smintheus, in Chryse

9. Ἐν δὲ τῇ Χρύσῃ ταύτῃ καὶ τὸ τοῦ Σμινθέως Ἀπόλ-
 λωνός ἐστιν ἱερὸν καὶ τὸ σύμβολον τὸ τὴν ἐτυμότητα
 τοῦ ὀνόματος σῶζον, ὁ μῦς, ὑπόκειται τῷ ποδὶ τοῦ ξοά-
 νου. Σκόπα δ᾽ ἐστὶν ἔργα τοῦ Παρίου ...

 Strabo xiii.604

9. And in Chryse there is the temple of Apollo
 Smintheus, and the mouse—the symbol that pre-
 serves the etymology of the god's name, lies beneath
 the foot of the image. These are the works of Skopas
 of Paros.

10. Φησὶ γὰρ ἡ ἱστορία ὅτι ἐν τῇ Χρύσῃ Σμινθέως
 ἐστὶν ἱερὸν καὶ μῦς ὑπόκειται τῷ ποδὶ τοῦ ξοάνου, Σκό-
 πα ἔργον τοῦ Παρίου...

 Eustathius 34.16

10. The story is that there is a temple of Apollo
 Smintheus in Chryse, and a mouse lies beneath the
 foot of the image, the work of Skopas of Paros ...

Ares, later in Rome

11. Nunc vero praeter supra dicta quaeque nescimus
 Mars etiamnum est sedens colossiaeus eiusdem (Sco-
 pae) manu in Templo Bruti Callaeci apud circum
 eundem (Flaminium).

 Pliny, *Naturalis Historia* xxxvi.26

11. And then, in addition to the works I have listed
 and those unknown to us, there is a colossal seated
 Ares by the same sculptor in the temple of Brutus
 Callaecus near the same circus (the circus Flaminius).

Artemis Eukleia, in Thebes

12. Πλησίον δὲ Ἀρτέμιδος ναός ἐστιν Εὐκλείας· Σκό-
 πα δὲ τὸ ἄγαλμα ἔργον.

 Pausanias ix.17.1

12. And nearby there is a temple of Artemis Eukleia;
 the cult-statue is by Skopas.

Athena, in Knidos

13. Sunt in Cnido et alia signa marmorea inlustrium
 artificum, liber pater Bryaxidis et alter Scopae et
 Minerva.

 Pliny, *Naturalis Historia* xxxvi.22

13. There are other marble statues in Knidos by
 famous sculptors, a Dionysos by Bryaxis, another by
 Skopas and an Athena of his as well.

Athena, in Thebes

14. Πρῶτα μὲν δὴ λίθου κατὰ τὴν ἔσοδόν ἐστιν Ἀθηνᾶ
 καὶ Ἑρμῆς, ὀνομαζόμενοι Πρόναοι· ποιῆσαι δὲ αὐτὸν
 Θειδίας, τὴν δὲ Ἀθηνᾶν λέγεται Σκόπας· μετὰ δὲ ὁ ναὸς
 ᾠκοδόμηται.

 Pausanias ix.10.2

14. Firstly, by the entrance, are an Athena and a
 Hermes of stone, named the 'Pronaoi'; Pheidias made
 the latter, and Skopas the Athena. Behind them is the
 temple (of Ismenian Apollo).

Asklepios and Hygieia, in Gortys (Arcadia)

15. Ἔστι δὲ αὐτόθι ναὸς Ἀσκληπιοῦ λίθου Πεντελη-
σίου, καὶ αὐτός τε οὐκ ἔχων πω γένεια καὶ Ὑγείας ἄγαλ-
μα· Σκόπα δὲ ἦν ἔργα.

Pausanias viii.28.1

15. And there there is a temple of Asklepios in Pen-
telic marble, with the god himself, beardless, and a
statue of Hygieia; they are the work of Skopas.

Asklepios and Hygieia, in Tegea

16. Τῷ δὲ ἀγάλματι τῆς Ἀθηνᾶς τῇ μὲν Ἀσκληπιός, τῇ
δὲ Ὑγεία παρεστῶσά ἐστι λίθου τοῦ Πεντελησίου, Σκό-
πα δὲ ἔργα Παρίου.

Pausanias viii.47.1

16. On one side of the statue of Athena stands
Asklepios and on the other Hygieia, both of Pentelic
marble and the work of Skopas.

Dionysos, in Knidos

17. (See no. 13).

17. (See no. 13).

Hekate, in Argos

18. Τοῦ δὲ ἱεροῦ τῆς Εἰληθυίας πέραν ἐστὶν Ἑκάτης
ναός, Σκόπα δὲ τὸ ἄγαλμα ἔργον. τοῦτο μὲν λίθου· ...

Pausanias ii.22.7

18. Beyond the temple of Eileithuia is that of Hek-
ate. The statue, of stone, is by Skopas.

Hermes

19. Ὦ λῷστε, μὴ νόμιζε τῶν πολλῶν ἕνα
Ἑρμᾶν θεωρεῖν· εἰμὶ γὰρ τέχνα Σκόπα.

Anthologia Planudea 192

19. Stranger, don't think you're looking at one of
the vulgar crowd of Herms; for I am the work of Sko-
pas.

Hestia, *campterae* and *canephoros*
later in Rome

20. ... item (fecit) ... Vestam sedentem laudatam in
Servilianis hortis duosque campteras² circa eam,
quorum pares in Asinii monumentis sunt, ubi et
canephoros eiusdem.

Pliny, *Naturalis Historia* xxxvi.25

20. He also made the famous seated Hestia in the
gardens of Servilius, and two pillars beside her,
whose pendants are in the galleries of Asinius,
where, too, is his basket-bearer.

Leto and Ortygia, in Ephesus

21. Ὄντων δ' ἐν τῷ τόπῳ πλειόνων ναῶν, τῶν μὲν ἀρ-
χαίων, τῶν δ' ὕστερον γενομένων, ἐν μὲν τοῖς ἀρχαίοις
ἀρχαῖά ἐστι ξόανα, ἐν δὲ τοῖς ὕστερον Σκόπα ἔργα· ἡ
μὲν Λητὼ σκῆπτρον ἔχουσα, ἡ δ' Ὀρτυγία παρέστη-
κεν ἑκατέρα τῇ χειρὶ παιδίον ἔχουσα.

Strabo xiv.640

21. There are several temples here, some archaic
and some later; in the archaic ones are ancient
wooden images, and in the others works of Skopas: a
Leto holding a sceptre, and Ortygia standing beside
her with a small child in each arm.

Personifications and demigods
Two Furies, in Athens

22. Μὴ οὖν ἀμφιβάλλετε, εἰ τῶν Σεμνῶν Ἀθήνησι
καλουμένων θεῶν τὰς μὲν δύο Σκόπας ἐποίησεν ἐκ τοῦ
καλουμένου λυχνέως λίθου, Κάλως δὲ τὴν μέσην
αὐταῖν· ...

Clemens Alexandrinus, *Protrepticus* 41

22. Do not doubt, then, that of the goddesses at
Athens called the Venerable Ones, Skopas made two
out of the stone called lychneus, and Kalos (Kalamis
?) the middle one ...

23. Τρεῖς ἦσαν, ὧν τὰς μὲν δύο τὰς ἑκατέρωθεν Σκόπας ὁ Πάριος πεποίηκεν ἐκ τῆς λυχνίτου λίθου, τὴν δὲ μέσην Κάλαμις.

Scholia in Aeschines *contra Timarchum* 188 (Dindorf)

24. Φύλαρχός φησι δύο αὐτὰς εἶναι, τὰ δὲ Ἀθήνησιν ἀγάλματα δύο. Πολέμων δὲ τρεῖς αὐτάς φησι.

Scholia in Sophocles *Oedipus Coloneus* 39

25. Πλησίον δὲ ἱερὸν θεῶν ἐστιν ἃς καλοῦσιν Ἀθηναῖοι Σεμνάς, Ἡσίοδος δὲ Ἐρινῦς ἐν Θεογονίᾳ. ... τοῖς δὲ ἀγάλμασιν οὔτε τούτοις ἔπεστιν οὐδὲν φοβερὸν οὔτε ὅσα ἄλλα κεῖται θεῶν τῶν ὑπογαίων.

Pausanias i.28.6

Eros, Himeros and Pothos, in Megara

26. Μετὰ δὲ τοῦ Διονύσου τὸ ἱερόν ἐστιν Ἀφροδίτης ναός ... Σκόπα δὲ Ἔρως καὶ Ἵμερος καὶ Πόθος, εἰ δὴ διάφορά ἐστι κατὰ ταὐτὸ τοῖς ὀνόμασι καὶ τὰ ἔργα σφίσι.

Pausanias i.43.6

Herakles, in Sicyon

27. Ἐν δὲ τῷ γυμνασίῳ τῆς ἀγορᾶς ὄντι οὐ μακρὰν Ἡρακλῆς ἀνάκειται λίθου, Σκόπα ποίημα.

Pausanias ii.10.1

Mortals
Canephoros, later in Rome

28. (See no. 20).

Maenad

29. Τίς ἅδε; Βάκχα. Τίς δὲ μιν ξέσε; Σκόπας.
Τίς δ’ ἐξέμηνε, Βάκχος, ἢ Σκόπας; Σκόπας.

Anthologia Planudea 60 (Simonides)

30. Ἀ Βάκχα Παρία μέν, ἐνεψύχωσε δ’ ὁ γλύπτας
τὸν λίθον· ἀνθρώσκει δ’ ὡς βρομιαζομένα.
ὦ Σκόπα, ἁ θεοποιὸς ⟨ἄπιστον⟩ ἐμήσατο τέχνα
θαῦμα χιμαιροφόνον Θυιάδα μαινομέναν.

Anthologia Palatina ix.774 (Glaucus of Athens)

31. (1) Οὐ ποιητῶν καὶ λογοποιῶν μόνον ἐπιπνέονται τέχναι ἐπὶ τὰς γλώττας ἐκ θεῶν θειασμοῦ πεσόντος, ἀλλὰ καὶ τῶν δημιουργῶν αἱ χεῖρες θειοτέρων πνευμάτων ἐράνοις ληφθεῖσαι κάτοχα καὶ μεστὰ μανίας προφητεύουσι τὰ ποιήματα· ὁ γὰρ δὴ Σκόπας, ὥσπερ ἔκ τινος ἐπιπνοίας κινηθεὶς εἰς τὴν τοῦ ἀγάλματος δημιουργίαν τὴν θεοφορίαν ἐφῆκεν. τί δὲ ὑμῖν οὐκ ἄνωθεν τὸν ἐνθουσιασμὸν τῆς τέχνης διηγοῦμαι;

23. There are three of them, the two at the sides being the work of Skopas in the stone called lychnites, and the middle one that of Kalamis.

24. Phylarchos says there are two of them, and two statues of them at Athens. Polemon, though, says there are three.

25. Nearby is the sanctuary of the goddesses whom the Athenians call the Venerable Ones, and Hesiod, in the *Theogony*, Erinys but there is nothing terrible about these statues of them, nor about those of the other gods of the Underworld there.

26. After the sanctuary of Dionysos comes the temple of Aphrodite ... Skopas made the statues of Love, Longing and Yearning (if indeed their functions are, like their names, distinct).

27. In the gymnasium of the agora, not far away, is a stone statue of Herakles, by Skopas.

28. (See no. 20).

29. ... "Who's this?" "A maenad." "Who carved her?" "Skopas." "Who make her frenzied, Bacchus or Skopas?" "Skopas."

30. The maenad is of Parian marble, but the sculptor made the stone to live; she springs us as if in Bacchic fury. Skopas, your god-creating art has produced an incredible wonder, a Thyad, a frenzied slayer of goats.

31. (1) It is not the art of poets and prose writers alone that is inspired when divine power from the gods descends onto their tongues, but the hands of sculptors also, when seized by the gift of a more divine inspiration, give utterance to creations that are possessed and full of frenzy. So Skopas, moved as it were by some inspiration, imparted to the production of this statue the divine frenzy within him. Why

should I not describe to you from the beginning the inspiration of this work of art?

(2) Ἦν βάκχης ἄγαλμα ἐκ λίθου Παρίου πεποιημένον ἀλλαττόμενον πρὸς τὴν ὄντως **βάκχην**. ἐν γὰρ τῇ οἰκείᾳ τάξει μένων ὁ λίθος τὸν ἐν λίθοις νόμον ἐκβαίνειν ἐδόκει· τὸ μὲν γὰρ φαινόμενον ὄντως ἦν εἴδωλον, ἡ τέχνη δ᾽ εἰς τὸ ὄντως ὂν ἀπήγαγε τὴν μίμησιν. εἶδες ἂν ὅτι καὶ στερεὸς ὢν εἰς τὴν τοῦ θήλεος εἰκασίαν ἐμαλάττετο γοργότητος διορθουμένης τὸ θῆλυ καὶ εἰς ἐξουσίαν ἀμοιρῶν κινήσεως ᾔδει βακχεύεσθαι καὶ τῷ θεῷ εἰσιόντι τὰ ἔνδον ὑπήχει.

(2) A statue of a maenad, carved from Parian marble, has been transformed into a real maenad. The stone retained its own nature, yet seemed to depart from the laws governing stone; what one saw was really an image, but art carried imitation over to reality. You might have seen that, hard though it was, it became soft like the feminine (its vigour, though, correcting the feminity), and that, though it had no power to move, it knew how to leap in the Bacchic dance and would respond to the god when it entered into its inner being.

(3) Πρόσωπόν γε μὴν ἰδόντες ὑπὸ ἀφασίας ἔστημεν· οὕτω δὴ καὶ αἰσθήσεως συνείπετο δήλωμα μὴ παρούσης αἰσθήσεως, καὶ βάκχης ἐκβακχεύων θειασμὸς ἐμηνεύετο θειασμοῦ μὴ πλήττοντος καὶ ὅσα φέρει μανίας οἰστρῶσα ψυχὴ τοσαῦτα πάθους διέλαμπε τεκμήρια ὑπὸ τῆς τέχνης ἀρρήτῳ λόγῳ κράθεντα. ἀνεῖτο δὲ ἡ κόμη ζεφύρῳ σοβεῖν καὶ εἰς τριχὸς ἄνθησιν ὑπεσχίζετο, ὃ δὴ καὶ μάλιστα τὸν λογισμὸν ὑπεξίστη, ὅτι καὶ τριχὸς λεπτότητι λίθος ὢν ἐπείθετο καὶ πλοκάμων ὑπήκουσεν μιμήμασιν καὶ τῆς ζωτικῆς ἕξεως γεγυμνωμένος τὸ ζωτικὸν εἶχεν.

(3) When we saw the face we stood speechless; so obvious upon it was the evidence of feeling, though it felt not; so clear an intimation was given of a maenad's divine possession stirring Bacchic frenzy, though no such possession aroused it; so strikingly there shone from it, fashioned by art in a manner not to be described, all the signs of passion a soul goaded by madness displays. The hair fell loose, to be tossed by the wind, and was divided to show the glory of each strand, which was what most transcended reason, seeing that, stone though the material was, it lent itself to the lightness of hair and yielded to imitation of locks of hair, and though lifeless, had vitality.

(4) Ἔφης ἂν ὅτι καὶ αὐξήσεως ἀφορμὰς ἡ τέχνη συνήγαγεν· οὕτως καὶ τὸ ὁρώμενον ἄπιστον καὶ τὸ μὴ πιστὸν ὁρώμενον. οὐ μὴν ἀλλὰ καὶ χεῖρας ἐνεργοὺς ἐπιδείκνυτο· οὐ γὰρ τὸν βακχικὸν ἐτίνασσε θύρσον, ἀλλὰ τι σφάγιον ἔφερεν ὥσπερ εὐάζουσα, πικροτέρας μανίας σύμβολον· τὸ δὲ ἦν χιμαίρας τι πλάσμα πελιδνὸν τὴν χρόαν· καὶ γὰρ τὸ τεθνηκὸς ὁ λίθος ὑπεδύετο—καὶ μίαν οὖσαν τὴν ὕλην εἰς θανάτου καὶ ζωῆς διῄρει μίμησιν, τὴν μὲν ἔμπνουν στήσασα καὶ οἷον ὀρεγομένην Κιθαιρῶνος, τὴν δὲ ἐκ τοῦ βακχικοῦ θανατωθεῖσαν οἴστρου καὶ τῶν αἰσθήσεων ἀπομαραίνουσαν τὴν ἀκμήν.

(4) You might say that art has brought to its aid the impulses of growing life, so unbelievable is what you see, so visible is what you do not believe. It actually showed hands in motion—for it was not waving the Bacchic thyrsus, but carried a victim as if uttering the Evian cry, the token of a more poignant madness. The figure of the kid was livid in colour, for the stone assumed the appearance of dead flesh; and though the material was one and the same, it imitated now life, now death, for it made one part instinct with life, as if eager for Cithaeron, and another brought to death by Bacchic frenzy, its keen senses withered away.

(5) Ὁ μὲν οὖν Σκόπας καὶ τὰς ἀψύχους εἰδωλοποιῶν γενέσεις δημιουργὸς ἀληθείας ἦν καὶ τοῖς σώμασι τῆς ὕλης ἀπετυποῦτο τὰ θαύματα, ὁ δὲ τὰ ἐν λόγοις διαπλάττων Δημοσθένης ἀγάλματα μικροῦ καὶ λόγων ἔδειξεν εἶδος αἰσθητὸν τοῖς νοῦ καὶ φρονήσεως γεννήμασι συγκεραννὺς τὰ τῆς τέχνης φάρμακα. καὶ γνώσεσθε δὲ αὐτίκα, ὡς οὐδὲ τῆς οἴκοθεν κινήσεως ἐστέρηται τὸ εἰς θεωρίαν προκείμενον ἄγαλμα, ἀλλὰ καὶ ὁμοῦ δεσπόζει καὶ ἐν τῷ χαρακτῆρι σῴζει τὸν γεννήτορα.

(5) So Skopas, fashioning creatures without life, was an artificer of truth and imprinted miracles on bodies of inanimate matter; while Demosthenes, fashioning images in words, nearly made visible a form of words by mingling the pigments of art with the creations of mind and intelligence. You will recognise at once that the image set up to be gazed at has not been deprived of its native power of movement; it is at the same time master of and with its whole being keeps alive its own creator.

Callistratus, *Statuarum descriptiones* ii

Architectural sculpture

From Bithynia, later in Rome

32. Sed in maxima dignitatione delubro Cn. Domitii in circo Flaminio Neptunus ipse et Thetis atque Achilles, Nereides supra delphinos et cete aut hippocampos sedentes, item Tritones chorusque Phorci et pristrices ac multa alia marina, omnia eiusdem manu, praeclarum opus, etiam si totius vitae fuisset.

Pliny, *Naturalis Historia* xxxvi.26

32. But most highly regarded of all is the group in the temple of Cn. Domitius in the Circus Flaminius: Poseidon himself, Thetis and Achilles, Nereids on dolphins and sea-monsters, or sitting on hippocamps, Tritons and the companions of Phorcus, sea-beasts and many other marine creatures, all by the same hand—a marvellous work, even were it that of a lifetime.

At Ephesus

33. Universo templo longitudo est ccccxxv pedum, latitudo ccxxv, columnae cxxvii a singulis regibus factae lx pedum altitudine, ex iis xxxvi caelatae, una a Scopa.[3]

Pliny, *Naturalis Historia* xxxvi.95

33. The full length of the temple is 425 feet, its breadth 225; the columns are 127 in number, each erected by a different king and 60 feet high. Thirty-six of these are carved, one by Skopas.[4]

At Halicarnassus

34. Scopas habuit aemulos eadem aetate Bryaxim et Timotheum et Leocharen, de quibus simul dicendum est, quoniam pariter caelavere Mausoleum. sepulchrum hoc est ab uxore Artemisia factum Mausolo, Cariae regulo, qui obiit olympiadis cvii anno secundo. opus id ut esset inter septem miracula, hi maxime fecere artifices. patet ab austro et septentrione sexagenos ternos pedes, brevius a frontibus, toto circumitu pedes ccccxxxx, attollitur in altitudinem xxv cubitis, cingitur columnis xxxvi. pteron vocavere circumitum. ab oriente caelavit Scopas, a septentrione Bryaxis, a meridie Timotheus, ab occasu Leochares, priusque quam peragerent, regina obiit. non tamen recesserunt nisi absoluto, iam id gloriae ipsorum artisque monimentum iudicantes; hodieque certant manus. accessit et quintus artifex. namque supra pteron pyramis altitudinem inferiorem aequat, viginti quattuor gradibus in metae cacumen se contrahens; in summo est quadriga marmorea, quam fecit Pythis. haec adiecta cxxxx pedum altitudine totum opus includit.

Pliny, *Naturalis Historia* xxxvi.30-1

34. Rivals and contemporaries of Skopas were Bryaxis, Timotheos and Leochares, who must be mentioned with him, for they all shared in the work on the Mausoleum. This is the tomb erected by Artemisia for her husband Maussolos, prince of Caria, who died in the 2nd year of the 107th Olympiad [351 B.C.]. That it is one of the seven wonders of the world is largely due to these sculptors. The north and south sides are 163 feet long; the façades are shorter, and the total perimeter is 440 feet; the height is 25 cubits, and the number of columns 36. This colonnade is called a pteron. Skopas carved on the east, Bryaxis the north, Timotheos the south, and Leochares the west, but before they had finished, the queen died. They did not, however, leave off until it was complete, judging it a monument to their own glory and to art as well, and even today they vie for the prize. There was also a fifth sculptor. For above the pteron is a pyramid, equal in height to the lower part, and consisting of 24 steps rising to a cone; on the top is a marble chariot and four horses, made by Pythis [Pytheos ?]. Including this the total height is 140 feet.[5]

35. Namque singulis frontibus singuli artifices sumpserunt certatim partes ad ornandum et probandum Leochares, Bryaxis, Scopas, Praxiteles, nonnulli etiam putant Timotheum, quorum artis eminens excellentia coegit at septem spectaculorum eius operis pervenire famam.

Vitruvius vii praef. 13

35. For on each side different craftsmen took their share in carving and in directing the work, in competition with each other: Leochares, Bryaxis, Skopas, Praxiteles, and some add Timotheos. The outstanding excellence of their work caused the fame of the Mausoleum to be included in the seven wonders of the world.

At Tegea

36. Τεγεάταις δὲ Ἀθηνᾶς τῆς Ἀλέας τὸ ἱερὸν τὸ ἀρχαῖον ἐποίησεν Ἄλεος· χρόνῳ δὲ ὕστερον κατασκευάσαντο οἱ Τεγεᾶται τῇ θεῷ ναὸν μέγαν τε καὶ θέας ἄξιον. ἐκεῖνο μὲν δὴ πῦρ ἠφάνισεν ἐπινεμηθὲν ἐξαίφνης, Διοφάντου παρ᾽ Ἀθηναίοις ἄρχοντος, δευτέρῳ δὲ ἔτει τῆς ἕκτης καὶ ἐνενηκοστῆς Ὀλυμπιάδος, ἣν Εὐπόλεμος Ἠλεῖος ἐνίκα στάδιον. ὁ δὲ ναὸς ὁ ἐφ᾽ ἡμῶν πολὺ δή τι τῶν ναῶν, ὅσοι Πελοποννησίοις εἰσίν, εἰς κατασκευὴν προέχει τὴν ἄλλην καὶ ἐς μέγεθος. ὁ μὲν δὴ πρῶτός ἐστιν αὐτῷ κόσμος τῶν κιόνων Δώριος, ὁ δὲ ἐπὶ τούτῳ Κορίνθιος· ἑστήκασι δὲ καὶ ἐντὸς⁶ τοῦ ναοῦ κίονες ἐργασίας τῆς Ἰώνων. ἀρχιτέκτονα δὲ ἐπυνθανόμην Σκόπαν αὐτοῦ γενέσθαι τὸν Πάριον, ὃς καὶ ἀγάλματα πολλαχοῦ τῆς ἀρχαίας Ἑλλάδος, τὰ δὲ καὶ περὶ Ἰωνίαν τε καὶ Καρίαν ἐποίησε. Τὰ δὲ ἐν τοῖς ἀετοῖς ἐστιν ἔμπροσθεν ἡ θήρα τοῦ ὑὸς τοῦ Καλυδωνίου· πεποιημένου δὲ κατὰ μέσον μάλιστα τοῦ ὑὸς τῇ μὲν ἔστιν Ἀταλάντη καὶ Μελέαγρος καὶ Θησεὺς Τελαμών τε καὶ Πηλεὺς καὶ Πολυδεύκης καὶ Ἰόλαος, ὅς τὰ πλεῖστα Ἡρακλεῖ συνέκαμνε τῶν ἔργων, καὶ Θεστίου παῖδες, ἀδελφοὶ δὲ Ἀλθαίας, Πρόθους καὶ Κομήτης· κατὰ δὲ τοῦ ὑὸς τὰ ἕτερα Ἀγκαῖον ἔχοντα ἤδη τραύματα καὶ ἀφέντα τὸν πέλεκυν ἀνέχων ἐστὶν Ἔποχος, παρὰ δὲ αὐτὸν Κάστωρ καὶ Ἀμφιάραος Ὀικλέους, ἐπὶ δὲ αὐτοῖς Ἱππόθους ὁ Κερκυόνος τοῦ Ἀγαμήδους τοῦ Στυμφήλου. τελευταῖος δέ ἐστιν εἰργασμένος Πειρίθους. τὰ δὲ ὄπισθεν πεποιημένα ἐν τοῖς ἀετοῖς Τηλέφου πρὸς Ἀχιλλέα ἐστὶν ἐν Καΐκου πεδίῳ **μάχη**.

Pausanias viii.45.4-7

36. The ancient sanctuary of Athena Alea was made for the Tegeans by Aleos; later on, however, the Tegeans built a big temple for the goddess and one worthy of her. This was completely destroyed by a sudden fire when Diophantos was archon at Athens, in the 2nd year of the 96th Olympiad [395 B.C.], when Eupolemos of Elis won the Olympic foot-race. The present temple is far superior to all other temples in the Peloponnese on many grounds, especially for its size and splendour. The exterior order is Doric, the interior Corinthian; within the temple there are also Ionic columns. The architect, I learnt, was Skopas of Paros, who made statues in many parts of ancient Greece, and in Ionia and Caria.

And as for the pediments, on the front is the Hunt of the Calydonian boar; the boar is right in the centre, and on one side are Atalante, Meleager, Theseus, Telamon and Peleus, Polydeukes, Iolaos, Herakles' partner in most of his labours, and also the sons of Thestios and brothers of Althaia, Prothoos and Kometes; behind the boar, in addition, are Ankaios, who has already been gored and has dropped his axe, with Epochos supporting him. Behind him come Castor, Amphiaraos the son of Oïkles, and next Hippothoos the son of Kerkyon, son of Agamedes, son of Stymphalos; last of all is Peirithoos. On the rear pediment is represented the battle between Telephos and Achilles on the plain of the Kaïkos.

Uncertain or spurious

Niobe and her children

37. Par haesitatio est in templo Apollinis Sosiani, Niobae liberos morientes⁷ Scopas an Praxiteles fecerit.

Pliny, *Naturalis Historia* xxxvi.28

37. It is likewise uncertain whether Skopas or Praxiteles made the group of the dying children of Niobe in the temple of Apollo Sosianus ...

Hermes Dikephalos

38. ... item (par haesitatio) Ianus pater, in suo templo dicatus ab Augusto ex Aegypto advectus, utrius manu (Scopae an Praxitelis) sit, iam quidem et auro occultatus.

Pliny, *Naturalis Historia* xxxvi.28

38. ... or again (it is uncertain) which of them made the 'Janus' brought from Egypt by Augustus and dedicated in his own temple, especially since it is now covered with gilding.

Eros

39. Similiter in curia Octaviae quaeritur de Cupidine fulmen tenente; id demum adfirmatur, Alcibiaden esse, principem forma in ea aetate.

Pliny, *Naturalis Historia* xxxvi.28

39. There is a similar problem with the Eros holding a thunderbolt, in the council-house of Octavia; it is only certain that it is a portrait of Alcibiades, the handsomest man of his day.

Artemis

40. —Ἀλλά τοί γε τὴν θεόν, ἦ δ' ὃς ὁ Εὔδημος, θαυμά-
σας—Ἄπτεμις γάρ ἐστιν αὐτοῖς ἐν μέσῃ, Σκοπάδειον
ἔργον—ταύτῃ προσπεσόντες ὅ τε Δαμασίας καὶ ἡ γυνὴ
αὐτοῦ, πρεσβῦτις ἤδη καὶ τὴν κεφαλὴν πολιὰς ἀκρι-
βῶς, ἱκέτευον ἐλεῆσαι σωᾶς· ἡ δὲ αὐτίκα ἐπένευσεν, καὶ
σῶς ἦν, καὶ νῦν Θεόδωρον, μᾶλλον δὲ περιφανῶς Ἀρτε-
μίδωρον ἔχουσι τὸν νεανίσκον, ἀνέθεσαν οὖν αὐτῇ τά τε
ἄλλα καὶ βέλη καὶ τόξα, ὅτι χαίρει τούτοις· τοξότις
γὰρ καὶ ἐκηβόλος καὶ τηλέμαχος ἡ Ἄρτεμις.

Lucian, *Lexiphanes* 12

Biographical and general

41. Scopae laus cum his (Praxiteli, Cephisodoto
minore) certat.

Pliny, *Naturalis Historia* xxxvi.25

42. Argenti genus omne comparasti,
 et solus veteres Myronos artes,
 solus Praxitelus manum Scopaeque ...

Martialis iv. 39.1-3

43. Τῶν περιωνύμων γὰρ καὶ οὗτος ἀγαλματοποιός.

Scholia Lucian *Lexiphanes* 12

44. Fingebat Carneades in Chiorum lapicidinis saxo
difisso caput exstitisse Panisci. Credo aliquam non
dissimilem figuram, sed certe non talem, ut eam a Sco-
pa factam diceres. ... Carneadem fingere dicis de
capite Panisci. quasi non potuerit id evenire casu, et
non in omni marmore necesse sit inesse vel Praxitelia
capita! illa enim ipsa efficiuntur detractione, nec quid-
quam illuc affertur a Praxitele ...

Cicero, *De Divinatione* i.13, ii.21

45. ... neque tu pessima munerum
 ferres; divite me scilicet artium,
 quas aut Parrhasius protulit aut Scopas,
 hic saxo, liquidis ille coloribus
 sollers nunc hominem ponere, nunc deum.

Horace, *Carmina* iv.8.4-8

46. Non me Praxiteles Scopasve fecit
 Nec sum Phidiaca manu politus ...

Priapea x.2-3

40. "But then," said Eudemos, "Damasias,
thunderstruck, invoked the goddess—they have an
Artemis in the middle of the hall, a Skopaic piece—
he and his wife, who's an old crone and grey as a
goose, threw themselves upon her and begged her to
pity them. She at once inclined her head, and he was
right as rain; so now they have a godsend, or rather
an Artemisend, in the young man. They then dedi-
cated all sorts of things to her, bows, arrows and such
like, since she likes them; for she's an archeress, a
long-range shooter, a global gladiator, is our Arte-
mis."

41. The praise of Skopas vies with theirs [i.e. Praxi-
teles and his son **Kephisodotos**].

42. You've collected every kind of silverware,
you're the only one with Myron's antique works of
art, the only one with stuff by Praxiteles and Sko-
pas ...

43. He was one of the famous sculptors of cult-
statues.

44. Carneades used to have a story that once, in the
Chian quarries, a head of Pan appeared when the
rock was split. I agree that the features were not un-
like his, but certainly not so close that you could
ascribe the piece to a Skopas ... You say Carneades
had a story about a head of Pan. As if that could not
have happened by chance, and as if there were not
Praxitelean heads latent in every piece of marble! For
that kind of thing is made by carving stone *away*—
Praxiteles doesn't *add* anything to it ...

45. Nor would you have the worst of my gifts,
naturally, if I were rich in works of art, of Parrhasios
or Skopas: the one in stone, the other in liquid
colours skilled in fashioning now a god, now a
mortal.

46. Praxiteles or Skopas made me not, nor was I
polished by Pheidias' hand.

47. Post quas nos tua pocula et tuarum
Musarum medius torus tenebat,
quales nec statuas imaginesque
aere aut marmoribus coloribusque
Mentor, Praxiteles, Scopas dederunt,
quantas nec Polycletus ipse finxit
nec fit Phidiaco figura caelo.

Sidonius Appollinaris, *Carmina* xxiii.500-506

47. Afterwards, your cups and a couch amid your Muses would claim us; no statue or picture, of bronze, marble or pigmented colours, was ever comparable to these, whether by Mentor, Praxiteles or Skopas. Polykleitos himself never fashioned anything so great, nor did Pheidias' chisel.

48. ΑΓΑΛΜΑΤΟΠΟΙΟΙ
ΦΕΙΔΙΑΣ Ο ΠΡΑΞΙΤΕΛΗΣ
ΣΚΟΠΑΣ

Laterculi Alexandrini col. 7, 3-5

48. ... Makers of cult-statues: Pheidias, Praxiteles, Skopas.

C. DESCENDANTS (2nd–1st centuries B.C.)

49. [Hercules invictus cognominatus vulg]o olivarius Opus Scopae minoris

NS 1895, 458 (Rome)

49. Hercules the unconquered, popularly called 'olivarius', the work of Skopas minor.

50. Γάιον Βιλλιῆνον Γαίου υἱόν, πρεσβευτὴν ᾿Ρωμαίων, οἱ ἐν Δήλωι ἐργαζόμενοι εὐεργεσίας ἔνεκεν τῆς εἰς ἑαυτοὺς ἀνέθηκαν.
᾿Αγασίας Μηνοφίλου ᾿Εφέσιος ἐπόει
᾿Αρίστανδρος Σκόπα Πάριος ἐπεσκεύασεν.

Inscriptions de Délos 1710

50. Gaius Billienus the son of Gaius, Roman ambassador. Erected by the merchants of Delos in recognition of his good services to them.
Made by Agasias, son of Menophilos, of Ephesos. Restored by Aristandros, son of Skopas, of Paros.

51. L. Munatium C. f. Plancum
Italicei et Graeci quei Deli
negotiantur
᾿Αγασίας Μηνοφίλου ᾿Εφέσιος ἐπόει
᾿Αρίστανδρος Σκόπα
Πάριος ἐπεσκεύασεν

Inscriptions de Délos 1696, 1697

51. Lucius Munatius Plancus, son of Gaius. Erected by the Greek and Italian merchants of Delos.
Made by Agasias, son of Menophilos, of Ephesos.
Restored by Aristandros, son of Skopas, of Paros.

52. ᾿Αγασίας Μηνοφίλου
᾿Εφέσιος ἐποίει
᾿Αρίστανδρος Σκόπα Πάριος ἐπεοκεύασεν

Inscriptions de Délos 2494

52. Made by Agasias, son of Menophilos, of Ephesos.
Restored by Aristandros, son of Skopas, of Paros.

Notes

1. Only one MS reads 'pothon et phetontem', and another 'phetontem' alone; for the former, adopted here, see Kerényi, *Symbolae Osloenses* 31 (1955), 141-53.

2. Stark, *AZ* 17 (1859), 73 proposed 'lampteras' here, without MS authority.

3. For Murray's emendation to 'imo scapo' see p. 152.

4. The MSS differ as regards the figures, but these are the generally accepted readings.

5. The MSS differ as regards the figures, but these are the generally accepted readings.

6. ᾿Εντός Frazer et al.; ἐκτός MSS. The two are often confused in the manuscripts.

7. One MS has 'nioben cum liberis morientem', but this is the generally accepted reading.

Appendix 2

CLASSICAL, HELLENISTIC AND ROMAN REPRESENTATIONS
OF THE CALYDONIAN HUNT

ABBREVIATIONS

M: H. Metzger, *Les représentations dans la céramique attique du IVe siècle* (1951), 312-13.

B: F. Brommer, *Vasenlisten zur griechischen Heldensage²* (1960), 235-37.

D: G. Daltrop, *Die kalydonische Jagd in der Antike* (1966).

K: F. S. Kleiner, 'The Kalydonian hunt: a reconstruction of a painting from the circle of Polygnotos,' *Antike Kunst* 15 (1972), 7-19.

I CLASSICAL

(a) **Before the Hunt** (B, 235 refers)

(1) RUVO, Jatta 1418 (hydria); *ARV²*, 1412; M.25; B.B5; M. Jatta, *Japigia* 3 (1932), 30 fig. 23; H. Sichtermann, *Griechische Vasen in Unteritalien* pl. 38. (c. 400–375).

(b) **The hunt itself** (B, 236-37 refers; K, 10-19 shows that nos. 3-6 and 8-15 [to which add no. 7, which he does not know] probably reflect a composition of the mid-fifth century [not no. 2: K, 18], perhaps Polygnotan in style).

(2) Picture mentioned in Pliny, *Naturalis Historia* xxxv.138 (*SQ* 1127):
'Aristophon [Iaudatur] Ancaeo vulnerato ab apro cum socia doloris Astypale.'
('Aristophon is praised for his picture of Ankaios wounded by the boar, with Astypale his partner in suffering.')

(3) ATHENS 1489 (dinos): *ARV²*, 577; B, 238.B1; K.1 and pl. 2 (c. 450).

(4) BERLIN 2538 (cup): *ARV²*, 1269; B.B1; D pl. 20; K.2 (c. 440).

(5) VIENNA (S. frieze from Heroon at Gjölbaschi-Trysa): D pl. 16 (part); K.3 and pl. 3, 1-3; *KiB* pl. 262, 3; F. Eichler, *Die Reliefs des Heroon von Gjölbaschi-Trysa* (1950) pls. 8-9 (c. 400).

(6) LENINGRAD B4528 (pelike): M.26 and pl. 41, 4; B.B2; D pl. 21; K.4; FR iii, 112 fig. 54; Schefold, *U* pl. 6 (c. 370). PLATE 28a.

(7) VARNA vi.495 (relief lekythos): E. A. Zervoudaki, *AM* 83 (1968), 27 fig. 3 and pl. 2, 3-4 (c. 370).

(8) BOSTON 05.59 (bronze mirror-case): D pl. 17; K.5; Züchner, *Klappspiegel*, 59 fig. 29 (c. 350).

(9) BERLIN 3258 (Apulian volute-krater): B.D1; D pl.22; K.6; FR iii, 112 fig. 55 (c. 340). PLATE 28b.

(10) TRIESTE S.380 (Apulian Panathanaic amphora): B.D3; D pl. 23; K.7 and fig. 1; *CV* iv.d pls. 14-15 (c. 330).

(11) BERLIN 3256 (Apulian amphora): K.8 and fig. 2 (c. 330).

(12) ISTANBUL 2922 (relief hydria); B.E1; D pls. 24-25; K.9; *MonPiot* 10 (1903) pls. 6-7; Zervoudaki, op. cit., 38 no. 80 (c. 325). PLATE 28c.

(13) BERLIN Inv. 8296 (terracotta mould from Smyrna): K.10 and fig. 3; W. Fröhner, *Terres-cuites d'Asie de la Collection Gréau*, (1886) pl. 89, 5; id., *Collection Julien Gréau, Terres-cuites Grècques* (1891) no. 1067; Furtwängler, *AA* 1892, 107; Dugas, 85 fig. 32 (c. 330). Lost.

(14) ROME, Villa Giulia Inv. 24 787 (bronze lid of the Ficoroni cist): K.11 and pl. 3, 4; Helbig⁴ 2976 (c. 320).

(15) IZMIR 348 (limestone stele): K, 13 n. 44a (fourth century?).

(16) ISTANBUL 368 (socle frieze of the sarco-phagus of Mourning Women): K,9; F. Hiller, *Marburger Winckelmanns-Programm* 1960 pl. 1 (c. 350).

(c) **After the hunt** (B, 235 refers)

(17) VIENNA 158 (volute-krater); *ARV²*, 1408; M.22; B.B1 (c. 400–375).

(18) WÜRZBURG 522 (calyx-krater): *ARV²*, 1410; M.24 and pl. 39,2; B.B2 (c. 400–375).

(19) ATHENS 15113 (neck-amphora): *ARV²*, 1411; M. 21 and pl. 40,4; B.B3 (c. 400–375).

(20) TORONTO 388 (neck-amphora): *ARV²*, 1411; M.23; B.B4; Robinson, Harcum and Iliffe, *Greek Vases at Toronto* pl. 69 (c. 400–375).

II HELLENISTIC AND ROMAN

(21) ST. REMY (frieze from Monument of the Julii): K,18; *AJA* 61 (1957) pl. 31,7; H. Rolland, *Le mausolée de Glanum (Gallia suppl. 21, 1969)* pl. 45 (first century B.C.).

(22) PARIS, Bib. Nat. (Severan coin of Tegea): Mionnet, *Médailles Antiques* ii (1807), 256 no. 75; *NCP* pl. V,20; Frazer, *Pausanias* iv, 429 fig. 44 (c. 200 A.D.). PLATE 29a.

For representations of the hunt on Roman sarco-phagi and mosaics, see D pls. 28-31; K.13-17 and pl. 4,1-2 also fig. 5; C. Robert, *Die Antiken Sarkophag-Reliefs* iii.2 (1904) pls. 70-88 (new edition in preparation); B. Andreae and others, *JdI* 87 (1972), 388-432; G. Koch, *AA* 1974, 291-98.

Appendix 3

THE ARCADIAN DYNASTY

(after Pausanias viii. 1-5: kings of
Arcadia numbered and in italics)

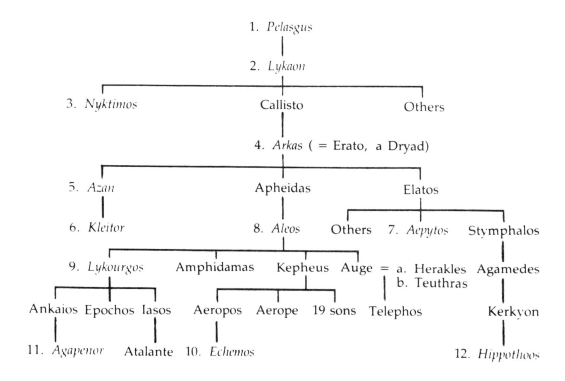

As for chronology, Aleos (8) was contemporary with Herakles, and Ankaios, before taking part in the Calydon hunt, accompanied the Argonauts to Colchis; Echemos (10) defeated Hyllos and ended the first Dorian invasion of the Peloponnese, a little before the Trojan war, in which his contemporary, Agapenor (11) took part. The second (successful) Dorian invasion took place in the lifetime of Kypselos, grandson of Hippothoos (12).

Appendix 4

COPIES OF MAJOR WORKS
CONSIDERED IN CHAPTERS 7-9

ABBREVIATIONS:

D: H. Dütschke, *Antike Bildwerke in Oberitalien* (1874–82)

M: A. Michaelis, *Ancient Marbles in Great Britain* (1882)

MD: F. Matz and F. von Duhn, *Antike Bildwerke in Rom* (1881–82)

The name of a town signifies the chief collection in it; where the place name is omitted the collection is in Rome. The words 'stanza', 'sala' and 'galleria' are generally omitted. Restorations are not given unless misleading or incorrect; 'head alien' or 'statue alien' means that the head does not belong to the body or vice versa.

A. HERAKLES PLATES 30-31, 52
(LOS ANGELES—GENZANO TYPE)

Stands on left leg with right slightly relaxed. Pose unchiastic. Right arm lowered, hand holds club (lower end rests on ground); lion's skin draped over extended left forearm, left hand holds apples of Hesperides. Head beardless, turned to raised left shoulder, wreathed with white poplar. Hair bound with broad fillet descending to shoulders, locks parted over right eye; repeated pattern of short hook-curls over left forehead distinctive. Ht. of original, 1.76 m.

Variants: ivy or oak-leaf crown.
Versions: stance altered (though remains unchi-astic); hair style changed, once (A20) Romanised.

Most of the copies are herms, where the turn of the head is varied to suit the intended position of the piece in the room.

Copies collected and studied by B. Graef, *RM* 4 (1889), 189-216; A. Preyss, text to B-B 691-92 (1926); Mustilli, *MusMuss*, 80-81; Arias, 104-8; A. Linfert, *Von Polyklet zu Lysipp* (diss. Freiburg, 1966), 33-37, 71-75; S. Howard, *The Lansdowne Herakles* (J. Paul Getty Mus., *Publication no. 1*, 1966), 30-31. Neugebauer (text to B-B 717-18, 6) remarked upon the great divergences in the copies of the head, while Ashmole (*JHS* 42 [1922], 241-45 figs. 6-8) believes Graef to have conflated two types, one Skopaic and one Praxitelean, and Stuart-Jones, *PalCons*, 90-92 considers the Conservatori herm (see Appendix to Chapter 7, section 4) to be a Dionysos. Thus, the following should be removed from the lists altogether:

(1) The Herakles Lansdowne and its replicas (E1-10). The deciding factors here are the hair style and great depth of the skull.

(2) The herm Mus. Cap. Nuovo Inv. 934, Helbig[4] 1731. Ashmole, loc. cit.; Graef 2; Preyss 6; Mustilli 1; Arias 6; Linfert Bb). Closely related to the Olympia Hermes and definitely Praxitelean. The dimple in the chin and hair style are distinctive; apparently the only copy of its type.

(3) The Conservatori herm (see above).

The hair styles of some of the 'versions' listed below also diverge markedly from the scheme described above, and it is possible that the type should be restricted even further.

I. Copies

1. Statue, Los Angeles 50.33.22. S. Reinach, *RA* 6 (1917), 460-61 fig. 1; Linfert Aa. PLATE 31a-c. For full bibliography, see note 7, Chapter 7. Antonine.

2. Torso, Cairo 27445. C. C. Edgar, *Catalogue générale des antiquités égyptiennes du Musée du Caire* iv pl. 4; Linfert Ab. Replica of Hellenistic copy?

3. Herm, London, BM 1731 (Genzano herm). Smith, *BMCat* iii pl. 5,2; Graef 7; Preyss 5; Mustilli 2; Arias 4 and pl. 2,6 (reversed) and 7; Linfert Ba. Hadrianic. PLATES 30, 52a-c.

4. Herm, Vatican Geografica 64. Helbig[4] 581; *SVM* iii.2, 490 and pl. 224; Graef 11; Preyss 8 and fig. 2; Mustilli 3; Arias 8; Linfert Bc. Poplar crown wrongly restored as ivy. Hadrianic.

5. Head (restored as herm), Pal. Corsini MD 138.

Graef 8 and fig. on p. 195; Preyss 7; Mustilli 6; Arias 7; Linfert Bd.

6. Head (restored as herm), Conservatori, Guerre Puniche 12 (formerly Mus. Cap. Terrene a Dritta 23). Stuart-Jones, *MusCap*, 71 and pl. 13; Graef 15; Preyss 11; Mustilli 7; Linfert Be. Antonine, copy of copy, as A7-9?

7. Head, Vatican, Chiaramonti 693. *SVM* i, 85; Graef 4; Preyss 19; Mustilli 16; Arias 14; Linfert Bj.

8. Head, Dresden 104. *EA* 152-53; Lawrence, *Classical Sculpture* pl. 89b; Preyss 16; Mustilli 12; Arias 13; Linfert Bl.

9. Head, Copenhagen, NyC 255. *EA* 4170-71; *Billedtavler* pl. 18; Graef 10; Mustilli 9; Linfert Bg.

II. Variants

Most of these and versions at least twice removed from original.

10. Bust, Madrid 53-E. *EA* 1619-20; A. Blanco, *Catalogo de la Escultura* (1957) pl. 33; Preyss 14; Mustilli 10; Arias 11; Linfert Bh. Ivy crown.

11. Herm, Brocklesby M 33. *EA* 4862; Michaelis, 232; Graef 16; Preyss 9; Mustilli 14; Arias 9; Linfert Br. Ivy crown.

12. Herm, Mus. Torlonia 186. Graef 20; Preyss 13; Mustilli 18; Arias 10; Linfert Bs. Ivy crown.

13. Double herm, Leningrad 62. Waldhauer, *Die antiken Skulpturen der Ermitage* i, 74 and pl. 37. Oak-leaf crown.

III. Versions

14. Statue (two-thirds lifesize), Osterley Park. *AJA* 59 (1955), 144 no. 4 and pl. 45,26. Ivy crown. Antonine?

15. Colossal statue, Pal. Torlonia MD 97. Clarac pl. 790 no. 1970; Preyss 30; Arias 20. Very fragmentary, heavily restored. Head modern.

16. Statue (head alien), Jerusalem, Israel Mus. S. Applebaum, *Bull. Mus. Haaretz* 13 (1971), 14-17 and pl. 2. I thank Michael Vickers for this reference.

17. Bust, Venice Inv. 3 (D 334). *EA* 2618-19; Graef 9; Preyss 20; Mustilli 4; Arias 15; Linfert Bk. Oak-leaf crown.

18. Herm (restored as bust), Florence 30. Mansuelli, *Uffizi* i, 52 and fig. 28; B-B 693; Preyss 21; Arias 16; Linfert Bt. Oak-leaf crown.

19. Head, Dresden 105. *AA* 1894, 27 no. 9 and fig; Mustilli 11. Oak-leaf crown.

20. Head (restored as herm), Mus. Cap. Terrena a destra 1 (formerly Filosofi 17). *EA* 429-30; Stuart-Jones, *MusCap*, 226 and pl. 56; Graef 12; Preyss 10; Mustilli 17; Arias 26; Linfert Bq. Hair style Romanised. Heavily restored; possibly even a replica of Herakles Lansdowne type (E).

IV. Replicas in other media

21. Coin of Sicyon, London, BM. *BMCat* (*Peloponnesus*), 56 no. 247 and pl. 9,22; *NCP* 30 no. 7 and pl. H, 11; Picard, *Man* iii.2 fig. 307; Preyss 38; Arias 36 and pl. 1,5. PLATE 31d.

22. Relief, Bucharest 131. E. Bordenache, *Scultura Greche e Romane*, 71 and pl. 58.

23. Fresco, Pompeii (House of the Priest Amandus). G. Picard, *Roman Painting* pl. 62.

B. MAENAD PLATE 32
(DRESDEN TYPE)

Stands on right leg with left withdrawn. Pose chiastic. Wears a long chiton, girdled above waist and open down left side to reveal buttock and leg. Right arm lowered, perhaps to hold chiton clear of ground, left arm flexed, holding goat against left shoulder. Back arched (left shoulder raised and thrust forward), head flung back and turned to left. Long hair streams free behind. Height of original unknown.

> Versions: stance, drapery altered. For pieces eclectically dependent upon this and Kallimachean types, see below.

Copies collected by Arias, 126-27. Studies by Treu, *Mélanges Perrot* (1902), 317-24; Neugebauer, *Studien*, 51-75; *contra*, J. Six, *JdI* 33 (1918), 38-48. Two types with tympana are investigated by T. Lorenz, *BABesch* 43 (1968), 52-58 and M. Maaskant-Kleibrink, ibid., 70-74; these are related to the Skopaic χιμαιροφόνος but should not be conflated with it. I would judge them as probably eclectic.

I. Copy

1. Statuette, Dresden 133. Arias 1 and pl. 10,34-36; Boardman et al., *Art and Architecture* pl. 255. PLATE 32.

II. Replicas in other media

2. Mirror-case, Leningrad B991. Züchner fig. 16 (KS 55).

3. Neo-Attic reliefs in Rome and elsewhere. F.

Hauser, *Die Neuattischen Reliefs* (1889) pl. 2,30; Treu, op. cit. fig. 2; Fuchs, *Vorb*, 83-84, 86 and pl. 19a-b.

III. Derivation from the Dresden type

4. Amazon, London, BM 1014 (from the Mausoleum). Lullies-Hirmer pl. 214; Lippold, *Plastik* pl. 92,2; Ashmole, *Architect and Sculptor* figs. 207, 212.

C. APHRODITE PANDEMOS PLATE 33a

Rides side-saddle on a goat leaping (or running) to spectator's right; clad in long chiton and himation. Latter billows over head, held by right hand. Only small scale variants and versions preserved, exact pose of legs, arms and head uncertain. Height of original unknown.

Copies collected and studied by Züchner, *Klappspiegel*, 7-10 (KS 4-7); L. Lacroix, *Les Réproductions de Statues sur les Monnaies Grècques* (1949), 316-17; Arias, 125-26. For further comments see *NCP*, 72 no. 5; Picard, *Man* iii.2, 699-703 (with bibliography), and Schlörb, 59 n. 182. The type is to be distinguished from its derivation, the Athenian Aphrodite *Epitragia* (Arias 9; Furtwängler, *Die Antike Gemmen* i pl. 57,22; Schefold, *U*, 81, 89 and fig. 29, also pl. 10,1).

Replicas on coins, etc.

1. Coin of Elis, London, BM (Hadrian). *NCP*, loc. cit. and pl. P,24; Lacroix, loc. cit. and pl. 28,5; *BMCat (Peloponnesus)*, 75 no. 156 and pl. 16,4.

2. Coin of Elis, Athens NM (Severus). *NCP*, loc. cit. and fig.; Lacroix loc. cit.; Arias 1 and pl. 7,25 (confused with C1).

3. Mirror-case, Paris 1707. Züchner KS 4 and pl. 6; Arias 6. PLATE 33a.

4. Mirror-case, Athens NM 7421. Züchner KS 5; Arias 7 and pl. 7,26.

5. Mirror-case, Berlin Antiquarium 8064. Züchner KS 6; *JdI* 3 (1888), 251 no. 7 and fig.; Arias 5.

6. Mirror-case, Berlin Antiquarium 8393. Züchner KS 7 and fig. 1.

7. Marble disc, Paris Inv. 978. *MonPiot* 1 (1894), 143-50 fig. 2; Arias 8.

8. Relief, Sparta. *EA* 1314 with bibliography; Arias 4.

9. Statuette, Vienna (Lanckoronski). *ÖJh* 31-32 (1922–24) fig. 81; Arias 3.

10. Terracotta, Paris. S. Reinach and E. Pottier, *La Nécropole de Myrina* (1887), 23 no. 39 and pl. 6; Arias 2.

D. APOLLO PALATINE PLATE 33b

Stands on left leg with right relaxed and set slightly to side. Pose chiastic. Clad in long peplos with relatively high girdle and apoptygma, himation hangs from shoulders. Right arm extended with patera, left holds cithara against upper torso. Head frontal or turned to right shoulder. Small fold bundle over centre of girdle and deflection of folds over instep of left foot characteristic. No statue preserves head. Height of original c. 2 m.

Variations largely in drapery style and turn of head.

Copies collected and studied by O. Deubner, *Hellenistische Apollogestalten* (1934), 5-9 and 71-72; Arias, 101-2. See also Arndt, text to *EA* 334; Lippold, *Kopien*, 224-28; Rizzo, *BullComm* 60 (1932), 51-66; Becatti, **BullComm** 64 (1936), 19-25; Picard, *Man* iii.2, 639-50. The so-called 'Ariadne-Apollo' head (Deubner, op. cit., 71-72; Picard, op. cit., 647-50 fig. 275) could be Skopaic, though I know it only from reproductions; if so, it is early.

Of Arias' 'copies', 12 and 16 are the Apollo Patroos of Euphranor, Agora S 2154, 8, 13 and 14 its replicas and variants (Thompson, *AE* 1953–54 [1961] 3, 30-44), 9-11 are a third type, possibly close to Kephisodotos' Eirene (Thompson, op. cit., 39) and 15 shows a fourth, datable to the first quarter of the century by comparison with the 'record' reliefs (eg. Süsserott pl. 3,1).

I. Copies

1. Statue (headless), Catania 12. Libertini, *Il Museo Biscari*, 9 and pl. 6; Deubner 22b; Arias 7.

2. Torso, Munich (Bünemann). H. Marwitz, *AP* 6 (1967), 47-48 figs. 31-32 and pls. 28-29.

3. Lower torso, Florence, Pal. Corsini. *EA* 334; Rizzo, op. cit., 65 fig. 8; Deubner 22c; Arias 4 and pl. 1, 2. Upper torso restored.

4. Statuette (headless), Salviano (Todi), Fattoria Corsini. Becatti, op. cit. fig. 1; Picard, loc. cit. fig. 274; Arias 5.

II. Versions

5. Colossal statue, Pal. Borghese MD 1374. *EA* 494; Arias 6.

6. Statue, Belgrade. Reinach, *Répertoire* iv pl. 58,5; Deubner 22d.

III. Replicas in other media

7. Statue-base, Sorrento. Rizzo, op. cit. pl. 3; Lip-

pold, *Plastik* pl. 89, 1; Deubner 22a; Arias 3. PLATE 33b.

8. Coin of Augustus (denarius). Rizzo, op. cit. pl. D,1; Arias 1.

9. Coin of Antoninus Pius (sestertius). Becatti, op. cit., 25 fig. 2.

10. Coin of Antoninus Pius (denarius). Rizzo, op. cit. pl. D,3; Arias 2 and pl. 1,1a.

11. Coin of Antoninus Pius (denarius). Rizzo, op. cit. pl. D,2; Arias 2 and pl. 1,1b (both this and D10 confused with D9).

E. HERAKLES (LANSDOWNE TYPE) PLATES 42, 52

Stands on right leg, left set to side. Pose chiastic. Right arm relaxed, holds lion's skin with right hand. Left forearm extended, supports club resting (perhaps originally on a chlamys) on left shoulder. Head beardless, turned to left shoulder (raised and thrust forward slightly), hair bound with narrow fillet. Parting over right eye, pattern of curls over forehead related to, but distinct from and more varied than on heads of Los Angeles-Genzano type (A). Height of original, 1.95 m.

Variants: omit or elaborate fillet, add wreath in analogy with type A, or alter facial modelling and proportions.

Type hitherto not distinguished from Los Angeles-Genzano, though Linfert, *Von Polyklet zu Lysipp*, 71-75 excludes E1 from list of replicas of this type; see above, under A, for discussions.

I. Copies

1. Statue, J. Paul Getty Mus., Malibu (formerly London, Lansdowne). B-B 691-92; Arias 1 and pl. 1, 3 and 4; Lippold, *Plastik* pl. 91, 1; S. Howard, *The Lansdowne Herakles*, passim; Richter, *Sc⁴* fig. 754. Hadrianic. PLATES 42a-c, 52a-c.

2. Head, once Roman Market (formerly Jandolo). *EA* 2001-2; Preyss 2; Arias 3; Linfert Bo; Howard 2 and fig. 16.

3. Head, Florence 29. *EA* 85-86; Mansuelli, *Uffizi* i fig. 26; Graef 14; Preyss 1; Arias 2; Linfert Bm; Howard 1. Antonine?

4. Head, Vatican (formerly Lateran). Helbig⁴ 1081; *EA* 2181-82; Graef 17; Preyss 3; Linfert Bn; Howard 3. Crude.

II. Variants

5. Head (restored as herm), Dresden 132. *EA* 164-

65; *AA* 1894, 171-72 no. 5 and fig; Preyss 15; Arias 12; Linfert, 75 n. 23 (c); Howard 15. Olive crown, narrow fillet.

6. Head, Copenhagen, NyC 254. *EA* 4168-69; *Billedtavler* pl. 18; Mustilli 5; Linfert Bf. Poplar crown, narrow fillet.

7. Bronze bust, Naples 848. B-B 365; Picard, *Man* iii. 2 fig. 312; Preyss 4; Arias 25; Linfert Bu; Howard 4. Olive crown, twisted as narrow fillet. Before 79 A.D. (Augustan ?).

III. Replicas in other media

8. Pelike, Leningrad St. 1792. *ARV²*, 1476; FR pl. 70 (whence PLATE 42d); Schefold, *U*, 40-42 (no. 368) and pl. 35.

9. Parastas, Athens NM. *ADelt* 11 (1927–28), *Parartema*, 50 no. 177 fig. 9; Schweitzer, *ÖJh* 39 (1952), 106 n. 21.

10. Gem, London, BM 1892. Furtwängler, *Die Antiken Gemmen* pl. 49,20; Preyss 22 and fig. 1; Howard 22 and fig. 2. Forged ? (ibid., 31-32 n. 2).

F. MELEAGER PLATES 44, 48d, 52

Stands on right leg with left relaxed. Pose chiastic. Right arm flexed, hand held against right buttock; left arm holds boar-spear against shoulder. Head turned towards left shoulder, which is raised and thrust forward. Hair tousled, two S-curls over centre of forehead, small curl at right temple distinctive. Presence of chlamys (draped across shoulders and around left arm), dog, boarshead and rock uncertain. Heads differ over age of subject. Height of original, 2.10 m.

Variant: stance and attribute changed.
Versions: statue adapted for portrait or deity.

Copies listed and studied by Graef, *RM* iv (1889), 218-26; Johnson, *Lysippos*, 241-43; van der Kolf, in *RE* s.v. 'Meleagros' cols. 470-72 (1931); M. Cagiano de Azevedo, *Le Antichità di Villa Medici* (1951), 84-85; Arias, 127-31. Additions by Harrison, *Hesp* 29 (1960), **381-82**; Sichtermann, *RM* 69 (1962), 43-44; V. Karageorghis and C. Vermeule, *Sculptures from Salamis* (1964), 18-19, 30-31; E. Berger, *Antike Kunst* 10 (1967), 66.

See also Buschor, *Antike Plastik für Amelung*, 55-56; **Becatti**, *RivIst* 8 (1940), **64-68**; Sichtermann, *RM* 69 (1962), 43-51; id., *RM* 70 (1963), 174-77; G. M. A. Hanfmann and J. G. Pedley, *AP* 3 (1964), 61-66; J. Fink, *RM* 76 (1962), 239-52 for further discussions, also the works listed in **notes 3-6, Chapter 9.**

The following should be excluded from the lists altogether:

(1) Statue, Holkham Hall M 20. *EA* 4872; C. Vermeule and D. von Bothmer, *AJA* **63** (1959), 153-54; Arnold, 258 no. 35; Graef 2; Johnson 2; van der Kolf 200; de Azevedo 13; Arias A7. 'Narcissus' type, restored as Meleager by Cavaceppi.

(2) Statue, Pal. Barberini. Reinach, *Répertoire* i pl. 486,1; Graef 12; Johnson 12. Leans on tree trunk: replica of 'Narcissus' type?

(3) Statue, Versailles Park. E. Pinatel, *Les statues antiques des jardins de Versailles,* 188 no. 18 and pl. 18; Graef 5; Johnson 5; van der Kolf 197. Not antique.

(4) Statue, Naples 677. Sichtermann, *RM* **69** (1962), 50 n. 39 and pl. 21, 4; van der Kolf 196. Not antique.

The following are doubtful:

(5) Statue, Vatican. Clarac pl. 805, no. 2020, whence Reinach, *Répertoire* i pl. 479,1; Graef 3; Johnson 3; van der Kolf 221; de Azevedo 20; Arias A12. Seen neither by Graef nor any subsequent scholar, and in some details suspiciously like F1. Possibly a dittography of Reinach's.

(6) Statue, Pal. Doria. Furtwängler, *Masterpieces,* 304 n. 3; Johnson 17; van der Kolf 213; de Azevedo 19. Apparently seen by Furtwängler, who gives some details, but now lost. Restored and therefore doubtful.

(7) Statue, Mus. Torlonia 19. Furtwängler, loc. cit; Johnson 15; van der Kolf 212. Restored as Hermes and therefore again dobutful.

(8) Torso, Paris. Furtwängler, loc. cit. ('from Rome, 1884'); Johnson 16; van der Kolf 214; de Azevedo 21. Lost, no drawing survives: could have been Meleager or 'Narcissus'.

I. Copies

1. Statue, Vatican Animali 40. Helbig[4] 97; B-B 386; *SVM* ii, 33 no. 10 and pls. 3 and 12; Lippold, *Plastik* pl. 102,4; Fink, op. cit. pls. 76, 1;78, 1-2; Graef 1; Johnson 1; van der Kolf 192; Arias A4 and pl. 12,43; de Azevedo 2. Antonine. PLATES 44b, c, 48d, 52a-c.

2. Statue, Copenhagen, NyC 387. *EA* 4595; *Billedtavler* pl. 25; Detail, Fink, op. cit. pl. 80, 2; Johnson 13; van der Kolf 198; Arias A2; de Azevedo 15. Flavian?

3. Statue, Berlin K235. Blümel, *KatBerlin* v, 22 and pl. 48; Graef 9; Johnson 9; van der Kolf 193; Arias A1;

de Azevedo 11. Heavily restored, head modern. From Sta. Marinella, as F32.

4. Statue, Mus. Torlonia 264. Arias A10 and pl. 11, 40.

5. Statue (headless), Tripoli. Sichtermann 1 and pl. 18.

6. Statue (headless), once Munich Market. I thank Prof. Ashmole for notice and a photograph of this piece. Excellent quality; Trajanic?

7. Statue (headless), Salamis K8. Karageorghis and Vermeule, op. cit., 18 and pl. 16; Hanfmann and Pedley, op. cit. fig. 6. Flavian?

8. Statue (head alien), Vatican (formerly Lateran). Helbig[4] 1006; *EA* 2110-11; Graef 10; Johnson 10; van der Kolf 210; Arias A8; Sichtermann 2 and pl. 21,1-3.

9. Statue (head restored), Villa Borghese 28. Helbig[4] 1946; *EA* 2714; Graef 7; Johnson 7; van der Kolf 195; Arias A5; Sichtermann 5 and pl. 19, 2; Fink, op. cit., 246.

10. Statue (head restored), Pal. Barberini MD 1104. Graef 4; Johnson 4; van der Kolf 199; Arias A9; Sichtermann 3 and pl. 19, 3.

11. Torso, Verona D 557. Graef 11; Johnson 11; van der Kolf 211; Arias A11; Sichtermann 6 and pl. 20, 1-3.

12. Torso, Venice Inv. 87. Sichtermann, op. cit., 44 n. 6.

13. Head (statue alien), Villa Medici 115. Bulle, *Der schöne Mensch* pl. 212; Picard, *Man* iii. 2 figs. 314-15; Richter, *Sc*[4] fig. 755; Graef 13; Johnson 1; van der Kolf 201; Arias B1 and pl. 11,42; de Azevedo 1 and pls. 37-38. PLATES 44d, 52a, b.

14. Bust, Kalydon (formerly Athens NM). E. Dyggve, F. Poulsen and K. Rhomaios, *Das Heroon von Kalydon* (1934) figs. 91-93; Becatti, loc. cit. figs. 42-47; Picard, op. cit. fig. 318; Arias B13; de Azevedo 10. Lower face restored; Hellenistic.

15. Head, Vienna D 676. *EA* 48; Johnson 12; Arias B2; de Azevedo 12.

16. Head, Vatican Chiaramonti 509. *SVM* i, 645 and pl. 69; Graef 16; Johnson 4; van der Kolf 203; Arias B4; de Azevedo 3.

17. Head (statue alien), Vatican Chiaramonti 453. *SVM* i, 609 and pl. 64; Johnson 10; van der Kolf 204; Arias B5; de Azevedo 4.

18. Head, Catania 13. Libertini, *Il Museo Biscari,* 10 and pl. 7; Arias B7. Antonine?

19. Head, London, BM. *Catalogue of the Burlington Fine Arts Club* (1904) pl. 14; Smith, *Marbles and Bronzes* pl. 38; Johnson 8; de Azevedo 14; Fink, op. cit., 243 n. 40. Antonine.

20. Head, Naples 104. *EA* 518-19; Graef 15; Johnson 3; van der Kolf 206; Arias B9; de Azevedo 8; Fink, op. cit., 243. Hadrianic.

21. Herm, formerly Deepdene M 16. *EA* 4865; Preyss, text to B-B 691-92, 5 no. 17 (wrongly listed as replica of Lansdowne type, E, followed by Mustilli, *Il Museo Mussolini*, 80 no. 13); Picard, *Man* iii. 2 fig. 320; Arias B17 (confused with the Herakles, A1); Vermeule, *AJA* 59 (1955), 134. Antonine.

22. Head (torso alien), Venice D 148. *EA* 2499-2502; Johnson 11; van der Kolf 207; Arias B11; de Azevedo 9.

23. Head, Leningrad 142. Waldhauer, *Die antiken Skulpturen der Ermitage* ii figs. 39 and 40; Johnson 13; Arias B8 and 12; de Azevedo 17; Fink, op. cit., 243 n. 40. Antonine.

24. Head, Agora S 1227. Harrison, *Hesp* 29 (1960), 381 and pl. 85b. Early imperial.

25. Head, Agora S 2035. Harrison, loc. cit. and pl. 85a. Early imperial.

26. Head, Basle BS 223. K. Schefold, *Führer durch die Antiken-museum Basel* (1966), 139 no. 203; E. Berger, *Antike Kunst* 10 (1967), 66 and pl. 18, 4.

27. Head, Terme 542. Helbig[4] 2220; Graef 14; Johnson 2; van der Kolf 202; Arias B6; de Azevedo 5.

28. Head, Copenhagen, NyC 362. Arndt, *GNC* pl. 100; *Billedtavler* pl. 24; Johnson 9; van der Kolf 205; Arias B3; de Azevedo 16. Poor; copy of copy?

29. Herm, Villa Albani 57. Morcelli, Fea and Visconti, *La Villa Albani* (1869) 57; Graef 18; Johnson 6; de Azevedo 7.

30. Head (statue alien), Mus. Torlonia 473. Graef 19; Johnson 7; van der Kolf 209; de Azevedo 6.

31. Head, Terme 52. *EA* 277-78; Graef 17; Johnson 5; van der Kolf 208; Arias B10; de Azevedo 23. Hadrianic?

II. Variant

32. Statue, Cambridge, Fogg Mus. 1926.48.11. Hanfmann and Pedley, op. cit., passim; Johnson 14; van der Kolf 194; Arias A3 and pl. 11,39; de Azevedo 18. Trajanic? PLATE 44a.

III. Versions

33. Statue of Perseus, Ostia Inv. 99. Helbig[4] 3047; *AA* 1934, 435-37 fig. 3. See note 21, Chapter 9 for bibliography.

34. Statue of Domitian, Naples 6077. Fink, op. cit. pl. 80, 1; Graef 6; Johnson 6; van der Kolf 215.

35. Portrait statue, Pal. Corsini MD 1048. Graef 8; Johnson 8; van der Kolf 220; Arias A6; Sichtermann 4 and pl. 19, 1; Fink, op. cit. pls. 77, 1; 79, 1.

36. Statue, Gall. Doria Pamphili MD 1101. Reinach, *Répertoire* i pl. 480 no. 3; Fink, op. cit., 240 n. 10; Johnson 17; van der Kolf 229; de Azevedo 19. Right arm raised.

37. Torso, Salamis 22. Karageorghis and Vermeule, op. cit., 31-32 and pl. 28,1 and 3. Portrait?

38. Fragments, Villa Albani. Morcelli, Fea and Visconti, op. cit., 222; Fink, op. cit., 240 n. 10. Right arm raised.

39. Portrait head, Houghton Hall. F. Poulsen, *Greek and Roman Portraits in English Country Houses* (1923), 39 no. 11 and fig. 11.

40. Portrait head, Vatican Busti 338. Helbig[4] 178; *SVM* ii, 528 and pl. 72; Fink, op. cit. pls. 76,2; 78,3 and 4; 79,3.

41. Portrait head, New York 135. Richter, *MetMus*, 77-78 and pl. 101.

42. Head of Dionysos, Terme 537. Helbig[4] 2221; Fink, op. cit. pls. 77,2; 79,2 and 4; Arias B16.

43. Head, Copenhagen, NyC 361. *EA* 4484-85; *Billedtavler* pl. 24; Arias B14.

G. POTHOS PLATE 45a, c

Winged figure, characterised as effeminate youth. Stands on right leg with left crossing in front. Pose chiastic. Left arm reaches up to grasp staff, right crosses body to hold centre of staff at chest height; body and staff lean to left. Upper part of left arm covered by drapery falling vertically onto back of goose beside right foot. Head looks up and to spectator's right. Hair style often misunderstood by copyists: hair combed to sides from central parting, overlaid by locks from temples combed back and gathered into bun. Height of original (excluding staff), 1.80 m.

Variants: reverse pose and/or alter hair style.

Versions: characterise as hermaphrodite or Eros and vary attribute: torch, phallos, thyrsos or lance.

Type first recognised by Furtwängler, *SbBayAk* 1901, 783. Copies studied and listed by Arndt, text to B-B 616-17; Bulle, *Jdl* 56 (1941), 121-50; W. Müller, *Jdl* 58 (1943), 154-82; Arias 131-34. See also A. M. Colini, *Capitolium* 15 (1940), 870-75; G. Becatti, *Le Arti* 3 (1941), 401-12; P. Mingazzini, *Le Arti Figurative* ii.3 (1946), 137-

48; Bulle, *ÖJh* 37 (1948), 3-5; Picard, *Man* iii. 2, 653-63; O. Kerényi, *Symbolae Osloenses* 31 (1955), 141-53; W.-H. Schuchhardt, *Gnomon* 1968, 405.

I. Copies

1. Statue, Conservatori Inv. 2417. Helbig⁴ 1644.6; Colini, op. cit. figs. 10, 12, 14; Picard, *Man* iii. 2 figs. 282, 284; *EncWA* xiii pl. 42; *EncAA* vii, 368 fig. 463; Bulle ID and fig. 4; Arias A1 and pls. 13, 44; 14, 46-7. Hadrianic. PLATE 45a, c.

2. Statue, Florence 31. B-B 616-17; Mansuelli, *Uffizi* i, 53 and fig. 31; Picard, *Man* iii. 2 figs. 278, 283; Bulle IA; Arias A3. Forearms and hands restored.

3. Statue, Mus. Cap. 31. Helbig⁴ 1392; Stuart-Jones, *MusCap,* 294 and pl. 72; Bulle IF; Müller fig. 1 (before restoration); Arias A4. Restored as Apollo.

4. Statue (headless), Conservatori Inv. 2416. Helbig⁴ 1644.5; Colini, op. cit. fig. 11; Bulle IE and fig. 5; Arias A2 and pl. 14, 45. Hadrianic.

5. Statue (head alien), Florence 32. Mansuelli, *Uffizi* i, 54 and fig. 32; Bulle IC and fig. 2; Arias A5. Hands restored; for the head, see Chapter 10, section 4 (E).

6. Statue (head alien), Florence, Pal. Vecchio D 510. *EA* 340; Lippold, *Plastik* pl. 91, 3; Bulle IB and fig. 3; Arias A7. Fingers lost, but original action of hands preserved.

7. Statue (head alien), Naples 249. Picard, *Man* iii. 2 fig 279; Bulle IG; Arias A6. Restored as Apollo.

8. Statue (head restored), Versailles. Pinatel, *Les statues antiques des jardins de Versailles,* 163-66 no. 11 and pl. 14; Bulle IH; Müller fig. 2; Arias A9. Restored as Apollo.

9. Statue (head alien), Leningrad. Bulle IJ; Müller fig. 3; Arias A11. Restored as Apollo.

10. Statue (headless), Heraklion. Bulle IL: Arias A12.

11. Torso, once Deepdene M 2. Clarac 476B, 905C; Bulle IK; Arias A10; *AJA* 59 (1955), 134 no. 2. Restored as Sauroktonos.

12. Torso, Vienna (private). Eichler, *Belvedere* 12 (1928), 131 figs. 1-3; Bulle IM; Arias A14.

13. Torso, Vatican Chiaramonti 590. *SVM* i, 707 and pl. 76; Bulle IN; Arias A13.

14. Torso, Terme 479. Helbig⁴ 2228; Bulle IO; Müller fig. 4; Arias A16.

15. Fragment (goose and drapery), Palatine, stadium hemicycle. Colini, op. cit. fig. 13; Bulle IQ; Arias A21.

16. Fragment (goose and drapery), Cherchel. Picard, *Man* iii. 2 fig. 280; Arias A22.

17. Fragment (goose), Rome, Antiquario Communale. *BullComm* 39 (1911), 99 fig. 1e; Bulle IP; Arias A20.

18. Head, Berlin K218. Blümel, *KatBerlin* v, 15 and pl. 32; Arndt figs. 4-6; Bulle IIS; Arias B3 and A8. Hadrianic.

19. Bust, London, BM. Arndt figs. 1-3; Bulle IIT; Arias B5. Hadrianic.

20. Head (on statue of Vestal), Pal. Colonna. *EA* 1148; Bulle IIU; Arias B6.

21. Head, Copenhagen, NyC 75. Arndt, *GNC* pl. 116; Bulle IIR; Arias B2. Poor.

22. Head, Belgrade 16. Grbić, *Choix de Plastiques,* 37, 124 and pl. 22.

23. Head, Würzburg Inv. H5040 (formerly Wilton House M 107). *AJA* 60 (1956), 347 and pl. 104, 5; *AA* 1968, 148-49 figs. 35-36; Bulle IIV; Arias B1. Early imperial?

24. Head, Villa Albani (on statue of Artemis Colonna). *EA* 4043; Bulle IIW; Arias B4.

II. Statuettes

25. Statuette, Paris 541. Bulle IIIa; Müller fig. 5; Arias A19. Restored as Apollo.

26. Statuette, Dresden 113. Bulle IIIB; Müller fig. 6; Arias A17.

27. Torso, once Marbury Hall M 12. Bulle IIIc; Arias A18; *AJA* 59 (1955), 142. Restored as Satyr.

28. **Torso, Mus. Cap. Nuovo 94. Helbig⁴ 1685; Mustilli,** *MusMuss,* **40 and pl. 27; Bulle IIId; Arias A15.**

III. Variants

29. Statuette, Florence, Mus Arch. D. Milani, *Il Museo archeologico di Firenze* i, 306; ii pl. 147; Bulle IVe and figs. 8-10; Picard, *Man* iii. 2 fig. 285; Arias B7.

30. Head, Belgrade 19. Grbić, op. cit., 37-38, 124 and pl. 23.

IV. Versions

31. Eros, from Dionysos group, Brocklesby M 90. *EA* 4864; Picard, *Man* iii. 2 fig. 345.

32. Torso, Conde de Lagunillas coll. (U.S.A.). *Ancient Art in American Private Collections,* 28 no. 168 and pl. 48.

V. Replicas (versions) in other media

a. With torch

33. Gem, Copenhagen, Thorwaldsen Mus. 783.

Fossing, *Antique Engraved Gems*, 127 and pl. 10; Müller Vλ and fig. 8; Arias C7.

34. Gem impression, Copenhagen, Thorwaldsen Mus. 365. Fossing, op. cit., 75 and pl. 5; Müller Vµ; Arias C6.

35. Gem, Berlin 8200. Furtwängler, *Verzeichnis*, 300 and pl. 59; Bulle Vγ; Müller Vγ. Perhaps a torch.

b. With phallos

36. Gem, Berlin 8199. Furtwängler, *Die Antike Gemmen* i pl. 43, 52; ii, 208; Bulle Vα and fig. 11; Picard, *Man* iii. 2 fig. 277; Arias C1. Hermaphrodite.

c. With thyrsos

37. Gem, Florence. Reinach, *Pierres Gravées* pl. 48 no. 33; Müller Vη; Arias C4.

38. Gem, Leningrad. Reinach, op. cit. pl. 121 no. 39; Müller Vζ; Arias C5.

d. With lance

39. Gem (cast in Dresden; whereabouts unknown). Reinach, *Antiquités du Bosphore Cimmérien* pl. 17, 1; Müller Vκ; Arias C8.

40. Gem impression (whereabouts unknown). Müller Vι with bibliography; Arias C3.

41. Gem (whereabouts unknown). *AZ* 1858 pl. 118, 7; Bulle Vβ.

e. Uncertain/other attributes

42. Glass impression, Munich 1051. *Antike Gemmen in Deutschen Sammlungen* i.2, 85 and pl. 118. Phallos or thyrsos.

43. Gem impression, Berlin 3779. Furtwängler, *Verzeichnis* pl. 39; Muller Vθ. Hand covers attribute.

44. Impression, Copenhagen (Arndt). Arndt, op. cit. n. 2; Bulle Vδ; Müller fig. 7; Arias C2. Battered.

45. Fresco, Pompeii. Reinach, *Répertoire de peintures* pl. 23 no. 1; Bulle Vζ. Apollo.

H. PHAETHON PLATE 45b, d

Stands on left leg with right crossing in front. Chiastic pose, wingless; characterised as effeminate youth. Left arm flexed, hand against left buttock; right arm directed down and away from body to side, hand presumably grasped staff (torch ?) to support body. Chlamys over right shoulder with brooch, behind back and over left biceps to hand behind forearm and down left side. Head turned to right. Height of original (excluding staff), c. 1.80 m.

Variant: pose reversed.
Versions: pose, drapery altered.
C. Kerényi, *Symbolae Osloenses* 31 (1955), 141-53.

I. Copy

1. Torso, Salamis. Karageorghis, *BCH* 93 (1969), 547-48 fig. 185. PLATE 45b.

II. Variant

2. Torso, Mus. Torlonia 263. Visconti, *Il Museo Torlonia* no. 263; *I Monumenti del Museo Torlonia* (1884) no. 8.

III. Replicas in other media

3. Fresco, Rome (Massimi). *BullComm* 1895, 178; Reinach, *Répertoire de Peintures* pl. 29 no. 2.

4. Fresco, Naples 9320. Roscher i col. 2802; Reinach, op. cit. pl. 68 no. 6; Kerényi, op. cit., 145.

5. Sarcophagus, Copenhagen, NyC 783. Arndt, *GNC* pl. 153; *Billedtavler* pl. 67; C. Robert, *Die Antiken Sarkophagreliefs* iii.3 pl. 108 no. 336. PLATE 45d.

Appendix 5

PROPORTIONS OF THE LOS ANGELES HERAKLES, LANSDOWNE HERAKLES AND MELEAGER
(cf. PLATES 31, 42 and 44)

	Total ht.	Head	Torso ht.[2]	Torso w.[3]	Legs l.[4]
Herakles, Los Angeles (A1):[1]	176.5	25.8	53.2	30.2	91.2
Herakles, Malibu (E1):	196.4	27.4	58.7	38.5	101.8
Meleager, Vatican (F1):	198.0	27.0	57.5	37.2	105.2
For comparison:					
Hermes, BM 1599:	201.4	28.0	63.1	37.5	104.5
Apoxyomenos, Vatican:	197.5	26.5	58.0	35.5	104.0

Ratios:	Head ht: Total ht.	Torso ht: Total ht.	Legs: Total ht.	Torso ht: Legs	Torso w: Torso ht.
Herakles, (A1):	1:6.841	1:3.318	1:1.935	1:1.714	1:1.773
Herakles, (E1):	1:7.168	1:3.345	1:1.929	1:1.734	1:1.524
Meleager, (F1):	1:7.333	1:3.443	1:1.886	1:1.826	1:1.546
For comparison:					
Hermes	1:7.192	1:3.192	1:1.927	1:1.656	1:1.683
Apoxyomenos	1:7.453	1:3.405	1:1.899	1:1.793	1:1.657

[1] Measurements kindly furnished by J. Frel.

[2] Measured from sternum depression to pubis top.

[3] Measured across iliac crests.

[4] Measured from pubis top to sole of foot of engaged leg.

The tendency in the three Skopaic pieces is for the head to get smaller in proportion to the total height, and for the torso to get shorter and the legs to lengthen. The difference is particularly noticeable here between the Los Angeles and Lansdowne Herakles in the first case, and between this and the Meleager in the second and third. In addition, the torso broadens as its height is reduced, though in the Meleager there is a slight retrenchment, presumably because it was felt that the combination of so stocky a torso and even longer legs would begin to look incongruous, even perhaps slightly grotesque. However, and interestingly enough for the often made comparison between this statue and the Doryphoros of Polykleitos,[1] the proportions of the torso of Skopas' statue quote those of Polykleitos' exactly, both being 1:1.546 in the ratio of breadth: height—an alternative explanation for the change?

The proportions of the 'Hermes Farnese', BM 1599,[2] and the Vatican Apoxyomenos,[3] representing the Praxitelean and Lysippic schools respectively, are sufficiently different from those of Skopas' three statues to show that one can speak of 'Skopaic proportions' as a class apart.

1. Doryphoros: measurements taken from the Naples copy.
2. 'Hermes Farnese', BM 1599: B-B 18 (replica in Athens, NM 218); Lippold, *Plastik,* 275 and pl. 96,4.
3. Apoxyomenos: see note 3, **Chapter 10.**

SELECT BIBLIOGRAPHY

Although it is almost a century since the first excavations at Tegea (by Milchhöfer in 1879), no critical study of the whole of Skopas' surviving *oeuvre* has yet emerged. To date, the nearest is Arias' *Skopas* (1952), which has a useful bibliography, but which unfortunately abounds in errors, both factual and typographical, and also includes a large amount of extraneous material with a minimum of critical comment. The most sensible of the many discussions limited to only a few works are Graef's 'Herakles des Skopas und Verwandtes' (*RM* 4 [1889], 189-226), which discusses the copies of the Genzano Herakles and the Meleager, and Neugebauer's *Studien über Skopas* (1913), which deals with Tegea, the Maenad and the Mausoleum; both were written before Dugas' publication of the Tegea sculptures and are now rather out of date, and in both cases study of the Tegea material at first hand was limited to the heads alone. Other contributions to the debate, such as those of Berchmans in *Mélanges Holleaux* (1913), and Morgan in *Studies presented to Edward Capps* (1936), are less satisfactory.

Accounts of Skopas' career in the handbooks are numerous but by their very nature cursory. A really firm base for their attributions, in the form of a strong grasp of the essentials of the Tegea style, is often lacking, and some of the attributions themselves highly improbable in consequence. Perhaps the best are to be found in Lippold's *Die griechische Plastik* (1951) and in the *Encyclopedia of World Art*, s.v. 'Skopas' (1967); Furtwängler's comments in *Masterpieces of Greek Sculpture* (English edition, 1895) are still useful. Of those surveys more accessible to the layman, the most informative and shrewd is undoubtedly that in A. W. Lawrence's *Greek and Roman Sculpture* (1972), which is perhaps the best account of ancient sculpture now available in any language.

As for the Tegea sculptures themselves, Dugas', Berchmans' and Clemmensen's *Le Sanctuaire d'Aléa Athéna à Tégée* (1924) is still the definitive publication of all the sculptures found up to that date, although it, too, has its defects, especially when compared with Treu's exemplary publication of the Olympia sculptures some twenty-five years earlier. The most glaring are the lack of any discussion of the technique of the fragments, which is remediable, and the failure to record their exact find-circumstances, which is not. Berchmans' study of Skopas, mentioned above, and his attribution to him, for example, of the 'Maussolos' from Halicarnassus (BM 1000), further weakens my confidence in his critical acumen. Recent excavations by the Greek Archaeological Service at Tegea have yet to be published; preliminary notices are listed in the bibliographies in the Catalogue. The iconographical studies of the Tegea material by Picard and Delivorrias are discussed in Chapter 3.

Finally, specialist studies of works attributed to Skopas are many, and would be impossible to comment upon here; these are assembled in the bibliographies to the various copies in Appendix 4.

To p. 1ff.

For a recent attack on even the *possibility* of salvaging anything worthwhile concerning the great sculptors and painters of antiquity see P. Bruneau, 'Situation methodologique de l'histore de l'art antique', *L'Antiquité Classique* 44 (1975), 425-87, esp 443-452. This article, though rigorously argued and disturbing in its implications for the methodology of the history of Greek art as at present practised, does not, however, seem to me seriously to damage the premises upon which the present study is based, for three reasons. First, to dismiss the copies entirely is clearly mistaken: if the pointing machine were used, then once the original was reduced to a series of measurements, the fidelity of the copy (as defined in Appendix 4) to the composition of its model was guaranteed. Since in classical Greek art posture and gesture tell us as much, if not more, about a statue than the features themselves, this is surely no small gain. Secondly, to work synchronically, concentrating on periods, is certainly permissible and may ultimately prove to be highly rewarding—provided that one remembers that in classical antiquity differences in style between the major sculptors (and painters) were keenly felt; that these differences may be less obvious today in a monument like the Mausoleum is rather a measure of our own present inadequacies as judges of style, than an argument for the simple *substitution* of the study of periods for that of personalities—a move which, I believe, would therefore not only be misguided but also unhistorical. Thirdly, as far as concerns Skopas himself, information of various kinds and covering various stages of his career enables the construction of a pyramid of largely independent yet nevertheless mutually supporting propositions as to his output and style that is a far cry from the precarious sequence of inferences contingent upon one or two primary hypotheses that so often passes for a reconstruction of the career of a sculptor like Naukydes or Silanion.

To p. 30f.

Nos. 27, 28 and perhaps also 29: since the figures to which these heads belonged exceeded the height of the metopal frame by about 40%, 30% and 15% respectively, it is possible that the first two, and perhaps even the third, are not to be attributed to the metopes at all, but to the altar frieze, which showed 'Rhea and the nymph Oenoe holding the baby Zeus. On either side are four figures: on one, Glauke, Neda, Theisoa and Anthracia; on the other, Ide, Hagno, Alcinoe and Phrixa.' (Pausanias viii. 47.3). Thus, it is also possible that the baby, no. 32, which would originally have stood to about two-thirds the height of the metopes, is not the baby Telephos as suggested in Chapter 2, but Zeus. If this were the case, since the cornice mouldings of the altar are very like those of the temple itself (see Chapter 3, note 78) and style of no. 27, at least, is Skopaic, the likelihood would be that Skopas' atelier was responsible for this part of the project also.

To p. 39.

Miss Amanda Claridge suggests to me that the tool used on the lower part of the back of no. 1 (PLATE 2c) may have been a drove, not a flat chisel. Certainly, the marks look more regular than those on, say, the grave statue in the Louvre (Adam, *Technique* pl. 32b), yet if Adam is right (op. cit., 23-25 and pls. 9-10) that this tool is not found in use after the Archaic period, the question must, I feel, remain open.

To p. 57.

In his recent discussion of nos. 9, 16 and 17, L. A. Schneider, *Asymmetrie griechischer Köpfe vom 5. Jh.bis zum Hellenismus* (1973), 58, 63-64, concludes that the distortions apparent in these three heads, if determined simply by some (presumed) preference for three-quarter poses, would be self-contradictory, and can thus only be explained as the fruits of an attempt to enhance the actual movement of the heads to left or right. As regards the displacement of the *axes* of the face (not particularly striking at Tegea), Schneider would appear to have proved his point; yet the almost complete correlation between (in what one can only presume to have been the withdrawn side of the face) lack of finish and flatter modelling on the one hand, and definite broadening of the features on the other, is surely strong evidence for the point of view already expressed in the text. If, then, both systems were in use in Tegea regardless of the contradictions that resulted (as seems at least possible), this would appear to cast something of a new light upon the practice of at least one fourth century atelier when confronted with what was apparently an insoluble dilemma in the realm of optical theory.

To p. 74 (note 38)

On the increasing part played by the problem of individual character and emotion (ἦθος and πάθος) in fourth century art theory and criticism see esp. J. J. Pollitt, *The Ancient View of Greek Art* (1974), 30-31 and 184-89.

To p. 78 (note 70)

For a novel and, I think, potentially fruitful approach to some of the problems posed by the Late Classical period and its relation to the classical style of the fifth century, see A. H. Borbein, 'Die griechische Statue des 4. Jahrhunderts v. Chr.'. *JdI* 88 (1973), 43-212.

To p. 80 (notes 5 and 7)

For an excellent discussion of the whole question of architects' models and on-site instructions, together with a comprehensive list of the sources, see now Pollitt, *The Ancient View of Greek Art*, 204-15.

To p. 81 (note 10)

On the plan of the Tegean temple and its relation to Bassae and the temple of Apollo at Delphi, see now J. J. Coulton, *BSA* 69 (1974), 61-86, esp. 77-78 and 82 (Rule 1, variation 1a).

To p. 82 (note 17)

On τύποι see now the comprehensive treatment of the problem in Pollitt, op. cit., 272-93; on p. 291 Pollitt decides against translating the word in the Epidaurus inscription as 'sculptors' models', but does admit nevertheless that, 'There admittedly exists . . . a residue of passages in which τύπος does seem to have been used to refer to a mold-made image or perhaps any sort of statue that resembled a mold-made image'. With this in mind, I would adhere to my suggestions as given in the text.

To p. 95 (note 3)

Further evidence for a link between the Mausoleum and Tegea comes from the architecture of the building itself: the same 'Arcadian' foot of 0.2985 m was used on both structures, and there are apparently other similarities as well, according to Jeppesen's recent report in *AJA* 79 (1975) 67-79, esp. 78 no. 42.

To p. 96 (note 15)

The latest attempt to parcel out the friezes, again on purely internal evidence and with no reference to Tegea or Epidaurus, by no means changes my views as expressed here: see W. Schiering, 'Zum Amazonenfries des Maussoleums in Halikarnass', *JdI* 90 (1975), 121-35. BM 1013-15 are, as usual, given to Skopas, together with 1009 and 1025; 1011-12 are allotted to Leochares, and 1007-8-10 to Timotheus.

To p. 96 (note 17)

Mr. B. F. Cook informs me that he believes that the torso and head at

present joined to BM 1012.47 do not actually belong to this slab. Though I have studied the slab since, the plaster that covers the join prohibits a thorough examination, and so the point is not to be proved one way or the other for the present. Suffice it to say, however, that wherever these pieces may eventually be found to belong, I still feel that they are sufficiently Skopaic in style for the remarks advanced here to stand (or fall) on their own merits.

To p. 101.
Jeppesen, op. cit., 79 believes that work on the Mausoleum slowed down gradually after 350 and finally stopped around 340, when Ada was forced to withdraw to Alinda by Pixodarus; cf. also id., 'Nisi absoluto iam: observations on the building of the Mausoleum at Halicarnassus', in *Mélanges Mansel* (1974), 735-48. I see no reason why, given the circumstances of workshop production as outlined in Chapter 5, Skopas's activities at Tegea and in Halicarnassus could not have overlapped.

To p. 102.
Preliminary results of Dr. Craig's analysis of the marble of the Alba Youth indicate that it could be from Dolianà; this, however, is by no means decisive as far as concerns a Tegean source for the statue, since not only do its provenience, scale, technique and style militate against this, as noted in the text, but it also seems that the Dolianà quarries may have been in extensive use for some time before the mid fourth century: samples of the frieze slabs from the temple of Poseidon at Sounion (c. 430), from Bassae and from the Asklepieion at Epidaurus are apparently very close in both carbon and oxygen isotopic ratio to my own from Dolianà itself.

To p. 116.
To the wider circle of Skopas' imitators may perhaps be allotted the original of a somewhat crude copy of a head of Herakles in Zurich: C. Isler-Kerényi, *AA* 1973, 462-70 figs. 1-4. The proportions and style are much as the Delos piece A6992 (no. 4), though the Skopaic bulge over the corners of the eyes has gone.

To p. 116 (note 16)
To the list of sculptures utilising versions of the Ludovisi-type head, add: (13) Head of a Roman on a republican frieze slab, Pal.Cons. Braccio Nuovo Sala II: Helbig[4] 1603; W. von Sydow, *JdI* 89 (1974), 187-216, esp. figs. 4-5.

To p. 118 (note 36)
The latest study of the 'Ariadne' (E. Pochmarski, *AM* 90 [1975], 145-62 and pls. 52-58) adheres in essence to Studniczka's conclusion, though with reference now to further copies and versions of the original in Venice, Basel, Albenga and the Palazzo Barberini, plus an exhaustive bibliography.

To p. 120 (note 55)
For a list of further replicas see *Corinth* ix (1931), 22-23 no. 12.

To p. 128 (no. 7)
The first two lines of this quotation (i.e. lines 5 and 6 of the poem) should be omitted from any discussion of Skopas's statue, since they refer not to Skopas's Apollo Palatinus but to Apollo *Actius*, commissioned by Augustus to commemorate his victory at Actium in 31 and placed by him in the forecourt of the temple (see H. Cahn, 'Zu einem Münzbild des Augustus', *Museum Helveticum* 1 [1944], 203-8, and, apparently independently, H. Last, 'The Tabula Hebana and Propertius ii.31', *Journal of Roman Studies* 43 [1953], 27-29). This statue, which stood on its right leg, not its left, and held a plectrum, not a patera (see, e.g., the coins illustrated in A. S. Robertson, *Roman Imperial Coins in the Hunter Coin Cabinet* i [1962] pl. 6 nos. 200 and 209) is confused with Skopas' by, among others, Bieber in her recent essay in *Aufsteig und Niedergang der Römischen Welt* i.4 (1973), 889-91 and fig. 27b. For a list of further sources which refer to Skopas' statue, but without actually describing it or naming its author, see S. B. Platner and T. Ashby, *A Topographical Dictionary of Ancient Rome* (1927), 17-18, to which add Zosimus, *Historia Nova* ii.5.15 and possibly also Horace, *Carmen Saeculare* 62-65.

To p. 135 (no. 48)
To this papyrus fragment add now one from Oxyrrhynchus:
48 *bis.* [. . . ανδριαντοπ]οιοι δε
[Πολυκλειτος Πυθ]αγορας Σκο
[πας ζωγραφοι Πολυγ]νωτος
Oxyrrhynchus Papyri x. 1241. 1. 3-5
. . . and makers of statues of mortals:
Polykleitos (?), Pythagoras, Skopas. Painters: Polygnotos

To p. 137.
For new fragments of sarcophagi and Renaissance drawings showing lost sarcophagi with representations of the Calydonian hunt, see G. Koch, *AA* 1973, 287-93; 1975, 530-38, also 551 fig. 32.

To p. 143.
Add now the following as replicas of the Meleager (F):
10 *bis.* Statue (minus head and lower legs), Antioch. D. B. Brinkerhoff, *A Collection of Sculpture in Classical and Early Christian Antioch* (1970), 29-30 and figs. 34-35.
10 *ter.* Statue (minus head and lower legs), Brooklyn. C. C. Vermeule, *AJA* 79 (1975), 324 and pl. 51A. Perhaps from Alexandria.
10 *quater.* Statue (minus head and lower legs), Brussels. Deutsches Archäologisches Institut (Rom), neg. 1935.3744.
11 *bis.* Torso, Messina. DAI Rom, neg. 71.949.
11 *ter.* Torso, Seville. DAI Rom, neg. 1930.4333.
12 *bis.* Upper torso, Vienne. DAI Rom, neg. 1931.12372.

Note 5 to Chapter 9 should now be emended to read '6 or 7 copies with dog, 12 with chlamys, 3 with boar's head, 1 with rock.'

To p. 143 (no. 14)
The Kalydon bust is now in Agrinion: P. Petsas, *ADelt* 26.B.2 (1971), 322.

To p. 174 (note 26)
On the Dallas statue see now Vermeule and Ternbach, *Archaeology* 25 (1972), 217-21.

NOTES

To avoid multiplication of cross-references, references to illustrations are in general given in the notes only the first time that a piece is mentioned in the text. On subsequent occasions the reader is asked to turn to the Index for information as to the original page and note number where the references in question are to be found.

Introduction

1. On the chronology of Skopas' career, the best account is still Bieber's, in Thieme-Becker, *Allgemeines Lexikon der bildenden Künstler* (1937) s.v. 'Skopas (I)'; see also Lippold in *RE* (1937) and Arias in *EncAA* (1966), both s.v. 'Skopas (I)', and Ashmole in *EncWA* (1967), s.v. 'Skopas'.

Chronology: (1) Tegea: see Chapters 3 and 5.
(2) Mausoleum: Riemann, *RE* s.v. 'Pytheos' col. 373. Provision was made for the Mausoleum in the new layout of the city which followed the *synoecismos* of c. 368/7 though the green ragstone used in the foundations and basement was not employed on Maussolos' earlier buildings, which should date the inception of work on the tomb to c. 360 (see G. E. Bean and J. M. Cook, *BSA* 50 [1955], 169).
(3) Ephesus: 'imo scapo' has been proposed for the 'una a Scopa' of the MSS by A. Murray, *JournRIBA*, 3rd Ser. 3 (1895), 47, also Overbeck, *Griechische Plastik*³ (1882), 95. Although A. Bammer, *Die Architektur des jüngeren Artemision von Ephesos* (1972), 22 suggests that the sculptured drums were at the *top* of the columns, which would rule out this emendation entirely, this is surely wrong: cf. W. H. Plommer, *JHS* 94 (1974), 250. Interestingly, the sima seems to be a more florid version of the Tegean: M. Schede, *Antikes Traufleistenornament*, 78-80 and pl. 7,41; Bammer, op. cit., 33, 42 and pl. 3f-g.
(4) Thebes: razed by Alexander in 335 (see Hammond, *History of Greece*, 599-600).

2. Appendix 1 (Sources), nos. 12, 14, 33, 34, 36.

3. Skopas' travels: Appendix 1, no. 36 and passim. Secondary evidence about his career is minimal; ancient authors clearly regarded him as a contemporary of Praxiteles, whose activity perhaps spanned the years from c. 375 to c. 325 (Marcadé, *Recueil* ii, 115, 116, 119-22; Arnold, 161, 210).

4. The date of his birth (around 380) given by Arias, *Skopas*, 97 and *EncAA* s.v. 'Skopas (I)', 364, would seem to be rather low.

5. Aristandros: Bieber, loc. cit; O. Rubensohn, *JdI* 50 (1935), 51; the suggestion was first made by Böckh in 1843 (*CIG* ii. 2285b). See also Appendix 1, nos. 49-52 for the family in the late Hellenistic period. Pliny lists the Skopas who *floruit* c. 420 as a bronze-worker, whereas our Skopas worked almost exclusively in stone.

6. Appendix 1, nos. 1, 2.

7. 'Attic', 'Peloponnesian' and 'Asiatic' periods: Urlichs, *Skopas, Leben und Werke* (1863), passim; *contra*, Lippold, *RE* s.v. 'Skopas (I)', col. 569, and *Plastik*, 249.

8. Not quite; see below.

9. Morgan, *Studies presented to Edward Capps* (1936), 253. Unfortunately, by not taking into account the find-circumstances of the 'Hygieia', NM 3602, his results fail to meet his own high standards and must be discarded in consequence.

10. The terms are taken from B. S. Ridgway, *The Severe Style in Greek Sculpture* (1970), 56.

11. On the sources in general, see esp. J. J. Pollitt, *The Art of Greece* (1965), ix-xviii; Ridgway, op. cit., 76-79; Lawrence, *GRS*, 44-48.

12. Sauroktonos: *Naturalis Historia* xxxiv.70; Lippold, *Plastik*, 240 and pl. 84,3.

13. Polykleitan school: *SQ* 978-1013; Arnold, *Die Polykletnachfolge*; A. Linfert, *Von Polyklet zu Lysipp* (diss. Freiburg, 1965).

14. Pausanias vi.1-10; Pliny, *Naturalis Historia* xxxiv.91.

15. Literary sources on Skopas: Morgan, op. cit. (note 9), 253-55; Arias, 59-93.

16. See, in general, Appendix 1.

17. Ἀγαλματοποιοί and ἀνδριαντοποιοί: see G. Rodenwaldt, 'Θεοὶ ῥεῖα ζῶοντες', *AbhBerlAkad* (1943), 13, 3-4; cf. Appendix 1, nos. 43 and 48.

18. Copies of cult statues are discussed by Lippold, *Kopien*, 14, 46 and 147ff; cf. Ridgway, op. cit. (note 10), 76.

19. Quintilian xii.10.9 (*SQ* 1296).

20. The two names occur together in Appendix 1, nos. 5, 35, 37-39, 41, 42, 44, 46, 47, 48.

21. Appendix 1, nos. 37-39.

22. Beazley and Ashmole, *Greek Sculpture and Painting*, 56.

23. Thumbing through the pages of *SQ*, I can find only one other case not immediately explicable by the desire to give a statue a famous name (often involving the substitution of the 'master's' name for that of his 'pupil': cf. *SQ* 829, 836ff.; 847). This is *SQ* 1307 (Vitruvius ii.8.11); there is one marginal example in Pliny (*Naturalis Historia* xxxiv.64: *SQ* 1492).

24. Morgan, op. cit. (note 9), 255.

25. 'Skopas Minor': *NS* 1895, 458ff; Petersen, *RM* 11 (1896), 99-102; Loewy, *RM* 12 (1897), 56-60, 144-47; *RE* s.v. 'Skopas

(II)'. Cf. Mingazzini, *Le Arti Figurative* ii.3 (1946), 137-48; *contra*, Richter, *Sc*⁴ 213 n. 50. For his son's work as a restorer on Delos, see Appendix 1, nos. 50-52. Mingazzini has recently published an updated version of his theory in *RivIst* 18 (1971), 69-90, discussed in the notes to Part II, below.

26. See Appendix 1, no. 49.

27. He is listed among the marble sculptors by Pliny (Appendix 1, no. 41); the sources mention only one work in bronze by him, the Aphrodite Pandemos in Elis (Appendix 1, no. 3: see the Appendix to Chapter 7).

28. Marble copies of bronzes: Lippold, *Kopien*, 123ff; cf. Carpenter, *Greek Sculpture*, 170-173.

29. See Chapter 4, passim.

30. Cf. Panofsky, *Meaning in the Visual Arts* (1955), 9: 'We are apparently faced with a hopeless vicious circle. Actually it is what the philosophers call an "organic situation". Two legs without a body cannot walk, and a body without legs cannot walk either, yet a man can walk . . .'

31. Copies: see, in general, Lippold, *Kopien*. I have in my possession photographs of all but a few of the copies listed in Appendix 4, upon which, together with personal examination of many of the pieces, the conclusions advanced here and in Chapters 7-10 are based.

32. Dresden Maenad: Neugebauer, *Studien*, 57-59. Cf. Carpenter, op. cit. (note 28), 164: '. . . visualisation in geometrical terms was congenial to the Hellenic mind . . . as though in spite of its emotional appeal art was to be ruled and guided by rational thought undisturbed by sentiment; very possibly this is the quality in classicism which the modern mentality least comprehends and most deeply disapproves.'

33. For two-dimensional models see Süsserott, 22-25 and passim; Bulle, *ÖJh* 37 (1948), 1-42. The latter was in reaction (as was much of Bulle's work) to what he believed to be an over-use of Morelli's method in a discipline not entirely susceptible to it.

34. For a definition of 'manner' one can do no better than to turn to *ABV*, p. x.

Select Catalogue

1. On the history of the Tegean site since excavations began in 1879, see Dugas, ix-xiv (Préface); recent excavations and fragments found during the cleaning of the museum are reported in *ADelt* 20.B.1 (1965), 169-70; 21.B.1 (1966), 153-54; 23.B.1 (1968), 149; 24.B.1 (1969), 130.

2. Tegea findspots: Dugas, 78-80.

3. Epidaurus and Olympia findspots: cf. Crome, passim; Roux, 105; M. L. Säflund, *The East Pediment of the Temple of Zeus at Olympia* (*Studies in Mediterranean Archaeology* 27 [1970]), 151-62.

4. Tegea iconography: Neugebauer, *Studien*, 1-9, 31-40; Dugas, 77-91; Pfuhl, *JdI* 43 (1928), 31-37; Picard, *REG* 46

(1933), 381-422; 47 (1934), 385-420; 48 (1935), 474-504; id., *Man* iv.1, 154-205; E. Lapalus, *Le fronton sculpté en Grèce* (1947), 204-11; Delivorrias, *BCH* 97 (1973), 111-135.

5. Tegea metopes: see Dugas, 35, 103, and Chapter 2, below.

6. Tegea marble: Furtwängler, *SBBayAkad* (1906), 383; E. A. Gardner, *Six Greek Sculptors* (1910), 183; Neugebauer, *Studien*, 10-11; Dugas, 79; Pfuhl, op. cit., 35; Picard, *Man* iv.1, 196; Bieber, 24. On Aegean marble in general see C. Renfrew and J. S. Peacey, *BSA* 63 (1968), 45-66 and the reply by Ashmole, *BSA* 65 (1970), 1-2; H. and V. Craig, *Science* 176 (1972), 401-3.

7. The figures quoted by Ashmole, *Architect and Sculptor*, 17 give some idea of the ruinous cost of land transport in the fourth century.

8. Diminution in heights of figures at Tegea and elsewhere: Neugebauer, *Studien*, 31; Dugas, 91-92, 97, 134-36.

9. On the monumentality of the Tegean temple, see Pausanias viii. 45.5 (Appendix 1, no. 36); Dugas 57-64; Pfuhl, op. cit., 27 and passim; Roux, 365-66; Lawrence, *Greek Architecture*, 191; for truly the largest temple in the Peloponnese, see Dinsmoor, *Hesp Suppl* 8 (1949), 104-15.

10. 'Neoptolemos': Schlörb, 10 n. 32 and pl. 1; J. Charbonneaux, *Classical Greek Art* (1972) fig. 228; cf. Vitruvius iii.5.12 on the relative proportions of akroteria and pediments.

11. The Tegean central floral akroteria have been restored by Clemmensen (Dugas, 29 and fig. 10) and, more recently, by Gropengiesser (*Die pflänzlichen Akrotere klassischer Tempel* [1961], 29-42, 48-49, 51 and pls. 23-29); new fragments have since been excavated by Christou. The crux of the matter is whether one accepts Vitruvius' prescription (loc. cit.) that: 'The corner akroteria are to be as high as the middle of the tympanon; the middle ones are to be one-eighth higher than those at the angles,' and the combined testimony of the akroteria from temples at Aegina, Sounion, Kaulonia, Epidaurus and Samothrace that roughly these proportions were in fact observed for both floral and figural akroteria in Greek antiquity (see esp. Lehmann, *Samothrace* iii.1 [*The Hieron*], 351-58 and figs. 302-7; also ibid., 386 n. 235 for the heights of the figural akroteria from Delos [temple of the Athenians] and Epidaurus [temple of Asklepios]). In any case, at Tegea as at Samothrace, it is absurd to imagine the central floral akroterion as *shorter* than the lateral figural ones. Gropengiesser's reconstructions fail on this count in particular, since to obtain the required height (at Tegea, about 2.10m.) is virtually impossible while the central stalks only describe a single curve outwards before reaching the crowning palmette—as they do in every one of her drawings, in flat contradiction to all the examples already cited, which either undulate twice or, in the case of Kaulonia, three times. Her heights are too low by about one-third, yet an akroterion of the correct size with only the one undulation and six spirals she restores would look ridiculously bare and, I submit, would not stand up in a wind. In consequence, the central akroteria are restored in PLATE 53, hypothetically, as rising, with a double undulation and

fourteen spirals, to a height of about 2.10m, exceeding the lateral akroteria (roughly equal to the tympanon in height) in canonical fashion.

12. For the marble, cf. Pfuhl, *Jdl* 43 (1928), 35: 'von parischem kaum zu unterscheiden . . .', also Chapter 1.

13. Akroteria of the temple of Artemis, Epidaurus: N. Yalouris, *ADelt* 22.A (1967), 25-37 and pls. 22-24.

14. On the movement, see Picard, *Man* iv.1, 198; L. Alscher, *Griechische Plastik* iii (1956), 200-1 n. 33.

15. Until 1964 the attribution of this piece to the temple was bitterly controversial; the discovery of her sister (no. 3) in that year settled the argument once and for all. References to the controversy, now purely of antiquarian interest, are to be found in Picard, loc. cit.

16. See esp. Furtwängler, *Jdl* 19 (1904), 79; Neugebauer, *Studien,* 21; Dugas, 120; Picard, *REG* 46 (1933), 417.

17. Nike with hydria: Züchner, *Klappspiegel* fig. 56.

18. Nike holding a wreath: C. M. Kraay and M. Hirmer, *Greek Coins* pl. 14; for the roll of stone as support see e.g. Furtwängler, *Aegina* ii pl. 88, 27. Calydon heroes with crowns: Appendix 2 nos. 1, 17-20.

19. It is suggested by Megaw that she was winged, presumably after Christou's hint of additional proof that she was a Nike (loc. cit.). Neither Christou nor I can find any trace of wing feathers embedded in the drapery, though metal wings are still a possibility, set in sockets as on the Nikai from the Epidaurus Artemision (Yalouris, op. cit. [note 13] pls. 23, 26, 28). Unfortunately, the loss of the back and shoulders has removed any possibility of proving this one way or the other.

20. Paionios' Nike: Lullies and Hirmer pl. 178.

21. Cyrene Nike: Paribeni, *Cirene,* no. 38 and pl. 41.

22. Asklepieion head: Crome, 23 no. 3. Artemision heads: Yalouris, op. cit. (note 13), pls. 22-24, 32-33.

23. Holes in jaw: see Milchhöfer, *AZ* 38 (1880), 190-91; *contra,* Treu, *AM* 6 (1881), 400-1; Dugas, 85; Adam, *Technique,* 66.

24. Masi: *BCH* 44-45 (1940–41), 245 fig. 14; see Schlörb, 56-59, where this detail is not mentioned.

25. Dugas, 84.

26. Dogs: AkrM 143: *Guide Sommaire* pl. 6; NM 4763: nowhere illustrated.

27. For Artemis' clothing see e.g. Bieber, *Griechische Kleidung* pl. 54.

28. Anatomy of the 'Tegean eye': E. F. Benson, *JHS* 15 (1895), 196; Neugebauer, *Studien,* 43-47; Dugas, 116; also the discussion in Chapter 4.

29. Helmets etc. at Tegea: Neugebauer, op. cit., 31-32.

30. Rhomaios, *Praktika* 1909, 310-11.

31. Dugas, 94.

32. Tegea lion spouts: Dugas pls. 46; 86,B.

33. Attic helmets: Snodgrass, *Arms and Armour of the Greeks,* 69, 93-94. Helmets are only found on the provincial Gjöl-

baschi-Trysa frieze, Appendix 2 no. 5. For the attribution, see Neugebauer, *Studien,* 33; Dugas, 90; Pfuhl, *Jdl* 43 (1928), 34; Picard, *Man* iv.1, 185, 188-89.

34. For the action and anatomy see esp. Neugebauer, *Studien,* 38, 42-43, 47.

35. Olympia, east P: Treu, *Olympia* iii, 67; Ashmole and Yalouris, *Olympia* pls. 4 and 7; west U: ibid., 22 and pl. 66. The lying figures from Epidaurus, Schlörb figs. 22-23 and pl. 6, either lay on their own cloaks or directly on the pediment floor.

36. BM 1016.25: Buschor fig. 7; cf. Snodgrass, op. cit., 53. BM 1013-14: Lullies and Hirmer pl. 214.

37. Compare the head of a dying woman from Epidaurus, NM 154 (PLATE 26c), now joined to the torso fragment NM 4754, also the heads of the dead warriors illustrated by von Graeve, *Alexandersarkophag* pls. 63-64.

38. Alexander sarcophagus: see previous note.

39. Metopes: Dugas, 36 and pl. 59.

40. Frieze crown: Dugas, 30, 37 and pls. 12-14, 52,A and 59.

41. For a charioteer's dress, see Bieber, op. cit. (note 27), pl. 17, 5 and 6.

Chapter 1

1. Tegean marble: Furtwängler (*Jdl* 19 [1904], 79 n. 76) thought that both nos. 1 and 2 were Parian; Gardner reached a similar conclusion independently in the same year (*JHS* 26 [1906], 169 and 283). Arvanitopoullos (*AE* 1906, 38) added Dugas 99, but Neugebauer (*Studien,* 22), omitting Dugas 99, followed Furtwängler.

2. Epidaurus akroteria and pediments: *IG* iv.²1.102.89-92, 97-99, 111-12. Trans: Burford, 215-17.

3. For the backs of fourth century figures in general, see Adam, *Technique,* 31, 37 and pls. 5 and 32b.

4. Backs of classical akroteria: Palatine 'Aura': Helbig⁴ 2256; *MonPiot* 39 (1943), 69 fig. 6. Nikai in Paris: ibid. fig. 2 and pl. 6. Formia Nereids: *AP* 9 (1969) pls. 29, 36, 38; cf. fig. 8 to p. 60. Epidaurus 'Aurai': Crome pl. 6. Epidaurus Nikai: *ADelt* 22.A (1967) pls. 23, 26, 28.

5. Adam, *Technique,* 15.

6. Backs of late archaic and classical pedimental figures: Furtwängler, *Aegina* i, 245-47 figs. 199, 201-2; H. A. Thompson, *Hesp* 18 (1949) pls. 49-51 (Hephaisteion); Brommer, *Die Skulpturen der Parthenon-Giebel* pls. 34, 40, 51 etc; F. Eichler, *ÖJh* 19-20 (1919) figs. 23b, 26b (Argive Heraeum); Crome pls. 14, 25, 28, 32 (Epidaurus).

7. Alterations to Parthenon sculptures: P. E. Corbett, *JHS* 86 (1966), 276; on the inner horse of Helios' chariot, however, the cutting was apparently planned (Brommer, op. cit. pl. 24).

8. Statues in New York (from a pediment ?): Richter, *MetMus* no. 94 and pl. 76; Adam, *Technique,* 15-16.

9. Olympia backs: Treu, *Olympia* iii figs. 55, 62, 67, 74, etc.

10. Carpenter, *Greek Sculpture,* 127-28.

11. Delphi pediments: F. Croissant and J. Marcadé, *BCH* 96 (1972), 887-95; Pausanias x. 19.4. For the date, compare e.g. the drapery of the Dionysos (ibid, fig. 1) with Euphranor's Apollo Patroos (Adam, *Technique* pl. 42: note the similar positions of the girdles), and the drapery of the fragments ibid. figs. 8, 9 and 12 with the grave-relief NM 2574 (Lullies and Hirmer pls. 240-41), datable to c. 320. The temple sima is dated by inscription to 342-340 (Schede, *Antikes Traufleisten-ornament*, 48), and no mention of sculptures occurs in the accounts, giving a *terminus post* of 338 (cf. Marcadé, *Recueil* ii, 112 *verso*–113 for sculptor and date).

12. The backs of the metopal fragments will be dealt with separately below.

13. Fourth century claw work: Adam, *Technique*, 20.

14. Fourth century flat chisel work on drill channels and drapery: ibid. 31, 34-35, 67 and pl. 15b.

15. BM 1052 and 1056: Buschor figs. 36, 39, 59. Epidaurus heads: Crome pl. 35; Schlörb fig. 24. Argive Heraeum: C. Waldstein, *The Argive Heraeum* i pls. 31,2-3; 32,3.

16. Dugas 47 and 48 (detail, ibid. pl. 111,A): cf. e.g. Furt-wängler, *Aegina* ii pl. 89,58.

17. Fifth and early fourth century drill work on drapery: Adam, *Technique*, 50-53, 57-58, 60-61 and pls. 23-30.

18. *Ansätze*: ibid., 80-82.

19. Berlin Triton: see Neugebauer, *JdI* 56 (1941), 197-98 and Blümel, *KGS*, 85-86 for the date.

20. 'Maussolos': Neugebauer, op. cit., 198-99 and figs. 6-10; Lullies and Hirmer pls. 211-13; Adam, *Technique*, 68.

21. Adam, *Technique*, 68.

22. Regarding the Mausoleum in general I am indebted to Dr. G. B. Waywell for the following account: 'Concerning the use of the running drill on the nude parts of statues, it certainly was used on the elbow numbered 181 (red), 262 (black), but on the only other well-preserved'elbow (numbered B.66.3—found by Biliotti) it was apparently not used. And there is no sign of its use on the few bare knees that are preserved. Drilled grooves do, however, divide the lips on the heads BM 1051, 1054, 1055, 1058. Maussolos' lips are not drilled. This is all the evidence there is, I think, for its usage on flesh.'

23. As on the Mausoleum lions (Adam, *Technique*, 69).

24. Rasping and textured drapery: ibid., 75-77.

25. *Ergasteria*: Mallwitz and Schiering, *Olympische Forsch-ungen* v; Ashmole, *Architect and Sculptor*, 98-99 fig. 110 (Parthenon); Roux, 89; Burford, 58-59 (Epidaurus, Asklepi-eion).

26. Olympia statues with staffs and spears: Treu, *Olympia* iii pl. 1; Ashmole and Yalouris, *Olympia* pls. 59-61 ('seer').

27. Erechtheum frieze: Stevens-Paton, *The Erechtheum*, 290-91 (lines 77-82), 314; P. N. Boulter, *AP* 10 (1970), 23.

28. 'Epione', NM 155: new additions shown in J. Char-bonneaux, *Classical Greek Art* (1972) fig. 231.

29. Inset heads on the Hephaisteion and Parthenon: Thompson, *Hesp* 18 (1949) pl. 52, 1; Brommer, op. cit. (note 6) pls. 97-101.

30. Shields at Epidaurus: Crome no. 15.

31. Appendix 1, no. 36.

32. Epidaurus west, central group: Crome pls. 13, 15 (pun-telli on belly and above right foreleg of horse); 28-29; 31-33. The fallen warrior is illustrated complete in *BCH* 90 (1966), 784 fig. 5.

33. Pediment construction (horizontal cornice): Dugas pl. 45; Rodenwaldt, *Korkyra* i pls. 24-25 (Corfu); Furtwängler, *Aegina* i, 203 and pl. 46,9; Thompson, op. cit. (note 29) fig. 2 and pls. 56-58 (Hephaisteion). At Olympia, though the sculptures probably did stand on a step, it must have been made from separate blocks and thus contributed nothing to the strengthening of the cornice: Dörpfeld, *Olympia* ii, 7; Treu, *Olympia* iii fig. 166. See also Brommer, op. cit., (note 6), pls. 8-19 (Parthenon); Roux figs. 18-21 (Epidaurus).

For the installation of pedimental groups on the above buildings, see in addition Furtwängler, op. cit., 204 and Beil. 3 and 4; Treu, *JdI* 10 (1895), 15 (Olympia). On the Parthenon, the exception is east pediment G, possibly another correction: compare the line of the shoulders of the corner figures in Brommer, op. cit. (note 6) pl. 38, 1; Harri-son, however, (*AJA* 71 [1967], 47) thinks the cutting was planned.

34. Roux, 99.

35. Structural iron: Dinsmoor, *AJA* 26 (1922), 156-58; A. K. Orlandos, 'Υλικὰ δομῆς ii fig. 11; Orlandos' drawing is slightly at fault since from the Parthenon it appears that the practice was merely to counterweight the bars by the tympanon blocks, not to angle them upwards behind the tympanon wall.

36. Information from Dr. N. Yalouris. See Schlörb figs. 9, 18, 22, 23 and pl. 4.

37. Clamping arrangements (plinths): Dugas pl. 45 (cf. Treu, *JdI* 10 [1895], 24; id., *Olympia* iii figs. 64, 119 [letter 'l'], 120 etc.).

38. Clamping arrangements (backs): Dugas, 27 and pl. 50; cf. e.g. Adam, *Technique*, 48 (Eretria).

39. Sectioning of the heads: Neugebauer, *Studien*, 24-31. Treu, *Olympia* iii fig. 90; Smith, *BMCat* i, 116 (Parthenon); cf. Rodenwaldt, *Kunstgeschichte in Bildern* pl. 264,9 (Nereid Monument, BM 925); von Graeve, *Alexandersarkophag* pls. 66-68.

40. Neugebauer, *Studien*, 30.

41. Metope blocks: Dugas, 36-37 and pls. 58, Ec; 59, Ba.

42. Inscriptions: *IG* v.2. 78, 79; Dugas, 35 and pls. 58,E; 88,A.

43. Hephaisteion cult statues and Erechtheum frieze: Dins-moor, 181; Stevens-Paton, *The Erechtheum*, 314; Boulter, loc. cit., (note 27).

44. Ilion: Lippold, *Plastik* pl. 110,1; B. M. Holden, *The Metopes of the Temple of Athena at Ilion* (1964) figs. 1, 37, 42 etc. For the date, see W. Hoepfner, *AM* 84 (1969), 175-81 (after 300 to after 281).

45. Tegea and Olympia: Dugas, 108.

46. Adam, *Technique*, 25.

Chapter 2

1. The findspots, except in the case of no. 13, are not an issue.

2. Perspective: J. White, *Perspective in Ancient Drawing and Painting* (JHS Suppl 7, 1956); D. Gioseffi, in *EncWA* xi s.v. 'Perspective', 183-221; G. M. A. Richter, *Perspective in Greek and Roman Art* (1970); distortions in sculpture: A. B. Cook, *JHS* 61 (1941), 7; E. Boehringer, *RM* 59 (1944), 7-16; S. Stucchi, *Ann.* 30-32 (1952–54), 23-73; E. Bielefeld, *Pantheon* 25 (1967), 153-59; also, in general, M. H. Pirenne, *Optics, Painting and Photography* (1970). I thank Professor Ashmole for this reference and for his valuable help on this complicated problem in general.

3. Plato, *Sophista* 235-236A (c. 360 or later) mentions that empirically calculated adjustments were employed by the sculptors of his time: cf. also Tzetzes, *Historiarum variarum chiliades* viii. 353 (SQ 772).

4. Corfu: Stucchi, op. cit., 47-48. Olympia, Pfuhl, *JdI* 21 (1906), 154; references to the controversy in Säflund, *The East Pediment of the Temple of Zeus at Olympia*, 81-82. Renaissance practice was to tone down such distortions as Pirenne, op. cit., 116-35, points out.

5. Dugas 81.

6. Both recognised and corrected by fourth century sculptors: Plato, *Sophista* 235E.

7. For Paionios' Nike see note 20, Select Catalogue; for 'Epione' see note 28, Chapter 1.

8. Epidaurus 'Aurai': Crome, 24 and pls. 7-9; Roux, 105—though his suggestion that the east akroteria were 'cavaliers' like their western counterparts is clearly wrong. For diagonally placed akroteria of the Archaic period, see Stucchi, op. cit., (note 2), 36-41.

9. Hermione akroteria (Nereids from Formia): Bielefeld, *AP* 9 (1969), 47-64 and pls. 25-39; id., *RM* 76 (1969), 93-102.

10. Tegean altar: Dugas, 67.

11. Dugas, 68-69; Shoe, *PGM*, 37.

12. Fourth century altars: Bammer, *ÖJh* 47 (1964–65), 143. For the Artemision in particular, see id., *AA* 1968, 420 and fig. 32, and *Die Architektur des jüngeren Artemisions von Ephesos*, figs. 5 and 43; cf. the lengths to which the architects of the Parthenon were prepared to go to position the spectator correctly before the temple: G. P. Stevens, *Hesp Suppl* 3 (1940), 1-7.

13. Iconography of the east pediment: note 4, Select Catalogue. Discussions of the hunt in Roscher s.v. 'Meleagros', cols. 2608-2622; C. Robert, *Die antiken Sarkophag-Reliefs* iii.2 (1904), 268-77; *RE* s.v. 'Meleagros', cols. 460-66; H. Metzger, *Les représentations dans la céramique attique du iv^e siècle* (1951), 312-18; G. Daltrop, *Die Kalydonische Jagd in der Antike* (1966). See also Chapter 3 and Appendix 2.

14. Pausanias viii.45.6-7; for the Greek, see Appendix 1, no. 36, and for the full story, see the following chapter.

15. Neugebauer, *Studien*, 7.

16. A résumé of reconstructions prior to 1952 is given in Arias, 118-19, and prior to 1954 in Picard, *Man* iv. 1 figs. 75-76. That Peleus and Telamon formed a group was first suggested in Urlichs' *Skopas: Leben und Werke* (1863), 21-22 and accepted with reservations by Neugebauer, *Studien*, 4. Welcker's discussion appeared in *Alte Denkmäler* i, 199; for the sarcophagi see Robert, op. cit., (note 13), 270 and pls. 77-81, 83-87.

17. Neugebauer, *Studien*, 5-6; cf. Pausanias v. 10.6.

18. Ovid, *Metamorphoses* viii. 378-81.

19. See Neugebauer, *Studien*, 6.

20. Dugas, 86 suggests that it ran to the right.

21. Compare Appendix 2, nos. 5, 9 and 12.

22. Delivorrias, *ADelt* 24.B.1 (1969), 130 and pl. 117β believes this to be a *lying* figure, presumably from the west pediment, since Pausanias' account rules out the east. This seems unlikely, for the following reasons: (1) the lying figure no. 20 clearly belongs here; (2) the scales of the two are very different; (3) there being no dowel, the head of no. 8 would have been completely unsupported in this position; (4) the tensions within her drapery seem to me clearly to indicate movement.

23. Severan coin: Appendix 2, no. 22.

24. See Neugebauer, *Studien*, 3, 32-33 and pl. 2,1-2; Ovid, *Metamorphoses* viii. 401-10. The heads of Ankaios and Telamon (?) would presumably have been nowhere near the cornice.

25. Dugas fig. 35. An axe is unlikely since it would confuse him with Ankaios: cf. Euripides, *Meleager*, frag. 530 (Nauck²): πελέκεως δὲ δίστομον ἔπαλλ' Ἀγκαῖος and Pausanias' Ἀγκαῖον ἀφέντα τὸν πέλεκυν. On the vases, the axe-swinger is omitted if Ankaios is shown wounded (e.g. Appendix 2 nos. 9 and 11: PLATE 28b) but included if not (nos. 3 and 6: PLATE 28a); see also *RE* s.v. 'Meleagros', cols. 462 (no. 12) and 463 (no. 14).

26. For a discussion of the anterior surface of no. 12 see Dugas, 94 n. 1, and for Berchmans' reconstruction, ibid., fig. 36. On no. 13 c. Dugas, 134-36 fig. 41; Picard, *Man* iv. 1, 184-85; Dörig in Boardman et al., *Art and Architecture* fig. 169 (reversed: here third hero from left), whence W. Fuchs, *Die Skulptur der Griechen* (1969) fig. 439.

27. For the restored position of this hero, cf. Appendix 2, nos. 3, 5, 6, 9–12; Robert, op. cit., (note 13), 270 and pls. 77-81, 83-87.

28. Epidaurus youth: Crome pl. 47 (cf. Dugas fig. 38). BM 1014: Lullies and Hirmer pl. 214, below.

29. BM 531: H. Kenner, *Der Fries des Tempels von Bassae-Phigalia* (1946) pl. 12 (and cf. pl. 22). NM 4642: Karouzou, *Guide*, 102 (nowhere illustrated).

30. Bassae Amazons: Kenner, op. cit., pl. 22.

31. For the proposed Polygnotan original of the vases see F. S. Kleiner, *Antike Kunst* 15 (1972), 7-19, and cf. Appendix 2 nos. 3-15, which certainly echo *a* common original, albeit with varying degrees of fidelity. As for the Tegean composition, the coin type (PLATE 29a) adds a quiver, which our no. 8 never possessed; I suspect license on the part of the

artist. Atalante with a spear is not as rare as might be thought: cf. R. von Schneider, *AA* 1892, 51 no. 78; Neugebauer, *Studien*, 12 nn. 54 and 58; Daltrop, *Kalydonische Jagd* pls. 1, 11, 13, 14.

32. As for influence from Tegea on other fourth-century hunting scenes, one possible beneficiary could have been the panther hunt on the Alexander Sarcophagus, PLATE 27b (see here von Graeve, *Alexandersarkophag*, 71-73).

33. On the Telephos battle, see in general Roscher s.v. 'Telephos', cols. 274-308; *RE* s.v. 'Telephos', cols. 362-71; C. Bauchhenss-Thüriedl, *Der Mythos von Telephos in der antiken Bildkunst (Beiträge zur Archäologie* iii, 1971). Reconstructions and interpretation by Neugebauer, *Studien*, 33-39; Pfuhl, *Jdl* 43 (1928), 34; Picard, *REG* 48 (1935), 475-504; id., *Man* iv. 1, 180-90, Dörig, op. cit., (note 26), fig. 169 (reversed), whence W. Fuchs, loc. cit., (note 26) (n.b. that in this reconstruction the proportions of the pediment are incorrect); A. Delivorrias, *BCH* 97 (1973), 111-35.

34. Pausanias viii.45.7; for the Greek, see Appendix 1, no. 36, and for the full story, see the following chapter.

35. For the pose and correct position see Neugebauer, *Studien*, 36-38 and pl. 2, 3; Pfuhl, op. cit. fig. 9; Delivorrias, op. cit., 125-27 and fig. 3.

36. Amazon sarcophagus: Bieber fig. 252. Paris bronze: ibid., fig. 687; Neugebauer, *Studien*, 37-38, n. 184. Cf. von Graeve, *Alexandersarkophag* pls. 32, 33 and 34, 1.

37. Identification as Telephos: Gardner, *Six Greek Sculptors*, 184; Bieber, 24; Delivorrias, op. cit. (note 33), 121-27.

38. Herakles and Telephos: cf. *Altertümer von Pergamon* iii.2, 170 and pl. 31, 6; E. Schmidt, *The Great Altar of Pergamon* pl. 63. A rather similar dilemma is described by Panofsky, *Meaning in the Visual Arts*, 36-38; the solution, an already existing, 'wayward' type, is perhaps instructive in our context, only here it is more than likely, considering the paucity of surviving representations of the theme, that the prototype, if any, has been lost.

39. 'Warrior defending fallen comrade': so Pfuhl, loc. cit., (note 33); swollen ears, n.b. are not necessarily an attribute of Herakles alone, as Neugebauer shows (*Studien*, 35 n. 172).

40. Tegea 48: Delivorrias, op. cit., (note 33), 131-35 and fig. 9. Found in the Tegean sanctuary. This head probably came from a free-standing statue, and not from the west pediment as Delivorrias believes, for the following reasons: (1) the piece is larger in scale, by about 15%, than nos. 16-18; (2) the hole for a μηνίσκος on the crown is not repeated elsewhere on the pedimental heads, not even on no. 16, which was certainly clear of the cornice; the other two holes in the sides of the head also seem to be for μηνίσκοι, and these, too, would be unique (see further under no. 4 in the catalogue); (3) the back is well carved, not merely planned as in the other pedimental heads; (4) the head was turned only very slightly on the body, to the spectator's left; if this were indeed Herakles appearing to rescue Telephos, it would be surprising if he were represented as turning *away* from the charging Achilles, whom he is meant to be restraining. On the style of this head, see below, Chapter 10, section 2.

41. Telephos' wound is usually in the left leg, see Roscher v, col. 283.

42. On the Pergamon frieze he wears a helmet; cf. PLATE 29c.

43. Telephos' status: see in general Roscher v, col. 282; at the moment of his fall Lycophron even calls him a lion (*Alexandra*, 213). For his pre-eminence among Herakles' sons see Roscher, loc. cit.: 'Überhaupt erscheint er als echter Heraklespross'; cf. Pausanias x.28.8: 'μάλιστα . . . ἐοικότα . . . τῷ πατρί'; also Picard, *Man* iv. 1, 176: 'Télephos, Héraklès Mysien. . .', and Delivorrias, op. cit. (note 33), 121-25.

44. Herakles at Tegea: Pausanias viii.45.3, 45.6, 47.4, 48.1, 53.9 and Picard, *REG* 47 (1934), 395-403, 407, 420; id., *REG* 48 (1935), 476-80 etc; also *Man* iv.1, 149-91 passim, esp. 160 n. 3, 176-77 for his links with the Athena temple.

45. Alexander portraits carried the lionskin cap at the latest by 312 (von Graeve, op. cit., 169 and pl. 49); see also Bieber, *Alexander the Great in Greek and Roman Art* (1964), 48-49 and figs. 30-32. As Delivorrias points out (op. cit. [note 33], 122 n. 39) others, too, wear the lion's skin, such as Agamemnon and Ajax in *Iliad* x. 23 and 177.

46. Decree of silence: Picard, *REG* 48 (1935), 488-504.

47. Pergamon and Tegea: *Altertümer* viii.1, 78-80 (no. 156); Pausanias i.4.6; summary, *IG* v.2, p. 5, lines 61-67.

48. 'Kladeos': Ashmole and Yalouris, *Olympia* pls. 4-12; Neugebauer, *Studien*, 33-34.

49. Borghese Warrior: Bieber figs. 686, 688-89; Neugebauer, loc. cit.; cf. e.g. the Masi warrior (middle of fourth century ?), *BCH* 64-65 (1940-41), 245 fig. 14, and the Conservatori Herakles (copy of a work of c. 340 ?): Arnold pl. 21a, c; Stuart-Jones, *PalCons* pl. 58.

50. BM 1037: Lawrence, *GRS* pl. 53a-b; Ashmole, *Architect and Sculptor* figs. 185-87.

51. Achilles: Pfuhl, op. cit., (note 33), 34; Delivorrias, op. cit. (note 33), 127-31; cf. Picard, *Man* iv.1, 185: Athena (!).

52. Reconstructions: Neugebauer, *Studien*, 38; Dugas, 89; Dörig, loc. cit. (note 26), second figure from left (right in Fuchs). Cf. Picard, *Man* iv.1, 182 n. 5: Telephos; *contra*, Delivorrias, op. cit., (note 33), 125.

53. E.g., BM 1013.29 (Lullies and Hirmer pl. 214, top); BM 1009.42 and 1012.49 (PLATES 34a, 40a).

54. Delivorrias restores no. 20 as the dead Hiera, Telephos' wife; Hiera, however, was killed *after* Telephos was wounded (Philostratus, *Heroicus* ii. 18; Roscher v, cols. 281, 283), so if she was shown at all at Tegea it was probably as still in the fight. The way in which the torso was raised, too, hardly coincides with Delivorrias' picture of '[une] position complétement étendue que nous connaissons par d'autres figures d'angle provenant de scènes de bataille' (op. cit., [note 33], 115).

55. Reconstruction: Dugas fig. 34, cf. Ashmole and Yalouris, op. cit. (note 48), pls. 4-12.

56. *Rapprochement* with no. 17: Neugebauer, *Studien*, 34. Contrast the twist of the torso of the Conservatori Herakles (see above) in the *opposite* direction. Dugas fig. 39 makes no allowance for this twist.

57. Dionysos and Herakles: see esp. Delivorrias, op. cit., (note 33), 116-18.

58. Phintias vase: Leningrad Inv. 1843 (St. 1275); *ARV²*, 23; Waldhauer, *AA* 1912, 104-10; A. A. Peredolskaya, *Krasno-figurniye Atticheskie Vasy v Ermitazhe* (1967), 31 (no. 26) and pl. 159,1-2.

59. Tegea pediment: dimensions, Dugas, 26-28 and pl. 45; for Epidaurus, compare Roux, 97-99. Comparative figures for the two temples are:

Epidaurus (a): depth 0.30m, height 1.25m, = 24%, or:
Epidaurus (b): depth 0.30m, height 1.15m, = 26.1%
Tegea (a): depth 0.62m, height 1.90m, = 32.6%, or:
Tegea (b): depth 0.70m., height 1.90m., = 36.8%

(pediment depth expressed as percentage of pediment height).

60. Olympia: for optical corrections analogous to those at Tegea, see Såflund, op. cit. (note 4) fig. 8 and pp. 81-96; cf. Stucchi, op. cit. (note 2), 31-32, 50 fig. 13.

61. Carpenter, *Greek Sculpture*, 164.

62. 'School of Athens': see Pirenne, op. cit. (note 2), 121-23. Distortions in Renaissance art in general (particularly the work of Uccello) are discussed in *EncWA* xi, col. 208.

63. Alexander Mosaic: ibid., col. 196 and p. 81.

64. Tegea metopes and inscriptions: see note 5, Select Catalogue. Discussions of the subjects in Dugas, 103-4; Picard, *REG* 47 (1934), 391-401; 48 (1935), 476-88; *Man* iv.1, 156-58, 176-78; see also Chapter 3.

65. For the stories see the following chapter, and for the genealogy, Appendix 3.

66. Kepheus legends: *RE* s.v. 'Kepheus', passim. Hiera: see note 54 above. Dr. Plommer suggests to me that Ares may have made love to Aerope from a chariot, but chariots are, to my knowledge, nowhere associated with Ares' amorous adventures in ancient literature or art.

67. Auge, Telephos and Aleos: Pausanias viii.48.7. Suckling scene: Schmidt, *The Great Altar of Pergamon* pl. 63.

68. Aerope and Aeropos: Pausanias viii.44.7-8; Picard, *REG* 47 (1934), 309-99; id., *Man* iv.1, 156-58. Dugas, 103-4, shows that the ΚΑΦΕΙΔΑΙ metope itself cannot have portrayed Aerope and Aeropos.

69. I owe these observations on the positioning of the frieze to Dr. Plommer. The ceiling, resting on the frieze, had also to come down a course; this arrangement had been anticipated, though for other reasons, only in the east hall of the Propylaea (see Plommer, *Ancient and Classical Architecture*, 177-78).

70. Parthenon: Stevens, *Hesp Suppl* 3 (1940), 1-7 fig. 4; R. Stillwell, *Hesp* 38 (1969), 231-41.

Chapter 3

Tegea iconography: see Select Catalogue, note 4 and Chapter 2, notes 13 and 33.

1. Alea Athena: *REG* 46 (1933), 384-90; *IG* v.2, p. 1, lines 96-102; Roscher i, col. 679.

2. Fourth century architectural sculpture: *Man* iii.1, 5-13.

3. Tegea cult statues: Appendix 1, no. 16. On Endoios' statue and its replacement, see Pausanias viii.46.1-47.1. Bronze: Dugas, *BCH* 45 (1921), 358-63 and pl. 13 (now Athens, NM 14828). Coins: Gardner, *Catalogue of Greek Coins in the British Museum (Peloponnese)*, 201-3, esp. nos. 11-12 (pl. 37, 14-15); *NCP*, 108 and pl. V,21; Mionnet, *Médailles Antiques* ii, 256 no. 72.

4. Battle offerings: Pausanias viii.47.2, cf. 48.4-5.

5. Tegean temple as refuge: Pausanias iii.5.6 and 7.10; Herodotus vi.72; Picard, *REG* 46 (1933), 385.

6. Athena Hygieia: Pausanias i.23.4; Picard, *REG* 47 (1934), 388-90; E. J. and L. Edelstein, *Asclepius* ii (1945), 23, 43, 120. For Skopas' statues see Appendix 1, no. 16.

7. 'Epione', NM 155, Artemision akroteria, and Cyrene Nike: see Select Catalogue, notes 13 and 21 and Chapter 1, note 28.

8. Wingless Nikai: Roscher iii. 1, col. 317; Neugebauer, *Studien*, 17 n. 82; Beazley, *Potter and Painter*, 8; *EncAA* s.v. 'Nike', 464. I know of only eight examples in vase-painting: (1) Athens 1183 (*ARV²*, 1123); (2) Berlin 2406 (*ARV²*, 1225); (3) Berlin 2479 (Inghirami, *Vasi Fittili* i pl. 2; *CRend* 1864, 80; 1874, 158: restored); (4) Berlin, Inv. 3308 (*ARV²*, 977); (5) BM 98.7-16.6 (*ARV²*, 1333); (6) Bologna 314 (*ARV²*, 1163); (7) New York 56.171.49 (*ARV²*, 1347); (8) Vatican (*ARV²*, 1039). All are flying, but wingless. In sculpture, the type is only securely attested by Pausanias v.26.6, all other references being to *Athena* Nike.

9. For ταινία and στεφάνη together, cf. e.g. Zeus' Nike at Olympia, Pausanias v.11.1, and Appendix 2, no. 9 (PLATE 28b).

10. Dryads: Roscher s.v. 'Nymphen', col. 522; for the distinction, Pausanias viii.4.2. Forest and tree nymphs (Dryads and Hamadryads) are not distinguished in early literature, e.g. Homer, *Hymnus ad Venerem* 256-72; Δρυάδες first appear in Plato, *Epigrammata* xxvi (= *Anthologia Palatina* ix.823), while in Callimachus fr. 354 (Schneider) they are called Δρυμίδες or Δρυμάδες. They were supposedly born on the same day as their oak-tree, and died when it died; thus, though long-lived, they were not immortal (Homer, loc. cit.; Callimachus, *Hymnus in Delum* 83-5; Plutarch, *Caesar 9*; Pausanias x.31.10). Thus, for the wreath, the στέφανος δρυός of a Delian second century inscription would be particularly appropriate (*SIG²* 588. 7).

11. Hunt in forest: Ovid, *Metamorphoses* viii.329. On Dryads, Artemis, hunting and hunters see Homer, *Odyssey* vi.102-9; Sophokles, *Trachiniae* 210-14; Callimachus, *Hymnus in Dianam* 51-56 and 170-224; *Anthologia Palatina* vi.253; Arrian, *Cynegeticus* i.35.

12. Munich hydria: Pfuhl, *MuZ* fig. 598.

13. Arcadian nymphs: Pausanias viii.4.2, 31.4, 38.3, 47.3; x.31.10.

14. Atalante and Artemis: Scholia Aeschylus, *Septem contra Thebas* 532; Euripides, *Phoenissae* 151; Xenophon, *Cynegeticus* xiii. 18; Callimachus, *Hymnus in Dianam* 215. Artemis' displeasure: Scholia Euripides, *Phoenissae* 151; Musaeus

151. A fragment of Euripides' *Meleager* (Nauck² 525) shows that Atalante was still a virgin at the time of the hunt.

15. Replicas of the Meleager type with *taeniae* etc. are collected by Fink, *RM* 76 (1969), 239-52 and pls. 76-79.

16. Eight accounts of the hunt and lists of hunters survive: (1) *Iliad* ix. 529-99; (2) a fragment of Stesichoros, Page, *Poetae Melici Graeci*, 119 fr. 45 (= *Oxyrhynchus Papyri* 2359); (3) fragments of Euripides' *Meleager*, Nauck² 515-39; (4) an elegiac fragment of c. 300–275, published in Appendix 1 to Hollis' commentary on Ovid, *Metamorphoses* viii, (5) Apollodorus mythographus i.8.2; (6) Hyginus, *Fabulae* 173; (7) Ovid, *Metamorphoses* viii.270-546; (8) Pausanias viii.45.

17. For the other, see *Iliad* ix. 529-99.

18. The genealogy is given in Appendix 3.

19. Hide and tusks: Pausanias viii.46.1, 47.2.

20. Atalante as 'crypto-Artemis': *RE* s.v. 'Atalante', cols. 1892–93; Picard, op. cit. (note 6), 407; cf. Pausanias iii.24.2. On her part in the hunt see e.g. Pausanias viii.45.2; Ovid, *Metamorphoses* viii.379-87. Most of the classical pictures place her well away from the boar, but it does not seem to have bothered the Romans that the bow was no weapon for use at close quarters; see e.g. Daltrop, *Kalydonische Jagd* pls. 27, 30-31. N.b. also that according to Ovid she wounded the boar well before Ankaios' ill-fated attempt to kill him.

21. Prothoos and Kometes: full story in Ovid, *Metamorphoses* viii. 425-525.

22. Cf. Appendix 3.

23. Cup in Munich, Antikensammlung 2243: Daltrop, op. cit. pl. 7; Arias and Hirmer pl. 50 **above**; cf. *RE* s.v. 'Iason', col. 770.

24. Ovid, *Metamorphoses* viii.391-93.

25. Euripides and the Meleager theme: *RE* s.v. 'Meleagros', cols. 453-55; Metzger, *Les Représentations*, 312-18; T. B. L. Webster, *The Tragedies of Euripides*, 233-36.

26. *REG* 48 (1935), 493.

27. ΚΑΦΕΙΔΑΙ: see note 68, Chapter 2, also Pausanias iii.15.3-5; viii.53.9.

28. Eruma: *REG* 47 (1934), 396-99; *Man* iv.1, 157-58; Pausanias viii.47.5. Coins: Frazer, *Pausanias* iv, 433-35 figs. 46-47; *NCP*, 109 and pl. V, 22-23; Gardner, *Catalogue of Greek Coins in the British Museum (Peloponnesus)*, 202-3 and pl. 37, 18-20.

29. Marpessa: Pausanias viii.47.2; 48.4-5.

30. Echemos and Hyllos: Pausanias viii.53.10; cf. 5.1; Gardner, op. cit., 201 (nos. 11-13) and pl. 37, 14-15. For the relief, see Christou, *ADelt* 20.B.1 (1965), 169 and pl. 150; Daux, *BCH* 92 (1968), 810-11 fig. 5.

31. For Aleos' family, see Appendix 3. Athena appeared in the Eruma story and was, of course, recognised as the protectress of Herakles, who led the sons of Kepheus against the Hippokoontidae, throughout antiquity, cf. Pausanias viii.53.9. It seems likely that this protection would have extended to Iolaos, Herakles' 'representative' on the east pediment.

32. Asklepios and the hunt: Hyginus, *Fabulae* 173; Edelstein, *Asclepius* ii, 38-39.

33. Appendix 3.

34. For both versions together, see Pausanias viii.48.7; the fragments of Euripides' *Telephos* and *Auge* preserve two variants of these (Webster, *The Tragedies of Euripides*, 238-39).

35. Picture of Auge: Pausanias viii.47.2. Ramp and fountain: Dugas, 69-71; Pausanias viii.47.4. Coins: Gardner, op. cit. (note 28), 202-3 (nos. 14, 15 and 24) and pl. 37, 16-17; *NCP*, 109 no. 4.

36. Telephos and Pergamon: Pausanias i.4.6; *Altertümer von Pergamon* viii.2, 239 line 11; *RE* s.v. 'Asklepios' col. 1674; Picard, *BCH* 46 (1922), 190-97. On the sanctuary of Athena see *Altertümer* viii.1, 78-80 no. 156, esp. notes to lines 18 and 23.

37. Auge-Eileithuia: Pausanias viii. 48.7; Frazer, *Pausanias* iv., 436-37; cf. Picard, *REG* 48 (1935), 484.

38. West pediment: Picard, op. cit. (note 6), 488-504; id., *Man* iv.1, 178-90; Delivorrias, *BCH* 97 (1973), 111-35.

39. On the word-order of Pausanias viii.45.7 see Appendix 1, no. 36, also Dörig in Boardman et al., *Art and Architecture*, 441; cf. Picard, *Man* iv.1, 182-85, also Delivorrias, op. cit., 122.

40. Pindar, *Olympian Ode* ix.72: '(he) turned to flight the valiant Danaans and attacked their ships by the sea'.

41. Podaleirios and Machaon: *Anthologia Palatina* v.225; Dictys Cretensis ii.6.10; *RE* s.v. 'Machaon', col. 146; s.v. 'Podaleirios', col. 1132; Edelstein, op. cit. (note 6), ii. 13. On Telephos and the Pergamene Asklepieion see Pausanias iii.26.9-10, cf. v. 13.3, also Suidas s.v. Χάραξ (= *Anthologia Graeca* iii.119), where Telephos and Herakles are both referred to by Asklepios' epithet ἀμύμων (cf. *Iliad* iv. 194); Edelstein, op. cit. (note 6), 203 n. 19.

42. Gorgon's blood: Apollodorus mythographus iii.10.3; *RE* s.v. 'Asklepios', col. 1653; Edelstein, op. cit. (note 6), 23, 43.

43. Neither vine nor Dionysos are mentioned in Philostratus, *Heroicus* ii.17; Quintus Smyrnaeus iv. 151, vii.379 and xiv.130 or *Anthologia Planudea* 110. See Roscher s.v. 'Telephos', cols. 282-83 for the others, also G. Daux and J. Bousquet, *RA* 19-20 (1942–43), 115-25. The vine alone sets the scene in Pindar, *Isthmian Ode* viii.49-50; cf. Daux and Bousquet, op. cit., 115-16.

44. Teuthrania and Arcadia: *REG* 48 (1935), 502; *Man* iv.1, 185; cf. *RE* s.v. 'Teuthrania'.

45. Other participants in the Kaïkos battle: Philostratus, *Heroicus* ii.14-18, cf. iii.28, 36; Picard, *REG* 48 (1935), 495-96; id., *Man* iv.1, 180-86. On Hiera, see Delivorrias, op. cit. (note 38), 114, with references.

46. Dionysos: Picard, *REG* 46 (1933), 381-422; cf. Pausanias viii.47.3 (Tegean altar); 31.4 (Table at Megalopolis: cf. Callimachus, *Hymnus in Jovem* 32-53); ii.25.2 (Oenoe).

47. Picard, *REG* 48 (1935), 491-92.

48. Meaning in art: cf. Panofsky, *Meaning in the Visual Arts*, passim; E. H. Gombrich, *Symbolic Images* (1972), 3-15. In this

context, cf. Aristotle on tragedy: 'The truth is that, just as in the other imitative arts one imitation is of one thing, so in poetry the story, as an imitation of action, must represent one action, a complete whole . . .' (*Poetica* 8, and cf. ibid. 17).

49. D. Sutherland, *On, Romanticism* (New York, 1971), 89-90.

50. 'Sphaleotas': Daux and Bousquet, op. cit. (note 43), 115-17; W. Peek, *AM* 67 (1942), 232-39; for the rest of the inscription see *SEG* xix. 399. Simon, *JdI* 76 (1961), 141-45 and 160 suggests that Dionysos was responsible for preserving Telephos' life when a baby, until the arrival of Herakles, and that Telephos' ingratitude could have caused his wrath. Yet, to judge from the inscription, the 'Sphaleotas' is an active and malign force (perhaps connected with this area of Asia: cf. Pindar *Isthmian Ode* viii.48: Μύσιον ἀμπελόεν / αἵμαξε Τηλέφου μέλαν ῥαίνων φόνῳ πεδίον) that requires soothing, not merely an affronted guardian deity.

51. Herakles: Picard, *REG* 48 (1935), 491-92.

52. Pausanias viii.45.5 (Appendix 1, no. 36).

53. Athens and the Parthenon: Herington, *Athena Parthenos and Athena Polias* (1955), esp. 48-67; id., *Parthenos and Parthenon*, in *Greece and Rome, suppl.* to vol. 10 (1963), 61-73.

54. Pheidian Parthenos: Pausanias i.24.5-7.

55. Athena Polias: Herington, *Athena Parthenos and Athena Polias*, 16-26, 44-47, and cf. Pausanias viii.47.5.

56. Local festivals: *RE* s.v. 'Panathenaia', cols. 474-86; *Altertümer von Pergamon* viii.1, 78-80.

57. Zeus: Herington, *Athena Parthenos and Athena Polias*, 57-58; id., *Parthenos and Parthenon*, 62-64; cf. Pausanias viii.47.3.

58. Metopes of the Parthenon: *Athena Parthenos and Athena Polias*, 59-67. A further example of this bond between Athena, her temple and her city, with the same iconographic scheme as the Parthenon and quite probably inspired by it, may be the early third century temple of Athena at Ilion.

59. Leuctra: the connection is suggested only, as far as I know, by Beloch, *Griechische Geschichte* ii (1897), 389 n. 2. For the history of Arcadia during this period see N. G. L. Hammond, *A History of Greece* (1959), 449-70, 482-511; J. A. O. Larsen, *Greek Federal States* (1968), 180-95; T. T. B. Ryder, *Koine Eirene* (1965), 25-86, also the useful summary in E. A. Gardner and others, *Excavations at Megalopolis* (*JHS Suppl* 1 and 2, 1892), 1-3.

60. Dipaea: Hammond, op. cit., 262.

61. Mantinea and Phlius: Larsen, op. cit., 181-83; cf. Dugas, 127.

62. Epidaurus, temple of Asklepios: on the date, see Chapter 6; on the sima, Dugas 60; Roux, 330; cf. also the tables of proportions given in Roux, 129-30, 177-78, 326, 410-23.

63. Arcadian alliance: Larsen, op. cit. (note 59), 180.

64. Pan-Arcadian nationalism: Xenophon, *Hellenica* vii.1.23-7.

65. Hanfmann and Pedley, *AP* 3 (1964), 64; cf. Pfuhl, *JdI* 43 (1928), 31; Burford, 32-35.

66. Arcadians in Elis: *Hellenica* vii, 4.12-32; Larsen, op. cit. (note 59), 189-90.

67. Older Parthenon: Dinsmoor, *AJA* 38 (1934), 408-38; id., *The Architecture of Ancient Greece,* 149-50; Herington, *Athena Parthenos and Athena Polias*, 38-39. The Erechtheum, completed 409-406, is another case in point (Dinsmoor, 188).

68. Burford, 32-35 and 92-95, 101.

69. Building at Mantinea: Larsen, op. cit. (note 59), 185-86; G. Fougères, *Mantinée et L'Arcadie orientale* (1897), 162-77, 466; A. N. Modona, *Gli Edifici Theatrali Greci e Romani* (1961), 47; W. A. McDonald, *The Political Meeting Places of the Greeks* (1943), 198-200.

70. Praxiteles at Mantinea: Pausanias viii.9.1 (*SQ* 1201); Pliny, *Naturalis Historia* xxxiv.49 (*SQ* 811); Rizzo, 86-89. The Mantinea base, NM 215-17, is probably very late fourth century, and thus does not affect the issue: cf. Lawrence, *LGS*, 102; Yalouris, *ADelt* 22.A (1967), 36.

71. Thersilion at Megalopolis: Pausanias viii.32.1; Larsen, op. cit., 185-87; Schede, *Antikes Traufleisten Ornament,* 47; Robertson, 174-76; *contra* e.g. E. Fiechter, *Antike Griechische Theaterbauten* iv (1931), 40, but Pausanias does say it was constructed for the original assembly of Ten Thousand, and in the reduced League after 362 (only Megalopolis, Tegea, and a few villages), the building would have been largely irrelevant.

72. Pausanias viii.27.8.

73. Theatre: Modona, op. cit. (note 69), 49.

74. Zeus Brontaios: Pliny, *Naturalis Historia* xxxiv.50 (*SQ* 1301); xxxiv.79 (*SQ* 1303); K. Schefold, *RM* 57 (1942), 254-56; G. Donnay, *REA* 61 (1959), 300-9; K. A. I. Braun, *Bartiger Köpfe auf attischen Grabreliefs* (Diss. Basel, 1966), 33 n. 1.

75. Zeus Philios: Pausanias viii.31.4 (*SQ* 1005); Arnold, 13 n. 81, 15-16, 19 n. 117.

76. Delphi *anathema:* in Pausanias x.9.5 (*SQ* 993) called the monument of the Tegeans, clearly in error. See esp. Arnold, 13, 15, 23, 189-93 and fig. 40b; the exact positions of these monuments are in dispute (see Roux and Pouilloux, *Enigmes à Delphes* [1963], Index s.v. 'Arcadiens').

77. On Leochares' career see Donnay, loc. cit. (note 74); on Praxiteles, Marcadé, *Recueil* ii, 115-22; Arnold, 161-62.

78. Tegean altar: Dugas, 68; Picard, *REG* 46 (1933), 383, 396-407; Pausanias viii.47.3, cf. 31.3-4 (Megalopolis). The images 'of Muses and of Memory' mentioned by Pausanias, if identical with those on show in the entrance-hall of the Tegea museum, are Hellenistic.

79. Peace of 363/2: Xenophon, *Hellenica* vii.4.35-36; Larsen, op. cit. (note 59), 190-91.

80. Date of the Tegean temple: Schede, op. cit. (note 71), 44-46, 49; Robertson, 143; Shoe, *PGM*, 70, 79 etc.; Plommer, *Ancient and Classical Architecture,* 193; Dugas, 127-28; Pfuhl, op. cit. (note 65), 31; Lawrence, *Greek Architecture,* 191; Dinsmoor, 220; Hanfmann, *AP* 3 (1964), 64.

81. Roux, 184. The Tholos referred to is that at Epidaurus.

82. Tegea and Bassae: Roux, 29, 55, 418, 420; Robertson, 143-44. The unequal front and flank intercolumniations on both buildings seem to derive from the stylobate size, which itself is not arrived at by calculating from a standard intercolumniation (as was normal from at least 480 onwards) but

from the overall size of the platform, of which the width was related to the length as the number of façade columns to the number of flank columns. At Bassae, then, the proportion width: length of stylobate is 6:15, at Tegea 6:14 (information from Dr. J. J. Coulton).

83. Tegea mouldings: (1) coffer: Dugas pls. 55-56; Shoe, *PGM* 129-30, 177 and pl. 61, 25-26; (2) sima: Dugas pl. 51,B, D and E; Shoe, *PGM*, 79 and pl. 26,21; cf. B. H. Hill, *The Temple of Zeus at Nemea* (1966) fig. 4; (3) epikranitis: Dugas pls. 52,B and 54; Shoe, *PGM*, 28 and pl. 15,18; (4) toechobate: Dugas pls. 64-65, 74, 93,B; Shoe, *PGM*, 87-88 and pl. 37,7; (5) pilasters: Dugas pls. 77; 88,D; Shoe, *PGM*, 30 and pl. 16,3.

84. Temple of Zeus: Hill, op. cit., 44-46.

85. Horizontal sima: Dugas pls. 46; 47,A; 86,B; the old restoration in Schede, op. cit. (note 71), pl. 5,29 is incorrect.

86. Delphi sima: Schede, op. cit. (note 71), 48 and pl. 5,33; Roux pl. 89,2.

87. Epidaurus sima: Schede, op. cit. (note 71), 67-68 and pl. 5,31; Roux pl. 43; cf. H. Möbius, *Die Ornamente der griechischen Grabstelen²* (1968), 111a, and Roux, 184 for the date.

88. Lion-spouts: cf. esp. the series of illustrations in P. W. Lehmann, *Samothrace* iii.1 *(The Hieron)*, 173-77, and D. Spittle, *Samothrace* iv.2 *(The Altar Court)*, 89-91.

89. Tholos akroterion: C. Praschniker, *Zur Geschichte des Akroters* (1929) pl. 3,5; Roux fig. 40.

90. Leonidaion antefixes: *Olympia* i pls. 64-65; Schede, op. cit. (note 71) pl. 6,34; Spittle, op. cit., 91 fig. 86.

91. Olympia, temple of Zeus: Ashmole and Yalouris, *Olympia*, 6-7 (begun just after 470, completed by 457); Parthenon: Dinsmoor, 159-60 (begun 447, structure complete in 438, pedimental sculptures in 432). On the labour force required see Burford, in *Parthenos and Parthenon (Greece and Rome, Suppl* to vol. 10 1963), 23-25 and esp. 31-32 where she estimates the number of men employed on site at any one time at about 200, and about 1,000 altogether. The cost was enormous: almost 150,000 drs. appear in one year's estimates (ibid., 24).

Any estimate of the cost of the Tegean temple is bound to be very approximate: there are too many unknowns. The only temple where exact costs are known is the temple of Asklepios at Epidaurus, but this was built not of marble but limestone, which is far easier, and thus cheaper, to work. The best analogy would be the Parthenon (of marble and, like Tegea, only about 8 miles from its quarries), but here costs are much disputed. Omitting foundations (at Tegea, largely of blocks reused from the earlier temple) and sculptures, the following are the results from Stanier's careful calculations (*JHS* 73 [1953], 68-76; cf. Burford, 81-85):

| Parthenon: | 7,942 cu.m. or c.22,000 tons of marble, cost c.400 talents. |
| Epidaurus: | 432 cu.m. or c.1,462 tons of limestone, cost c.21 talents. |

For the Parthenon, using about 18 times the amount of stone used at Epidaurus and, being of marble, with working costs about 5 times as high, the estimate (only 20 times the cost of the Asklepieion) is surely too low. Making some allowance for inflation between c. 440 and c. 370 Stanier is willing to emend his grand total to 640 talents (op. cit., 73 n.

23) which, minus about 60 talents for foundations and sculptures, comes to 580 talents, but the true figure was surely higher—perhaps between 600 and 750 talents. Applying this to our temple, the figures are:

| Tegea: | 2,750 cu.m. or 7,562 tons of marble, cost c.200-250 talents, and certainly not less than 150 talents (excluding sculptures and cult statues). |

This result compares favourably with the 300 talents quoted by Herodotus ii.180 for the sixth century temple of Apollo at Delphi (rather larger in size but of limestone), where transportation costs were astronomical—in the fourth century, over ten times the cost of quarrying, compared with only one-third at Epidaurus and perhaps about one-fifth at Athens and probably Tegea too (cf. Stanier, op. cit., 71 and 73). By comparison, the revenues of Tegea were minuscule—probably only a fraction of those of Athens even in the fourth century, which fluctuated between 200 and 400 talents (Demosthenes x.37-38; A. H. M. Jones, *Athenian Democracy*, 6-7). Tegea was not rich in natural resources and also had a relatively small population, perhaps no more than c.10,000 adult males in the fourth century (if the League assembly of 10,000 was based on a hoplite qualification, as seems likely, 3,000 hoplites would be about the maximum for Tegea: Larsen, op. cit. (note 59), 194-95; cf. Beloch, *Griechische Geschichte* iii.1, 279-80); it was also unable to rely, like Epidaurus and Delphi, upon an internationally known cult, tourism and pilgrimages for finance. With this in mind, an expenditure of 200 talents before even sculptures or cult statues were budgeted for must have been a heavy burden indeed.

92. Financial difficulties: Xenophon, *Hellenica* vii.4.33-40; Hammond, op. cit. (note 59), 506; Larsen, op. cit. (note 59), 190-91.

93. Burford, 33, n.4.

94. Building contract: *IG* v.2.6-8 (trans. Buck, *The Greek Dialects*, 202-3).

95. Burford, 92.

96. Theban garrison and internal troubles: Xenophon, *Hellenica* vii.4.33-40; Larsen, op. cit. (note 59), 190-92.

97. 362 and after: Diodorus xv.82.5, 89.1; cf. Ryder, op. cit. (note 59), 84 and 87.

Chapter 4

1. Discussions of Skopas' style and attributions prior to 1952 are conveniently listed in Arias, *Skopas*, 3-57. More recently, see Bieber, 23-29; Boardman et al., *Art and Architecture*, 439-42; Richter, *Sc⁴*, 207-13; Lawrence, *GRS*, 193-96. On Tegea, see Treu, *AM* 6 (1881), 393-423; Graef, *RM* 4 (1889), 189-226; Benson, *JHS* 15 (1895), 194-201 (although the head published here is actually a poor copy of the Apollo Lykeios: Karouzou, *Guide*, 160 no. 183); Neugebauer, *Studien*, 1-50; Pfuhl, *JdI* 43 (1928), 27-39; Lippold, *Plastik*, 249-54; Picard, *Man* iv.1, 149-205.

2. The 'Herakles/Telephos' head, no. 16, is wrongly said to be in Athens by Picard (*Man* iv. 1 pl. 4 to p. 176), Arias (*EncAA* s.v. 'Skopas' fig. 457) and Dörig (Boardman et al., *Art and Architecture* fig. 170).

3. Parthenon: cf. P. E. Corbett, *The Sculpture of the Parthenon* (1959), 13-14; Beazley and Ashmole, *Greek Sculpture and Painting*, 47; Ashmole, *Architect and Sculptor*, 22-23, 99-105 etc.

4. Sculptors at Samothrace: Lehmann, *Samothrace* iii.1 (*The Hieron*), 305.

5. On the Tegea style in general, see Lippold, *Plastik*, 251 '. . . überall stärkste Spannung, durchgreifende Bewegungen'. Neugebauer, *Studien*, 49: '. . . besonders weich sind die Leiber behandelt'. Ashmole, *JHS* 71 (1951), 17 also speaks of 'the rugged forms . . . of Tegea'.

6. E.g. Dugas 28, 57, 63, 65 and 66 (PLATES 20a, 22a-c).

7. E.g. Dugas 59 and 60.

8. E.g. Dugas 47 and 50 (PLATE 20c).

9. E.g. Dugas 47, 50, 56, 57, 63, 66 (PLATES 20c, 21d-f, 22a-c); cf. Table 2 above.

10. E.g. nos. 9, 11, 16 and 23.

11. E.g. no. 12.

12. Argive Heraeum: C. Waldstein, *The Argive Heraeum* i (1902) pl. 40b; F. Eichler, *ÖJh* 19-20 (1919) figs. 21a, b; 33a-c; 66a.

13. Epidaurus: Crome pl. 47; Schlörb pl. 3 and many of the as yet unpublished pieces. See Chapter 6.

14. Mausoleum: although drilled across its internal angle, the elbow marked 181 (red), 262 (black) hardly compares with its Tegean counterpart, Dugas 28 (PLATE 20a-b), and the same goes for most of the other pieces of free-standing sculpture from the building. As for the friezes, BM 1011-12 (PLATES 34-39) and perhaps 1018, and 1019, 1020 and 1021 are nearest in this respect. I would include 1022 if it had not been so obviously worked over (cf. Lullies and Hirmer pls. 216-17; Ashmole, *Architect and Sculptor* figs. 191-200).

15. Dugas 109-110.

16. BM 1013: Ashmole, op. cit. (note 14), fig. 206; Lullies and Hirmer pl. 214, above.

17. See Table 2; cf. e.g. the Dresden Oilpourer (PLATE 29b), where one gets the opposite impression.

18. Dugas 109.

19. Agias: T. Dohrn, *AP* 8 (1968), 34-35 and pls. 10-20. BM 1020.57: Ashmole, op. cit. (note 14), 173 and figs. 194, 198.

20. Epidaurus west, NM 4757: Crome pl. 29; cf. Arnold, 89 n. 326, 122. For an example of this style that is contemporary with Tegea, see the bronze 'Perseus' from Anticythera, normally considered a late work of the Polykleitan school: Carpenter, *Greek Sculpture*, 161-62 and pl. 28; Arnold, 207-10 and pl. 27c.

21. Epidaurus east and its style: Schlörb, 31, and Chapter 6 below.

22. E.g. nos. 17 and 23; Dugas 28 and 59 (PLATE 20a-b).

23. Cf. the descriptions of, e.g., nos. 1, 12 and 13 in the catalogue.

24. E.g. Dugas 53 and Tegea 2299 (PLATES 21a-c, 22d).

25. NM 4750: best photograph, Schlörb pl. 3 (leg fragment).

26. Dugas 110. He makes no attempt to reconcile what he says here concerning the Tegean style as a whole with his description of his no. 28 in n. 1 on the same page.

27. Dugas 70-72 and Tegea 2299 (PLATE 22d). See, in general, Table 2.

28. Dugas 56 and 58 (PLATE 21d-f).

29. Dugas 56, 57, 63 and 66 (PLATES 21d-f, 22a-c).

30. Nos. 14 and 26.

31. Nos. 13, 14 and 26.

32. Nos. 7, 9, 16, 17 and 23.

33. Neck: nos. 4, 11, 16-18, 22 and 23. Hands: no. 2; Dugas 47, 48 and 52 (PLATE 20c).

34. See Table 2.

35. Tegean heads: Neugebauer, *Studien*, 40-48; Dugas 115-16; for the typology also ibid., 112-13 and H. Bulle, *Der schöne Mensch* (1922), 149-51; Pfuhl, *JdI* 43 (1928), 29.

36. Neugebauer calls the expression 'physiologisch widerspruchsvoll' (*Studien*, 45) while Berchmans writes of 'une formule assez vague de l'émotion' (Dugas 116).

37. Olympia east: Ashmole and Yalouris, *Olympia*, 12-17; Såflund, *The East Pediment of the Temple of Zeus at Olympia*, passim; Ashmole, *Architect and Sculptor*, 30-40.

38. Cf. Ashmole, *The Classical Ideal in Greek Sculpture* (Semple Lectures, 1964), 13: 'Of the full classical, consistency is the hallmark.'

39. Facial expression: as far as I know, no really detailed work has been done on this topic for the Severe and Classical periods as a whole; besides the studies of Olympia cited above, there is also a short summary covering the whole of Greek sculpture in Richter, *Sc*[4], 50-56. Examples (c.550–c.350):

 (1) Aegina: Lullies and Hirmer pls. 84-85.
 (2) Olympia: ibid. pls. 110, 114-15, 121, 124; Ashmole and Yalouris, *Olympia* pls. 31-38, 51-61, 86-90, 147-48.
 (3) Parthenon: Lullies and Hirmer pls. 144-47, 162; Brommer, *Die Metopen des Parthenon* (1967) pls. 202-4, 229-30, 233-34.
 (4) Argive Heraeum: Waldstein, op. cit. (note 12), pls. 30-32; PLATE 24a.
 (5) Nereid monument: Picard, *Man* ii.2 (1939) fig. 345.
 (6) Epidaurus: Crome pls. 4-5, 34, 40-41; Schlörb fig. 17 and pl. 2; PLATE 26c,d.
 (7) Mausoleum: Buschor figs. 12-13, 36, 40-41, 43, 44; Ashmole, *Architect and Sculptor* figs. 193, 203, 212-13, 217; PLATES 35, 38-39, 41.

(I include architectural sculpture only, and exclude centaurs, for whom all things are possible at Olympia and thereafter.)

40. Cf. Sir Kenneth Clark, *The Nude*, 95-96, on de Chirico's footballs.

41. Anatomy of the Tegea heads: Neugebauer, *Studien*, 43-45, cf. Table 2, also Charles Darwin, *The Expression of the Emotions in Man and in Animals* (repr. 1965), 177-82. The classic case where *every* device is used is, of course, the Laocoön: Lullies and Hirmer pl. 279.

42. Anatomy of the mouth: Darwin, op. cit., 148-49.

43. Epidaurus sculptures: for the date see Chapter 6.

44. Cos Gaul: *Clara Rhodos* 9 (1938) figs. 25-27 and pl. 4; this

is not, of course, to say that this approach did not have its followers in the fourth century. As examples, one could cite the Masi sculptures (Patras 203-7: *BCH* 64-65 (1940–41), 245-46 figs. 14-15) and, e.g., the two mourning servant girls in Berlin, Blümel, *KGS* pls. 68-69.

45. Cf. the description of the arrangement of the planes around the eyes, in Table 2.

46. Richter, *Sc*⁴, 52; Neugebauer believed (*Studien*, 46-47) that the 'Tegean eye' was 'keineswegs ausgesprochen pathetisch' and that 'die Köpfe . . . durfen daher wohl kunstgeschichtlich als noch nicht ganz durchgeführte' The first statement is undoubtedly correct, but as for the second, it is difficult to see how much further it was possible to go without arriving at the very point the Tegea sculptors had sought to avoid in the first place. See Chapters 9 and 10.

47. BM 1022: Neugebauer, *Studien* pls. 7,4; 8,3-4; Buschor, figs. 38, 40, 41: Ashmole, *Architect and Sculptor* figs. 192-93. BM 1057: Buschor figs. 46, 49; Schlörb pl. 21. Mingazzini alone (*RivIst* 18 [1971], 84) prefers to see the Tegea heads as Pergamene.

48. Samothrace, Propylon: P. W. Lehmann, *Skopas in Samothrace* (1973), passim, and esp. figs. 34-37.

49. Origins of the Tegea style: Pfuhl, *JdI* 41 (1926), 158 n. 2 (the head cited is illustrated in Brommer, op. cit. [note 39] pls. 202-4); Kjellberg, *Studien zu den attischen Reliefs des V. Jahrh.* (1926), 102; Schuchhardt, *AM* 52 (1927), 161; Neugebauer, text to B-B 717-18 (1932), 7; Schlörb, 31 and fig. 17.

50. Patras 207: see Schlörb, 56-59.

51. BM 1006: ibid. pl. 19; Lullies and Hirmer pl. 215, below; for the style, see Ashmole, op. cit. (note 39), 177-78.

52. Artemision akroteria: Neugebauer, *Studien*, 15-16 and pl. 1,2. See also note 13, Select Catalogue.

53. On no. 4 cf. Dugas, 124-25 with Pfuhl, *JdI* 43 (1928), 36 n. 2: 'Hier haben wir die den Männern gegenüber entsprechend gemilderte weibliche Form des skopasischen Kopftypus von guter Gesellenhand . . .'

54. Ephesus bases: Bieber fig. 68; Boardman et al., *Art and Architecture* pl. 272; Bammer, *Die Architektur des jüngeren Artemisions von Ephesos* pl. 6g.

55. Acanthus column: Pouilloux and Roux, *Enigmes à Delphes* (1963), 140, 144; Möbius, *Ornamente griechischer Grabstelen*², 41, 112-13; Richter, *Sc*⁴ fig. 329.

56. Decree reliefs: Süsserott pl. 5.

57. Sisyphos I: Dohrn, *AP* 8 pl. 30; Adam, *Technique* pls. 47-49.

58. Herakles: Lippold, *Plastik* pl. 78,4; Boardman et al., op. cit. (note 54) pl. 259 (right). Lykeios: Rizzo pls. 119-23; Lippold, *Plastik* pl. 84,1. For the dates, Arnold, 210.

59. Richter, *Sc*⁴, 208-9.

60. 'Maussolos': Lullies and Hirmer pls. 211-13.

61. NM 870: Adam, *Technique* pls. 64, 66a; Diepolder pl. 47: see further Chapter 10, section 4(A).

62. Tegean drapery: Dugas, 111-12.

63. BM 1048: Buschor figs. 61-62.

64. Epidaurus west: cf. Crome pls. 20, 38; Schlörb pl. 6; PLATE 27a.

65. Overfolds: (1) Nike Parapet: Carpenter, *The Sculpture of the Nike Temple Parapet* pls. 7, 8, 17; Schlörb pls. 10, 14; (2) Epidaurus: Crome pls. 1, 13; Schlörb pl. 8; PLATE 26a; (3) Mausoleum: Lullies and Hirmer pl. 215, below; Schlörb pl. 19. Closer to Tegea are e.g. BM 1019.66 (Lullies and Hirmer pl. 216, above; Ashmole, *Architect and Sculptor*, fig. 200) and BM 1200 (above, note 54).

66. New York statue: Richter, *MetMus* pls. 76-77; cf. Bieber, figs. 206-12. NM 159: Yalouris, *ADelt* 22.A (1967) pls. 22-24.

67. Nos. 1, 3, 8; Dugas 55, 57, 101 (PLATE 22a-c).

68. NM 146: Schlörb pl. 4. Cf. e.g. the 'Maussolos', BM 1000.

69. Boar and dog: cf. Neugebauer, *Studien*, 47-49.

70. No comprehensive history of fourth century sculpture exists; for a recent denial of a fourth century classic style see B. R. Brown, *Anticlassicism in Greek Sculpture of the Fourth Century* B.C. This book is not yet available to me, but from a reading of the manuscript, kindly lent to me in 1971, it seems that the definition of 'classic' adopted by the author is perhaps rather narrow; to draw a parallel, no one would deny the vast differences between the Florentines of the early Quattrocento and those of the early Cinquecento, yet few would support a motion to divest Raphael of his title as a 'classic' painter.

Most students in fact describe the fourth century as 'classic' with little hesitation, yet at this time personalities may be more important than periods—Lysippos is hardly a 'classic' sculptor as normally defined, though he may well have been active as early as 370 (Marcadé, *Recueil* i, 66, 71-72). There is a tradition of non-Lysippan, 'anti-classic' sculpture running through the fourth century, it is true, but it is perhaps less extensive than the author believes; I am also unhappy about her choice of Epidaurus as its *fons et origo*—to me, the Argive Heraeum is more revolutionary. On this score, Beazley and Ashmole, *Greek Sculpture and Painting*, 54, probably strikes the most even balance.

71. See especially Ashmole, *The Classical Ideal in Greek Sculpture*, passim.

72. Carpenter, *Greek Sculpture*, 156.

73. Ibid., 162.

74. Ibid., v.

75. Ibid., 172.

76. E.g. Berchmans, in Dugas 111, 126; Adam, *Technique*, 20; for all his floridity, Picard, *Man* iv.1, 186-87 seems nearer the truth.

77. Dugas, 87.

78. Ibid., 88, cf. 126; Ashmole, op. cit. (note 71), 16 sees a similar 'starkness' in the 'Kladeos' from the east pediment of the temple of Zeus at Olympia, and for similar reasons.

79. Picard, loc. cit. (note 76).

80. On the supposed Peloponnesian affiliations of the Tegea sculptors see Treu, *AM* 6 (1881), 405-11; *contra*, Farnell, *JHS* 7 (1886), 114-17. Treu's ideas have recently been updated (but without specific acknowledgement) by Linfert, *Von Polyklet zu Lysipp* (Diss. Freiburg, 1966), 28-32, 39-40.

81. Ashmole, *JHS* 71 (1951), 15.

82. On Tegea and the 'Ionian style' see e.g. Schlörb, 30-31, though, significantly, Pfuhl omits Tegea from his discussion of 'Ionian' sculpture, in *JdI* 50 (1935), 9-48. Personally, I am inclined to disbelieve in the existence of any native 'Ionian' style, apart from the purely derivative and provincial, after the mid-fifth century; compare the poverty of the material cited by Lippold, *Plastik*, 230-32, 248-49, 260, 287-88, and Lawrence, *GRS* 172-79.

Chapter 5

1. Greek architects: see esp. J. A. Bundgaard, *Mnesikles* (1957), passim, and esp. ch. 4; Burford, 138-45; R. Scranton, in *The Muses at Work: Arts, Crafts and Professions in Ancient Greece and Rome* (ed. C. Roebuck, 1969), 5-10.

2. Preliminary descriptions and the Arsenal: Bundgaard, op. cit., 97, 117-32, cf. 249-55; Scranton, op. cit., 7-9.

3. Contracts: Bundgaard, op. cit., 97-116, 256-57; Burford, passim.

4. At Tegea, the relevant inscription (*IG* v.2. 6-8) consists of a long statement of general principles, followed by lists of payments (and occasionally, defaults and fines). The second part is exceedingly laconic, consisting only of names and sums of money, which, together with the wording of the preamble, seems to presuppose that the contracts themselves were recorded elsewhere, either on stone or papyrus, and have subsequently perished.

5. Models: Bundgaard, op. cit., 217-19 (with a list of occurrences); drawings of the whole building were out of the question, given the non-existence of accurate measuring tools, and in any case were irrelevant to the kind of problem faced by the architect, as Scranton, op. cit. (note 1), 6-7 points out.

6. Asklepios and Hygieia in Gortys: Appendix 1, no. 15.

7. Instructions: Bundgaard, op. cit., 113-16 (but see Plommer, *JHS* 80 (1960), 148-49 for the argument that these could be drawings of details after all).

8. On the problem of the frieze see Bundgaard, op. cit., 126-29 and esp. n. 255.

9. Tegea frieze and Arcadian 'feet': Dugas, 58-59 and 139, cf. pls. 12-17.

10. Bundgaard, op. cit. (note 1), 226 n. 255.

11. Astias and Kallinos: *IG* IV² 1.102 line 109; *Fouilles de Delphes* iii.5 no. 25 col. IIA, 13; cf. Burford, 142.

12. Appendix 1, no. 36.

13. Appendix 1, no. 16.

14. Lawrence, *GRS*, 194.

15. Tegean gargoyles: Dugas pls. 46; 86,B.

16. Tegean sima and Corinthian order: ibid. pls. 46, 47, 76, 86, 90-92; cf. also Pfuhl's remarks in *JdI* 43 (1928), 29.

17. Τύποι: Schlörb, 1-7 for discussion and bibliography.

18. Athena Promachos: Pausanias i.28.2 (*SQ* 637); cf. Pliny, *Naturalis Historia* xxxv.68 (*SQ* 1722).

19. On models see Carpenter, *Greek Sculpture*, 252-54; Blümel, *Greek Sculptors at Work*, 40-41.

20. Terracotta archetype: B. Neutsch, *Studien zur vortanagraïsch-attischen Koroplastik (JdI Erg* 17) pls. 12-13; R. Higgins, *Greek Terracottas*, 2-3 and pl. 1A-C. For the (presumed) use of models at Olympia and on the Parthenon see Ashmole, *Architect and Sculptor*, 58; Brommer, *Die Skulpturen der Parthenon-Giebel*, 136-40; Ridgway, in *The Muses At Work*, 108-10. Blümel suggests that *full-size* models in clay followed, from which casts were the final stage (op. cit., 42-46; cf. P. Johansen, *AA* 1923-24, 141-53; 1927, 50-58; *contra*, Brommer, loc. cit.; Corbett, *JHS* 86 [1966], 275-76). Surely, though, their unwieldiness (their colossal weight would have required massive internal support) and inflexibility would have turned these into a sculptor's nightmare. In any case, Skopas and Pheidias both had more important things to do, such as the carving of the cult statue(s), than to be undertaking the gargantuan task of modelling two complete sets of pediments, in all about 50 figures on the Parthenon and 36 at Tegea, in clay at actual size—and all this even before quarrying the marble! Given certain basic information, Greek sculptors were perfectly capable of realising their forms directly into stone without such stultifying intermediaries, as Gothic sculptors and Michelangelo were to do nearly two millennia later.

21. Techniques of mechanical copying: see e.g. Blümel, op. cit. (note 19), 53-57; Richter, *RM* 69 (1962), 52-58; on what appears to have been the system in use in classical times, see Blümel, op. cit., 48-53.

22. Olympia heads: Ashmole and Yalouris, *Olympia*, 9-10 and pls. 49, 90, 112-13, 148 etc. (indentations); 59, 144 ('puntelli'). See further, Ridgway, op. cit. (note 20), 109-10. For further comments on sculptors' methods see A. J. B. Wace, *An Approach to Greek Sculpture*, (1935), esp. 32ff, also id., *Ann* 24-26 (1946-48), 109-21; A. W. Byvanck, *BABesch* 30 (1955), 24-27; for Michelangelo's method of working with maquettes, see L. Goldscheider, *Michelangelo* (Phaidon Press, 1962), 16, 18, 22-23 and pls. 159, 204-6, and Appendix of plates, 2-5.

23. Corbett, *JHS* 86 (1966), 276.

24. E.g. Wace, *Ann*, loc. cit.

25. Ashmole, *JHS* 71 (1951), 17; also id. *Architect and Sculptor*, 167; but cf. Wittkower's remarks on Bernini's methods: 'While his personal contribution to the execution of works like the Baldacchino . . . was considerable, later he sometimes hardly touched a tool himself Stylistic integration depended not so much on Bernini handling the hammer and chisel himself, as on the degree of his preparatory work and the subsequent control exercised by his master mind.' (*Bernini* [Phaidon Press 1955], 39).

26. Wace, *Ann*, op. cit. (note 22), 111.

27. BM 1013-15: Buschor, 19, distinguishes two carvers at work here, yet, as Ashmole's photographs show (*JHS* 71 [1951] pls. 15-16) the three slabs 'are clearly the design of a single mind' (ibid., 17) and diligently and consistently reflect this master's style.

28. *Pace* Picard, *Man* iv.1,186.

29. See Appendix 1, no. 16.

30. Base for cult statues and cella: Dugas, 45-51, 54 and pls. 3-5, 9-11, 18-20; cf. Robertson, 138, 143-44, and contrast, e.g., the awkwardness of the internal arrangements of the Hephaisteion: S. Papaspyridi-Karusu, *AM* 69-70 (1954–55), 83 fig. 3.

31. NM 3602: the controversy is too long to be summarised. Cf. Dugas, 117-24 and pls. 113-15; Morgan in *Capps Studies* ii (1936), 253-59; Lippold, *Plastik*, 251 and pl. 90,2. Best photograph: Lullies and Hirmer pl. 205.

32. Hope Hygieia: Lawrence, *GRS* pl. 46c-d; cf. e.g. L. Curtius, *JdI* 19 (1904), 55-85, esp. 78ff.

33. Rhamnuntine relief: Ashmole, *AJA* 66 (1962), 233-34 and pl. 59.

34. Ibid., 234.

35. 'Ephraim' head, Louvre MA 3534: F. Croissant and C. Rolley, *BCH* 89 (1965), 324-31 figs. 9-12. Rhamnous stele, NM 833: Lullies and Hirmer pl. 227; details, N. Himmelmann-Wildschütz, *Studien zum Ilissos-Relief* (1956) pls. 26-30. Boston head: Lullies and Hirmer pl. 243.

36. Epidaurus Nikai: see note 13, Select Catalogue. Mantinea base: B-B 468; Lippold, *Plastik* pl. 85, 1-3.

37. Find circumstances: G. Mendel, *BCH* 25 (1901), 243-44, 260 n. 1; Rhomaios, *PAE* 1909, 304-5; Dugas 66-67, 117 n. 1 and pls. 3-5 (base G); on the ground-levels see A. Milchhöfer, *AM* 5 (1880), 52-55, 57.

38. Tegea torso: A. Delivorrias, *AAA* 1 (1968), 117-19 fig. 1.

39. Apollo Patroos: see Adam, *Technique*, 94-97.

40. Louvre relief: Süsserott pl. 25,4; U. Hausmann, *Kunst und Heiligtum* no. 146 and fig. 5.

41. Polykleitos: Burford, 144-45; Arnold, 16-17. Leochares: Roux, 355.

42. *JdI* 43 (1928), 29. I discount nonsense like Gropengiesser's observation that the 'pathetischer Wuchs' of the floral akroteria (!) 'weist gewissermassen auf die Giebelskulpturen des Skopas hin . . .' (*Die pflänzlichen Akrotere klassischer Tempel* [1961], 48-49).

43. Nemea capitals: Hill, *Nemea* figs. 33-36 and pls. 23 and 29; Roux, 365-67.

44. Roux, 370.

45. Ibid., 365.

46. Robertson, *Greek and Roman Architecture*, 141.

47. Roux, 15.

48. On architect and sculptor at Tegea see Dugas, 126.

Chapter 6

1. Carpenter, *Greek Sculpture*, 156.

2. On the 'rich style' in general see esp. Lawrence, *GRS*, 158-84; few others treat the period (c.430–370) as a unity.

3. Nike temple: Lippold, *Plastik*, 193-95 and pl. 69,3; Blümel, *JdI* 65-66 (1950–1), 135-65; arrangement of the battle scenes Harrison, *AJA* 74 (1970), 317-23. For the date, see Travlos, *Pictorial Dictionary of Ancient Athens*, 148-49. The battle friezes have their counterparts in the Gigantomachies and Centauromachies popular with painters like Aison (cf. the squat lekythos, Naples RC 239: *ARV²*, 1174; Arias and Hirmer pl. 205; Charbonneaux, *Classical Greek Art* fig. 306) and Aristophanes (cf. the cup, Boston 00.344: *ARV²*, 1319; FR pl. 128; Charbonneaux, op. cit., fig. 310).

4. Delos akroteria: *BCH* 3 (1879) pls. 10-12; F. Courby, *Délos* xii (1931) figs. 270-75; Lippold, *Plastik*, 192 and pl. 71, 1; Picard, *Man* ii figs. 317-18; Charbonneaux, op. cit. fig. 180 (best photo).

5. Diadoumenos: Lippold, *Plastik* pl. 59,2; see esp. Lawrence, *GRS* pl. 36a; Arnold, 25 notes how torsion was occasionally given extra emphasis by Polykleitos and his successors by setting their statues at an angle to their bases.

6. 'Protesilaos': Lippold, *Plastik* pl. 68,4; Frel, *BullMetrMus* N.S. 29 (1970–71), 170-77; Langlotz, *AA* 1971, 427-42; reply by Frel, *AA* 1973, 120-21. The same sculptor (Kresilas ?) appears to have experimented with a double twist in the Naples 'Diomedes': Frel, *BullMetrMus* 29 (1970–71) fig. 4; Lippold, *Plastik* pl. 48,4.

7. Vases: Florence 81947 (*ARV²*, 1312; Arias and Hirmer pl. 217: by the Meidias painter); Ruvo, Jatta 1501 (*ARV²*, 1338; Pfuhl, *MuZ* fig. 574; Charbonneaux, op. cit. fig. 318: by the Talos painter), etc. For the double twist, see the 'Diomedes' cited above, also e.g. the maenad on the Pronomos painter's krater, Naples 3240 (*ARV²*, 1336; Arias and Hirmer pl. 219) and another on a hydria from the Meidias painter's workshop, Karlsruhe 259 (*ARV²*, 1315; Charbonneaux, op. cit. fig. 330); cf, too, Schlörb fig. 32.

8. Argive Heraeum: C. Waldstein, *The Argive Heraeum* i (1902); Eichler, *ÖJh* 19-20 (1916-19), 15-153; Arnold, 55-58; for the architecture see Amandry, *Hesp* 21 (1952), 272; Roux 57-62.

9. Lawrence, *GRS*, 168.

10. Warrior and Amazon: Waldstein, op. cit. pl. 35, 1-2.

11. Heraeum heads: ibid. pls. 30-33.

12. Arnold, 57 (my translation).

13. Angled brows: Parthenon metope S. xxx (Brommer, *Die Metopen des Parthenon* pls. 229-30; Rodenwaldt, *Köpfe von den Sudmetopen des Parthenon* [1948] pls. 14 and 18); Heraeum head NM 1567: Waldstein, op. cit. (note 8), 182 and pl. 32,3. The motif becomes common at Bassae, c.400: Richter, *Sc⁴* figs. 207-8, 211.

14. Knees and elbows, etc; Waldstein, op. cit. (note 8), fig. 81 and pl. 40; Eichler, op. cit. (note 8), figs. 21a, b; 33a, c; 66a.

15. Heraeum and Polykleitos: Waldstein, op. cit. (note 8), 162-76; Lippold, *Plastik*, 202; Arnold, loc. cit. (note 8) and pls. 3c-d, 6, 7. *Contra*, e.g. Furtwängler, *Masterpieces*, 243: cf. Arnold, 56 n. 239 for others.

16. Vases: (1) Amphora, Louvre S 1677: *ARV²*, 1344; von

Salis, *JdI* 55 (1940), 125-33 and fig. 20; H. Walter, *AM* 69-70 (1954–55), 95-104 and pl. 11,1; Arias and Hirmer pl. 221; Charbonneaux, op cit. (note 3), fig. 316; by the Suessula painter; (2) Calyx krater (fr.), Naples 2883: *ARV²*, 1338; von Salis, op. cit., figs. 1, 2, 8 and 17; Walter, op. cit. pl. 11,2; Arias and Hirmer pl. 220; Charbonneaux, op. cit., fig. 313; PLATE 24c; related to the Pronomos painter; (3) Pelike, Athens 1333: *ARV²*, 1337; von Salis, op. cit., fig. 19; Charbonneaux, op. cit., fig. 312; near the Pronomos painter; (4) Volute-krater (frr.), Würzburg Inv. 4729 (4781): *ARV²*, 1338, 1345-46, 1690; von Salis, op. cit., figs. 21-24; akin to the Pronomos painter (Beazley).

17. Two-figure groups: H. Speier, *RM* 47 (1932), 1-94.

18. Parthenon Lapiths (metopes S. xvi and xxvii): Brommer, op. cit. (note 13) pls. 202-4, 217-20; Lullies and Hirmer pl. 143. Distortion at the waist occurs once on the Parthenon, on the Lapith of metope S. xxx (Brommer, op. cit. pls. 229-30) but not thereafter, as far as I know, for the next forty years or so. On the history of this mannerism see esp. D. B. Thompson, *Hesp Suppl* 8 (1949), 365-72 and pls. 49-50.

19. Delphi Tholos: J. Charbonneaux and K. Gottlob, *Fouilles de Delphes* II: *La Tholos du Sanctuaire d'Athéna Pronaia* (1925); P. Amandry and J. Bousquet, *BCH* 64-65 (1940–41), 121-27 (architecture only); for the date, see Roux, 129, 177-78, 183, 328-30, 362-65, 404. Sculpture: T. Homolle, *Revue de l'Art Ancien et Moderne* 10 (1901), 366-76 figs. 4-9, 15-20; A. W. Persson, *BCH* 45 (1921), 316-24 figs. 1-8; Picard, *Man* iii. 1, 178-89 figs. 54-57; P. Bernard, *BCH* 85 (1961), 447-73 and pls. 12-13; Charbonneaux, *Classical Greek Art* fig. 235.

20. Late Hellenistic statues: Bieber figs. 422, 645, 688-89.

21. Ridgway, *The Severe Style in Greek Sculpture*, 17.

22. Epidaurus, Asklepieion: (1) architecture: Roux, 83-130; (2) building accounts: *IG* iv² 1.102; Roux, loc. cit.; Burford, *BSA* 61 (1966), 256-63; ead., *The Greek Temple Builders at Epidauros* (1969), 54-61, 212-20 (translation); (3) Timotheos' Τύποι: see note 17, Chapter 5; (4) sculptures: Crome, *Die Skulpturen des Asklepiostempels von Epidauros* (1951); Schlörb, *Timotheos*, 1-35; Yalouris, *BCH* 90 (1966), 783-85; Arnold, 122, 182. I thank Dr. Yalouris for his permission to include much of the material below, in advance of his forthcoming publication of the sculptures.

23. Thrasymedes' cult statue: Cicero, *De Deorum Natura* iii. 34.83 (*SQ* 854a); cf. Pausanias ii. 27.2 (*SQ* 853). Inscription: *SEG* xv.208; Burford, *BSA* 61 (1966), 263-70; 'contemporary with, or only a little later than the Asklepios temple accounts'; B. Krause, *AA* 1972, 240-57 recognises a copy of the work in a statue in Copenhagen.

24. Nike ('Epione'): see note 28, Chapter 1; 'Aurai': Crome pls. 4-9; Richter, *Sc⁴* figs. 757-58.

25. West pediment: Crome pls. 13-25, 28-29, 31-38, 46-47; Yalouris, op. cit. (note 22), figs. 1-5; on the style, see Arnold, 122, 182.

26. NM 151: Crome pls. 31-33; Yalouris, op. cit. (note 22), fig. 5. NM 4753: Crome pls. 46-47; for the attribution, see Schlörb, 12. NM 4752 (grouped with Amazon, NM 139 + NM 149 + Epidaurus 67): Crome pls. 22-25.

27. Dead youths: (1) NM, unnumbered: Yalouris, op. cit. (note 22) fig. 1; (2) NM 4492: Crome pl. 26; Schlörb fig. 24 and pl. 6; PLATE 27a. Yalouris attributes these to the west pediment on account of their woolly, bunched drapery and their plinths. The drapery of the east pediment is sharp and metallic, and there are no plinths, even for reclining figures (cf. e.g. the torso Schlörb figs. 22-23).

28. East akroteria: 'Apollo': Schlörb fig. 1 and pl. 1; Charbonneaux, *Classical Greek Art* fig. 228; Nike, NM 162, see Schlörb figs. 25-26; Nike, NM unnumbered (stump of a wing on left shoulder): Schlörb figs. 7-8; fragments: ibid. figs. 27-28, 30-31. Once more, I am indebted to Dr. Yalouris for his permission to make use of his attributions.

29. 'Master B': Carpenter, *The Sculpture of the Nike Temple Parapet* pl. 7.

30. East pediment: Crome pls. 27, 39-45, 48-49; Schlörb figs. 2-5, 9-18, 22-23, 41-42 and pls. 2-5; Yalouris, op. cit. (note 22) figs. 6-8. Many of these fragments now newly reconstructed (e.g. NM 147, Schlörb pl. 3, with the two fragments ibid. figs. 9 and 11 to form NM 4750: Yalouris, op. cit. fig. 7).

31. Lunging youth, NM 148: Crome pl. 27; Schlörb pl. 5; right leg now complete. Lapith C: Ashmole and Yalouris, *Olympia* pls. 71-72.

32. Young man, NM (unnumbered): Schlörb figs. 2-3.

33. Heads (1) formerly NM 154, now part of dead woman NM 4754: Crome pl. 49; Schlörb fig. 17; PLATE 26c; (2) formerly NM 153, now part of group of woman bending over girl, NM 4642 (fragment, Schlörb figs. 41-42): Crome pl. 48.

34. 'Centaurs': references in Amelung, *Der Basis des Praxiteles*, 70.

35. Diskobolos of Naukydes: Lippold, *Plastik*, 199 and pl. 68,2; Arnold, 110-123; fig. 35 and pls. 8c, 11b, 12, 13b, 22a, 23a; Boardman, et al., *Art and Architecture*, 434 and pl. 242.

36. Athena Rospigliosi: Beazley and Ashmole, *Greek Sculpture and Painting*, 57 and fig. 115; Schlörb, 60-63 figs. 50-52 and pls. 17, 18; G. B. Waywell, *BSA* 66 (1971), 377-78 and pl. 71b.

Chapter 7

1. Lysippos' origins: Pliny, *Naturalis Historia* xxxiv. 61 (*SQ* 1444).

2. Epidaurus sculptors: *IG* iv.²1. 102. 89, 98-99, 111-12 (trans., Burford, 215-17); cf. ead., *BSA* 61 (1966), 259 and Schlörb, 1-8.

3. 'Epione': see note 28, Chapter 1; NM 146 and 4750: Crome pls. 42-44; Schlörb pls. 4-5; Yalouris, op. cit. fig. 7.

4. Τύποι: see note 17, Chapter 5. Metopal sculptures (so Roux, *BCH* 80 [1956], 518-21) seem unlikely, since no remains have been found: compare this with the hundreds of pieces from the pediments and akroteria. For moulded

terracottas see Blümel, *AA* 1939, 302-13, and id., *Greek Sculptors at Work*, 43-46, and cf. the discussion in Chapter 5, above.

5. Timotheos: Artemis: Pliny, *Naturalis Historia* xxxvi.32 (*SQ* 1328; Asklepios: Pausanias ii.32.4 (*SQ* 1329); athletes, hunters, etc. (unspecified): Pliny, *Naturalis Historia* xxxiv.91 (*SQ* 1330); Ares (uncertain): Vitruvius ii.8.11 (*SQ* 1307); Mausoleum: Appendix 1, nos. 34, 35.

6. Leda: Lippold, *Plastik*, 221 and pl. 79, 3; Schlörb, 51-56 figs. 47-49 and pl. 16; Boardman et al., *Art and Architecture* pl. 246.

7. Herakles (A1), bibliography: S. Reinach, *RA* 6 (1917), 460-61 fig. 1; J. Offord, *BullSocAlexandria* 17 (1919), 182-83 fig. 1; F. Poulsen, *Greek and Roman Portraits in English Country Houses* (1923), 39; S. Reinach, *Répertoire de la Statuaire grèque et romaine* v (1924), 81 no. 6; Spink catalogue, *Greek and Roman Antiquities* (1924 ?) no. 7; A. Preyss, text to B-B 691-92 (1926) no. 35; O. Brendel, text to *EA* 4168-69 (1936), 46; confused with a terminal head of Meleager (F21) by Arias, 131 no. 17; C. C. Vermeule, *AJA* 59 (1955), 134; A. Linfert, *Von Polyklet zu Lysipp* (1966), 71 (Aa); S. Howard, *The Lansdowne Herakles* (1966), 35. Now L. A. Co. Mus. of Art 50.33.22. The head belongs.

8. Pausanias ii.10.1: Appendix 1, no. 27.

9. The lion's skin, club, fillet and wreath all appear on the coin as in the statue, and Herakles is unbearded.

10. Linfert, op. cit., 34.

11. Herakles (of Myron ?): Lippold, *Plastik*, 139 and pl. 49,2; Richter, *Sc*⁴, 165 and fig. 43.

12. Alektryon base: Arnold, 36-44, 193ff and figs. 27, 40c; Pouilloux and Roux, *Enigmes à Delphes*, 46-51.

13. Hermes: Arnold, 123-25 and pl. 10a; Lippold, *Plastik*, 178; Blümel, *KatBerlin* iv pls. 47-48.

14. Athena: see note 36, Chapter 6 and cf. also the Ince 'Theseus': Ashmole, *Ancient Marbles at Ince* (1929) no. 43 and pls. 16-17. Both the Athena and our Herakles are related to a group of early Praxitelean works dated by Arnold to c.370, and in particular to the Dresden Artemis: Lippold, *Plastik*, 238: Rizzo pls. 16-18; Bieber fig. 40; cf. Arnold, 161.

15. For the attribution of the Dresden Maenad to Skopas and for alternative restorations see the bibliography to Appendix 4 (B).Six's reconstruction is vitiated by his insistence that the left leg is the engaged one. This is impossible, for the following reasons: (1) the right hip is very clearly raised (if the girdle be taken as horizontal), so the right leg must have taken the weight; (2) the remains of the left knee show that the left leg was flexed; (3) the 'sharp, straight cut' noted by Six below the left buttock is caused by the bending of the torso backwards, and is quite natural in life.

16. *Statuarum descriptiones* ii: Appendix 1, no. 31; cf. also nos. 29 and 30.

17. Maenad and Tegea no. 16: Treu, *Dresdener Jahrbuch* 1905, 11; Neugebauer, *Studien*, 59-60 and pl. 3,1-2.

18. As was usual at Tegea; cf. nos. 4, 9, 10, 16, etc.

19. On Skopaic *contrapposto* see Neugebauer, *Studien*, 57-59; the three- dimensional aspect is curiously ignored by Bulle, *ÖJh* 37 (1948), 18.

20. Views of the Maenad from her right: Treu, *Mélanges Perrot*, 319 fig. 1; Neugebauer, *Studien* pl. 4, 1.

21. Dating: Fuchs, *Vorb*, 83-84, 86, 107; Arnold, 236 n. 811, 242 n. 844. Mingazzini, *RivIst* 18 (1971), 69-72 prefers a date between c.200 and c.170, asserting that the contorted movement has no parallels in free-standing fourth century sculpture, and that Callistratus' description of the style (Appendix 1, no. 31) can only fit a work of the advanced Hellenistic period. As for the first, the sculptures from the Epidaurian Asklepieion, cited below, show otherwise, and concerning the second, the author would appear to be alone in his willingness to take the rhetorical hyperbole of a late Roman encomiast at its face value. In any case, Callistratus produces much the same platitudes about Praxiteles' Eros and Lysippos' Kairos as he does about the Maenad—unless these are Pergamene too, and their authors with them.

22. NM 155: see note 28, Chapter 1; the relationship is noted by Schlörb, 26 and Yalouris, *ADelt* 22. A (1967), 34-35.

23. Epidaurus youth: see note 27, Chapter 6; cf. Neugebauer, *Studien*, 57-58 and pl. 5.

24. Heads from BM 1013-15: see note 27, Chapter 5. The mirror-case in Leningrad (B2) appears to be another contemporary variant. Concerning the 'pseudo-Maenad' of BM 1014 and the Dresden statuette, Mingazzini's assertion (op. cit.[note 21], 70: based on a remark of Löwy apropos of the 'long man', BM 1020.57 and the Borghese Warrior) that developments in relief precede those in free-standing sculpture by as much as two centuries, merely illustrates the dangers of isolating any work of art from its context. It is Agasias who is returning to the fourth century for inspiration in an era of eclecticism and flagging imagination, not the sculptor of the Mausoleum warrior who is producing a 'foretaste' of Agasias' style. For illustrations of the two see Ashmole, *Architect and Sculptor* figs. 194, 198, and Bieber figs. 688-89.

25. Coins of Sicyon: *NCP*, 28-29 no. 3 and pl. H,6-7; Vibia Pytheas altar: Hauser, text to B-B 599, 12-13 fig. 11; cf. Furtwängler, *Masterpieces*, 396-97. The date of the originals should be near that of the akroteria from the Epidaurus Artemision (note 13, Select Catalogue). The evidence from the sanctuary of Dionysos at Sicyon is inconclusive. The temple itself has not been found, but Frickenhaus conjectured that the theatre was part of the same architectural scheme (notice in Neugebauer, *Studien*, 74-75), and suggested that it was erected shortly after the city was replanned in 303 (Frickenhaus, *Die altgriechische Bühne* [1917], 40; Fiechter, *Antike griechische Theaterbauten* iii [1931], 32). Dr. Plommer, however, sees the style of the proscenium capitals (Fiechter, op. cit. figs. 19-20) as 'sub-Bassae' and prefers to date the theatre earlier in the century.

26. *Statuarum descriptiones* ii.3 (Appendix 1, no. 31).

27. See Introduction and Chapter 5.

Chapter 8

1. Appendix 1, nos. 34 and 35; cf. Pausanias viii.45.5 (Appendix 1, no. 36). On the meaning of the sources see esp. Ashmole, *Architect and Sculptor*, 157-59, as a counter to e.g. Jeppesen, *Paradeigmata* (1958), 53-58.

2. Skopas in Asia: Appendix 1, nos. 13, 21, 32 (?), 33 (?); Leochares: *SQ* 1307; Bryaxis: *SQ* 1317, 1318; Timotheos: cf. *SQ* 1307.

3. Tegea relief: Richter, *Sc*[4], 209 n. 11 for the most sensible statement of the evidence, with references.

4. Wace, *Ann.* 24-26 (1946–48), 112.

5. *Anathemata:* Arnold, 6-17 and fig. 40a-c; Pausanias x.9.3-10 (*SQ* 979, 993). Sculptors: Marcadé, *Recueil* i, 22-24; *SQ* 987-994 (Daidalos of Sicyon); Marcadé, *Recueil*, 5-6; *SQ* 1006 (Antiphanes of Argos), etc. For a discussion of the compositional problems involved and the whole question of how the final results were arrived at, see Arnold, 97-109 and esp. 189ff, although the order of the bases has yet to be finally established, as Ridgway, *Hesp* 40 (1971), 340 n. 16 points out.

6. Lysippos and Polykleitos: Marcadé, *Recueil*, 66 verso - 67; Arnold, 16 n. 100 and fig. 32.

7. Lysippos and Leochares: Marcadé, *Recueil*, 74 n. 13; *SQ* 1490-91; Ridgway, op. cit., 345. A drawing of the relief in the Louvre that probably depicts the group appears in *JdI* 65-66 (1950–51), 229 fig. 15, whence Boardman et al., *Art and Architecture* fig. 175.

8. On workshops and craftsmen see Burford, 138-45; ead., *Craftsmen in Greek and Roman Society*, 78-80, 94-96 etc. Three or perhaps four carvers worked on the east pediment of the temple of Asklepios—mere 'journeymen' in Wace's scheme, though one of them may, just possibly, have been Skopas.

9. Wace, op. cit. (note 4), 118.

10. Compare the scheme for decorating the Campanile and façade of the Duomo in Florence, where over a period of almost two centuries from c. 1250–1435 works by masters like Arnolfo di Cambio, Andrea Pisano, Nanni di Banco and Donatello were again simply juxtaposed, apparently with little regard for stylistic homogeneity.

11. Ashmole, *Architect and Sculptor*, 147-91.

12. BM 1013-15: Buschor figs. 11-16; Ashmole, *JHS* 71 (1951) pl. 13; Lullies and Hirmer pls. 214-215, above; and new fragment, D. Strong and K. Jeppesen, *ActArch* 35 (1964), 195-97 figs. 1-4; Ashmole, *Architect and Sculptor*, 178-87 figs. 206-17. For the findspot, see C. T. Newton, *A History of Discoveries at Halicarnassus, Cnidus and Branchidae* ii.1 (1862), 100 and pls. 3-4; id., *Travels and Discoveries in the Levant* ii (1865), 95; Neugebauer, *Studien*, 85-91; Ashmole, *JHS* 71 (1951), 17; Jeppesen, *Paradeigmata*, 20-21.

13. That BM 1016, which was found with them, is in a very different style, is usually tacitly ignored (Ashmole, *JHS* 71 [1951], 17 and pl. 14a).

14. Ashmole, loc. cit. and pls. 15-16.

15. BM 1011-12: most students prefer Bryaxis or Leochares (summary of attributions in *RE* s.v. 'Pytheos' cols. 425-33); the futility of this merry-go-round of ascriptions, at least on the customary premises, is shown by Ashmole's new join (BM 1007-8-10: *JHS* 89 (1969), 22-23 and pl. 1; PLATE 40) which links slabs usually ascribed to different workshops (e.g. by Pfuhl, *JdI* 43 (1928), 46-50; Buschor, 25-27, 38-40; G. Donnay,

L'Antiquité Classique 26 [1957], 38ff). On the style of BM 1011-12 see e.g. Pfuhl, op. cit., 49:'in der Gruppe 47ff gibt sich der…Kunstler einen gewaltsamen Ruck zu brutaler Heftigkeit'.

16. Epidaurus: for leg fragment and attached female torso see note 25, Chapter 4. Torso fragment: Schlörb fig. 21.

17. Inorganically twisted torsos: the only places where anything even remotely resembling this mannerism occurs on the Mausoleum outside BM 1011-12 are to be found on the 'Leochares' series, BM 1013.28 and the new piece added to BM 1015 (see note 12 above).

18. Mould in Corinth: Thompson, *Hesp Suppl* 8 (1949), 369 dates it to c. 390 since 'such a distortion…would scarcely seem possible very far down into the fourth century', but considering its proximity in style to Tegea and BM 1012.47, it should really perhaps better belong in the second quarter of the century than the first.

19. BM 1007-8-10: Buschor figs. 24-26, 29, 31-32; Ashmole, *Architect and Sculptor* figs. 201-3; detail, Bieber fig. 65. Apart from these, no good detailed pictures have been published; I refer to Professor Ashmole's (unpublished) ones, which I have been able to study at length, for confirmation.

20. Ashmole, *Architect and Sculptor,* 182.

21. Backs of the slabs: Jeppesen, *Paradeigmata*, 24-26 fig. 10 though he omits to mention the unique tooling of 1008-10.

22. On the subject see Ashmole, *JHS* 89(1969), 22-23; *EncAA* s.v. 'Ippolyta'. Professor Ashmole suggests to me that, on this slab, Herakles and Hippolyte are the focus of the composition, with perhaps Telamon and Melanippe to the left (cf. Tzetzes, *ad Lycophronem* 1329; Scholia Pindar *Nemean Ode* iii. 64, and for the position of Telamon, D. von Bothmer, *Amazons in Greek Art*, 117, 133-43, etc.) and Theseus and Antiope to the right. This coincides with the tooling and, if correct, would suggest that the acquisition of the axe was indeed of central importance. As for Theseus, the marked indecisiveness of his fight with his adversary would then be explained by later events, for they came to terms and later married.

23. Olympia throne: Pausanias v. 11. 4.

24. Bassae frieze: von Bothmer, op. cit., 215-16 and pl. 88.

25. Labranda: Strabo xiv. 659; Plutarch, *Quaestiones Graecae*, 45.

26. *Synoecismos* and transfer of power: Strabo xiii.611; Pliny, *Naturalis Historia* v. 107; Diodorus Siculus xv. 90; Vitruvius ii.8.11; G. E. Bean and J. M. Cook, *BSA* 50 (1955), 96 and 169.

27. Maussolos, Labranda and Zeus Stratios: *EncAA* s.v. 'Labranda'; Bean, *Turkey beyond the Maeander*, 37-38; *JHS* 36 (1916), 65-70 figs. 1 and 2 (relief and coins): *BMCat (Coins): Caria and Islands*, 181-83 and pl. 28.

28. Bean, op. cit., 37.

29. Propylon: Jeppesen, *ActArch* 38 (1967), 36-42; *Archaeological Reports* 1970–71, 48-49 (building C).

30. Many earlier students have ascribed either 1007-8 or 1010 to the sculptor of 1011-12; of the better known studies, however, only those of Wolters and Sieveking (*JdI* 24 [1909],

171-91) and Lippold (*Plastik*, 255) attributed all three to the same man, both agreeing on Timotheos. In this context, it is perhaps worth mentioning that Yalouris is unable to find any stylistic link with Epidaurus, and thus with Timotheos, anywhere on the exhibited slabs. Bulle's objection, in *ÖJh* 37 (1948), 19 that the brutal savagery of 1012 is impossible for a Greek master is rejected by Bielefeld, *Amazonomachia* (1951), 87 and list e, where he assembles a number of parallels.

31. BM 1047: Buschor fig. 52; Jeppesen, op. cit. fig. 22.

32. MRG 39: Buschor fig. 19.

33. The wording of the accounts by Pliny and Vitruvius (Appendix 1, nos. 34-35) could even suggest that the four sculptors were only responsible for the reliefs: Ashmole, *Architect and Sculptor*, 157-59.

34. BM 1057: Buschor figs. 46, 49; Schlörb pl. 21, right.

35. Fragments from the north side: Newton, *History of Discoveries* ii.1, 102-7 (though some of these pieces are definitely from the crowning quadriga); Jeppesen, op. cit. (note 29), 21.

36. Against the conflation of the Genzano and Lansdowne types are Graef, *RM* 4 (1889), 207 n. 1; Furtwängler, *Masterpieces*, 301 n. 2; Johnson, *Lysippos*, 208-10; Neugebauer, Text to B-B 717-78 (1932), 6; Linfert, *Von Polyklet zu Lysipp*, 72. Of the Lansdowne type I only know of three direct copies (E2-4). The statue illustrated by Paribeni, *Cirene* no. 433 and pls. 186-87 is a version of the type, as could be his no. 434 (ibid. pl. 187); see also H. von Heintze, *RM* 73-74 (1966–67), 251-55 and pls. 90-91 for a related Herakles head on a double herm in Rome.

37. The eclectic and dependent types are too numerous and diverse to be discussed here. Examples are to be found in most of the lists of 'copies' of the two types mentioned in Appendix 4, and short discussions appear in P. W. Lehmann, *Statues on Coins* (1946), 53-62 and Arnold, 197. See Chapter 10, section 2 for more examples.

38. Against the attribution are Michaelis, Collignon, Gardner, Cultrera, Neugebauer, Sieveking (all cited in text to B-B 717-18, 6 n. 3; see also ibid., 7 for Neugebauer's view), also Linfert, op. cit. (note 36), 35-37, in a passage which I find wild.

39. Good profile views: B-B 692; Howard, *The Lansdowne Herakles* fig. 1.

40. Arnold, 230 n. 780 (my translation). Schweitzer believed, perhaps correctly, that some Polykleitan 'contamination' may have crept in via the Roman copyist (*ÖJh* 39 [1952], 107-11).

41. Antiphanes' Herakles: Arnold, 197-98 and pl. 26b. The position of the feet, the lion and support all agree with the marks on the base at Delphi, ibid. figs. 36, 40c; *contra*—but for what reason?—von Steuben, *Gnomon* 1972, 809.

42. Doryphoros: Lippold, *Plastik*, 163-64 and pl. 59, 1; Arnold pl. 1a; Boardman et al., *Art and Architecture* pl. 226.

43. Arnold, 160.

44. The importance of the S-curve and twist are correctly appreciated by Süsserott, 147, 168 n. 141, and Howard, op. cit. (note 39), 7, 10. This again is apparently prefigured in

the fifth century, in the 'Diomedes' attributed to Kresilas by Frel (see note 6, Chapter 6).

45. Howard, op. cit. (note 39), 10-11. Compare, however, the pathos of the Jandolo head, ibid. fig. 16 (E2).

46. On the date of the Herakles see Süsserott, loc. cit. (note 44), Arnold, 230. The Knidia (Lippold, *Plastik*, 239 and pl. 83,3; Rizzo pls. 70-88) is often dated to Praxiteles' ἀκμή of 364-361 (Pliny, *Naturalis Historia* xxxiv.50; *SQ* 1191; Picard, *Man* iii.2, 556-57; Bieber, 15 etc.). Lawrence's objection in *GRS*, 46 that Praxiteles' date has merely been adjusted to fit that of Euphranor, whose painting of the battle of Mantinea was commissioned in 362, is a fair one, though in this case perhaps Praxiteles was the principal: he is named first, and the Knidia was the most famous statue of antiquity. As external evidence, she was first commissioned, then rejected by the Coans: the new cult statue would have been appropriate after their *synoecismos* of 366/5 (Diodorus Siculus xv. 76.2; Strabo xiv.657; see G. E. Bean and J. M. Cook, *BSA* 52 [1957], 120).

47. Record relief of 362/1: Süsserott pl. 4,1; Lippold, *Plastik* pl. 88,3. Howard, op. cit. (note 39), 6-7 places too much emphasis on the conservatism of the Herakles, and his dating (after Neugebauer, text to B-B 717-18 and Lippold, *JdI* 26 [1911], 278 n. 2) is surely too early.

48. Schefold, *U*, 67, dates the Leningrad pelike to c.340-20 on numismatic evidence from Pantikapaion. N.b. that Howard notes that the area around the club on the left shoulder has been reworked, and suggests that a chlamys has been removed (op. cit. [note 39], 22 fig. 27); the Herakles on the vase has a chlamys in just this position.

49. For such private commissions see e.g. Plato, *Epistulae* xiii.361a (*SQ* 1302). The marble used for the free-standing sculptures of the Mausoleum and for the chariot frieze is Pentelic, so he may well have had to make several visits to the quarries to supervise the cutting.

50. Triton Grimani: Neugebauer, *JdI* 56 (1941), 178-200; Blümel, *KGS*, 85-86 K103 and figs. 142-45. See esp. Picard, *Man* iii.2, 682-86; Arias, 112-13 (no. 3); id., *EncAA* s.v. 'Skopas', 366; cf. Lippold, *Plastik*, 253 n. 9. Thanks to the kindness of the authorities of the Berlin Musuem I was able to spend two days examining the statue in August 1971.

51. State of preservation and technique: Neugebauer, op. cit., 187-95. The back is smoothly finished with a claw, in contrast to the roughly punched backs of the Tegea figures (cf. ibid. fig. 3 with, e.g. PLATES 6c, 12b and d, etc.).

52. Neugebauer, op. cit., 198.

53. 'Monument of the Bulls' (BM 2220): Smith *BMCat* iii, 272-73 fig. 36; Picard, *Man* iii.2, 677; *BCH* 75 (1951), 55-89 and pls. 6-17, esp. pl. 16; J. Marcadé, *Au Musée de Délos*, 359-62. It is just possible that this frieze and its companion-piece at Tinos were versions of Skopas' composition, but without further evidence of the original this must remain speculation.

54. Roman Tritons: (1) Lapidaria 105: *SVM* i pl. 27; Arias, 113 no. 5; (2) Statue 253: *SVM* ii pl. 46. Cf. Neugebauer, op. cit., 199; Picard, *Man* iii.2, 686 and figs. 295-96.

55. Triton and Leda: Neugebauer, loc. cit. (note 50); for the date, Arnold, 161.

56. On the Thiasos in general, see Picard's summary, *Man* iii.2, 673-86. For the so-called 'Altar of Domitius Ahenobarbus', see esp. Fuchs, *Vorb*, 160-64, and for the Formia Nereids, Bielefeld, *AP* 9 (1969), 47-64 and pls. 23-39; id., *RM* 76 (1969), 93-102 and pls. 41-43. As for Mingazzini's attempt, in *RivIst* 18 (1971), 79-81, to identify the Thiasos with the 'Ahenobarbus' reliefs themselves, as a work of 'Skopas IV' carved in 97 B.C., one can only say that the group is expressly stated by Pliny to have been the work of the Skopas who was contemporary with Praxiteles and Kephisodotos, that the reliefs (which, *pace* Mingazzini, seem to be complete: cf. Lawrence, *GRS*, 248) do not show Achilles, Thetis or even hippocamps, and that the whole argument by which they have been associated with the name of Skopas at all is entirely circular, for the identification of the 'delubrum Domitii Ahenobarbi' rests only on the unsupported conjecture that the Munich slabs are from the base of Skopas' group, as Nash, *Pictorial Dictionary of Ancient Rome* ii, 120, points out.

57. Pliny, *Naturalis Historia* xxxvi.26 (Appendix 1, no. 32).

58. Provenience of the Triton and Grimani collection: Neugebauer, op. cit. (note 50), 178-86; P. Paschini, 'Le Collezioni archeologiche dei prelati Grimani nel Cinquecento,' *Atti della Pontificia Accademia Romana di Archaeologia: Rendiconti* v (1928), 149-90.

59. Agrippa and Augustus: Paschini, op. cit., 151-52; Neugebauer, op. cit. (note 50), 180.

60. Eighteenth century description: Neugebauer, 178, cf. 184-85.

61. 'Guerriero': Neugebauer fig. 5; cf. Paschini, op. cit. (note 58), 153 no. 6.

62. Marino Grimani: Paschini, op. cit., 157-62.

63. Clark, *The Nude*, 271.

64. Giorgione's self-protrait: T. Pignatti, *Giorgione* (1971) pl. 214; Berenson, *Italian Painters of the Renaissance: Venetian School* i, 123; ii pls. 679-80; for the Mancini picture, see ibid. i, 107; ii pl. 693.

65. Ostia Nereid: Helbig⁴ 3001; Lippold, *Plastik*, 253 n. 8; Beazley and Ashmole, *Greek Sculpture and Painting*, 56 and fig. 117; Boardman et al., *Art and Architecture* fig. 171 (right-hand photograph reversed). Originally part of a relief.

66. Mingazzini, op. cit. (note 56), 72 dates the original to c. 200–170 by his late dating for the Dresden Maenad.

67. Appendix 1, no. 34.

68. For these, see the Appendix to Chapter 7 and to this Chapter, section 4, and that to Chapter 9, section 4 (lost works); for the relevant sources, see Appendix 1, nos. 13, 17, 21, and 33.

Chapter 9

1. For Skopas and Praxiteles in Knidos see Pliny, *Naturalis Historia* xxxvi.22 (Appendix 1, no. 13); ibid., xxxvi.20 (*SQ* 1227); cf. also Strabo xiv.641 (*SQ* 1283) and Vitruvius vii *Praefatio* 12-13 (Appendix 1, no. 35).

2. Aberdeen head: see esp. Furtwängler, *Masterpieces*, 346-47 and pl. 18; cf. also Wolters' comparison between this and the Genzano herm (A3) in *JdI* 1 (1886), 54-56 and pl. 5, and his conclusion that *both* were Praxitelean. Pfuhl, *JdI* 43 (1928), 23-24 believed that the style was a mixture of Praxitelean, Skopaic and Lysippic elements, but the unusual character of the piece seems well enough accounted for by a measure of Skopaic influence and a change in subject (a young Herakles ?). Perhaps we should think of revising some of our notions of Praxiteles' style—he has tended to become too effete of late.

In addition to Wolters', several articles over the years have brought out, sometimes unwittingly, the closeness of the two styles: for instance, Benson concluded after a minute examination of what is actually a head of the Apollo Lykeios that the style was Skopaic (Chapter 4, note 1), and Graef and others included the Museo Nuovo herm, in all probability a Praxitelean Dionysos, with the Genzano Herakles and its fellows (references, Appendix 4, section A).

3. Against an identification as Meleager are Neugebauer, *BWPr* 87 (1927), 8; W. Müller, *JdI* 58 (1943), 174 n. 2; Lippold, *Plastik*, 289; Linfert, *Von Polyklet zu Lysipp*, 32; J. Fink, *RM* 76 (1969), 239-52. Fink's argument rests on two or three versions of the head, with holes for horns cut roughtly into them or with individualised features (cf. F33-42); his views are open to question at many points, especially his statement that the 'wulstige Binde' in the hair of the Calydon copy (F14) is an attribute of a deified hero only: the vases cited in Chapter 3 show otherwise.

4. For the gift see Ovid, *Metamorphoses* viii.425-9, and for other accounts of the hunt, Chapter 3, above.

5. On the attributes cf. the figures given by Hanfmann and Pedley *AP* 3 (1964), 63. The issue is complicated by the disappearance of a much restored copy once in the Vatican (F[5]), and the existence of an excellent replica in a private collection in Germany, brought to my notice by Professor Ashmole, from which a dog has apparently been removed (F6). With a grand total of 12 statues (excluding variants and versions like the Fogg statue and Salamis 22 but including torsos like Verona D 557), my estimate is: 6 or 7 copies with dog, 8 with chlamys, 3 with boar's head, 1 with rock. See also, in this connection R. Tölle, *JdI* 81 (1966), 162, 164-65 figs. 17-18; T. Dohrn, *Festschr. Jantzen* (1969), 31-34 and pl. 7; as Arnold remarks, such 'zahlreiche Beiwerk' was a distinctive feature of the Delphi *anathemata* right from the beginning (Arnold, 104ff, 191ff; fig. 40a-c).

6. On the Fogg statue, see esp. Buschor, *Antike Plastik* (W. Amelung zum 60. Geburtstag, 1928), 56; Lippold, *Plastik*, 289; Hanfmann and Pedley, op. cit., passim; Sichtermann, *RM* 70 (1963), 174-75.

7. Herakles, NyC 250: Lippold, *Plastik*, 219 and pl. 78,4; *Billedtavler* pl. 18; Boardman et al., *Art and Architecture* pl. 259 (right). For the date, see Arnold, 210 n. 718, and for the ascription, Schuchhardt in *Festschr. Schweitzer* (1954), 223-24.

8. Sarcophagi: Sichtermann, op. cit., 175-77 and pls. 67-68.

9. Identification as Asklepios: Hauser, notice in Neugebauer, loc. cit. (note 3); Lippold, *Plastik*, 289; also Müller and Linfert, loc. cit. (note 3).

10. Appendix 1, no. 15.

11. Kalamis: Pausanias ii.10.3 (*SQ* 515).

12. Epidaurus statue: Pausanias ii.27.2 (*SQ* 853), and note 23, Chapter 6. Attributes: Edelstein, *Asklepios* ii, 225-31; the iconography remained fluid until after the mid fourth century.

13. Timotheos' statue: Pausanias ii.32.4 (*SQ* 1329); Schlörb, 48-50 fig. 45 recognises a copy in a headless statue in Venice, but surely it is just the attribute shared with Hippolytos—the hunting spear—that is lacking here, otherwise, why should the Troezenians have preferred to call the god Hippolytos?

14. Euripides, *Hippolytus*, 17-18: 'Through the greenwood, ever in the train of the Maid, with swift hounds he sweeps the wild beasts from the earth.'

15. Asklepios and the hunt: Hyginus, *Fabulae* 173; *RE* s.v. 'Asklepios', cols. 1652-53; Edelstein, op. cit., 38-42.

16. Contemporary variants: see esp. Brommer, 'Vorhellenistische Kopien und Wiederholungen von Statuen', *Studies presented to David M. Robinson* (1951), 674-82.

17. Artemis/Nike: Daremberg and Saglio, *Dictionnaire des Antiquités* s.v. 'Diana' figs. 2350, 2389-90, s.v. 'Victoria', 845; Scholia Aristophanes, *Aves* 574 (*SQ* 315).

18. Zeus/Poseidon: Ridgway, *Severe Style*, 62-63 and figs. 98-99.

19. Eros/Alkibiades: Pliny, *Naturalis Historia* xxxvi. 28 (Appendix 1, no. 39).

20. Hermes and Aberdeen head: cf. Lullies and Hirmer pls. 230-31 and PLATE 46c, d.

21. Perseus: Brendel, *AA* 1934, 435-37 fig. 3; Helbig⁴ 3047; Lippold, *Plastik*, 289; Schauenberg, *Perseus in der Kunst des Altertums*, 103; Arnold, 199 n. 685.

22. Helbig⁴ 3047.

23. Doryphoros: see note 42, Chapter 8; cf. Appendix 5.

24. Ovid, *Metamorphoses* viii.425-525.

25. Hanfmann, *AP* 3 (1964), 65.

26. Herakles Farnese: Lippold, *Plastik*, 281-82 and pl. 101,1; for the date, Arnold, 235-36 n. 806.

27. Agias: for the date (original c.342-338, Delphi replica 336-332), see Dohrn, *AP* viii (1968), 50.

28. 347/6 relief: Lippold, *Plastik*, 247 and pl. 88,4; Süsserott, 58-60 and pl. 4,3.

29. 340/39 Panathenaic: Süsserott, 60-61, 165 and pl. 4,4.

30. 'Perseus': Lullies and Hirmer pls. 218-20; Boardman *et al.*, *Art and Architecture* pl. 250; for the date, Arnold, 207-10.

31. Apollo Belvedere: for the date, ibid., 210 n. 719, but n.b. that G. Kleiner in *Festschr. Schweitzer*, 233 suggests that the usual sequence Apollo–Artemis–Ganymede (Bieber figs. 198-201, Lippold, *Plastik* pl. 98,1-3) be reversed.

32. Lykeios: Lippold, *Plastik*, 238-39 and pl. 84,1; Rizzo pls. 120-127; for the date, Arnold, 207-10.

33. Meleager and Calydon: see, e.g., *Iliad* ix.533-99; Ovid, *Metamorphoses* viii.324 (where he is called 'Calydonius'), etc.

34. Calydon: Pausanias vii.18.8-10; Heroon: E. Dyggve, F. Poulsen, K. Rhomaios, *Das Heroon von Kalydon* (1934); *EncAA* s.v. 'Kalydon' fig. 358.

35. Athena Mattei: Waywell, *BSA* 66 (1971), 373-82 and pls. 66-72.

36. Appendix 1, nos. 15 and 16.

37. Samothrace, Propylon: K. Lehmann, *Hesp* 20 (1951), 12-19; id., *Hesp* 21 (1952), 19-43; P. W. Lehmann, *Skopas in Samothrace* (1973), passim.

38. Coffer lids: P. W. Lehmann, op. cit., 9-10, 14; (1) Vienna, Inv. 675: ibid., fig. 51; (2) Vienna, Inv. 676: ibid. fig. 34; (3) Vienna, unnumbered: A. Conze, *Neue Archäologische Untersuchungen auf Samothrake* (1880), 14 fig. 3; (4) Samothrace 49.355; (5) Samothrace 55.149: Lehmann, op. cit. fig. 33; (6) Samothrace 66.611: ibid. figs. 35, 37; (7) Samothrace 70.848: ibid. fig. 36.

39. Propylon: restored elevation and plan, Lehmann, op. cit. figs. 14-15, 29. Frieze: *Hesp* 20 (1951) pls. 8-10; Lehmann, op. cit. figs. 10-13, 41, 45.

40. Rinceau sima: Lehmann, op. cit., fig. 26; ead., *Samothrace* iii.1 (*The Hieron*) fig. 118; cf. Dugas pls. 46; 86,B, and Bammer, *Die Architektur des jüngeren Artemision von Ephesos* pl. 3f-g. The rinceau of the Tegean interior frieze crown, Dugas pl. 88,C is, however, closer.

41. Antefixes: Lehmann, *Samothrace* iii.1 (*The Hieron*) fig. 136, cf. figs. 134-35, 137; Dugas pls. 46; 47,Ca; 86,B.

42. Lion spouts: detail, Lehmann, *Skopas in Samothrace* fig. 27; cf. Dugas pl. 86,B.

43. Date of the Propylon: Lehmann, op. cit., 14-15. Philippeion: Pausanias v.20.10.

44. Alexander portrait: Lehmann, op. cit. fig. 51. Azara-Geneva portrait: Johnson, *Lysippos* pls. 43-45; Bieber, *Alexander the Great in Greek and Roman Art*, 32-35 and figs. 13-17, 26-27. The Alexander AkrM 1331, which Lehmann compares with the Samothrace portrait, looks younger by a few years or so; Ashmole (*JHS* 76 [1951], 15-16) has shown that it was probably dedicated after 336, which thus ought to be a *terminus post*.

45. Nemea lion spouts: Lehmann, op cit. fig. 28.

46. Pothos: Furtwängler, *SbBayAkad* 1901, 783; *contra*, Müller, *JdI* 58 (1943), 154-82; Mingazzini, *Le Arti Figurative* ii.3 (1946), 137-48; Schuchhardt, *Gnomon* 1968, 405; Mingazzini's latest comments on the piece, in *RivIst* 18 (1971), 75-78 add nothing to his earlier ones, discussed below.

47. On the pose and drapery of the original see Bulle, *JdI* 56 (1941), 121-30; *contra*, Müller, op. cit., 166-69, 171 fig. 11; reply by Bulle, *ÖJh* 37 (1948), 3-5.

48. Hairstyle: see Arndt, text to B-B 616-17 (1912); Becatti, *Le Arti* 3 (1941), 404; Bulle, *JdI* 56 (1941), 147-48; Müller op. cit., 172-75. The hairstyle of the original is perhaps best represented by G1 (PLATE 45c), which is not an isolated variant as Müller believed. The ogival hairline and complex

coiffure recur in the Copenhagen head (G21), which also treats the eyes in the same way. The other copies, mostly classicising and dull, either reduce the hairstyle to a monotonous stereotype (e.g. G18, 19), replacing the subtly interwoven scheme of G1 and 21 with a series of uniform, parallel locks, and exaggerating the extent of the strands over the forehead that are parted to the side, or misunderstand the scheme altogether (G23).

49. Hands: the original action is preserved on the Palazzo Vecchio copy (G6).

50. On G1 see esp. Colini, *Capitolium* 15 (1940), 871-75; Müller, op. cit. (note 46), 172-73, though neither mentions Tegea no. 4. Apart from those attributable to the difficulties obviously experienced by the copyists in reproducing the hairstyle, the differences between the copies are really no wider than those within the Los Angeles-Genzano or Meleager series. Cf. also Bulle, *ÖJh* 37 (1948), 9-10.

51. On the 'Praxitelean' character of the Pothos see Müller, op. cit. (note 46), 176 for references, and cf. Becatti, op. cit. (note 48), 405. The (bronze) boy from Marathon, Lullies and Hirmer pls. VII and 221-22, seems rather different in approach from the Pothos, but the lack of originals on the Skopaic side makes this impossible to verify.

52. On the composition, see Süsserott, 185-86; Bulle, op. cit., 11-12.

53. The focus of the boy's attention can hardly be the tip of the staff, as Bulle, *JdI* 56 (1941), 122-23 and 134 suggests. The staff is completely integrated within the composition and reinforces the ascending movement; for it also to have to *absorb* it would be an anticlimax indeed. (The Berlin gem, G36, upon which Bulle bases much of his argument, is untrustworthy evidence, see note 64, below).

54. *Le Arti Figurative* 2.3 (1946), 139.

55. 'Narcissus': Lippold, *Plastik*, 165 and pl. 60,2; Arnold, 54-64 and pls. 3a, 4a.

56. 'Paris': Picard, *Man* iii.2, 866-69 fig. 391; N. Dacos, *BCH* 85 (1961), 371-99; U. Jantzen, *JdI* 79 (1964), 241-56.

57. Sauroktonos: Lippold, *Plastik*, 240 and pl. 84,3; Rizzo pls. 59-64.

58. Artemis: Lippold, *Plastik*, 221 and pl. 89,1; Schlörb, 66-68 fig. 54. On the connection with the Pothos see Becatti, op. cit. (note 48), 406; B. Neutsch, *Studien zur vortanagräisch-attischen Koroplastik* (*JdI Erg* 17, 1952), 20-21.

59. Votive reliefs: Süsserot, loc. cit. and pl. 22; Svoronos i pls. 35-36. Perhaps also deriving much of their inspiration from the Pothos are:
 (1) Leaning youth, New York 123: Richter, *MetMus* pl. 95.
 (2) Leaning youth, Sorrento, unnumbered: *NS* 1924, 378-79 figs. 4-5. See also the Ilissos youth (PLATE 49a) and the works dependent upon him (Chapter 10, section 4 [A]).

60. For the motif of the crossing arms see Lysippos' Eros (Lippold, *Plastik*, 281 and pl. 100,4; H. Döhl, *Der Eros des Lysipp* (Diss. Göttingen, 1968); for the date (? c.340-335) see Arnold, 210 n. 719: perhaps, therefore, a forerunner? Cf. also the Hygieia type discussed in the Appendix to this Chapter, section 3.

61. Late dating: Müller, op. cit. (note 46), 176 for references.

62. Ruvo amphora (now lost): Såflund, *The East Pediment of the Temple of Zeus at Olympia* fig. 92. An Erinys in a Pothos-type pose also appears on the neck of the Patroclus krater Naples 3254 by the Darius painter (FR ii, 156-60 fig. 52; M. Schmidt, *Der Dareiosmaler und sein Umkreis* [1960] fig. 11), dated to c.330–300 by Schmidt and c.350 by Trendall (cf. *The Red-figured Vases of Lucania, Campania and Sicily*, 159-60).

63. Mirror-case: Züchner, *Klappspiegel*, 13-14 (KS 14) and pl. 24. A date c.325 is suggested by the body-forms of the Eros, which are in the manner of the Marathon boy.

64. Hermaphrodites: see Mingazzini, op. cit. (note 46), 139. For the Meidias painter's Pothos see *ARV²*, 1312; Arias and Hirmer pl. 217. The 'Pothos' on the Berlin gem (G36) is definitely—and uniquely—hermaphroditic, which leads me to doubt its trustworthiness as a copy.

65. On the date, see Arnold, 210 n. 719. Süsserott's date of c.320–310 (185-86) would seem to be rather late. His system of dating would seem to be open to question at several points, not the least of which is that reliefs and vases do not accompany but *follow* major trends in fourth century art.

66. Appendix 1, nos. 4 and 26.

67. Megarian Pothos: Becatti, op. cit. (note 48), 407-9; Picard, *Man* iii.2, 653-55; Bulle, op. cit. (note 53), 140-41 draws attention to the apparent similarity between the Megarian figures.

68. Romans at Samothrace: P. M. Fraser, *Samothrace* ii.1 (*The Inscriptions on Stone*), 15-17.

69. O. Kerényi, *Symbolae Osloenses* 31 (1955), 141-53.

70. Veil: Bulle, op cit. (note 48), 141; N. Lewis, *Samothrace* i (*The Ancient Literary Sources*), 107 no. 229g-h; P. W. Lehmann, *Samothrace* iii.2 (*The Hieron*), 26-29.

71. Torches: G33-35; Müller, op. cit. (note 46), 165 fig. 8, cf. 181-82; Kerényi, *Symbolae Osloenses* 31 (1955), 148-52. On torches at Samothrace see Lehmann, *Samothrace* iii.1 (*The Hieron*), 135-37 figs. 89-90; iii.2, 73-74 fig. 384; also Lewis, op. cit. nos. 67, 69, 73, 151, 153n., 166, 167, 194n. Monument of the Cyzicans, showing torches: *Hesp* 12 (1943) pls. 3-5; Lehmann, *Samothrace* iii.2, 27 fig. 352.

72. Original setting: Bulle, op. cit. (note 53), 131-34.

73. After 340 the Samothracian sanctuary was undergoing extensive reconstruction (Lehmann, *Samothrace* iii.1, 236; iii.2, 51, 74-75; K. Lehmann and D. Spittle, *Samothrace* iv.2 [*The Altar Court*], 106, 116); perhaps the group was commissioned as a part of the new scheme. Lehmann suggested (*Hesp* 21 [1952], 29) that the group stood on a rough field-stone foundation, 'composed of a smaller south-western and larger north-eastern section' and 3.15m. long altogether, against the northwest wall of the Temenos. This, if correct, would militate against the presence of Phaethon, but from the plan published in *Skopas in Samothrace* fig. 7 the stones are so jumbled that even a rough restoration of the form of the base would be optimism indeed. The main pile, in the centre of the wall, does leave room for another statue (Phaethon ?) to the north-east, however, and there are plenty of large stones very close by that could have come from its base.

74. 'Risen Christ': A. E. Brinckmann, *Michelangelo Zeich-*

nungen (1925) pl. 46; L. Goldscheider, *Michelangelo Drawings* pl. 79.

75. Kerényi, op. cit. (note 69), 149, suggests that the Aphrodite was not copied owing to a religious prohibition stemming from the secret nature of the Mysteries; this would presumably not have affected a 'Nebengestalt'.

Chapter 10

1. The curving S-axis is first noticeable in Praxiteles' work with the Aphrodite from Arles (Lippold, *Plastik*, 237 and pl. 83,2; Rizzo pls. 34-42; Arnold, 161: c.370?), and is combined with an 'open' *contrapposto* in the Sauroktonos (Lippold, *Plastik*, 240 and pl. 84,3; Rizzo pls. 59-61; Arnold, loc. cit.: c.370–360 ? Cf. the relative immaturity of the head: Lawrence, *GRS* pl. 47b; Becatti, *The Art of Ancient Greece and Rome* fig. 175).

2. On Praxitelean idealism see esp. G. Rodenwaldt, 'Θεοὶ ῥεῖα ζῷοντες' *AbhBerlAkad* (1943) 13; Richter's remark that with Praxiteles: 'The gods have descended from high Olympos and have become charming, serene human beings' (*Sc⁴*, 202) surely has the emphasis misplaced.

3. Interrupted rhythms are noticeable even in the **Cophenhagen Herakles** (see note 58, Chapter 4), around 360-350; the *locus classicus*, though, is of course the Apoxyomenos (Schauenberg, *AP* 2 [1963] pls. 60-71; Lippold, *Plastik*, 279-80 and pl. 100,1; Boardman *et al.*, *Art and Architecture* pl. 258).

The momentary, 'impressionistic' character of Lysippos' work was embodied in his Kairos (*SQ* 1463-7), now known in relief form in several replicas: Boardman *et al.*, op. cit. pl. 261 above; Lawrence, *GRS* pl. 54b; Picard, *Man* iv.2 (1963) figs. 234-36 and pl. 14.

4. Ashmole, *JHS* 71 (1951), 15.

5. Apoxyomenos: see note 3, above. Eros: see note 60, Chapter 9; for the head, Johnson, *Lysippos* pl. 18; Bieber figs. 88-89. Alexander Azara: Johnson, op. cit. pls. 43-44; Bieber, *Alexander the Great in Greek and Roman Art* pls. 8-9; Lippold, *Plastik* pl. 97,1.

6. Kallimachos: Richter, *Sc⁴* figs. 553-54, 683; Lawrence, *GRS* pl. 41a.

7. On Pheidias, Athena and Periclean Athens see esp. Herington, *Athena Parthenos and Athena Polias*, 48-67.

8. All hail, all hail. High destiny shall be yours
　by right. All hail citizens,
　　seated near the throne of Zeus,
　　beloved by the Maiden he loves,
　　civilised as years go by,
　　sheltered under Athene's wings,
　　grand even in her father's sight.
(Aeschylus, *Eumenides* 996-1002, trans. Lattimore.)

9. Spiritual insecurity in the fourth century: see esp. E. R. Dodds, *The Greeks and the Irrational* (1951), chs. 6-7.

10. Cicero, *De Divinatione* i.13 (Appendix 1, no. 44).

11. Herakles-Telephos groups: Roscher s.v. 'Telephos' cols. 299-301, esp. fig. 8, and cf. *SVM* i pl. 79; ii pl. 21; for Tegea 48 see note 40, Chapter 2.

12. Thasos 24 (from the Agora): P. Devambez, *BCH* 66-67 (1942–43), 204-9 fig. 66; *Guide de Thasos*, 130 fig. 66.

13. Copenhagen Herakles, NyC 261: Arndt, *GNC*, 136 and pls. 89-92; *Billedtavler* pl. 18; Preyss, text to B-B 691-92 (1926) no. 39; Arias, 106 no. 23; Arnold, 197 n. 673; Lehmann, *Statues on Coins*, 53.

14. Munich Herakles, Mus. für antike Kleinkunst: Preyss, op. cit. no. 40 and figs. 3-7; Arias, 106 no. 35; B-B 693.

15. Eclectic types: brief discussions appear in Poulsen, text to *EA* 4773; Lehmann, op. cit., 53-62; Arnold, 197. On the Louvre–Ny-Carlsberg type see Graef, *RM* 4 (1889), 193 no. 3 and fig.; Arndt, *GNC*, 147 figs. 84-88 and pl. 101; *Billedtavler* pl. 18 no. 256; Richter, *MetMus* pl. 94 no. 122; Lehmann, op. cit., 7 and pl. 1. Compare also the Pitti Herakles, *EA* 231; Johnson, *Lysippos* pl. 40, A; Preyss, op. cit. no. 28; Arias, loc. cit. no. 30, and the 'Ercole Mastai', Vatican Rotonda 544: *SVM* iii pls. 37, 44; Helbig⁴ 38; Preyss, op. cit. no. 24; Arias, 106 no. 18.

16. Ares Ludovisi: copies listed and studied by Furtwängler, *Masterpieces*, 304; Johnson, *Lysippos*, 166-70; Lippold, *Plastik*, 289 n. 11; Arias, 135. See also Praschniker, *ÖJh* 21-22 (1922–24), 203-21; Bieber, 41. For variants, etc. see Bulle, text to *EA* 635-36; Lippold, *JdI* 26 (1911), 271-80; Dehn, *JdI* 27 (1912), 199-207 (though his Beil. 5d and 8d show the Munich head, not the Ludovisi one—a mistake repeated by Picard, *Man* iii.2 figs. 322-23 and which, I suspect, has misled others); Lippold, *Kopien*, 46, 197; Fink, *RM* 71 (1964), 152-57 (*contra*, Zanker, Helbig⁴ 2345).

Copies: (1) Statue (Ares Ludovisi), Terme 156. Helbig⁴ 2345; B-B 388; *EA* 254-55; Johnson, op. cit. pl. 28; Picard, *Man* iii.2 fig. 321; Lippold, *Plastik* pl. 102,2; Arias 1 and pl. 15, 50; Bieber fig. 103; Fink, op. cit. pl. 36; Eros partially restored (Bernini). PLATE 48a (2) Torso, Naples 293. *EA* 534-35; Johnson, op. cit. pl. 29; Arias 4 and pl. 15,51; Bieber fig. 105. (3) Head, Munich 272. *EA* 832-33; Lippold, *JdI* 26 (1911) fig. 8a-b; Dehn, op. cit. Beil. 5-8 (d); Picard, *Man* iii.2 figs. 322-23; Arias 2; Fink, op. cit. pl. 37, 1. PLATE 48b,c. (4) Head, Vienna Inv. 1026. Praschniker op. cit. figs. 76-77 and pl. 2; Arias 3; Fink, op. cit. pl. 37,4. (5) Head, Mus. Torlonia 24. Lippold, *Plastik*, 289 n. 11. (6) Head, Albano (restored on togatus). Lippold, loc. cit. (7) Head frag., Corinth 83. Johnson, *Corinth* ix, 59 and fig.

Versions: (8) Torso, Pergamon. Bieber fig. 104. (9) Head, Boston 71 (formerly Nelson). Caskey no. 71 and fig.; Dehn, op. cit. Beil. 5-8(b); Fink, op. cit. pl. 37,3. (10) Head, Athens NM 189. *EA* 656-57; Dehn, op. cit. Beil. 5-8(c); Fink, op. cit. pls. 35,3; 37,2; 38,2.

Statues utilising versions of the Ludovisi-type head: (11) Hermes from Atalanti, Athens NM 240. *EA* 635-36; Lippold, *JdI* 26 (1911) fig. 7a-b; Fink, op. cit. pl. 34. (12) 'Joven Orador', Madrid 39-E. A. Blanco, *Catalogo de la Escultura* (1957) pl. 21; Dehn, op. cit. Beil. 5-8(a); Fink, op. cit. pl. 35,1-2.

Version in relief: Campana plaque, Paris. Fink, op. cit., 156 n. 4 (with bibliography) and pl. 38,1.

17. Ares and Apoxyomenos: cf. Johnson, *Lysippos,* 169.

18. Eros: Bieber, 41; Helbig⁴ 2345.

19. Parthenon Ares: Smith, *The Sculptures of the Parthenon* (1910) pl. 33; Ashmole, *Architect and Sculptor* fig. 160 (no. 27).

20. Fink is the main protagonist for a first century date (op. cit.); he argues that since the head type recurs on nos. 11 and 12, and these are first century pieces, there is no reason to assume either that the heads ascribed to the Ares do not copy one of these, or that the Ares is not itself a late Hellenistic piece. This may be countered on three grounds: (1) the Hermes, its cousin the Eretria youth, and the 'Orador' are all pastiches of fifth and fourth century originals (Lippold, Dehn, op. cit.); there is no such stylistic discrepancy between the head and body of the Ares. (2) The Hermes and the youth are 'one-off' grave statues by third-rate sculptors, and no copies of these or the 'Orador', itself a pastiche, are likely; the Ares, however, was copied in antiquity (the Naples torso, no. 2), and a version in 'baroque' style from Pergamon, no. 8, certifies the Ludovisi type as almost certainly pre-second century and by a renowned artist at that; being of the same scale as the Ludovisi and Naples statues it is presumably not a direct replica of *Skopas'* original, a 'colossiaeus'. (3) The Vienna, Munich and Ludovisi heads undoubtedly do copy the same statue, whereas differences in the proportions (Dehn, op. cit., 207) and details of the hair, mouths and eyes show that the head of the Hermes and its fellows (nos. 9-12) are free *versions,* not copies, of the Ares type.

21. Lysikrates frieze: B-B 488; Winter, *Kunstgeschichte in Bildern* pl. 316,1.

22. ? Aphrodite: cf. 'Eros', above.

23. 'Ares sedens colossiaeus' and Brutus Callaecus: see bibliography to the Ares, above. The arguments advanced here circumvent the old problems of dating, material, etc., encountered by those who support the attribution to Skopas himself: cf. Lippold, *Kopien,* 44, 46; Johnson, *Lysippos,* 169-70; Picard, *Man* iii. 1,720-21 for summaries. Lippold, op. cit., 52 explains why we should not expect to find copies of the Ares or any other statue removed to Rome at an early date.

24. *Naturalis Historia* xxxvi.26 (Appendix 1, no. 11). This had in any case been rendered rather unlikely by the scale of the copies (all are life-size, proving that the original was also).

25. Ilissos sculptor: J. Frel, *Les sculpteurs attiques anonymes* (1969), 41-43 nos. 293-97. I omit the two lions (ibid. nos. 298-99) which Frel attributes to him, since I doubt whether any attribution is possible. For the dates, see ibid., 43 and Diepolder, 50-52, 56.

26. Imitations, etc. of the Ilissos sculptor: Frel, op. cit., 43-48 nos. 300-42. A grave statue of a youth, now in Dallas, is closely related to the Ilissos youth in both motif and style: Hoffmann, *Ten Centuries that Shaped the West* (1971), 12-17 fig. 4a-c; C. Vermeule, *Coll. Latomus* 103 (1969), 648-50 and **pl. 234**; J. Ternbach, ibid., **651ff. and pls. 238-42.**

27. Stele of Aristonautes (NM 738): Lippold, *Plastik,* 221

and pl. 79, 4; Diepolder, 52-53 and pl. 50; Arias, 144 no. 2 and pl. 16,55.

28. Paris head: F. Croissant and C. Rolley, *BCH* 89 (1965), 324-31 figs. 7-8 and pls. 6 and 7.

29. 'Ariadne' head: ibid. fig. 12; see also the following paragraphs.

30. Niobids: see Arias, 136-38 for a summary of the arguments; a more detailed discussion and exhaustive bibliography appears in Mansuelli, *Uffizi* i, 101-19, esp. 106, where the whole group is assigned to mid-Hellenistic times or later (cf. Lawrence, *GRS,* 227); H. Weber, *JdI* 75 (1960), 112-33 argues for a first century date, but ignores the copy of the head of Niobe and one other found in the Mahdia wreck and dated thereby to before 100: Merlin-Poinssot, *RA* 18 (1911), 104-5 figs. 2-3; W. Fuchs, *Der Schiffsfund von Mahdia* (1963), 36-37 nos. 45, 47 and pls. 55, 58. For the date of the wreck see ibid., 11 and *AJA* 64 (1960), 183.

31. Chiaramonti statue, now Lateran coll., Vatican Inv. 1035, Helbig⁴ 598: *SVM* i, 422 no. 176 and pl. 44; B-B 313. I examined this piece thoroughly in 1971 and 1972 and believe it not to be an original (*pace* Sieveking and Buschor, *Münchener Jahrbuch* 7 [1912], 119ff.) but a copy, possibly of Claudian or Neronian date. The 'Lederer' head does not belong (F. Hiller, *JdI* 75 [1960], 133).

32. 'Artemis' (east G): Brommer, *Die Skulpturen der Parthenon-Giebel* pls. 39-42; Lullies and Hirmer pl. 166.

33. Themis: Lippold, *Plastik,* 302, and pl. 108, 1; Bieber fig. 516. See Marcadé, *Recueil* i, 12 for the date.

34. Agora torso: M. E. Caskey, *AJA* 75 (1971), 296 and pl. 73,3.

35. Helios: Lippold, *Plastik,* 307 and pl. 110, 1: Bieber fig. 488. For the date, see Holden, *The Metopes of the Temple of Athena at Ilion,* 29; Hoepfner, *AM* 84 (1969), 179.

36. 'Ariadne': Studniczka, *JdI* 34 (1919), 107-44, esp. 110-13 figs. 7-12. Concerning the Niobe, Lippold, *RM* 33 (1918), 86-87 holds the Uffizi head to be the only true copy (PLATE 50b); the others are: (2) Oxford M 62. Studniczka, op. cit. fig. 7. (3) Brocklesby, *EA* 4859; Studniczka, op. cit. figs. 9, 11. (4) Nieborow. *AA* 1927, 58-70 figs. 1-2. (5) Villa Albani 125.

37. On the motif and identification of the 'Ariadne' as a Nike see Lippold, *Plastik,* 304; Helbig⁴ 1800. A 'sleeping Ariadne' with her eyes open would be unusual.

38. New York head and Alexander sarcophagus: see section 4 (C) of this chapter.

39. Cos head: Bieber fig. 33; ead., *JdI* 38-39 (1923-24) pl. 6; Richter, *Sc⁴* fig. 735 (unrestored—the head illustrated in fig. 734 is actually a separate piece of closely related style, now in a private collection in Germany).

40. Budapest statuette: Lippold, *Plastik* pl. 121,2; C. M. Havelock, *Hellenistic Art* figs. 118-19; Alscher, *Griechische Plastik* iv pl. 3. On Hellenistic heads see Horn, *RM* 52 (1938), 70-90 and pls. 9-21.

41. Lakrateides: ibid. pl. 19. Aristonoe, NM 232: Weber, op. cit., 130-31 figs. 10-11. In any case, the Niobids must be before c.100 for copies to have appeared in the Mahdia wreck, as was noted above.

42. Niobe and running girl: Mansuelli, *Uffizi* i pls. 70, 72; Lippold, *Plastik* pl. 111,1-2; Bieber figs. 258, 264.

43. Niobe and Leda: see e.g. Winter, *JdI* 38-39 (1923-24), 49-57 and Beil. 1; E. Künzl, *Fruhhellenistische Gruppen* (Diss. Köln, 1968), 32-36.

44. Tyche from Antioch: T. Dohrn, *Die Tyche von Antiochia*, passim.; Lippold, *Plastik*, 296 and pl. 106,2; Bieber fig. 102; Lawrence, *GRS* pl. 59b, c: dated to c.300–295 by the founding of the city and the sculptor's *floruit* in Pliny, *Naturalis Historia* xxxiv.51 (*SQ* 1516, cf. 1531-32).

45. Niobe copies: (1) Uffizi 70. (2) Heraklion 265. Bieber fig. 261; Weber, op. cit. (note 30) figs. 4-5. (3) Chiusi, Pal. Vittorio Veneto. Ibid. figs. 6-9.

46. Berlin gem, F319: Furtwängler, *Die Antike Gemmen* pl. 13, 18; Boardman, *Greek Gems and Finger-Rings* pl. 546.

47. Capuan Aphrodite: Lippold, *Plastik* pl. 101,3; Beazley and Ashmole, *Greek Sculpture and Painting* fig. 193; for the date, Arnold, 237.

48. 'Altar of Domitius Ahenobarbus': J.M.C. Toynbee, *The Art of the Romans*, 50; Bieber figs. 808-9; bibliography: E. Nash, *A Pictorial Dictionary of Ancient Rome* ii, 120. Since this apparently belongs around 50 B.C. I would imagine that the Uffizi versions of the original group are probably late Republican or Augustan.

49. Heads: Müller, *JdI* 58 (1943), 175-76 and figs. 12-14.

50. Seleukos, and the temple of Apollo Sosianus: see Lippold, *Plastik*, 308-9; résumé, Picard, *Man* iii.2, 750 n. 3.

51. Pliny, *Naturalis Historia* xxxvi.28 (Appendix 1, no. 37).

52. Bieber, 74.

53. Knidia: note 46, Chapter 8. A further example of this kind of eclecticism at the end of the century is the resting **athlete in the Vatican** (*SVM* i, 509-10 no. 297 and pl. 53; head in Vienna, *EA* 2416-7), a cross between the Praxitelean 'Lykeios' motif and Skopaic proportions and expression. The period as a whole shows a definite tendency to return to the past, as well as other signs of flagging imagination.

54. Apollo Citharoedus: Helbig⁴ 82; *SVM* iii.1, 60 no. 516 and pls. 6-7; Lippold, *Plastik*, 311 and pl. 110,3; H. von Heintze, *Roman Art* fig. 102.

55. Copy in Geneva: W. Deonna, *Catalogue des sculptures antiques au Musée d'art et d'histoire en Genève* no. 61; Richter, *Sc⁴* fig. 752. The Vatican statue was found with the Muses, Helbig⁴ 60, 63, 65, etc.; Bieber figs. 44-46, but from the style is clearly not of them.

56. Nicked tubular folds: cf. e.g. Carpenter, *The Sculpture of the Nike Temple Parapet* pl. 13. Here, the Vatican copy omits the final stage, but not the Geneva one.

57. **Rhodes workshop:** Lawrence, *BSA* 26 (1923–25), 67 and **pls. 8-9;** Frel, *IstMitt* 22 (1971), 121-24 and pls. 38-43.

58. Sarcophagus: von Graeve, *Alexandersarkophag* (photographs by D. Johannes), 13, 125-46 for the date, but cf. H. Lauter, *Gnomon* 1973, 178-84, esp. 182f.

59. New York 118: Richter, *MetMus*, 72 and pl. 91.

60. Followers (1): von Graeve, op. cit. pls. 49; 50,1-2; 62,1; cf. Frel, op. cit. pls. 38-43.

61. Berlin-Terme youth: Lippold, *Plastik*, 280 and pl. 97,3; B-B 717-8; Blümel, *KatBerlin* v pls. 45-46; Picard, *Man* iv.2 figs. 184-190 *bis*.

62. Followers (2): von Graeve, op. cit. pls. 60,2-61.

63. Influence: ibid. pls. 56-58,1 and others.

64. Others: ibid. pls. 48; 51,1; 53; 55; 62,3; cf. the Alexander, Lawrence, op. cit. (note 57) pl. 9 (whence id., *GRS* pl. 58b) with the Apoxyomenos.

65. On the bases, see Marcade, *Au Musée de Délos*, 479-81.

66. **Rhodes portrait head:** *Clara Rhodos* ii (1932) figs. 14-15 and pl. 1; Frel, op. cit. (note 57) pl. 41,1.

67. Copenhagen, NM 5623: Riis, *Festskr. Poulsen* (1941), 15-23 and pls. 1-2; Picard, *Man* iii.2 fig. 349.

68. Lysippos on Rhodes: Pliny, *Naturalis Historia* xxxiv.63 (*SQ* 1460); *Lindos* ii, col. 241 no. 50; Marcade, *Recueil* i, 68 *verso*. Chares: Pliny, *Naturalis Historia* xxxiv.41 (*SQ* 1539, cf. 1540-54); recent discussion by H. Maryon, *JHS* 76 (1956), 68-86. On Rhodian sculpture in general see Lawrence, op. cit.,; Bieber, 123-35; Marcade, op. cit., 471-83; G. S. Merker, *The Hellenistic Sculpture of Rhodes (Studies in Mediterranean Archaeology* xl, 1973).

69. Early Hellenistic naturalism: Carpenter, *Greek Sculpture*, 180-189; Lawrence, *GRS*, 213-21.

70.. Smyrna head (now lost—cast in Bonn): Furtwängler, *Masterpieces*, 397 fig. 174; *EA* 1342-3; *IstMitt* 16 (1966) pl. 19; from Tralleis. See in general, R. Lullies, *Die kauernde Aphrodite*, 26 and figs. 27-28.

71. The original of the Pitti Herakles (*EA* 228-30; Johnson, *Lysippos* pl. 40,B; Linfert, *Von Polyklet zu Lysipp*, 76 n. 23; Arnold, 197) must be about contemporary with the Uffizi 'pseudo-Pothos' head. It is an unlovely piece, not to be **confused with that cited in note 15, which is equally unpleasant.**

72. Asklepios, NM 258: Karouzou, *Guide* pl. 44; Picard, *Man* iii.2 fig. 299. On the date and style see Wolters, *AM* 17 (1892), 10ff; Lawrence, *LGS*, 121; Krahmer, *Nachrichten der Gesellschaft zu Göttingen* N.F. 1 (1936), 221-23; Becatti, *Rivlst* vii (1940), 49; Arias, 122.

73. On *Ansätze* see Chapter 1 and the Appendix to Chapter 8, section 1.

74. Hellenistic parallels for the crude technique of the head are the Poseidon from Melos, NM 235 (Karouzou, *Guide* pl. 66; *AP* 8 [1968] pl. 39). and the Cleveland Alexander head (Bieber figs. 334-35).

75. Zeus of Aegira, NM 3377: Karouzou, *Guide* pl. 69; Becatti, op. cit., 25-27 figs. 6 and 7; Bieber figs. 671-72. For the eyes, cf. the 'Kritios Boy', AkrM 698 (Payne-Young, *Archaic Marble Sculpture from the Acropolis* pls. 109-12; Ridg-**way, *Severe Style* fig. 43; the head is possibly alien to, but in the same style as the body: Payne-Young, op. cit., 44).** These observations on the Asklepios and Zeus stem from a study of the originals concerned and photographs taken in 1972 which, for reasons of space, cannot be included here.

76. **Copenhagen Herakles: see note 13, this Chapter.** Olympia Hermes: Lullies and Hirmer pl. 228; Lippold, *Plastik* pl. 84,2.

77. Nike of Samothrace: Lullies and Hirmer pl. 262; Lippold, op. cit. pl. 126,4; Bieber fig. 493. For the date (c.200–190) see *Hesp* 21 (1952), 20; *Samothrace* iv.2 (*The Altar Court*), 135-38. Venus de Milo: Lullies and Hirmer pl. 270; Lippold, op. cit. pl. 130,3; Bieber fig. 674.

78. On the end of the Polykleitan school see Arnold, 209-10, 213; for Skopas' influence on it see also p. above.

79. Parthenon frieze: Smith, *The Sculptures of the Parthenon* pl. 32; D. E. L. Haynes, *The Parthenon Frieze* (1958) pl. 38.

80. Agias: T. Dohrn, *AP* 8 (1968) pls. 10-20; Lawrence, *GRS*, 205-7 and pl. 57b; Richter, *Sc⁴*, 226 and figs. 790, 792-93; Beazley and Ashmole, *Greek Sculpture and Painting*, 61 and figs. 122, 128-29. On the composition, see Süsserott, 167-68; Dohrn, op. cit., 33-34.

81. Beazley and Ashmole, *Greek Sculpture and Painting*, 61.

82. Agias and the Pharsalos group: see esp. Marcadé, *Recueil* i, 67 *verso* -68; Adam, *Technique*, 97-99; Dohrn, op. cit., 42-46, 48-50; Arnold, 210-13; Lawrence, loc. cit.; E. K. Tsirivakou, *AE* 1972, 70-85, esp. 84-85, and pls. 22-33. Tsirivakou identifies the torso Delphi 1360 as the missing Telemachos (cf. Arnold pl. 27b), and considers the Agias alone to be a replica of Lysippos' work at Pharsalos, for the following reasons: (1) no argument can be founded upon the type of support common to the Agias, Telemachos, Agelaos and Daochos II (cf. Dohrn, op. cit., 45, 49) since the statues of the newly discovered Kallithea monument from Piraeus have the same kind of support; (2) of the three brothers, only the Agias appears not to be based on a Polykleitan prototype (the Telemachos and Agelaos being versions of the Kyniskos and Diadoumenos respectively); (3) the sculptor of the Agias was responsible for this alone, the other nudes being the work of a different hand. On the whole, this seems convincing.

83. For the Apoxyomenos, cf. Schauenberg, *AP* 2 (1963) pls. 60-71.

84. Leochares: Ashmole, *JHS* 71 (1951), 13-28 and pls. 1-16.

85. Ganymede, Apollo, Artemis: Lippold, *Plastik*, 268-72 and pl. 98; Kleiner, *Festschr. Schweitzer*, 233; Bieber, 62-63 and figs. 198-200; Arnold, 210 n. 719; see also Harrison, *Hesp* 29 (1960), 382-89.

86. Style of the Demeter: Bieber, 29; Ashmole, op. cit., 15.

87. Style of the Apollo: Bieber, 63. N.b. that the sinuous curve of the axis of the body is completely absent from all three figures ascribed to 'Leochares II'.

88. It seems unlikely that Timotheos' career extended much beyond 350; cf. Schlörb, 77-78.

89. Centaur head: Buschor figs. 53-54.

90. BM 1054: Smith, *BMCat* ii pl. 20,1; Buschor figs. 9-10; Jeppesen, *Paradeigmata*, 54 and figs. 44-45; Bieber fig. 73.

91. NM 717: Diepolder, 45 and pl. 42,1; Lippold, *Plastik*, 229 and pl. 81,2. NM 737: Diepolder, 50, 54 and pl. 46; Lippold, *Plastik*, 245 and pl. 87,2. See also the heads illustrated by Frel, *Les Sculpteurs attiques anonymes* pls. 39-41, 47-50.

92. Ny-Carlsberg heads: *Billedtavler* pl. 16; cf. also Blümel, *KGS* figs. 15, 52.

93. 'Philandridas': see Appendix to Chapter 8, section 4. Berlin K233: see note 61, (the Lysippic elements in the style are far too strong for this to be a 'follower' of Skopas, at least as I understand the term). Boxer: Richter, *MetMus* pl. 128; Lawrence, *LGS* pl. 5.

94. Sophokles: Richter, *The Portraits of the Greeks* i figs. 675-82; Bieber figs. 181, 183; Lawrence, *GRS* pl. 56b (original dedicated c.330 by Lycurgus: Lippold, *Plastik*, 271 n. 4 for references). Boston head: Bieber, *Alexander the Great in Greek and Roman Art* fig. 39a-b (c.320-310 ?); for the controversy over its (presumed) authorship see W. N. Bates, *AJA* 13 (1909), 151-57; *contra*, Caskey, *Mus. of Fine Arts Bulletin* 8. 46 (Aug. 1910), 26; Hyde, *AJA* 18 (1914), 462-78; id., *Olympic Victor Monuments*, 305-20; to me, it seems most closely to resemble the Berlin youth, K233 (see above). Menander (identification now certain: Ashmole, *AJA* 77 (1973), 61 and pls. 11-12): Richter, op. cit. ii figs. 1514-1643; Bieber figs. 150-7; Lawrence, *GRS*, 217 and pl. 60c.

95. Lawrence, *LGS*, 15.

96. Ephesus drum: see Appendix to Chapter 8, section 4.

97. Amazon sarcophagus: B-B 493; Bieber fig. 252; detail, Neugebauer, *JdI* 56 (1941), 199 and fig. 11.

98. For the Skopaic head see Holden, op. cit. (note 35), 26 and fig. 53.

99. Ibid., 8 and fig. 29.

100. Ibid., 13-18; clearly, however, a Skopaic style was current also in Rhodes at the time as well as a 'Lysippic', as the discussion above demonstrates. See also above remarks on fourth century local schools; apart from the completely provincial, are they not more *personal* than local?

101. For Skopas' influence on provincial Italian (Tarentine) sculpture, see esp. Bernabò Brea, *I Rilievi Tarentini in Pietra Tenera* (1952), 69-73 and 115ff, esp. figs. 79-81; H. Klumbach, *Tarentiner Grabkunst* (1937), 69-71, though his definition of 'Skopaic' is somewhat wider than mine.

Note: Architectural sculpture is indexed under its place of origin. Helbig numbers are given wherever possible for collections in Rome and Ostia; for abbreviations used for other guide-books, catalogues and museums see pp. xiii-xvi and Appendix 4. An asterisk before a page-number indicates the principal discussion of the subject in question; a superscript after the page number gives the number of the note for that page in which the piece is also discussed. The listing of attributions to a sculptor, followed by the abbreviation 'attr.', does not necessarily imply acceptance of the attribution on the part of the author.

Abbreviations

Amph.: amphora
Attr.: attributed
B.: base
Br.: bronze
F.: female
Fr.: fragment
Gp.: group
Hd.: head

Imp.: impression
Kr.: krater
M: male
M.c.: mirror-case
Mon.: monument
Mus.: museum
P.: portrait
Pan.amph.: Panathenaic amphora
Ped.: pediment

Pel.: pelike
Rel.: relief
Sarc.: sarcophagus
St.: statue
Stte.: statuette
T.: temple
T.c.: terracotta
Vol.-kr.: volute-krater

181

Corrigendum: for Salamis, Cyprus Museum, read Nicosia, Cyprus Museum. The sculptures concerned are *from* Salamis and *in* Nicosia.

1. Literature

Aeschines, *contra Timarchum* 188 (Schol.).: 111, 130
Aeschylus, *Eumenides* 996-1002: 114; *Septem contra Thebes* 532 (Schol.): 60[14]
Anon (iii B.C.), elegiac fr.: 61[16]
Anthologia Palatina iii.119: 64[41]; v.225: 64[41]; vi.253: 60[11]; ix.774: 91[16], 130; ix.823: 60[10]
Anthologia Planudea 60: 91[16], 130; 110: 64[43]; 192: 112, 129
Apollodorus mythographus i.8.2: 61, 62; iii.9.1: 63; iii.10.3: 64[42]
Aristophanes, *Aves* 574 (Schol.): 105[17]
Aristotle, *Poetica* 8: 65[48]; 17: 65[48]
Arrian, *Cynegeticus* i.35: 60[11]
Callimachus, *Hymnus in Delum* 83-5: 60[10]; *Hymnus in Dianam* 51-6: 60[11]; 170-224: 60[11]; 215: 60[14]; *Hymnus in Jovem* 32-53: 65; fr.354 (Schneider): 60[10]
Callistratus, *Statuarum descriptiones* ii: 91, 93, 130-1
Cicero, *De divinatione* i.13: 115, 134; ii.21: 134; *De natura deorum* ii.34.83: 88[23]
Clemens Alexandrinus, *Protrepticus* 41: 111, 129
Demosthenes x.37-38: 69[91]
Dictys Cretensis ii.6.10: 64[41]
Diodorus Siculus xv.76.2: 99[46]; xv.82.5: 69[97]; xv.89.1: 69[97]; xv.90: 97[26]
Euripides, *Auge*: 63; *Hippolytus* 17-8: 105; *Meleager* fr.515-539: 61[16], 62; fr.525: 60[14]; fr.530: 52[25]; *Phoenissae* 151: 60[14]; *Telephos*: 63[34]
Eustathius 34.16: 111, 128
Herodotus ii.180: 69[91]; vi.72: 59[5]
Homer, *Hymnus in Venerem* 256-72: 60[10]; *Iliad* iv.194: 64[41]; ix.529-99: 61[16], 61[17], 107[33]; x.23: 54[45]; x.177: 54[45]; *Odyssey* vi.102-9: 60[11]
Horace, *Carmen Saeculare* 62-5: 151; *Carmina* iv.8.4-8: 134
Hyginus, *Fabulae* 173: 61, 63, 105[15]
Kallistratos: see CALLISTRATUS

Laterculi Alexandrini col.7, 3-5: 2[17], 2[20], 135
Lucian, *Lexiphanes* 12: 94, 112, 134; 12 (Schol.): 2[17], 134
Lycophron, *Alexandra* 213: 54[43]
Martial iv.39.1-3: 2[20], 134
Notitia: descriptio urbis Romae, Regio x: 93, 128
Ovid, *Metamorphoses* viii.270-546: 61; viii.324: 107[33]; viii.329: 60[11]; viii.378-81: 51; viii.379-87: 61[20]; viii.391-3: 62; viii.425-525: 61[21]; viii.425-29: 104[4]
Oxyrrhynchus Papyri 1241: 151; 2359: 61[16]
Pausanias i.4.6: 54[47], 64[36]; i.23.4: 59[6]; i.24.5-7: 66[54]; i.28.2: 82; i.28.6: 111, 130; i.43.6: 109[66], 111, 130; ii.10.1: 91[7], 130; ii.10.3: 105[11]; ii.22.7: 111, 129; ii.25.2: 65; ii.27.2: 88[23], 105[12], ii.32.4: 90[5], 105[13]; ii.5.6: 59[5]; iii.7.10: 59[5]; iii.15.3-5: 62[27]; iii.18.8: 1[6], 127; iii.26.9-10: 64[41]; v.10.6: 51; v.11.1: 60[9]; v.11.4: 97[23], v.13.3: 64[41]; v.20.10: 108[43]; v.26.6: 60[8]; vi.1-10: 2[14]; vi.25.1: 3[27], 93, 127; vii.18.8-10: 107[34]; viii.1-5: 138; viii.4.2: 60[10], 60[13]; viii.5.1: 62; viii.9.1: 67[70]; viii.27.8: 68[72]; viii.28.1: 80[6], 105, 107[36], 111, 129; viii.31.4: 60[13], 65[46], 68[75], 68[78]; viii.32.1: 67[71]; viii.38.3: 60[13], viii.44.7-8: 58[68], viii.45.2: 60[13]; viii.45.3: 54[44]; viii.45.4-7: 1[2], 1[3], 5, 7[9], 14, 22, 26, 48, 50-6, 61, 64, 66, 81, 95[1], 133; viii.45.4: 66; viii.45.5: 7[9], 66, 95[1]; viii.45.6: 54[44], 81; viii.45.7: 53[34], 64; viii.46.1-47.1: 59[3]; viii.46.1: 61[19]; viii.47.1: 6, 59[3], 59[7], 81[13], 107[36], 129; viii.47.2: 59[4], 61[19], 62, 63[35]; viii.47.3: 60[13], 65[46], 67[57], 68[78], 150; viii.47.4: 54[44], 63[35]; viii.47.5: 62[28], 66[55]; viii.48.1: 54[44]; viii.48.4-5: 59[4], 62; viii.48.7: 58[67], 63[34], 64[37]; viii.53.9: 54[44], 62[27], 62[31]; viii.53.10: 62; ix.10.2: 1[2], 111, 128; ix.17.1: 1[2], 94, 128; x.9.3-10: 95[5]; x.9.5: 68[76]; x.19.4: 40[11]; x.28.8: 54[43]; x.31.10: 60[10], 60[13]
Philostratos, *Heroicus* ii.14-18: 65; ii.17: 64[43]; ii.18: 55[54]; iii.28: 65; iii.36: 65
Pindar, *Isthmian Ode* viii.48: 65[50]; viii.49-50: 64[43]; *Nemean*

Ode iii.64 (Schol.): 97[22]; *Olympian Ode* ix.72: 64
Plato, *Epigrammata* xxvi: 60[10]; *Epistulae* xiii.361A: 99[49]; *Sophista* 235-36A: 48[3], 49[6];
Pliny, *Naturalis Historia* v.107: 97[26], xxxiv.41: 121[68]; xxxiv.49: 1[6], 67[70], 127; xxiv.50: 99[46]; xxxiv.51: 119[44]; xxxiv.53-93: 2; xxxiv.61: 90[1]; xxxiv.63: 121[68], xxxiv.64: 3[23]; xxxiv.70: 2[12]; xxxiv.91: 2[14], 91[5]; xxxv.68: 82[18]; xxxv.138: 136; xxxvi.20: 104[1]; xxxvi.22: 94, 95[2], 101[68], 104[1], 112, 128, 129; xxxvi.25: 2[20], 3[27], 93, 107, 109[66], 112, 127, 129, 130, 134; xxxvi.26: 2[20], 95[2], 100, 110-11, 112, 117, 127, 128, 132; xxxvi.28: 2[20], 2[21], 105, 112, 133; xxxvi.30-31: 1[2], 80, 90[5], 95, 98[33], 101, 132; xxxvi.32: 90[5]; xxxvi.95: 1[2], 95[2], 101[68], 103, 132
Plutarch, *Caesar* 9: 60[10]; *Quaestiones Graecae* 45: 97[25]
Priapea x.2-3: 2[20], 134
Propertius ii.31: 93, 128, 151
Quintilian xii.10.9: 2[19]
Quintus Smyrnaeus iv.151: 64[43]; vii.379: 64[43]; xiv.130: 64[43]
Sidonius Appollinaris, *Carmina* xxiii.500-506: 2[20], 135
Sophocles, *Oedipus Coloneus* 39 (Schol.): 111, 130; *Trachiniae* 210-214: 60[11]
Stesichoros, fr.45 (Page) = POxy 2359: 61[16]
Strabo xiii.604: 111, 128; xiii.611: 97[26], xiii.613: 63; xiv.640: 95[2], 101[68], 111-12, 129; xiv.641: 104[1]; xiv.657: 99[46]; xiv.659: 97[25]
Suidas, s.v. 'Χάραξ': 64[41]
Tzetzes, *ad Lycophronem* 1329: 97[22]; *Historiarum variarum chiliades* viii.353: 48[3]
Vitruvius ii.8.11: 3[23], 90[5], 97[26]; iii.5.12: 9[11]; vii.Praef.12-13: 104[1]; vii.Praef.13: 2[20], 80, 90[5], 95, 98[33], 132
Xenophon, *Cynegeticus* 13: 60[14]; *Hellenica* vii.1.23-27: 67[64]; vii.4.12-32: 67[66]; vii.4.33-40: 69[92], 69[96]; vii.4.35-36: 68[79]
Zosimus, *Historia Nova* ii.5.15: 151

2. Epigraphy

Altertümer von Pergamon viii.1.156, 18 and 23: 54[47], 64[36]
 viii.2.324, 11: 64[36]
Corpus Inscriptionum Graecarum ii.2285b: 1[5]
Fouilles de Delphes iii.5.25 col.IIA, 13: 81[11]
Inscriptions de Délos 1696, 1697, 1710 and 2494: 1[5], 3[25], 135
Inscriptiones Graecae iv².1.102: 69[91], 87[22]
 iv².1.102, 89-92 and 98-99: 39[2], 90[2]
 iv².1.102, 109: 39[2], 81[11]
 iv².1.102, 111-112: 39[2], 90[2]
 v.2.6-8: 66, 67, 68, 80[4]
 v.2.78 and 79: 46, 57, 62
Lindos ii, 241 no.50: 121[68]
Notizie degli Scavi 1895, 458: 1[5], 3[25], 3[26], 135
Supplementum Epigraphicum Graecum xv.208: 88[23]
 xix.399: 65[50]
Sylloge Inscriptionum Graecarum 588.7: 60[10]

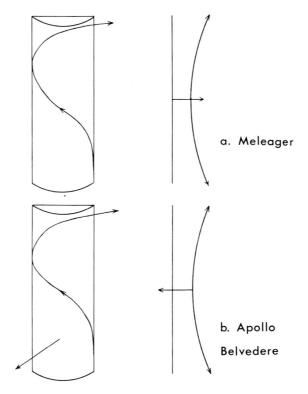

Fig. 1. Motion lines and axes

a. Meleager

b. Apollo
Belvedere

Cornice sections from Greek temples

Fig. 2. Cornice sections: (1) Aegina, (2) Olympia, (3) Hephaisteion, (4) Parthenon, (5) Epidaurus, (6) Tegea

Fig. 3. Tegea: clamping arrangements for the pediments

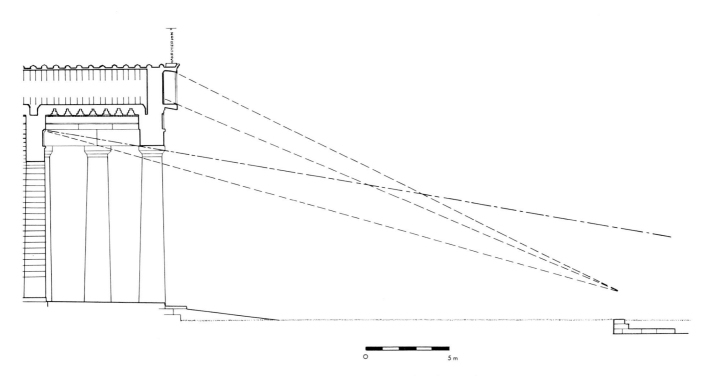

Fig. 4. Tegea: sight-lines from altar (section)

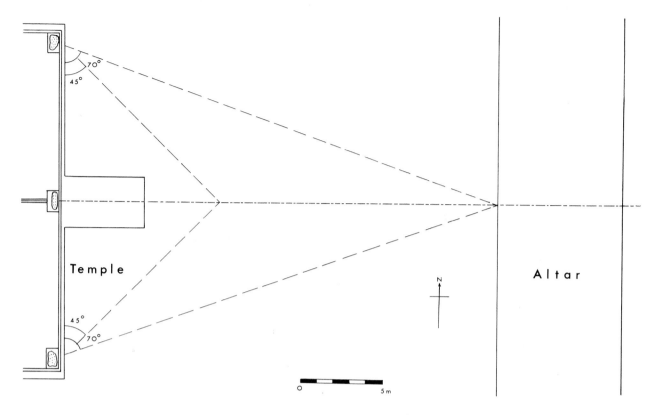

Fig. 5. Tegea: sight-lines from altar (plan)

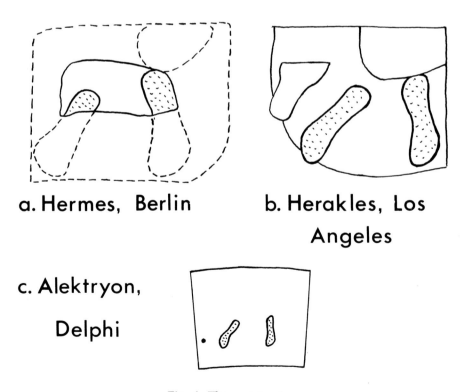

a. Hermes, Berlin b. Herakles, Los Angeles

c. Alektryon, Delphi

Fig. 6. Three statue bases

Fig. 7. Group of Aphrodite, Pothos and Phaethon, Samothrace: suggested reconstruction

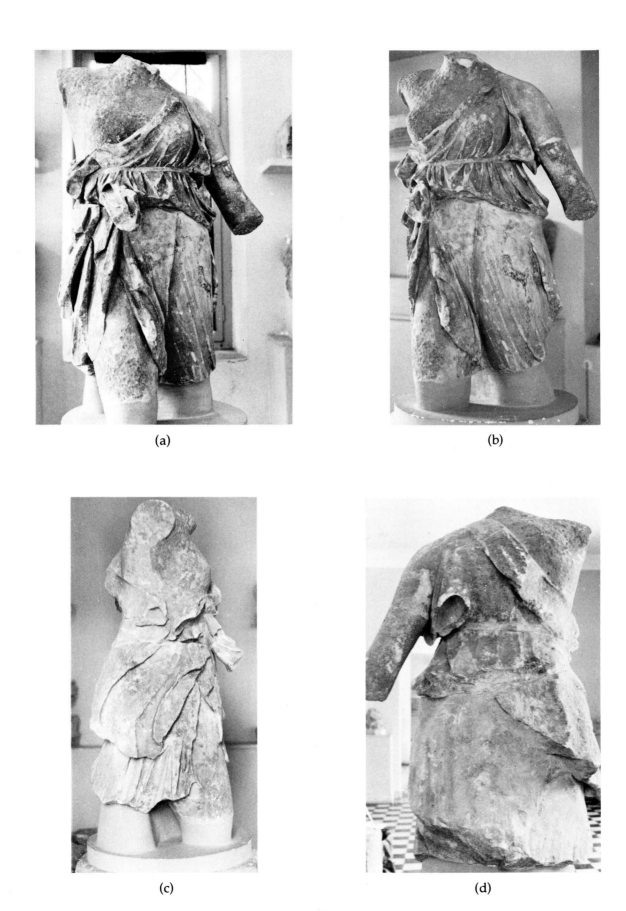

(a)

(b)

(c)

(d)

Plate 1. No. 1

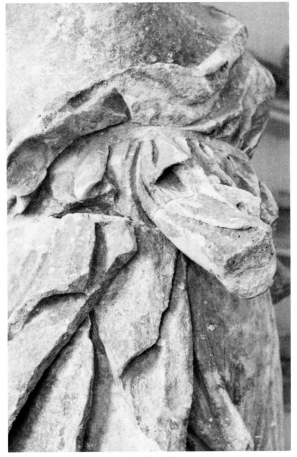

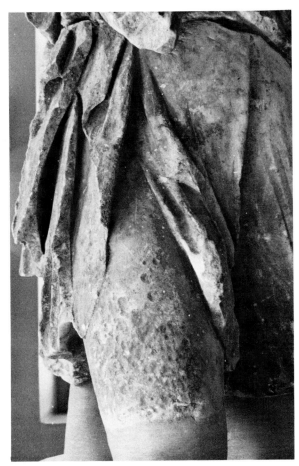

(a) No. 1

(b) No. 1

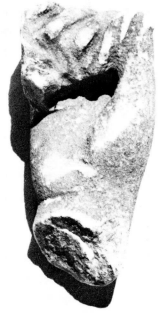

(c) No. 1

(d) No. 2

Plate 2

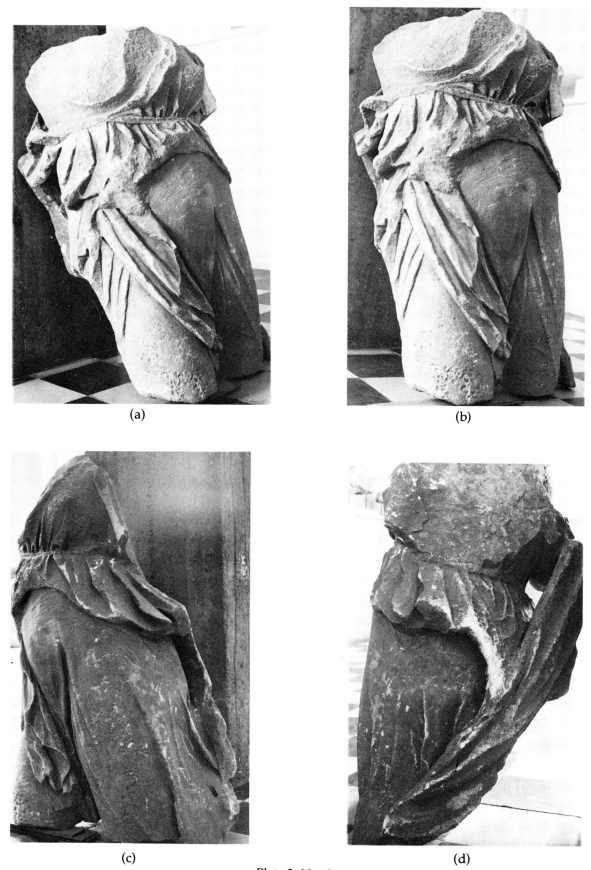

(a)

(b)

(c)

(d)

Plate 3. No. 3

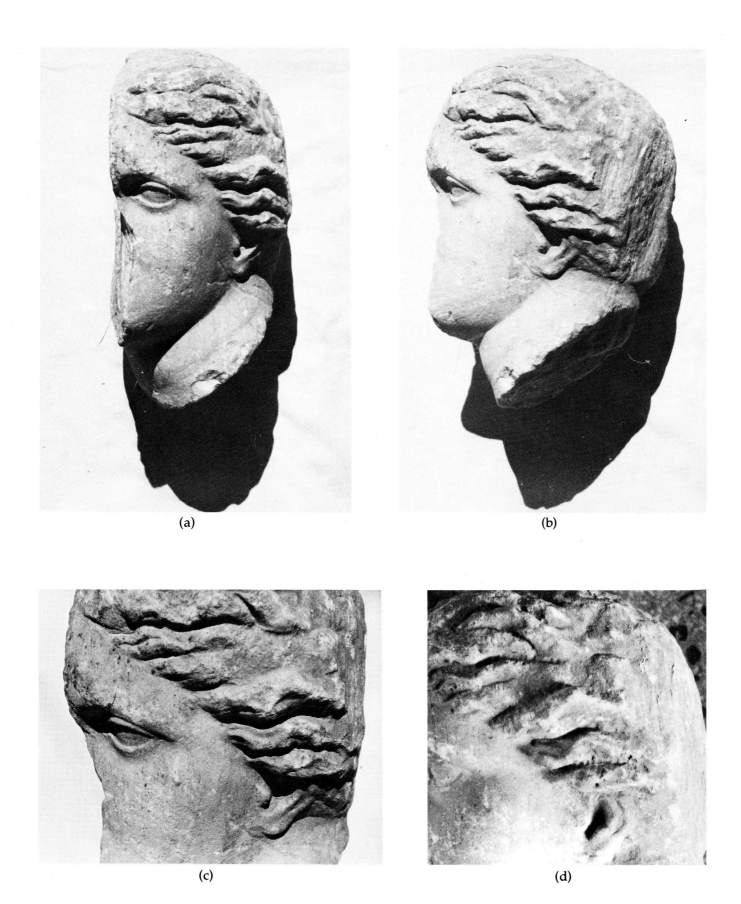

(a)

(b)

(c)

(d)

Plate 4. No. 4

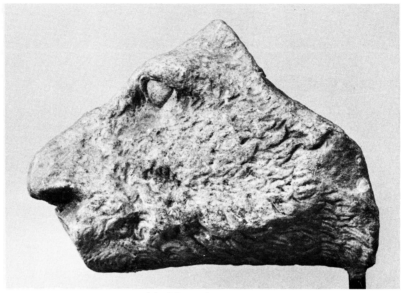

(a) No. 5 (NM 178)

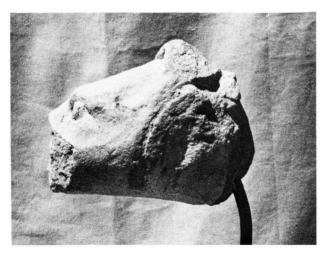

(b) No. 6

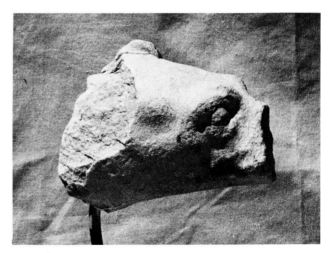

(c) No. 6

Plate 5

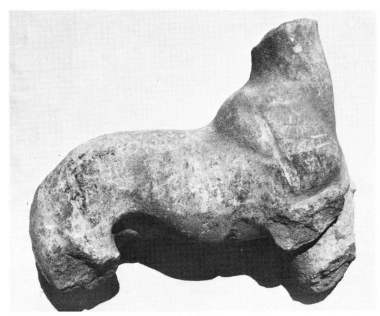

(a) No. 7

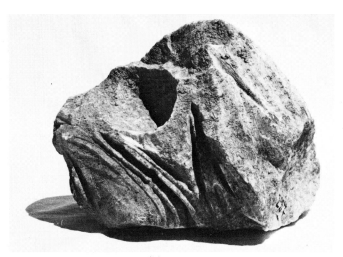

(b) No. 8

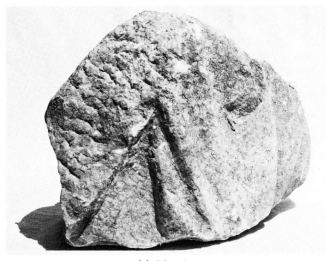

(c) No. 8

Plate 6

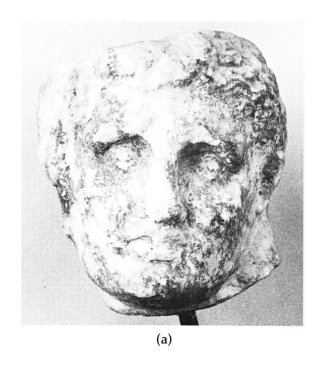
(a)

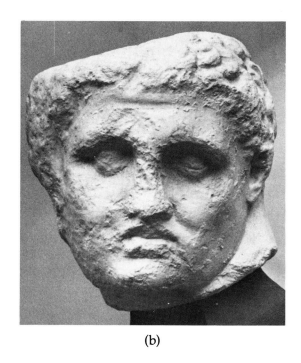
(b)

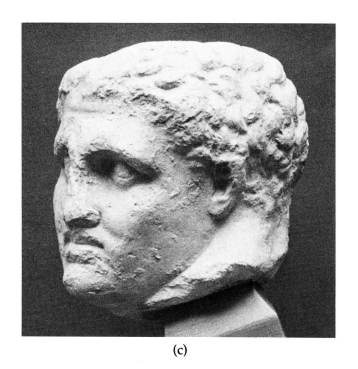
(c)

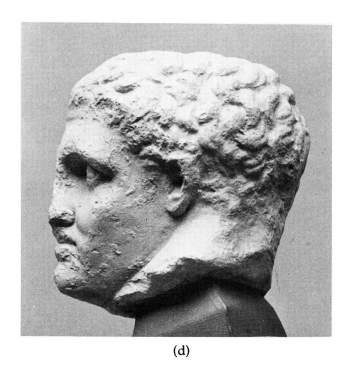
(d)

Plate 7. No. 9 (NM 179)

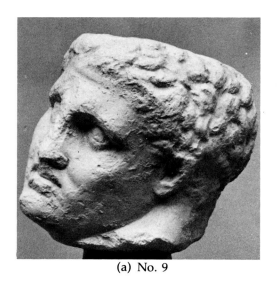
(a) No. 9

(b) No. 9

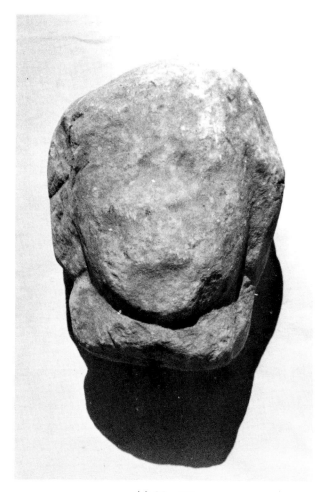
(c) No. 10

(d) No. 10

Plate 8

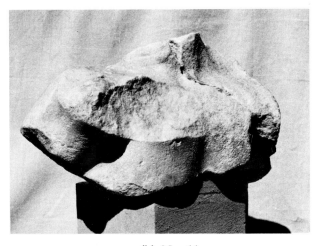

(a) No. 11 (b) No. 11

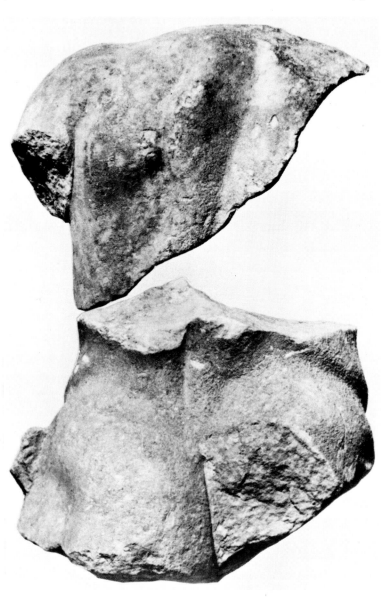

(c) Nos. 12 and 13: montage

Plate 9

(a)

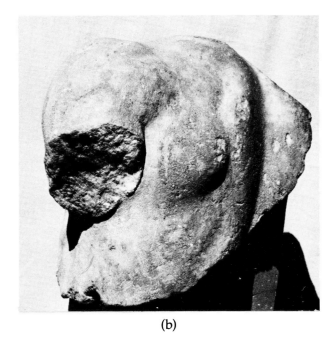

(b)

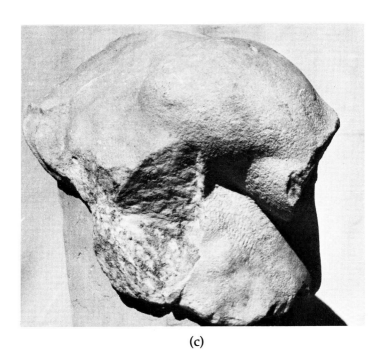

(c)

Plate 10. No. 12

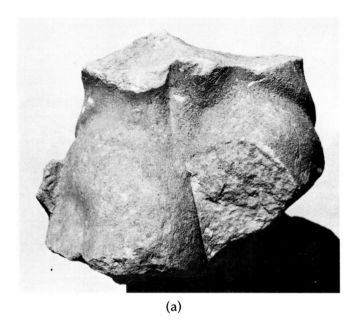

(a)

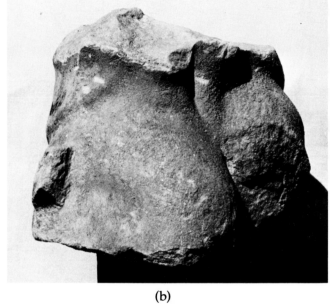

(b)

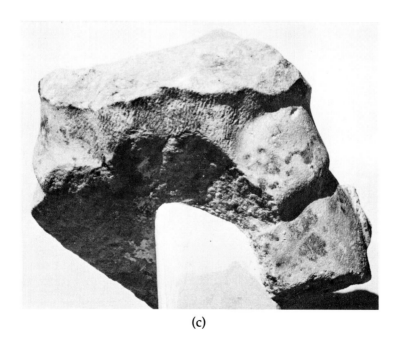

(c)

Plate 11. No. 13

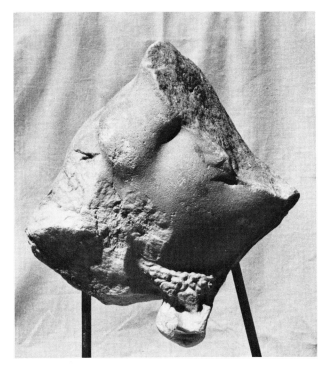

(a) No. 14

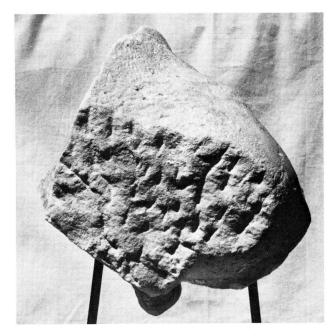

(b) No. 14

(c) No. 15

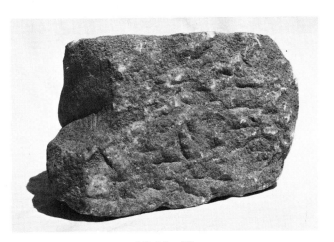

(d) No. 15

Plate 12

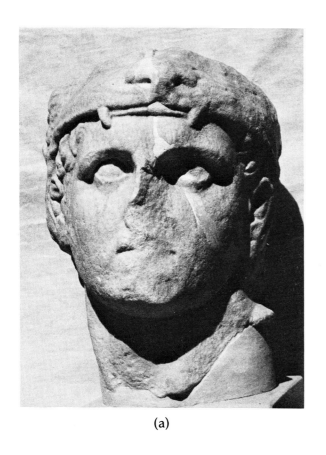

(a)

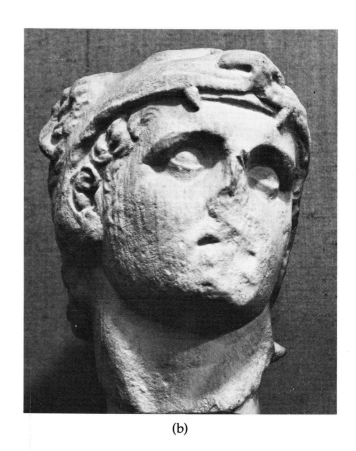

(b)

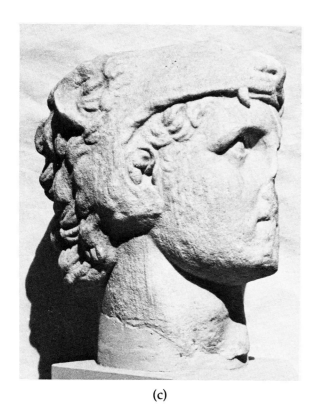

(c)

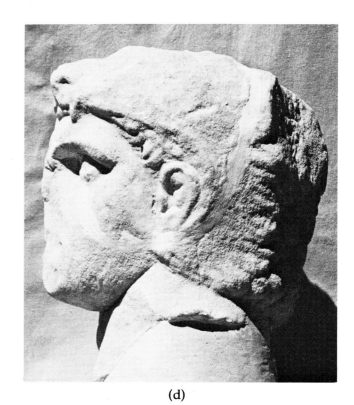

(d)

Plate 13. No. 16

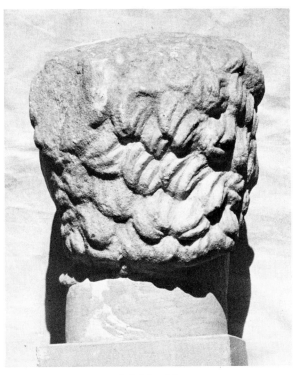

(a) No. 16

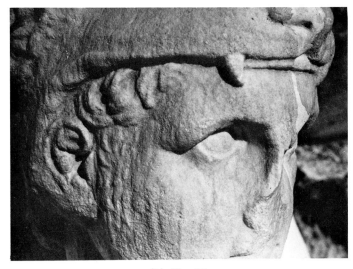

(b) No. 16

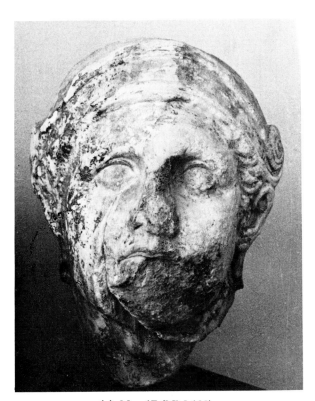

(c) No. 17 (NM 180)

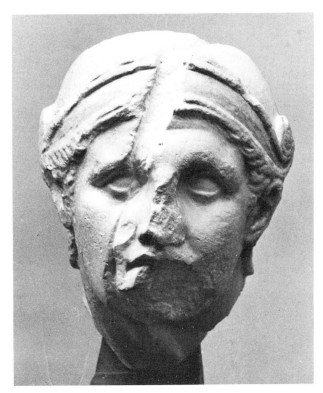

(d) No. 17 (NM 180)

Plate 14

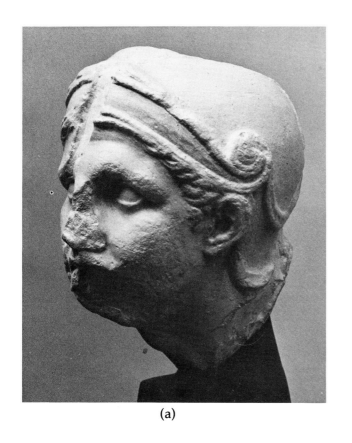

(a)

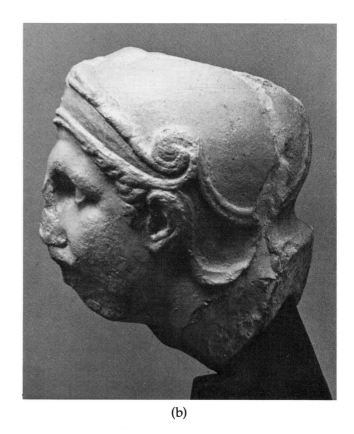

(b)

(c)

Plate 15. No. 17

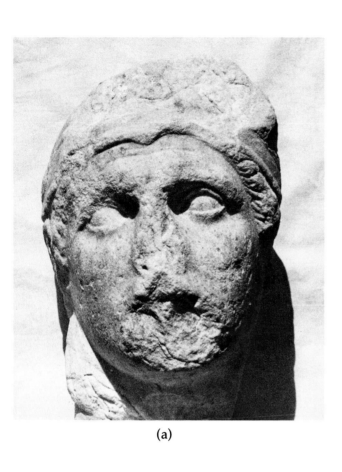

(a)

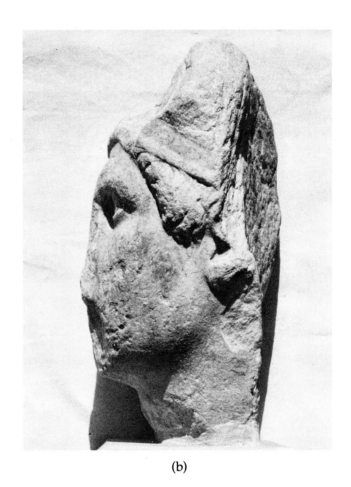

(b)

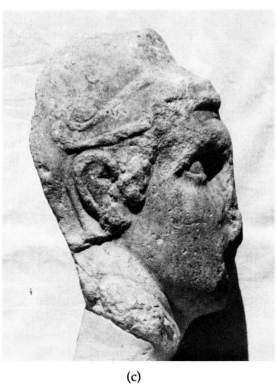

(c)

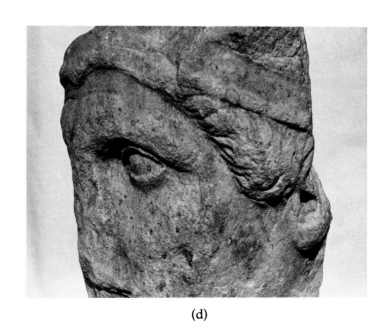

(d)

Plate 16. No. 18

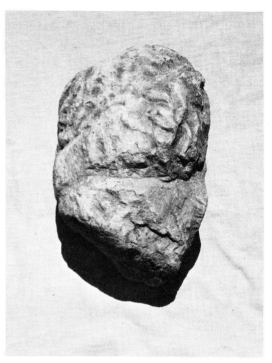

(a) No. 19

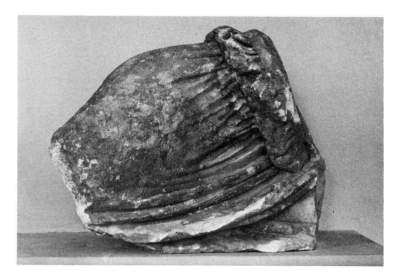

(b) No. 20

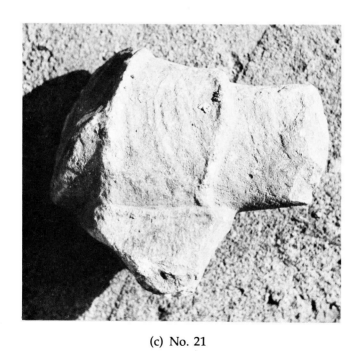

(c) No. 21

Plate 17

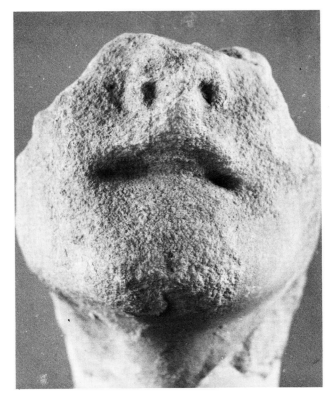

(a) No. 22

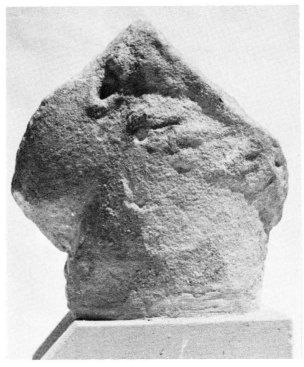

(b) No. 23

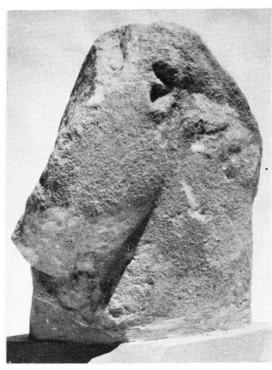

(c) No. 23

Plate 18

(a) No. 24

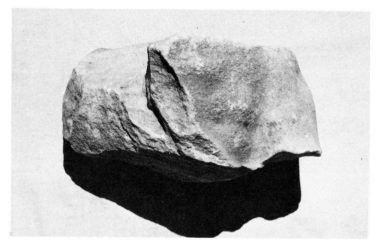

(b) No. 25

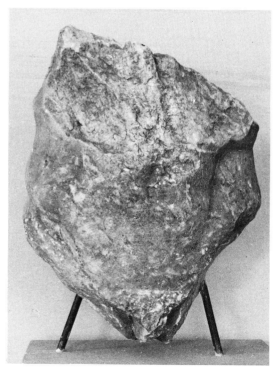

(c) No. 26

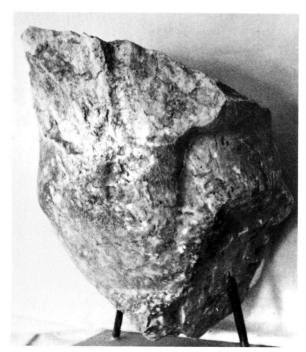

(d) No. 26

Plate 19

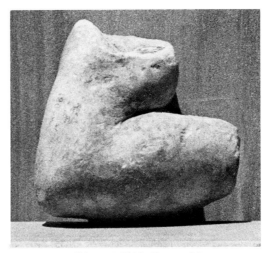

(a) NM 180β: Dugas 28

(b) NM 180β: Dugas 28

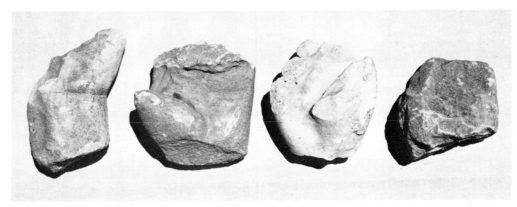

(c) Dugas 46-8, 51

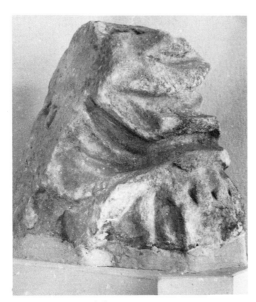

(d) Dugas 6

(e) Dugas 6

Plate 20

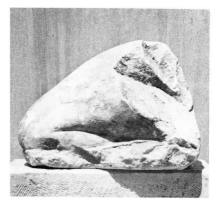

(a) NM 180α: Dugas 53

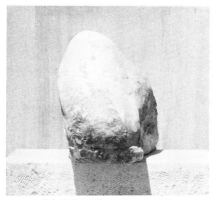

(b) NM 180α: Dugas 53

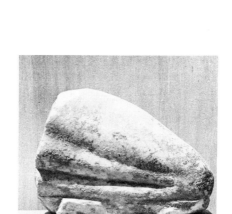

(c) NM 180α: Dugas 53

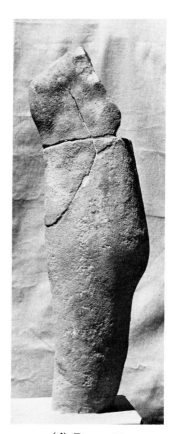

(d) Dugas 56

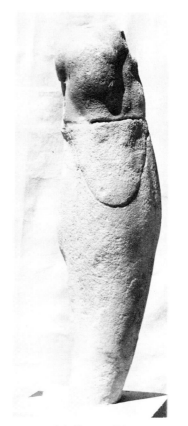

(e) Dugas 56

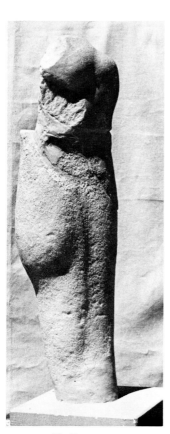

(f) Dugas 56

Plate 21

(a) Dugas 57

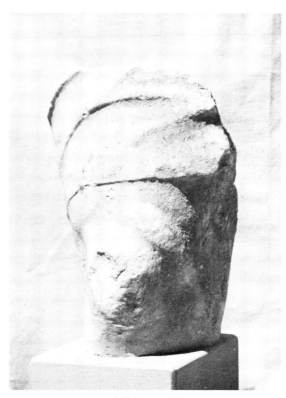

(b) Dugas 57

(c) Dugas 57

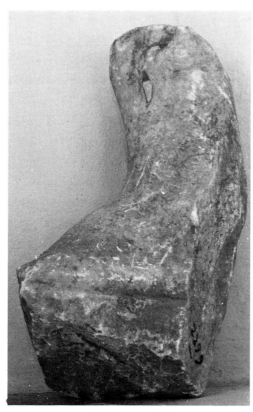

(d) Tegea 2299

Plate 22

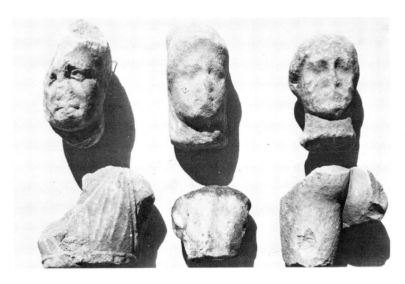

(a) Nos. 27-32

(b) Nos. 27, 29 and 31

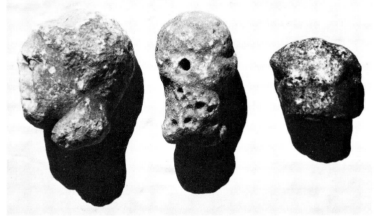

(c) Temple of Alea Athena, Tegea

Plate 23

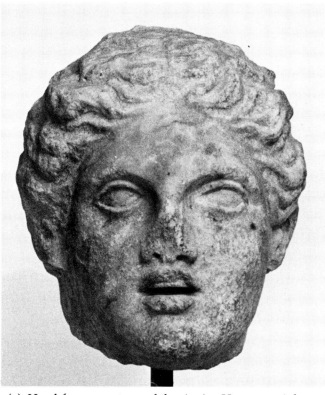

(a) Head from a metope of the Argive Heraeum, Athens

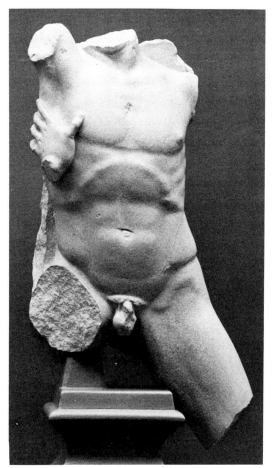

(b) Torso from a metope of the Argive
Heraeum, Athens

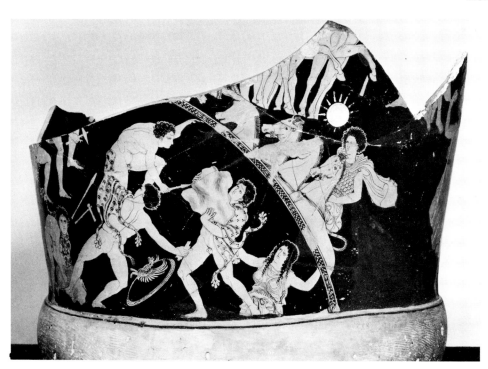

(c) Calyx-krater, Naples

Plate 24

(a) Athenian war-memorial of 394/3, Athens

(b) Torso from a metope of the tholos, Delphi

(c) Metope from the Tholos, Delphi

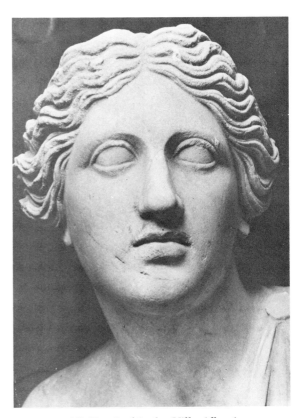

(d) Head of Leda, Villa Albani

Plate 25

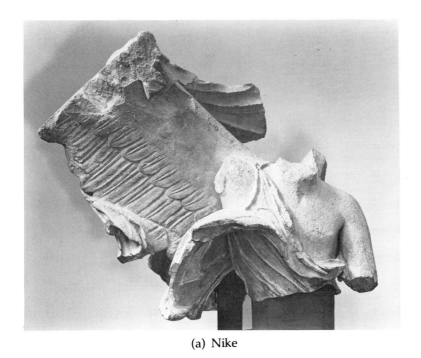

(a) Nike

(b) Male torso

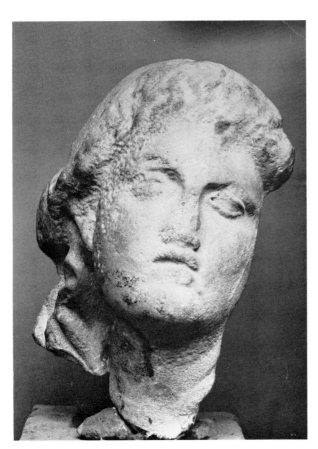

(c) Female head

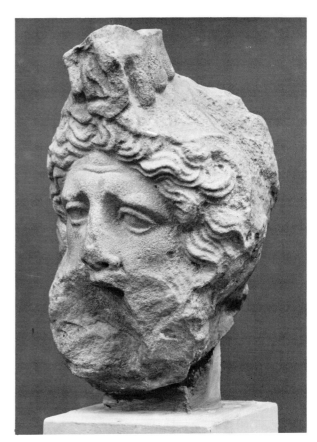

(d) Head of Priam

Plate 26. Fragments from the Temple of Asklepios at Epidaurus, Athens

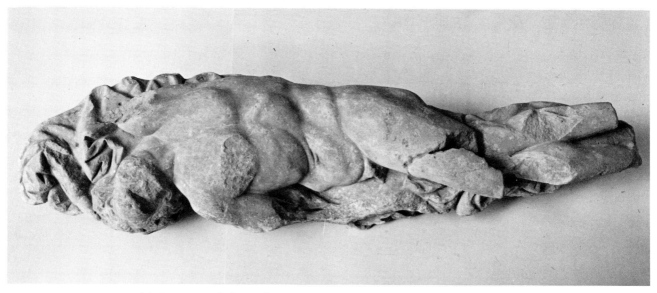

(a) Lying youth from the temple of Asklepios at Epidaurus, Athens

(b) Alexander sarcophagus, Istanbul

Plate 27

(a) Pelike, Leningrad

(b) Volute krater, Berlin

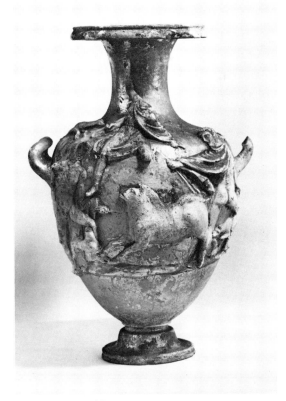

(c) Hydria, Istanbul

Plate 28

(a) Tegean coin, Paris, Bibliothèque Nationale

(b) 'Oilpourer', Dresden

(c) Slab from the Telephos frieze, Berlin

Plate 29

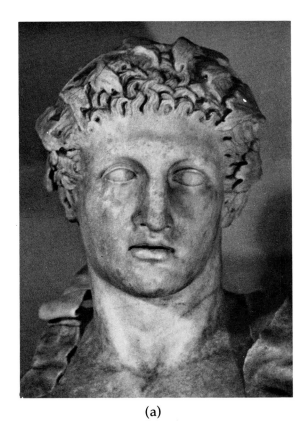

(a)

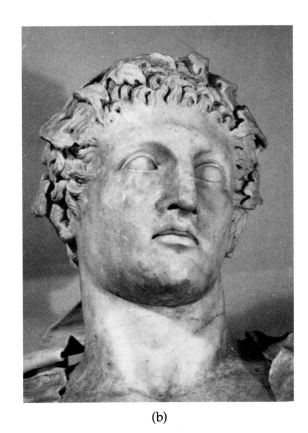

(b)

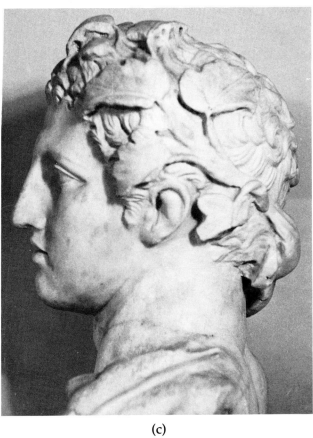

(c)

Plate 30. Genzano herm, London

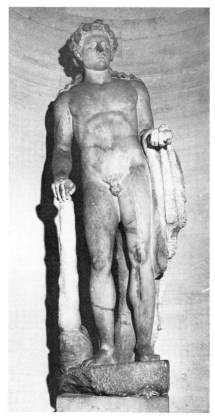

(a) Herakles, Los Angeles

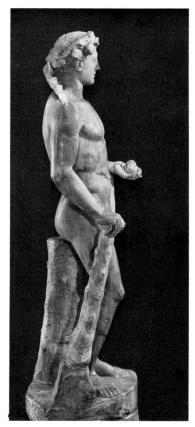

(b) Herakles, Los Angeles

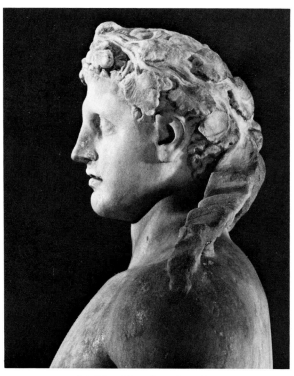

(c) Herakles, Los Angeles

(d) Sicyonian coin, London

Plate 31

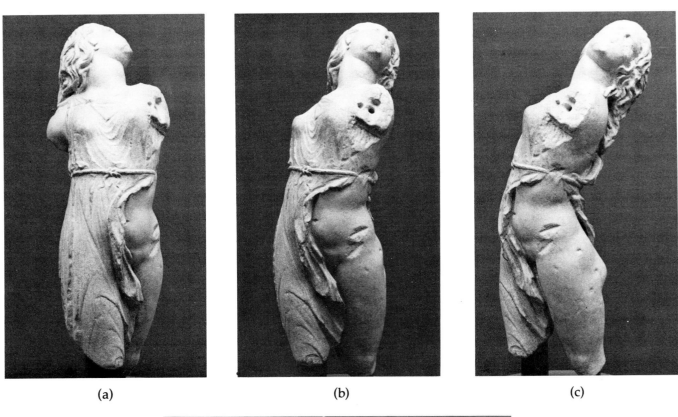

(a) (b) (c)

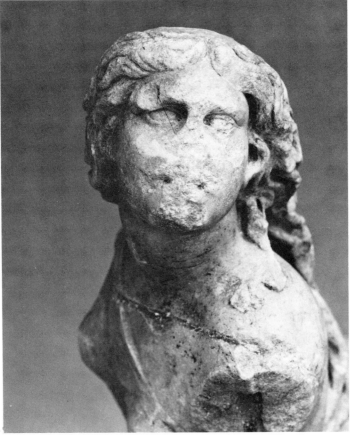

(d)

Plate 32. Maenad, Dresden

(a) Mirror-case, Paris

(b) Statue-base, Sorrento

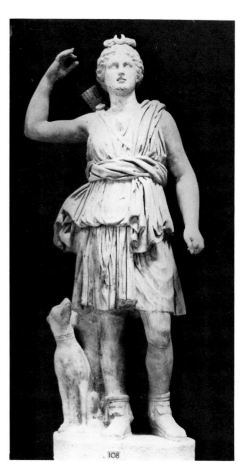

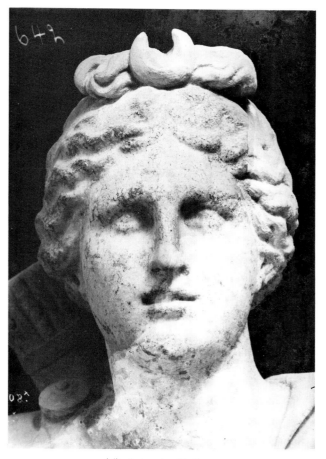

(c) Artemis, Vatican

(d) Artemis, Vatican

Plate 33

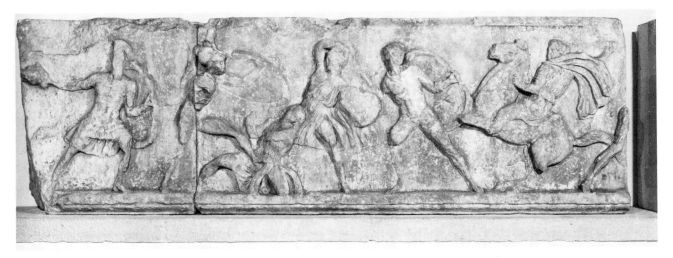

(a) Frieze slabs from the Mausoleum, London, BM 1011-12

(b) BM 1011-12.47

Plate 34

(a) BM 1011-12.47

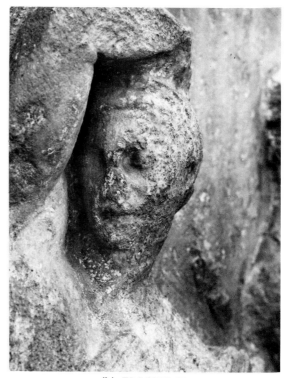

(b) BM 1012.49

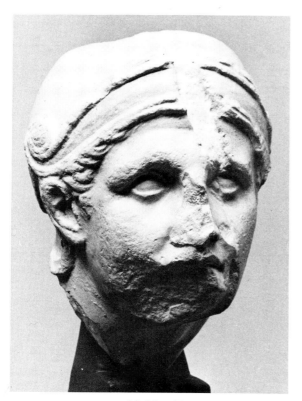

(c) No. 17

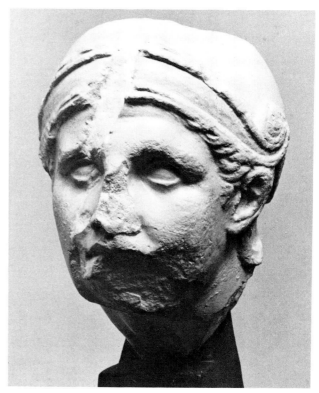

(d) No. 17

Plate 35

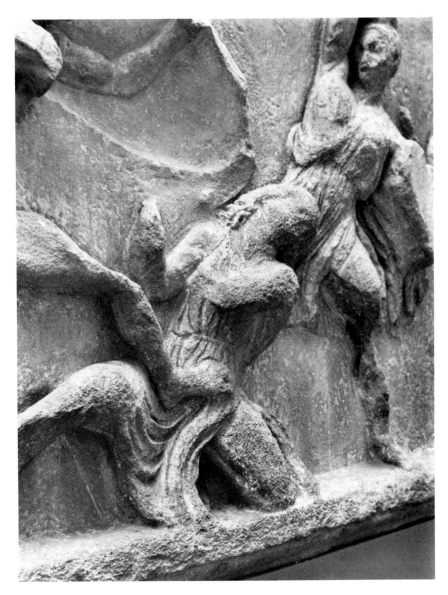

Plate 36. BM 1012.47-9

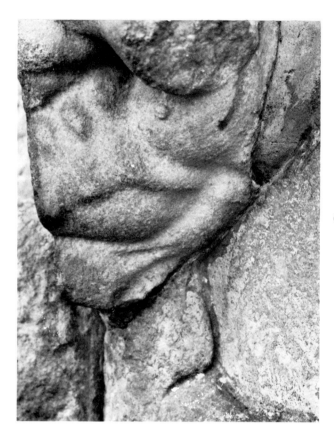

(a) BM 1012.47

(b) BM 1012.50

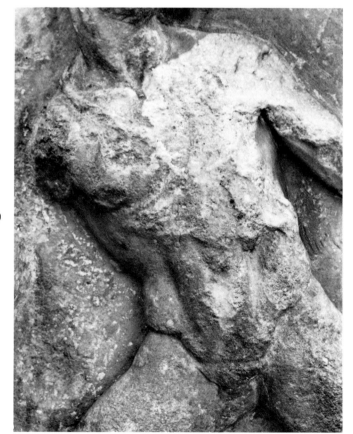

Plate 37

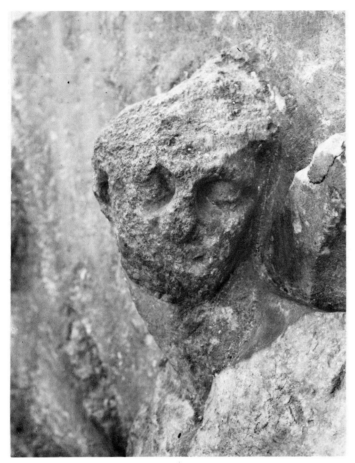

(a) BM 1012.50

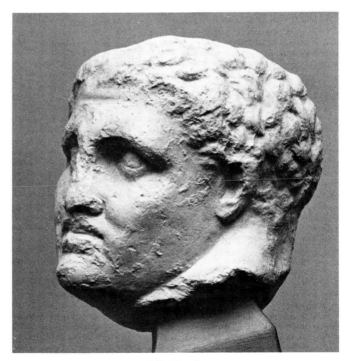

(b) BM 1012.51

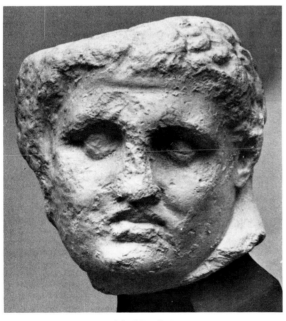

(c) No. 9

(d) No. 9

Plate 38

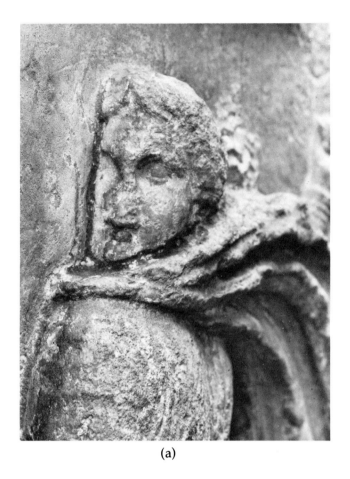

(a)

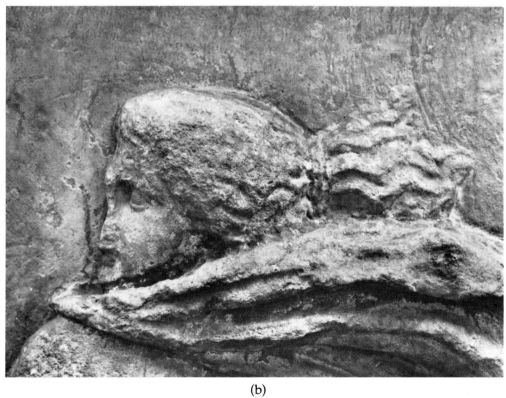

(b)

Plate 39. BM 1012.51

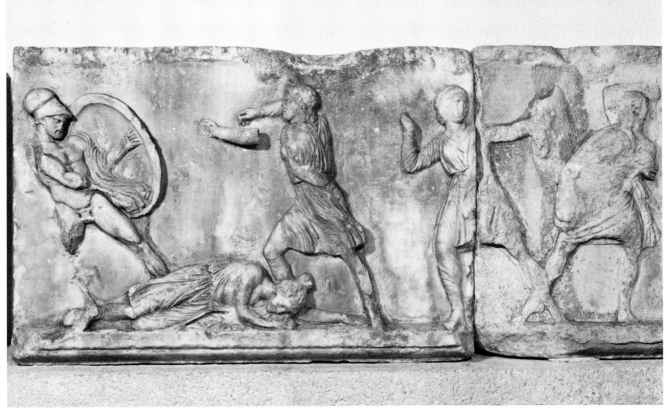

(a)

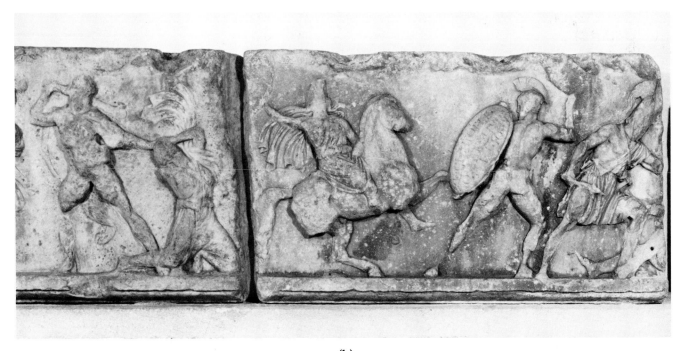

(b)

Plate 40. Frieze slabs from the Mausoleum, London, BM 1007-8-10

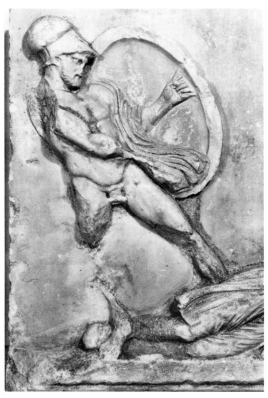

(a) BM 1007.38

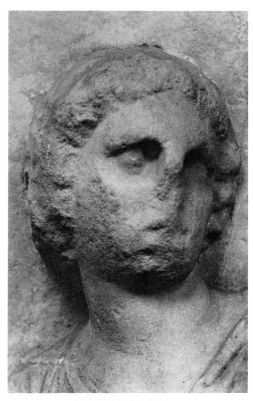

(b) BM 1007.8.41

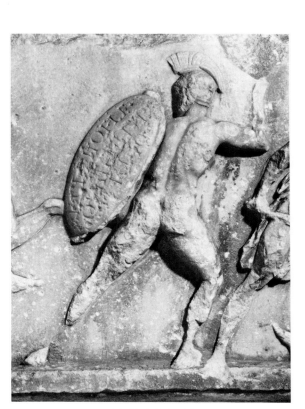

(c) BM 1010.14

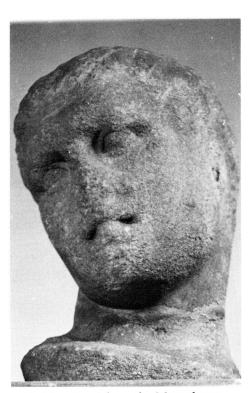

(d) Male head from the Mausoleum,
London, BM 1056

Plate 41

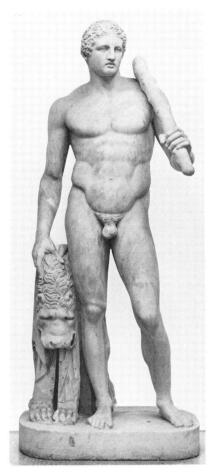

(a) Herakles Lansdowne, Malibu

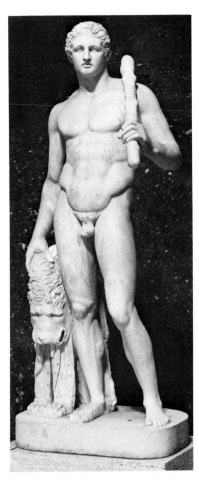

(b) Herakles Lansdowne, Malibu

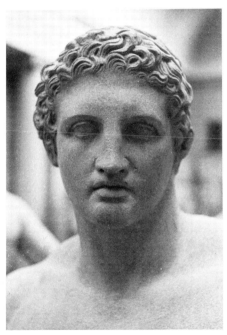

(c) Herakles Lansdowne, Malibu

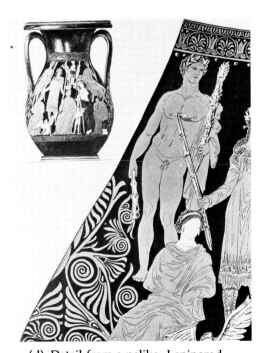

(d) Detail from a pelike, Leningrad

Plate 42

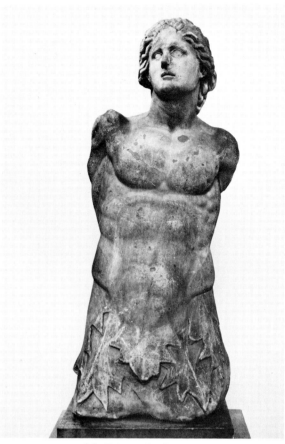

(a) Triton, Berlin

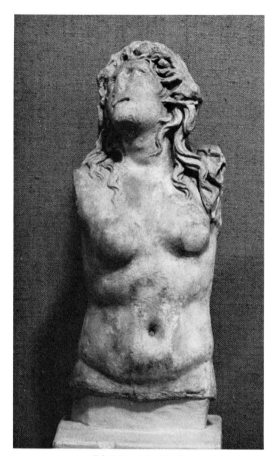

(b) Nereid, Ostia

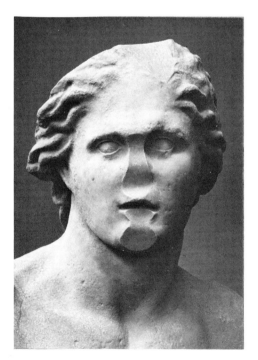

(c) Triton, Berlin

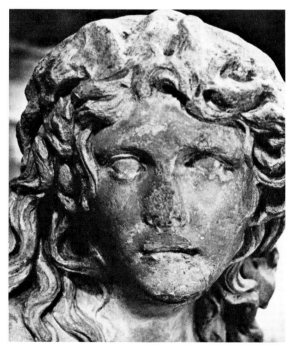

(d) Nereid, Ostia

Plate 43

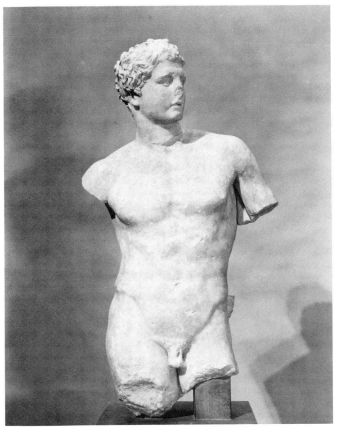

(a) 'Meleager', Cambridge

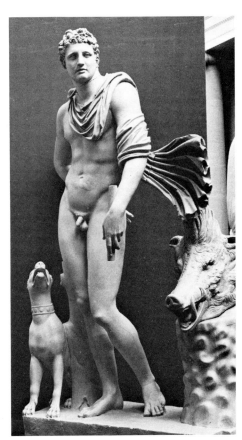

(b) Meleager, Vatican

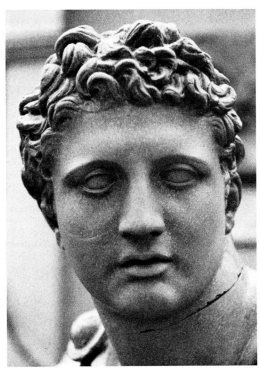

(c) Meleager, Vatican

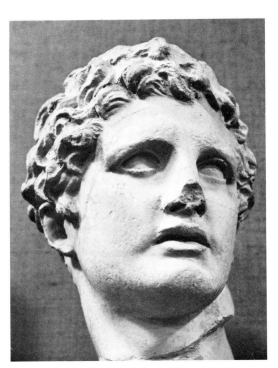

(d) Head of Meleager, Villa Medici

Plate 44

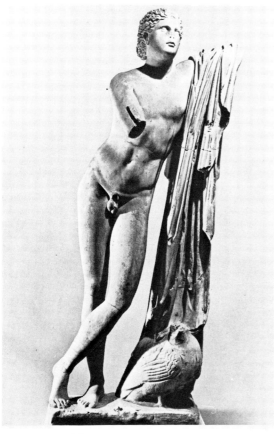

(a) Pothos, Conservatori

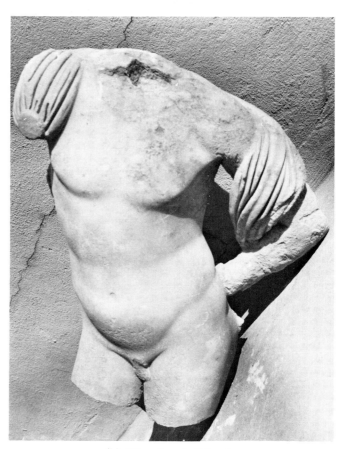

(b) 'Phaethon', Salamis

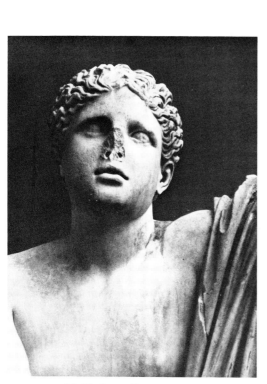

(c) Pothos, Conservatori

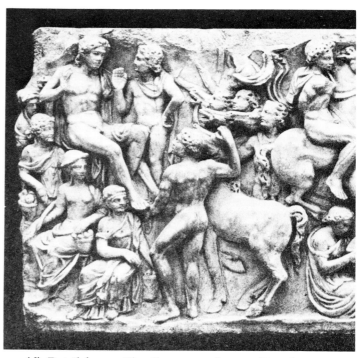

(d) Detail from a Phaethon sarcophagus, Copenhagen

Plate 45

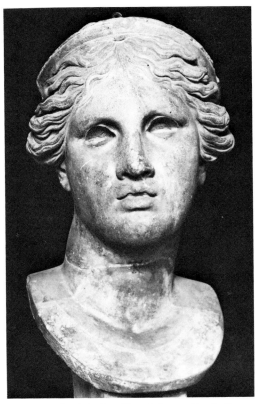

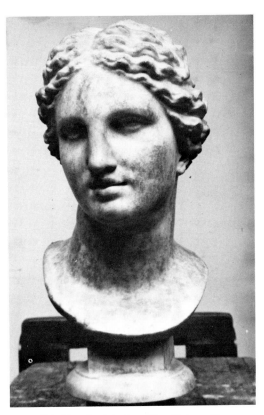

(a) Head of Aphrodite, Museo Capitolino

(b) Head of Aphrodite, Petworth

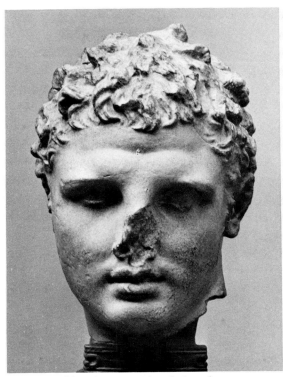

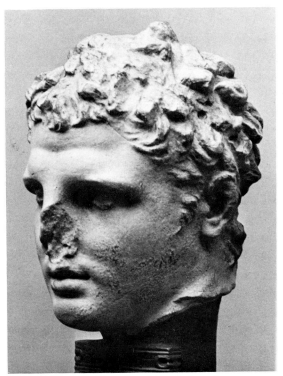

(c) 'Aberdeen' head, London

(d) 'Aberdeen' head, London

Plate 46

(a) Head of Herakles, Tegea

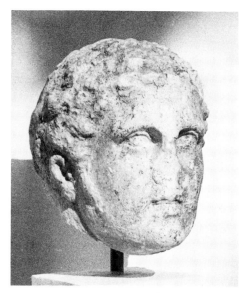

(b) Male head, Thasos

(c) Male head, Thasos

Plate 47

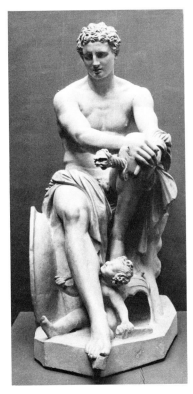

(a) Ares Ludovisi, Terme

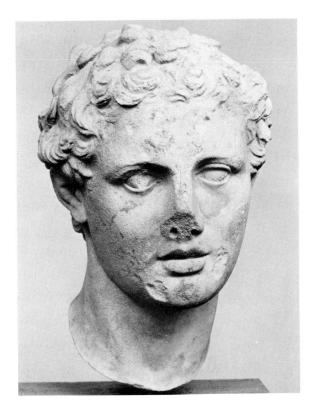

(b) Head of Ares, Munich

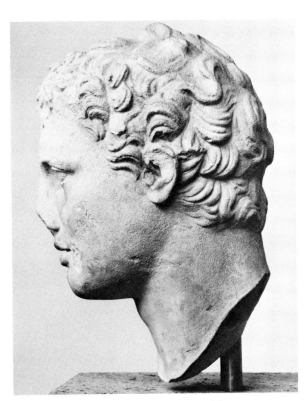

(c) Head of Ares, Munich

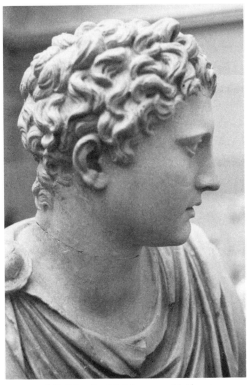

(d) Head of Meleager, Vatican

Plate 48

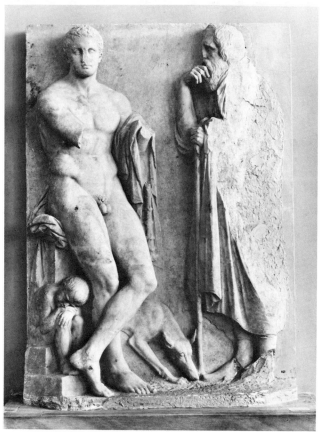

(a) Ilissos stele, Athens

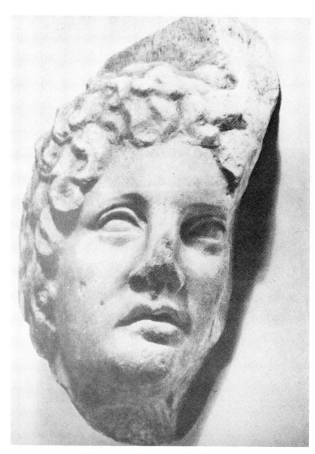

(b) Head from a relief, Leipzig

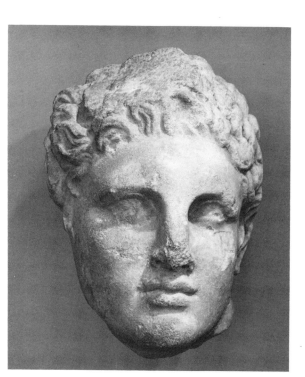

(c) Head from a relief, New York

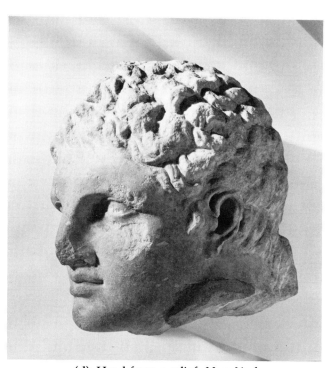

(d) Head from a relief, New York

Plate 49

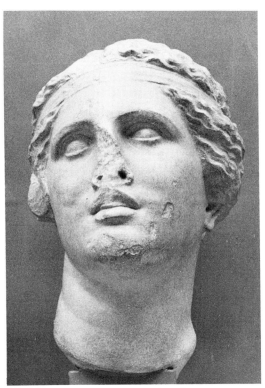

(a) 'Ariadne' head, Athens

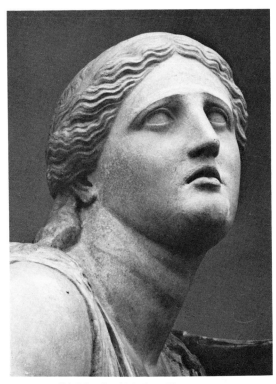

(b) Head of Niobe, Florence

(c) Chiaramonti Niobid, Vatican

(d) Apollo Citharoedus, Vatican

Plate 50

(a) Agias, Delphi

(b) Apollo Belvedere, Vatican

(c) Lysikrates frieze, Athens

Plate 51

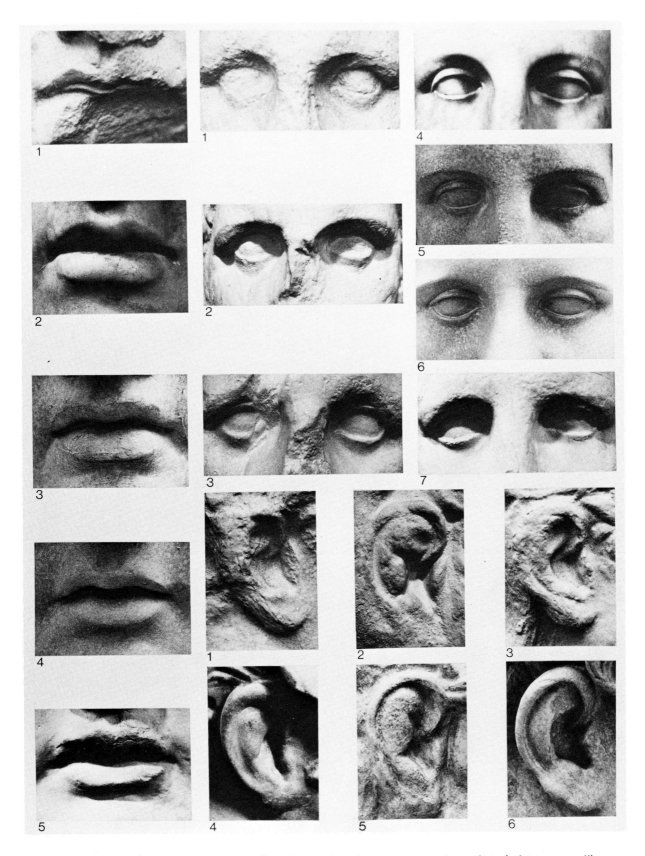

Plate 52. Details from Skopaic heads (for a key to the pieces represented, see list of plates on p. xii).

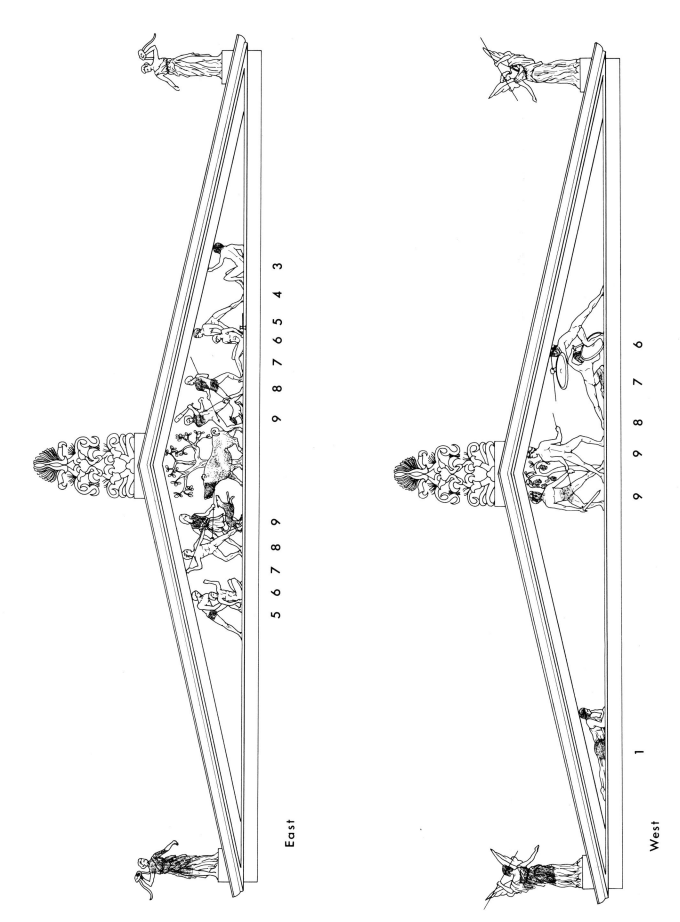

East

West

Plate 53. Suggested reconstruction of the Tegea pediments and akroteria.